PIC 6/19
ART POTTERY
13 $8-

Art Pottery
of the United States

To the artists and artisans
 whose work inspired this work, and
To the many
 who encouraged it and helped bring it to fruition
 through their interest and co-operation,
This book is gratefully dedicated.

Art Pottery
of the United States

AN ENCYCLOPEDIA OF PRODUCERS AND THEIR MARKS

TOGETHER WITH A DIRECTORY OF STUDIO POTTERS
WORKING IN THE UNITED STATES THROUGH 1960

SECOND EDITION
REVISED AND ENLARGED

Paul Evans

FEINGOLD & LEWIS PUBLISHING CORP.
New York, N.Y.

Library of Congress Catalog Card Number: 87-82250
ISBN 0-9619577-0-0

Published and distributed by
FEINGOLD & LEWIS PUBLISHING CORP.
1088 Madison Avenue
New York, New York 10028

Introduction

The purposes of *Art Pottery of the United States* are three. The first is to establish an accurate and reliable history of the various art pottery operations. This book is designed as an encyclopedia of the producers and their marks, with foremost emphasis on the individuals involved, not on the pottery plants or even on the artistic influences manifest in their work. An understanding of the people encompasses the facilities and products which evolved from their efforts. As a student of social and economic history rather than of artistic influences and movements, I have not attempted to place the United States' art pottery movement in the more universal context necessary for a full appreciation of the field. It is intended that this work should be the foundation on which such further analysis and appreciation can be constructed. Facts are reliably established and documented, and it is hoped that others more thoroughly trained in art history will further analyze, interpret, and apply the material herein presented.

The second purpose has been to provide a comprehensive listing of marks; this has been done in the last paragraph of each chapter. Little original work has been undertaken in this regard since Edwin AtLee Barber published his researches, especially *Marks of American Potters* in 1904. More than half the marks included here have never been illustrated and identified before. Marks are the easiest part of an artist's work to reproduce, and the greater the interest in a field, the more likely are marks to be forged. For the serious student, identification must rest on more than a mark. Style; quality of the body, glaze and decoration; and integrity of the object itself are the hallmarks of the work; the mark simply adds a degree of conviction to an attribution made using these criteria. While the importance of marks is considerably overrated today, they represent an artist's pride in his work, to the degree of affixing his name to it as a sign of its quality. Without an appreciation of marks our knowledge of the history of the various potteries would be incomplete. In short, marks are of considerable value to the researcher, but the ultimate value of an object must be based on its overall artistic and technical merit and not on the signature it might bear.

The third purpose has been to indicate where examples of a particular potter, artist, or factory can be studied. An attempt has been made to locate pieces made by every art pottery in the United States, particularly in public collections. The penultimate paragraph of each chapter contains such information.

An auxiliary benefit of the inclusion of such material might be to discourage the continued sale of native art pottery by museums attempting to raise funds for the acquisition of foreign treasures. This has occurred all too frequently in the past, the most regrettable instance being the disposal by the Philadelphia Museum of Art of the important collection assembled by Edwin AtLee Barber between 1890 and 1915. The most positive force offsetting such developments has been the work of the Smithsonian Institution in maintaining and actively adding to their art pottery holdings, the nucleus of which is the collection of Marcus Benjamin. This collection at the National Museum of History and Technology of the Smithsonian is the most comprehensive available for study.

A book of this scope is never the work of one person. The extensive footnotes give less than half the credit. The greater credit is to those individuals, far too numerous to mention by name, who have so willingly shared their knowledge and assisted in the research. It is to these—museum directors, curators and their assistants; the staffs of libraries, historical societies and federal, state and local governmental agencies; fellow-researchers, collectors, dealers and critics; the relatives and friends of the various potters, and in some instances those individuals directly involved in the work of the potteries—that this book is dedicated. Without their generous contribution of time and knowledge, this work would never have been accomplished.

Numerous problems have been encountered along the way, not the least being to define the field itself (dealt with at considerable length in the opening essay). Occasionally it has been necessary to depend on a single source for information; whenever possible, facts have been authenticated by at least a second and unrelated source.

This process of authentication has resulted in a number of corrections to previously published

material; attention is called to these in footnotes. Such corrections are offered with humility, realizing that even the most careful of researchers makes mistakes. One of the awkward situations arising from research such as this is the need to dispel myths which have developed with time. In some cases these result from earlier, well-publicized misinformation; in others, they are based on the recollections of people directly related to the various potters or potteries which do not coincide with established facts. In all instances the material presented has been authenticated to the satisfaction of the author; where conflicts occur, it is felt the conclusions reached are justified by the facts at hand.

No attempt has been made to include listings of *all* the articles published on some of the more "interesting" potteries—especially those appearing in the popular journals of the period—unless they contain significant material. Illustrations of ware have been drawn from museum collections (principally to encourage further research and study and to assure the continuing availability of such objects to the greatest number of interested people), private collections and, in some instances, from popular and trade journals. They have been chosen to give an impression of the work done by a potter or pottery with reference in the text to the location of individual pieces illustrative of a particular technique or ware or to publications in which various lines of a pottery are shown.

Art pottery in the United States is discussed and defined in the opening essay. By the definition evolved, the work of industrial art schools such as that of the Pennsylvania Museum or vocational training schools such as the New York State School of Clayworking and Ceramics at Alfred has been excluded because of their limited production and the very nature of the work produced. For similar reasons the pottery of instructors at such institutions, such as Charles F. Binns and Frederick E. Walrath, is not extensively considered. Nor have producers of folkware such as Jugtown, Pisgah Forest or Maria pottery,[1] or of utilitarian ware such as Dorchester pottery[2] been included, since by our established definition they are not "art potteries." Likewise, by definition, Parian, Belleek, and other factory artwares have not been considered as art pottery. Those operations devoted primarily to the production of art tiles, such as the American Encaustic Tiling Company, have not been included.[3] While of the same period and ethos, they represent a completely different, though related, field of inquiry.

The symbol* following the first reference in each chapter to a pottery indicates that information relating to the operation so marked is included in a separate chapter under that (or a closely similar) heading.

June 15, 1974
Mill Valley, California

An introductory bibliographic essay to the second edition is to be found beginning on page 343. Appendix V provides a listing of substantive changes made in the original text. A Directory of Studio Potters immediately precedes the index, which covers the original edition and the Addenda.

Above all, this new edition provides the opportunity for me to renew the original dedication: to all who have been so generous in their encouragement and support.

August 17, 1987
Saratoga Springs, New York

1. See Jean Crawford, *Jugtown Pottery: History and Design* (Winston-Salem, North Carolina: John F. Blair, 1964); Marcia Ray, "Pisgah Forest Pottery," *Spinning Wheel*, XXVII (January-February 1971), pp. 16-17, 58; and Helen Ellsberg, "Maria Pottery," *Western Collector*, VII (May 1969), pp. 206-11.

2. See P. Evans, "Stoneware and the Dorchester Pottery," *Western Collector*, VI (May 1968), pp. 7-11.

3. See P. Evans, "Victorian Art Tiles," *Western Collector*, V (November 1967), pp. 18-22; also E. Stanley Wires, Norris F. Schneider and Moses Mesre, *Zanesville Decorative Tiles* (Zanesville, Ohio: privately published, 1972).

Art Pottery
of the United States

Art pottery has become a generally accepted and widely used term to describe pottery—earthenware, stoneware and porcelain[1]—produced primarily for aesthetic, decorative purposes. So extensive are the use and misuse of the term that it is essential to arrive at a working definition.

Art pottery can not be defined simply by naming producers. All of a firm's production, even if principally of artware, is not necessarily art pottery. Weller*, for example, for a time produced art pottery; however, most of that firm's output after 1910 must be considered industrial artware.[2] It *can* be said that Weller produced art pottery, but it *can not* be said that all pottery bearing the Weller name is art pottery.

Neither can art pottery be defined by a particular coherent style or technique, as evidence of many earlier approaches can be seen in the spectrum of ware produced by art potters in the United States. Furthermore, stylistic and technical developments were introduced on this side of the Atlantic by artists and artisans from European potteries. As unique as some of the developments in the field were, they can be understood and fully appreciated only in a more universal context.[3]

Nor does the inclusion of the word *art* in the title of a particular operation establish it as a producer of art pottery. Van Briggle*, at the time it inserted "Art Pottery" into its official designation, had ceased to produce art pottery, manufacturing only industrial artware. Similarly, there is no indication that firms such as the Crooksville Art Pottery of Crooksville, Ohio, ever produced art pottery. Also to be taken into consideration is the fact that for a time several producers of art pottery, such as Rookwood* and the Chelsea Keramic Art Works*, made blanks which bore the firm designation, but which were decorated by amateurs in a manner not in keeping with the high degree of competence associated with the firms whose names appear on the ware. These can not be considered art pottery in spite of their markings.[4]

Nor can art pottery be defined by any strict adherence to a particular span of years. For convenience it can be said that the art pottery era in the United States lasted from 1870 to 1920. These dates are arbitrary, and simply because a firm operated within or without them does not establish it as being or not being an art pottery. What was occur-

1

ring in Massachusetts in the 1870s did not begin in California until the 1880s, and what was occurring in Ohio in that decade did not begin on the West Coast until the 1890s; thus in California the art pottery era actually continued until about 1930, long after its demise in the east. Then too, there is the Kenton Hills* operation, begun in Kentucky in the late 1930s, which must be considered an art pottery.

Art pottery must be defined chiefly by the philosophy—the attitude—of the people who were involved in its execution, and in this way it can be seen as closely associated with the Arts and Crafts movement. During the period roughly spanning 1870-1920, it remained possible to hold in creative tension the work of the artist and the artisan (or technician) within a sustaining commercial organization. Where one aspect of this union was repressed or eliminated, the result ceased to be art pottery.

All art pottery was motivated to some degree by commercial considerations, and sometimes relatively large-scale factories were established. Persons associated with art potteries usually derived their primary income from such employment, and all left personal impressions of artistic individuality on their work: some by modeling or throwing, some by glaze or body development, others by skillful decoration, and still others by various combinations of these endeavors. It is upon this commercially-supported individuality, its expression and growth, that the definition of art pottery itself relies.

In philosophy and commercial consideration, art pottery was very much a product of its time. Thus it is important to appreciate the period in which it developed and flourished. By the mid-nineteenth century, the Industrial Revolution had swept through Europe; across the Continent and the Atlantic a reaction began to develop against the lifeless uniformity and sterilization of expression that followed in the wake of its application to the arts.

While utilitarian objects could easily be produced en masse to supply domestic items to a rapidly growing population, art objects when subjected to the techniques of mass production, were deprived of personal creativity. As the artisan was replaced by less-skilled workmen, originality and creative expression were replaced by quantity and ease of manufacture.

By 1870 there were in many parts of the world numerous ceramic craftsmen who were attempting to strike out against the inadequacy of industrial artware. Imbued with a certain nineteenth-century romanticism, their idealism was nonetheless tempered by the reality of a need for a financially stable venture. Like so many other movements of that age, this too was basically a revival—in this particular case a revival of the traditional relationship of artist and object. It could be seen in France and England, where William Morris put his

poetical idealism to practice and with a group of similarly disposed friends formed Morris, Marshall, Faulkner & Company in 1861. His efforts, and those of his followers who organized societies to promote individual artistic expression, achieved fruition in the Arts and Crafts movement of the 1880s and thereafter. In the United States this productive idealism was manifest in the growth of utopian societies, at some of which—such as Byrdcliffe*, Rose Valley* and Halcyon*—ceramic operations were established.

The Industrial Revolution actually provided a two-pronged impetus to the art pottery movement. It unwittingly created a rebellion by craftsmen against industrial artware, and in a more positive vein it provided the opportunity for ordinary people to acquire art objects. In the earlier agrarian society, only utilitarian wares were of importance in the average home. With the development of the middle class and its purchasing power, the demand for art objects increased considerably.

The Centennial Exposition at Philadelphia in 1876 gave the general populace of the United States its first view of the art treasures of the world and provided the primary stimulus for the emergence of an art pottery industry. Attending the ceramics exhibit at the exposition were the Robertsons of Chelsea, Massachusetts, and Mary Louise McLaughlin of Cincinnati, Ohio.

The decorative treatments pursued thereafter by the Robertsons and M. L. McLaughlin were to be the prototypes of art pottery decoration in the United States for almost a quarter century. The Robertsons were inspired by classical shapes and monochrome glazes, and by 1878 their Chelsea Keramic Art Works was producing superb translations of Greek and Oriental objects. McLaughlin's (Losanti*) interest was stimulated by Haviland's new faience line of underglaze slip-decorated ware, exhibited for the first time in the United States. Her experiments in its reproduction resulted in the development of Cincinnati faience and were the basis for the establishment in 1880 of that technique's most successful exponent, the Rookwood Pottery.

McLaughlin's and the Robertsons' decorative techniques remained unchallenged until the mid-1890s when William Grueby pioneered the commercial application of matt glaze and subdued, modeled decoration. Thereafter, reflecting the success of Grueby* and Van Briggle, matt glazes and modeled decoration were to be two of the decorative mainstays for the remainder of the art pottery era.

In production techniques the Robertson firm followed the movement's ideal: for the most part, the person who conceived of the initial shape threw it and decorated it. This produced the integrated expression of form and decoration by an individual craftsman who was creatively involved with the piece from start to finish.

Rookwood, on the other hand, took advantage of some of the more modern industrial techniques and produced its wares through a division of labor, with the separation of potting and decorating operations. Specialized fields of interest were pursued, and it was at Rookwood in 1885 that the first ceramic chemist, Karl Langenbeck, was employed. In some instances as many as twenty-one people would be involved in the execution of a single piece of pottery. Whereas the Robertson firm achieved its integrity through the artist himself, Rookwood's resulted from the co-operative union of artist and artisan. This latter approach, with its various divisions of labor, offered a potentially wider scope of expression and allowed new stylistic developments or trends—such as the growing interest in Art Nouveau—to be incorporated.

For these reasons, as well as for the expanded output which was possible through the application of modern technology, it was the Rookwood approach which was taken by most of the art potteries of the United States. The degree to which harmony was achieved in these various divisions, especially between artist and artisan, marked the degree to which the pottery itself was artistically a success.

Perhaps the foremost indigenous development in the field in the United States was the role of the amateur, and in particular the work of women. Originally interested in the parlor pleasure of china painting, a number of women who became leaders in the art pottery movement refined their tastes and directed their interest to professional ceramic work. These included M. L. McLaughlin, M. L. N. Storer, Pauline Jacobus, the Overbecks, Laura Fry, Mary C. P. Stratton, Susan Frackelton, Clara Poillon, and Adelaide A. Robineau. In addition, many decorating staffs were composed largely of women, exclusively so in the case of the Arequipa*, Newcomb* and Paul Revere* operations.

Numerous unique technical achievements resulted from the study and use of native clays. No one explored this field more thoroughly than Alexander Robertson, who was convinced that the finest clays required by an art pottery industry could be found in the United States. His work, that of Charles Hyten at the Niloak Pottery* using native Arkansas clays, and A. A. Robineau's use of Texas kaolin for her porcelain ware give ample evidence of the possibilities offered when such scientific ingenuity and artistic imagination were combined.

Working contrary to the underlying philosophy of the art pottery movement were the economic pressures of the Industrial Revolution. The Robertsons' method did not offer the means for financial survival—that is, an art pottery industry based on the ideal of artistic expression could not succeed in the United States without due regard for commercial consideration. The Chelsea Keramic Art Works of the

Robertsons failed in 1889; it was only able to reopen in 1891 when the income-producing Dedham-type ware was introduced, allowing for the inclusion of the division of labor already practiced at Rookwood and elsewhere.

At other potteries the compromise which resulted in the standardization of shapes led in many instances to extensive casting rather than throwing, and eventually to the mass production of industrial artware with little evidence of originality. Thus, that which the art pottery movement was created to counteract—the mass production of sterile pottery—became the only means of economic survival, as evidenced by much of the later work of Weller, Roseville*, Van Briggle and Rookwood.

By 1920 the art pottery movement was overcome by the industrial methods which it had attempted to harness for its financial survival. Once again artistic originality and creative expression were threatened with replacement by quantity production and ease of manufacture. A few firms attempted to maintain high artistic standards, and they struggled on into the depression of the 1930s. For the most part, however, the productive tension between artist and artisan on an industry-wide basis had succumbed by 1915 and the Panama-Pacific International Exposition at San Francisco. By that time the emphasis was already shifting from the work of commercial potteries to the work of individual artists.

What followed on the one hand was voluminous production of industrial artwares. On the other, those interested in the more "pure" approach to the ceramic art became the basis of the studio pottery movement. This movement was primarily a return to the techniques of the Robertsons, but with the lesson learned that such techniques could not provide the basis for an art pottery industry.

The distinguishing characteristics of art pottery and studioware can best be delineated by a comparative study of both. In place of the division of labor which became a part of the art pottery industry, one person, the studio-potter himself, was responsible for a piece from beginning to end: from the pugging of the clay to the firing of the kiln and the removal of his personally thrown and decorated piece from it. Rather than working in a relatively large pottery with its numerous kilns, the studio-potter worked in his own quarters (studio) in which his small kiln was located, or else he would affiliate with a school or university whose kilns would be at his disposal. Such affiliation reduced his financial dependence on the sale of his work, and offered him greater freedom.

To emphasize the importance of the potter himself, the studio worker almost always incised his piece with his own name. Art pottery, in contrast, most often bore the formal cipher or mark of the

5

works at which it was produced, sometimes with the added initials or other signatures of the various craftsmen such as the potter, the decorator, or the designer.

Studioware, which tended to be a unique expression of the potter, was most often built or thrown instead of cast. Because there were few stock designs, one rarely finds catalogs or the shape numbers which were commonly impressed in art pottery. Seldom did the studio-potter attain the speed or the proficiency of the specialist of the art pottery era; although highly skilled in his particular work, the specialist rarely had the studio potter's overall command of the art.

Above all, the studio-potter was primarily interested in the continuation of a tradition—the tradition of the artist-potter—rather than in the extensive production or application of a particular technique. His primary intentions were to experiment and to instruct rather than to build an industry. As a result, studio potters most often received their training in an art or ceramic school[5] rather than by serving an apprenticeship in a pottery plant.

As with most periods or philosophies, there are no precise lines which divide the art pottery movement from its antecedents or successors. The work of Adelaide Alsop Robineau at Syracuse, New York, and Frederick Hurten Rhead at Santa Barbara, California, reflected the trend toward studio pottery several years prior to our 1920 dating. Periods and their philosophies overlap; generalizations regarding them vary with the locale and the individuals involved.

By 1920, however, the breakdown of the fragile balance between artistic and technical expression within a commercial framework was obvious, and a definite division between the two approaches was taking place. Prior to this there had been a place in the art potteries for both artist and artisan. With the economic pressures which were exerted during and after World War I, these workers were forced into either institutional or industrial situations: Robineau went to Syracuse University, Rhead to the American Encaustic Tiling Company of Zanesville.

Art pottery, then, is not identified by particular styles or techniques, specific operations or span of years, but rather by the philosophy or attitude of the individuals involved in its execution. The term itself defines the product of the creative tension between artistic and technical skills within a commercial organization. When combined with the

productive techniques of the age, this union resulted in the output of art objects which bear witness to the unique talents of those involved in their execution.

The challenge in the manufacture of art pottery was to achieve a harmonious synthesis of structure and ornament on a commercially sound basis, either through the work of a single individual or through the successful division of labor which allowed for the co-operative union of artist and artisan. That this period is now economically beyond revival further reinforces its importance in the history of art in the United States.

1. Pottery, in the broadest sense, includes everything made of a burnt admixture of clay(s), minerals and water. As used throughout this text, pottery is a generic term encompassing:
 a. Earthenware (synonymous with faience, no distinction being made between the various bodies or treatments): low-fired opaque ware, glazed or unglazed, but requiring at least one post-biscuit firing with a glaze to render it non-porous.
 b. Stoneware: opaque ware fired at a high temperature which vitrifies the generally natural-clay body (hence the name), rendering it non-porous after the first firing. Glazes on stoneware, as opposed to earthenware, are decorative rather than practical.
 c. Porcelain: also a vitrified ware, the result of high firing. Porcelain differs from stoneware essentially in the greater purity of its ingredients; hence it possesses a naturally white body which is most often translucent, although not necessarily so by definition. Aside from this "true" or "hard" porcelain there are other varieties, in which the biscuit firing is at a high temperature, the glaze being added at a subsequent, lower-temperature firing, or in which the body is of an imperfectly vitrified mass formed by the partial fusion of sand and fluxes; but the use of these various "soft" or "artificial" types was never extensively pursued in the production of art pottery in the United States.
2. *Industrial artware* is used throughout to signify artware, often in imitation of hand-craftsmanship, produced by the application of industrial techniques and mass manufacture. Such potteries as Camark, Haeger, Hull, Muncie and Red Wing must be considered producers of industrial artware rather than art pottery. Ultimately the distinction between the two is subjective, based on the quality of the concept and the execution of the particular example itself.
3. An analysis of these various influences has already been begun by Martin Eidelberg in "American Ceramics and International Styles," a paper delivered at the Princeton University symposium *Aspects of the Arts and Crafts Movement in America* (November 11, 1972); and by Marion John Nelson, "Art Nouveau in American Ceramics," *The Art Quarterly* of The Detroit Institute of Arts, XXVI (number 4, 1963), pp. 441-59.
4. The appearance of the firm cipher in most cases indicates an approved standard of excellence with regard to the work, many firms—such as Newcomb, Rookwood and California Faience*—carefully defacing their marks when an item was not considered successful by their criteria.

5. The first school of ceramics in this country was that of Ohio State University, begun in 1894 and directed in its formative years by Edward Orton, Jr. The second was the New York State School of Clayworking and Ceramics at Alfred. Charles F. Binns was its director from its establishment in 1900 until his retirement in 1931. The third to be organized was the New Jersey School of Clayworking and Ceramics at Rutgers University, New Brunswick, established in 1902 under the direction of C. W. Parmelee. In 1905 a fourth such school was organized at the University of Illinois, and in 1907 the Iowa State Legislature made provision for a similar school to be located at Ames.

* This symbol, following the first reference in each chapter to a pottery, indicates that information relating to the operation so marked is included in a separate chapter under this (or a closely similar) heading.

Alberhill Pottery

Alberhill, California

The Alberhill-Corona district in western Riverside County was one of the three most important clay-producing areas in California in the early twentieth century. The largest producer in that district was the Alberhill Coal and Clay Company, which was originally organized to work the coal beds located there. From 1882 until 1895 the property was developed solely as a coal mine; the output of clay began in 1895. At that time the company had no clay-working plants, but sold its clay, which included some of a very high grade, to many manufacturers throughout California. Among these, and interlocked with Alberhill, was the Los Angeles Pressed Brick Company of Los Angeles, where the work of Fred Robertson (Robertson Pottery*) was executed.[1]

After leaving the Halcyon Pottery*, in 1912 Alexander W. Robertson was engaged by James H. Hill, president of the Alberhill Coal and

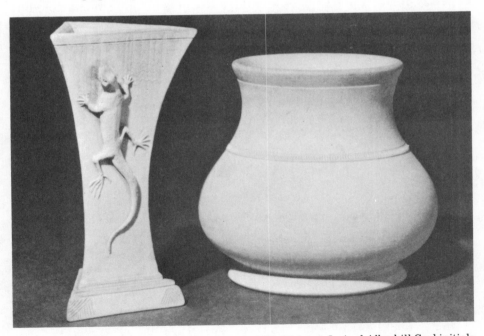

[left] Alberhill three-sided cream bisque vase; h. 6¼" (15.9 cm). Incised Alberhill Coal initials, the cipher of A.W. Robertson and dated July 18, 1913. *Private collection.* [right] Unglazed Alberhill vase; 5¼" (13.4 cm). Impressed mark, incised A. W. Robertson cipher and dated October 4, 1914. *Private collection.*

Clay Company, to experiment with the available Alberhill clays. In this work, which spanned a two-year period, Robertson produced many finely crafted examples of the potter's art which received a Gold Medal at the San Diego exposition.[2]

Glazed ware was undertaken on a limited basis. The bulk of the work was left unglazed to show the qualities of the clay. The bisque vases range from red terra cotta to the softest pink and white, most pieces being of the lighter colors. Each was thrown on the wheel, skillfully decorated in classical motifs and carefully marked.

Vases displaying the potential development of an art line using Alberhill clays were displayed as an exhibit in the 1914 lawsuit, the Alberhill Coal and Clay Company and the Los Angeles Pressed Brick Company vs. the State of California. At that time Riverside County wanted to take a portion of the land containing the clay deposits for a public highway.[3]

Plans for production of art pottery were not carried through; Robertson left late in 1914. Consideration of the possibility was again raised in 1920 when Alberhill contemplated the erection of a pottery at Riverside, California, envisioned as employing 200 to 300 workers. The commercial manufacture of pottery would have been a new venture for Alberhill interests;[4] but these plans were not pursued, and the expertly-formed pieces by Alexander Robertson remain the sole output of Alberhill art pottery. Several of these pieces were part of the Barber collection sold at public auction in 1917.[5]

Early pieces were incised with "A.C.C.Co. Cal.," but later work bears the impressed Alberhill mark, as shown. Most examples bear the personal A.W.R. monogram of Robertson, and are often dated. Other marks, such as an incised anchor, are also to be found. These are codes relating to the particular clay used.

ALBERHILL

1. J. H. Hill, "Clay Deposits of the Alberhill Coal and Clay Company," California State Mining Bureau, State Mineralogist's Report XIX, 1923, pp. 185-210. W. F. Dietrich, *The Clay Resources and the Ceramic Industry of California*, pp. 93-94; 162-69. *The Clay-Worker*, LXX (July 1918), p. 38.
2. *The Potter*, I (December 1916), p. 38.
3. The Riverside *Press*, February 26, 1914, p. 4.
4. *The Clay-Worker*, LXXIII (January 1920), p. 70. These plans, while five years prior to the death of Robertson, undoubtedly did not involve him as he had retired from ceramic work after the San Diego exposition at the age of seventy-five.
5. Sales catalog of the collection of E. A. Barber by Samuel T. Freeman & Company, Philadelphia, 1917, p. 86.
* Information relating to this pottery is included in a separate chapter

American Art-Ceramic Company

Corona, New York

Several short-lived art potteries were in existence at Corona at the turn of the twentieth century, prior to the beginning of Tiffany's* commercial ceramic work at that location. Volkmar (Volkmar Pottery*) operated there from 1895-1903; Jervis' Corona Pottery* in 1903; and the American Art Pottery Company, which was incorporated in New York State as the American Art-Ceramic Company on December 13, 1901 by Simon Marten, Solomon Markstein, Jacob J. Wallenstein and Alonzo L. Tuska.[1]

The purpose of the organization was the manufacture of artistic terra cotta, and it was reported that a fine line of "real terra cotta and pottery, most of the subjects being true reproductions of the best examples of imported styles," was produced.[2] Barber noted their entry into business[3] but makes no mention of them in the 1909 edition of *The Pottery and Porcelain of the United States*, by which time, presumably, the production of artware had ceased.

An impressed mark was used; "Ungaren" (sic) meaning Hungary in German.

1. Records on file at the New York State Corporation Bureau, Albany; E. A. Barber, *Marks of American Potters*, p. 87.
2. *China, Glass and Pottery Review*, IX (September 1901), p. 45.
3. *Loc. cit.*
* Information relating to this pottery is included in a separate chapter

American/Edgerton Art Clay Works

Edgerton, Wisconsin

The output of the American/Edgerton Art Clay works can be considered "art pottery" only when the term is applied in its broadest sense. Most accurately, it is a type of ceramic sculpture which was produced, and it does not appear that any thrown or decorated art pottery as such was made. The company is included here primarily because of its relation—or lack thereof—to the Pauline Pottery.*[1]

Plans for the firm were first announced in June 1892, and included the erection of a new building and kiln.[2] Also known as Samson Brothers and Samson Brothers & Ipson, the firm was composed of Thorwald P. A. Samson and Louis Ipson. Both men had worked for a year prior to that time at the Pauline Pottery. They were joined by Thorwald's brother, Hans C. H. Samson, who had taught languages at the Lake Forest Theological Seminary in Illinois before moving to Edgerton.

Production at the new pottery was begun in the late summer of 1892, and by January 1893 sufficient inventory had been produced for the firm to advertise locally a series of bronzed figures.[3] Busts and statuettes were produced for the wholesale and retail trade, and the firm executed a life-sized bust of Grover Cleveland for exhibit at the Chicago World's Fair in 1893.[4] This piece, and numerous other examples of the firm's work, never arrived at the Fair as the result of an amusing yet tragic local affair. A visiting revivalist was greatly offended by some of the firm's ware, which included copies of the "Venus de Milo" and "Eve and the Apple." The ensuing uproar brought the pottery considerable publicity which created difficulty with their local backers. When objection was voiced by the State's senator, who lived in the area, the work was destroyed.[5]

In 1895 Louis H. Towne, an Edgerton lawyer, took over the American Art Clay Works and renamed it the Edgerton Art Clay Works (not to be confused with the Edgerton Pottery*, successor to the Pauline Pottery). The Samson brothers and Ipson, all native Danes, remained associated with the firm and supervised its work. Towne also engaged Helen (Nellie) Farnsworth Mears, who became one of Wisconsin's best-known sculptors, to model statues for casting. Most of the work

consisted of redware and buff clay figures and busts, made from locally dug clays. Pieces were most often unglazed, although, as indicated before, some were bronzed.

Ipson returned to Denmark in 1896, but work continued at the pottery until T. Samson returned to his homeland in 1899. Part of the building was converted to a bottling works in 1900, and apparently production ceased in that year.[6]

Thorwald Samson returned to Edgerton in 1902 and the Edgerton Art Clay Works was started up again.[7] In June 1903 a new kiln was placed in operation and new designs were announced. Later that summer T. Samson and Ipson, who had also returned to Edgerton, left the Art Clay Works and built a new kiln on the property of Wray Watson.[8] By September they were again in business on their own, operating as the Norse Pottery*.

Principal public collections of the Art Clay Works production are at the Kenosha [Wisconsin] Public Museum, the Edgerton Public Library and the Rock County Historical Society. Three plaster pieces by H. F. Mears are to be found at The Paine Art Center and Arboretum, Oshkosh, Wisconsin.[9]

Only a portion of American/Edgerton's work was marked. Pieces bearing the "American Art Clay Works" or the "Samson Bros. & Co." designation date from 1892-95. From 1895 until 1900, during Towne's ownership, work was marked "Edgerton Art Clay" or "Art Clay Works, Edgerton, Wis." It is Raney's hypothesis that pieces bearing an impressed ECW (Edgerton Clay Works) in a vase-shaped cartouche were produced in the 1902-03 period.[10] The initials of some

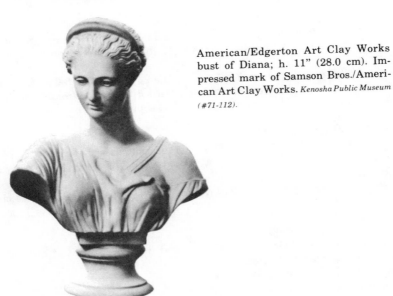

American/Edgerton Art Clay Works bust of Diana; h. 11" (28.0 cm). Impressed mark of Samson Bros./American Art Clay Works. *Kenosha Public Museum (#71-112).*

of the artists can be found on their work, especially those of N.F.M. ("Nellie" F. Mears). The signature "M. Samson" has also been noted, designating Martina, wife of Thorwald Samson.

SAMSON BROS. & CO.

American Art Clay Works

Est'd 1892

Edgerton, Wis.

1. As noted in the account of the Pauline operation, credit for the untangling of the various Edgerton operations belongs to E. M. Raney, principal authority on those potteries.
2. Wisconsin *Tobacco Reporter* (Edgerton), June 24, 1892, as cited in E. M. Raney, "Edgerton Potters: The Samson Brothers," *Rock County Chronicle* of the Rock County [Wisconsin] Historical Society, VIII (Spring 1962).
3. *Ibid.*, January 27, 1893.
4. *Ibid.*, March 2; April 21, 1893.
5. *The Clay-Worker*, XXI (April 1894), p. 437. The molds were not destroyed, however, and a plaster figure of the "Venus de Milo" is in the collection of the Edgerton Public Library.
6. *Tobacco Reporter*, April 3, 1896; November 24, 1899; May 18, 1900; as cited in Raney, *op. cit.*
7. *Ibid.*, September 19, 1902.
8. *Ibid.*, September 18, 1903.
9. One of these, "The Morning Wind" executed in red terra cotta, has also been studied in a private collection.
10. *Rock County Chronicle*, p. 7.
* Information relating to this pottery is included in a separate chapter

Arc-En-Ciel Pottery

Zanesville, Ohio

The Arc-En-Ciel Pottery Company was incorporated in Ohio on July 20, 1903, by numerous individuals including James Buckingham, a trustee for A. Radford's* Zanesville pottery,[1] and John Lessell. The latter, who for a brief time (around 1911) was to operate his own pottery, the Lessell Art Ware Company*, is best-known for his work at Weller*, where he designed their LaSa line. The Arc-En-Ciel plant, equipped to turn out artware exclusively,[2] began operation in late 1903 in the Radford pottery, which had evidently experienced financial difficulties.

The iridescent gold luster wares produced by the firm were exhibited at the 1904 St. Louis exposition,[3] but the art line never produced sufficient income to warrant its continuation. In early 1905 the plant was changed over to the production of utilitarian items in place of the artware.[4] The line, called Brighton cooking ware, included general kitchen utensils: mixing bowls, baking dishes, pitchers, teapots, soup bowls, custard cups, cracker jars and honey dishes.[5]

Shortly after the introduction of the Brighton line, the firm changed its name to The Brighton Pottery Company.[6] Production of this ware continued for about two years, and the plant closed down in early 1907.[7] In June of that year the principals of the pottery organized a new firm called The Brighton Company, Inc., for the "manufacturing and publishing of picture frames and art goods."[8]

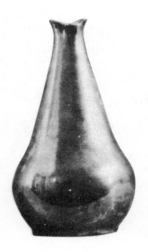

Arc-En-Ciel vase with typical luster glaze; h. 7¾" (19.7 cm). Impressed mark/535/3. *Private collection, courtesy Blaine Andrus and G. Crim.*

A pitcher of the iridescent gold luster ware is in the Benjamin collection of the National Museum of History and Technology, Smithsonian Institution (#379,625).

The name of the firm, Arc-En-Ciel (often incorrectly spelled "Ceil"), is the French term for "rainbow." It is most often found impressed within the half-circle of a rainbow. In many instances the mark is partially or totally obscured by the glaze.

1. N. F. Schneider, Zanesville *Times Recorder*, February 4, 1962, p. B-3.
2. *The Clay-Worker*, XL (September 1903), p. 259.
3. *Transactions* of The American Ceramic Society, VII (1905), p. 350.
4. *Glass and Pottery World*, XIII (March 1905), p. 23.
5. *Ibid.*, pp. 19-20.
6. *Clay Record*, XXVII (September 15, 1905), p. 35.
7. *Glass and Pottery World*, XV (June 1907), p. 28.
8. Articles of Incorporation, State of Ohio.
* Information relating to this pottery is included in a separate chapter

Arequipa Pottery

Fairfax, California

Influenced by the initial success of the work of Dr. H. J. Hall with pottery at his Marblehead* institution, Dr. Philip King Brown organized a similar center on the West Coast.[1] Henry E. Bothin of Ross, California, gave the beautifully wooded section of land and a large amount of money for an establishment "for the treatment of early cases of tuberculosis in wage earning women."[2]

After some initial work in basketry (which proved too inconvenient for bed cases and too costly), the pottery was established in October 1911. Frederick H. Rhead, art director at Roseville* from 1904-08[3] and later director of the Rhead Pottery*, was employed as ceramist, and he and his wife Agnes served as instructors. At first lessons were given in all departments of pottery work, and during this time Rhead carried on a great deal of experimentation using native California clays from Placer County.[4]

The conflict between occupational therapy and the establishment of a commercial pottery led to an attempt to separate the pottery from the medical facility, as was done at Marblehead; and in February 1913 The Arequipa Potteries was incorporated in California. This attempt was apparently unsuccessful; the Rheads left that July, and the corpo-

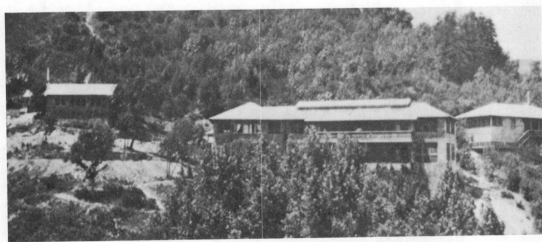

Arequipa Sanitorium (c. 1913) in the Marin County hills. Pottery building is at the far left. *Miss Phoebe H. Brown.*

17

ration was voluntarily dissolved in 1915. Albert L. Solon, who succeeded Rhead as pottery director in 1913,[5] came from a famed family of ceramists. His father, Louis M. Solon, was associated with Sèvres and Minton and was the author of *The Art of the Old English Potter,* among other works; and his grandfather Leon Arnoux, according to Jervis, occupied a position at the Minton works paralleled only by that of A. Broginiart at Sèvres. Solon was born in England and attended the Victoria Institute, where he trained to become a ceramic engineer. After serving an apprenticeship in an English tile factory he came to California.[6]

Under Solon's direction the pottery and the market for its ware expanded considerably. The third Annual Report of Arequipa (1914) notes "we have been able to employ more than twice the number of girls employed before, and market our wares in the best known art stores in the East." Solon continued to struggle with the difficulties

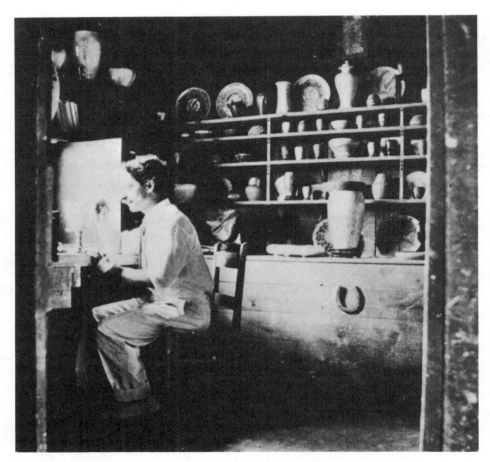

F. H. Rhead decorating in his Arequipa studio. *Miss Phoebe H. Brown.*

inherent in establishing a high grade art pottery as well as with his experiments using local clays and fuel. At this time a body containing about sixty percent local clay, found about two hundred feet from the pottery, was the most generally used. A great deal of the ware was thrown, with large pieces pressed and irregular forms cast. Later, casting was used more extensively. Three updraft, oil-burning muffle kilns were used, the largest of which held about 230 pieces.[7] During the period of Solon's direction of the pottery numerous new glazes were introduced including some outstanding Persian faience ones; the most interesting of these, in Solon's own estimation, was the transparent turquoise blue.[8]

Almost all work at the pottery was done by hand with the patients responsible for the finishing and decorating. This was accomplished under the careful supervision of the director. During Solon's tenure designs, supplied by himself and area artists, were sketched or traced on the damp clay and then carved or painted. When this was finished the director inspected the workmanship. If, in his opinion, the design had been well carried out, the worker initialed the bottom of the piece.

The pottery perhaps gained its greatest notoriety from the large booth it had at the Panama-Pacific exposition in 1915. There one could watch the girls engaged in the various processes of making pottery and also acquire examples of the finished product, which received a Gold Medal at the exposition. A Bronze Medal and two certificates of honor were given for individual work of the pottery.

In May 1916 Solon left Arequipa to teach at what has since become California State University, San Jose, and was followed by Fred H. Wilde.[9] Wilde, who came to the United States from England in 1885, had been associated with several tile operations including the Robertson Art Tile Company of Morrisville, Pennsylvania, and the Pacific Art Tile Company of Tropico, California, which became the Western Art Tile Company. When he came to Arequipa he brought considerable technical knowledge and also new glaze formulas.[10] Wilde continued his predecessor's attempts to replace all male help by trained girls, but there is no evidence that he was any more successful.

One of the major problems which had plagued all three directors was the rapid turnover of patients. The average length of time a patient worked in the pottery was between four and five months, so the best workers were constantly leaving and new, untrained personnel were constantly being taken on. For this reason there was little advanced decoration. Moreover, the short tenure of directors prevented any from impressing his personality to such a degree as to give Arequipa a distinctive type ware, as was the case at Marblehead. The work of the pottery ranges from mediocre to extremely successful, with examples of all gradations between.

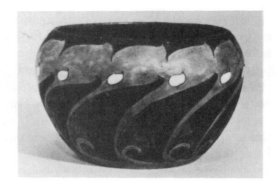

Arequipa bowl by F. H. Rhead. Ground is a rough texture matt brown with tan and white decoration; h. 5" (12.7 cm). Incised mark. *Private collection.*

Wilde developed a market for handmade tiles, especially translations of the Spanish type, and numerous important homes were decorated with them.[11] Just as these were becoming the mainstay of the pottery, the war in Europe raised havoc with prices, and the pottery operation was brought to a close in 1918.[12] The Sanitorium itself remained in operation until 1957.

The collection of the National Museum of History and Technology (Smithsonian Institution), while small at the present time, includes examples acquired from the pottery in 1916 which offer excellent evidence of some of the best work done at Arequipa.

The foremost motif of the company's mark is a jug under a tree. Many varieties of this exist, impressed, incised and painted underglaze (the latter two are often found with the dates 1912 and 1913 indicating the Rhead period). The same motif was also used on the paper label which often appears in addition to the permanent mark. Initials of the directors are occasionally found on pieces of their work.

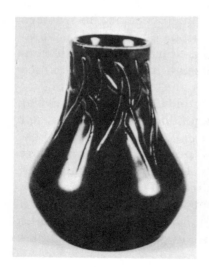

Black glazed Arequipa vase; h. 4¾" (12.1 cm). Incised mark. *Michiko and Al Nobel.*

1. IV Annual Report of the Arequipa Sanitorium, September 1915.
2. Program of the opening, September 9, 1911. A report of the events leading to the occasion was carried in the San Francisco *Call,* September 8, 1911, p. 5.
3. L. & E. Purviance and N. F. Schneider, *Roseville Art Pottery in Color,* plate 4.
4. *The Craftsman,* XXIV (June 1913), p. 345.
5. While the fourth Annual Report indicated Solon joined the pottery in July 1914, this is an apparent typographical error, since the members' directory of The American Ceramic Society published in *Transactions,* XV (1913), lists Solon at Arequipa, and the San Francisco *Chronicle* of June 7, 1914, p. 23, reports that Solon was director of pottery making.
6. W. P. Jervis, *The Encyclopedia of Ceramics,* pp. 391-92; also personal correspondence of A. L. Solon dated April 10, 1934, on file at the Oakland [California] Museum. Solon's brother Leon V. was for many years associated with the American Encaustic Tiling Company. Prior to his coming to the United States in 1909, he was art director at Minton and recipient of many awards resulting from his work in Europe.
7. *Pottery and Glass,* XIV (January 1915), p. 27 (reprinted from *The Brick and Clay Record);* also the San Francisco *Chronicle,* June 7, 1914, p. 23.
8. Solon personal correspondence, *op. cit.*
9. After 1921 Solon was to produce tiles in partnership with F. Schemmel as Solon & Schemmel at San Jose, California. For a survey of that operation see *The Clay-Worker,* XCI (February 1929), p. 181.
10. Personal correspondence of F. Wilde as reported in *The Bulletin* of The American Ceramic Society, XXII (May 15, 1943), pp. 132, 148.
11. Sixth Annual Report of Arequipa Sanitorium, September 1917.
12. Ninth and tenth Annual Report of Arequipa Sanitorium, January 1, 1922. After leaving Arequipa, Wilde joined the Pomona Tile Manufacturing Company of Los Angeles at the time of its formation in 1923 and remained there as ceramic engineer until his retirement in 1940, according to the notes of Drew Schroeder of Pomona Tile as reported in *The Bulletin,* XXII (May 15, 1943), p. 149.

* Information relating to this pottery is included in a separate chapter

Avon Pottery
Cincinnati, Ohio

This short-lived pottery continues to be of interest because of the quality of its work and the importance of its founder, Karl Langenbeck. As a young boy, in the summer of 1873, he received a set of china-painting colors from an uncle in Germany. The set captivated the interest of his neighbor Mrs. Maria Longworth Nichols (Storer), who used his colors until her own supply could be imported. Thus the seeds of the Rookwood Pottery* were sown.[1]

Langenbeck was graduated from the College of Pharmacy in Cincinnati in 1882 and thereafter attended the Federal Polytechnic School of Zurich and the Royal School of Technology in Berlin. By January 1885 he had joined Rookwood in a technical capacity which has earned him the credit of being the first ceramic chemist in the United States;[2] within a short time he had become superintendent of the works. His association there was marked by successful production and elimination of the losses which had plagued the operation. But Taylor, Rookwood's director, decided the pottery would have to be closed because of its uncertain future. Langenbeck was discharged. While the management reconsidered its lack of faith, Langenbeck had already begun to organize his own art pottery, Avon.[3] Taylor, of course, would have been greatly concerned, not so much about Langenbeck's access to Rookwood's trade secrets as Peck[2] suggests, but because of his superior technical expertise. Such fears proved unfounded due to the short life of Avon.

The Avon Pottery, not to be confused with the later Avon Faience (Vance/Avon Faience*), was founded in January 1886 and located at the northeast corner of 8th and Lock in Cincinnati. It was in existence for about two years when, according to Langenbeck, "personal handicaps" forced its closing. Associated with Langenbeck was David Stern, a fellow chemist. The pottery's leading artist was James MacDonald, who deserves primary credit for the firm's outstanding decorative work.[4] Artus Van Briggle, founder of the Van Briggle Pottery*, served as an apprentice at Avon prior to his joining Rookwood in 1887.[5] No evidence has been found to substantiate Jervis' contention that Matt Morgan was associated with Avon, much less as its director.[6]

One type of Avon ware was of a yellow body, decorated in colored

slips and modeled or etched in part. This was then treated in a smear or dull glaze finish. Another variety was made of a white body using western Kentucky clays.[7] Avon produced from this clay a number of experimental pieces which were at the museum of the Kentucky Geological Survey at Frankfort for a long time, but which are now lost. This ware, decorated on the biscuit with atomized colors and painted designs, became the basis of the factory's production. Covered with a brilliant, untinted transparent glaze, the body burned a soft ivory-white which was unique. The effect of the atomized coloring was a gradual shading of the ground from light to darker tints including pink, olive, violet, blue and brown. The ram's horn-handled mug of

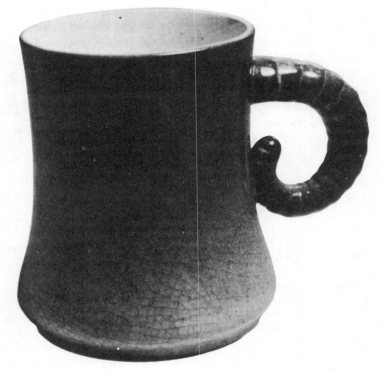

Avon Pottery's ram's horn-handled mug; h. 3¹³/₁₆" (9.7 cm). *National Museum of History and Technology (Smithsonian Institution; #379,601), Benjamin collection.*

this variety described by Barber[8] is now in the Benjamin collection of the National Museum of History and Technology, Smithsonian Institution (#379,601). All work was thrown; some was finished with modeled handles. A number of small covered vases were decorated with elephant-head handles.[9]

After the closing of Avon in 1888, Langenbeck remained a figure of importance on the ceramic scene, writing *The Chemistry of Pottery,*

the standard text on the subject, serving as president of The American Ceramic Society and contributing numerous articles to its Bulletins. He was also associated with the American Encaustic Tiling Company. With Herman C. Mueller, he organized the Mosaic Tile Company of Zanesville, Ohio. Later he succeeded Grueby as superintendent and technician of the Grueby Pottery* and in 1922 became chief ceramist of the United States Tariff Commission. He also served as consulting engineer at the National Bureau of Standards prior to his death in 1938.[10]

A collection of seven pieces of Avon pottery was acquired in 1893 by the Pennsylvania Museum (since 1939 the Philadelphia Museum of Art) from the collection of E. A. Barber. Six of these (small vases, a covered vase and a covered bowl) are listed in the Pennsylvania Museum's *Catalogue of American Potteries and Porcelains*.[11] The seventh piece was a plate with brown raised leaves around the edge and a medallion in the center with a lion in relief, all in a lighter brown. None of these pieces are in the present museum collection, having been dispersed a number of years ago.

The only known mark is that recorded by Barber.[12] The piece referred to which is in the Smithsonian's collection is unmarked.

Avon

1. W. Stout *et al.*, *Coal Formation Clays of Ohio,* p. 90.
2. H. Peck, *The Book of Rookwood Pottery,* pp. 33-34.
3. Stout, *op. cit.,* p. 93. Stout reports that his information is based largely on private correspondence with Langenbeck.
4. *Ibid.,* p. 95.
5. Peck, *op. cit.,* p. 147.
6. *The Encyclopedia of Ceramics,* p. 116.
7. Earlier Langenbeck had experimented with use of this clay for the Rookwood Pottery. The 1888 *Geological Survey of Kentucky* (pp. 5-6) reports that "the Survey is also indebted to Mr. W. Taylor, Superintendent, and Karl Langenbeck, Ph.D., chemist of the Rookwood Pottery, Cincinnati, for tests made with more than thirty samples of clay sent from the Purchase counties."
8. *The Pottery and Porcelain of the United States,* p. 303.
9. E. A. Barber, *Marks of American Potters,* pp. 126-27.
10. *The Bulletin* of The American Ceramic Society, XVII (October 1938), pp. 429-30.
11. 1893; Class C—American Faience, numbers 42-47.
12. At variance with this observation are the attributions of Lucile Henzke, *American Art Pottery* (Camden, New Jersey: Nelson, 1970), p. 183; Ralph M. and Terry H. Kovel, *Dictionary of Marks—Pottery and Porcelain* (New York: Crown, 1953), p. 12; C. Jordan Thorn, *Handbook of Old Pottery & Porcelain Marks* (New York: Tudor, 1947), p. 116. The marks therein illustrated are those of the Vance/Avon* pottery.

* Information relating to this pottery is included in a separate chapter

J. A. Bauer Pottery

Los Angeles, California

The J. A. Bauer Pottery Company was organized in Los Angeles by John "Andy" Bauer in 1909. Bauer was a familiar name in ceramic circles, the family having organized the Paducah Pottery of Paducah, Kentucky, for the manufacture of jugs and other earthen and stoneware utilitarian objects. Operations of that plant, begun in 1885, were not improved and few changes were made to meet expanding demands or to include new methods of production. By the time the founder, John Bauer, died in 1898 the plant was antiquated and unable to meet the demands placed upon it, even though about sixty men were employed.[1] Bauer's family attempted to continue the operation, but that did not prove entirely satisfactory, and the plant closed after several years.[2] In October 1905 the pottery was incorporated and the plant modernized with the new capital. Located at the corner of Seventh and Trimble Streets, the firm produced various kinds, sizes and shapes of Bristol glazed stoneware and flowerpots, together with growlers, mugs, cuspidors, filters, measures, coolers, jars, nappies, bail-handled jugs, druggists' jugs, flue thimbles, churns, crocks and vases.[3] Whereas capacity was 80,000 flowerpots in 1903, a single month's production in 1909 totaled 100,000.[4]

In the latter part of that same year Bauer started his Los Angeles operation, bringing sixteen of the twenty workers with him from Kentucky.[5] Five carloads of machinery were also shipped from the eastern works,[6] and clay was obtained from the nearby Alberhill/Elsinore beds.[7] Bauer's son, Edwin A., joined the business in 1914.[8] At that time production included numerous utilitarian items and a line of molded artware which received a Bronze Medal at the San Diego exposition.[9]

Business continued to prosper and the plant was expanded in 1919.[10] Artware, which evidently was never produced at the Kentucky plant, continued to be made at Los Angeles through the early 1920s. At that time their four-kiln plant was the only one in Los Angeles still manufacturing flowerpots, which, although less than half their business, were still the largest single item turned out.[11] The pottery was sold by Bauer and incorporated in the 1922-23 period as the J. A. Bauer Pottery Co., Inc., with W. E. Bockmon[12] as president. Ten years later the financially distressed Batchelder tile operation was

acquired;[13] the firm remained in business until about 1958.

The art line, molded for the most part, usually bears the Bauer designation in-mold. Other ware is usually imprinted in cobalt.

1. *The Clay-Worker,* XXX (September 1898), p. 222.

2. *Ibid.,* L (July 1908), pp. 22-24. *Clay Record,* XXIII (October 29, 1903), p. 31, reports plans by Bauer to have an operative miniature pottery at the St. Louis exposition in 1904. At that time the firm was reported producing an extensive line of white earthenware from Kentucky clays.

3. *Kentucky Geological Survey,* 1905, p. 121.

4. *Pottery and Glass,* IV (May 1910), p. 16.

5. *American Pottery Gazette,* X (December 1909).

6. *Pottery and Glass,* II (June 1909), p. 31.

7. *The Clay-Worker,* LII (December 1909), p. 664.

8. Local Los Angeles directories.

9. *The Potter,* I (December 1916), p. 38. Inclusion of Bauer in a consideration of art pottery is based on this award, the author not having seen any work that would definitely qualify as "art pottery" as opposed to industrial artware.

10. *The Clay-Worker,* LXXI (June 1919), p. 708.

11. W. F. Dietrich, *The Clay Resources and the Ceramic Industry of California,* p. 98.

12. Variously, but erroneously, also spelled "Backman" and "Bockman".

13. For a detailed account of the Batchelder works see Elva Meline, *Spinning Wheel* XXVII (November 1971), pp. 8-10, 65.

Bennett Pottery

Baltimore, Maryland

(see entry: Edwin Bennett Pottery)

Biloxi Art Pottery

Biloxi, Mississippi

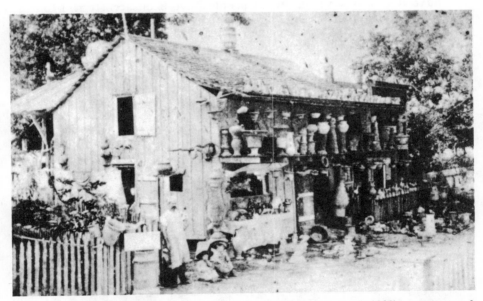

George Ohr in front of his original Biloxi Art Pottery (destroyed by fire in 1893). *J. W. Carpenter & R. W. Blasberg.*

Without question, the most controversial art pottery produced any-where in the world was executed by George E. Ohr at Biloxi, Missis-sippi. Benjamin indicates that Ohr established his pottery at Biloxi in 1878,[1] but Ohr's own autobiography indicates a date almost five years later.[2] Prior to 1884 he amassed about 600 pieces of his work which was then exhibited at the New Orleans Cotton Centennial Exposition.

27

The Biloxi production was interrupted for a time in the late 1880s when Ohr joined Joseph Meyer, also of Biloxi, at the newly organized New Orleans Art Pottery*.

Ohr's work and personality were already well-known by the turn of the century, when W. A. King, in a critical lecture on the work displayed at the Arts and Crafts Exhibition at Buffalo, wrote:

> Mr. Ohr is an American potter who stands in a class by himself —both in his personality and his pottery. Sometimes he is referred to as "the mad potter of Biloxi." He calls himself the "Second Palissy"; issues a challenge to all the potters of the world to compete with him in making shapes and producing colors—and all this is done in the most delightfully original manner. He is ever making and as a comparative few are buying, he is accumulating a vast quantity of pottery, having upwards of 6,000 or 7,000 pieces, no two of which are just alike in shape and decoration; and every one of these, he is quite satisfied in his own mind, will some day be worth its weight in gold. While much of Mr. Ohr's work will not meet the requirements of accepted standards, his one aim is to not have it in any way like what people have been accustomed to. There is art—real art—in the Biloxian's pottery, albeit at times he has a way of torturing the clay into such grotesque shapes that one can well believe it to cry out in anger and anguish against the desecration.[3]

Ohr was rarely assisted by anyone other than his eldest son, Leo, who worked with him in preparing the clays.[4] Work was thrown and

Ohr in front of his rebuilt pottery. *The Clay-Worker.*

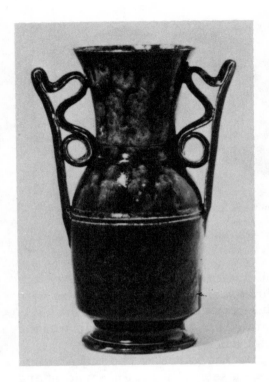

Biloxi Art Pottery vase. Mottled high gloss blue and black glaze with aventurine effect; h. 8⅝" (22.0 cm). Impressed mark. *Private collection.*

decorated to reflect Ohr's philosophy that since God made nothing in the world exactly like another, it would be against the canons of nature for him to attempt to make duplicates. So individual was each piece that, in 1905, Ohr wrote to the American Potters' Association "I send you four pieces, but it is as easy to pass judgement on my productions from four pieces as it would be to take four lines from Shakespeare and guess the rest."[5]

The characteristic Ohr technique was his "torture" of the clay. The extreme thinness of the walls of the objects—most often seeming no thicker than the shell of an egg and similar in that respect to Trenton Belleek—gives further evidence of his skilled accomplishments. White and red burning clays were used, from Florida and the Biloxi area. Pieces, ranging in size from miniature and toy vases to vases the size of a man, were twisted, crushed, folded, dented and crinkled into odd, grotesque and graceful shapes while in a plastic state. These were then fired at very low temperatures and uniquely glazed.

Few of the critics during his lifetime were more favorable than King. Jervis[6] held Ohr up to ridicule, and the generally complimentary Barber observed that whereas Ohr claimed "more merit for his shapes than for any other feature, yet by far the most pleasing and artistic are those which are the simplest in outline and the least eccentric in treatment."[7] Later, however, Paul E. Cox,[8] who knew Ohr

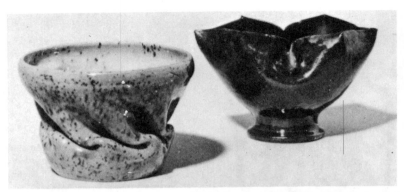

[left] Yellow glazed vase with brown flecks and a deeply twisted center; h. 2⅜" (6.0 cm). Impressed Ohr mark. *Private collection.*

[right] Egg-shell thin, six-pointed vase; h. 2⅜" (6.0 cm). Impressed Ohr mark. *Private collection.*

well, wrote "It is said that Ohr could work on the wheel whichever way it turned. Certainly he could throw wares of considerable size with walls much thinner than any other potter ever has accomplished. It is quite probable that George Ohr, rated simply as a mechanic, was the most expert thrower that the craft has ever known."

Output of the Biloxi works spans the gamut of the imagination. Barber[9] reports having seen crabs, seashells, the head of a wildcat and pieces with handles in the semblance of lizards, serpents and dragons; while some of the more elaborately decorated cups and vases bear more or less appropriate inscriptions, original and quoted. To this list Benjamin[10] adds puzzle mugs, a Rough Rider's hat, Abraham Lincoln's log cabin, a Mississippi mule and various vegetable shapes. Yet a 1909 observer was moved to comment "if it were not for the housewives of Biloxi who have constant need of his flower pots, water coolers and flues, the family of Ohr would often go hungry."[11]

While his contemporaries were negatively disposed to Ohr's treatment of the shapes of his work as a violation of all the basic elements of design, they were considerably more enthusiastic about his achievements with glazes. "The principal beauty of the ware," concludes Barber, "consists in the richness of the glazes, which are wonderfully varied, the reds, greens, and metallic luster effects being particularly good."[12] At the 1904 St. Louis exposition the glazes shown were mostly bright in color, although luster and matt surfaces were also exhibited.[13]

There is considerable uncertainty as to when Ohr ceased his potting. It would appear that he abandoned his efforts some time before his death in 1918. Pieces of his work were shown in 1906,[14] and the late-1909 feature on Ohr's work in *Crockery and Glass Journal* gives every indication that the potter was still active.[15] In any case, Ohr

packed his creations away in Biloxi because they were not appreciated. After his death Ohr's sons offered his work to the public, maintaining a salesroom in their Biloxi residence.[16] Thousands of pieces remained unsold and were again stored by the family until they were sold as a lot in 1972.

Several examples of Ohr's work, acquired from the potter, are included in the collection of the National Museum of History and Technology (Smithsonian Institution). A piece of particular historical note is to be found in the collection of The State Historical Society of Wisconsin (#1958.1320). Dated 1899, it was thrown by Ohr and decorated by Susan Frackelton (Frackelton Pottery*). Some work bears the initials of J. H. Proctman, an assistant of Ohr's who is reported to have worked at the Biloxi pottery in 1899.[17]

Ohr carefully signed his work, and most of it bears his name and often the town designation, either incised or impressed.

**G. E. OHR,
BILOXI.** **GEO. E. OHR
BILOXI, MISS.**

1. M. Benjamin, *American Art Pottery*, pp. 40-41.
2. George E. Ohr, *Crockery and Glass Journal*, LIV (December 12, 1901). Ohr is listed in the New Orleans directories of 1880 and 1881, where he was associated with Joseph Meyer who was to become a leading figure in the Newcomb Pottery* and with whom Ohr worked at the New Orleans Art Pottery.
3. As reported in the Buffalo *Express*, April 21, 1900. Ohr's observations regarding this article can be found in *Crockery and Glass Journal*, LIII (June 13, 1901), p. 29. King later served as a member of the committee on Fine Arts for the Pan-American Exposition at Buffalo in 1901. According to *Illustrated Glass and Pottery World* (IX, May 15, 1901, p. 117), it was anticipated that Ohr would appear in person at the exposition.
4. Dolores D. Smith, *Popular Ceramics*, XVII (September 1965), pp. 8-11.
5. Quoted by D. Smith, catalog of Gulf South Ceramic Show, 1967, p. 9. Some more elaborately executed examples were molded, although such work was not commonplace with Ohr.
6. W. P. Jervis, *The Encyclopedia of Ceramics*, p. 420.
7. E. A. Barber, *The Pottery and Porcelain of the United States*, p. 499.
8. Paul E. Cox, *Ceramic Age*, XXV (April 1935), p. 140.
9. *Pottery and Porcelain*, p. 499.
10. *American Art Pottery*, pp. 40-41.
11. *Crockery and Glass Journal*, LXX (December 23, 1909), p. 50.
12. E. A. Barber, *Marks of American Potters*, p. 155.
13. S. Geijsbeek, *Transactions* of The American Ceramic Society, VII (1905), p. 347. Ohr himself demonstrated his skills at the St. Louis exposition, where he operated a small kiln (*The Clay-Worker*, XLIV, September 1905, p. 227).
14. *The Clay-Worker*, XLVI (November 1906), p. 32.
15. *Crockery and Glass Journal*, LXX (December 23, 1909), p. 50.
16. Cox, *op. cit.*, p. 119.
17. J. W. Carpenter, *The Antique Trader*, XVI (September 19, 1972), p. 42.

* Information relating to this pottery is included in a separate chapter

Brush Guild

New York City, New York

The first steps in the organization of the Brush Guild were taken about 1897 by a group of students working under the inspiration and tutelage of George deForest Brush.[1] For their models and methods they looked to the ancient Etruscan *bucchero nero* ware,[2] which adapted itself readily to the principles of the Guild. All clay forms were built, as in the earliest Etruscan tradition.[3]

Finished pieces were monochrome black, occasionally appearing blackish-brown. Some experimentation was done with the use of "black clay" derived by the addition of iron and similar to that used in Wedgwood's Basalt, but that was mostly abandoned by 1903 in favor of polished surfaces.[4] Decorations, also the result of studies of actual Etruscan examples in the collection of The Metropolitan Museum of Art in New York City, were hand-carved into the wet clay, giving an effect similar in appearance to repoussé metal. No duplications were produced.[5]

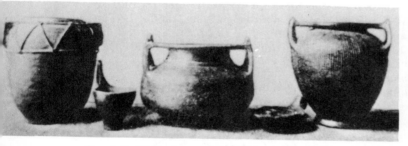

Brush Guild black terra cotta ware as shown in 1903. *The House Beautiful.*

While the Dahlquists, who established the Shawsheen Pottery*, were possibly associated with the Brush Guild,[6] the principal personalities were Mrs. Annie F. Perkins; her daughter Lucy F. Perkins (Ripley), a competent and trained sculptor who had studied for a time with Augustus St. Gaudens; and Mrs. C. B. Doremus of Bridgeport, Connecticut. A 1903 report indicates that "the Brush Guild was a sort of 'nom-de-kiln'" in acknowledgment of Brush's encouragement.[7] Four plates of their vases are pictured in the January 1903 issue of *The Craftsman,* and thereafter their pottery was regularly shown at exhi-

bitions, especially in New York City. One particularly noteworthy award was a Bronze Medal at the 1904 St. Louis exposition to L. F. Perkins for her handbuilt and modeled work.[8]

By 1908 the Perkinses had moved to Bridgeport, Connecticut, and continued to work there, producing a "brownware of metallic lustre."[9] It has not yet been established how long after that time they continued to work, and whether such work entailed use of the Brush Guild name.

A single example of Brush Guild work is in the collection of the Worcester Art Museum (#1903.8).

The mark of the pottery is as shown. The abovementioned example bears only an incised X and the inscription "Perkins" in red crayon on the bottom.

Brush Guild black terra cotta vase; h. 6" (15.3 cm). Incised X. *Worcester Art Museum (#1903.8).*

1. *Scribner's Magazine,* XXXIII (March 1903), p. 383; W. G. Bowdoin, *The Art Interchange,* L (April 1903), p. 89. Brush, a disciple of William Morris, shunned all use of machinery in the production of artware. He prohibited not only use of molds but also of the potter's wheel (*International Studio,* XI, August 1900, p. ix).
2. See W. E. Cox, *The Book of Pottery and Porcelain,* pp. 67-69; and W. P. Jervis, *The Encyclopedia of Ceramics,* pp. 204-05.
3. The brief account by C. F. Binns, *Pottery & Glass,* XII (March 1912), pp. 13-14, would appear to indicate a lack of understanding of the Guild's ambition to capture in their work the styles and early methods of the Etruscan potters.
4. The earliest noted exhibition of Brush Guild work was at the Guild of Arts and Crafts, New York City (*International Studio,* XIII, April 1901, p. 155). A note dated April 15, 1903 from the Brush Guild Studio, 126 West 104th Street, New York City, to the Worcester [Massachusetts] Art Museum, cautions against putting water into any of their wares "as the glazing is often imperfect—but if spar varnish is used they are all right."
5. Oliver Coleman, *The House Beautiful,* XIV (September 1903), pp. 240-42.
6. *Keramic Studio,* XIII (September 1911), p. 105.
7. Coleman, *op. cit.,* p. 240.
8. *Keramic Studio,* VI (April 1905), p. 269.
9. Clara Ruge, *Pottery & Glass,* I (August 1908), p. 6.
* Information relating to this pottery is included in a separate chapter

Buffalo Pottery
Buffalo, New York

The Buffalo Pottery, begun as an industrial enterprise of maximum efficiency, continued as such throughout its existence. It was organized in 1901, and the first kiln was fired two years later in October 1903. The pottery was an adjunct of the Larkin Soap Company of Buffalo and was established to satisfy the china and pottery premium needs of that company. Louis Bown, who until going to Buffalo represented the Crescent Pottery of Trenton, New Jersey, became the first general manager. He brought with him William J. Rea, who became the first superintendent of production. When it was built, the new factory at Seneca Street and Hayes Place was one of the few potteries in the world to be operated entirely by electricity.[1]

Production was completely molded either by jiggering or casting, and was decorated by both overglaze and underglaze methods. The pottery made all its own underglaze colors; as a result, completely new designs and colors could be attempted. Some objects were decorated by hand—primarily Abino ware and the firm's famous Deldare line—but most utilized decalcomania.

The distinctive Deldare body color was developed by Rea in 1905, but the line was not named Deldare until 1907.[2] "Deldare" refers to the

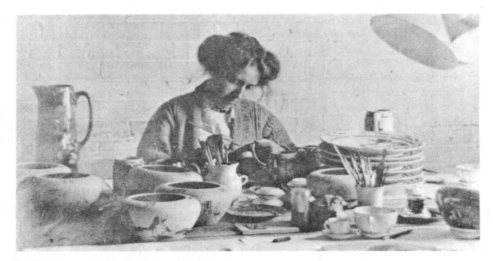

Buffalo Pottery decorator at work, 1909. *H. H. Larkin, Jr., and V. & S. Altman.*

Emerald Deldare ware vase, 1911; h. 8"
(20.4 cm). *V. & S. Altman.*

solid olive-green color of the body, obtained by adding a small percent-
age of oxide of chrome to the pottery's regular body,[3] and does not
indicate any particular style of decoration. The selection of scenes and
the original drawing of them was the work of Ralph Stuart, who was
head of the art department and supervisor of decorators until his
departure from the pottery in 1942. The bulk of early Deldare was
made in 1908 and 1909. In 1911 Emerald Deldare was introduced;[4]
due to its very limited production and superior design and decoration,
it is the most sought after of all the Buffalo ware. The firm reproduced
the Deldare line from 1923 until 1925, but because of the cost of labor
it was again discontinued. There is, however, no difference between
the ware of the two periods, and in some instances even the same
decorators were working at both times.

Each piece of Deldare was hand-decorated over a transfer print.
Work was carefully controlled and colors were applied according to a
rigidly prescribed pattern; the only latitude allowed the decorator was
in the positioning of the white clouds. Those pieces which were not up
to Deldare standards were classified as "seconds," "thirds," and
"fourths" and were sold at greatly reduced prices. A few of the dec-
orators, such as Stuart and Robert Helmich, were formally trained,
but most of the decorating staff had no such background. Approxi-
mately two dozen dinner plates could be executed by experienced
decorative artists in an eight-hour day, and at the peak of Deldare
production not more than fifteen such workers were on the staff.

Deldare, whose primary decorative motifs were Fallowfield Hunt

scenes, Ye Olden Days, Ye Lion Inn and Dr. Syntax, was not listed as a Larkin premium except in the 1922-23 catalog. Pieces of the ware, ranging from pitchers and plates to full drinking, tea and dinner sets, and including vases, bowls and candlesticks, commanded high prices in many of the leading stores throughout the country. A small teapot, for instance, cost $10.

Abino Ware was intended to supersede Emerald Deldare as the prestige line of the pottery. Produced between 1911 and 1913, it was hand decorated; as far as is now known, no transfer prints were used. Identical shapes were employed for both Deldare and Abino work, but decoration was entirely different in theme and color. For the most part the scenes were derived from Point Abino, a boating enthusiast's mecca on the Canadian shore a short distance from Buffalo. The sailboats often incorporated into the decoration are almost as much a signature as the imprinted block letters "Abino Ware."

Other lines were produced at Buffalo, but they would be of greater interest to the china and advertique collector than to the art pottery student.[5] In 1915 a change was made from semi-vitreous ware to vitrified china, and thereafter all pieces of vitrified china bore the "Buffalo China" mark instead of "Buffalo Pottery." While the pottery

"American Beauty" Emerald Deldare vase by M. Gerhardt, 1911; h. 13½" (34.4 cm). *V. & S. Altman.*

continues in operation today, its foremost line for the past half century has been varieties of institutional china. Of limited interest to some collectors because of the Buffalo Pottery background is the series of Christmas plates issued by the firm between 1950 and 1962, with the exception of 1961. In 1956 the name of the pottery was changed from the Buffalo Pottery to Buffalo China, Inc., thereby removing all trace of connection between today's factory and the producer of the hand-decorated artware.

The principal public collection of Buffalo Pottery and particularly of Deldare ware is at the Historical Society Museum, Buffalo.

Nearly all Deldare and Abino ware is dated and decorator-signed, either by initials or full name.[6]

Buffalo Abino ware vase by C. Harris, 1912; h. 6¾" (17.2 cm). *Mr. & Mrs. R. Stuart and V. & S. Altman.*

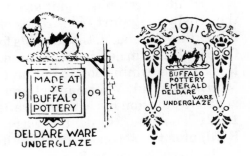

1. The principal account of the Buffalo Pottery is provided by Seymour and Violet Altman, *The Book of Buffalo Pottery*. Unless otherwise indicated, it and personal correspondence with the Altmans are the sources for the information herein presented.
2. *Crockery and Glass Journal*, LXVI (December 19, 1907), pp. 149, 196.
3. Dee A. Gernert, *Spinning Wheel*, XIX (March 1963), pp. 14-15.
4. Emerald Deldare was produced prior to 1911 (cf. Altman, *op. cit.*, plate 187, p. 108) but pieces do not carry the Emerald Deldare identification. In most instances these bear only the Buffalo Pottery mark and the date.
5. These are all studied in the Altman work and include Blue Willow and Gaudy Willow; Fish, Fowl and Deer sets; Historical, Commemorative and Advertising wares; Christmas plates; commercial services and railroad china.
6. A partial listing of decorators appears in Altman, *op. cit.*, pp. 81-82.

Byrdcliffe Pottery

Woodstock, New York

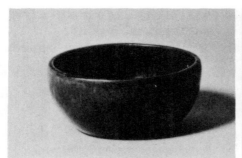 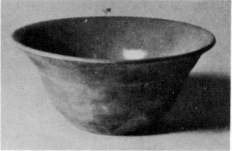

[left] Byrdcliffe bowl with dark glossy green glaze on part of outer surface extending into dull matt blue-green glaze; h. 2¾" (7.0 cm). Impressed mark. *The Newark Museum (#18.651).*

[right] Byrdcliffe bowl with interior glaze of light blue-green and exterior glaze of unevenly washed pink-lavender; h. 3½" (8.9 cm). Impressed mark. *The Newark Museum (#18.653).*

Byrdcliffe's establishment as an arts and crafts colony grew out of the rebellion against the inroads of the Industrial Revolution. Ralph Radcliffe Whitehead, the colony's founder, was a student of Ruskin at Oxford. He returned to the United States an enthusiastic disciple of Ruskin's determination to put an end to the factory system. William Morris and Walt Whitman both had an influence on Whitehead as he began to envision his arts and crafts colony, which came to fruition in 1902. The name "Byrdcliffe" was made up of his wife's middle name, Byrd, plus the second syllable of his.[1]

The first Byrdcliffe Summer School of Art was held in 1903, and among the projects undertaken was pottery-making. It is uncertain whether or not this was the beginning of the Byrdcliffe Pottery but Whitehead himself took an interest in ceramic work, and pursued and encouraged its continuation. In those early years of the twentieth century, Edith Penman and Elizabeth R. Hardenbergh of New York established the Byrdcliffe Pottery; they were later joined by Mabel Davidson. Charles Volkmar (Volkmar Pottery*) fired the first pieces, which were produced and characterized by pure handicraft; no wheel was used and later work was fired in open-air kilns. Color was the principal trait of the Byrdcliffe work, with the most noteworthy glazes designated "Byrdcliffe blue," "apple green," and "withered rose."[2]

Output, exhibited as early as 1907 at the New York Society of Keramic Arts, was well-received.[3] The 1916 *American Art Annual* lists all three principals at New York City addresses, Edith Penman and Elizabeth Hardenbergh then being associated with the Van Dyke Studios.[4] Each is given as Master Craftsman of The Arts & Crafts Society, Boston. The last noted exhibition at the New York Society of Keramic Arts was in 1922,[5] although work was evidently still being done as late as 1928.[6]

Examples of Byrdcliffe Pottery can be studied at The Newark [New Jersey] Museum.[7]

The mark, as shown, is usually impressed.

1. Evers, Alf, *The Catskills: From Wilderness to Woodstock* (Garden City, New York: Doubleday & Company, 1972), *passim.*
2. Notes of The Newark Museum. Several variant spellings are noted: Hardenburgh and Hardenberg; also Davison.
3. *Keramic Studio,* IX (June 1907), p. 41 (pictured, p. 39); Mira B. Edson, *Arts & Decoration,* I (April 1911), p. 260; *Keramic Studio,* XIII (May 1911), p. 8 (pictured, p. 10).
4. Florence N. Levy, ed., XIII.
5. *Keramic Studio,* XXIV (June 1922), p. 22.
6. *The Bulletin* of The American Ceramic Society, VII (September 1928), p. 298. By this time Zulma Steele (Parker), a protégée of Whitehead, was producing at Woodstock a pottery of her own which she designated *Zedware.*
7. Acquisition was made by the museum in 1918, their numbers 18.650-654.
 * Information relating to this pottery is included in a separate chapter

California Faience
Berkeley, California

The association which was to evolve into the California Faience Company was organized in 1916 by Chauncey R. Thomas and William Victor Bragdon. Bragdon was a ceramic engineer trained at the New York State School of Clayworking and Ceramics at Alfred and an early member of The American Ceramic Society.[1] After graduation in 1908 he taught ceramics at the University of Chicago (1909-12) and at the University City Pottery* (1912-14). He came to Berkeley in 1915 to join the faculty of the California School of Arts and Crafts.[2]

Thomas & Bragdon, as it was initially known, occupied an old store at 2336 San Pablo Avenue, Berkeley. The pottery was in a shed at the rear of the premises. By 1922 the pottery had relocated at 1335 Hearst Avenue and was known as The Tile Shop, a rather misleading name, since both tile and art pottery were produced. Two years later the California Faience designation was adopted as the firm name. Red-burning clays were used in the production of most ware although occasionally some buff-bodied artware is found. The art pottery was mostly cast; the tile and decorative inserts were made by hand-pressing in plaster molds.[3] Thomas was responsible for most of the glaze development, Bragdon for the technical aspects of the pottery including mold making.

The operation was slightly larger than its nearby neighbor and competitor, the Walrich Pottery*, with two or three men usually employed in addition to the owners. Two kilns were used: one, as at Walrich, was a Calkins (Pewabic Pottery*) Revelation kiln and the other a round down-draft kiln, thirteen feet in diameter and ten feet high, with a continuous bag-wall extending nearly to the crown. In the case of artware, the biscuit and glaze firing were often done together, the kilns being set so that the ware to be biscuited received the greater heat.[4]

The art pottery was primarily simple in design and execution, most often decorated with a monochrome matt glaze, although high-gloss glazes were also used. A considerable quantity of the output was devoted to florist ware, of which a large portion was shipped to eastern markets.[5] Tiles, on the other hand, were polychrome decorated. While there was no staff of designers, local talent was drawn upon, such as Stella Loveland Towne, who created a number of tile patterns. An

California Faience vases. From left to right: yellow ocher, h. 4" (10.2 cm); deep matt blue, h. 8" (20.4 cm); rose-lavender, h. 5" (12.7 cm); purple matt, h. 5½" (14.0 cm). All with regular mark. *National Museum of History and Technology (Smithsonian Institution; #290,235; 290,240; 290,238; 290,234).*

incised design was cut into a plaster-of-Paris mold into which clay was pressed. The raised portion of the design created natural raised lines of red clay which remained unglazed while the design was filled in with glazes—most often of the matt variety in turquoise, rose, yellow, blue and white. This decorative technique was also occasionally used on art pottery.

In the mid-1920s *California Porcelain* was produced by the firm but not for or at the pottery. The West Coast Porcelain Manufacturers of Millbrae, California, hired the staff of California Faience to develop and produce art porcelain in addition to their regular line of sanitary ware. Artware molds were produced. Bragdon and Thomas reworked the glaze formulas for the much more intense heat the glazes were subjected to at Millbrae. This work was continued for a little more than a year by Bragdon and Thomas, and it appears to have been carried on at Millbrae for a short time after they returned to regular work in Berkeley.[6] During this time the Berkeley operation continued to be run by other employees.

All production of artware ceased early in the Depression, and none was produced after 1930. Some tile work was resumed about 1932 for the Chicago World's Fair, but commercial artware was never again produced. The facilities of the pottery were used by local artists and amateur decorators who had their work fired in the kilns, and the firm sold glazes. For a time dolls' heads were cast and fired for Mrs. H. T. Epperson of the California Bisque Doll Company in Berkeley, who had her own employees glaze them at California Faience.[7] These were not marked California Faience, as the firm designation was not used on "outside" production.

Bragdon bought Thomas out in the late 1930s, and the latter relocated in Glendale, California. Bragdon continued to operate the business under the California Faience name, although no commercial artware was produced. He sold the operation in the early 1950s but continued to work for the new owners for a time. Bragdon died in 1959.

Examples of California Faience's earliest work, acquired in 1916, are to be found at the National Museum of History and Technology (Smithsonian Institution); other artware is at The Oakland Museum. A large variety of tiles is in the collection of The Newark [New Jersey] Museum.

The artware bears the incised California designation, which was apparently used even when the firm name was The Tile Shop.[8] Tiles were marked in a similar fashion, but with a hand stamp. California Porcelain was also incised in a manner identical to the California Faience artware. Occasionally tile work is found with a designer's cipher, such as that of S. L. Towne.

California
Porcelain

1. The first listing of Bradgon as an associate member appears in *Transactions* of The American Ceramic Society, IX (1907), which lists him as a student at Alfred.
2. Undated (c. 1936-37) Summer Session catalog of the California School of Arts and Crafts, Oakland. The two basic sources for the information herein presented, unless otherwise noted, are interviews with Stella Loveland Towne, a designer for California Faience, and David R. Schalchli, an employee of the pottery from 1922 until the early 1950s. Prior to his association with California Faience, Schalchli had worked for Arequipa* under Rhead, Solon and Wilde.
3. W. F. Dietrich, *The Clay Resources and the Ceramic Industry of California,* p. 39.
4. *Ibid.*
5. One of the eastern distributors was Howard G. Selden, an art and gift dealer in New York, according to *The Clay-Worker,* LXXXVI (July 1926), p. 56. It is difficult to ascertain Selden's relationship with the pottery. He appears to have been involved in other potteries of various designations such as Bybee Pottery Company of Lexington, Kentucky, and Tolbert Pottery of the same location, neither of which is known to have manufactured their own ware. It is possible that some of this work may have been produced by California Faience, although Schalchli doubted this, indicating that California Faience never used any other marks but their own on their work.
6. Dietrich, *op. cit.,* p. 216, notes that West Coast Porcelain "has recently developed a line of crystalline-glazed artware, and many attractive shapes and color schemes are being produced."
7. *Ibid.,* pp. 38-39.
8. A paper label on #290,231 in the Smithsonian's collection reads "California Faience/ Made at/ The Tile Shop/ Berkeley, Calif."
* Information relating to this pottery is included in a separate chapter

Cambridge Art Pottery

Cambridge, Ohio

In October 1900 it was announced that architect's plans for a new pottery in Cambridge had been approved and accepted.[1] Two months earlier The Cambridge Art Pottery Company had been incorporated in Ohio, organized by Charles L. Casey, who became its president and manager.

By February of the following year the plant was completed and production begun. Charles B. Upjohn, who had been a designer for Weller* and who later established the C. B. Upjohn Pottery*, joined the pottery as its designer and modeler. Chemists, responsible for the development of glazes, were George Cunningham and Frank Haws. They produced several fine glazes including red, brown and mulberry, as well as a number of successful blends.[2] Output of the pottery, made from local Guernsey County clays,[3] was the usual line of jardinieres, pedestals, umbrella stands, cuspidors, tankards and steins.

The first ware was offered in the spring of 1901;[4] artware, similar to the standard underglaze slip-decorated lines of other Ohio potteries, was introduced the following year and designated *Terrhea*.[5] Several artists were employed by the company during the short time Terrhea was produced, and their initials can be found on their work. Included was Arthur Williams, who also was associated with the Owens* and Roseville* potteries.[6] Another line was *Oakwood* (not to be confused with the Oakwood Pottery*), which was a similar brown-glazed ware without the slip underglaze decoration, and was probably sold as a less-expensive line. Experimentation was begun in 1902 in the production of cooking utensils with an earthenware brown body and a porcelain white lining;[7] when this line was publicly introduced in late 1903 it was designated *Guernsey*.[8] Another line introduced prior to 1904 was *Acorn*.

In 1904 the company began devoting the whole capacity of the plant to the production of the very well-received Guernsey kitchenware.[9] Evidently the desire to produce artware remained strong, and in 1907 a new line, *Otoe*, was introduced.[10] Otoe, a matt-green glazed ware in the then-popular style of Grueby*, made use of existing molds from the earlier period and probably required little additional financial outlay. At the Jamestown exposition in 1907 the Otoe and Guernsey wares were awarded first prizes.[11] For the most part Otoe is rather

pedestrian, although some pieces with a webbed effect in the matt green glaze are quite handsome. Manufacture of the line, the only artware then being offered, was discontinued in 1908, and the plant was again devoted exclusively to the production of the Guernsey kitchenware.[12]

The following year the name of the pottery was changed to The Guernsey Earthenware Company to reflect its primary product. At this time several incorporators of the original company formed The Cambridge Pottery Company, which was incorporated in Ohio, apparently for the continuation of artware production. It does not appear that any work was actually undertaken, and there are no listings for the company in the Cambridge directories.

Guernsey Earthenware changed ownership in 1925. It was operated for about a year as The Globe China Company, and then consolidated with The Atlas China Company of Niles, Ohio. The resulting corporation, The Atlas Globe China Company, was closed in 1933.[13]

Marks of Cambridge's art pottery were impressed, usually indicating the line designation as well as the Cambridge cipher. Occasionally an incised cipher (appearing somewhat similar to the incised Clifton Art Pottery* mark which was used on their Crystal Patina ware) is found on Cambridge's Terrhea line; and, as indicated above, artist's initials are sometimes to be noted. Pieces with the name Cambridge impressed and the firm cipher are also found, but it is unclear as to whether "Cambridge" was another line of artware. The Guernsey mark is usually imprinted. None of the pieces examined by the author have contained the Cambridge cipher within an acorn, as shown by Barber.[14]

Cambridge Art Pottery vase; h. 2⅝" (6.7 cm). Impressed mark/238. Artist signed "M.W." in slip. *K. & T. Dane.*

1. *Illustrated Glass and Pottery World,* VIII (October 1900), p. 14.
2. *Ibid.,* IX (February 15, 1901), p. 45.
3. William G. Wolfe, *Stories of Guernsey County, Ohio* (1943), p. 769.
4. *Crockery and Glass Journal* reports having received examples (LIII, May 30, 1901, p. 19).
5. *China, Glass and Pottery Review,* XI (August 1902), pp. 18, 20. W. P. Jervis, *The Encyclopedia of Ceramics,* p. 83, mistakenly identifies this as "Torrhea."
6. E. A. Barber, *Marks of American Potters,* p. 133; L. & E. Purviance and N. F. Schneider, *Roseville Art Pottery in Color,* plate 5.
7. W. Stout *et al., Coal Formation Clays of Ohio,* p. 62.
8. Advertised in *Crockery and Glass Journal,* LVIII (December 17, 1903), p. 137, and mistakenly reported as "Gournsey" by *The Clay-Worker,* XLI (May 1904), p. 644.
9. *Glass and Pottery World,* XIII (March 1905), p. 24; Cyrus P. B. Sarchet, *History of Guernsey County, Ohio* (1911), p. 502.
10. *Glass and Pottery World,* XV (March 1907), p. 29.
11. Sarchet, *op. cit.,* p. 502.
12. *Pottery & Glass,* I (August 1908), p. 22.
13. Wolfe, *op. cit.,* p. 770.
14. *Op. cit.,* p. 137.
 * Information relating to this pottery is included in a separate chapter

Chelsea Keramic Art Works

Chelsea, Massachusetts

The Chelsea Keramic Art Works was founded in 1872, when James Robertson and his son George W. joined with two of James' other sons, Alexander W. and Hugh C., to form a successor to A. W. & H. C. Robertson, as their enterprise was styled. That firm was itself a

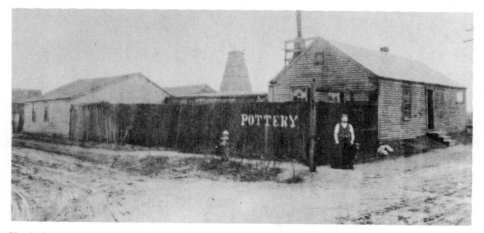

Hugh C. Robertson with dog Toby in front of Chelsea pottery, c. 1888. *Robertson family.*

successor to the original pottery established by Alexander in 1865 for the manufacture of brownware at the same location at Willow and Marginal Streets in Chelsea. When Hugh joined him in 1868, brownware was discontinued and the manufacture of plain and fancy flowerpots was substituted.[1] A single example of artware was made in 1868, but as the public was not attracted to it, the more profitable line of flowerpots and other utilitarian ware was pursued.[2] Contrary to other published information, pottery made during this period was not marked.[3]

Without doubt, the art pottery established in 1872 was one of the most important in the United States. James was the fourth generation of a family of potters with Scotch and English training. Until 1873 nothing in the way of artware was again attempted.[4] During that year several "antique" shapes were thrown, but it was not until two years later that the Robertsons' artware was offered for sale. In that year

46

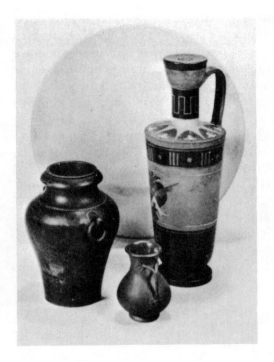

Group of early Chelsea redware. Miniature urn in forefront with oak-leaf handles and glazed interior was executed by A. W. Robertson in 1876, h. 2⅜" (6.0 cm); incised notations. The oil-finish, handled vase at the left is marked with the impressed cipher; h. 4½" (11.5 cm). The Greek tear vase was decorated by John Low and is unmarked; h. 8" (20.4 cm). In the rear is an undecorated redware plaque which is an excellent example of the remarkably fine texture of Chelsea redware; impressed two-line mark; 8" (20.4 cm) diameter. *Private collection.*

translations of ancient Greek terra cotta were produced and, for the first time, universally marked. A unique treatment of the remarkably fine-textured redware was developed in 1876 which consisted of polishing the ware with boiled linseed oil. For lack of public support, however, this line was shortly abandoned, and by 1878 all redware production was discontinued. Its replacement by a yellow or buff body marks the transition from the early to the middle period in the pottery's history.

Chelsea faience was introduced in 1877, making use of many of the outstanding glazes developed by the family over past years. It was this work which brought Chelsea to the attention of connoisseurs of the day. Shapes were classically simple; glazes for the most part were soft in color and have proven remarkably free from crazing. Some forms, however, give evidence of contemporary Victorian ideas of decoration, in which unrelated designs and shapes were applied to traditional bodies. All work was thrown, except pieces whose design required them to be molded, such as the flat-sided pitchers, vases and teapots; Hawes[5] designates these as "metal shapes", as they appear to have been inspired by the designs of the metal craftsman.

Other decorative techniques employed during this period include the hammering of the moist surface prior to firing, again adopting a style of the metal craftsman.[6] Another was the process called Bourg-la-Reine of Chelsea. It consisted of painting primarily on blue and

green grounds with colored slips in the manner of the Haviland faience, and was accomplished about the same time M. L. McLaughlin (Losanti*) was producing her first experimental pieces of underglaze slip-decorated ware. This type of work was not pursued at Chelsea as extensively as it was in Cincinnati. Natural flowers and grasses were pressed into the moist clay of vases and tiles, providing yet another means of decoration. When John G. Low, one of the students associated with the Chelsea pottery, left in 1878 to form the Low Art Tile Works* he used this process extensively. George Robertson left with Low and remained associated with him until 1890, when he founded his own firm, the Robertson Art Tile Company of Morrisville, Pennsylvania.

Only a few artists outside the Robertson family designed artware. In

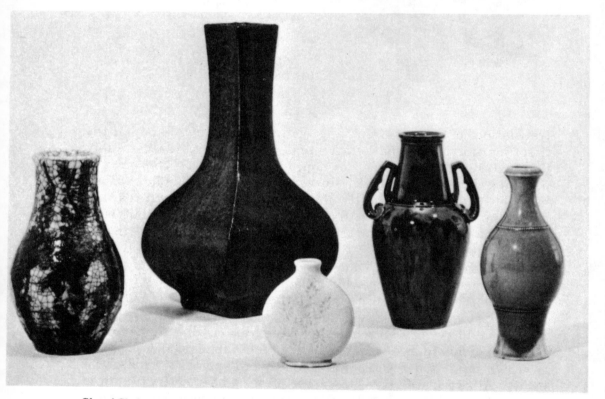

Glazed Chelsea artware, reading from left to right. Experimental crackle vase with modernistic design in blue and green (pictured in *The House Beautiful*, II, September 1897, p. 92); impressed cipher; h. 6" (15.3 cm). Metal shape with oxblood glaze; h. 9½" (24.2 cm); impressed cipher. The yellow snuff bottle was made in 1878 by George Robertson and is decorated with pressed natural flowers, a technique popularized by John Low in his early art tiles; h. 3" (7.7 cm); impressed cipher. The two-handled vase has a soft olive-green glaze and brown mottling; h. 6¼" (15.9 cm); impressed cipher. Apple-green vase with beaded decoration; h. 5¼" (13.4 cm); impressed cipher. *Private collection.*

the early period, in addition to Low,[7] G. W. Fenety, noted Boston artist, executed several pieces of redware, as did Franz X. Dengler[8] and Isaac E. Scott.[9] During the middle period Hugh Robertson's pupil and sister-in-law, Josephine Day, assisted and, as she grew up, did considerable artwork on her own.

By 1878 an unglazed line of about forty standard shapes was offered for sale to artists and amateur decorators, ornamented, polished, or in simple biscuit form.[10] It is uncertain whether these blanks were marked; it appears, however, that they might have been, since some pieces of a quality decidedly inferior to the high Robertson standards are sometimes found bearing the firm mark.[11] As at Rookwood*, the Robertsons fired amateur work along with their regular ware.[12] Commercial items such as earthenware pitchers, pots and stewpots were also produced at this time, but unmarked.[13] Standard shaped high-glazed predominantly monochrome ware was offered and sold in lots of a dozen for between $8 and $120, with the more expensive often individually decorated.

James Robertson died in 1880. The business continued to operate as before until Alexander Robertson went to California in 1884 (Roblin*). His departure marks the end of the middle period and the beginning of the late Chelsea period, when there was little commercial production and even more attention paid to unique accomplishments in the art pottery field.

Numerous new glazes were developed in the tradition of the finest Chinese periods, largely the result of Hugh Robertson's relentless search to discover the "lost" oxblood glaze. A high-fired stoneware body was developed and no ornamentation was used, allowing the superb glazes and simple shapes to be appreciated unmarred. Glazes developed included deep sea-green, apple-green, mustard-yellow and turquoise, in addition to the rich and very successful oxblood, which was first obtained in 1885 and finally perfected in 1888. Three hundred examples of the true oxblood were produced. Great confusion exists over this limited number, since many trial oxblood pieces are credited with being genuine *Robertson's Blood*. Only superior examples which are the color of "fresh arterial blood, possessing a golden lustre, which in the light glistens with all the varying hues of a sunset sky,"[14] should be so designated. Hugh Robertson felt the finest oxblood examples were the Twin Stars of Chelsea, now in the collection of the Museum of Fine Arts, Boston (#65.1709-10). According to Robertson, they, along with one perfectly colored peachblow vase, were his greatest achievements. Second to these was a pair of pigeon-feather oxblood vases. The peachblow and the pigeon feather vases are presently in private collections. These pieces, with his other work, earned top honors for the pottery wherever it was shown, including the expo-

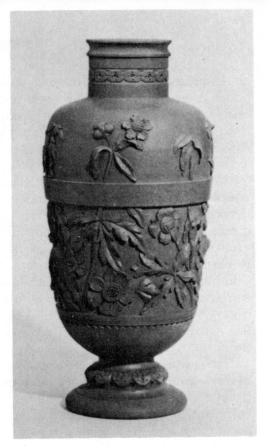

Chelsea Keramic Art Works terra cotta vase designed by G. W. Fenety, 1874; h. 14" (35.7 cm). Impressed cipher and full two-line designation. *Private collection.*

sitions in Paris (1900), St. Louis (1904) and San Francisco (1915).

Another important glaze achievement was the rediscovery of the Oriental crackle in 1886. The glaze, found by critics[15] to compare favorably with the centuries-old examples, was to become a hallmark of the Dedham Pottery*.

Devotion to artistic success in the classical tradition as practiced by the Robertsons at Chelsea did not provide the means for economic survival. Hugh's long period of experimentation and his discoveries were not without their price; in 1889, nearly penniless and without funds to buy fuel to fire the kiln, he closed the pottery. It was able to reopen only when the commercial Dedham-type ware was introduced in 1891, allowing for the inclusion of manufacturing techniques of the period.

The National Museum of History and Technology (Smithsonian Institution) and The Brooklyn Museum have two of the most extensive public collections of Chelsea pottery. Representative pieces are in the collection of the Chrysler Museum at Norfolk [Virginia] and the Worcester Art Museum.

Work produced prior to 1874 was not generally marked. The full two-line mark, with the top line slightly curved, was one of the first used.[16] It was followed by the full three-line style, which was used

until the death of James Robertson in 1880. The CKAW lozenge-shaped cipher was used from 1875 until 1889. The pottery designation was impressed, while decorator ciphers were most often incised. For a brief time the paper label was used on Dedham-type ware produced at Chelsea.

CHELSEA KERAMIC
ART WORKS
ROBERTSON & SONS.

1—Hugh C. Robertson 4—Franz Dengler
2—Josephine Day 5—Alexander W. Robertson
3—G. W. Fenety

1. E. A. Barber, *Popular Science Monthly,* XL (December 1891), p. 162.
2. Unattributed article from a local newspaper dated December 31, 1877.
3. The apparent source of such information is the article in *Antiques* (X, August 1926, pp. 116-21) by Mabel M. Swan, in which she indicated that such a mark had been adopted (p. 117).
4. J. Young, *The Ceramic Art,* p. 469.
5. L. E. Hawes, *The Dedham Pottery,* p. 19.
6. An excellent example of this work is a small covered redware urn in the collection of the Society for the Preservation of New England Antiquities, Boston (#1934.1969 a,b).
7. One of the finest examples of Low's work, a large two-handled redware urn, is in the collection of the Museum of Fine Arts, Boston (#77.248), a gift of James Robertson & Sons in 1877.
8. An example of Dengler's work is to be found at the Worcester Art Museum (#1899.12).
9. Four Scott vases made for the Glessner family are with the furnishings of the Glessner House in Chicago (see *The Arts and Crafts Movement in America 1876-1916,* ed. R. J. Clark, entry 170, p. 129).
10. Price List issued by the pottery in 1878.
11. Such pieces often bear the unidentified decorator's name or cipher. For a discussion of this and its resultant problems with regard to Rookwood, see H. Peck, *The Book of Rookwood Pottery,* p. 26.
12. Unattributed newspaper article entitled "A Study in Pottery," c. 1884.
13. Unattributed article from a local newspaper dated December 31, 1877.
14. E. A. Barber, *The Pottery and Porcelain of the United States,* p. 265.
15. An example of its reception is provided by Prof. Edward S. Morse, a noted authority of the day, whose favorable criticism appears in the Boston *Herald* of December 3, 1893.
16. A biscuit plaque bearing this mark is in the collection of the Smithsonian (#65.4).
 * Information relating to this pottery is included in a separate chapter

Chicago Terra Cotta Works
Chicago, Illinois

Decorative terra cotta work, although pursued in Europe since the fifteenth century, does not appear to have been introduced in the United States until after 1850. While most manufacturers turned their attention to architectural ornaments, several experimented with the production of terra cotta artware, a large portion of which was provided in the biscuit state for decorative artists and students.

Whereas in the Cincinnati area interest gravitated toward the slip-painted underglaze decorative technique, in the northeast interest centered on the decoration of translations of classical forms, especially Greek. This is evident in New England in the earliest work of the Chelsea Keramic Art Works* and that offered by the A. H. Hews & Company pottery at Cambridge.[1] Fine terra cotta was produced in New York by the Halm Art Pottery*, and about the same time the Hudson River Pottery (William A. MacQuoid & Company) began producing such items for decorators.[2] In Pennsylvania both Moorhead & Wilson[3] of Spring Mills and Galloway & Graff[4] (later known as the Galloway Terra-Cotta Company) of Philadelphia supplied terra cotta blanks for decorators, but the latter's output gradually evolved into an extensive line of decorative garden pottery, while little is recorded about the former.

This type of work was not limited entirely to the northeast. One of the earliest terra cotta firms outside that area was the Chicago Terra Cotta Works, established in 1866. Three years later the pottery, located on Laflin N.W. at the corner of Catherine Street, had seventy-five employees.[5] The services of James Taylor, an English potter (who shortly thereafter became the Chicago firm's superintendent), were secured in 1870.[6] Under his direction production included architectural ornamentation, statuary, and garden, lawn, and park ornaments. In addition, a line of unglazed terra cotta vases was produced between 1876 and 1879. There is no listing for the firm in the Chicago directory for 1880, and Taylor was reported as superintendent of the New York Architectural Terra-Cotta Company at the end of 1885.[7]

In the Chicago area two other terra cotta manufacturers also produced artware after Chicago Terra Cotta's early endeavor, the most successful being the Teco* work of the American Terra Cotta and Ceramic Company. The Northwestern Terra Cotta Company*, proba-

Chicago Terra Cotta vase; h. 5¼" (13.4 cm). Impressed mark. *National Museum of History and Technology (Smithsonian Institution; #96,676).*

ble successor to Chicago Terra Cotta, also executed an art pottery line of short duration.

Several examples of the artware of Chicago Terra Cotta are in the collection of the National Museum of History and Technology (Smithsonian Institution), gifts of Sanford E. Loring, firm president.

Not all work of the firm was marked; that which was marked bears an impressed style as shown.

CHICAGO TERRA COTTA WORKS, 1876

1. See L. W. Watkins, *Early New England Potters and Their Wares*, pp. 43-44; 222-23. Also, E. A. Barber, *The Pottery and Porcelain of the United States*, pp. 88-90. It would appear that Hews' primary art work was in supplying unmarked terra cotta blanks to the decorating trade, as was the case with Galloway & Graff, and hence it is not considered extensively here.
2. J. Young, *The Ceramic Art*, p. 457, indicates such work was begun about 1876, but it was short-lived, as W. C. Ketchum, Jr., *Early Potters and Potteries of New York State*, p. 39, reports the works closed in 1879.
3. All work at the pottery of A. S. Moorhead and William L. Wilson had apparently ceased by the turn of the century.
4. The firm was organized in 1868, continuing a business established in 1810. See *The Clay-Worker*, XXXI (April 1899), p. 342-43; also LX (December 1913), p. 688.
5. *The Industrial Interests of Chicago* (1873), p. 142. H. Ries and H. Leighton, *History of the Clay-Working Industry in the United States*, p. 82, cite an establishment date as early as 1857, but this is apparently a misreading of Barber.
6. Barber, *op. cit.*, pp. 385-86. Taylor should not be confused with the other James Taylor, also an English potter who worked at the American Pottery Company, and who appears to have turned his attention to white granite ware in East Liverpool and Trenton; Barber himself seems to have fallen victim to this confusion (cf. *ibid.*, p. 444).
7. *Ibid.*, pp. 388, 390.
* Information relating to this pottery is included in a separate chapter

Cincinnati Art Pottery

Cincinnati, Ohio

Cincinnati Art Pottery ewer, deep yellow ground with gold decoration. Made from the same mold later used by Dell (see Dell illustration); h. 11¹³/₁₆" (30.1 cm). Impressed Kezonta mark.
National Museum (Smithsonian Institution: #379.598).

The Cincinnati Art Pottery—not to be confused with an earlier Cincinnati Pottery Company[1]—was established in 1879, apparently to provide new capital to the Coultry-Wheatley combine.[2] This partnership at the Coultry Pottery* was dissolved early in 1880, and by April of that year T. J. Wheatley established the T. J. Wheatley & Company* enterprise in Cincinnati. The Cincinnati Art Pottery was formally incorporated in the State of Ohio on December 24, 1880 by A. T. Voll, Ed. Bohnert, T. J. Wheatley, John M. Foster and J. D. MacNeale, undoubtedly to provide additional funds for the expansion of Wheatley's work in the underglaze decorated Cincinnati faience. The name Cincinnati Art Pottery was not generally used, however, until after T. J. Wheatley severed his connection with the works in 1882.[3]

It does not appear that Cincinnati faience was produced after Wheatley's departure in 1882. Two years later Cincinnati Art Pottery's capital was increased by $30,000, and this is presumably when Frank Huntington became president of the firm.[4] By that time the lines of *Hungarian faience* and *Portland blue faience* had been successfully introduced. The latter was so named on account of its rich dark blue glaze, simulating the color of the famous Portland vase, and offering an excellent contrasting ground for the overglaze gold decorative effects often employed. Similar gold highlighting was used on the Hungarian faience, consisting of in-mold designs which were then painted by decorators in varied colors including pastel blue, pink and yellow, dark blue and black on a light background.

The highest achievement of the pottery was its *Kezonta* ware. These ivory-colored faience vases and bowls were decorated with gold scroll-work and natural-colored flowers, particularly chrysanthemums. Kezonta ware was produced until operation of the pottery ceased in 1891. William Dell, manager of the Cincinnati Art Pottery, thereafter used some of the molds—especially of the Hungarian faience line—at the Wm. Dell Pottery*.

Examples of each of the lines of the Cincinnati Art Pottery are to be found in the collection of the Cincinnati Art Museum. Two well-executed Kezonta pieces are in the Benjamin collection of the National Museum of History and Technology (Smithsonian Institution).

The first mark adopted after the shift from the T. J. Wheatley & Company designation was the impressed "C.A.P./Co."[5] Barber[6] indicates another early mark was a lone impressed turtle (the Indian name for turtle being *kezonta,* hence the use of that name by the pottery), although no example of this mark without the later Kezonta designation in addition has been noted by the author. According to Barber,[7] the Kezonta designation was sometimes printed in red on the finer grades of ware and impressed on the plainer wares furnished to the decorators who worked both at and outside of the pottery. Many pieces were not marked at all, although attribution—especially of the Hungarian faience line—is relatively uncomplicated.

1. H. Ries and H. Leighton, *History of the Clay-Working Industry in the United States,* p. 122.
2. E. A. Barber, *The Pottery and Porcelain of the United States,* pp. 299-300.
3. Several pieces in the collection of the Cincinnati Art Museum appear to refute this, especially #1915.29 and #1881.26, both of which bear an incised "C.A.P.", the former being dated 1879, the latter 1881. These incised initials indicate the decorator, Mrs. C. A. Plimpton, and *not* the Cincinnati Art Pottery. Another piece, #1881.39, bears the impressed Cincinnati Art Pottery mark, but this was made late in 1882 by the pottery after Wheatley had left (see the extensive explanation of the anomaly of the accession date predating the date when the piece was made in note 13 of the chapter on T. J. Wheatley & Company). The first listing in the Cincinnati directories for the Cincinnati Art Pottery, as such, is in 1883, and the first located reference to the Cincinnati Art Pottery, as such, occurs in *Crockery and Glass Journal,* XVI (September 21, 1882), p. 46, with the reference to "the Cincinnati Art Pottery (Wheatley)" exhibit at the Tenth Cincinnati Industrial Exposition.
4. Huntington was evidently the chief financial backer of the Cincinnati Art Pottery and became the firm's successor upon the termination of the pottery's existence. Extensive research has been unable to substantiate E. A. Barber's (*op. cit.,* p. 300, and *Marks of American Potters,* p. 125) association of Huntington with the pottery as early as its formation in 1879. The first listing of Huntington as a Cincinnati Art Pottery officer in the Cincinnati directory is in 1885, when he is given as president.
5. Barber (*Marks,* p. 125) indicates this was a late mark, introduced in 1890. However #1881.39 (discussed above in note 3) in the collection of the Cincinnati Art Museum refutes this; that piece, bearing the initial cipher, was produced in 1882.
6. *Pottery and Porcelain,* pp. 302, 412.
7. *Marks,* p. 125.
* Information relating to this pottery is included in a separate chapter

Clewell Metal Art

Canton, Ohio

C. W. Clewell inspecting an example of his work. *The Canton Art Institute.*

During the years of art pottery production there was an eclecticism of technique as well as of style. Some of the most influential "outside" techniques employed in the ceramic field were borrowed from then-contemporary metal craftsmen, who were experiencing a renaissance of their own, as well as from much earlier metal forms. Some of the metal shapes produced by the Chelsea Keramic Art Works* as well as their hammering of moist clay to produce a "hammered" ware are illustrative of this. Metal sculpture, especially that of Rodin, can be seen as an influence, particularly in the work of Van Briggle*. Finishes on metal, often the effect of natural decomposition processes, also inspired art potters to attempt to reproduce these on their wares. Work imitating burned bronzes was produced by the Florentine*, Markham* and J. W. McCoy* potteries, while Weller's* Coppertone and Clifton's* Crystal Patina tried to capture the oxidization of copper and bronze respectively. Considerable support can be found even for

the hypothesis that there was a direct relationship between this metal-art influence and the matt green craze which swept the United States in the wake of Grueby's* initial success, as being another attempt at the reproduction of an oxidized surface on clay. Nor was the application of a metallic coating to ceramics a new technique—the various lusters having been popular for several centuries—but Clewell's work appears to have been the first of the period to totally mask the ceramic body with a metal coating (a technique later employed in the production of Tiffany's* Bronze Pottery). Charles Walter Clewell opened his studio about 1906.[1] By early 1909 he was advertising ceramic objects with copper, burnished copper or silver metal finishes.[2] Clewell was not a potter, he was a metalworker. From the Weller, Cambridge*, Owens*, and Knowles, Taylor and Knowles potteries were reportedly purchased bisque blanks upon which a thin, skintight shell of metal was deposited. Sometimes these coatings would be hammered, a technique used especially in early stein and tankard sets.

In an effort to introduce color to his work, Clewell experimented with oxidation of the copper and patination of the bronze coatings. He developed techniques to chemically induce the changes, and to stop the action when the desired effect and contrast with the tarnished, darkened metal surface was achieved. If allowed to continue, the chemical process would produce a velvety matt-green or a light blue-green surface, two colors on which Clewell was to concentrate in his later work. Cast bronze vases and jardinieres designed by Clewell were also produced at his studio.

Early Clewell ware, ceramic base probably Owens; h. 14" (35.7 cm). Impressed Clewell Metal Art designation. *Private collection.*

Two Clewell vases: h. 11¼" (28.6 cm); h. 8⅞" (22.6 cm). *The Canton Art Institute (#399, 96), gifts of C. W. Clewell.*

Clewell, a Master Craftsman in The Society of Arts and Crafts, Boston, was awarded the Diplome de Medaille d'Argent at the 1937 Paris International Exposition. His artwork was interrupted when, from 1942 until the early 1950s, he was employed by the Timken Roller Bearing Company. He returned to his metalware for a brief time before retiring altogether. Clewell, who died in 1965 at the age of eighty-nine, always operated a small shop, with little help. He felt that no one could do his artwork as he did it, and hence, never taught his process to others.[3]

A collection of the Clewell work, all of the bronze variety, can be found at The Canton [Ohio] Art Institute, the gift of Clewell in 1943-44. At The Newark [New Jersey] Museum are two pieces (#26.11 and 27.422), one of which has had an incision made at the base so the structure can be studied.

Clewell's work was normally marked, the most common being the incised designation. Several less-common impressed marks are also shown. In some instances the mark of the pottery, such as Owens or Weller, from which the ceramic blanks were secured also appears on the base.

1. The Canton directories first list the Clewell Studio in 1906-07, located at 1951 East 9th. No evidence has thus far been produced to substantiate the claim that Clewell worked in Zanesville, Ohio, or ever produced a line of artware for any of the Zanesville firms. As noted in the concluding paragraph of this chapter, occasionally pieces are found which bear both the Clewell name and that of the pottery furnishing the ceramic blanks which Clewell decorated.
2. *Pottery & Glass,* II (February 1909), p. 83.
3. "The Bronze Production of C. W. Clewell of Canton, O."; privately printed brochure.
* Information relating to this pottery is included in a separate chapter

Clifton Art Pottery

Newark, New Jersey

The Clifton Art Pottery was established in 1905 at 51 Clifton, Newark, by Fred Tschirner, a chemist and graduate of the University of Berlin and the University of Michigan, and William A. Long, an organizer of the Lonhuda Pottery* in 1892 and later of the Denver China and Pottery Company* in 1901. The first kiln was fired in October of that year,[1] and for the length of the firm's existence employees rarely exceeded a dozen at any one time.[2]

Two distinct types of pottery comprised the principal production and are most associated with the name "Clifton". The first was designated *Crystal Patina*. Produced since the first kiln, it had a dense white body, resembling true porcelain, which was decorated with a pale green subdued-crystalline glaze; its likeness to the green oxidation of bronze suggested the line name. Later a variety of pale semi-matt colors was used including yellow, green and tan.[3] The glaze treatment most often was such as to create a flowing effect and the successful blending of the colors.

The second principal line, introduced in mid-1906, was the *Clifton Indian Ware*. Form and decoration for this were reproduced or adapted from the pottery of American Indians, using as a ground the unglazed native New Jersey red clay body.[4] The interior of the vessel was then usually coated with a high-gloss jet black glaze to make it impervious to water. Clifton's Indian ware appears to be the first large-scale

W. A. Long working at his Clifton studio in 1906. *Crockery and Glass Journal.*

production of this kind of work, and its success undoubtedly led to the imitation of it by Owens* and Weller*.[5] Output of this line consisted of vases, jugs, mugs, jardinieres, pedestals, fern dishes, candlesticks and umbrella stands;[6] the ware served as the basis for a line of souvenir pieces, as it did for a line of cooking utensils also.

Several other lines were offered by Clifton, including a matt-glazed ware with the same dense white body as the Crystal Patina, glazed most often in a pale blue and designated *Robin's-egg Blue* by the firm.[7] A later line was *Tirrube,* of matt ground with flowers of conventional form in light-colored slip.[8] A line of low-relief Art Nouveau designs was produced for a time, somewhat similar in style to Denver China and Pottery's Denaura.

Clifton artware, reading from left to right. Pink and white mottled vase dated 1905, h. 5⅞" (15.0 cm); incised Clifton, impressed shape number 142. Crystal Patina vase, h. 9⅜" (23.9 cm); incised Clifton CAP cipher and 1906, shape number 156 impressed. Clifton Indian Ware, h. 2¾" (7.0 cm); impressed Clifton/Mississippi and shape number 213, incised cipher. *Private collection.*

Long returned to Ohio in 1909 and joined the staff of Weller. He remained there for several years and in 1912 was listed in the Zanesville directory as in the employ of the Roseville Pottery*. Two years later he worked for the American Encaustic Tiling Company at Zanesville. He died in Cincinnati in 1918.[9]

Clifton continued to produce art pottery until 1911,[10] when it was last shown at the eighteenth annual exhibition of the New York Society of Keramic Arts that February.[11] Work shifted to the production of porcelain-fired wall tile and vitrified floor tile in all colors, using the leadless glazes developed by Charles Stegmeyer. The Steg-

Clifton vase with molded fish decoration; h. 3½" (8.9 cm). Incised Clifton/1906; shape number 108. *New York, private collection.*

meyer process, in addition to eliminating the continuous hazard to the workers of lead poisoning, was also advertised as offering a non-crazing product at a price considerably below that of the so-called flint tile.[12] By 1914 the name had been changed to the Clifton Porcelain Tile Company, reflecting the change in emphasis of production.[13]

Examples of Clifton's work are included at both The Newark Museum and the National Museum of History and Technology (Smithsonian Institution); the former's collection is the more extensive.

The Clifton designation is usually found incised on the Crystal Patina and impressed on the Indian ware. In addition to the impressed mark on the Indian ware there is often some indication of the location of the Indians from whom the shape or design was derived (e.g., Missis-

Clifton Tirrube vase with nasturtium decoration; h. 8½" (21.6 cm). Incised Clifton; shape number 140. *Mr. & Mrs. Zane Field.*

61

sippi, Arizona). One of two ciphers is found on Clifton's work: style A appears on the Crystal Patina ware, style B on the Indian. Two imprinted marks were also used, that designating the "Clifton Indian Cooking Ware" and the large "C" mark similar to that of the Craven Art Pottery*. Shape numbers are found impressed, the 100 series usually applying to shapes of the Crystal Patina line, the 200 series to Indian ware shapes. Early pieces are often dated.[14]

 CLIFTON

STYLE A STYLE B

1. A few pieces from this first kiln have been noted, one of which is in the collection of the New Jersey State Museum, Trenton (#67.78.2).
2. *The Clay-Worker,* LVIII (April 1912), p. 638.
3. *American Pottery Gazette,* V (May 1907), p. 12.
4. E. A. Barber, *The Pottery and Porcelain of the United States,* pp. 572-73. A single example on a buff body has also been noted in the collection of the Newark [New Jersey] Museum (#16.152). It is presumed that this was an experimental effort and that Indian Ware was not produced on a buff body on any regular basis.
5. Use of Indian designs by Clifton was not the first on art pottery of the United States. H. Peck (*The Book of Rookwood Pottery,* p. 15) indicates that Indian designs were experimented with at Rookwood about 1881. It is the contention of Marion John Nelson (*Antiques,* LXXXIX, June 1966, p. 846-50) that such interest as Long's in Indian pottery and the underglaze slip-decorated faience ware is not as unrelated as might first appear, and that there is a direct relationship between the Ohio artware such as Lonhuda and American Indian pottery.
6. *Crockery and Glass Journal,* LXIV (August 30, 1906), p. 26. It was noted that where no prehistoric originals existed, work was modeled and decorated in a manner identical with pieces for which such existed. For an extensive illustration of this line see *ibid.,* p. 13.
7. M. Benjamin, *American Art Pottery,* pp. 19-20.
8. *Pottery & Glass,* II (January 1909), p. 34.
9. N. Schneider, Zanesville *Times Recorder,* February 7, 1971, p. B-1.
10. *The Clay Products of New Jersey at the Present Time,* exhibition catalog of The Newark Museum, 1915, pp. 15-16.
11. Mira Burr Edson, *Arts and Decoration,* I (April 1911), p. 260; *Pottery & Glass,* VI (March 1911), p. 14; *Keramic Studio,* XIII (May 1911), p. 8.
12. *The Clay-Worker,* LXII (October 1914), p. 409; *ibid.,* LXII (December 1914), p. 629; *Keramic Studio,* XVI (January 1915), p. 179.
13. The first listing in the Newark directories reflecting the name change occurs in 1915. The pottery was formally incorporated in New Jersey under this title on August 5, 1914.
14. There should be little confusion with the Clifton designation used by the D. F. Haynes pottery of Baltimore in the late 1880s on their Clifton ware. That mark, as illustrated by E. A. Barber, *Marks of American Potters,* p. 148, consists of a double crescent with the name "Clifton" in the upper portion and the D. F. Haynes cipher in the center.

* Information relating to this pottery is included in a separate chapter

Cook Pottery

Trenton, New Jersey

The Cook Pottery Company was incorporated in 1897 after formation three years earlier, when it acquired the Etruria works of Ott & Brewer in Trenton. The latter firm traced its history back to 1863, when the Etruria Pottery was established by Ott and others. John H. Brewer joined the firm in 1865, and shortly thereafter it became known as Ott & Brewer. Until 1875 the chief products were white granite and cream-colored ware. In that year several parian busts modeled by Isaac Broome were produced by the firm for exhibition at the Centennial Exposition.[1] In 1882 the pottery became the first to begin the manufacture of Belleek ware in the United States.[2] Excellent work was done. Business remained good until the combination of an extensive pottery workers' strike in Trenton and the Depression of 1892 forced its closure.

Charles Howell Cook, head of the Cook Pottery, had been involved in the Trenton potting scene for some time. In 1881 he and W. S. Hancock established the Crescent Pottery for the manufacture of sanitary and cream-colored wares. The firm became one of the leading potteries of Trenton; in 1892 it combined with the Delaware, Enterprise, Empire (Coxon & Company) and Equitable potteries to form the Trenton Potteries.

Cream-colored and white granite wares were produced, as were an American Belleek[3] and an American Delft line. Barber rated the firm's Etruria Delft as the "best imitation of the old Dutch faience which has been produced in this country."[4] A great deal of the cream-colored ware was decorated with transfer prints.[5] The Delft line, introduced in 1896, was often hand-painted, frequently by P. Paul Gasper. In 1898 underglaze decorated ware was introduced, with six to eight colors used on the flower work. One of the notable accomplishments of this line, according to Barber, was the achievement of distinct shades of carmine and pink beneath the glaze.[6]

By 1906 Cook was producing some fine soft-glazed art pottery. *Nipur ware,* a matt glaze over a textured surface, was developed to resemble pieces of pottery exhumed from the ruins of the ancient city of Nippur.[7] A second line of art pottery from the same period was *Metalline ware,* which had a smooth surface with muted metallic glazes. These lines were possibly the result of work by Harrold P.

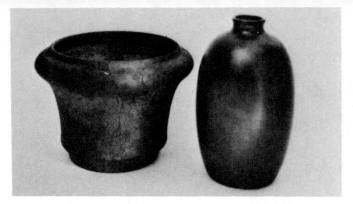

[left] Cook Pottery Nipur ware jardiniere, cedar green and purple with touches of iridescence; h. 8 1/8" (20.7 cm). Marked "Nipur". *National Museum of History and Technology (Smithsonian Institution; #244,542).* [right] Metallic maroon (deep cranberry color) glazed vase, Cook's Metalline ware; h. 10 3/4" (27.4 cm). Marked with overglaze "C". *National Museum of History and Technology (Smithsonian Institution; #244,543).*

Humphrey, the ceramic chemist employed at the firm at that time.[8] Art pottery production does not appear to have been very extensive; the company devoted its primary attention after the early years of the twentieth century to the manufacture of hotel china. Charles Cook retired from the business in 1926.

An example of each of the two art pottery lines is in the collection of the National Museum of History and Technology (Smithsonian Institution): Nipur ware (#244,542) and Metalline ware (#244,543). Both were a gift of the Cook Pottery in 1906.

Work is marked on the base with a "C" in a metallic yellow glaze.

1. A number of examples of such work by Broome, including the bust of Cleopatra and the Baseball Vase, are in the Brewer collection of the New Jersey State Museum, Trenton.
2. E. A. Barber, *Marks of American Potters*, pp. 52-54.
3. A large portion of their Belleek-type work was offered to china painters. "Some vases and ewers," Barber observed in *The Clay-Worker*, XXII (November 1894), p. 429, "with full relief modeling of the cactus and the lotus are among the best original designs produced by this firm. By using the natural tints of the plant, green and pink, and employing dainty colors and gold on the swell of the body, most artistic effects are obtained."
4. *Marks*, p. 54. A ten-page booklet with blue half-tone illustrations of this line including jardinieres and pedestals, plates, ewers and bowls "which are modeled with an artistic freshness and a departure from beaten paths which is delightful in these days of mass duplication" was reported by *China, Glass and Lamps*, XI (April 1, 1896), p. 20.
5. A particular example of this work, a pitcher made to commemorate Dewey's victory at Manila in May 1898 during the Spanish-American war, is in the collection of the New Jersey State Museum, Trenton.
6. *The Pottery and Porcelain of the United States*, p. 487.
7. *Crockery and Glass Journal*, LXIV (December 20, 1906), pp. 163-64.
8. Directory of The American Ceramic Society, *Transactions*, VII (1905).
* Information relating to this pottery is included in a separate chapter

Corona Pottery

Corona, New York

After leaving the Vance/Avon Faience* pottery in mid-1903, William P. Jervis opened a studio at the Corona Pottery of Anton Benkert, at 64 Metropolitan Avenue. Little record is found of what type of work was done there by Jervis other than that it was of an art pottery nature.[1] Benkert was a producer of stoneware.[2]

In early December of that same year, with a large stock of ware ready to place on the market,[3] the pottery was destroyed by a fire which caused an estimated $10,000 loss to the buildings and their contents.[4] At first it was thought that Jervis would use the old Volkmar Pottery* plant at Corona, vacated by Volkmar a short time earlier,[5] but instead he joined the Rose Valley Association.*

Marked examples are unknown at this time.

1. *Crockery and Glass Journal,* LVIII (December 17, 1903).
2. H. Ries, *Clays of New York: Their Properties and Uses,* p. 823.
3. *Crockery and Glass Journal,* LVIII (December 17, 1903).
4. *The Clay-Worker,* XLI (January 1904), p. 26; *China, Glass and Pottery Review,* XIII (January 1904), p. 33.
5. *Crockery and Glass Journal,* LVIII (December 17, 1903).
 * Information relating to this pottery is included in a separate chapter

Coultry Pottery
Cincinnati, Ohio

The Coultry Pottery was established in 1859 as the Dayton Street Pottery by Samuel Pollock for the manufacture of Rockingham and yellow ware. After a successful career, Pollock died in 1870, and the business was conducted by his family until 1874, when Patrick L. Coultry took it over.[1]

Had it not been for a visit to the Coultry works, at 53-59 Dayton Street, in September 1877 by M. Louise McLaughlin (Losanti*), Coultry's reputation might have rested on his production of yellow ware and antique cream-colored pottery in Egyptian, Greek, Etruscan and Roman forms.[2] McLaughlin's successful execution of underglaze-decorated ware after the manner of Haviland's faience during the next several months made the Coultry operation the first in Cincinnati to produce such work. Newspaper publicity accompanying the McLaughlin achievements drew considerable attention to the pottery, and by early 1879 Coultry had taken the young artist T. J. Wheatley* into the firm to decorate ware for the pottery and to teach a class in the faience decorating process.[3] Students in that course included John Rettig, his brother Martin (who was for a short time after 1883 a decorator at Rookwood*) and Matt Daly.[4]

The association of Coultry and Wheatley lasted less than a year. In the spring of 1880 Wheatley established his own works on Hunt Street, where all the processes including the preparation of the clays, molding, glazing, firing and decorating were done by him.[5] During the same spring John Rettig and Albert R. Valentien taught a class in the execution of Cincinnati faience, using bodies produced and fired at the Coultry works.[6] The style and technique of Rettig and Valentien were

extremely similar to those of Wheatley: "the same colors predominate; similar treatment is manifest."[7]

Thus, by 1880 there were three rival operations producing Cincinnati faience: the Coultry Pottery with its facilities the basis of the Rettig-Valentien "Limoges Class"; the Dallas Pottery*, where the Pottery Club did its work, and which in early 1880 hired a decorator of its own; and the newly established pottery of T. J. Wheatley. Before the year's end a fourth, the Rookwood Pottery, was to appear.

The Coultry works continued their regular production of yellow and Rockingham-type ware as well as the regular firing of Cincinnati faience for the amateur decorators,[8] some of whom had attained the perfection of the professional decorator.[9] Business was so good that plans were drawn up for a new plant, The Ironton Pottery, at Ironton, Ohio.[10]

By the middle of 1882 the decorated-ware crush was reported as "practically played out . . . so far as it is a profitable business."[11] Within a year's time the Dallas Pottery, T. J. Wheatley & Company and Coultry's Cincinnati works had all ceased operation.[12] The extensive Ironton Pottery, whose plant covered almost an entire acre, was sold at a sheriff's sale in October 1882—after the building was completed, but prior to the installation of the machinery.[13] Coultry gave some consideration to resuming business,[14] but this apparently never materialized.

The principal collection for the study of Cincinnati art pottery of this period (1877-82) is at the Cincinnati Art Museum.

During the time when Cincinnati faience was produced at Coultry's,

a great deal of amateur work was done. Little of this output bears the potter's mark, the decorators usually incising their own identification when the clay was green. Several pieces of M. L. McLaughlin's work in the collection of the Cincinnati Art Museum (esp. #1881.44)[15] which can definitely be established as having been potted and fired at Coultry's bear her signature but no indication of the pottery. Pieces produced by the Rettig-Valentien Limoges Class usually bear incised an R-V and occasionally can be found with the decorator identification and the 1880 date. A single example bearing an incised Coultry designation, also in the collection of the Cincinnati Art Museum (#1970.573), is not of the Cincinnati faience type but rather has an applied decoration.

R-V

Coultry

Exceptional example of work by student in the Rettig-Valentien Limoges Class; h. 12" (30.5 cm). Incised R-V and dated 1880. *Luther collection.*

1. W. Stout *et al., Coal Formation Clays of Ohio*, p. 20.
2. *American Pottery and Glassware Reporter*, I (September 11, 1879), p. 10.
3. M. L. McLaughlin, *The Bulletin* of The American Ceramic Society, XVII (May 1938), p. 224. The first piece of Cincinnati faience by Wheatley was fired at Coultry's in April 1879, according to the Cincinnati *Daily Gazette*, October 7, 1880.
4. McLaughlin, *op. cit.*, p. 225; also *Crockery and Glass Journal*, X (November 20, 1879), p. 28.
5. Mrs. Aaron Perry, *Harper's New Monthly Magazine*, LXII (May 1881), pp. 834-45.
6. *Crockery and Glass Journal*, XI (June 24, 1880), p. 4. A listing of the initial members of the class is given in *ibid.*, XI (March 18, 1880), p. 28. For examples of the work of this class, see *Spinning Wheel*, XXVIII (September 1972), p. 17. 1972), p. 17.
7. *Crockery and Glass Journal*, XII (September 16, 1880), p. 10.
8. *Ibid.*, XIII (February 10, 1881), p. 26.
9. *Ibid.*, XV (March 2, 1882), p. 14.
10. *Ibid.*, XIV (July 7, 1881), p. 21.
11. *Ibid.*, XVI (August 3, 1882), p. 12.
12. The Coultry works, after having been closed for almost a year (Cincinnati *Enquirer*, April 9, 1884, p. 4), was destroyed by fire. Another account of the same date appears in the Cincinnati *Daily Times Star*, p. 2.
13. The Ironton *Register*, January 12, 1882, and October 26, 1882.
14. *Crockery and Glass Journal*, XVIII (September 27, 1883), p. 44.
15. This particular piece, actually dated 1877 but drawn from the Coultry kiln in January 1878, was considered by McLaughlin to be her first successful piece done at Coultry's (McLaughlin, *op. cit.*, p. 218).
* Information relating to this pottery is included in a separate chapter

Cowan Pottery

Cleveland, Ohio
Rocky River, Ohio

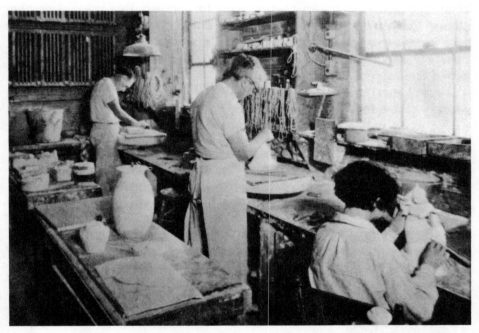

Interior of Cowan studio showing Guy Malcolm, Jack Waugh and Thelma Frazier at work. *The Western Reserve Historical Society.*

R. Guy Cowan, founder of the Cowan Pottery Studio, came from a family of potters who lived and worked in East Liverpool, Ohio, for several generations. Before finishing high school he had become a potter of the utilitarian-type ware so common to that area. To round out his training he attended the New York State School of Clayworking and Ceramics at Alfred, where he was a pupil of the renowned Charles Binns, the school's director.[1]

After graduation in 1908 Cowan went to Cleveland, Ohio, to teach ceramics and design at the Cleveland Technical High School.[2] At Cleveland he came under the influence of Horace Potter and for several years studied and experimented at the Potter Studio at Euclid and 107th Street. In 1912 Cowan's work came to the attention of The

Cleveland Chamber of Commerce, with whose encouragement and assistance and under whose auspices his pottery was started.[3] Located on Nickerson Avenue, Cleveland, the works was incorporated in Ohio as The Cleveland Pottery and Tile Company.[4] For the next several years the three small kilns turned out both tile and artware, for which a line of excellent glazes of various colors and lusters was developed; Cowan felt it was necessary to have these to cover the red clay body of the ware.[5]

In 1917, after four years of struggle to produce "art pottery . . . sound in design and correct in taste"[6] and to succeed in developing new glazes, Cowan's efforts received their first official recognition when they were awarded First Prize at the International Show at The Art Institute of Chicago. The same year Cowan closed his pottery and joined the army.[7]

He returned in 1919 and reopened the old studio, but its facilities quickly proved inadequate; in 1920 the pottery was moved to 19633

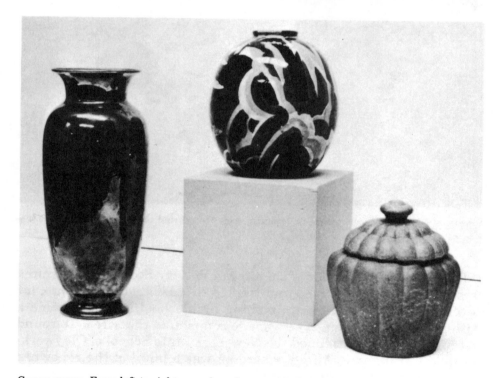

Cowan wares. From left to right: urn-shaped vase with foot and flared rim, h. 11¾" (29.3 cm); standard Cowan form with unique enamel decoration in Art Deco style in shades of blue and black by Edward Winter, h. 7" (17.8 cm); covered tobacco jar with orange-red matt glaze with flecks of yellow, h. 6½" (16.5 cm). All pieces marked Cowan. *The Western Reserve Historical Society (#70.82.31; 69.135.1; 73.61.2A,B).*

Lake Road in Rocky River. Wendell G. Wilcox associated with Cowan as manager of the new works, which had a total of nine kilns. The old redware body was replaced with a high-fired porcelain body made primarily from English clays; emphasis was shifted to ceramic sculpture.[8] After this time awards and honors were received in great profusion: from The Metropolitan Museum of Art, The Cleveland Museum of Art and The Art Institute of Chicago, to name a few.[9]

To achieve a product that was both praised by art critics and also commercially successful, it was necessary for Cowan to put all his efforts into a ware which could be sold at a reasonable price. "It has left no room for time and effort to be put in on individual work. Some of my friends," wrote Cowan,[10] "feel that this is a great mistake and that it is commercializing whatever ability we have. I have been working, however, on the idea that in duplication of a good design, it does not of necessity injure the product from an art standpoint."

The work—all of which was now molded—encompassed a wide range of objects. The porcelain figures were perhaps most popular and were often made in limited editions of fifty to one hundred. When an edition was limited, the mold was destroyed after the set number was produced. Cowan's leading artist, particularly for the modeling of figurines, was Waylande Gregory. Among other artists associated with the studio were Arthur Baggs (Marblehead*), Thelma Frazier Winter, Edward Winter, F. Luis Mora, Richard O. Hummel, Alexander Blazys, Paul Bogatay, Whitney Atcheley, Walter Sinz, Viktor Schreckengost, Jose Martin, Raoul Josset, Margaret Postgate, Elmer L. Novotny, "Mr. MacDonald," Elizabeth Anderson and Russell Barnett Aitkin.[11]

Art pottery vases were made with shapes modeled by Richard Hummel, who also originated a number of glaze formulas including the very successful Oriental red glaze of the pottery. Inexpensive items were produced en masse and included lamp bases, jars and decorative figures which sold for as little as one dollar.

A limited amount of translucent porcelain in several solid colors was produced. One of the special effects obtained thereon was that used in decorating cast fish plates with a raised design. Various colored slips were sprayed on the surface and rubbed off, leaving the color in the recess. Sets of a dozen of these plates could be specially ordered as service places for dinner or luncheon use. Tan-bodied tiles were produced from Eastern Ohio clays. There were both production and special tiles, the latter made for fountains, ecclesiastical use, counter facings and organ stop knobs. Ceramic sculptures were sometimes combined with the tiles to form fountains. A set of door knobs in Alice-in-Wonderland subjects was also made. In all cases, Cowan was emphatic that each piece should be carefully inspected and those of a

second quality destroyed. No seconds were sold or distributed.[12]

Glazes continued a specialty, even after the red-bodied ware was no longer produced. Lusterware and crackleware in a wide variety of colors were offered. One of the more unusual treatments at the pottery was the coating of the white body with a black slip through which designs were etched back to the body.[13]

By the late 1920s, over 175,000 pieces a year were being turned out by the fifty men and women who were employed. Their production was offered in approximately 1,500 retail outlets across the country, including some of the most prestigious stores and gift shops.[14] The Cowan Potters, Inc., was formed in August 1929[15] with plans for the erection of a modern pottery at a new location and an expansion of the product line.[16] None of these plans came to fruition; in late 1931 the pottery closed, a casualty of the Great Depression. Cowan became art director for the Onondaga Pottery Company of Syracuse, New York, producers of Syracuse china. He died in 1957.[17]

Several fine public collections of Cowan are extant, foremost of which are those at The Western Reserve Historical Society and The Cleveland Museum of Art. A small collection is maintained at the Rocky River Public Library by the Library and the Rocky River Historical Society. Shortly before the plant closing in 1931, two photographic studies with text of the processes involved in the making of Cowan pottery were undertaken. These are in the library of The Western Reserve Historical Society.

Most Cowan pottery was carefully marked. The very earliest bore the designation *Lakewood,* which should not be confused with the later *Lakeware,* a line of mass-cast ware for the dime-store trade

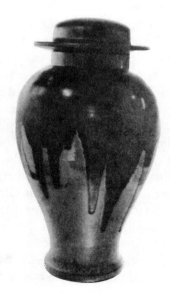

Cowan redware vase with black glaze flowing over an orange ground; h. 12" (30.5 cm). Incised Cowan Pottery, Cowan cipher and 19. *John Brodbeck.*

produced during the last four years of Cowan's operation. Lakeware did not normally bear the Cowan name, but sometimes a confused workman would apply the Cowan mark to it. Redware of the 1913-17 period was incised with "Cowan Pottery" and often Cowan's cipher in addition. After the introduction of the porcelain body, "Cowan" was imprinted and impressed. On later work the stylized semi-circular Cowan mark with the initials of R. G. below it was imprinted.[18]

COWAN coWan
 POTTERY Cowan Pottery

LAKEWARE

1. Carle Robbins, "Cowan of Cleveland," *Bystander,* XI (September 7, 1929), pp. 10-13. Cowan is first listed in the directory of *Transactions* as a member of The American Ceramic Society (VIII, 1906) while a student at Alfred.
2. *Transactions* of The American Ceramic Society, XI (1909), p. 15; *The Clay-Worker,* L (September 1908), pp. 256-57.
3. 1926 Cowan catalog, p. 7; a copy of this catalog is in the archives of the Rocky River Public Library.
4. According to the records of the Ohio Secretary of State, this designation was formally changed in 1927 to The Cowan Pottery Studio, a name which had been well-established by that time.
5. "Cowan Potters, Inc., 1912-1931," an anonymous, comprehensive set of notes on file at the Rocky River Public Library. A number of the early redware pieces are in the collection of The Western Reserve Historical Society.
6. Personal letter of R. Guy Cowan to the Newark [New Jersey] Museum, June 24, 1926.
7. Robbins, *op. cit.*
8. "Cowan Potters, Inc."
9. Robbins, *op. cit.*
10. *Ibid.*
11. "Cowan Potters, Inc."
12. Robbins, *op. cit.,* and "Cowan Potters, Inc."
13. A full description of the various glaze colors, textures and bowl linings is contained in the Cowan catalog, and especially pp. 11-16 of the 1926 issue.
14. Cleveland *Press,* March 9, 1964.
15. While the 1930 Cowan catalog indicates that Cowan Potters, Inc., was the successor to the Cowan Pottery Studio, the records of the Secretary of State's office in Ohio list both corporations as active until their licenses were cancelled November 16, 1931.
16. Robbins, *op. cit.*
17. Examples of his work at Syracuse are shown and discussed in H. E. Stiles' *Pottery in the United States* (esp. pp. 127, 129-31), for which Cowan wrote the Foreword.
18. John Brodbeck, *Spinning Wheel,* XXIX (March 1973), pp. 24-27.
 * Information relating to this pottery is included in a separate chapter

Craven Art Pottery
East Liverpool, Ohio

William P. Jervis, after leaving the Rose Valley Pottery* in mid-1905, joined the Craven Art Pottery later the same year at East Liverpool. Craven, Trentvale* and Benty's Oakwood Pottery Company* were the only art pottery works at East Liverpool.[1] The Craven Art Pottery Company, which took over the old Oakwood Pottery Company plant, was incorporated in Ohio in late 1904 by Leonard Forester, Allen Fink, M. A. Sutton, Walter B. Hill and Albert L. Cusick,[2] who had been a decorator at Vance/Avon Faience* under Jervis and was later to be associated with the Zanesville potteries.

The first output was an earthenware decorated in a manner similar to the work done at Vance/Avon, using what has become known as the squeeze-bag technique. This method was first introduced in the United States by Jervis and F. H. Rhead at Vance/Avon and later used so effectively at Weller* in the Jap Birdimal line after its introduction there by Rhead. The firm also produced some very effective incised decorative work, and in 1906 introduced a line of matt-glazed ware developed by Jervis.[3] Often several tones or even colors—ranging from matt green, blue, yellow, orange and pink to crimson and

Craven Art Pottery vase; h. 5½"
(14.0 cm). Incised mark, identified
by M. Benjamin as Craven; dated
in pencil 1907. *National Museum of History and Technology (Smithsonian Institution; #379,664), Benjamin collection.*

black—were used on the same piece, thus avoiding, according to Jervis, the monotony so often associated with matt decoration. Successful results were obtained on a body of common Ohio yellow clay, New Jersey marl, or on earthenware body similar to that used by several of the East Liverpool dinnerware producers at the time.[4]

Jervis was still listed as at Craven in late 1907,[5] but earlier that year he had considered joining the Cheboygan [Michigan] Pottery;[6] this evidently did not come to fruition, and in 1908 he left East Liverpool to organize the Jervis Pottery* at Oyster Bay, Long Island. At that time it was observed that "the proposition to establish a small art pottery at East Liverpool, Ohio, seems to have amounted to nothing. The head decorators of several potteries in that district had plans very well in hand early this season, but the depression in the business world caused them to delay final action indefinitely."[7] Craven was formally dissolved in November 1908, at which time W. T. Tebbutt and his family controlled the works.[8]

A single piece of Craven's matt work is in the Benjamin collection of the National Museum of History and Technology (Smithsonian Institution).[9] Four vases, illustrating various decorative techniques, are in the extensive pottery collection of the East Liverpool Historical Society.[10]

Marks noted are an incised "Craven", an incised "Jervis", or both.

1. Katherine Morrison McClinton, *Antique Collecting for Everyone* (New York: McGraw-Hill, 1951, p. 71), lists an East Liverpool Art Pottery, but this presumably is the East Liverpool Art China Company, a producer of chinaware.
2. *The Clay-Worker,* XLII (November 1904), p. 479; erroneously reported as "Crown" Art Pottery Company by *China, Glass and Pottery Review,* XV (November 1904), p. 44. M. Benjamin, *American Art Pottery,* p. 40, mistakenly indicates that the pottery was established by Jervis.
3. *Glass and Pottery World,* XIV (May 1906), p. 19.
4. Benjamin, *loc. cit.*
5. *Glass and Pottery World,* XV (December 1907), p. 35. The first annual report of the Society of Arts and Crafts, Detroit, 1907 (p. 23), places Jervis in East Liverpool. He is not listed in the 1908 report.
6. *Clay Record,* XXX (May 30, 1907), p. 35; *ibid.,* XXX (June 29, 1907), p. 35.
7. *The Clay-Worker,* L (July 1908), p. 44.
8. Records of the Secretary of State of Ohio.
9. Their #379,664.
10. Due to the refusal of that organization's museum curator to allow careful study of the pieces, it is impossible at this time to definitely authenticate these or to indicate the marks used. All four vases appear to be their identification number 265.
* Information relating to this pottery is included in a separate chapter

Dallas Pottery

Cincinnati, Ohio

The Dallas Pottery, located at the southeast corner of Hamilton Road (later McMicken Avenue) and Dunlap Street, was established in 1856 as the Hamilton Road Pottery by Michael and Nimrod Tempest for the production of yellow and Rockingham-type wares and brownware fruit jars. In 1865 the pottery was purchased by Frederick Dallas, and four years later it was refitted for the manufacture of cream-colored and stone china wares.[1]

In the latter part of 1879 two new kilns were built for the firing of decorated ware.[2] The cost of the kiln for underglaze work of the Cincinnati faience type was advanced by M. Louise McLaughlin (Losanti*), while Maria L. Nichols (Rookwood*) provided for the building of the overglaze kiln. The Cincinnati Pottery Club, which until just prior to that time had been working at the Coultry Pottery*, rented a large studio from Dallas. A separate, smaller studio was likewise rented by Mrs. Nichols, who was never a member of the Pottery Club, and Mrs. William Dodd.[3] Evidently goaded on by the McLaughlin success in underglaze work, Mrs. Nichols began her first experiments with clay and glazes at Dallas'.[4] Greenware, both molded and thrown, and biscuit ware from the pottery were delivered to the studios where the women worked.

One of the earliest exhibitions of the decorative ware produced at the Dallas Pottery was at the Seventh Cincinnati Industrial Exposition, held in the fall of 1879. Shown were "a large number of articles in white ware, such as find their way into every household, but of a quality that has given the Hamilton Road Pottery a very enviable reputation. Then there are numerous pieces of plain decorated ware with mechanical designs, whole sets for the table or for the bedroom in pink, blue or a delicate green ... But a large part of the exhibit consists of the decorated pieces of the Cincinnati ladies, made and fired at the Dallas pottery."[5]

In early 1880 Dallas employed an unidentified professional artist for his own staff, opened a showroom adjoining his office, and thereby joined in competition with the Coultry Pottery and the Wheatley* pottery in the production of Cincinnati faience.[6] At the Eighth Industrial Exposition, in September 1880, the Dallas Pottery was able to display a collection of Cincinnati faience which "easily rivals that of

the Pottery Club."[7] As well as the amateur work of the ladies, Dallas produced a large quantity of professionally decorated Cincinnati faience work, but this was evidently unmarked as few examples are to be found. In addition to their own work, the work of the Pottery Club and of other Cincinnati women, ware was also burned which had been decorated by ladies as far away as Washington and Chicago.[8] While the Pottery Club met at Dallas', a major exhibition-reception was held each year to show the latest and most successful work of members.[9]

Dallas died in June 1881. A year earlier when Mrs. Nichols was planning the establishment of the Rookwood Pottery she had asked Joseph Bailey, Sr., superintendent of the pottery since Dallas took it over, to join the new works. Bailey declined on the basis of his long-standing relationship with Dallas and suggested his son Joseph, Jr., instead who was also employed at Dallas'.[10] A month after Dallas' death, Bailey, Sr., became superintendent of the Rookwood works in addition to his connection with the Dallas plant. At that time it was observed "that a very large part of the success of the Hamilton Road Pottery has been due to the thorough knowledge, energy, and faithfulness of the gentleman who has so long been the foreman of the establishment. And it is with the knowledge of this past success that we anticipate equal success for the Rookwood Pottery under his management."[11]

The Pottery Club shortly thereafter followed Bailey and William Auckland[12] to Rookwood, and in early 1882 all underglaze decorated faience work was abandoned by the Dallas pottery, then under the

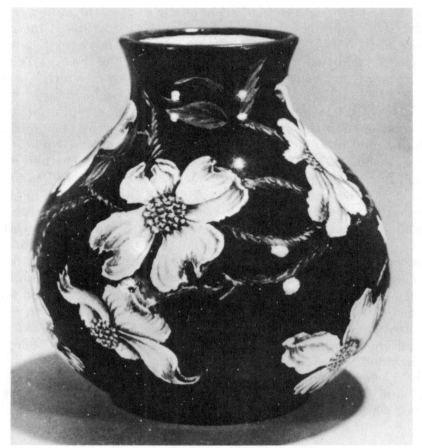

Dallas Pottery Cincinnati-faience vase decorated by Henrietta D. (Mrs. E. G.) Leonard of the Cincinnati Pottery Club; h. 7½" (19.1 cm). *Cincinnati Art Museum (#1881.21), gift of the Women's Art Museum Assn.*

direction of Dallas' widow. "It was found that the time and care requisite for a successful firing of such ware were scarcely commensurate with the profits to be derived; and as the trade in the regular overglaze decorated ware was already large, and on the increase, the pottery found enough to do to produce that kind of goods."[13]

Plans were made to incorporate the pottery, and indeed the Dallas Pottery Company was organized in the State of Ohio;[14] with the new capital a pottery was to be erected on the west side of Dunlap Street on the same property where a portion of the old pottery was located. In late July these plans were abandoned, and announcement of the closing of the works and their sale was made.[15]

Several marked examples of Dallas' ware are at the Cincinnati Art Museum (especially #1970.622, 670; 1940.49; 1881.73, 21).

Few other examples of marked Dallas pottery have been found,

especially of the Cincinnati faience type. Work especially of the gold-banded variety, done between 1880 and 1882, bears an impressed mark and date, and often the initials of a decorator. The black-lettered mark appears on a redware pitcher in the Cincinnati Art Museum's collection (#1885.19).

DALLAS

FRED. DALLAS.
Pure Red Clay.
HAMILTON ROAD POTTERY
CIN. O
AUG. 1880

1. W. Stout *et al., Coal Formation Clays of Ohio,* pp. 20, 82.
2. *Crockery and Glass Journal,* X (December 18, 1879), p. 30.
3. Mrs. Aaron Perry, *Harper's New Monthly Magazine,* LXII (May 1881), pp. 834-45; also Clara Chipman Newton, *The Bulletin* of The American Ceramic Society, XVIII (November 1939), p. 446. Some confusion exists over the membership of the Pottery Club. H. Peck (*The Book of Rookwood Pottery,* p. 5) incorrectly indicates that the membership never changed. A comprehensive listing of members and the years of their membership is presented by C. C. Newton in *The Bulletin,* XIX (September 1940), p. 348. One of the earliest membership listings is given in *Crockery and Glass Journal,* XI (January 29, 1880), p. 14.
4. M. L. N. Storer, *The Bulletin,* XI (June 1932), p. 157.
5. *Crockery and Glass Journal,* X (October 9, 1879), p. 19. A thorough description of the pieces shown is also included.
6. *Ibid.,* XI (April 1, 1880), p. 10. Pieces of Dallas artware in the collection of the Cincinnati Art Museum were decorated by Elizabeth W. (Mrs. Aaron F.) Perry and H. D. Leonard (their numbers 1885.19 and 1881.21 respectively).
7. *Ibid.,* XII (September 16, 1880), p. 10.
8. *Ibid.,* XIII (February 10, 1881), p. 26.
9. The first, held May 5, 1880, is extensively reported in *Crockery and Glass Journal,* XI (May 13, 1880), p. 28; the second, April 29, 1881, is likewise covered in the same journal (XIII, May 12, 1881, p. 26); the third, held in May 1882, received thorough coverage, again in *Crockery and Glass Journal,* XV (May 25, 1882), p. 12. These annual receptions were terminated in 1890.
10. Evidently Bailey through his son was very influential in the establishment of the Rookwood Pottery. Peck (*op. cit.,* p. 58) records the notation from Rookwood's minutes in Taylor's own hand that it was Bailey, Sr., "who through his son, Jos. Jr., and then himself, settled the practical potter's side of Rookwood in its earliest years."
11. *Crockery and Glass Journal,* XIV (July 7, 1881), p. 21.
12. According to C. C. Newton (*The Bulletin,* XVIII, November 1939, p. 446), Auckland, who was responsible for many of Rookwood's early shapes, was the thrower for the Dallas Pottery.
13. *Crockery and Glass Journal,* XV (March 2, 1882), p. 14.
14. Incorporators were Aris B. Sherwood (nephew of F. Dallas and executor of his estate), Robert Laidlaw, John B. Gibson and Thomas McDougall, all of Hamilton County, Ohio, and Edwin D. Albro of Kenton County, Kentucky.
15. *Crockery and Glass Journal,* XVI (July 27, 1882), p. 28.
* Information relating to this pottery is included in a separate chapter

Dayton Porcelain Works

Dayton, Ohio

Little has been recorded about the pottery work at Dayton, yet some early work of significance was done there. About five years after the establishment of the Oakwood Pottery*, Matt Morgan and Isaac Broome organized the Dayton Porcelain Works in 1882.[1]

Broome, a Canadian by birth, had already established his reputation as a very versatile artist by 1875. In that year, at the age of forty, he was engaged by Ott & Brewer of Trenton, New Jersey, to design and model a series of works in parian for the Philadelphia Centennial Exposition of 1876. Two of the most successful of these pieces were the much-heralded Baseball Vase and the bust of Cleopatra.[2] Prior to this, Broome, who became interested in ceramics while studying abroad to become a painter and sculptor, had established a terra cotta factory at Pittsburgh where he made vases and other ceramic wares,[3] and another at New York, neither of which was successful.[4]

In addition to his abilities as a ceramist and sculptor, Broome was also an expert in ceramic art manufacture; and in 1878 he went to the Paris exposition as Special Commissioner on Ceramics by appointment of the State of New Jersey and the United States government.[5] Broome returned to this country and built a small pottery in Miami City, a suburb of Dayton now known as West Dayton, where the women in the Dayton vicinity could fire their china-painting and receive instruction.[6] Evidently this was in conjunction with the Free Night Industrial School established by the Dayton Board of Education in 1877. Broome joined its staff in late 1880 when the school was expanded.[7] Under the direction of Broome and Charles B. Nettleton, the School of Free-hand Drawing was a great success.[8]

The Dayton Porcelain Pottery built a new, two-kiln plant at 24 Summit in Dayton.[9] This presumably was the location of the pioneering work using a vitrified body reported by Barber. "The body, the underglaze coloring and the glaze were thoroughly incorporated together, producing a soft, rich, mottled effect different from any other ware produced in America. Only about 100 pieces, mostly small vases, were made, and these were soon absorbed in private collections, and highly valued. They were marked with an arbitrary device, a modification of the sign of Jupiter, similar to the mark on old Plymouth (England) porcelain. It was scratched in the body below the glaze."[10]

This operation, too, was short-lived; by late 1882 Morgan had gone to Cincinnati and established the Matt Morgan Art Pottery*, and Broome had returned to Trenton.[11] There he resumed his modeling work, which he successfully carried out at the Trent, Providential and Beaver Falls tile companies, as well as at Lenox. He died in New York City in 1922.

Aside from the markings described and illustrated by Barber, no others have been noted.

1. Dayton city directories, especially 1883-84.
2. Both of these are in the Brewer Collection of the New Jersey State Museum, Trenton. For a study of Broome's work see Barbara White Morse, *Spinning Wheel*, XXIX (January/February 1973), pp. 18-21.
3. J. Young, *The Ceramic Art*, p. 464.
4. W. P. Jervis, *The Encyclopedia of Ceramics*, p. 71.
5. Catalog of New Jersey Pottery exhibition, New Jersey State Museum, 1956, p. 40.
6. *Crockery and Glass Journal*, XIV (September 15, 1881), p. 29.
7. *The History of Montgomery County, Ohio* (1882), p. 697.
8. *History of Dayton, Ohio* (1889), p. 241.
9. The festivities surrounding the laying of the last kiln brick were reported in the Dayton *Journal*, September 1, 1882, and also by *Crockery and Glass Journal*, XVI (September 7, 1882), p. 22.
10. E. A. Barber, *Marks of American Potters*, pp. 54, 56.
11. *Crockery and Glass Journal*, XVIII (October 4, 1883), p. 22; also see *ibid.*, XXI (March 19, 1885), p. 17.
 * Information relating to this pottery is included in a separate chapter

Dedham Pottery
Dedham, Massachusetts

After the closing of the Chelsea Keramic Art Works*, Hugh C. Robertson and his brother George W., who had been associated with John G. Low at the Low Art Tile Works*, joined together and formed the Chelsea Keramic Art Tile Works in 1890 at Morrisville, Pennsylvania.[1] Before the buildings and kilns were completed funds were exhausted. Arthur D. Frost was induced to put up the necessary capital to complete the work, and the Robertson Art Tile Company was organized with Frost as president and G. Robertson as superintendent.[2]

At the same time, a number of influential Bostonians were banding together to reopen the Chelsea pottery. The Chelsea Pottery, U. S., was formed in 1891, with Arthur A. Carey serving as president and Hugh Robertson as director of the pottery's work. While Robertson was encouraged to continue his high-quality artwork, his new backers convinced him of the necessity to produce a marketable ware. Assisted by his son William he returned to the kiln to perfect the crackle glaze which he had discovered five years earlier, so that it could be applied to flat objects as well as vases.

The first and most popular blue inglaze decoration for the resultant *Cracqule Ware* was the rabbit designed by Joseph L. Smith. At first the rabbits went counter-clockwise around the border of the plates, the pattern facing to the left. Due to the difficulty in decorating "in the reverse," Charles Mills, who was in charge of decoration, changed the direction of the rabbits so that by the end of 1891 they faced to the right.[3] New designs were secured through an offering of special prizes

Interior of the Dedham Pottery showroom.

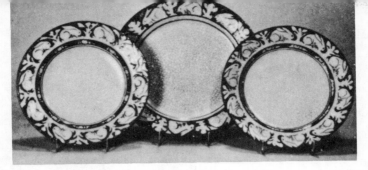

Dedham rabbit-pattern plates. Note variations: at left, 8½" (21.6 cm), one-eared rabbit; center, 10" (25.5 cm) counter-clockwise rabbit of early Chelsea period; at right, typical 8½" (21.6 cm) breakfast plate. *Private collection.*

by the Museum of Fine Arts School, Boston, in their bulletin of 1892 "for the best design for a dinner-plate for reproduction by the Chelsea Pottery." The conditions were that the design should be blue, simple in treatment, upon a gray crackled ware, with competition open to past and present pupils of the school. The clover, horse chestnut and pineapple patterns were successful entries by art students.[4]

To achieve uniform execution, the designs of the earliest pieces produced were raised. The pattern was engraved on the mold, and after the clay bat was hand-shaped on it and fired it remained for the decorator only to follow the raised outline with a brush. This resulted in a stiff decoration, and in the loss of a great many pieces through cracking on the mold. The technique was discontinued prior to 1895 and the molds smoothed. Not all were smoothed enough, however, to prevent a slight impression of the original pattern, and in some cases a pattern of a different motif from the one painted in blue can be found.[5]

Because of its proximity to a source of red clay the Chelsea location had been ideal when the pottery was established there twenty-five years earlier. With the change in body and the high-firing necessary for the crackle ware, the location was far less suitable. In 1893 construction was started on a new pottery in Dedham, and production began there in 1895.[6] The name was changed from the Chelsea Pottery to the Dedham Pottery at the time of the move, primarily to eliminate the confusion with the English Chelsea potteries which "led some people to suppose that the American Chelsea Ware was an imitation of the English product."[7]

At Dedham the only other ware beside the crackle made to any extent were vases with a high-fired glaze on a high-fired base, all hand thrown. These included flambés and what has become known as "volcanic Dedham" or "volcanic ware." This particular effect was achieved with the use of at least two glazes, one running down over the other and blending with it. Except for a few notable examples, this ware is heavy and lacks the warmth, fine lines and proportions of the pieces of artware produced at Chelsea.

The famed crackleware which became synonymous with the name

DEDHAM POTTERY

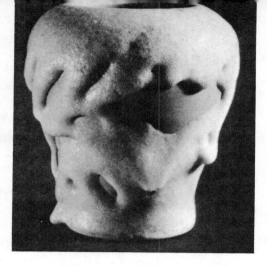

Dedham vase with flowing lava-type white glaze; h. 7" (17.8 cm). Incised mark and Hugh Robertson cipher. *Worcester Art Museum (#1900.57).*

Dedham Pottery was produced in over fifty patterns of tableware spanning the gamut of any zoo and greenhouse. Most popular were the rabbit, duck, grape, azalea, magnolia, horse chestnut, polar bear, iris, water lily, butterfly, turkey, snow tree and clover. Other patterns, such as the elephant, swan, dolphin, lion, owl, chicken, crab, lobster, turtle and birds-in-orange tree, were all offered on special order.[8] Numerous other designs such as the Golden Gate and the Fairbanks House of Dedham appeared from time to time, and unique (unlisted) patterns and variations of others continue to be uncovered. All designs were executed freehand, with no stencils or decalcomania ever used.[9]

As unique and distinctive a feature as the cobalt-blue inglaze decoration is the crackle glaze. Its secret, carefully guarded, was first revealed in 1968 by Charles Davenport, brother of Dedham's foremost decorator Maud Davenport; he joined the pottery in 1914 and became head of the decorating department, a position he held when the pottery closed. After the ware was taken from the glost kiln it was quickly cooled, and the crackle that the sudden cooling produced was rubbed by hand with Cabot's lamp black powder to produce the spider-web veining.[10] Several experiments were undertaken to tint the glaze, and pieces with a green, brown or pink cast were produced.[11]

Both Hugh and William held the degree of Master Craftsman of the Society of Arts & Crafts, Boston. Their work received numerous awards including First Prizes at Paris and San Francisco and the Gold Medal at St. Louis.[12]

In spite of severe injuries received in a test kiln explosion at the pottery in 1904 which disfigured his hands to the extent of preventing him from carrying on the modeling of his father, William Robertson was able to assume management of the Dedham works upon the death of Hugh Robertson four years later. The operation continued to prosper until the onset of World War I, when coal used for the kilns was available only in very poor quality and chemicals from abroad were unavailable; an inferior product was produced for a time. By 1925 this

was corrected and output reached new heights. Upon William Robertson's death in 1929, J. Milton Robertson became the superintendent of the works. He continued in that capacity until 1943, when the pottery was forced to close by a combination of a shortage of skilled personnel, rapidly increasing costs and the inability to pay workers for the years of apprenticeship required. The remaining inventory of both Chelsea and Dedham ware was offered for sale by Gimbels, New York, in September of that year.[13] In 1966 J. Milton Robertson died on the East Coast and George B. Robertson (Robertson Pottery*) died in California, bringing to a close the Robertson dynasty of potters after seven generations of artistic craftsmanship.

An excellent collection of artware vases of the Dedham period (produced between 1895 and 1908) and early crackleware patterns is to be found at the Worcester [Massachusetts] Art Museum. Other representative collections of Dedham pottery can be studied at the Dedham Historical Society, Dedham, and at the National Museum of History and Technology (Smithsonian Institution).

The various marks used offer an accurate means of dating Dedham ware. The CPUS in a clover leaf was impressed from 1891 until 1895. In 1895 the foreshortened rabbit was impressed. The familiar blue imprinted mark was adopted in 1896. The foreshortened rabbit mark can be found impressed once or twice in addition to the blue mark, but the only time it is of significance is when it is found alone, without the imprinted designation. The word "Registered" was added to the imprinted mark in 1929, and a special mark was used during 1936 to commemorate the town of Dedham's tercentenary celebration. Only two decorators normally signed their Dedham ware work on the face: Hugh Robertson, whose mark was a small square, and Maud Davenport, who joined the pottery in 1904 and remained until 1929. Her mark is a small "o" hidden in the design, although the fine brush and stroke which she used are even more obvious. Most of the pieces of Dedham volcanic ware and other vases produced at Dedham are incised "Dedham Pottery" and bear Hugh Robertson's personal monogram.

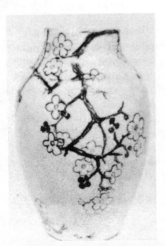

Dedham crackle vase, similar to earlier Chelsea Keramic Art Works crackle ware, blue underglaze decoration; h. 8 1/2" (21.6 cm). Incised mark and Hugh Robertson cipher. *Private collection.*

DEDHAM
TERCENTENARY
1636 – 1936

1. E. A. Barber, *The Pottery and Porcelain of the United States,* pp. 381-82.
2. *The Bulletin* of The American Ceramic Society, XX (November 1941), p. 413; also Everett Townsend, *ibid.,* XXII (May 15, 1943), p. 132.
3. According to the notation of H. C. Robertson. The distinction of the "reverse" rabbit is that it faces to the left, not to the right. Sometimes rabbit-decorated candlesticks, bowls, cups, saucers, and similar items appear to have "counter-clockwise" rabbits, but the rabbits all face to the right, not the left, and these should not be confused with the earliest designed items of which only a few plates are known to exist. Because of the short period during which it was made and the few known examples, the reverse rabbit pattern is the rarest of the Dedham ware.
4. E. A. Barber, *The Clay-Worker,* XXIII (May 1895), p. 580.
5. Letter from J. Milton Robertson to Frederick W. Allen, *Hobbies,* LVII (September 1952), pp. 81, 99.
6. While some sources suggest an 1896 date, the 1895 dating seems more accurate and is the one always used by the pottery itself. See especially J. Milton Robertson, *Dedham Pottery,* 1938, p. D (reprinted *The Bulletin,* XX, November 1941, p. 411-13).
7. *Dedham Pottery,* 1896, a brochure for the firm (reprinted *Spinning Wheel,* IX, January 1953, pp. 24-25).
8. A price list (c. 1920) indicates the birds-in-orange tree as a regular pattern and also offered the pineapple, French and English mushroom, quail, poppy and tiger lily as special patterns. By the 1937 price list the birds-in-orange tree had become a special pattern, and the abovementioned special patterns from the earlier period were not offered at all. The 1942 price list makes no distinction between regular and special patterns and omits the clover, lion, chicken and birds-in-orange tree. These regular and special patterns are all pictured in L. Hawes, *The Dedham Pottery,* pp. 39-43, as are some of the more unusual patterns. Hawes mistakenly identifies the water lily as "pond lily" and the tiger lily as "day lily".
9. An extended discussion of the process for producing crackle ware is presented by Harry I. Shumway, *American Cookery,* XXXVII (May 1933), p. 643-49, from which an extraction was made by P. Evans, *Western Collector,* V (May 1967), pp. 7-12.
10. Hawes, *op. cit.,* p. 38.
11. Pieces so tinted bear the imprinted mark used between 1896 and 1929. Some modern "decorators" have taken to coloring the rabbits and cabbages with pink and green, but this was never done at the pottery. Experimental colors were in the nature of glaze tints, which covered the entire body and which can be most readily detected on the back of the piece. A variant of the snow tree pattern with a pink glaze is in the collection of the Worcester Art Museum (#1900.55).
12. J. Milton Robertson, *op. cit.; Keramic Studio,* VI (April 1905), p. 269.
13. New York *Times,* September 19, 1943, p. 52.
* Information relating to this pottery is included in a separate chapter

Wm. Dell Pottery
Cincinnati, Ohio

William Dell acquired numerous molds from the Cincinnati Art Pottery* when it ceased business in 1891. Dell had been foreman of the Cincinnati Art Pottery from its earliest days, and by 1887 was superintendent and manager.[1] After that pottery closed he carried on some of its artware production under the style Wm. Dell & Company. Work is in the manner of Cincinnati Art Pottery's Hungarian Faience, obviously made with that firm's molds and glazes.

One can only speculate on the eventual success of the operation by this competent young potter, for it was ended by Dell's untimely death in January 1892 at the age of thirty-five.[2] The Dell firm was never incorporated in Ohio, and due to its short existence little information is available regarding it.

The mark used by Dell was the incised "Wm. Dell & Co., Cin. O." as shown. An incised number, presumably relating to the shape, also appears on the few pieces available for study.

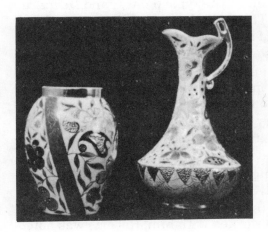

[left] Dell Hungarian-faience type vase with underglaze floral decoration on a white ground, overglaze gold embellishment; h. 7¼" (18.5 cm). Incised mark and "No. 18". *Private collection.* [right] Dell ewer (note identical shape pictured in Cincinnati Art Pottery chapter), Hungarian-faience type decoration; h. 11¹³/₁₆" (30.1 cm). Incised mark and "No. 25". *Private collection.*

1. Cincinnati directory listings for William Dell, beginning 1875.
2. A notice of his death appears only in the Cincinnati *Enquirer* of January 3, 1892, which indicates the date of death, home address and that there were no survivors.
* Information relating to this pottery is included in a separate chapter

Denver China and Pottery

Denver, Colorado

William A. Long, founder of the Lonhuda Pottery*, organized the Denver China and Pottery Company in 1901,[1] and it began operation within weeks of the opening of the Van Briggle Pottery*. Located at the southwest corner of Alcott and West 16th Avenue in Denver, the company began to produce Long's underglaze decorated brownware from materials almost completely native to Colorado, with clays primarily from Golden, Colorado, beds.[2] So successful was Long's application of native ingredients (including uranium from the Rocky Mountain area) that Weller* later gave serious consideration to following Long to Colorado and building a pottery at Colorado Springs of a size equal to their plant in Zanesville, Ohio. Weller's motivation at the time was to reduce the high cost of shipping their articles west.[3]

Three classes of goods were produced by the pottery. The first and most ordinary was a flint blue line of cuspidors, bowls, toilet sets, mugs and baking dishes. The second was a line of colored glazed jardinieres, pedestals, umbrella stands, cuspidors and pitchers. The art line was the finest of the Denver output. This included the *Lonhuda* ware, which Long originated in Ohio and which was now also offered with a light ground as well as the typical dark, and *Denaura,* which was introduced in 1903. This later line incorporated modeled low-relief Art Nouveau designs of native Colorado flowers in the body, and was similar in concept to some of the early Van Briggle work. Denaura was produced in various glazes, which were sometimes iridescent, "showing flits of rich metallic, prismatic coloring," according to Barber.[4] The most common glaze was the popular matt green which swept over the art pottery world in the wake of the Grueby* success, although Denaura's texture is distinctive in that it is of a smoothness comparable to fine satin-glass, and of a very high quality.

Originally associated with Long were Lee A. Reynolds and Charles H. Keyes, Vice President and Secretary-Treasurer, respectively. Eugene Roberts and Claude Leffler, pottery artists, were brought by Long from Ohio, where they had worked with him. Roberts was noted for his slip-painting of fruit on the Lonhuda line, and Leffler for flowers.

Two kilns were connected with the plant, the larger of which had a capacity of 30,000 pieces of tableware. The smaller kiln had an

8,000-piece capacity. In 1902 about twenty workers were employed, and it was expected that Long would bring out additional workers from the east.[5]

Several production techniques were employed at Denver. One was "jollying," used primarily on the more coarse, large objects such as jardinieres and umbrella stands. The mold of the article to be made was placed on the jolly-wheel. The clay was then placed inside the mold and pushed tightly against the sides. The wheel was quickly, mechanically revolved, while a shoe pressed the clay still tighter against the inside of the mold and hollowed out the center as well. A second technique involved flattening the clay like a pancake and then pressing it over the mold. This was most often used for making oval shapes and old-fashioned pitchers. A third method, used exclusively for the best wares produced, was casting. Molds, made of plaster of Paris, were filled with liquid slip which was allowed to dry to the desired thickness before the remainder was poured out. After sufficiently dry, the formed piece would be removed.

When the pottery was merged into the newly-formed Western Pot-

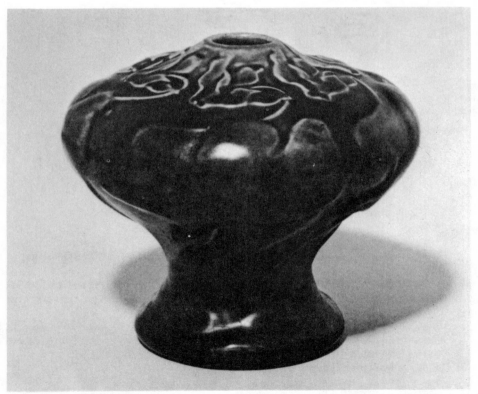

Denver Denaura vase; h. 5½" (14.0 cm). Impressed Denver/173/LF cipher; imprinted Denaura mark; dated 1903. *Private collection.*

tery Manufacturing Company in 1905,[6] Long left for Newark, New Jersey, and there established the Clifton Art Pottery* later that year.

An example of Denver's Lonhuda ware is in the collection of the Colorado State Museum of the State Historical Society at Denver (#M 3617); the underglaze slip decoration is of a burro, executed by Claude L. Leffler. Another, with the underglaze decoration of a milkweed plant, is in the Clement collection of The Brooklyn Museum (#43.128.149). Examples of Denaura ware are at The Brooklyn Museum (#43.128.48) and the Smithsonian's National Museum of History and Technology (#379,616). Neither of these, however, represents the most skillfully designed items of the Denaura line (cf. illustration).

Several marks were employed at Denver: often pieces were signed with both the impressed "Denver" and the Lonhuda Faience cipher within the shield, and also with the imprinted "Denaura" and arrow mark, where appropriate. Occasionally pieces were dated.

1. *Glass and Pottery World,* IX (October 1901), p. 248; *Clay Record,* XIX (October 14, 1901), p. 23.
2. Denver *Times,* June 29, 1902, p. 12. By December 1902 a display of the firm's ware had been held, principally exhibiting the Lonhuda line, according to the report in *Clay Record,* XXI (December 15, 1902), p. 28.
3. *American Pottery Gazette,* VIII (November 1908), p. 9; *The Clay-Worker,* L (November 1908), p. 538; *Pottery & Glass,* I (December 1908), p. 26; *Clay Record* XXIII, (November 16, 1908), p. 31.
4. *Marks of American Potters,* p. 165.
5. Denver *Times,* June 29, 1902, p. 12.
6. *Clay Record,* XXVII (August 31, 1905), p. 35.
* Information relating to this pottery is included in a separate chapter

Plate 1. Tiffany pottery vase at left has molded decoration of fern fronds; h. 9 ⁷/₈" (25.1 cm). Incised Tiffany cipher/7/P485 L.C. Tiffany Pottery/9089. On the right is a vase with Queen Anne's Lace decoration, h. 8 ¼" (21.0 cm). Incised Tiffany cipher/7. *Martin Eidelberg.*

Plate 2. Newcomb Pottery of the early period: left h. 8" (20.4 cm), Newcomb marks, JM/U/K94; right, h. 9" (22.9 cm) Newcomb mark, Henrietta Bailey and Joseph Meyer ciphers, and codes W/AE. *Martin Eidelberg.*

Plate 3. Dedham Pottery Lotus-design bread-and-butter plate by Maud Davenport (note "o" rebus at six-o'clock position), 6" (15.3 cm) diameter, imprinted Dedham mark. The two miniature vases are incised Dedham Pottery and bear the HCR cipher; h. 3" (7.7 cm), 3 ³/₄" (9.5 cm). *Private collections.*

Plate 4. Rhead Pottery. The low bowl at the left displays Rhead's technique of incising the design, filling it in with various colored glazes and then recutting it so that the body of the ware is exposed. Primary glaze is Rhead's prized mirror black; 8 ³/₄" (22.3 cm) diameter. Impressed linear Rhead/Santa Barbara. Three-legged vase is Rhead's Elephant Breath glaze; h. 3 ¹/₂" (8.9 cm). Mark obscured by glaze. *Oakland Museum (#75.75.4-5).*

Plate 5. California Faience tile and vase. The tile, encased in a Dirk VanErp copper frame, displays the standard California Faience glazes; 5 ¹/₂" (14.0 cm) diameter. Vase is "California Faience blue"—one of the colors most associated with the firm's work; h. 4 ¹/₈" (10.5 cm). Regular mark. *Private collections.*

Plate 6. Valentien Pottery vase with raised Art Nouveau freesia design; h. 8" (20.4 cm). Impressed mark, shape number Z21. *Oakland Museum (#75.75.6).*

Plate 7: Weller Pottery vase by Jacques Sicard; h. 9" (22.9 cm). *National Museum (Smithsonian Institution; #393,654), Kirk collection.*

Plate 8. University City Pottery. Left to right: scattered crystalline glazed mate to vase at far right, h. 4 ¹/₂" (11.5 cm), imprinted circular mark of the American Woman's League; Diffloth's feathery crystalline glazed vase, h. 7 ¹/₄" (18.5 cm), incised L of E. G. Lewis; overall crystalline glaze, h. 5 ¹/₄" (13.4 cm), printed U.C./57/1913; oxblood vase, h. 5¹/₄" (13.4 cm), imprinted circular mark of the American Woman's League/UC 1910/ED cipher; far right, h. 4 ¹/₂" (11.5 cm). *Private collections.*

Plate 9. Artus Van Briggle's famed Lorelei vase with extremely high-quality dead matt glaze; h. 9³/₄" (24.8 cm). Regular Van Briggle mark/1902/III incised; shape 17. *Private collection.*

Plate 10. Marblehead vase with conventionalized grape motif; h. 4 ¹/₄" (10.8 cm). Regular impressed mark and "HT". *Janeen & James Marrin.*

Plate 11. Middle Lane Pottery's Flame Ware, produced by the Fire Painting process developed by T. A. Brouwer and considered by him to be the peak achievement of his ceramic work, h. 11 ¹/₂" (29.2 cm). Incised Brouwer, Flame and flame sketch. *Private collection.*

Plate 12. Rookwood Pottery's Standard ware; h. 18 ¹/₄" (46.5 cm). Impressed 4-flame mark (1890), shape number 30A; signed by the Japanese artist Kataro Shirayamadani. *The Minneapolis Institute of Arts (#84.90).*

Plate 13. Rookwood scenic vase identified by the same shape number (30F), h. 7 ¹/₈" (18.2 cm). Regular mark (1918) and artist signed by Edward Diers. *K. & T. Dane.*

Plate 14. Biloxi Art Pottery crimped and twisted vase typical of Ohr's "torture" of the clay. Remarkable thinness of body is evident at rim; h. 6 ¹/₂" (16.5 cm). Incised Ohr signature. *Private collection.*

Plate 15. Denver China and Pottery's Denaura line was notable for both the quality of the glaze and the decorative motifs; h. 8 ¹/₂" (21.6 cm). Imprinted Denaura mark; impressed Denver/166/LF cipher. *R. A. Ellison.*

Plate 16. Grueby Pottery vase executed by Annie V. Lingley; h. 12" (30.5 cm). Impressed circular mark of Grueby Pottery. *Martin Eidelberg.*

Plate 17. Grand Feu Art Pottery's Mission glaze; h. 7^1/$_2$" (19.1 cm). Impressed mark. *Oakland Museum (#75.75.7).*

Plate 18. Arequipa pottery displaying various decorative techniques. Left to right: molded vase, h. 6 1/$_8$" (15.6 cm), impressed elliptical mark/207/16, *private collection;* thrown vase, h. 4 1/$_8$" (10.5 cm), freehand-drawn Rhead mark; Rhead-executed vase, h. 7 1/$_2$" (19.1 cm), freehand-drawn Rhead mark, dated 1913; squeeze-bag decoration, h. 3 1/$_2$" (8.9 cm), freehand-incised Rhead mark/680. *Oakland Museum (#s 75.75.8-10).*

Plate 19: Group of underglaze slip decorated work of the Cincinnati faience type so popularized by the Rookwood Standard success. From left to right: Weller Lonhuda Faience, h. 8 ³/₄" (22.3 cm), impressed Lonhuda Faience cipher and initialed by the decorator, Eugene Roberts, *private collection;* T. J. Wheatley faience vase, h. 8 ¹/₂" (21.6 cm), "T.J.W.Co./17/Pat. Sep. 28, 1880" incised on base, *National Museum (Smithsonian Institution; #75.77);* Denver China and Pottery's Lonhuda ware, h. 3 ³/₄" (9.5 cm), impressed Denver/Lonhuda Faience cipher/108, *private collection;* Stockton's Rekston line, three-handled mug, h. 4 ¹/₂" (11.5 cm), impressed marks, *Oakland Museum (#75.75.11).*

Plate 21. Losanti porcelain of M. Louise McLaughlin, h. 4 ³/₄" (12.1 cm). Incised McLaughlin cipher and 326. Losanti imprinted in blue. *National Museum (Smithsonian Institution; #393,687), Kirk collection.*

Plate 20. Robineau Pottery crystalline glazed vase with separate porcelain base and cover in matt ivory titanium glaze in which design is excised, h. 4 ⁷/₈" (12.4 cm). Each piece is marked with AR cipher (bowl excised; base and lid incised)/1912/8. Exhibited at the Panama-Pacific International Exposition, catalog number 36. *Martin Eidelberg.*

Plate 22. Robertson Pottery of the early period. Left to right: h. 5 ³/₄" (14.6 cm); h. 5 ¹/₂" (14.0 cm); h. 8 ¹/₄" (21.0 cm). All bear the impressed F.H.R./Los Angeles mark. *Oakland Museum (#s 75.75.12-14).*

Plate 23: Chelsea Keramic Art Works. From left to right; early Chelsea matt, h. 5 ¹/₂" (14.0 cm), impressed cipher; miniature vase, h. 2 ¹/₂" (6.4 cm), impressed cipher; hammered vase, h. 9 ¹/₄" (23.5 cm), impressed cipher; pigeon-feather oxblood vase, one of a matched pair considered by Hugh Robertson to be his most important sang de boeuf achievement after the Twin Stars of Chelsea, h. 6" (15.3 cm), impressed cipher; Peachblow vase which H. Robertson considered his greatest single success, part of the prize-winning Paris exposition of 1900, h. 7" (17.8 cm), indecipherable notations on base. *R. A. Ellison.*

Durant Kilns

Bedford Village, New York

Mrs. Clarence C. (Jean) Rice, organizer of the Durant Kilns, studied ceramics with Charles and Leon Volkmar at the Volkmar Kilns*.[1] After a period of intensive work she requested Leon Volkmar to come to Bedford Village and build a kiln and aid in starting a small workshop. In the summer of 1910, with the aid of a sculptor Mrs. Rice designed and modeled some pottery which was decorated with glazes mixed by L. Volkmar. From these samples enough orders were forthcoming that in the fall of that year she requested him to join her, she furnishing the plant and Volkmar the technical direction.

Production by Rice and Volkmar was begun in April 1911 at Bedford Village under the name Durant Kilns (Mrs. Rice's family name). Some of their earliest experimental work was an attempt to reproduce the fine white Italian enamels of the sixteenth century. At the first important showing in 1912 the Durant ware was well-received. The following year an exhibition studio was leased at 16 West 56th Street in New York City. This was maintained until 1918, when due to business

Pottery drying outside the Durant kiln house. *Crockery and Glass Journal.*

Durant Kiln vase with aubergine glaze; h. 7⅞"
(20.0 cm). *The Metropolitan Museum of Art (#23.19), gift of
Mrs. John C. Saltonstall and Arden Studios, 1923.*

conditions and Mrs. Rice's failing health the gallery was closed. Arden
Studios of 599 Fifth Avenue, New York City, were then appointed sole
agents for the Durant Kilns, an arrangement which continued until
1925.[2]

Jean Durant Rice died in early 1919, leaving Volkmar a life interest
in her investment and the land on which the pottery was built, with
the right to purchase all for a sum equal to the original investment.
This Volkmar did in 1924.

Both table and artware comprised early production,[3] with emphasis
on glaze development, where Mrs. Rice's "unusual taste and intelli-
gent criticism" were of great value.[4] In particular the copper blues,
reds, aubergine and yellow received considerable acclaim. Glaze
treatments were varied, but one of the most successful and popular
was allowing the glaze to thicken toward the foot in irregular outlines.
The reverse technique—thinning the glaze so a lighter shade is ob-
tained at the base—was also employed. The interior of a vase or bowl
was often glazed in a complementary or contrasting color. Simple
forms, predominantly of cream earthenware and showing a Near-
Eastern influence, were the staple of Volkmar's work, which he exe-
cuted with great skill and which received a Bronze Medal at the Paris
exposition of 1937.[5]

From 1913 to 1920 a number of workers were employed at the
Durant Kilns, but none of them had any creative part in the work; at
all times every piece bearing the Durant name was finished by Volk-
mar. After 1920 Volkmar's work took on more and more a "studio"
nature. The shift was graphically accomplished in 1930, when the
Durant Kilns designation was dropped and work thereafter bore only
the Volkmar name. Volkmar was later to express having made "a

serious tactical mistake when I abandoned the name Durant."[6]

In addition to teaching at the Volkmar and Durant Kilns and his positions with Pratt and the Pennsylvania Museum school, Volkmar also taught at Columbia University and the University of Cincinnati. Many of his students became accomplished potters, including Manuel Jalanovich, San Francisco studio potter who, with his associate Ingvardt Olsen, produced Jalan ware.[7] Volkmar himself died in California in 1959 after an extremely successful and productive career.

Typical work of the Durant Kilns is in the collections of The Brooklyn Museum, The Newark [New Jersey] Museum, The Galleries of Cranbrook Academy of Art, The Detroit Institute of Arts, The Art Institute of Chicago and The Metropolitan Museum of Art.

With a few exceptions in 1910, prior to the pottery's formal establishment, every piece of work bears the Durant name and date incised. In 1919 Volkmar added the stylized "V" similar to that used earlier by both Volkmars.[8] Later he incised the full Volkmar name; the Durant trade name was discontinued in 1930. It appears that immediately following 1930 the Roman numeral II was added to the stylized V to distinguish it from its earlier use, although this was soon dropped and only the V was retained. Care should be exercised in the attribution of the V mark, using stylistic and glaze treatments to determine its correct application in cases where pieces are not dated or otherwise marked.

1. Unless otherwise indicated, the primary source for the material herein contained is "A Brief History of the Durant Kilns," prepared by Leon Volkmar (1930).
2. Arden Studios acted as limited agents from 1925-28, after which there was no longer a regular agent.
3. Work of this type is illustrated in *Arts & Decoration*, III (January 1913), pp. 96-97; a unique table decoration set of thirty-one pieces is described in *Pottery & Glass*, XII (May 1914), p. 12.
4. Volkmar, *op. cit.*
5. W. E. Cox, *The Book of Pottery and Porcelain*, pp. 1056-57.
6. Letter of March 29, 1943, by L. Volkmar to The Brooklyn Museum.
7. A study, by P. Evans, of the work of the Jalan studio appears in *Spinning Wheel*, XXIX (April 1973), pp. 24-25, 48.
8. For comparison see the example in The Newark Museum collection (#11.509) from the Volkmar Kilns dated 1910 and that in The Art Institute of Chicago collection (#23.358 a,b) dated 1922 from the Durant Kilns. The stylized V was also used at the Volkmar Pottery* according to a report in the Brooklyn *Daily Eagle*, March 17, 1901, p. 14.

* Information relating to this pottery is included in a separate chapter

Edgerton Pottery
Edgerton, Wisconsin

Upon the failure of the Pauline Pottery* in April 1894, the Edgerton Pottery was organized by several shareholders of the former operation to take over the plant. It acquired the assets of the Pauline Pottery and began production of utilitarian ware shortly thereafter.[1] Utilitarian work included the manufacture of the porous body for the Field water filter produced by H. Geissel & Company of Chicago. It appears that the artware production of the Pauline Pottery was also continued, under the name *Rock Pottery*. This, undoubtedly, derived from Edgerton's location in Rock County.

Little is known of the Rock Pottery—whether, in fact, it was an independent operation or the name of Edgerton Pottery artware. It has been observed that a marked example of Rock Pottery has the identical elaborate C-scroll handle as a marked piece of Pauline Pottery in the collection of The Wisconsin Historical Society, Madison.[2] An example of Rock Pottery in the collection of the Lincoln-Tallman Museum, Rock County Historical Society, Janesville, Wisconsin,[3] is remarkably similar to the Norse Pottery* ware of Samson and Ipson. Possibly this type of ware had been experimented with at the Pauline Pottery while Samson and Ipson were associated there in 1891. Another piece in their collection[4] is a typical Pauline Pottery shape and decorated in typically Pauline style. It can be hypothesized that the molds for the Rock Pottery artware were acquired by the Edgerton

Edgerton/Rock Pottery bowl; mottled brown, green and yellow ground with clover leaf design strikingly similar to Pauline Pottery work; h. 4" (10.2 cm). Incised Rock Pottery mark and "40". *Rock County Historical Society (#P1-1953.2).*

Pottery along with the Pauline plant.[5] There is no indication that the Pauline name was involved in the transaction or that Pauline Jacobus was ever associated with the Edgerton Pottery prior to its sale under foreclosure in 1901.[6]

Four marked examples of Rock Pottery are presently in the collection of the Lincoln-Tallman Museum, Rock County Historical Society.

The artware bears the incised mark "Rock Pottery" and the designation "Edgerton, Wis".

Edgerton/Rock Pottery ewer. Yellow ground with geometric motif in blue, brown and green; h. 16¾" (42.7 cm). Incised Rock Pottery mark and "20". *Rock County Historical Society (#P2-1952.2).*

Rock Pottery,
Edgerton, Wis.

1. *China, Glass and Lamps,* XI (April 8, 1896), p. 19.
2. Personal correspondence with Mrs. Joan L. Severa, Curator of Decorative Arts, The Wisconsin Historical Society.
3. Their #P2-1952.1
4. Their #P1-1953.2; cf. their #P12-1972.
5. E. M. Raney, historian of the Edgerton potteries, reports that no reference has been found to the Rock Pottery in his inspection of local newspapers.
6. *Clay Record,* XIX (July 29, 1901), p. 24.
* Information relating to this pottery is included in a separate chapter

Edwin Bennett Pottery
Baltimore, Maryland

The Edwin Bennett Pottery Company occupies a prominent place in the history of pottery in the United States, principally for the production of high grade commercial wares. Edwin Bennett came to this country in 1841 to join his brother James in establishing Bennett & Brothers, one of the earliest yellow ware works in East Liverpool, Ohio.[1] Edwin Bennett left that firm in 1844 and the following year organized his own pottery at Baltimore. The growth of that operation was continuous, and goods of the highest quality were associated with its name.[2]

Following the 1893 Chicago exposition, art wares were introduced by the Edwin Bennett works. In 1894 *Brubensul* ware was produced, the name derived from the first three letters in the names of the foremost figures of the pottery: Brunt, Bennett and Sullivan. This earthenware line, principally of jardinieres and pedestals, featured a combination of majolica-like glazes, especially of rich browns, orange, crimson, blue and green, which flowed and blended together in the

[above] Edwin Bennett; reprinted from E. A. Barber, *The Pottery and Porcelain of the United States.*

[right] Edwin Bennett Albion vase, olive-green ground, decorated by Kate DeWitt Berg; h. 13" (33.2 cm). Incised Edwin Bennett/1896/Albion. *National Museum of History and Technology (Smithsonian Institution; #237,937).*

96

firing. The following year *Albion,* a slip-painted underglaze ware, was introduced. Designs were painted using colored slips on grounds which were mostly in green tones, and a transparent glaze of a neutral tint covered both ground and design. The designs were often of an Oriental nature incorporating hunting and hawking scenes of the desert and jungle, elephants, camels and Arabian steeds with riders, attendants and dancers. By the turn of the century this work had been abandoned because of insufficient public acceptance.[3] Edwin Bennett, twice elected president of the United States Potters' Association, died in 1908 at the age of ninety, and no further ventures into artware production were undertaken by the Bennett works prior to the closing of the pottery in 1936.

The Albion vase Barber indicates as being at the Pennsylvania (Philadelphia) Museum can no longer be found. A pair of Albion vases decorated by Annie H. Brinton in 1895 is in the collection of the Maryland Historical Society, and a single example of that ware is in the collection of the National Museum of History and Technology, Smithsonian Institution, (#237,937). An example of the Brubensul ware remains in the collection of the Philadelphia Museum of Art (#'95-63, 64), the gift of the pottery.

The Brubensul line was generally marked with a paper label as shown. Albion was marked with the Bennett name and the Albion designation, as well as the date and artist's cipher. The two most notable decorators were Kate DeWitt Berg and Annie Haslam Brinton, whose ciphers are illustrated.

1. The Bennett operation is generally considered the first such yellow ware producer in East Liverpool, although William H. Vodrey, Jr., (*The Bulletin* of The American Ceramic Society, XXIV, August 15, 1945, p. 282) raises the possibility of an earlier yellow ware operation there.
2. E. A. Barber, *The Pottery and Porcelain of the United States,* pp. 194-99; W. P. Jervis, *The Encyclopedia of Ceramics,* pp. 43-44. An extensive survey of the work of the Bennett Pottery is presented by Eugenia Calvert Holland, *Edwin Bennett and the Products of His Baltimore Pottery* (monograph published by The Maryland Historical Society, Summer, 1973).
3. Barber, *op. cit.,* pp. 472-75; E. A. Barber, *Marks of American Potters,* p. 146.

Enfield Pottery
Laverock, Pennsylvania

Output of the Enfield Pottery and Tile Works, like that of the Byrdcliffe Pottery*, was hand built. Also organized in the early years of the twentieth century, the firm produced artware of the folk variety until about 1910, when emphasis shifted completely to the manufacture of tile and tile mosaics. The artware was decorated with a heavy, enamel or majolica-type glaze, typical of most Enfield work.[1]

Work exhibited at the Jamestown exposition of 1907 sounds competitive with that of the Moravian Pottery and Tile Works;[2] handmade tiles in historic designs, some from medieval models and others from California mission patterns, are reported by Benjamin.[3] Enfield Pottery, designed by J. H. Dulles Allen, was later shown at the Fifteenth Annual Exhibition of Applied Art and Original Designs for Decorations (1915) at The Art Institute of Chicago, and an elaborate fireplace facing designed and executed by Enfield is pictured by Binns.[4]

Little further reference is found relating to the Enfield operation,but it appears to have been in production as late as 1928.[5]

A jug (#379,603) and a loving cup (#379,661) are in the Benjamin collection of the National Museum of History and Technology, Smithsonian Institution. Several tiles (#393,818-820) are in the Wires collection of the National Museum.

The Enfield name was sometimes incised; items normally bore paper labels.

1. *Handicraft,* V (May 1912), p. 21.
2. The similarity of names seems to be more than coincidence; it appears that artware was also produced at Moravian in its early years (c. 1902-03), although no conclusive evidence of that has yet been found. Correspondence between Taft and Belknap of New York and the Worcester Art Museum (1902-03) gives every indication that it was, on a very limited basis. For an illustrated descriptive account of the extensive Moravian tile operation see Robert W. Blasberg, *Spinning Wheel,* XXVII (June 1971), pp. 16-19; also see Benjamin H. Barnes, *The Moravian Pottery* (The Bucks County Historical Society, Doylestown, Pennsylvania, 1970).
3. M. Benjamin, *Glass and Pottery World,* XV (October 1907), p. 23.
4. Charles F. Binns, *The American Magazine of Art,* VII (February 1916), p. 134.
5. *The Bulletin* of The American Ceramic Society, VII (September 1928), p. 298.
* Information relating to this pottery is included in a separate chapter

Etruscan Antique Art Works
Sebring, Ohio

Sebring became a center for the production of white granite and semi-vitreous porcelain (china) at the turn of the twentieth century, when the Sebring Pottery Company, originally located in East Liverpool in 1887, and the French China Company, established in 1895 also in East Liverpool, moved to Sebring in 1900 and 1901 respectively. In 1900 the Limoges China Company was also established there.[1]

No record has thus far been found of the Etruscan Antique Art Works, which evidently operated for a short time in the 1906-07 period. Marcus Benjamin provides the only mention of the concern in his account of pottery exhibited at the Jamestown exposition. "Of considerable interest," he wrote, "was the exhibit of the Etruscan Antique Art Works of Sebring, Ohio, which was confined to the new art ware, simulating a metallic surface with iridescent sheen, the beauty of which promises to make it one of the most interesting of recent artwares."[2]

There is no record of the firm's incorporation in Ohio, and no other reference to the pottery has thus far been located.

Marked examples are unknown.

1. W. Stout *et al., Coal Formation Clays of Ohio,* p. 83; see also E. A. Barber, *Marks of American Potters,* p. 135.
2. *Glass and Pottery World,* XV (October 1907), p. 23.

Faience Manufacturing Company

Greenpoint, New York

Edward Lycett

The Faience Manufacturing Company began operations in 1880 producing decorated ware, often with applied modeled ornamentation which was painted under the glaze. A showroom was maintained in New York City; the factory was located at Greenpoint in Brooklyn's eastern district, which by 1860 was a well-established pottery center. In 1848 Charles Cartlidge had established the Greenpoint Porcelain Works.[1] The old Boch works in the same area, operated as the Union Porcelain Works by Thomas C. Smith, was the supplier of blanks for the earliest work of M. Louise McLaughlin (Losanti*).

Four years after Faience Manufacturing's organization, Edward Lycett joined the firm. Lycett had come to the United States in 1861, after having received outstanding training in ceramic work and decoration in his native England. After his arrival here, he devoted most of his energy to the professional decoration of china; for his continuous association with that field for four decades, in work and teaching, Barber felt it not improper to consider him the father of china painting in the United States.[2]

Initially Lycett worked only with imported blanks, but these were thereafter abandoned for native bodies, principally those of his own compounding. During his association with Faience as a decorator and director of the factory, he introduced a new porcelaneous body. This process possessed many of the advantages of earthenware and at the same time allowed for the superior glaze of hard porcelain.[3] Lycett's abilities as a decorator and a practical potter had many successful consequences, including the perfection of fine metallic luster glazes. He also designed numerous new shapes and hired and directed some of the best artists—about twenty-five—to execute the decoration. When Faience became the agent for a French factory in 1890, Lycett retired from active business and associated with his son William's studio in Atlanta. There he continued his experimentation, giving special attention to the application of his metallic lusters to modern wares including tiles.[4]

Edward Lycett died in Atlanta in 1909, having survived the Faience Manufacturing Company by some seventeen years; it had ceased its

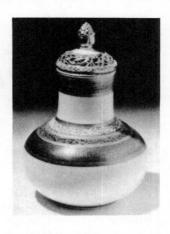

[right] Faience Manufacturing covered vase; h. 9¼" (23.5 cm). Signed by Edward Lycett. *Philadelphia Museum of Art (#'03-12), gift of E. Lycett.*

[left] Faience Manufacturing white graniteware covered vase; h. 28" (71.2 cm). Signed by Joseph Lycett and dated 1889. *Henry Ford Museum (#60.135).*

operations in 1892, shortly after Lycett's departure.

Examples of both the earlier pre-Lycett work of Faience Manufacturing and some of Lycett's own work including that of the Atlanta period are in the collection of the National Museum of History and Technology (Smithsonian Institution).

The earliest Faience Manufacturing Company mark is the incised initials of the firm. The mark used on the artware of the Lycett period was initially the crowned-R designation for *Royal Crown* ware, but this was of very short duration, being replaced by the entwined monogram, as shown. Lycett signed his own name to his later work, sometimes including the date. The numbers which appear on some of the Faience pieces relate to the shapes and decoration. Artists usually did not sign their work.

FMC

E Lycett

1. For a comprehensive historical sketch of this operation see E. A. Barber, *The Clay-Worker,* XXIII (June 1895), pp. 688-89; *ibid.,* XXIV (July 1895), pp. 23-25; *ibid.,* XXIV (August 1895), pp. 120-22; *ibid.,* XXIV (September 1895), p. 266-27; *ibid.,* XXIV (October 1895), pp. 330-32.

2. E. A. Barber, *The Pottery and Porcelain of the United States,* pp. 314-19; 460-65. A comprehensive and extensively illustrated study of Lycett's work by Barber, entitled "The Pioneer of China Painting in America," appears in *The Ceramic Monthly,* II (September 1895), pp. 5-20.

3. Barber (*ibid.,* p. 316) describes the body as a true porcelain, yet entirely devoid of bone. "It is fired in the reverse of the usual method, being burned hard in the biscuit and softer in the glaze, in which no lead or borax is present."

4. E. A. Barber, *Marks of American Potters,* pp. 83-85; 153-54.

* Information relating to this pottery is included in a separate chapter

Faience Pottery

Zanesville, Ohio

Another of the small Zanesville producers of art pottery was The Faience Pottery Company, not to be confused with the earlier Faience Manufacturing Company*. The Zanesville firm was incorporated in Ohio in May 1902 for the purpose of "manufacturing all kinds of common, fancy and art pottery and clay specialties."[1] Operations were under the direction of George B. Cunningham, William O. Josselyn and Stephen J. Sebaugh. Their output was evidently well-received, and plans were made for the expansion of the works in 1903.[2] While it is reported that artware was produced for exhibition at the 1904 St. Louis exposition, "typical of the kind that is manufactured in Zanesville,"[3] no record of its ever having been exhibited at St. Louis has been found. The pottery, on Maysville Avenue, Zanesville, has been described as "a rather ramshackle 'hoodooed' plant," located on ground that was too low and thus often flooded.[4]

The firm encountered financial difficulties in 1906; a receiver was appointed[5] and the corporation was dissolved. In August of that year the incorporation of The Taylor Pottery Company, headed by E. L. Taylor, was undertaken to operate the Faience Pottery.[6] There is no evidence that this pottery ever became operative, and in early 1907 it was transferred to the Fisher Veneer Tile Manufacturing Company.[7]

The mark of the Faience Pottery is unknown.

1. Articles of Incorporation, Columbus, Ohio.
2. *China, Glass and Pottery Review,* XIII (September 1903), p. 21. Names of individuals are spelled as they appear on the incorporation papers.
3. *Ibid.,* XIV (April 1904), p. 33.
4. *Glass and Pottery World,* XV (July 1907), p. 28.
5. Common Pleas Court rendering, S. J. Sebaugh vs. FaiencePottery, Journal, Volume 51, p. 475, in Muskingum County, Ohio.
6. *The Clay-Worker,* XLVI (August 1906), p. 184.
7. *Clay Record,* XXX (May 30, 1907), p. 35.
 * Information relating to this pottery is included in a separate chapter

Florentine Pottery

Chillicothe, Ohio

Chillicothe, lying midway between Cincinnati and Zanesville, presumably offered an ideal location for the establishment of an art pottery, and in 1900 an attempt was made to organize a plant there.[1] By the end of the year $5,000 was raised by local interests, so that operations could be begun on a small scale with the hope of expansion as business grew.[2]

The Florentine Pottery Company was chartered as a West Virginia corporation in December 1900 with W. E. Eberts as president and Frederick C. Arbenz as secretary and treasurer. The following month ground was broken for the plant at Chillicothe.[3] The plan was for a four-kiln pottery with preparations made for an additional four kilns when business so warranted.[4] The initial stage was completed by May,[5] and George J. Bradshaw, an English potter, became general superintendent of the new works. Prior to his move to Chillicothe, Bradshaw had been superintendent of the J. B. Owens* works at Zanesville, and subsequently associated with the Homer Laughlin plant at East Liverpool.[6]

Operation of the pottery, which was located at the end of Washington Avenue at the Baltimore and Ohio Railroad, was begun about July 1, 1901; but it was not fully in action until a year later, at which time its capacity was three kilns a week.[7] Output consisted of artware vases, jardinieres, pedestals and umbrella stands.[8] Bradshaw, who joined the Florentine works in February 1901 and who was responsible for its earliest work, died in April of the following year.[9] He was succeeded by his assistant F. J. A. Arbenz. Just before Bradshaw's death, a kiln "accident" produced a unique glaze which was bronze in appearance with gradations from silver to gold in a rich metallic luster.[10] After considerable work, continued under Arbenz' direction, this bronze glaze was perfected and the line was named *Effeco*.[11] It was apparently this ware which was shown by the pottery at the 1904 St. Louis exposition.[12]

The artware venture was not financially successful. Production of all pottery of this nature was discontinued and the corporation reformed in Ohio in 1905 by F. C. Arbenz and Herbert Machin. Production of sanitary ware was commenced at that time.[13] Two years later it was reorganized by W. E. Eberts and F. C. Arbenz and the manufac-

ture of sanitary ware continued. In 1919 the works was relocated in Cambridge, Ohio, where one of the most modern plants of that time was constructed.[14]

In addition to the mark recorded by Barber,[15] the impressed cipher, as illustrated, has been noted on a piece of souvenir ware made in the first decade of the twentieth century.

1. *Illustrated Glass and Pottery World,* VIII (November 15, 1900), p. 11.
2. *Ibid.,* VIII (December 15, 1900), p. 21.
3. *Ibid.,* IX (January 1901), p. 18; *China, Glass and Lamps,* XXI (January 17, 1901), p. 2.
4. *Illustrated Glass and Pottery World,* IX (February 1901), p. 51.
5. *Crockery and Glass Journal,* LIII (May 16, 1901), p. 19.
6. Local directory, Zanesville, Ohio, 1896; *Brick,* XIV (March 1901), p. 169.
7. H. H. Bennett, ed., *The County of Ross* (1902), p. 149.
8. E. A. Barber, *Marks of American Potters,* p. 138.
9. Chillicothe's *Scioto Gazette,* April 25, 1902.
10. *Illustrated Glass and Pottery World,* X (February 1902), p. 21.
11. W. Stout *et al., Coal Formation Clays of Ohio,* p. 97.
12. S. Geijsbeek, *Transactions* of The American Ceramic Society, VII (1905), p. 350.
13. *Pottery* (Trenton, New Jersey: Thomas Maddock's Sons, 1910), p. 30.
14. Stout *et al., op. cit.,* p. 88; *The Clay-Worker,* LXXIII (June 1920), p. 750.
15. *Op. cit.,* p. 138.
 * Information relating to this pottery is included in a separate chapter

Frackelton Pottery
Milwaukee, Wisconsin

Susan Stuart Goodrich Frackelton is of special interest due to her influence in the development of mineral painting, her introduction of a portable gas kiln for china decorators, her extensive experimentation with local Wisconsin clays and her work with high-fired stoneware, especially of the salt-glazed variety.

The daughter of a brickmaker, Mrs. Richard G. Frackelton was a china painter; this activity, which lay behind the formation of numerous potteries including Rookwood*, Newcomb*, and Pauline*, led her, by 1883, to establish the Frackelton China Decorating Works in Milwaukee.[1] Professionally trained decorators were employed, and average weekly production fired at their kilns ranged from 1,500 to 2,000 pieces.[2] By 1892 she had organized the National League of Mineral Painters to bring into closer association the mineral artists of the United States and to assist in the development of a national school of ceramic art. At the turn of the century the League numbered about 500 and held annual exhibitions of their work. One prominent member was Adelaide A. Robineau (Robineau Pottery*), whose interest also grew to encompass clay work.[3]

The Frackelton Dry Water Colors, gold and bronzes, developed for painting on china, were awarded medals by Leopold II, King of the Belgians, in the competition at Antwerp in 1894. Related to this was the publication by D. Appleton & Company, New York, of the enlarged

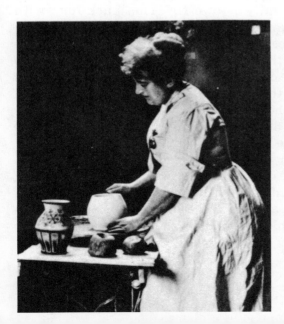

S. S. Frackelton at work. *Milwaukee County Historical Society.*

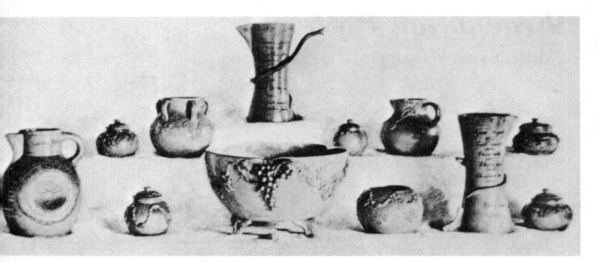

Frackelton stoneware as shown in *Tried by Fire* (3rd edition, 1895).

third edition of Frackelton's book, *Tried by Fire,* which was first copyrighted in 1885.[4]

Frackelton's china painting work gained recognition as early as 1881, when it was awarded a Gold and Silver Medal at the International Cotton Exposition in Atlanta.[5] Her first art stoneware was shown at the Columbian Exposition and was awarded a Gold Medal. The salt-glazed pieces exhibited there were designed by Susan Frackelton exclusively to show the quality of local clay—much in the same manner as A. W. Robertson's work at Roblin*—and not for commercial purposes, although some art work was done commercially. Examples ranged from vases to hanging bowls; from Hungarian-type decorations to shapes modeled after those of ancient Egypt.[6]

Two particular salt-glazed pieces produced by the traditional single-firing method are especially noteworthy. The "Luck Jug," with its four-leaf clover and Romany texts, was modeled in 1881 in Louis Pierron's pottery in Milwaukee and remained in a greenware state for twelve years, being fired for the 1893 exposition.[7] The famed "Olive Jar," acquired for $500 for the collection of the Pennsylvania Museum by E. A. Barber, consists of three pieces. The lid is decorated with several well-modeled olives, the upper one of which serves as a knob or handle. The jar proper, about 30" high, tapers to about 18" at the base and is signed and dated at the neck. The feet of the stand on which it rests are feline claws to which wings were added. Above each claw is a large olive in bas-relief. Three olive branches filled with fruit, in relief also, are carefully intertwined around the body.[8]

In the United States little artistic use was made of common salt-glazed stoneware. With the sole exception of the work at the Graham

Pottery*, Frackelton stood alone. Her success demonstrated that salt-glazed stoneware need not be confined to utilitarian objects such as butter crocks, jugs, steins and sewer pipe, but could be fashioned into artware objects which could hold their own in any competition.

Aside from the salt-glazed stoneware with its cobalt-blue, incised and applied decoration, Frackelton successfully produced a blue underglaze decorated ware, of a type similar to that executed by Charles Volkmar (Volkmar Pottery*) in the 1896 period. The Delft-appearing ware was produced extensively for the 1900 Paris exposition.[9] Tiles depicting cherubs, windmills, ships and other Dutch motifs were also produced by this technique.[10]

Frackelton's work was always hampered by the lack of necessary facilities. Her earliest experiments in salt-glazed stoneware were fired over one of the arches in a brickmaking kiln.[11] After about a year, work was abandoned for lack of adequate working arrangements.[12] Upon special invitation she returned to her work, but pieces for the Paris exposition were bisque-fired in Milwaukee and had to be sent to Red Wing, Minnesota, for glazing.[13] The following year she had work for the Buffalo exposition thrown at the pottery of Fred Weis in Milwaukee and then shipped to Akron, Ohio, for firing.[14] The obstacles evidently proved insurmountable; Frackelton abandoned potting prior to the St. Louis exposition and relocated in Chicago. There is no evidence that she continued her ceramic work there,[15] although she lectured on a variety of subjects until her death in Chicago in 1932.

A good collection of most aspects of the Frackelton work is maintained by The State Historical Society of Wisconsin, Madison, a large part of which is the gift of Susan Frackelton's daughter. Both the Milwaukee Public Museum and the Milwaukee County Historical Society also have illustrative examples.

Frackelton artware was marked either with the incised Frackelton name or the incised "S.F." cipher. Pieces often bear the date as well as the Frackelton signature.

Frackelton blue underglaze decorated vase; h. 5¼" (13.4 cm). Incised cipher and dated 1900. *Michiko & Al Nobel.*

FRACKELTON POTTERY

Frackelton two-handled tyg made for the Buffalo exposition. Reverse side pictures buffalo roaming the plains at sunset and bears the inscription "Toward the setting sun, Far sighted are our stately subtle Red Men." h. 6¾" (17.2 cm). Frackelton cipher incised, dated 1901. *Private collection.*

1. A detailed description of an extensive Frackelton-decorated dinner service for eighteen is reprinted in *Crockery and Glass Journal*, XIV (September 29, 1881), p. 14, from the *Evening Wisconsin.*
2. *Crockery and Glass Journal*, XXVII (June 7, 1893), p. 22. A critical analysis of the Frackelton work is offered by Clarence Cook, *The Atelier*, XX (December 1888), p. 5, after examination of ware displayed at the American Pottery and Porcelain Exhibition in Philadelphia.
3. E. A. Barber, *The Pottery and Porcelain of the United States*, pp. 512-16.
4. *The Clay-Worker*, XXIV (July 1895), p. 56; *Clay Record*, VI (June 12, 1895), pp. 17-18.
5. *The Sunday Times-Herald* (Chicago), February 17, 1901.
6. The Work of S. Frackelton at the Columbian Exposition is extensively reported by Richard G. Frackelton in *The Clay-Worker*, XXI (April 1894), p. 437-38; XXI (May 1894), pp. 538-40; XXI (June 1894), pp. 640-42. In many instances Mrs. Frackelton is not identified by name, but the reference is obvious. See also *Clay Record*, IV (April 14, 1894), p. 23.
7. *Ibid.*, XXI (April 1894), p. 438; XXI (May 1894), p. 540. In actuality it was probably the pottery of Charles Herman, founded in 1856. According to Robert G. Carroon (*Historical Messenger of the Milwaukee County Historical Society*, XXVI, March 1970, pp. 16, 18) Pierron, Herman's stepson, did not become a partner in the firm until 1882. He became sole proprietor in 1886 and the pottery operated until 1935.
8. This piece was still in the collection of the Philadelphia Museum of Art in 1971 (#'93-309).
9. *Illustrated Glass and Pottery World*, VIII (March 1900), pp. 12-13; *The Art Amateur*, XLIV (January 1901), pp. 51-52. The Blue and Gray ware was produced by an entirely different process; at Buffalo in 1901 it was exhibited with the National League of Mineral Painters' work, while the salt-glazed pieces were shown in the Wisconsin Building according to *Keramic Studio*, III (December 1901), p. 166.
10. Several tiles of this type are in the collection of the Milwaukee County Historical Society.
11. *The Clay-Worker*, XXI (May 1894), p. 539.
12. M. L. McLaughlin, *The Craftsman*, III (January 1903), pp. 255-56.
13. *Illustrated Glass and Pottery World*, VIII (March 1900), pp. 12-13. This was evidently at either the Red Wing or Minnesota Stoneware plant. For a brief description of the various Red Wing stoneware producers see Darlene Dommel, *Spinning Wheel*, XXVIII (December 1972), pp. 22-24.
14. Milwaukee *Sentinel*, March 31, 1901.
15. A possible exception is a piece dated 1904 in the collection of the Wisconsin Historical Society (#1958.1316). In addition to the Frackelton cipher and the date, it also bears the letter "C", perhaps indicating the Chicago location.

* Information relating to this pottery is included in a separate chapter

Fulper Pottery

Flemington, New Jersey

Fulper Pottery, like the American Terra Cotta Company (Teco*), was well-established long before its line of artware was introduced. While numerous sources date the beginning of the Fulper works as 1805, this date is without factual foundation.[1] The operation which was to become the Fulper Pottery was established in 1814 at the corner of Mine and Main Streets, Flemington, by Samuel Hill.[2] In 1860, two years after Hill's death, his family sold the pottery to Abra(ha)m Fulper. Fulper had worked for Hill for some time, and it appears that for at least a year prior to Hill's death Fulper may have been renting the pottery from him.[3] Following the death of Abram Fulper in 1881 the pottery was operated by his sons, George W., William H., Charles and Edward B., under various styles including

Fulper (Vasekraft) exhibit at the Panama-Pacific International Exposition, 1915. *Pottery & Glass.*

Fulper vase with light blue ground and light green crystallization; h. 9½" (24.2 cm). Vertical raised marks. *Private collection.*

G. W. Fulper & Bros. and Fulper Bros.[4] The firm was incorporated in New Jersey in early 1899 as the Fulper Pottery Company.

After considerable experimentation, Fulper introduced the *Vasekraft* (or Vase-Kraft) art pottery line in late 1909.[5] The body, of natural New Jersey clay, was of the same heavy stoneware that was used in the production of Fulper filters, crocks and cooking utensils and was fired at a very high temperature along with this commercial ware.[6]

The regular Vasekraft line included jardinieres, vases, blossom cups, bowls, bookends, tobacco containers, candleholders, clock cases, desk sets, lamps (hanging, desk and table), coffee sets, cooking ware, mugs, decanters, pitchers and tiles.[7] Even more extensive than the items themselves were the hundreds of glazes which encompassed luster, crystalline, matt and high-gloss finishes in monochrome and polychrome treatments. Their descriptions ranged from "café au lait" (chocolate) and "mission matte" (brown-black) to "verte antique" (rich green) and "Alice blue" (pale blue); from "smoke green" and "Chinese blue" to "elephant's breath," "leopard skin" (a luster crystalline on a slate or mauve color) and "cat's eye."[8]

While all of the glazes were of a noteworthy character—far exceeding the quality of the body for artware[9]—the most prestigious glaze line was the "famille rose," developed by W. H. Fulper, Jr. Fulper considered this the rediscovery of the ancient Chinese secret, and hence the glaze was applied to classical Chinese shapes. Prices on this line began at ten times the cost of the most expensive Vasekraft items, with valuations as high as $100 an object. Colors offered in the famille rose were "deep rose" matt, "peach bloom," "old rose," "true rose," "apple blossom" and "ashes of roses."[10] Fulper pledged to loan "for exhibition purpose (with privilege of sale)" a piece of the famille rose to dealers who regularly stocked the Vasekraft wares.[11] Three examples of the famille rose ware were given to the Philadelphia Museum of Art in 1911 by the pottery.[12]

J. Martin Stangl is first listed as superintendent of the technical division of the pottery in 1911,[13] about the same time that George W. Fulper withdrew from the works after fifty years of service.[14] Under Stangl's direction numerous new glazes were introduced; they continued to attract considerable attention, culminating with the pottery's award-winning display at the San Francisco exposition in 1915.[15] For a short time between 1915 and 1920 Stangl left Fulper's employ and developed the industrial artware line for Haeger Potteries, which was placed on the market about 1917.[16]

Fulper, like the Paul Revere Pottery*, produced dolls and dolls' heads for a time during World War I. These bisque items, in excess of 1,000 a day, were turned out during the 1918-21 period, and were usually marked with the Fulper name, vertically on the back or the back of the head. In addition to the dolls' heads of several sizes, life-sized heads for retail display purposes were also produced.[17]

All lines of the business continued very successfully, and in 1928, the year in which William H. Fulper died,[18] a new plant was placed in operation on New York Avenue in Trenton, New Jersey.[19] The following year the main plant at Flemington was completely destroyed by fire. Included in the loss was a large stock of artware which had been produced in anticipation of that year's holiday trade.[20] The plant in Trenton, as well as the second Fulper plant on Mine Street, Flemington, both operated thereafter at peak capacity to meet the demand for Fulper ware.[21] In 1930 Stangl acquired the Fulper firm; artware continued to be produced on a very limited scale at the Mine Street location until 1935, when that plant was closed.[22]

After 1935 emphasis was shifted from artware to dinner ware produced under the Stangl name, and in the post-1940 period ceramic

Fulper vase with green crystalline glaze and remarkably thin body for Fulper ware; h. 6⅞" (17.5 cm). Imprinted vertical mark. *The Newark Museum (#15.12).*

Fulper globular-body vase, rose-pink matt glaze; h. 12⅛" (30.9 cm). Vertical raised mark. *The Newark Museum (#15.407).*

Fulper olive-green and ocher cattail vase with interior dark brown matt glazed; h. 12¾" (32.5 cm). Imprinted vertical mark. *Michiko & Al Nobel.*

figures were introduced. Manufacture of industrial art, gift and dinner ware continued, also under the Stangl name, as late as 1972, the year of Stangl's death. In late 1955 the corporate title was formally changed to the Stangl Pottery Company,[23] although the Stangl name had been used for almost ten years prior to that time.

The most important collection of Fulper artware was that formerly at the Philadelphia Museum of Art, given by the firm in 1911. Another collection, important primarily because of its acquisition largely prior to 1916, thus establishing a definite date for items, is at The Newark [New Jersey] Museum. In The Newark Museum collection are also examples of the earlier, nineteenth century Fulper production. The New Jersey State Museum at Trenton also has a good collection of Fulper art pottery.

The Fulper ware, while rarely dated, was carefully marked with any one of a number of impressed, in-mold and imprinted designations. There is apparently no way of using the various marks in dating, as the numerous vertical marks were all used on pieces of early manufacture. The impressed horizontal mark would appear to be later, since it is not found on earlier items for which dates can be established. The Vasekraft designation is often found on early paper labels which were affixed in addition to the permanent mark.[24] The illustrated cipher of Martin Stangl is sometimes found on pieces.

1. The 1805 date was evidently adopted for its advertising effect. Even before the turn of the century the totally fictitious claim was advanced that "the pottery was established by Fulper in 1805" (*The Clay-Worker,* XXXI, April 1899, p. 365). This date was repeated in early artware advertising and in *The Clay Products of New*

Jersey (1915 exhibition catalog of The Newark [New Jersey] Museum Association), p. 16; and it was also incorporated into the registered Fulper trademark (see note 24).

2. Letter from Hiram Deats, since 1884 a personal friend of W. H. Fulper, Jr., written to Miss Dorothy F. Lucas of the New Jersey State Library, Trenton, in reply to her letter of February 17, 1944. The information contained therein is corroborated by M. Lelyn Branin's extensive search of deeds, probate records and other material. Deats, in his letter, notes the source of the erroneous 1805 dating: "Bill Fulper [William Hill Fulper, Jr.] . . . found an old plate mold, that [we] used to call a 'chum' with the date 1805, and always claimed that was the date it started."

3. Samuel Hill's will (Hunterdon County, Book 10, page 100), dated May 2, 1857.

4. Pieces with impressed marks bearing these designations are in the collection of The Newark Museum. See *The Pottery and Porcelain of New Jersey, 1688-1900* (1947 exhibition catalog of The Newark Museum), pp. 32-33.

5. *The Fra,* IV (December 1909), p. xiv; *Pottery & Glass,* VII (September 1911), pp. 17-18. The 1947 Newark Museum catalog (p. 16) indicates that art pottery was made as early as 1906. While it is possible that experimental work was carried on at that time, it was not until 1909 that regular production of such ware was begun.

6. *Pottery & Glass,* IX (December 1912), pp. 41-42.

7. Pictured in an early advertisement in *Pottery & Glass,* V (August 1910), pp. 42-43; discussed in the same publication, VII (September 1911), pp. 17-18.

8. *Ibid.,* XV (July 1915), pp. 9-10.

9. Criticism of the heavy weight and forms of Fulper pottery is offered by *Keramic Studio,* XIV (January 1913), p. 197.

10. *Pottery & Glass,* V (August 1910), pp. 15-16.

11. *Ibid.,* p. 43.

12. Their #'11.275-277; '11.276 and '11.277, with an "old rose" glaze, are still in the museum's collection, although the former has been on extended loan to another institution.

13. Members' directory of The American Ceramic Society, *Transactions,* XIII (1911).

14. *Pottery & Glass,* V (December 1910), p. 24.

15. *Ibid.,* XV (July 1915), pp. 9-10.

16. Robert W. Blasberg, *Spinning Wheel,* XXIX (October 1973), pp. 14-18; *Keramic Studio,* XIX (August 1917), p. 57. For a history of the Haeger Potteries see *The Bulletin* of The American Ceramic Society, XXIV (October 15, 1945), pp. 356-57.

17. *Crockery and Glass Journal,* XC (December 18, 1919), p. 133; also Ruth Ricker, *Spinning Wheel,* XII (July 1956), p. 28. Two examples of dolls from the Fulper works are in the collection of The Newark Museum, a Kewpie (#20.1151) and a Peterkin (#20.1152).

18. *The Bulletin,* VII (December 1928), pp. 380-81.

19. *The Clay-Worker,* XC (July 1928), p. 27.

20. *The Clay-Worker,* XCII (October 1929), p. 288.

21. *Ibid.,* XC (November 1928), p. 382.

22. *Stangl: A Portrait of Progress in Pottery,* privately published brochure of the Stangl Pottery, 1965.

23. Corporate records, State of New Jersey, Trenton.

24. According to the statement filed with the United States Patent Office for registration of the trademark of the potter at the wheel, this mark was first used July 12, 1911. It was duly registered May 20, 1913, #91,655.

 * Information relating to this pottery is included in a separate chapter

Graham Pottery

Brooklyn, New York

Frackelton* and Graham were the only two United States potteries to work seriously with the artistic potential of salt-glazed stoneware. While Charles and William Wingender of Haddonfield, New Jersey, achieved most handsome results in their decoration of utilitarian wares such as steins, tankards, wine pitchers and the like, their work for the most part did not encompass decorative artware.

The Charles Graham Chemical Pottery Works was organized in 1880 for the manufacture of chemical stoneware.[1] While work was primarily of a utilitarian nature, experiments were soon undertaken in the use of the available material and facilities for the production of a line of artware. In 1884 Graham filed an application for a patent on a unique method of decorating such work, and patent 315,021 was granted on April 7, 1885. The technique was analogous to the etching of metal: a portion of the surface of black, chocolate or other dark shades of salt glaze was removed with diluted hydrofluoric acid at certain places, exposing a white, light cream or other light-colored body. The design, so executed, would then appear in the natural body color of the ware, while the ground retained the darker salt glaze covering.

Later Charles C. Benham joined Graham. Benham, probably the first in the United States to earnestly pursue the carving of ornamental designs on salt-glazed stoneware, began his work prior to the 1876 Centennial Exposition. The technique used by him was considerably

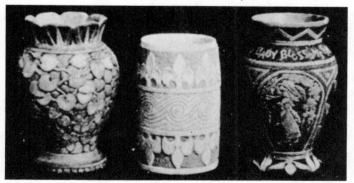

Carved stoneware by C. C. Benham; reprinted from E. A. Barber, *The Pottery and Porcelain of the United States.*

Drawing of Graham acid-etched ware as filed with patent papers.

Graham vase show-
ing patented acid-
etched technique; h.
7³/₈" (18.8 cm). Im-
pressed mark with
patent date. *H. Hennings.*

different from that patented by Graham, and perhaps the latter was abandoned because it proved too costly for a limited production. Rather than decorating a fired piece as with Graham's patented method, Benham cut, carved or incised green ware which had been covered with a dark coating, much in the nature of the sgraffito style of decoration in which designs were etched to reveal the clay body beneath them. Benham then fired the ware in the classical stoneware manner at over 2,000 °F. so that the body, glaze and decoration vitrified and matured together. Salt-glazing was particularly suitable for his work, as the salt vapors entirely coated the objects with a high-gloss, thin, impervious coating without injuring or obscuring the sharpness of the carvings.[2]

Shortly after the turn of the century all artwork was abandoned,[3] and the main output of the works continued to be acid receivers, vats, jars, stopcocks, sinks, pumps and other articles for chemical work. Production was principally from New Jersey clays, although clay from Long Island was sometimes used.[4]

The marks, as illustrated, were impressed. On the patented-type ware the patent date was also indicated.

1. H. Ries and H. Leighton, *History of the Clay-Working Industry in the United States,* p. 50.
2. E. A. Barber, *The Pottery and Porcelain of the United States,* pp. 505-09.
3. The last noted reference to Benham's art pottery is by W. G. Bowdoin, *The Art Interchange,* L (April 1903), p. 90.
4. H. Ries, *Clays of New York: Their Properties and Uses,* p. 823.
* Information relating to this pottery is included in a separate chapter

Grand Feu Art Pottery
Los Angeles, California

Pathetically little information is available on this producer of outstanding art pottery. Apparently the pottery began operation in Los Angeles sometime late in 1912 under the ownership and direction of Cornelius Brauckman. The works, listed in the Los Angeles directory in only the 1913 edition, was located on the south side of West 96th, second west of South Main. While no further listings occur in Los Angeles, Brauckman's Grand Feu pottery was awarded a Gold Medal at the San Diego exposition in 1915.[1] It was later exhibited at the First Annual Arts and Crafts Salon, Los Angeles, held in February 1916,[2] indicating the pottery was still in operation at that time.

Grand Feu, by definition, is a ceramic ware fired at a high temperature which can mature body and glaze simultaneously. Both porcelain and grès are *grand feu* wares, the Grand Feu pottery concentrating on the latter. Gres-Cerame, as the Grand Feu advertising brochure[3] described their product, is a vitrified body like porcelain but differs from it by being neither pure white nor translucent. The Chinese used grès for many of their monochrome glazes, and toward the end of the nineteenth century it was used extensively in France by many including August Delaherche and Taxile Doat (see University City*).

One can speculate that Brauckman was influenced by Doat's book on *grand feu* work,[4] the same text which served as Robineau's* inspiration. Yet to date it has been impossible to establish any direct relationship between Brauckman and Doat while Doat was in the United States.

No applied or painted designs were used, Grand Feu relying on the natural effects created by the interplay of glaze and heat (the ware was fired at 2500 °F.). Particular glazes of the pottery were Turquoise, Mission (mottled chocolate brown), Tiger Eye, Blue, Yellow, Green, Red and Moss Crystals, Green and Blue Ramose, Moss Agate (sponged appearance of green over light tan), Multoradii, Venetian Green and Sun Ray (shadings of brown, buff and pale green produced by melting

Grand Feu "Sun Ray" ware; h. 4¾" (12.1 cm) and 4½" (11.5 cm). Impressed Grand Feu mark on both pieces. *National Museum of History and Technology (Smithsonian Institution; #279,769-770).*

glaze).[5] In addition to the uniqueness of each piece achieved through glaze development in firing, nearly all work was thrown in classically simple forms.

Four pieces of Grand Feu work are in the collection of the National Museum of History and Technology (Smithsonian Institution), given by Brauckman in September 1913.[6] Each attests to the high caliber of his work, as do all other pieces thus far found. The quality of craftsmanship places them among the finest art pottery produced in the United States.

All work was carefully marked, most often with an impressed Grand Feu designation; the impressed "Brauckman Art Pottery" mark, as shown, has also been noted and would appear to be of a slightly later period (c. 1916-18). In addition an incised number, whose meaning has not yet been established, appears, and occasionally the impressed letters "TT".

Grand Feu "Mission" glazed vase; h. 4¾" (12.1 cm). Impressed Brauckman Art Pottery mark. *Private collection.*

Grand Feu mottled green and tan matt vase; h. 3¾" (9.5 cm). Impressed Grand Feu mark. *Private collection.*

BRAUCKMAN
ART
POTTERY

GRAND FEU
POTTERY
L. A., CAL. TT

1. *The Potter,* I (December 1916), p. 38.
2. Exhibition catalog, p. 12, notes pieces loaned by Kanst, who also loaned pieces of Overbeck*, Paul Revere* and Arequipa* pottery.
3. "Grand Feu Art Pottery," published c. 1913. It indicates that the work of the pottery was on sale at F. H. Taber's, 415 South Spring Street, Los Angeles.
4. T. Doat, *Grand Feu Ceramics.*
5. "Grand Feu Art Pottery."
6. Their #279,767 is an example of the Moss Agate glaze; #279,768 of Mission; #279,769-770 are examples of Sun Ray.
 * Information relating to this pottery is included in a separate chapter

Grueby Pottery

Boston, Massachusetts

The Grueby Pottery. *Glass and Pottery World.*

Grueby was by no means the inventor or originator of the matt glaze in the United States. The Chelsea Keramic Art Works* had achieved an excellent matt finish about 1885 as did Rookwood* about a year later, but neither was developed to any extent commercially at that time. It was Grueby's technique and the application of it, however, which made their name synonymous with the highest quality of matt-decorated artware. Yet a history of this works has remained unclear, largely because researchers have attempted to draw the facts related to Grueby into a single account. Actually, there was not one but three different Grueby operations.

William Henry Grueby, after whom the firm was named, was born in 1867. About 1880 he began work and training at the Low Art Tile Works*, where he remained for ten years.[1] In September 1890 Grueby started a plant at Revere, Massachusetts, for the production of architectural faience, and in the early part of 1891 he joined the firm of Fiske, Coleman & Company in association with Eugene R. Atwood, doing business as Atwood & Grueby.[2] This partnership was short-lived, and in 1894 the Grueby-Faience Company began operation at the same address, producing a large variety of glazed bricks, tiles and architectural terra cotta.[3] Prior to this firm's incorporation in 1897, the primary work of Grueby-Faience was the application of W. H. Grueby's enamels[4] to architectural decoration, although a limited amount of experimentation was conducted in producing art pottery.[5] It was to expand into this latter area that the Massachusetts corporation was formed in 1897.

Principals of Grueby-Faience were Grueby himself, who was responsible for the development of glazes and who served as general manager of the pottery; William Hagerman Graves, a wealthy young architect who had graduated in 1893 from the Massachusetts Institute of Technology and who served as Grueby's business manager; and George Prentiss Kendrick, a designer and craftsman who gained prominence for his work with brass and silver and who was responsible for early designs of Grueby's artware.

It appears that the first display of Grueby art pottery may have been at the first exhibition of The Society of Arts & Crafts of Boston in 1897.[6] From this introduction, recognition of the artistic merit of the pottery was immediate at home and abroad. In 1900 the firm's display of one hundred pieces at the Paris exposition was awarded one Silver and two Gold Medals,[7] and the following year at St. Petersburg, Russia, another Gold Medal was secured.[8] Yet these were only the beginning of Grueby's honors, which included the Grand Prize at St. Louis in 1904.[9]

All the artware was thrown, using clay from New Jersey and Martha's Vineyard.[10] Since this was basically the same body as that used in the production of their tile work, it tended to make the ware coarse and heavy.[11] The shapes distinguished Grueby ware every bit as much as the glaze, as they depended not on intricacy or elaborateness of design and ornamentation, but rather on integrity and contour. The work of Delaherche offered some initial inspration for the Grueby forms, Delaherche's pottery having come to Grueby's attention at the 1893 Chicago exposition.[12]

Most of the modeling and decoration at Grueby were executed by young female graduates of Boston's Museum of Fine Arts School, the Massachusetts Normal School, and the Cowles Art School.[13] The designs for decoration included many common flowers, such as daffodil and narcissus, often with their leaves receiving the prominent treatment. In many instances only leaves were employed, the most popular being mullein, plantain, water lily and magnolia. None of these were produced from patterns or stamps. After the vessel was allowed to dry slightly the decorator outlined the design—a leaf, for example—freehand on it. A piece of clay, frequently rolled out to about the

Grueby covered jar displaying cloisonné technique with green, mauve, white and oatmeal glazes; h. 6⅝" (16.9 cm). Impressed Grueby Pottery circular mark. *Private collection.*

119

thickness of a knitting needle, followed the sketched design. It was then pressed out on the inner side and rolled up on the outer, until a perfect leaf was formed. When flowers were made, the same method was followed except in the detail of the modeling.[14]

Following the decorating, the pieces were biscuit-fired and then glazed with Grueby's matt enamels. While blue, yellow, brown, some gray tones and an ivory-white crackle were produced, the most successful by far was the cucumber Grueby green. A second color, and occasionally even a third, was introduced on later pieces, and some notable effects were achieved by their sparing use on raised parts of the design. Grueby's matt avoided the French extremes of a dullness; it is soft in texture and varied in tone, and resulted from careful firing and not from any subsequent treatment with sand or acid.

So well-received was Grueby's matt green that it became as imitated as Rookwood's Standard glaze, and its name became a generic one for all similar green glazes. Van Briggle*, Hampshire*, Teco*, Pewabic*, Wheatley Pottery*, Rookwood, Merrimac* and Denver* all attempted to participate in the success of Grueby's matt green ware, as did the art potteries of Zanesville, which were offering similarly decorated work by 1906.

The business divided naturally into two distinct endeavors: the architectural faience line and the art pottery. Its achievements in the former undoubtedly gave encouragement to Rookwood and numerous other companies to open architectural faience departments of their own to produce, among other items, faience tiles. In 1899 the Grueby Pottery designation was applied to artware produced by Grueby-Faience, with the Faience designation (most often by then without the hyphen) reserved for the architectural faience.[15]

In 1907 the Grueby Pottery Company was independently incorporated in Massachusetts with Grueby as president. Others involved with the Pottery were: Graves; Addison B. LeBoutillier, Boston architect who in 1901 had succeeded Kendrick as Director of Design; and Henry W. Belknap, formerly associated with Tiffany & Company in New York, who became general manager.[16] About the same time Augustus A. Carpenter of Chicago became president of Grueby Faience, which entered receivership in 1909. Upon the cessation of production, Grueby secured the release of his name and processes from the receivers,[17] whereupon he organized the Grueby Faience and Tile Company for production of architectural wares using his glazes and processes.

When Grueby returned to the architectural business in 1909, Graves became head of the Grueby Pottery. Karl Langenbeck, previously associated with Rookwood and the Avon Pottery* and who joined Grueby in 1908 as superintendent of the Faience Company,

replaced Grueby as superintendent and technician of the Pottery Company.[18] Even Langenbeck's technical skill could not rescue the Grueby Pottery from financial collapse, and the last artware was produced about 1911.[19]

Grueby Faience and Tile continued its operation at the same location, East 1st and K Streets, under the direction of Grueby until 1913, when the pottery burned.[20] It was rebuilt and production of architectural faience was resumed as the result of the infusion of new capital again by A. A. Carpenter. In 1919 James Michael ("Boss") Curley, who had been a director of Grueby Faience and Tile Company as early as 1909, joined the firm and turned it into a profitable operation.[21] So successful was Curley as a salesman that he ended up arranging sale of the company itself that same year to the C. Pardee Works of Perth Amboy, New Jersey. In 1921 Pardee moved the Grueby operation to New Jersey. William Grueby moved to New York City, where he died on February 23, 1925.

Examples of Grueby's work are to be found in most important museum collections of art pottery. The collection at the Museum of Fine Arts, Boston, is particularly noteworthy and includes a number of the medals received by Grueby at the various expositions. The collection at The Newark [New Jersey] Museum also offers insight into the scope of Grueby's artware production.

Grueby artware was carefully marked with an impressed designation, although the heavy glaze occasionally obscures it. The Grueby Faience mark, as observed in footnote 15, predates the Grueby Pottery mark, but both were used randomly after the latter's introduction in 1899.[22] Pieces made after 1905 appear to be consistently marked Grueby Pottery. Artists' initials can often be found, but, as Eidelberg observes, these are not of great significance as they imply little artistic creativity.[23] Paper labels were also used depicting the company's lotus trademark.[24]

Grueby vase, dark green matt designed by G. P. Kendrick; h. 11⅞" (30.2 cm). Impressed Grueby Faience circular mark. *Private collection.*

Grueby vase with five modeled leaves and handles, light green matt glaze; h. 10⅝" (27.1 cm). Impressed Grueby Pottery circular mark and the incised cipher of Ruth Erickson, who executed the piece. *The Newark Museum (#11.487). Similar examples of this design are to be found at the Museum of Fine Arts, Boston (#65.214, h. 8⅞" [22.6 cm], matt green glaze), and The Metropolitan Museum of Art (#69.91.2; h. 10⅞" [27.7 cm], matt yellow glaze).*

HAUTEVILLE GRUEBY

GRUEBY
BOSTON.MASS

GRUEBY POTTERY
BOSTON.U.S.A.

1. Personal letter of W. H. Grueby to A. Marquand, Princeton, New Jersey, dated March 9, 1894; Boston *Evening Transcript,* November 11, 1907, p. 10. The early training of Grueby at Low was evidently well-publicized while the pottery was in operation, although few references have been found recording this significant association in current literature. Arthur Russell alludes to it in *The House Beautiful,* V (December 1898), p. 3, and Pendleton Dudley makes direct reference to it in *Arts & Decoration,* I (November 1910), p. 20.

2. Their address is listed as 164 Devonshire, also the office address for Fiske, Coleman & Company (also Fiske, Homes & Co. and Fiske & Co.), managers and agents of the Boston Fire Brick Works, whose plant was at the corner of East 1st and K Streets, South Boston. Grueby leased space from Fiske. As Fiske's representative at the 1893 Chicago exposition Grueby met many of the world's foremost ceramists, according to the personal notes of W. H. Graves. Grueby's work in the 1891-94 period included architectural faience installations in the waiting room of the Philadelphia station of the Philadelphia & Reading Railroad; the entrance and wall decoration of the Charlesgate Hotel, Boston; wainscoting of the Union Passenger Station, St. Louis; and the wall decoration of the offices of Hiram Walker & Son, Walkerville, Ontario.

3. *The Clay-Worker,* XXIII (April 1895), p. 514. The Boston directory of 1894 includes the first listing of Grueby-Faience. It does not appear that Grueby was at any time involved in the Hartford, Connecticut, tile operations of either Atwood Faience or Hartford Faience (cf. the erroneous account by Everett Townsend in *The Bulletin* of The American Ceramic Society, XXII (May 15, 1943), p. 133, and other sources based on this material).

4. Grueby always made a careful distinction between the clear "glazes" popular at the time and his "enamel," which was opaque. Since enamels are understood to be a particular type of glaze, this distinction has not been maintained in this text; moreover, such a distinction breaks down when dealing with matt "glazes." This is discussed in some detail by C. F. Binns and E. Orton, Jr., in *Transactions* of The American Ceramic Society, VI (1904), p. 114.

5. Initially art pottery production was undertaken to utilize waste space at the center of the kiln, where it was too hot to fire the terra cotta ware which the firm had been producing, according to Mary Chase Perry (Pewabic*), *Keramic Studio,* II (April 1901), p. 250.

6. Records of The Society of Arts & Crafts, Boston, indicate that four of the twelve pieces exhibited were vases and lamps designed by Kendrick. Moorish tiles, the work of John Levalle, were also shown. This is probably the exhibition to which C. H. Blackall makes reference in an illustrated article in *The Brickbuilder,* VII (August 1898), pp. 162-63.

7. W. G. Bowdoin, *The Art Interchange,* XLV (December 1900), p. 137.

8. Walter Ellsworth Gray, *Brush and Pencil,* IX (January 1902), p. 243.

9. *Keramic Studio,* VI (January 1905), p. 189.

10. M. Benjamin, *American Art Pottery,* p. 24.

11. Criticism of the body for not being of a finer grain is offered by *Keramic Studio,* VI (February 1905), pp. 216-17.

12. Grueby's indebtedness to Delaherche was never hidden, but the Grueby ware was far more than a "copy" of Delaherche's. See Martin Eidelberg, *The Connoisseur,* CLXXXIV (September 1973), p. 49; also Perry, *op. cit.,* p. 251. For an extensive and illustrated study of the work of Delaherche see Gabriel Mourey, *International Studio,* III (December 1897), pp. 112-18.

13. Gray, *op. cit.,* p. 241.

14. *Crockery and Glass Journal,* LIV (December 12, 1901); also Annie M. Jones, *The Script,* I (March 1906), pp. 197-99.

15. The "Grueby Pottery/Boston, U.S.A." surrounding the lotus flower was registered December 19, 1899, as a trademark for pottery by the United States Patent Office (#33,905). Prior to that time the lotus—the essential feature of the trademark—was surrounded with the Grueby Faience designation. Use of the lotus mark began in October 1898. In 1905 the Grueby Pottery trademark was extended to include its use on tiles and faience work (#44,837).

16. Personal notes of W. H. Graves; *Glass and Pottery World,* XVI (June 1908), pp. 13-14. Both operations shared common mechanical departments for glazing and firing, but were under separate managements. An article by Belknap while serving as general manager was published in *Pottery & Glass,* I (November 1908), pp. 12-14.

17. By order of the Circuit Court of the United States, District of Massachusetts, Philip McKim Garrison vs. Grueby Faience Company, dated July 23, 1909.

18. Personal notes of W. H. Graves; also members' directory of The American Ceramic Society, *Transactions,* X, XI (1908, 1909), and Boston directories.

19. The erroneous 1907 date for the cessation of Grueby work possibly originated with F. H. Norton, *The Bulletin,* XVIII (May 1939), p. 183, and has been given credence by no less an authority than L. W. Watkins in *Early New England Potters and Their Wares,* p. 232. Art pottery of the firm was part of the exhibition of the National Society of Crafts in New York City in December 1908 (*Keramic Studio,* X, February 1909, p. 222), and the 1909 exhibition of The Art Institute of Chicago (*Keramic Studio,* X, March 1909, p. 251).

20. Following the fire the Grueby Pottery was shown to be without assets on the annual Certificate of Condition filed with the Commonwealth of Massachusetts.

21. John F. Dinneen, *The Purple Shamrock: The Hon. James Michael Curley of Boston* (New York: W. W. Norton, 1949), pp. 123-24. See also Louise R. Luther, *Spinning Wheel,* XXVIII (March 1972), pp. 40-41. The photograph of Mary Baker Eddy from which the W. Clark Noble Grueby medallion was produced was published by *Time,* C (November 13, 1972), p. 62.

22. The scarab paperweight introduced at the St. Louis Exposition in 1904 (*Keramic Studio,* VI, February 1905, p. 217) can be found marked "Faience" as often as "Pottery."

23. Eidelberg, *loc. cit.* E. A. Barber, *Marks of American Potters,* p. 100, includes a partial listing of artists.

24. Two other registered Grueby trademarks were the Hautenville designation (#214,028) and the large G (#213,151; 214,027), neither of which were used on artware.

* Information relating to this pottery is included in a separate chapter

Halcyon Art Pottery
Halcyon, California

Halcyon, a small settlement in a fertile coastal valley of California near Pismo Beach, began as one of that state's utopian colonies.[1] It was settled in 1903 by a Theosophist group under the leadership of William H. Dower and Mrs. Francia A. LaDue, who opened a sanatorium there a year later to provide for the physical regeneration of man. The Temple of the People, as the community was called, was also concerned with social, political and economic regeneration, and to that end the Temple Home Association was organized. Incorporated in California in 1903, the Association was a co-operative venture wherein the workers made a membership investment and in return were cared for by the community.

From this Association in 1909 evolved a plan for a pottery project. The first stage was to be a school and an art pottery which, if successful, could develop into a large-scale commercial industry.[2] The following year these plans were brought to fruition with the opening of an art pottery of which Leon Awerdick was the manager. Alexander W. Robertson, who until 1906 was one of the principals of the Roblin Art Pottery*, was the instructor and pottery director.

By September 1910, after only a few months of operation, an exhibition was held of the ware which had been produced and which was then ready for firing. Two kilns, the gift of Robertson, were in the process of

Halcyon ware handmade by A. W. Robertson. The small incense burner (h. 2¾"; 7.0 cm) in the front row slightly left of center is dated May 6, 1912, with Robertson's initials also incised. The handled low bowl (h. 2¼"; 5.7 cm) on the lower level, second from right in rear, is dated August 23, 1912, and bears Robertson's initials. The incense burner is also marked with the triangular impressed designation. Identified pieces are in a private collection.

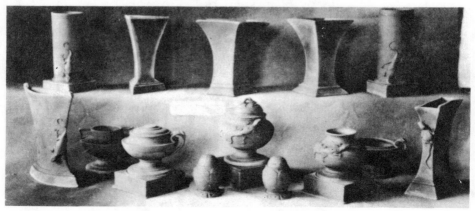

being installed and the kiln chimney was near completion. A few plaster molds were also made for the production of pieces of unusual shape to be decorated by students, some of whom were to take the University City* pottery course offered by Frederick Hurten Rhead.[3] One of the most talented was Mrs. J. B. Painter, whose initials are found on some examples of her work. The success of the pottery, even at so early a time, gave rise to plans for the pottery to serve as the basis of an Industrial School of Arts and Crafts at Halcyon.[4]

There had been three kiln firings by March 1911, all of which had been most successful.[5] Local clays from San Luis Obispo County were used, and, while no deposits of high-grade clays were known to exist in the county, the available red-burning clays proved exceedingly plastic and offered great opportunity for modeling and carving—work which was carried almost to an extreme by decorators at the pottery.

A critical evaluation of the early work, which was largely built by hand, observed that "at present the idea of decoration seems more allied to sculpture than to pottery decoration. There is, no doubt, a fascination about modeling natural forms and they have their place even in pottery, as paperweights, small figurines, etc. As decoration, however, they must be conventionalized to be appropriate, as a pottery form must be a thing of beauty itself, and the decoration should be subordinate as in overglaze work. A modeled thing must exist for itself alone. 'No man can serve two masters,' either the vase or other piece of pottery must be the important thing or the sculptured form. The latter is more beautiful alone than applied to a vase or dish. The vase or dish is more beautiful with a flat decoration which is not fully seen until examined closely, the beauty of the form being the first thing noted."[6]

While most of the pieces produced at Halcyon bore a modeled decoration applied by students of the school, frequently in natural forms of which the lizard appears to have been the most popular, a few plain examples were produced. Robertson himself made a number of significant pieces including incense burners and clay whistles. In addition to these, paperweights, toothpick holders, match holders, vases, bowls and pitchers were crafted.

By 1913 a revision of the Temple Home Association was undertaken whereby all mortgages were retired by the sale of available property, the actively co-operative work of the colony was discontinued and the Association became no more than a land-holding adjunct of the Temple. Prior to that time several small industries had been established to sustain the colony financially, the most ambitious of which was the pottery operation.[7] This work was now suspended and the pottery closed.[8]

An attempt was made in the early 1930s to put to use the long-idle facilities and to revive pottery work. Gertrude Rupel Wall (Walrich*)

was engaged to offer summer classes at Halcyon in Pottery Making and Plastic Art in 1931[9] and again in 1932 under the direction of the University of California Extension department.[10] Instead of the earlier-used local red-burning clays, white-burning clays were used. Whereas the earlier pieces were primarily unglazed, those done in this later period were devoid of applied decoration but were coated with glazes which had been developed by the Walls at the Walrich Pottery. Economic conditions of the times did not lend themselves to the resurrection of the dream, however. The pottery was dismantled in the early 1940s, and the Temple Home Association was formally dissolved in 1949. A remnant of the community was still active in 1971.

Two impressed marks were used, as shown. While all work is believed to have been marked. Halcyon's coarse red-clay body and modeled decoration are both such distinctive features that between them attribution of any unmarked pieces could be made with considerable confidence. Decorators' initials are often found, along with those of A. W. Robertson, the potter. A number of various keys and symbols were also incised, and a great deal of work is also dated. During the revival of the early 1930s, neither of the impressed marks was used. Instead the incised HP cipher was placed on some of the work, although many pieces were unmarked at that time.

HALCYON
CALIF.

1. For an informative perspective of such ventures see Robert V. Hine, *California Utopian Colonies* (San Marino, California: The Huntington Library, 1953). The word "halcyon" means tranquil, and is the name of a mythical bird with the power of charming the wind and waves into calmness.
2. *Temple Artisan* (originally a monthly magazine of the community and the Temple Home Association), X (September 1909), p. 81.
3. *Keramic Studio,* XII (September 1910), p. 89.
4. *Temple Artisan,* XI (September 1910), pp. 71-72. This school did materialize and its advertisements later appeared regularly in the *Temple Artisan.*
5. *Ibid.,* XI (March 1911), pp. 186-87.
6. *Keramic Studio,* XII (October 1910), pp. 111, 113.
7. *A Visit to the Temple,* published by authority of the Temple of the People, 1911, p. 10.
8. The last advertisement for the pottery and the Industrial School of Arts and Crafts appears in the January 1913 issue of the *Temple Artisan.*
9. *Temple Artisan,* XXXI (February-March 1931), pp. 82-83.
10. *Ibid.,* XXXII (March-April 1932); also *The Clay-Worker,* XCIX (March 1933), p. 103.
 * Information relating to this pottery is included in a separate chapter

Halm Art Pottery

Sandy Hill, New York

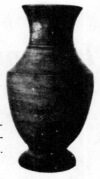

Halm redware vase with four decalcomania roses (possibly a later addition) around the rim; h. 8⅞" (22.6 cm). *Private collection.*

In the years immediately preceding and following the Centennial Exposition at Philadelphia in 1876, many potteries tried their hand at the production of terra cotta artware.[1] The most successful of these operations was the Chelsea Keramic Art Works*, which experimented in the medium as early as 1868. Another of the few which accomplished anything distinctive during this period, according to Young,[2] was the Halm Art Pottery of Sandy Hill (later to become Hudson Falls), New York.

Ketchum[3] indicates that the pottery was established in 1877 by George R. Halm, and that by the following year it was turning out 1,000 pieces a week. The works was not successful, and by June of 1880 ownership had changed. There is no evidence that later owners attempted the production of art pottery, and in any event the entire operation was closed down less than a decade after it was begun. Little more is known of the pottery.[4]

The only presently-known piece of Halm's work, now in a private collection, was that shown as part of a 1931 exhibition of Early American Pottery and Early American Glass at the old Grand Central Palace in New York City from the collection of George S. McKearin. In his notes McKearin described the piece as a "lathe turned vase of classic shape, red earthen ware."[5]

The mark, as shown, is impressed.

1. See discussion of the early production of terra cotta artware in the United States in the chapter devoted to the Chicago Terra Cotta Works.
2. J. Young, *The Ceramic Art*, p. 468.
3. W. C. Ketchum, Jr., *Early Potters and Potteries of New York State*, p. 109.
4. A letter from Halm to the New York *Tribune*, March 23, 1878, p. 2, offers no information relating to the pottery.
5. *Catalogue of a Loan Exhibition of Early American Pottery and Early American Glass* (1931), with notes and descriptions by G. S. McKearin, p. 17, no. 155.
* Information relating to this pottery is included in a separate chapter

Hampshire Pottery

Keene, New Hampshire

Keene, New Hampshire, located in an area of rich clay deposits, has been the home of several potteries. One of the earliest dates back to 1787, when utilitarian wares were produced for local use.[1]

In 1871 James Scholly Taft and his uncle James Burnap established what was to become New Hampshire's most successful commercial pottery. After purchasing the Mile Stone Mill, which stood on the bank of the Ashuelot River, they converted it into a pottery and prepared to manufacture flowerpots. Before the first kiln could be fired the building burned, and over $4,000 was lost by the firm.

By that winter, however, the structure had been replaced. The local paper noted that "Messrs. J. S. Taft & Co. have . . . recommenced the manufacture of earthenware. The interruption of their business by fire which destroyed their old building was only six weeks duration. Their new building is 160 ft. long and two stories high and has been very thoroughly and substantially built."

At first only redware was produced, but it was not long before the firm introduced stoneware items. In 1874 they acquired another Keene pottery (also begun in 1871 under the style of Starkey & Howard and later known by that of their successors, W. P. Chamberlain and E. C. Baker). This plant was then used as a redware pottery, while the original Hampshire works continued the manufacture of stoneware.

Cadmon Robertson working at the Hampshire pottery.

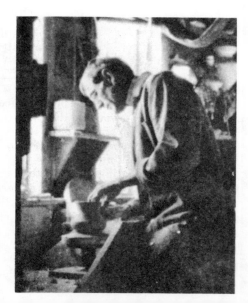

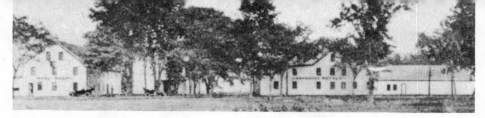

The Hampshire pottery.

A bill headed "Main Street Works/Keene Stone & Earthenware Manufactory" indicates that in 1876 Hampshire's own plant produced jugs, molasses jugs, butter and cake pots, covered preserve jars, pitchers, churns, water kegs and spittoons. Under the heading "Myrtle Street Works/Earthen Ware" is a list of items produced at the newly-acquired plant which included hanging vases, flowerpots, bracket pots, cuspidors, florists' ware and Rockingham teapots. Watkins observes that here, as at other places, "the word 'Rockingham' probably denotes a brown glaze on red earthenware."[2]

Thomas Stanley came from England to join the Hampshire firm as its superintendent in 1879, and shortly thereafter a highly-glazed ware of the majolica type was introduced. Mugs, pitchers, tea sets and vases were made of a hard white body over which rich, dark glazes were applied.[3]

This led to the firm's realization of the potential market for decorative pottery, and in 1882 a new kiln for the firing of this type of work was placed in operation. Some items were decorated in the underglaze technique popularized by the success of Rookwood's* Standard ware; and under the direction of Wallace L. King, an artist, full scale production of a Royal Worcester-type ware was also begun.

This line, with its muted ivory ground, was to be in large part the basis of Hampshire's souvenir and specialty ware. Plates, bonbon dishes, brush and comb trays, rose bowls, pitchers and various other pieces were produced and embellished with transfer-printed designs, especially of scenes of places throughout the eastern and southern parts of the United States. One of the noted items of this ware was the Witch Jug made in 1892 for jewelery and silver retailer Daniel Low, Salem, Massachusetts, to commemorate the witchcraft delusion at Salem two centuries earlier.[4]

Barber[5] reports that in the early 1890s Hampshire employed about forty workers, almost half of whom were engaged in decorating. Such decoration was primarily the application and coloring of transfer designs, although several decorators produced individual artware which sometimes bears their name or initials. The Keene *Sentinel* in 1895 made note of the firm's employment of a Japanese artist who executed "many original Japanese designs."[6] Other decorators included Blanche Andrews, Ida Jefts, Emma Mercure, Marion Grinnell, Mrs. John Dennison, F. L. Gillride, Wallace King, E. Andrick and Eliza Adams.[7]

Page of the Hampshire catalog (c. 1916). Numbers in catalog correspond with numbers found on the base of ware.

Cadmon Robertson, brother-in-law of Taft and no direct relation of the Robertsons at the Chelsea Keramic Art Works*, joined the pottery in 1904 and was soon made its superintendent. A notable chemist, he introduced no fewer than 900 formulas and was responsible for the great variety of matt glazes from green and peacock (two-tone) blue, to old blue, gray, bronze, brown and yellow.

These colors appear on a whole line of art pottery including vases, bowls, flower holders, candlesticks, clock cases and lamp bases.[8] Originally the body of this line was an earthenware, but it gradually approached the composition of semi-porcelain. Foreign clays, especially English ball clays, were used, although for some varieties of items domestic clays from New Jersey and Southern Florida were employed.[9]

King's retirement in 1908 deprived the firm of its leading artist and designer; Robertson's death in 1914, of its leading innovator. With the loss of both, Taft evidently found he could not continue on his own and ceased production later that year.

Taft sold the pottery in 1916 to George M. Morton, who had been connected with Grueby*. The sale included the buildings and machinery as well as the stock, process records and formulas developed by Robertson. In May of 1916 Morton fired a kiln containing over 1,000 pieces of some of the most popular shapes and colors from past years as well as several new designs.

According to a catalog issued by Morton shortly after the firing, the pottery offered by mail "all the more favored of Hampshire designs in art ware" which had previously been fired there. The scope of the color line was expanded, with the Robertson glazes being applied to a far more extensive line of ware. Included in the catalog were candlesticks,

pitchers, jars, tea and coffee services, clock frames, lamp and fairy-lamp bases.

The pottery continued in operation for a year under Morton's management, but with the onset of World War I it was closed in 1917, and Morton returned to Grueby. He resumed his work at Keene after the end of the war and added machinery necessary to produce common white china for hotels and restaurants at the Hampshire plant. Later he added presses for the manufacture of mosaic floor tile, and from 1919 until 1921 Hampshire remained busy with these lines.[10]

Increasingly intense competition forced Hampshire to close permanently in 1923. Before the year's end, the saga of the pottery for all intents and purposes was drawn to a close with the death of the firm's founder, J. S. Taft, the dismantling of equipment and the destruction or scattering of the molds.

One of the leading public collections of Hampshire pottery is to be found at the National Museum of History and Technology (Smithsonian Institution), comprising almost all areas of the firm's production.

Taft's utilitarian stoneware was often marked, but other items such as the early majolica pieces produced beginning in 1878 were often unmarked. The early white ware is generally marked in red "Hampshire Pottery/J. S. Taft & Co.," with the Taft name in script. Individual artists' monograms are sometimes found on the decorated pieces, and a partial listing of these decorators has been included above. The designation Keene, New Hampshire, was often included, even where the letters J.S.T. & Co. or the name J. S. Taft & Co.

[left] Hampshire mottled blue vase; h. 6¾" (17.2 cm). Incised mark and "113". *Janeen & James Marrin.*

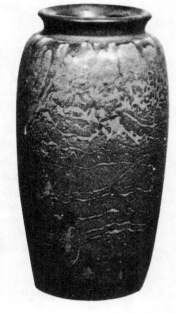

[right] Hampshire blue glazed vase; h. 8⅛" (20.7 cm). Hampshire mark and "138" impressed. *R. W. Blasberg.*

appeared without the Hampshire name. Examples of the artware of the later period most commonly found today bear the impressed name Hampshire Pottery. Occasionally one finds items marked with an M inside an O. These were pieces designed by Robertson and the cipher was a tribute to Emoretta, his wife. Not all pieces were marked, and examples of the same shapes and mold decoration have been noted marked and unmarked. Paper labels were also used, as is evidenced by the pieces in the Smithsonian's collection.

 **J.S.T.&CO.
KEENE.N.H.**

HAMPSHIRE

Hampshire
pottery

1. Unless otherwise indicated, the primary source for the material herein presented is L. W. Watkins, *Early New England Potters and Their Wares,* especially pp. 117-18; 230-31.
2. *Ibid.,* p. 218.
3. An excellent color presentation of the wide range of artware objects produced at Hampshire is made in J. Pappas and A. H. Kendall, *Hampshire Pottery Manufactured by J. S. Taft & Company, Keene, New Hampshire.*
4. E. A. Barber, *The Pottery and Porcelain of the United States,* p. 271. A Witch Jug is part of the Benjamin collection at the Smithsonian (#379,586).
5. *Ibid.*
6. July 2, 1895, quoted by A. H. Kendall in his privately published monograph "The Story of Hampshire Pottery" (1969).
7. Listing of artists is drawn from Kendall's monograph (*ibid.*), and Pappas and Kendall, *op. cit.,* Introduction.
8. According to Watkins, *op. cit.,* p. 231, glass shades for the lamp bases were produced by a Connecticut firm.
9. M. Benjamin, *American Art Pottery,* p. 25.
10. Information regarding the last years of Hampshire's operation is largely drawn from Kendall's monograph, *op. cit.* According to private correspondence with Kendall, he has had access to several sources close to Morton, including his widow.
 * Information relating to this pottery is included in a separate chapter

Jervis Pottery

Oyster Bay, New York

William Percival Jervis is better known as the author of the comprehensive book *The Encyclopedia of Ceramics* and lesser publications including *Rough Notes on Pottery* and *A Pottery Primer* than for his work as a potter. Born in Stoke-on-Trent, the first reference to Jervis' involvement in ceramic activities in this country is in 1898, when it was noted that "we found W. P. Jervis and Mr. Unick at the Astor with full lines of their potteries' wares."[1] Evidently prior to this time Jervis was engaged in prestige copy design for printing and advertising.[2]

By the fall of 1902 Jervis had become manager of Vance/Avon Faience*. The following year he was associated with the Corona Pottery*. In 1904 he operated the pottery at Rose Valley* and in 1905 joined the Craven Art Pottery*. The Jervis Pottery, "too large to be called a 'studio' and too small to be called a 'factory,' "[3] was organized in 1908. There with Jervis was Frederick Hurten Rhead, who had resigned his position as art director of Roseville* to become associated with Jervis' venture.[4] Rhead, who had previously been associated with Jervis at Vance/Avon Faience, was at Oyster Bay only a short time before leaving to join the newly formed University City Pottery*.

The Oyster Bay location—on the north side of the Long Island Railroad tracks, across from the station, in what is now part of Roosevelt Park—was chosen because of the close proximity of suitable materials, and especially of the soft red clay obtained from Lloyd's Neck. Work was designed by Jervis and molded, since the pottery was

The Jervis pottery and workers. *Crockery and Glass Journal.*

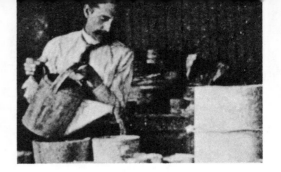

W. P. Jervis at work in Oyster Bay pottery. *American Homes & Gardens.*

not large enough to justify the expense of a thrower of the quality Jervis desired.[5] Rhead was possibly responsible for throwing the pieces from which the original molds were made.

"The primary and dominating idea in my pottery," Jervis emphasized, "has always been form and color. Form is suggested by the use the article is intended for. In designing a shape the chief thought is how it can be most simply expressed and at the same time fulfill all the requirements for which it is intended. Take, for instance, a water jug; however graceful the lines, it can lay no claim to artistic excellence unless it also serves utility and convenience. If these qualities are united, the shape, usually, takes care of itself. It is this unity that endears to us much of the pottery of our forefathers."[6]

Decoration of the ware was also designed by Jervis, and assisting him in its execution after Rhead's departure was Miss C. F. Temple, a graduate of the Pennsylvania Museum's School of Industrial Art. In his estimation pottery was not a desirable medium upon which to paint. "We are satisfied to leave it to the china decorators to *paint* pottery; we *decorate* it."[7] Several decorative techniques were employed, including a sgraffito one based on that used by Rhead especially at Roseville*.[8] The redware was coated with a layer of liquid white clay into which the design was incised by the artist when it was sufficiently dry. One particularly advantage to the use of the white slip covering was that when additional color was used it was not affected during the firing as it would have been if applied directly on the red body. The white slip covering was then removed from around the design, leaving the latter in colored relief on the clay body. A piece so decorated would then be completed with an opaque or matt glaze. Another decorative technique was the application of a modeled leaf or flower to the body, but this was not often practiced.

Glazes tended to be subdued in color. "Pottery today is no longer regarded as mere ornament," Jervis observed; "it must serve a utilitarian purpose, and as such should be as unobtrusive as possible. I have relied, therefore, on the so-called matt glazes."[9] In addition to these, metallic glazes, especially of copper color, and an iridescent glaze were also successfully used.

Vessels, flowerpots, pitchers and vases were produced, as was a line of steins with mottoes taken from early English writers. These were

glazed with a matt blue with decorations in a different tint of blue and the inscriptions in white.[10]

No evidence has yet been found of the pottery's post-1912 operation, nor of any Jervis ceramic activity thereafter.

Work was marked with Jervis' name incised vertically as shown. Often, however, this is obscured by the glaze. Occasionally the "O.B." designation for Oyster Bay can be found, as can the shape or mold numbers.

Jervis vase, possibly the work of F. H. Rhead, teal blue ground with decoration of avocado green, navy blue, cream and brown; h. 4" (10.2 cm). Incised mark. *Sonia & Walter Bob.*

Jervis vase; h. 9¼" (23.5 cm). Incised Jervis/Oyster Bay mark. *The Harold Krafts.*

1. *Illustrated Glass and Pottery World,* VI (March 1898), p. 8.
2. An advertisement for artistic advertising with "specially prepared and copyright designs . . . beautifully executed" appears on page 109 of *Rough Notes.* The address given for Jervis at that time (1896) is 62 James Street, Newark, New Jersey. Jervis had come to the United States about 1892. In an article by Jervis (*The Sketch Book,* VI, November 1907, p. 308) he indicates that since his life had been spent in "an atmosphere of pottery," many of its processes were familiar, "but it was a familiarity of observation, not of experience. . . . But," he goes on, "it is wonderful how much can be accomplished in the space of three years with a fair amount of perseverance and a faculty for drawing deductions from failures and the predominating feeling of what remains to learn."
3. *Crockery and Glass Journal,* LXXVI (December 19, 1912), pp. 181-82.
4. Members' directory of The American Ceramic Society, *Transactions,* XI (1909).
5. *Crockery and Glass Journal,* LXX (December 23, 1909), p. 184.
6. *Ibid.,* LXXVI (December 19, 1912), p. 191.
7. *Ibid.,* LXX (December 23, 1909), p. 184.
8. This process and Rhead's experience of introducing it at Roseville are covered by Rhead in *The Potter,* I (January 1917), pp. 55-58.
9. *Crockery and Glass Journal,* LXXXVI (December 19, 1912), p. 181.
10. *Ibid.,* LXX (December 23, 1909), p. 183.
* Information relating to this pottery is included in a separate chapter

Kenton Hills Porcelains

Erlanger, Kentucky

What might be considered one of the final attempts at the production of art pottery in the United States was staged at Erlanger, Kentucky, in the few years surrounding our entry into World War II. Rookwood*, like many operations of the time, was seriously affected by the Great Depression. Production had been drastically curtailed, and by 1938 voluntary bankruptcy was considered.[1] Harold F. Bopp, who had become Rookwood superintendent in 1929, was aware of the

Kenton Hills fireplace showroom. *David Seyler.*

situation and attributed many of Rookwood's problems to the firm's consignment method, which left it rich in terms of finished pottery, but poor in cash.[2] Bopp suggested to the management that those items be produced which could be sold outright to wholesalers; but when it became obvious that no action would be taken Bopp decided to start a more efficient plant on his own and eventually, if necessary, preserve Rookwood if it failed. Thus in 1939, assisted by Chester Starrett, a commercial engineer, the Erlanger location was chosen and the new pottery built by Bopp.[3]

By the time Bopp had begun production, many of his anticipated

Kenton Hills vase, white ground with underglaze pastel floral decoration; h. 6⅝" (16.9 cm). Impressed HB mark with incised cipher of the designer, W. E. Hentschel, and signature of the decorator, Rose Brunner. Shape number 126 is impressed. *Private collection.*

wholesale outlets were discontinuing business, as sustaining lines could no longer be imported because of the eruption of the war. To alleviate the strain on his health and financial resources, Bopp took the young and talented artist David Seyler in with him. Seyler studied at the Cincinnati Art Academy; in 1938 at the Seventh National Ceramic Exhibition he received an honorable mention for sculpture, and the following year was awarded the purchase prize for ceramic sculpture at the eighth exhibition.[4] Seyler brought not only enthusiasm but also the financial support of his family, and in November 1940 the pottery was formally organized in Kentucky as Kenton Hills Porcelains, Inc.

Seyler was art director of the firm, Bopp was production manager and ceramic chemist. Raymond Dawson and his son Jack were casters and finishers of the pottery.[5] Native clays were used; decorations and glazes were quite similar to those employed at Rookwood during the same period (for obvious reasons), and work was of a high quality. Even Rookwood's goldstone was most successfully reproduced at Kenton Hills.

Bopp left in 1942, and while a few additional kilns were fired after

Exterior of south end of Kenton Hills pottery. *David Seyler.*

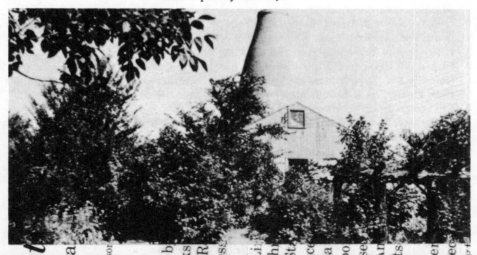

his departure, the war with its restrictions and draft forced Kenton Hills to suspend operations. It was planned that after hostilities ceased work would be resumed,[6] but such never transpired.

At Erlanger, as at Rookwood, work was carefully marked. The original impressed mark (1939-40) was the conjoined initials of Harold Bopp within a lotus blossom. The Kenton Hills name and impressed mark were adopted when Seyler assumed control and were used for the duration of production. William Hentschel, formerly a Rookwood decorator, modeled a number of shapes which bear his incised cipher. Ciphers[7] found on Bopp and Kenton Hills ware include:

> William Hentschel
> Alza Stratton (Hentschel)
> David Seyler
> Rosemary Dickman
> Harold Bopp
> Julian Bechtold
> Arthur Conant
> Charlotte Haupt
> Rose Brunner Dickman (whose work is usually signed in script "Rose Brunner D.")

A shape number was also impressed on the ware; pieces were not usually dated.

1 WILLIAM HENTSCHEL
2 ALZA STRATTON (HENTSCHEL)
3 DAVID SEYLER
4 ROSEMARY DICKMAN
5 HAROLD BOPP
6 JULIAN BECHTOLD
7 ARTHUR CONANT
8 CHARLOTTE HAUPT

1. See especially H. Peck, *The Book of Rookwood Pottery,* chapter 19, for an appreciation of this period at Rookwood.
2. The suggested reorganizational changes offered by Lucien Wulsin touched on the same problem (*ibid.,* p. 118).
3. Unless otherwise noted, material herein presented is from personal correspondence with Harold Bopp, who until his retirement in 1965 was active in glass research and development at the Corning Glass Works.
4. Cincinnati *Enquirer,* October 28, 1939, p. 9; Helen E. Stiles, *Pottery in the United States,* p. 313. In both cases Seyler is listed as associated with Rookwood, although Peck (*op. cit.,* p. 126) indicates he is not listed as a Rookwood decorator.
5. Cincinnati *Post,* February 6, 1941, p. III-21.
6. W. E. Cox, *The Book of Pottery and Porcelain,* p. 1056.
7. A brochure of Kenton Hills Porcelains.
* Information relating to this pottery is included in a separate chapter

Kiss Art Pottery

Sag Harbor, New York

The Kiss Art Pottery was organized in 1910 by Charles Kiss of Sag Harbor and J. E. Rierdan of Brooklyn for the manufacture of art pottery "by a secret process,"[1] and was located on Madison Street in Sag Harbor. Two years later the pottery was reorganized as the Peconic Pottery Company, of which C. E. Fritts was the head.[2]

The plant was moved to the annex of the old school building on lower Main Street, which was secured from the village trustees for two years. A stock building and a large modern kiln were built, and work began in June 1912 with over twenty employees. Clay was obtained locally, and the first orders taken were reported to have been sufficient to keep the plant busy for at least six months.[3]

Thrown and molded work was decorated by the "secret process" developed by Charles Kiss, who served as superintendent of the Peconic Pottery and was assisted by two brothers, Aaron and Coleman. A former employee has indicated that the process consisted of body, decoration and glaze being fired in a single operation. Time has proved the method unsuccessful, and the glazed surfaces on the several jardinieres at The John Jermain Memorial Library, Sag Harbor, are reported as crumbled.[4]

By 1921 Kiss had moved to Meriden, Connecticut, where the Kiss Brothers Manufacturing Company is listed as "manufacturers of art and decorative pottery" from 1921-1925.[5]

The above-noted pieces which have been attributed to the Kiss Peconic pottery are unmarked. No marked examples are known to exist.

1. *Crockery and Glass Journal,* LXXII (December 22, 1910), p. 152.
2. *Pottery & Glass,* VIII (May 1912), p. 16.
3. *Ibid.,* VIII (June 1912), p. 12; also undated report contained in the Sag Harbor *Express* (1912).
4. Personal correspondence.
5. *Pottery & Glass Directory* 1920-21 through 1925; unlisted in 1926.
* Information relating to this pottery is included in a separate chapter

Lessell Art Ware

Parkersburg, West Virginia

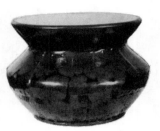

Lessell Art Ware with impressed mark; h. 5 3/4" (14.5 cm). *Doris Reddy.*

John Lessell (sometimes spelled Lassell) had been superintendent of the decorating department of the Ford City (Pennsylvania) China Company until mid-1899 and thereafter moved to Jersey City, New Jersey.[1] In 1903 he was employed by the Bohemian Pottery,[2] a Zanesville, Ohio, producer of utilitarian ware.[3] Later that year he was one of the incorporators of the short-lived Arc-En-Ciel Pottery*, after which he was employed by Owens*.

The Lessell Art Ware Company was organized and incorporated in West Virginia in March 1911, and by the middle of that year their work was being exhibited by their New York representative, W. H. Dunn & Company. It was reported to be "a unique line of art pottery in imitation of copper and bronze. Each piece has the effect of being made of metal sheets riveted together.[4]

Expansion of the line to include imitation silver and gold was planned,[5] but whether this was accomplished before the firm dissolved in mid-1912 is uncertain.[6] Lessell later went on to become a Weller* designer in the early 1920s, there creating the LaSa line. In 1924 the Art China Company, manufacturer of decorated china and semi-porcelain ware, was organized in Zanesville with Lessell as its head pottery expert. The following year it acquired property in West Newark, Ohio, and removed there.[7] In 1926 the name was changed to the Art Pottery Company, and operation ceased about the time of Lessell's death in December of that year.[8]

The impressed mark is as shown.

1. *Brick,* X (May 1, 1899), p. 244; *ibid.,* X (June 1, 1899), p. 248.
2. Norris F. Schneider, Zanesville *Times Recorder,* February 4, 1962, p. B-3.
3. *The Clay-Worker,* XL (December 1903), p. 586.
4. *Pottery & Glass,* VII (August 1911), p. 33.
5. *Ibid.*
6. Corporation records, Office of the Secretary of State, West Virginia.
7. Zanesville *Signal,* February 19, 1925, p. 13.
8. Corporation records of the Ohio Secretary of State. The Art China Company was incorporated on February 13, 1925; on May 29, 1926, the name was changed to the Art Pottery Company. The corporation charter was cancelled November 15, 1928.
* Information relating to this pottery is included in a separate chapter

Lonhuda Pottery
Steubenville, Ohio

Laura A. Fry. *The Art Amateur.*

Cincinnati faience, the underglaze-decorated pottery so popularized by Rookwood's* Standard ware, soon became the object of imitation in the various pottery centers of Ohio. In Cincinnati that particular decorating technique was first produced at the Coultry Pottery* by M. L. McLaughlin (Losanti*) and later by T. J. Wheatley* and others, and finally at Rookwood.[1]

The first to apply the Cincinnati-faience decorating technique on a large-scale basis outside Cincinnati was William A. Long, a competent chemist, oil-painter and Steubenville pharmacist. Culminating experiments begun possibly as early as 1880,[2] Long produced his first successful piece of Lonhuda-type ware in 1889.[3] He was joined by W. H. Hunter, editor of the Steubenville *Daily Gazette,* and Alfred Day, secretary of the United States Potters' Association and an organizer in 1879 of the Steubenville Pottery Company.[4] They began experimenting with clays and glazes in 1890 using a single kiln six feet in diameter built at the rear of Long's Market Street drugstore.[5] Two years later, in the fall of 1892, the Lonhuda Pottery—the name a combination of the names of the three organizers: (Lon)g, (Hu)nter and (Da)y—began regular production of jardinieres, vases and other artware.[6]

A number of good artists were employed as decorators, including Jessie R. Spaulding, who executed some of the most remarkable work, and Laura A. Fry, perhaps the most well-known. Born in 1857, she was a pupil of Noble in drawing, Rebisso in modeling, her grandfather Henry L. Fry and her father, William H. Fry, who taught for almost a half-century at the Art Academy in Cincinnati, in woodcarving.[7] She mastered the practical side of pottery manufacture from throwing to decorating at Trenton, New Jersey. Miss Fry became a charter member of the Cincinnati Pottery Club in 1879; two years later, when the decorating department was formally organized at Rookwood, she was a member and one of the few people who were associated with both the Pottery Club and the Rookwood Pottery. At Rookwood, Fry was one of the instructors in the School for Pottery Decoration and one of the few decorators who also designed the shapes of early pieces.[8] In July 1884[9] she introduced a method of applying background and decoration to vases and other ceramic objects using an atomizer. The

technique, because of its superiority in achieving an even application of coloring-matter which could be delicately shaded and blended, came into extensive use at Rookwood by Fry and others, especially in the production of their Standard ware. Two years later she filed a patent application for the process, and patent number 399,029 was awarded on March 5, 1889. Fry left Rookwood about 1887 and, after working for a time for the firm on a freelance basis, became professor of Industrial Art at Purdue University in 1891 and subsequently founded the Lafayette [Indiana] Ceramic Club. She remained at Purdue until mid-1892, when she joined the Lonhuda works. The underglaze slip-painted ware decorated by the Fry process became Lonhuda's primary line, and, since it was patented, an attempt was made in 1893 to enjoin Rookwood from its use. The case was eventually decided in late 1898 in Rookwood's favor, with Judge William Howard Taft ruling that, while it was a new use for an old tool, the process was not a new one.[10] Regardless of the outcome, the Fry method had a far-reaching influence, and in only a short time it became the almost universal method of applying underglaze grounds and the glaze itself in the United States. Fry remained at Lonhuda until 1894. That year she organized the Porcelain League of Cincinnati at her Cincinnati studio.[11] Two years later she returned to Purdue University, an association which continued until her retirement in 1922. She died in Cincinnati in 1943.[12]

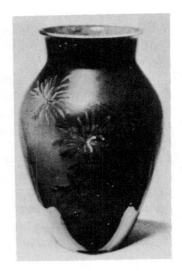

[right] Lonhuda "Cincinnati faience" type vase with underglaze slip decoration by Jessie R. Spaulding; h. 10¼" (26.1 cm). Impressed Indian mark/Lonhuda Pottery Company cipher/1893/180. Artist's cipher incised. *Philadelphia Museum of Art (#'93-307).* [below] Lonhuda underglaze decorated ware; h. 4½" (11.5 cm). Impressed Indian mark/Lonhuda Pottery Company cipher/1893/115. Cipher of artist Sarah R. McLaughlin incised. *National Museum of History and Technology (Smithsonian Institution; #379,676), Benjamin collection.*

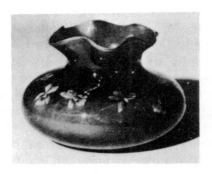

The application of the Fry technique at Lonhuda was exhibited at the Chicago exposition in 1893, at which time it attracted considerable attention including that of S. A. Weller.[13] While the Steubenville operation had been a great success artistically, it was not so commercially, due perhaps to the fact that it was only a side-business for each of the partners, and according to one source was left to run itself.[14] In late 1894 Weller* acquired an interest in the Lonhuda Pottery, which was removed to the Weller plant at Zanesville early the following year.[15] There *Lonhuda Faience* was produced on a large-scale basis. Long remained with Weller a little more than a year, by which time Weller had learned the Lonhuda methods and no longer needed Long. After Long's departure, Weller renamed the Lonhuda line *Louwelsa*.[16] Long joined the J. B. Owens Pottery* in 1899, remaining there until his departure for Denver, where he established the Denver China and Pottery Company* in 1901.

An excellent example of early Lonhuda decorated by Jessie Spaulding is in the collection of the Philadelphia Museum of Art (#'93-307). Another piece by the same decorator of the same year, 1893, is at the National Museum of History and Technology, Smithsonian Institution (#393,661), in whose collection is also an 1893 vase by the artist Sarah R. McLaughlin (#397,676).

The first mark used by the Lonhuda Pottery was the impressed conventionalized monogram of the pottery with the Lonhuda designation above it. The solid impressed Indian mark was adopted in 1893 and was most often used in addition to the earlier mark. Barber[17] notes that this was used to connote shapes adapted from American Indian pottery forms as opposed to the Oriental influence so prevalent at the time. Later an impressed Indian profile replaced the solid Indian mark. The "LF" for Lonhuda Faience was used in the 1895-96 period when the Lonhuda process was used by the partnership of Long and Weller. This later mark was also used by the Denver China and Pottery Company, but as the Denver designation is always found with it there should be no confusion. Most early pieces were dated, and the impressed numbers aside from the date relate to the shape. Artists in addition to L. A. Fry, J. R. Spaulding and S. R. McLaughlin included Helen M. Harper and W. A. Long himself.[18]

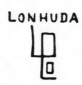

1. For an extended discussion of Cincinnati faience see P. Evans, *Spinning Wheel,* XXVIII (September 1972), pp. 16-18.

2. *China, Glass and Lamps,* VII (December 20, 1893), p. 18; *Clay Record,* V (November 14, 1894), p. 25.

3. Denver *Times,* June 29, 1902, p. 12.

4. Joseph B. Doyle, *Twentieth Century History of Steubenville* (1910), pp. 294, 871. See also E. A. Barber, *The Pottery and Porcelain of the United States,* pp. 336-37. Day evidently retained his association with Steubenville Pottery during the duration of the Lonhuda enterprise (see *China, Glass and Lamps,* VIII, November 7, 1894, p. 15), remaining as manager until 1900 when he joined the American China Company at Toronto, Ontario (*Brick,* XII, June 1900, p. 293).

5. *Glass and Pottery World,* XIII (May 1905), p. 33. Marion John Nelson (*The Art Quarterly,* XXVI, 1963, p. 442) suggests that at least the shapes of these early pieces were of an obvious Indian character, reflecting Long's interest in the ceramic work of the American Indian. This interest also manifests itself in the Lonhuda marks.

6. *Pottery and Glassware Reporter,* XXVIII (December 15, 1892), p. 15. This source goes on to observe: "like its rival [Rookwood] it is somewhat costly and beyond the reach of many who may admire its worth, but good things are never cheap, and the Lonhuda is surely deserving of a rank among the best."

7. Her proficiency in carving is exemplified by several pieces of carved earthenware in the Fry collection of the City Art Museum of St. Louis, including their #81-84:11 and 95:11. Another collection of Fry work is at The American Ceramic Society, Columbus, Ohio.

8. These include shapes number 4, 5, 18, 24, 35, 70, 114, 215, 222, 240, 269, 297, 300, 307, 308, 313, 314, 367, 409, as noted in H. & M. Peck, *Catalog of Rookwood Art Pottery Shapes.*

9. In what is evidently a typographical error, Peck (*The Book of Rookwood Pottery,* p. 29) indicates a date of July 1883, which is repeated by M. Eidelberg in *The Arts and Crafts Movement in America 1876-1916,* p. 119.

10. Laura A. Fry vs. Rookwood Pottery Company, *Federal Reporter,* XC (1899), p. 494-500.

11. For further information on the League, an outgrowth of the Cincinnati Pottery Club, see *The Bulletin* of The American Ceramic Society, XIX (September 1940), pp. 351-53. In 1896 Fry was again executing work at her own Cincinnati studio; an example dated in that year is in the Cincinnati Art Museum (#1896.45).

12. Kenneth E. Smith, *The Bulletin,* XVII (September 1938), pp. 368-72; H. Peck, *The Book of Rookwood Pottery, passim;* and *The Art Amateur,* XXXV (September 1896), p. 79.

13. *China, Glass and Lamps,* VII (December 20, 1893), pp. 17-18; Norris F. Schneider, Zanesville *Times Recorder,* February 7, 1971, p. B-1.

14. *Glass and Pottery World,* XIII (May 1905), p. 33.

15. *The Clay-Worker,* XXII (November 1894), p. 493; *China, Glass and Lamps,* VIII (November 7, 1894), p. 15. Original plans, according to this latter source, were for Weller to expand the Steubenville operation at its original location, with Long devoting his entire attention to the production of Lonhuda ware. By December, however, plans were announced to move the Lonhuda operation to Zanesville (*Brick,* I, December 1894, p. 419).

16. Schneider, *op. cit.,* p. B-1.

17. *Marks of American Potters,* pp. 130-31.

18. Their various ciphers are to be found in Barber, *loc. cit.*

* Information relating to this pottery is included in a separate chapter

Losanti

Cincinnati, Ohio

Mary Louise McLaughlin.
The Art Amateur.

"I make no claim," wrote Mary Louise McLaughlin in 1938,[1] "of being the first to use the process of 'slip' painting, which, of course, had been known from time immemorial, whereas the basic principle of my 'Limoges faience' was new and a really novel discovery . . . I prefer, however, to rest my reputation as a ceramist upon the [Losanti] porcelain."

Like numerous other women of the period, Miss McLaughlin was first attracted to the ceramic art through the medium of china painting. In the Cincinnati display at the 1876 Philadelphia exposition she exhibited a carved cabinet and a number of pieces of china painting. While at the exposition she saw Haviland's new faience line of underglaze slip-decorated ware made at Limoges, France, which was exhibited for the first time in the United States.[2] During that same year McLaughlin had painted blue underglaze designs on white porcelain blanks of Thomas C. Smith and Sons (Union Porcelain Works) at Greenpoint, New York.[3]

Experiments by McLaughlin to reproduce the Haviland faience decoration were begun in September 1877[4] at the P. L. Coultry Pottery* of Cincinnati, and in October the first McLaughlin piece of this underglaze decorated ware was drawn from the Coultry kiln, making it the first piece of this ware produced in Cincinnati.[5] Through her inexperience and technical naïveté, Miss McLaughlin worked with an unfired clay slip on a damp body rather than using a slip made from finely-ground fired clay and then applied to a thoroughly dried piece—the technique used by Volkmar (Volkmar Pottery*) and Haviland itself. This created numerous difficulties which had to be overcome, but the fact that all later Cincinnati faience, including Rookwood's Standard ware, followed the McLaughlin technique is rather conclusive evidence as to who initiated it.[6]

While the piece of Miss McLaughlin's work executed in October 1877 only hinted at the discovery of a process for Haviland's type of decoration, the first which was completely successful, a pilgrim vase, was drawn from the Coultry kiln in January 1878[7] and is now part of the collection of the Cincinnati Art Museum (#1881.44). By May of that year enough work had been completed for a showing in New York;[8] and a few items were sent to Paris, after the opening of that

McLaughlin's "American Faience" as shown by E. A. Barber, *The Pottery and Porcelain of the United States.*

McLaughlin's first successful piece of Cincinnati faience. Pilgrim vase, h. 10¼" (26.1 cm). Incised McLaughlin initials, Cincinnati location and dated 1877. *Cincinnati Art Museum (#1881.44), gift of the Women's Art Museum Assn.*

Losanti porcelain vase with oak leaf decoration and green glaze; h. 5" (12.7 cm). Imprinted mark, McLaughlin cipher and "78". *Worcester Art Museum (#1903.12).*

[left] Losanti porcelain vase, raised tulips, lavender on white glaze; h. 5" (12.7 cm). Imprinted mark, McLaughlin cipher and "12". *Worcester Art Museum (#1903.9).*

year's exposition, where they received an honorable mention.[9]

Due to extensive newspaper publicity of the McLaughlin accomplishment, a class was begun at the Coultry Pottery under the direction of T. J. Wheatley*, who fired his first piece there in April 1879. That same month Miss McLaughlin formed the Cincinnati Pottery Club,[10] which carried on its early work in a room rented from the Cincinnati Woman's Art Association. Work continued to be fired at Coultry's until the Club's move to the Hamilton Road Pottery (Dallas Pottery*) in the early fall of 1879.[11] Thus, a year prior to the formation of the

Rookwood Pottery*, there were two different groups of decorators, one at work at Coultry's pottery and the other at Dallas'. It was at the latter that McLaughlin executed her successful and prized Ali Baba vase, which Barber rated one of her finest pieces produced during this period.[12]

In 1881 the Pottery Club followed the manager of the Dallas works, Joseph Bailey, Sr., to Rookwood, renting from them the former studio of Mrs. M. L. Nichols (Storer).[13] While the Pottery Club was to continue until 1890, its Cincinnati faience work was dealt a death blow in 1882 when the Club was evicted from Rookwood, a move which prompted the senior Bailey's resignation.[14] For a time Rookwood blanks were sent for by the Club, but transporting them "proved a very risky business and was gradually given up," according to C. C. Newton's account.[15] Left without access to the workmen who had thrown and glazed their work and who had thereafter been hired by Rookwood, the Club returned to overglaze decoration which could be carried out without the ready resources of a pottery. It was at this time that Miss McLaughlin also ceased her output of Cincinnati faience, thus concluding the first period of her ceramic activity (1877 to 1885).[16]

The following ten years were occupied with china-painting and some design work for the Kensington Art Tile Company of Newport, Kentucky.[17] In 1895 McLaughlin resumed her full-scale work, prompted by a desire to test a new method of decoration with inlaid clays. This process, called "American faience" by Miss McLaughlin, was patented in 1894[18] and executed by her for a short time at the Brockmann Pottery Company.[19] The decorative pattern was painted with white or colored slip on the interior surface of a plaster mold, the vessel then being cast in a different-colored clay. When removed from the mold the design had been taken into the body and imbedded in the surface of the piece. "This method of inlaying," observed Barber,[20] "has some advantages over that of carving and the device of filling in, since greater facility and freedom are obtained in the outlining and the execution of the work." Plagued by not being able to control the entire process, Miss McLaughlin abandoned this work as well.

The third, and by far the most artistically important, period in the McLaughlin work began in 1898, possibly an outgrowth of interest generated by the Porcelain League of Cincinnati, founded in 1894 by members of the old Pottery Club.[21] Proceeding only on the basis of trial and error, she embarked upon the production of hard-paste decorative porcelain, for which a kiln was constructed at the rear of the McLaughlin home on Eden Avenue, Cincinnati. "If there was a single detail of the work where the way was not made hard," she was to later write, "memory fails to recall it."[22]

Prior to achieving a successful body composition in 1900, eighteen

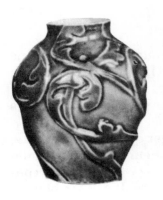

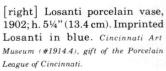

[left] Losanti porcelain vase; h. 5⅛" (13.0 cm). Imprinted mark, McLaughlin cipher and "87". *The American Ceramic Society (#388).*

[right] Losanti porcelain vase, 1902; h. 5¼" (13.4 cm). Imprinted Losanti in blue. *Cincinnati Art Museum (#1914.4), gift of the Porcelain League of Cincinnati.*

different bodies were produced and approximately forty-five companion glaze formulas were developed.[23] This early work was first shown at the spring exhibition of the Cincinnati Art Museum in 1899. A number of the pieces sent to Paris in 1900 were of the later successful body. Yet it was not until about March 1901 that the best results were secured by a single firing at over 2,500°F., wherein the native-clay body and glaze matured together. This creamy-white, translucent ware, named *Losanti* after the original name of Cincinnati —Losantiville—was first extensively featured at the 1901 Pan-American Exposition at Buffalo, [24] where it was awarded a Bronze Medal.

After perfection of the body, McLaughlin's attention was turned to perfecting schemes of decoration. Early carved or modeled floral motifs were criticized by design-conscious A. Robineau (Robineau Pottery*) as being "a little heavy and not always interesting."[25] Robineau, however, was quick to acclaim her achievements in the making of true porcelain, something in which she herself was becoming very interested at the time. A technique employed by Miss McLaughlin which offered even more translucence than the porcelain itself was the cutting out of the design in the clay and filling the openings with glaze. When successful this offered some extremely interesting effects, although many pieces were so weakened by the cutting away of the body that they would collapse in the kiln. The range of McLaughlin's non-lead glazes was expanded from the traditional high-temperature ones to include delicate blues and old-rose tints with touches of light green, almost bordering on a peachblow.

Miss McLaughlin abandoned her porcelain work in 1906, saying only that "it seemed wise for me to desist from following it further,"[26] and turned her attention to non-ceramic interests. She lived to the age of ninety-one, but never actively returned to her ceramic work prior to her death in 1939.

Important collections of her early Cincinnati-faience work (1877-1885) are to be found at St. Louis' City Art Museum, the Cincinnati Art Museum and The American Ceramic Society, Columbus,

Ohio. Collections of the Losanti work (1898-1906) are also at The American Ceramic Society and the Cincinnati Art Museum; the Worcester [Massachusetts] Art Museum has three pieces; and a single excellent example is to be found in the collection of the National Museum of History and Technology, Smithsonian Institution (#393,687).

All the McLaughlin work is carefully marked, pieces of the early period bearing her incised cipher, possibly an incised butterfly, and often a date. Numerous pieces also contain the mark of the pottery at which they were produced for Miss McLaughlin's decoration,[27] including Rookwood's, for whom she never worked. An examination of pieces in the Cincinnati Art Museum collection suggests, contrary to Laura Fry's notation,[28] that the incised numbers do not indicate the opus numbers of McLaughlin's work. Losanti ware bears an incised or blue-lettered monogram and the underglaze, blue-lettered "Losanti," often in Oriental fashion. The numbers on the bases of Losanti were cataloged by McLaughlin, and from her records she could determine the color and general character of each piece.[29] The location of the Losanti record book is presently unknown.

1. M. L. McLaughlin, *The Bulletin* of The American Ceramic Society, XVII (May 1938), pp. 217-25.
2. *Ibid.*, p. 218; *The Atlantic Monthly*, XLIV (October 1879), p. 544.
3. McLaughlin, *op. cit.*, p. 218. Irene Sargent (*The Craftsman*, IV, August 1903, pp. 331-32) is in error when she says that prior to 1877 Miss McLaughlin's work had been decorated exclusively overglaze. The first successful piece of underglaze work is a plate made at the Union Porcelain Works in 1876 which is now in the collection of the Cincinnati Art Museum (#1881.13).
4. Cincinnati *Daily Gazette*, October 7, 1880. 1877 was the same year in which Miss McLaughlin's first book for china painters, *China Painting*, was published. This and her other works on the subject were the authoritative ones as long as china painting was popular.
5. This piece was in the collection of the Philadelphia Museum of Art (#'94-31), but has since been disposed of. At about the same time as this success the Chelsea Keramic Art Works* also reproduced the Haviland-type decoration, but it was not commercially produced as at Cincinnati.
6. McLaughlin's methods are extensively detailed in her book *Pottery Decoration Under the Glaze.*
7. McLaughlin, *The Bulletin,* XVII (May 1938), p. 218.
8. *Ibid.*, p. 219.
9. *The Atlantic Monthly*, XLIV (October 1879), pp. 544-45.
10. The Pottery Club is also discussed in the chapter devoted to the Dallas Pottery.

11. McLaughlin, *The Bulletin*, XVII (May 1938), pp. 219, 224; Clara Chipman Newton, *The Bulletin*, XIX (September 1940), p. 348. Also reported in *Crockery and Glass Journal*, X (November 20, 1879), p. 28.

12. E. A. Barber, *The Pottery and Porcelain of the United States*, p. 287. This piece, dated 1880, is in the collection of the Cincinnati Art Museum (#231.1900). For an overall perspective of the historical development of Cincinnati faience, see P. Evans, *Spinning Wheel*, XXVIII (September 1972), pp. 16-18.

13. H. Peck, *The Book of Rookwood Pottery*, p. 16.

14. Peck (*ibid.*, p. 15) is in error when he indicates that Bailey, Sr., did not leave Rookwood until 1885. *Crockery and Glass Journal*, XVI (September 21, 1882), p. 46, reported that "the new departure at Rookwood [expulsion of the Pottery Club] results in Mr. Joseph Bailey's withdrawal." The same publication (XVIII, September 27, 1883, p. 44) further reported that "Mr. Joseph Bailey, Sr., is no longer at Mrs. M. L. Nichols' Pottery but has gone to Chicago to work there." See note 2, Pauline Pottery.

15. *The Bulletin*, XVIII (November 1939), p. 446.

16. The Pottery Club reorganized briefly for the exhibition at the 1893 Chicago exposition. This showing included many of the earlier items executed by members of the Club. For illustrations of pieces shown at Chicago see E. W. Perry, "The Work of Cincinnati Women in Decorated Pottery," *Art and Handicraft in the Woman's Building of the World's Columbian Exposition, Chicago 1893*, ed. M. H. Elliot (Chicago: Rand, McNally, 1894), pp. 101-06.

17. A tile designed for Kensington with the McLaughlin cipher on the face is in the collection of the Cincinnati Art Museum (#1970.607).

18. United States Patent #326,669, September 25, 1894.

19. Originally Tempest, Brockmann & Co. (Richmond Street Pottery) when it began work in 1862, it was renamed Tempest, Brockmann & Sampson Pottery Co. in 1881; in 1887, when C. E. Brockmann bought the entire business, it was again renamed, as above (Barber, *op. cit.*, pp. 274-75). The plant was sold to John Douglas Co. in 1912 and abandoned in 1916 (W. Stout *et al.*, *Coal Formation Clays of Ohio*, p. 82).

20. Barber, *op. cit.*, p. 511. The inlaid vase pictured by Barber (figure 271) was at the Philadelphia Museum of Art (#'95-65) but has since been sold.

21. Miss Alice B. Holabird, at whose home the original meeting of the Pottery Club was held on April 1, 1879, and who became the Pottery Club treasurer, convened the organizational meeting of the Porcelain League on January 10, 1894 (C. Newton, *op. cit.*, p. 446).

22. M. L. McLaughlin, *Keramic Studio*, III (December 1901), p. 178. Many of the vicissitudes of the early McLaughlin porcelain work are chronicled by her in *The Bulletin*, XVII (May 1938), pp. 220-22.

23. M. L. McLaughlin, *The Craftsman*, III (December 1902), pp. 185-86; also see Irene Sargent, *ibid.*, IV (August 1903), p. 335.

24. M. L. McLaughlin, *Keramic Studio*, III (December 1901), pp. 178-79.

25. *Keramic Studio*, V (June 1903), p. 36.

26. M. L. McLaughlin, *The Bulletin*, XVII (May 1938), p. 222; the biography prepared by Miss McLaughlin for The Arts & Crafts Society, Boston, in 1906 indicates that she was making Losanti ware up to that time.

27. Several of the shapes used by McLaughlin were designed by her, such as Rookwood's shape #164.

28. City Art Museum, St. Louis, document #66-106:11, pp. 3-4.

29. Correspondence dated January 22, 1903, with the Worcester Art Museum.

* Information relating to this pottery is included in a separate chapter

Low Art Tile Works
Chelsea, Massachusetts

John G. Low outside pottery showroom.
Mrs. John G. Low, II.

John Gardner Low, who as a young artist studied landscape painting in Paris from 1858 to 1861 under Couture and Troyon, began ceramic work at the Chelsea Keramic Art Works*, where he executed many fine pieces, particularly of a Grecian variety.[1] He became so fascinated with the tile pressing technique developed there several years earlier that with his father, the Honorable John Low, he formed his own business in 1878 under the style J. and J. G. Low Art Tile Works. The plant was located at 948 Broadway in Chelsea, Massachusetts, and successfully fired for the first time in 1879. Low was joined by George Robertson, brother of the founders of the Chelsea Keramic Art Works, and within five months the firm had received a Silver Medal at the 1879 Cincinnati Industrial Exposition. In September 1880 a series of their art tiles was awarded a Gold Medal at an exhibition at Stoke-on-Trent, where competition included the most famous manufacturers of the United Kingdom.[2]

By 1879 Arthur Osborne joined John G. Low in the artistic development of the business.[3] Osborne was an English-trained sculptor whose designs and work decidedly reflected that influence. In all of the pottery's output, glazes were used to modify the effect of the design. George Robertson was the glaze technician, lending the firm formulas which had been developed by several generations of the Robertson family in England and the United States. For this reason one is able to see a remarkable similarity in the glazes used at the Chelsea Keramic Art Works and at the Low establishment. It is interesting that John F. Low, who joined his father in 1883 when J. Low retired from the business, was also an expert chemist.

Like numerous other tile producers, such as American Encaustic,[4] for whom F. H. Rhead executed a limited amount of artware, the Low firm could not resist the temptation to use the materials on hand to

The Low pottery as shown by E. A. Barber, *The Pottery and Porcelain of the United States.*

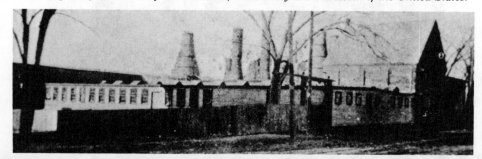

produce artware also. By 1882 jugs and vases with hand-modeled relief work, some of which were by Osborne, had been produced.[5]

During the first years of the twentieth century the firm introduced a regular line of Chelsea ware,[6] artware vases whose glazes and shapes closely resembled some of the Japanese pottery. Pieces were usually small- or medium-sized, simple in form and of a composition similar to the firm's ordinary white tile body. The surface was most often undecorated with the exception of the classical glazes which were applied. These ranged from dark cream to chocolate; delicate claret to a deep, almost oxblood, red. Occasionally two or more glazes were combined on a single piece giving combinations of browns, greens, blues, grays and yellows.[7] It is probable that Low's firm was encouraged in the development of this line by Hugh C. Robertson after his Chelsea Keramic Art Works abandoned their similar efforts in favor of the crackle ware and moved to Dedham. There is far greater similarity than name alone between the Low Chelsea Ware and the ware of the other Chelsea works.

Fifteen small vases of Low's were part of the 1903 exhibition at the Worcester [Massachusetts] Art Museum, but regrettably none were purchased by the museum at that time. Correspondence between the Low firm and the museum in preparation for the exhibit indicates that there were only about 200 pieces on hand at the Low pottery, mostly very small, and not representing their finest work.

The Low pottery was liquidated in 1907, the same year as J. G. Low's death, evidently the result of changing conditions and tastes as well as a general inability to maintain high artistic standards in the face of low-priced imports.[8] It appears, however, that production ceased sometime prior to 1907.

A single unmarked pitcher in the collection of the Worcester Art Museum (#1902.11) could possibly be attributed to Low and identified as their Chelsea Ware. Marked examples are rare: a single example

Low's Chelsea Ware, 1902. *Scribner's Magazine.*

Low Art Tile showroom (c. 1902). Note numerous art pottery vases on display, presumably Low's Chelsea Ware. *Mrs. John G. Low, II.*

has been noted and is incised "Low Tile Co." and dated 1890. Other work may have borne the firm's trademark, as shown, possibly on a paper label. Watkins indicates that marked paperweights, clock cases, candlesticks, bonbon boxes and small ewers and flower holders were made, but this apparently was an application of their art tile production and not art pottery.[9] Art tiles bear the mark of J. and J. G. Low prior to 1883; thereafter the mark of J. G. and J. F. Low was used. The initials "A. O." or the cipher of an "A" within an "O" are the marks of Arthur Osborne.

1. One of the finest examples of Low's work of this type is a large two-handled redware urn in the collection of the Museum of Fine Arts, Boston (#77.248).
2. For reference to Low's art tile production see *Century Magazine*, XXIII (April 1882), pp. 896-904; Lura W. Watkins, *Antiques*, XLV (May 1944), pp. 250-52; Barbara W. Morse, *Spinning Wheel*, XXV (March 1969), pp. 18-22; *ibid.*, XXVI (September 1970), pp. 28-31; *ibid.*, XXVI (December 1970), pp. 12-15; *ibid.*, XXVII (July-August 1971), pp. 26-28; *ibid.*, XXVII (September 1971), pp. 16-19.
3. *Crockery and Glass Journal*, X (July 31, 1879), p. 30.
4. This work was not done on any regular basis at American Encaustic. A single vase is illustrated in L. & E. Purviance and N. F. Schneider, *Zanesville Art Pottery in Color*, plate 22.
5. *Century Magazine*, XXIII (April 1882), pp. 902, 903.
6. *Scribner's Magazine*, XXXII (November 1902), pp. 639-40. Evidently to provide new capital for this venture, the Low Tile Company was incorporated in Maine in May 1899. The charter for the corporation was suspended in 1909.
7. E. A. Barber, *The Pottery and Porcelain of the United States*, pp. 518-19.
8. Morse, *Spinning Wheel*, XXV (March 1969), p. 22.
9. L. W. Watkins, *Early New England Potters and Their Wares*, p. 228.
* Information relating to this pottery is included in a separate chapter

J. W. McCoy Pottery

Roseville, Ohio
Zanesville, Ohio

The J. W. McCoy Pottery was organized by James W. McCoy in 1899. Production, begun early the following year on Perry Street in Roseville, at first consisted only of common ware, but in the course of a few months this was expanded to encompass a line of ornamental goods including mugs, tankards, jardinieres and pedestals. By 1902 daily production was about 5,000 pieces, with three jiggers and three casters working on white-bodied ware and four jiggers making the twice-fired cooking ware. About one hundred workers were employed.[1]

In April of the following year the entire stock of pottery, the warehouse, kiln sheds and packing departments were destroyed by fire.[2] The plant was largely rebuilt at the Roseville location by the end of 1903 and production thereafter resumed. In January 1905 the J. W. McCoy Pottery Company was incorporated in Ohio, giving the firm considerable new capital.

One of the earliest art lines was introduced in late 1902 and given the name *Mont Pelee* ware. Inspiration for the line of sober, dull-black lava-type pottery with occasional iridescence came from the art treasures found in the ruins of St. Pierre, Isle of Martinique, about that time. In conjunction with this white-bodied line a small booklet was published describing the ware, a great deal of which was destroyed in the 1903 fire.[3] In mid-1906 the firm introduced a matt-green art line of vases, jardinieres, cuspidors, fern dishes and umbrella stands,[4] and in 1908 the *Loy-Nel-Art* line was created. This latter ware, named by combining the given names of McCoy's sons, was hand-decorated and offered in both the standard brown glaze similar to Weller's* Louwelsa and matt green with embossed and incised decoration.[5]

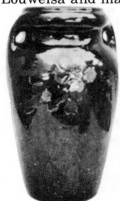

[left] J. W. McCoy's underglaze slip decorated line, Loy-Nel-Art; h. 13" (33.2 cm). Impressed mark and artist-signed "T.S." in slip on body. *Virgil Weare.*

[right] Brush-McCoy Navarre ware.
Crockery and Glass Journal.

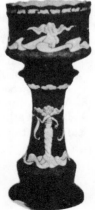

By this time, George S. Brush had become manager at McCoy. Brush had joined the Owens Pottery* in 1901 as editor of *The Owens Monthly,* and in 1905 he was made sales manager of that firm. He left Owens and organized the Brush Pottery Company, in late 1906, and served as its manager.[6] The following year that operation acquired the old Upjohn Pottery* building in Zanesville. The plant had most recently been used by the Union Pottery; Brush took over their molds for cereal and mixing bowls and general kitchen ware,[7] and a full line of stoneware specialties was produced.[8] This operation was destroyed by fire in 1908, after which Brush joined McCoy.

The name of the J. W. McCoy Pottery was changed in 1911 to the Brush-McCoy Pottery Company. A year earlier, with backing from James McCoy, his son Nelson had organized the Nelson McCoy Sanitary & Stoneware Company,[9] thereby creating considerable confusion for outsiders between the two firms, both located in Roseville.[10] The principal output of the Nelson McCoy works was stoneware kitchen utensils, in the production of which they soon became a leader. In 1926 this firm expanded its operations to include production of industrial artware.[11] The name was simplified seven years later to the Nelson McCoy Pottery, and in 1967 it was purchased by the Mount Clemens Pottery Company of Mount Clemens, Michigan,[12] which continued production of industrial artware under the Nelson McCoy name as late as 1972.

In 1912 Brush-McCoy purchased the A. Radford Pottery*, and it was anticipated that they would continue to manufacture a number of Radford's best sellers.[13] That same year Brush-McCoy began operation of the former Owens pottery at Zanesville[14] in addition to the Roseville plant. Some Owens molds were also acquired, and by the end of 1912 *Navarre* was introduced.[15] Made from the Owens molds for the Henri Deux line, the Brush-McCoy ware was a more simple version in matt green and white. During the next few years numerous other such lines were offered including *Venetian, Basket Weave* and *Green Woodland. Sylvan,* a line decorated with trees in relief and apparently copied by Weller for their Forest ware, was introduced in 1915.[16] Another line of the same year was *Old Egypt,* reproducing the Egyptian beetle decoration in various forms. That year the MITUSA trademark was first used. Coined by Brush, it was an adaptation of the phrase "Made in the United States of America."[17] Later that same year *Moss Green,* a matt green line, was first shown,[18] and in the spring of 1916 *Vogue* and *Bon-Ton* were being advertised.[19]

Utilitarian wares were also produced at the Zanesville location[20] until it was completely destroyed by fire. Thereafter all manufacturing operations were moved to the Roseville site, where several new artware lines were introduced.[21]

Late in 1925 the name of the firm was again changed, and thereafter it was the Brush Pottery—not to be confused with the original Brush Pottery which operated in 1907 and 1908, and which was legally dissolved in 1912.

Little of the J. W. [Brush-] McCoy art lines was ever of a very high quality, and the mass-produced late lines can hardly be considered art pottery. Perhaps for this reason little of the work is ever found with marks. One exception to this is the Loy-Nel-Art ware, which often bears the impressed "Loy-Nel-Art," sometimes accompanied with the impressed "McCoy" mark.

LOY-NEL-ART
McCOY

1. *The Clay-Worker,* XXXVIII (September 1902), p. 228. McCoy, according to Ohio corporation records, was one of the principals of the Midland Pottery, Roseville, a producer of utilitarian stoneware.
2. Zanesville *Courier,* April 17, 1903; *Glass and Pottery World,* XI (May 1903), pp. 12-13; *The Clay-Worker,* XXXIX (June 1903), p. 657.
3. *China, Glass and Pottery Review,* XII (February 1903), p. 31; *The Clay-Worker,* XXXVIII (December 1902), p. 562.
4. Advertised in *Glass and Pottery World,* XIV (August 1906), p. 45.
5. *Glass and Pottery World,* XVII (February 1909), p. 43.
6. *Clay Record,* XXIX (December 31, 1906), p. 37.
7. Norris F. Schneider, Zanesville *Times Recorder,* September 16, 1962, p. A-6.
8. *The Clay-Worker,* XLVII (March 1907), p. 554; *Glass and Pottery World,* XV (June 1907), p. 28.
9. Zanesville *Signal,* April 25, 1910, and May 30, 1910; also see N. McCoy obituary, *Times Recorder,* April 20, 1945.
10. Lucille Henzke in *American Art Pottery* (Camden, New Jersey: Nelson, 1970) makes no distinction between the various operations, and erroneously attributes the Loy-Nel-Art line to the Nelson McCoy firm.
11. William Watson Wilson, "A History of the Roseville Village School District" (a thesis presented for the degree of Master of Arts at Ohio State University, 1939), p. 93.
12. Ken Deibel, *Spinning Wheel,* XXIV (December 1968), p. 56.
13. *Pottery & Glass,* VIII (May 1912), p. 16.
14. In 1913 the Royal Photo Film Company of Columbus, Ohio, made a documentary film showing the techniques of pottery manufacture used at the Zanesville plant of Brush-McCoy, and extensively depicting the various lines produced. *The Clay-Worker,* LX (November 1913), pp. 522-24.
15. *Crockery and Glass Journal,* LXXVI (December 19, 1912), p. 95.
16. *Pottery & Glass,* XIV (September 1915), p. 5.
17. *Ibid.,* XIV (July 1915), pp. 20-21.
18. *Crockery and Glass Journal,* LXXXIII (January 20, 1916), p. 6.
19. *Ibid.,* LXXXIII (March 9, 1916), p. 31.
20. *The Clay-Worker,* LXX (July 1918), p. 22.
21. Schneider, *op. cit.,* p. A-6.
 * Information relating to this pottery is included in a separate chapter

Marblehead Pottery
Marblehead, Massachusetts

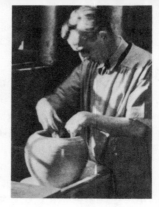

Arthur E. Baggs working at Ohio State University. *The American Ceramic Society.*

The Marblehead Pottery began in 1904 as part of a group of industries known as the Handcraft Shops, which included handweaving, woodcarving and metal work as well as pottery.[1] They were operated in a fashion similar to the later Arequipa* in that the crafts served as therapeutic workshops for convalescing patients. The demands of the pottery enterprise proved so exacting, however, that before the end of the first year it was separated from the medical plan.[2] Experimental ceramic work continued for over three years before it finally assumed the individual characteristics now associated with Marblehead.

The name of the pottery's early work supervisor, Arthur E. Baggs, is far more closely related to the ceramic production than is that of the founder, Herbert J. Hall, M.D. Baggs, a student of C. F. Binns at Alfred, directed the pottery operation, which by 1908 had a weekly output of 200 pieces including vases, jardinieres, electric lamp stands and tiles, most with simple, well-designed shapes and severely conventional decoration. The plant was a small one containing a kick wheel, a turning lathe and a six-burner kerosene kiln, in addition to working areas for designers and decorators. The staff in 1909, aside from Baggs, who served as a designer also, consisted of Arthur Irwin Hennessey and Miss Maude Milner, both designers; a decorator, Mrs. E. D. Tutt; John Swallow, an English potter of considerable experience who did the throwing; and the kiln man, E. J. Lewis. Two artists who were not on the staff but who contributed designs were Miss Annie E. Aldrich and Miss Rachel Grinwell. Mrs. Swallow assisted when orders exceeded capacity, which was often the case.[3]

In 1912 a tin-enameled faience line was introduced. Until that time only matt-glazed items were offered in shades of gray, brown, blue and yellow. Decoration of the new line, established for the production of teapots, drinking mugs, children's cereal sets, and small breakfast and luncheon sets, was in soft colors on backgrounds of cream, white or light gray. For such objects the standard Marblehead ware was unsuited both because of the heavy character of the body and also the slight porosity of the matt glaze. The requirements for the new ware were a white or light colored body which could be fashioned into thin ware without serious warping; a smooth, non-porous glaze; and a not-too-difficult method of applying decoration in a wide range of

colors; further, the whole had to burn at a comparatively low tempera-
ture into a dense ware with a good ring and no crazing. Success was
achieved and manufacture of the line begun on a commercial basis.[4]
An exceptionally well-executed set of twelve-inch plates, undoubtedly
influenced by the success of the Dedham* ware, was designed by
Hennessey in 1912. Covered with a white enamel, the borders of blue
sea horses and fish encircled center designs of ships at sea in blues,
blue-greens and browns.[5] Other experiments were conducted and
wares with an applied luster were produced, as were pieces glazed
with rich blues obtained from copper in an alkaline glaze and bright
reds developed with selenium as a coloring agent.[6]

In 1915 Baggs became owner of the plant. At that time the year-
round staff was still a small group of closely-knit workers, most of
whom had been with the pottery during most of its existence. Baggs
continued in charge of the technical and artistic direction of the work,
as from the beginning. He spent at least part of each year in resident
work at Marblehead, while devoting part of his time to teaching. From
1913 until 1920 he taught pottery at the Ethical Culture School and
the School of Design and Liberal Arts in New York; between 1925 and
1928 he was associated with the Cowan Pottery* while teaching at the
Cleveland School of Art.[7]

A Marblehead catalog was issued in 1919 showing some of the
decorated pieces, but a price list dated May 1, 1924, indicates that such
work was considerably more expensive than the plain matt-glazed
items which were becoming more and more the staple of the pottery.
The latter were offered in stock colors of Marblehead blue, a warm
gray, wistaria, rose, yellow and tobacco brown, although other
colors were produced upon order, as were decorative jars, lamps, sculp-
ture and garden ornaments. The clay mixture from which all the
products of the pottery were made at this time was composed of two
parts of clay from New Jersey mixed with one part from
Massachusetts.[8] Designs, either by Baggs or done under his direction,
were carried out in simple schemes of three or four colors, usually with
an incised outline, but sometimes flat. The subjects treated were
well-adapted to the ware and included flowers, fruits, animals and sea
motifs. In all cases, work remained simple in form and decoration.

Molds were used for only a few articles such as bookends and tiles;
the major portion of the ware was thrown. Some of the more successful
designs of the artware were reproduced, but since Baggs emphasized
that they were not molded, no two pieces would be identical.[9] A
number of special decorated pieces and experimental glaze effects
were made in the latter years of the pottery, but most were the
personal product of Baggs himself. These special pieces always bear
the A.E.B. monogram.

Marblehead received the J. Ogden Armour prize in 1915 at the annual exhibition of the applied arts at The Art Institute of Chicago. Baggs also received The Arts & Crafts Society, Boston, medal in 1925, the highest award granted by that organization. In 1928 he was awarded the Charles F. Binns medal; first prize for pottery from the Cleveland Museum of Art in 1928; first prize for pottery at the Robineau Memorial Exhibition, Syracuse Museum of Fine Arts, in 1933; and first prize for pottery in the National Ceramic Exhibition at Syracuse, New York, in 1938.

Baggs became professor of Ceramic Arts at Ohio State University in 1928. During the following years he worked at Marblehead during the summer while continuing his affiliation with the University the remainder of the year. This arrangement continued until the pottery

Marblehead vase with medium green matt ground and geometric design in black; h. 3½" (8.9 cm). *Michiko & Al Nobel.*

Unusual high-glazed Marblehead vase with mirror blue ground and design in light blue; h. 5½" (14.0 cm). Marks covered by paper label. *The Newark Museum (#26.10).*

Marblehead vase, matt green ground with brown, black and yellow matt decoration; h. 7" (17.8 cm). Inpressed mark and initials HT indicating decoration by Hanna Tutt. *The Newark Museum (#11.489).*

closed in 1936. Baggs continued his association with Ohio State until his death in 1947.

An outstanding example of Baggs' own work is a high-gloss, midnight blue glazed vase in the collection of The Newark [New Jersey] Museum (#26.10).[10] Another is to be found at The Metropolitan Museum of Art, New York (#24.207). Three examples of the "typical" Marblehead work are in the collection of the National Museum of History and Technology (Smithsonian Institution; #62.831, 834, 839). A representative collection of the Marblehead work can be found at The Newark Museum.

Almost all Marblehead ware is marked with the ship and MP cipher as shown. Decorated pieces have been examined with the incised A.B. cipher of Baggs plus a "T", and with an "H" and "T". Evidently these indicate the designer (Baggs and Hennessey in these cases) and perhaps the artist, Mrs. E. D. (Hannah) Tutt.

Marblehead vase as pictured in 1908, *Keramic Studio*.

1. 1919 catalog of the Marblehead Pottery.
2. Herbert J. Hall, *Keramic Studio,* X (June 1908), pp. 30-31.
3. *Ibid.*
4. *Handicraft,* V (June 1912), pp. 42-43. A. E. Baggs provides his own account of the development of this body in *The Handicrafter,* I (April-May 1929), p. 9.
5. Two pieces of this series are illustrated by Jonathan A. Rawson, Jr., *The House Beautiful,* XXXI (April 1912), p. 148.
6. Baggs, *op. cit.,* p. 9.
7. *The Bulletin* of The American Ceramic Society, XXVI (March 15, 1947), p. 105.
8. Gertrude Emerson, *The Craftsman,* XXIX (March 1916), pp. 671-73.
9. Personal correspondence of A. E. Baggs, October 9, 1925, with The Newark [New Jersey] Museum.
10. This particular piece is illustrated in *Spinning Wheel,* XXVIII (March 1972), p. 20.
 * Information relating to this pottery is included in a separate chapter

Markham Pottery

Ann Arbor, Michigan
National City, California

Herman C. Markham was a traveling salesman living in Ann Arbor, Michigan. He is listed in the local directories beginning in 1883-84, and, as the story is told, was an ardent grower of roses.[1] He never had sufficient vases in which to place all that he cut, especially vases which harmonized with the flowers rather than competing with them for the viewer's attention. Another problem directly related to his interest in roses was that most vases were of a material which allowed the water to warm and subsequently wilt the blooms. Unable to purchase containers to meet his requirements, he began potting in a most primitive fashion using clays from his own yard. The pottery was operated at the Markham home at 562 Seventh Street, Ann Arbor.

The first pieces were simple, undecorated forms, but they met the potter's primary objective of keeping the water cool. During this experimental period the pottery was called "Utile" to emphasize the ware's primary attribute: utility. Continuous experimentation and discovery added to these early utilitarian forms unique surface decorations which were inspired by Markham's interest in ancient potters' vessels.

Markham was joined by his son Kenneth S. in 1905, at which time commercial production of Markham pottery was begun. The Utile designation was dropped as a name because it no longer suggested what had become the unique attribute of the pottery, its decoration.

The ware itself appears to have been recently excavated from some long-buried chamber. There are two general styles of surface treatment, both entirely without gloss. *Reseau* has a fine texture and delicate web-like veinings which are slightly raised, almost appearing to be applied. *Arabesque* is coarser in texture, rough to the touch, and the design is a maze of raised, irregular fine lines. The pattern itself seems to be in relief, as if achieved by some chemical action on the surface of the piece. The most common glaze coloring was an earth or wood brown, with hints of red, green or other subtle colorings. Both types of ware often have a metallic appearance.[2]

Few mechanical conveniences were available, and all the labor involved in the production of the pottery was done by Herman or Kenneth Markham; being novices in pottery-making, they worked

mostly by trial and error. Prototypes were thrown, and from these molds were made. Shapes were modifications of classical forms, with no decoration other than that occurring in the surface patterns or veinings in the glaze. The technical aspects of the ware have been criticized for not "ringing true," and lacking good ceramic qualities because of its single low firing for both body and glaze.[3]

Yet it attracted considerable public attention wherever it was exhibited. An early price list indicates that vases ranged from $1 to $50. The wide range of prices for pieces of the same shape reflected the difference in design and coloring original to each piece. The more intricate designs and brilliant colorings commanded the higher prices, and indicate what the potters considered the hallmarks of their most successful achievements.

In 1913 the pottery moved to National City, California,[4] where the required clays could be locally obtained. Work space was provided in a portion of the plant of the California China Products Company, which produced the ceramic tiles for the buildings of the 1915 San Diego exposition. The Markhams had first been attracted to National City as visitors to the factory of that company. Having previously decided to move to the West Coast from Michigan, and after encouragement from Walter H. Nordhoff, president of California China Products, they located their plant there. At the time of its reception of a Gold Medal at the Panama-California Exposition, San Diego, 1915,[5] output consisted of art vases, mantel tile, steins and water pitchers, ornamental tea sets and sundials.[6]

In National City the Markham works was located at 1212 Seventh Avenue until about 1917; they moved to 1123 B Avenue and continued to flourish there until 1921, when operations ceased. Evidently an attempt was made at that time to raise new capital by incorporation in California. As this was not successful, the effort was abandoned and

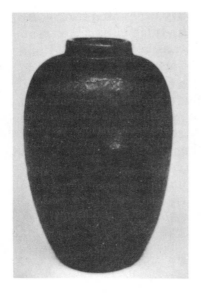

Markham's Reseau ware; h. 5" (12.7 cm). Incised mark and piece number 6939. *Private collection.*

162

Markham's Arabesque ware as pictured
in pottery catalog.

the corporation charter suspended in 1922, nine months prior to the death of Herman Markham.[7]

Representative examples of the early and later Markham work are in the collection of the Fine Arts Gallery, San Diego. A particularly interesting piece is an 8⅛" vase (#37:43), with orange and green highlights.

Each piece of artware was carefully incised with the potter's signature; and even if this were not the case, as with Niloak*, the uniqueness of the work would permit easy identification. At first the UP cipher was used, but this was shortly changed to the Markham designation. Also incised on each base was the individual piece number. The potters maintained a record of these numbers which described the size, shape, colors, surface design and history of each example produced.[8] An examination of numerous pieces would appear to indicate that numbers above 6,000 were made at National City, with those below produced at Ann Arbor.

1. Lillian Gray Jarvie, *Sketch Book,* V (November 1905), pp. 123-29; reprinted in an advertising brochure entitled *The Markham Pottery Book,* published by the pottery.
2. *Ibid.*
3. *Keramic Studio,* IX (June 1907), p. 41.
4. National City *News,* September 13, 1913, p. 1; see also *The Clay-Worker,* LX (October 1913), p. 400.
5. *The Potter,* I (December 1916), p. 38.
6. National City local directory, 1914, p. 79.
7. A brief obituary notice appears in the San Diego *Union,* November 19, 1922, p. 5.
8. *The Markham Pottery Book.* A piece bearing the number 3648 is in the collection of the Fine Arts Gallery, San Diego (#35.73), dated August 17, 1907.
 * Information relating to this pottery is included in a separate chapter

Massanetta Art Pottery
Harrisonburg, Virginia

In the fall of 1902 reports were published that the Massanetta Art Pottery Company would operate the old Virginia Pottery at Harrisonburg, and that Leonard Forrester would have charge of the plant.[1] At that time advertisements were carried in East Liverpool, Ohio, for workers, and it was observed that the pottery's locale offered "a wealth of suitable material for artware, the dark clay of the Shenandoah Valley being of fine quality."[2]

Massanetta's office was located at 41 Barclay Street, New York City, New York, the state in which the firm was incorporated. While the corporation was not dissolved until 1926,[3] no evidence has been found that art pottery was ever actually produced.

No marked examples are known to exist.

1. *Clay Record,* XXI (September 15, 1902), p. 26; *Brick,* XVII (November 1902), p. 167.
2. *Illustrated Glass and Pottery World,* X (November 1902), p. 18.
3. Records of the Corporations Bureau, State of New York.

Matt Morgan Art Pottery

Cincinnati, Ohio

The figures associated with the Matt Morgan Art Pottery Company and the work they produced are important to a degree not expected for such a short-lived operation. The pottery, located on Nixon Street in what is now the Corryville area of Cincinnati, was organized in late 1882 and incorporated in Ohio on January 1 the following year for "the designing, manufacturing and selling of art pottery."[1] Matthew Somerville Morgan, an English caricaturist and scenic painter, had gained some knowledge of pottery making in Spain and was brought to this country in 1873 by magazine publisher Frank Leslie. In 1878 he moved to Cincinnati to head the lithographic department of Strobridge & Company.[2] For a time in 1882 he worked with Isaac Broome at the Dayton Porcelain Pottery*.

Prior to the beginning of the Matt Morgan works, Morgan had George Ligowsky of Cincinnati (inventor of the clay pigeon) experiment with clays and glazes in the attempt to reproduce vases with an old Hispano-Moresque decorative motif.[3] This was successful, and upon his return to Cincinnati from Dayton he set about the manufacture of vases and plaques of such ware, reflecting his own taste and the eclectic spirit of the times. In addition to the rich colorings and lusters

Matt Morgan studio. *Cincinnati Historical Society.*

of the Moresque pottery, underglaze slip-decorated faience was produced, as was a deep blue, high glazed ware with profuse gold gilt, similar to the Portland blue faience later produced by the Cincinnati Art Pottery*.[4] In early 1884 a new terra cotta cameo ware was first shown. It was a line decorated with low relief sculptures in which the ground color is brought out in a single firing in any one of a variety of colors.[5]

The shapes were principally designed and modeled by Herman C. Mueller, working in conjunction with Morgan. Mueller was a competent mechanic as well as a sculptor. He had been trained at the School of Industrial Arts, Nuremberg, and at the Academy of Fine Arts, Munich,[6] and had modeled figures in the porcelain factories of Thuringia.[7] He came to the United States in 1875 and settled in Cincinnati about four years later.. There he made models for the Kensington Art Tile Company of Newport, Kentucky, as well as for the Morgan pottery. In 1886 he went to work for the American Encaustic Tiling Company, Zanesville, where he remained until he began the Mosaic Tile Company in the same town with Karl Langenbeck (Avon Pottery*) in 1893. He founded his own company, the Mueller Mosaic Tile Company, in 1908 at Trenton, New Jersey. Active with that firm until his death in 1941, he was acknowledged as one of the foremost tile men in the United States.[8]

Two outstanding decorators were associated with the Matt Morgan works: N. J. Hirschfeld and Matthew A. Daly.[9] The initials of both, who were thereafter to join the decorating staff of the Rookwood Pottery*, can be found incised on Matt Morgan pottery.

The failure of the company, according to Mueller,[10] was caused by the efforts of the stockholders to place the business on a commercial basis at the expense of the artistic element. After the company failed,

Matt Morgan underglaze decorated vase by N. J. Hirschfeld; h. 4⅜" (11.2 cm). Impressed mark with Cincinnati location.
Mr. & Mrs. Zane Field.

[left] One of a pair of Matt Morgan vases with dark blue glaze and gold decoration in the panels; h. 18½" (47.1 cm). Impressed mark with Cincinnati location. *Cincinnati Art Museum (#1933.2 and .3), bequest of Mrs. W. F. Boyd.*

[right] One of a matched pair of Matt Morgan vases, ochre with gold trim and white flowers on turquoise ground, decorated by N. J. Hirschfeld; h. 19" (48.4 cm). Impressed mark with Cincinnati location. *National Museum of History and Technology (Smithsonian Institution; #61.1 A,B).*

the molds, models and remaining stock of ware were practically thrown away. The firm was reorganized in the spring of 1884 and Ligowski became superintendent. Morgan devoted the bulk of his time to his work at Strobridge. Matt Morgan pottery was exhibited in May 1884, but output of art pottery apparently ceased by the year's end. Subsequently Morgan made his home in New York City, where he died in 1890.

Examples of the firm's production can be studied at the Cincinnati Art Museum and The Brooklyn Museum.

The mark is usually the impressed name of the company, often with the location abbreviated in the center. As noted above, a decorator's initials may also be found incised. In some instances only a paper label was used, hence "unmarked" pieces are also likely to be found.

1. Articles of Incorporation.
2. John W. Merten, *Bulletin* of the Historical and Philosophical Society of Ohio, VIII (January 1950), pp. 24, 26, 28.
3. E. A. Barber, *Marks of American Potters,* p. 125; *Crockery and Glass Journal,* XIX (March 6, 1884), p. 22. This latter account also offers some interesting insights into Morgan's career in England.
4. Two excellent matched vases of this ware are in the collection of the Cincinnati Art Museum (#1933.2 and 1933.3). Report of an early exhibition at Detroit of Morgan work appears in *The Studio* [New York], II (October 20, 1883), p. 171.
5. *Crockery and Glass Journal,* XIX (May 8, 1884), p. 24.
6. E. A. Barber, *The Pottery and Porcelain of the United States,* p. 354.
7. W. Stout *et al., Coal Formation Clays of Ohio,* pp. 27-28.
8. *The Bulletin* of The American Ceramic Society, XXI (January 1942), pp. 1-3.
9. An example of Daly's work done during this time is at the Cincinnati Art Museum (#1967.1363), an example of Hirschfeld's is at the National Museum of History and Technology (Smithsonian Institution; #61.1a).
10. *Crockery and Glass Journal,* XIX (May 8, 1884), p. 24.
* Information relating to this pottery is included in a separate chapter

Merrimac Pottery

Newburyport, Massachusetts

The Merrimac Ceramic Company was formally organized in January 1897 by Thomas S. Nickerson and incorporated in Maine for the manufacture of inexpensive florists' ware and enameled tile.[1] He was joined in 1898 by W. G. Fisher, and output was expanded through the acquisition of additional machinery.[2] Nickerson, who studied under Sir William Crookes in England,[3] shifted his emphasis in 1900 from the more common work to decorative and glazed artware. He was soon producing shapes which were so pure that they attracted considerable attention,[4] and on January 1, 1902, the firm name was changed to the Merrimac Pottery Company, reflecting this change of interest and production.

The initial art pottery output consisted of small objects, principally vases and flower containers. During the first year of production glazes were limited primarily to matt greens and yellow,[5] but by early 1903 colors included various tones of green, soft matt purple and violet hues, rose, blues and purples with a metallic luster and iridescence, matt black, light yellow and dark orange, as well as fine crackle glazes.[6] These were all the result of Nickerson's experiments with Crookes and on his own after his return to the United States. No painted decoration was attempted either over or under the glaze, as Nickerson, the pottery's director, stressed simplicity in all aspects of his work, extending to both color and form.

From his success in this area he expanded his output to include high-class garden pottery, which was offered in twenty-three different shapes in 1903.[7] White clay was used to produce a whiteware of considerable strength, although the standard terra cotta body was used far more extensively for the gardenware, especially that which was modeled on the severe Etruscan forms. Most of the gardenware was unadorned; however, a few of the larger pieces had modeled decoration of festoons, rosettes and satyrs' heads resembling old and modern Italian pottery.[8]

In addition to the regular artware and garden pottery, another line, identified as *Arrhelian* ware, was introduced prior to 1903.[9] This work was based on reproduction of the Arrhetian (or, more properly, Arretine) redware which was made in the early days of the Roman Empire and became the prototype of an industry carried into all the Roman

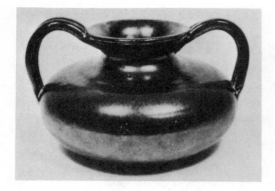

Merrimac low, handled vase, gray-black high glaze; h. 4¾" (12.1 cm). Impressed mark. *Private collection.*

colonies, flourishing especially in France. Nickerson's work for the most part was a technical reproduction of original molds then in the possession of the Museum of Fine Arts, Boston. These molds were taken from vases of the fine metals such as gold and silver and well-illustrate the expertise of the Greek goldsmiths and silversmiths. The founder of the principal establishment in Arrhetium was Marcus Perennius, examples of whose work, as well as that of Rasinius, were among the signed pieces offered.[10] As a result of the technique employed, pieces are similar to the originals from the kilns of Arrhetium in their deep red color, texture and decoration in low relief.

At the St. Louis exposition in 1904 the Merrimac Pottery exhibited a large number of pieces in matt greens, black, yellow, blue and gray, as well as the terra cotta work based on the ancient models, for which the pottery received a Silver Medal.[11] The lines of shapes, which were mostly thrown, and glazes of superior merit were continually expanded. Lamps produced from matt-glazed pieces also received particular acclaim from critics.

Due to the close proximity to Boston and the skillful work with enamels, Nickerson's pottery was often seen as a copy of Grueby's*. "That accusation," according to a contemporary account,[12] " . . . is not borne out by a careful study and comparison of both wares. Save in the color of certain green pieces, the resemblance is very little; and really the greens of Merrimac, so far as one writer has observed, are not at all comparable to the Grueby, with its soft, kid-glove-like surface and finish. The Merrimac has, however, so much to offer in scope of variety (and this cannot be said of the Grueby) that very interesting and charming products come up for consideration quite independent of the green specimens. Many of the Merrimac pieces show a cheerful, tender, bright, radiant character, which is wholly lacking in the Grueby. The soft color of the Merrimac is especially pleasing and the metallic glow on some of the articles is most effective, rich and brilliant. This metallic finish is the finer and more acceptable, as seen upon the

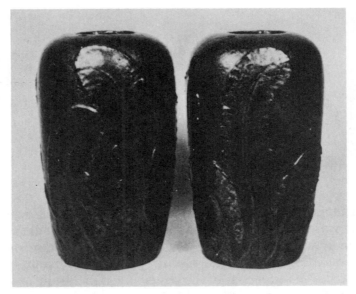

Pair of Merrimac vases with modeled decoration, dark green high glaze; h. 7⅝" (19.4 cm) and 7¾" (19.7 cm). Paper label. *Private collection.*

low-tone pieces, such as on the soft dull violet, rose and similar colorings."

In October 1908 the pottery was left in ruins by fire, which destroyed both plant and stock. Reports at the time[13] indicate that the pottery had not been in operation for some time. Nickerson had sold the works and inventory to Frank A. Bray a short time prior to the fire. A closeout sale was held in November 1908[14] liquidating the remainder of the Merrimac work. The pottery never resumed operation. No

Merrimac vase with coiled surface and applied handles, medium green matt glaze; h. 8½" (21.6 cm). Impressed mark and paper label showing original price of $12. *Private collection.*

connection has been established between the Merrimac Clay Products Company of Boston, which was incorporated in 1922 for the manufacture of brick and tile,[15] and the earlier Merrimac Pottery Company.

In addition to three pieces of Merrimac in the collection of the Worcester Art Museum, acquired from the pottery in 1903, several pieces are in the collection of The Society for the Preservation of New England Antiquities, Boston. A half-dozen examples of Merrimac work from M. C. P. Stratton's (Pewabic*) private collection are at the Pewabic Museum, Detroit.

Early ware in the period from 1897 to 1900 does not appear to have been marked. From September 1900 until August 1901 a paper label depicting a sturgeon—the meaning of the Indian word "merrimac"—was attached to all pieces. Following the latter date, the mark was impressed or incised.[16]

1. Reported in *The Clay-Worker,* XXVII (February 1897), p. 186; also see E. A. Barber, *The Pottery and Porcelain of the United States,* p. 564. Four sets of these tiles were shown at the 1899 exhibition of The Arts & Crafts Society, Boston (catalog, p. 33). Nickerson, like Grueby*, was a member and an early contributor to the Society, by which he was judged a Master Craftsman.
2. *The Clay-Worker,* XXX (August 1898), p. 134.
3. Irene Sargent, *The Craftsman,* IV (July 1903), p. 248.
4. W. P. Jervis, *The Encyclopedia of Ceramics,* p. 385.
5. *Illustrated Glass and Pottery World,* X (September 1902), p. 19. A 1901 exhibition of Merrimac work by The Arts & Crafts Society, Boston, is reported in *Illustrated Glass and Pottery World,* IX (July 15, 1901), p. 173, a report taken from the Boston *Globe.*
6. Newburyport *Daily News,* January 24, 1903, p. 7.
7. *Ibid.*
8. Henry Lewis Johnson, *The House Beautiful,* XIII (February 1903), pp. 177-80.
9. "Arrhetian Ware," a brochure of the pottery, was issued to describe this ware and the eight items originally produced in the line.
10. *Ibid.* Two different bowls of this type by Bargates, a workman for Perennius, are in the collection of the Worcester [Massachusetts] Art Museum (#1903.14-15).
11. *Keramic Studio,* VI (April 1905), p. 269.
12. By Jane Layng, as reported in the Newburyport *Daily News,* January 24, 1903, p. 7.
13. Newburyport *Daily News,* October 23, 1908, p. 1.
14. *Ibid.,* November 7, 1908.
15. *The Clay-Worker,* LXXVII (June 1922), p. 708.
16. E. A. Barber, *Marks of American Potters,* p. 101.
* Information relating to this pottery is included in a separate chapter

Miami Pottery
Dayton, Ohio

Another less formally organized (cf. Brush Guild*) artware producer was the Miami Pottery. This venture centered about the Dayton Society of Arts and Crafts, which was formed in the fall of 1902. Classes in crafts and design were offered under the direction of Forrest Emerson Mann.[1]

The work, principally by students rather than experienced craftsmen or accomplished artists, was made from yellow clay found in the Miami River valley. Shapes were hand-fashioned and simple in form, sometimes with modeled decoration in low relief. A display was held in 1903 at the Syracuse, New York, Arts and Crafts exhibit of pieces by Mrs. J. B. Thresher, William Cochrane and Albert Loose, with special note taken of the glaze which "was of a rich dark brown color, full of life and having a soft, luminous quality on its matt surface, which is distinctive of the work."[2]

The pottery appears to have operated for less than two years;[3] marked examples of its work are not known to exist.

Miami Pottery ware as shown in *Keramic Studio.*

1. C. R. Conover, *Dayton and Montgomery County,* Vol. I, p. 212; also Dayton Art Institute Annual Report, 1931, p. 2.
2. *Keramic Studio,* V (June 1903), p. 36.
3. The only Dayton directory listing for the Society appears in 1904-05.
* Information relating to this pottery is included in a separate chapter

Middle Lane Pottery

East Hampton, New York
Westhampton, New York

T. A. Brouwer engaged in Fire Painting. *Crockery and Glass Journal.*

The unique pottery produced by Theophilus Anthony Brouwer, Jr., has achieved a reputation far exceeding its limited production. As early as 1893 Brouwer began experimenting with luster glazes and met with success within a year's time.[1] In 1894 he opened his small pottery on Middle Lane in East Hampton, the location providing the pottery name. All of the work was done by Brouwer—he turned the pieces, made his own molds, did his own pressing and casting, and developed his own techniques for decorating. An Indian or two were employed as assistants, but the artist-potter was responsible for the work from beginning to end, much in the manner of the later studio potters.[2]

His methods were extremely unorthodox, and in many respects his break with the accepted ways of doing things was analogous to the work of George Ohr at the Biloxi Art Pottery*. Brouwer had no previous knowledge of potting but was a very creative and versatile artist, as evidenced by his metalwork, woodcarving, plaster modeling and oil painting.

Brouwer's work, by 1900, was arranged in five classes. The first, designated *Fire Painting,* displayed prismatic colorings of gray-green, yellow, red, orange and brown, all with an iridescent high-gloss surface.[3] The Fire Painting process, which earned for Brouwer the respect of connoisseurs and ceramic experts alike, called for the man-

173

ipulation of the biscuit-fired, raw-glazed piece in what was practically an open reduction kiln. The pottery was exposed almost directly to the ultimate heat of the open furnace, the maturing and lustering of the piece taking place in as little as seventeen minutes, once the process was fully refined. The piece was then withdrawn with tongs, placed on a heated iron plate and allowed to cool in the atmosphere of the ordinary room. All decorative effects were accomplished in this manner and were a compound part of the glaze, resulting from the action of the flames alone. No brushwork or hand illumination whatsoever took place. The glaze itself could be applied with a brush, either smoothly or roughly, and was such that if the emerging color or design were not satisfactory the piece could be returned to the fire and the color scheme or design wholly transformed. Or, if placed in an ordinary furnace, the entire decoration could be erased leaving a plain white surface, which could be redecorated if returned to the fire by Brouwer.[4]

Iridescent Fire Painting, the second class of Brouwer work, was similar to regular Fire Painting but of a single tone with a heavy encrustation of color. *Sea-Grass Fire Painting,* a third class, was decorated with sea-grass forms in tones of green, brown and gray radiating outward from the center of a plain glaze, again solely the work of the fire. Another class was *Kid Surface* ware, offered in dull, smooth, solid colors such as robin's-egg blue, snow, brown, gray and green. Here the glaze was not flowed on but applied roughly, the finish of the surface depending on the composition of the materials and the manner of firing.

The final class of work offered by 1900 was designated *Gold Leaf Underglaze.* It consisted of glazing over pure gold leaf, the metal being inlaid between layers of colored glaze which could be fired without danger of the rearrangement of the gold even if the glaze should flow. Explaining this process, Brouwer wrote "I diffused first a crystaline glaze over the gold on a pot, and then set up a solid glaze which would melt at a lower temperature to restore the transparency. In this way I was enabled to overcome the tendency of the glazes previously used to run in irregular forms and creep away from the gold, and also to make a perfect covering of glaze evenly over the surface."[5]

In 1902 the pottery in East Hampton was sold; the following year work was begun in Brouwer's new plant on the Montauk Highway,

Middle Lane iridescent Fire Painted vase; h. 4" (10.2 cm). Incised whale-bone mark and Brouwer signature. *Private collection.*

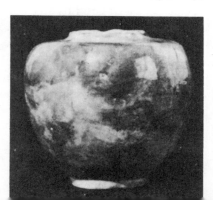

174

Westhampton, where it was generally known as the Brouwer Pottery. At Westhampton one of the three buildings was erected in the novel form of a miniature castle, having been designed and built entirely by Brouwer with the aid of a mason tender only. Behind the castle was the pottery where Brouwer's *Flame* ware was perfected. Flame, first successfully produced at East Hampton, was to occupy his chief ceramic interest; it was achieved by combining the various decorative techniques previously developed in such a way as to secure the best effects of each on the particular form on which he was working. These included bowls, vases and animal representations. Brouwer considered Flame the peak achievement of his work, "each example being a carefully studied combination of form, color and texture."[6] For this process only a hard body was used, and each piece of work was unique in concept as well as glaze treatment, the latter best described as catching and retaining "the prismatic hues of the spectrum with a true rainbow iridescence."[7] Barber observed that "this product promised to be of greater art value than anything that has preceded it."[8]

By late 1911 Brouwer's interest was occupied with new pursuits. At that time he wrote that "although I am not now dependent upon the sale of pottery, still it is my intention to both lecture on pottery and sell as much as may be demanded."[9] Finally in 1925 Brouwer was persuaded to capitalize on his Fire Painting technique, and the Ceramic Flame Company was incorporated in New York "to maintain a factory, pottery, studio, store, office or show-room for the manufacture and sale of pottery, tile and all products of clay, according to the secret formulas or processes of Theophilus A. Brouwer, heretofore used in the manufacture of the products known as 'Fire Painted Brouwer Pottery'."[10] No evidence of this firm's work has been noted, although the Ceramic Flame Company was listed from 1927 until late 1932 as a manufacturer of art and decorative pottery in the *Pottery and Glass Directory*. The corporation itself was dissolved in 1946, fourteen years after Brouwer's death in 1932.

A modest but important collection of Brouwer material, including sample molds and pieces developed from them, is maintained by the East Hampton Historical Society. The National Museum of History and Technology (Smithsonian Institution) has several pieces which on the whole are not representative examples of Brouwer's successful work.

The distinctive Brouwer mark is a representation of the jawbones of a large whale which had been captured off Long Island and which formed the entrance to the original pottery on Middle Lane. The incised and impressed bone-mark enclosed the letter M for Middle Lane. All completed work of the pottery was marked. Flame ware bears the word "flame" incised, an incised flame itself or both.

Brouwer's signature was also often added. Use of the whalebone mark was continued at the Westhampton location.[11] Marked ware of the Ceramic Flame Company is unknown.

1. Babylon, Long Island, *Signal,* May 13, 1893; E. A. Barber, *The Pottery and Porcelain of the United States,* p. 493. Several pieces of this early experimental period were in the collection of the Philadelphia Museum of Art (#'94-33 through '94-39), but they have since been dispersed.
2. W. P. Jervis, *The Encyclopedia of Ceramics,* pp. 72-74.
3. It is emphasized that Brouwer's iridescent glaze was not achieved either by the application of metallic luster over a glazed body as did the Italians, or by the painting of a metallic-ochreous mixture over a fired copper glaze and then subjecting this to a certain reducing fire, as in the process used by Clement Massier in France and introduced in the United States by Massier's pupil Jacques Sicard at the Weller Pottery*, but was obtained solely by exposure to the flames of the kiln.
4. Anne Winslow Crane, *The Art Interchange,* XLV (August 1900), pp. 32-33; Frederick H. Rhead, *The Potter,* I (January 1917), pp. 43-49.
5. Rhead, *op. cit.,* pp. 47-48. "With regard to the manner of my discovering this 'Fire Painting,'" Brouwer is quoted by Rhead, "I am frequently asked if it was by accident. It certainly was not, unless one considers the seeing of a bit of iridescent color on the bottom of a little sand crucible an accident. I saw this bit of color and determined to find out how it got there. It took me months of hard work, literally day and night before my muffle furnace door."
6. Brochure of the pottery entitled "Middle Lane Pottery", c. 1900.
7. M. Benjamin, *American Art Pottery,* p. 36.
8. Barber, *op. cit.,* p. 496.
9. Letter to the Editor, dated December 16, 1911, from T. A. Brouwer, probably published in the East Hampton *Star.* One of these pursuits was the execution of sculptured figures, not by the artist making a model of clay and then entrusting the converting of the design into permanent form to a foundry or stone cutting machine, but by the actual carving by hand of the statue or design from the block by Brouwer himself, without previous sketch, model or study. Work was executed in concrete that, by one of Brouwer's processes, was converted into a material as hard and durable as stone. The lion and giant cavaliers which stood in front of the castle as late as 1971 were so executed, as were the eagle statue in front of the old East Moriches (Long Island) school and that of a soldier planting a flag in front of the Eastport (Long Island) high school. For elaboration of this aspect of Brouwer's work see the Brooklyn *Times Union,* August 7, 1932; Harry W. Hudson, *Long Island Forum,* XXXII (July 1969), pp. 126-27; Leroy Wilcox, *Long Island Forum,* XXXV (August 1972), pp. 167-71.
10. Articles of Incorporation. While a Southampton office address is given, the new firm operated the Brouwer works at Westhampton.
11. Correspondence between T. A. Brouwer and the Macbeth Gallery, New York City, *Archives of American Art,* NMc5, frame 608. Also see *Crockery and Glass Journal,* LXXIV (December 21, 1911), p. 193.
* Information relating to this pottery is included in a separate chapter

Morgan, Matt, Art Pottery
Cincinnati, Ohio

(see entry: Matt Morgan Art Pottery)

Nashville Art Pottery
Nashville, Tennessee

Much in the same manner as numerous other potteries of the period, the Nashville Art Pottery was closely related to a local art school, in this case the Nashville School of Art. The school, headed by Nashville-born Miss Bettie J. Scovel, was located at the corner of McLemore and Furman streets.[1]

Miss Scovel went to Cincinnati in 1882 to study the school there as well as the Rookwood* operation. She returned to Nashville and in 1883 secured the McGavock building, where there was room for modeling, clay work, plaster-of-Paris and pottery work, as well as space for a kiln. Room was also reserved for crayon and painting classes.[2]

The first kiln was fired early in 1884,[3] and by 1885 work was

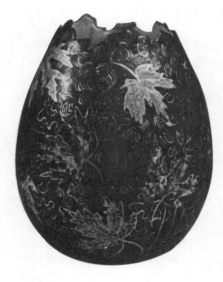

Nashville Art Pottery vase, red ground and green leaf decoration, edged in gold with gold cobwebs, interior glazed yellow; h. 5¾" (14.6 cm). Incised mark. *The Art Museum, Princeton University (#37-141).*

177

Nashville Art Pottery brown-glazed redware pitcher; h. 8" (20.4 cm). Incised mark. *The Art Museum, Princeton University (#37-137).*

expanded to include a pottery and a fireman to do the heavy work. Miss Scovel made all her own molds and modeled the forms, which were noted for their artistic shapes. At first a red earthenware was used. Later a white body was also employed, and experiments were carried on using native Tennessee clays.

Two unique wares were introduced in 1888. *Goldstone,* with a rich dark-brown glaze over a red body, had a brilliant golden appearance as a result of high firing. *Pomegranate* was another high-fired ware; its white body was decorated with a red-veined effect on a mottled pink and blue-gray ground which resulted from the firing. Prior to the introduction of these lines, most work was glazed with a good brown glaze.[4]

Two marked[5] and one attributed piece of the Nashville Art Pottery remain in the Trumbull-Prime collection of The Art Museum, Princeton University.

The only noted mark is the incised designation as shown.

Nashville Art Pottery

1. Nashville city directories.
2. Nashville *Banner,* June 25, 1883, p. 4.
3. *Ibid.,* June 26, 1884, p. 4.
4. E. A. Barber, *The Pottery and Porcelain of the United States,* p. 334, 470-71. Barber offers a variant spelling of Miss Scovel's name, giving it as "Scoville," but no other source has been found to justify that spelling.
5. One is a vase of the redware variety (#37-137) and the other a white-bodied vase (#37-141). The latter piece also bears the date 1886.
* Information relating to this pottery is included in a separate chapter

New Orleans Art Pottery

New Orleans, Louisiana

In mid-1888 George Ohr (Biloxi Art Pottery*) and Joseph Meyer, who later achieved fame as one of the major Newcomb* potters, returned to New Orleans from Biloxi, Mississippi, to work at the recently reorganized New Orleans Art Pottery at 249 Baronne Street.[1] The establishment of this operation was evidently to fill the void created by the sporadic production of the Louisiana Porcelain works, and to meet the market for earthenware rather than porcelain blanks for embellishment by local decorators.

The New Orleans Porcelain Factory had been organized in late 1880 by Eugene Surgi, a longtime resident of New Orleans although a native of France who was a civil engineer by profession, and Abel d'Estampes, also a French native, who had previously been director of the large porcelain factory at Vierzan, France. D'Estampes had come to the United States about 1870 and shortly before this association with Surgi had manufactured porcelain on a small scale in New Orleans using French kaolin. By March 1881 6,000 pieces had been produced using a Texas kaolin, and the first kiln was fired in August of that year. The large, three-story pottery building containing the circular-shaped, coal-fired kiln with two compartments eleven feet in diameter and thirty feet in height was located at 326 Carondelet Walk

New Orleans Art Pottery workers, Joseph Meyer in foreground and George Ohr at rear, as shown in an oil painting by William Woodward. The painting, dated 1889, was given to the Biloxi Public Library by Woodward and in 1974 was hanging in the Biloxi City Hall. *J. W. Carpenter & R. W. Blasberg.*

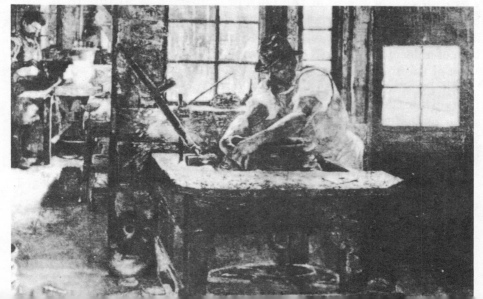

New Orleans Art Pottery ware as shown in *Ceramic Age*.

on the Old Basin canal. The association of Surgi and d'Estampes was tenuous from the start and of short duration; d'Estampes formed his own firm in 1883, the French Porcelain Company, which was apparently short-lived. The first underglaze decorated porcelain was to have been fired by the New Orleans Porcelain Factory in mid-1883, but no report of the results has been found. The operation of that works was hindered by a lack of skilled technical help, and when it was unable to obtain any artisans from France it abandoned its work later that year. Thereafter the facilities were operated for a time by L. M. Gex.[2] Still later the plant was operated by Bertrand Saloy and Joseph Hernandez as the Louisiana Porcelain Manufacturing Company.[3] Biscuit ware of imported French kaolin, similar in quality to Limoges, was offered. It was Jules Gabry, one of the potters connected with this firm, who became the first potter at the Newcomb Pottery. He was from Sèvres and had studied under Massier. Plans were being made for the addition of a decorating department when the pottery closed, at about the time of the formation of the New Orleans Art Pottery.[4]

The local art league was quick to patronize the New Orleans Art Pottery for the firing of their decorated ware, and it offered much the same opportunity in New Orleans that the Dallas Pottery* did in Cincinnati. And, like its Cincinnati counterpart, the work of the small operation has been completely overshadowed by the success of its indirect offspring, the Newcomb Pottery.

The New Orleans Art Pottery was fostered by William Woodward, an instructor in drawing and painting at Tulane University. He and

his brother Ellsworth, who was to become the first director of New-comb, were educated at the Rhode Island School of Design. William went on to receive further training in Paris, while Ellsworth studied at Munich.[5]

The venture continued for little more than a year when it closed for lack of funds. During its existence it became the center for ceramic activities in New Orleans. Immediately upon its failure the Art League Pottery Club was formed as its successor, taking full advan-tage of the Baronne Street facilities.[6] William Woodward headed the group, which met monthly at Tulane and was composed mainly of advanced students who had studied art methods at Sophie Newcomb and Tulane Colleges.[7] Apparently both Ohr and Meyer remained with the new group, which became known as the Baronne Street Pottery or the Baronne Street Venture and which operated successfully for about five years. Mary G. Sheerer, Newcomb's first supervisor, reported that "many very creditable pieces came from its kilns . . . Like so many other efforts . . . it proved to be the suggestion for the more substantially planned pottery which followed it . . . at Newcomb."[8]

Three jardinieres, one with a pedestal base, made at the New Or-leans Art Pottery are in the collection of the Louisiana Crafts Council at the Louisiana State Museum, New Orleans.

The incised mark "N. O. Art Pottery Co." is to be found on the work of the firm.

1. *Advance!,* I (June 1888), p. 13. Kenneth E. Smith, *The Bulletin* of The American Ceramic Society, XVII (June 1938), p. 257. The only year in which Ohr and the New Orleans Art Pottery are listed in the local directories is 1889. Paul E. Cox, *Ceramic Age,* XXV (May 1935), pp. 152-56, presents an account whose facts vary somewhat from those contained herein. Based on other sources, especially that cited in note 6, it is felt that Cox is in error.
2. *Crockery and Glass Journal,* XIII-XVIII (1881-83), *passim.*
3. This firm is listed in the 1887 New Orleans directory; thereafter as the Louisiana Porcelain Works, Hernandez & Co. It ceases to be listed in 1890.
4. E. A. Barber, *The Pottery and Porcelain of the United States,* p. 313.
5. Paul E. Cox, *The Bulletin,* XIII (May 1934), pp. 140-42. For an extensive study of E. Woodward, see Estelle H. Barkemeyer, "Ellsworth Woodward: His Life and Work" (a thesis presented for the degree of Master of Arts at Tulane University, 1942).
6. New Orleans *Daily Picayune,* January 5, 1890, p. 6; New Orleans *Times Demo-crat,* January 6, 1890, p. 2.
7. New Orleans *Daily Picayune,* June 15, 1890, p. 6.
8. M. G. Sheerer, *Journal* of The American Ceramic Society, I (August 1918), p. 518. Sheerer's dating is vague and does not appear to agree with the above, but based on the other cited sources the above would seem more accurate.
 * Information relating to this pottery is included in a separate chapter

Newcomb Pottery

New Orleans, Louisiana

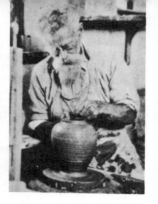

Joseph F. Meyer at Newcomb.
Ceramic Age.

Newcomb College, the women's college of Tulane University, was organized in 1886, and in 1895 the pottery was established under the supervision of Ellsworth Woodward.[1] Operated in conjunction with advanced art and design courses, it was to serve as a laboratory where art and science could be blended and where students could obtain practical information as to a method of earning a living through the training offered.[2] Patterning the enterprise on the Rookwood* model with its divisions of labor, Woodward brought in a succession of potters and ceramists to throw the ware and perfect the body and glazes. Foremost of these were Joseph F. Meyer and Paul E. Cox.

Like Rookwood, Newcomb grew indirectly from a local pottery enterprise at which a club of women worked at producing art pottery. Work began at the New Orleans Art Pottery*, where Meyer and George Ohr (Biloxi Art Pottery*) threw the ware and glazed and fired the work which the women had decorated. The first potter at Newcomb was Jules Gabry, who had been associated with the Louisiana Porcelain Works. He left in December 1895 and was followed for a short time by George Wasmuth, who was succeeded by Meyer in April 1896.[3]

To supervise the women, Mary G. Sheerer joined the staff at the very beginning. She had studied at the Cincinnati Art Academy and had been associated with the women who helped develop Rookwood. She was a china painter of considerable skill and together with Meyer guided the experimental stages of bodies, glazes and decorative treatments, all of which were to reflect an art product distinctively of the South.

Initially the clays used at the Newcomb works were red and a sandy, buff-firing ball clay found near Biloxi, Mississippi. By the turn of the century a white-firing clay of the same nature was used for some of the ware. Earliest pieces were stamped on the bottom with various letters from the end of the alphabet designating the clay mixture, such as "W" for the white clay and "Q" for the buff-colored body. Later, when the clay was obtained primarily from St. Tammany Parish, Louisiana, these notations were abandoned.

At first the decorators were girls working as undergraduates, who usually took their work home with them. They were basically artists

applying decorations to ware made and finished by other hands. As the pottery developed it had a regular decorating group of about five women who worked at the pottery on a permanent basis, usually after their graduation from the school. The bowls, vases, lamp bases, tiles and coffee sets produced by the pottery were hand thrown as well as hand decorated.

The earliest attempts at decoration were the use of natural clay slips and underglaze colors applied to the surface of the green ware. Both painting and spraying of the slip and underglaze colors were undertaken, after which a piece would be covered inside and out with a transparent, bright, raw lead glaze. The slip technique was abandoned quite early in favor of underglaze painting on a low-fired biscuit. After unsuccessful attempts to secure the desired texture on the clay surface as it came from the wheel, it was discovered that it could be achieved by the sponging of the unfired surface by the decorator. This led to incised designing on the wet clay and the painting of the design after the first fire. Colors found most practical for this were blue, green, black and yellow, the transparent high-gloss glaze still being employed.[4] During this early period a limited amount of undecorated ware was produced and sold to generate additional income.[5]

When Cox, an Alfred graduate and student of Binns, arrived at Newcomb in 1910, the popularity of high-gloss finishes was on the wane, with a sharp rise of interest in matt-finished objects. Cox improved the body and the following year developed a matt glaze to be used over the same underglaze colors,[6] thus embarking upon the middle or matt period of the pottery.[7] The underglaze blues and greens were particularly successful with the matt glaze and quickly displaced the glossy glazed ware as the standard Newcomb type, stereotyped in color (blue and gray-green), design and decorative treatment (the most typical motifs for which continued to be drawn from the surrounding Bayou country).[8]

Cox was succeeded as ceramist in 1918 by Frederick E. Walrath,[9] who remained at Newcomb until his untimely death two years later.

George Ohr (on left) at the Newcomb Pottery during its first year of operation. *J. W. Carpenter & R. W. Blasberg.*

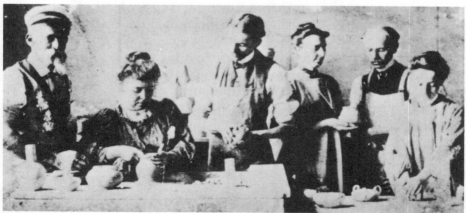

Newcomb Pottery exhibit at 1901 Buffalo exposition. *Sunset.*

He was followed by Vincent Axford, who was followed by Harry Rogers.[10] He in turn was followed by Kenneth Smith in 1929. Several of the later ceramists threw ware, as was the case with Smith, who also served as instructor. Other instructors following Miss Sheerer were Miss Juanita Gonzalez and Miss Angela Gregory.

The departure of Cox in 1918 and the removal of the pottery to the basement of the Art Building on the new Newcomb campus brought about a marked change in the "personality" of the pottery; emphasis shifted from that of a semi-commercial venture by graduate students to an educational laboratory where undergraduate students could explore the more varied use of decorative mediums and the making of the entire piece from start to finish. Meyer, who died in 1931, stayed on through the change until loss of vision forced his retirement in the mid-1920s.

The middle period ended in 1930. At that time a plain ware was introduced with some success, but it was in no way comparable to the earlier work,[11] and production of the familiar matt ware ceased; the following year Woodward retired, thus concluding Newcomb's art pottery era. A limited output was continued, however, into the 1940s

under the name of "The Newcomb Guild."[12] Most of the pottery's finest work was done in the early and middle periods. Echoing this judgment is the impressive list of medals earned by Newcomb at Paris in 1900, Buffalo in 1901, Charleston in 1902, St. Louis in 1904, Portland in 1905, Jamestown in 1907, Knoxville in 1913 and San Francisco in 1915.

Due to the number of decorators involved for various lengths of time, a complete listing is almost impossible. In the opinion of Cox, "Miss Sadie Agnes Estelle Irvine was the greatest of the decorators in the history of the enterprise. A prolific but less inspired designer was Miss Fannie Simpson . . . Miss Henrietta Bailey never gave all of her time to pottery decoration but more of her ware went into prize-winning shows than her general average of work would predict. These three women have been the 'standbys' of the Pottery."[13]

Wares of the early and middle periods are represented in the collections of most major museums in the United States, including the National Museum of History and Technology (Smithsonian Institution); The Newark [New Jersey] Museum; and The Metropolitan Museum of Art, New York. Important collections of Newcomb art pottery are maintained by Newcomb College and the Louisiana Crafts Council at the Louisiana State Museum, New Orleans. Three pieces at the Museum of Fine Arts, Boston (#99.74-76) are of importance because of their acquisition in April 1899.

During the early period, 1895-1910, the first three illustrated marks were used, most often the NC cipher colored and beneath the high-gloss glaze. Thereafter, and especially on the Newcomb matt ware, the underside was not glazed and the N-within-C cipher is not colored. Later, "hand built" pottery was introduced; it was identified by the letter H to the left of the N-within-C cipher and a B to the right.

Transitional vase between early and middle Newcomb periods (c. 1910). This high glazed piece by Sadie Irvine bears the Bayou scene which was so extensively repeated on the matt ware; h. 5⅝" (14.3 cm). Regular marks, Irvine cipher. *The American Ceramic Society (#321).*

High glaze Newcomb vase; h. 7½" (19.1 cm). Standard Newcomb mark, "BB61", Meyer cipher and cipher of C. Richardson. *Mr. & Mrs. John Zanoni.*

The letter M beneath this particular mark indicates a handbuilt piece from which a mold had been made so that it could be reproduced at less cost and sold at a lower price. An effaced mark indicates that the piece was not satisfactory or representative of the work of the pottery. A single scratch through the cipher denotes a second quality piece. Artists were encouraged to sign their work, and many of the decorators and their ciphers have been identified.[14] Other notations appearing on Newcomb ware include the initials of the potter, registration marks and occasionally an indication of the clay used, as discussed above.

Matt glazed Newcomb vase with wheat design by Henrietta Bailey; h. 8⅛" (20.7 cm). Regular marks, Bailey cipher. *National Museum of History and Technology (Smithsonian Institution; #290,222).*

1. The pottery was established in 1895, and Woodward ordered a kiln built by an East Liverpool, Ohio, builder. The following year, with Meyer's arrival, a smaller kiln was constructed and used. Whether the earlier kiln was ever used is doubtful, hence the use of an 1896 date by many for the beginning of the pottery operation. For example see E. Robinson, *Sunset,* XI (June 1903), pp. 131-35; Irene Sargent, *The Craftsman,* V (October 1903), pp. 70-76; and an early brochure of the pottery (c. 1905). Susan S. Frackelton, *The Sketch Book,* V (July 1906), p. 433, uses the 1895 date. The extensive production of Newcomb ware as it is recognized today was begun in 1897. The pottery is only one of a number of art industries connected with Newcomb College, and there is considerable interest in the crafts of the Newcomb style. For a broad overview of this see "The Art Industries of Newcomb College," by Harriet Joor, *International Studio,* XLI (July 1910), pp. 4, 6, 8, 10, 12, 14, 36, 38.

2. Paul E. Cox, *The Bulletin* of The American Ceramic Society, XIII (May 1934), pp. 140-42. It is fortunate that there are numerous primary accounts of the Newcomb operation: Mary G. Sheerer (Woodward's early assistant and instructor of pottery decoration), *Keramic Studio,* I (November 1899), pp. 151-52; M. G. Sheerer and

Paul E. Cox (ceramist) in the *Journal* of The American Ceramic Society, I (August 1918), pp. 518-28; the 1934 account by Cox cited above; P. E. Cox, *Ceramic Age*, XXV (May 1935), pp. 152-56; and Kenneth E. Smith (ceramist), *The Bulletin*, XVII (June 1938), pp. 257-59. There is also the possibility that the article by E. Woodword [*sic*], *Arts and Decoration*, I (January 1911), pp. 124-25, is actually by E. Woodward. Unless otherwise indicated, the material herein presented is drawn from these original sources.

3. Harriet Stevens (Burk), "The History of Ceramics at Newcomb College" (senior thesis at Newcomb College, 1948), p. 3.

4. Several examples of this early work are pictured in *The House Beautiful*, V (March 1899), pp. 156-58; and also in the Sheerer account in *Keramic Studio*, I (November 1899), pp. 151-52.

5. E. Woodword, *op. cit.*, pp. 124-25; Walter Ellsworth Gray, *Brush and Pencil*, X (April 1902), p. 38.

6. Jonathan A. Rawson, Jr., *The House Beautiful*, XXXI (April 1912), p. 148.

7. A slightly different delineation of periods is offered by Dawson D. Zaug, "Newcomb Pottery: An Essay" (a thesis presented for degree of Master of Fine Arts at Tulane University, 1965). His four-period scheme was followed with a slightly different dating by Jerry J. Mitchell, "An Analysis of the Decorative Styles of Newcomb Pottery" (a thesis presented for degree of Master of Arts at Louisiana State University, 1972). Both include an experimental period dating between 1895 and 1900.

8. The most stereotyped of all decorations was that of the oak tree and moon, attributed to Sadie Irvine. "I was accused," she wrote to R. W. Blasberg (*Antiques*, C, August 1971, pp. 250-51), "of doing the first oak-tree decoration, also the first moon. I have surely lived to regret it. Our beautiful moss-draped oak trees appealed to the buying public but nothing is less suited to the tall graceful vases—no way to convey the true character of the tree. And oh, how boring it was to use the same motif over and over and over, though each one was a fresh drawing (no Newcomb pot was ever duplicated unless the purchaser asked for it)."

9. Walrath was a pupil of Binns at Alfred, after which he taught at the Mechanics' Institute in Rochester, New York, and frequently entered his work at the New York Society of Keramic Arts exhibitions. Walrath worked alone for the most part, and it is doubtful that his output was ever produced on a commercial basis. For a general stylistic appreciation of Walrath's work see M. Eidelberg, *The Arts and Crafts Movement in America 1876-1916*, p. 180. Examples of Walrath's pre-Newcomb artware are in the collection of The Newark [New Jersey] Museum.

10. Robert Miller was hired to assist Meyer in his latter years; and Jonathan Hunt, whose cipher can be found on his work, appears to have succeeded him.

11. Robert W. Blasberg, *Antiques*, XCIV (July 1968), pp. 73-77. Examples of the ware produced during the 1930s are pictured by Cox in *Ceramic Age*, XXV (May 1935), p. 153; and by K. E. Smith, *Design*, XLVI (December 1944), pp. 8-9.

12. S. Irvine, quoted by Robert W. Blasberg, *Antiques*, C (August 1971), p. 251; Franklin Adams, *Two Decades of Newcomb Pottery*, 1963 exhibition catalog of Newcomb College.

13. Cox, *The Bulletin*, XIII (May 1934), p. 142. M. C. Sheerer's article in the New Orleans *Times-Democrat* (May 19, 1907, p. III-19) evaluates and offers brief biographical sketches of some of the early artists.

14. Ciphers were often used by the professional decorators, while students tended to use their full names. A list identifying over fifty such decorators has been compiled by the author, *Spinning Wheel*, XXX (April 1974), pp. 54-55.

* Information relating to this pottery is included in a separate chapter.

Nielson Pottery

Zanesville, Ohio

Both the original and the revised 1905 listings of art potteries by *Glass and Pottery World* include the Nielson works,[1] offering rather substantial evidence that Nielson was indeed a producer of artware. Christian Nielson was born in Denmark in 1870 and came to the United States in 1891, joining the C. Pardee Works at Perth Amboy, New Jersey. After a brief association with the Homer Laughlin works at East Liverpool, Ohio, he went to Zanesville in 1894 as a designer for the American Encaustic Tiling Company. That affiliation was continued until 1902 when Nielson became superintendent of the Roseville Pottery*.[2]

The Nielson Pottery Company, incorporated in Ohio in mid-February 1905 with Nielson serving as general manager, took over the one-kiln pottery of the Zanesville Filter and Pottery Company, which had moved into new quarters. At that time it was indicated that Nielson would continue the production of stoneware for which the plant was suited;[3] however another source indicates that majolica-type ware was produced, including "a large and elegant line of art pottery."[4]

The operation was short-lived, and before the end of 1905 it was reported that "the Nielson Pottery Company, of Zanesville, Ohio, has shut down indefinitely. It seems to be the general impression that the company sold its output at too low a figure. The production was stoneware and like lines only."[5] The plant stood unused throughout 1906[6] and in 1908 was acquired by H. A. Weller* for his new venture.[7]

Marked examples definitely attributable to the Nielson Pottery are unknown. Several examples of the work of C. Nielson remain in the family collection, the majority of which are unsigned.

1. *Glass and Pottery World,* XIII (May 1905), p. 27; *ibid.,* XIII (June 1905), p. 28.
2. J. Hope Sutor, *History of Muskingum County* (1905), pp. 288, 291.
3. *Glass and Pottery World,* XIII (March 1905), p. 23; *The Clay-Worker,* XLIII (March 1905), p. 437.
4. Sutor, *loc. cit.*
5. *The Clay-Worker,* XLIV (November 1905), p. 469.
6. *Clay Record,* XXIX (October 30, 1906), p. 37.
7. *Ibid.,* XXXIII (November 30, 1908), p. 30.

 * Information relating to this pottery is included in a separate chapter

Niloak Pottery

Benton, Arkansas

So novel is the principal ware of the Niloak Pottery that its name (which is "kaolin" spelled backward) has become synonymous with the swirled clays which provided the decoration for its classically-shaped forms. The unique treatment of the clay distinguished Niloak from other art potteries, and for this United States Patent No. 1,657,997 was granted on January 31, 1928. An earlier attempt at the "Niloak technique" was made in the United States by W. F. Willard at the Gay Head Pottery, Martha's Vineyard, Massachusetts. Since pieces of Gay Head were only sun fired, they were not practical and served only as souvenir items.[1]

It was Charles Dean "Bullet" Hyten, successor to his father as operator of the Hyten Pottery (later the Eagle Pottery) of Benton, who achieved the successful mixing of different colored, native Arkansas clays, treated in a manner so that they would not separate in drying or firing.[2] Once the clays were so mixed they were placed on the potter's wheel, where centrifugal force produced the pattern.

In early 1909 the Niloak Pottery Company was formed to manufacture this swirled artware (originally designated as Niloak's *Mission* pottery)[3] on a large scale. Hyten was superintendent of the works and later became president.[4] After a fire burned the original one-story pottery building, it was rebuilt with a second story added. The Eagle Pottery's stoneware was produced on the first floor and Mission ware on the second.[5] The new plant's capacity was 125 articles a day and included vases, clock cases, jardinieres, smoking sets, pitchers, steins, umbrella stands and an extensive line of novelties, all of which were marketed throughout the United States and Canada. Prices, even

C. D. Hyten at work at Niloak. *A. Raney.*

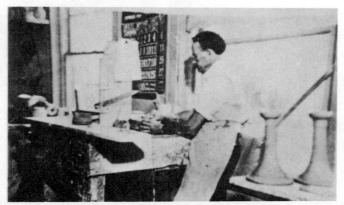

then, were not inexpensive. The novelties could be purchased for as little as fifty cents but vases, depending on size, ranged from $10–$50.[6]

As a result of the original process of superimposing a plurality of batches of specially treated, different-colored clays in plastic condition and then rotating them on the potter's wheel, an article could possess any combination of colors desired. These ranged from deep browns to pale creams, light greens and blues to pale pinks, with the colors

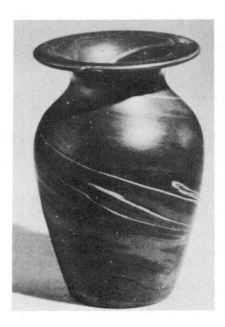

Niloak Pottery. An early example of Mission ware; h. 5½" (14.0 cm). Impressed art-lettered mark. *Private collection.*

Two typical miniature examples of Niloak's Mission ware; h. 2⅞" (7.3 cm) and 3½" (8.9 cm). Standard impressed mark. *K. & T. Dane.*

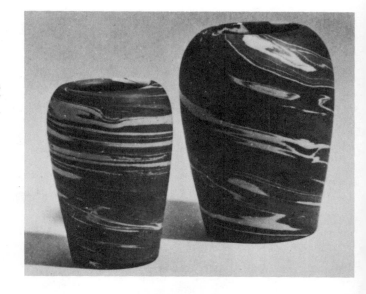

themselves varying in shade according to the degree of heat applied during the firing. In some instances it was necessary to use white clay which was artificially colored by the use of pigments, but this was done only if the naturally-colored clays were not available. For the most part naturally-colored clays were used.

Individual decorative effects were achieved in each article as the different colors were uniquely displaced with relation to each other. No two colors or no two pieces of the finished Mission ware were exactly alike; and, since each was thrown, no two were identical in shape. To demonstrate how original the work was, Hyten would often take to the road with his wheel, carrying a supply of native Arkansas clay, and give demonstrations of how art pottery was made at Benton. One such trip, made in 1927, included an appearance at the department store of Gimbel Brothers in Philadelphia.[7]

Output continued to expand; at one time six potters including Hyten turned the ware, which reached a peak annual production of 75,000 pieces. The plant itself became quite a tourist attraction, and just before the onset of the Depression a new building was constructed as a showroom. With the Depression, however, sales dwindled rapidly; to provide the income needed to maintain the operation, a line of cast-ware was introduced which was glazed in various high gloss and semi-matt finishes in solid and drip colors. This less-expensively produced line was called *Hywood* to distinguish it from the Mission ware. Because of its economy rather than its artistry it continued to displace the Mission ware during the 1930s, and that line was finally discontinued about 1942. The stoneware output of the Eagle Pottery (commercial wares consisting of jugs, jars, crocks, churns, flowerpots and the like) was continued by Hyten as long as he remained in business, as an entirely separate operation located two miles north of Benton.

Heavily in debt, ownership of the pottery changed hands in the mid-1930s. Hyten remained with the new management for a time, primarily on the road as a salesman. He later took a selling position with the Camark Pottery in Camden, Arkansas,[8] an association which continued until his death in 1944, about the same time the Niloak operation completely closed.

Some guides are available for the dating of Niloak, although none are conclusive. A great deal of experimenting was done with different colors, combinations, finishings and firings before the final Mission ware technique was attained. The earlier pieces tend to be more somber in color (tan, cream and brown), and some had a clear, high glaze or a waxed finish applied. For the most part the Mission ware has a soft, dull, unglazed exterior surface and a glazed interior to render it thoroughly waterproof.[9]

The standard impressed art-lettered "Niloak" mark as shown was

used continuously from September 1910 on the Mission ware and was a registered trademark of the pottery.[10] Immediately after the granting of the patent in 1928, pieces were also marked with the patent number. The Hywood imprinted mark was used for a time after the castware's introduction, and items so marked are worthwhile examples as they are the earliest and best-made cast pieces. Later cast pieces bear either an impressed Niloak (not in art lettering) or a raised Niloak inscription which was part of the mold and appears under the glaze.

 NILOAK *Hywood*
BY
Niloak

1. Further information on the Gay Head operation is to be found in L. W. Watkins, *Early New England Potters and Their Wares*, p. 231 (illustration, figure 135). Several pieces of Gay Head ware are in the collection of The Society for the Preservation of New England Antiquities, Boston.
2. A discussion of the methodology is contained in the patent application, from which an extraction was made by P. Evans, *Spinning Wheel*, XXVI (October 1970), pp. 18-20. Essentially, to achieve the multi-colored spiral pattern, with the varying colors used for the decorative process shrinking in a uniform fashion, a formula for the incorporation of the properly proportioned ingredients to control shrinkage was devised. This operation was done in the blunger mill, with the shrinkage-controlling material added to the clay while it was the consistency of cream.
3. *The Clay-Worker*, LIX (May 1913), pp. 739-41. The designation of the swirled Niloak ware as "Mission ware" appears in this article. It is used throughout this chapter to distinguish the swirled ware from the later mass-produced castware, which was cheaply made, and is a nomenclature highly recommended.
4. *Ibid.*, LXXXVIII (September 1927), p. 218.
5. Personal correspondence with the Hyten family.
6. *The Clay-Worker*, LIX (May 1913), p. 740. At least two catalogs and price lists were published by the pottery prior to 1929.
7. *Ibid.*, LXXXVII (May 1927), p. 484.
8. The Camden Art Tile and Pottery Company was established in 1926; the Camark Pottery in 1928, and was still in business in 1971. For a brief description of Camark's work see H. F. Stiles, *Pottery in the United States*, p. 184-85.
9. Because of the unglazed exterior surface, the pottery could recommend that any accidental marks or spots could be removed by the use of emery paper.
10. Trademark No. 195,889, registered March 3, 1925.

Norse Pottery
Edgerton, Wisconsin
Rockford, Illinois

Output of the Norse Pottery is, in its own way, as distinctive as Niloak*, Clewell* or Markham* ware. The pottery was established in Edgerton, Wisconsin, in 1903 by Thorwald P. A. Samson and Louis Ipson, both of whom had been employed at the Pauline Pottery* and thereafter associated with the American/Edgerton Art Clay Works*.

One of Norse's principal customers was the wholesale-crockery house in Rockford, Illinois, owned by Arthur Washburn Wheelock.[1] Not to be confused with the C. E. Wheelock Company of Peoria, Illinois, or the G. H. Wheelock Company of South Bend, Indiana, purveyors of souvenir china,[2] A. W. Wheelock was a native of Wisconsin and grew up in the crockery trade. His father, Wadsworth G. Wheelock, established such a business in Janesville, Wisconsin, in the 1850s. A. W. Wheelock began his Rockford business in 1888; in 1904 he acquired the Norse Pottery and moved it and its originators to Rockford in November of that year after a new pottery had been

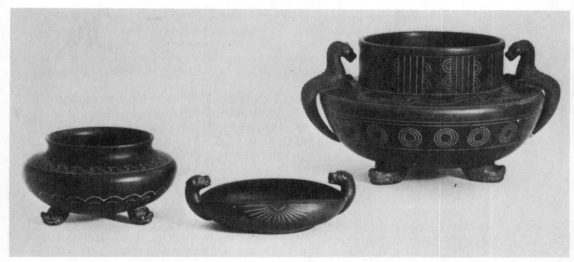

Norse Pottery ware, left to right: footed vase, h. 4⅛" (10.5 cm); dish, h. 2⅝" (6.7 cm); jardiniere, h. 7¾" (19.7 cm). **Regular mark.** *National Museum of History and Technology (Smithsonian Institution; #237,961, 237,962, 237,960).*

constructed.[3] In Illinois the works was incorporated as the Norse Pottery Company.[4]

Samson and Ipson, prior to the infusion of Wheelock's new capital, were not only doing all the manual labor connected with the manufacture of their ware, but were also doing the designing and decorating. Their distinctive Norse wares were translations of bronze relics excavated in Denmark, Norway and Sweden. To preserve the semblance of the originals, the work was decorated with a dull metallic glaze with highlights in the effect of verdigris in the corners, crevices and sunken lines of the etchings.[5]

A selection of the early Edgerton-period work was exhibited at the 1904 St. Louis exposition, and it was observed that "while it can not be classified as strictly ceramic ware, it being a red body painted with oil colors and finished in ancient Greek style, it must be said that the product had some merit."[6]

During the following years a wide variety of items was produced including vases, candlesticks, fern pots, cigar jars, bowls and ashtrays. Each piece was accompanied by an account of the history of the original. At first the work of the pottery was sold principally through the various Wheelock outlets,[7] but later numerous representatives and salesmen were employed.[8] The pottery, located at 111 South Water Street, Rockford, was operated until 1913, when production apparently ceased.[9]

Three examples of Norse ware, a gift of the firm in 1906, are in the collection of the National Museum of History and Technology (Smithsonian Institution; #237,960-962).

The mark of the pottery was impressed as shown.

1. E. M. Raney, *Rock County Chronicle* of the Rock County [Wisconsin] Historical Society, VIII (Spring 1962).
2. An account of the George Wheelock Company of South Bend is provided by E. Taylor Ashley, *Western Collector*, VI (September 1968), pp. 11-15.
3. Raney, *op. cit.; Clay Record*, XXVI (February 14, 1905), p. 41.
4. *Clay Record*, XXV (October 31, 1904), p. 35.
5. *Glass and Pottery World*, XI (December 1904), p. 22; *Pottery & Glass*, II (March 1909), pp. 132-34. It is possible that this ware was developed at the Pauline Pottery in 1891 (see discussion in Edgerton Pottery chapter).
6. S. Geijsbeek, *Transactions* of The American Ceramic Society, VII (1905), p. 351.
7. *China, Glass and Pottery Review*, XV (November 1904), p. 42.
8. Advertisement, *Glass and Pottery World*, XV (May 1907), p. 3.
9. After 1913 the location of the plant is no longer listed in the Rockford directories, although the pottery itself continues to be listed for the next three years. Samson also ceases to be listed in the Rockford directories after 1914. Ipson ceases to be listed after 1907.

* Information relating to this pottery is included in a separate chapter.

Northwestern Terra Cotta

Chicago, Illinois

[left] Norweta artware of Northwestern Terra Cotta with light blue crystalline glaze over cream and white ground; h. 5⅛" (13.0 cm). Impressed mark. *R. W. Blasberg.* [right] Norweta vase with gray-blue glaze and silver-gray to blue crystals; h. 4¾" (12.1 cm). Regular mark. *Sonia & Walter Bob.*

After the close of the Chicago Terra Cotta Works* about 1880, Gustav Hottinger joined in partnership with John Brunkhorst, John R. True and Henry Rohkam in True, Brunkhorst & Company.[1] The death of Brunkhorst in 1886 necessitated the reorganization of that firm, and the Northwestern Terra Cotta Company was the successor corporation.[2]

Formed in 1887, Northwestern continued operation at the True, Brunkhorst location at the intersection of Wrightwood and Clybourn, where it was to remain until the mid-1950s.[3] An 1893 catalog indicates output at that time of a wide variety of terra cotta building materials.

Evidently inspired by the success of the art pottery ware of American Terra Cotta (Teco*), and especially of their crystalline glazes exhibited at the St. Louis exposition, Northwestern produced a similar type ware with crystalline glazes in the post-1904 period.[4] It does not appear that this or any other art pottery was extensively produced by the firm before returning its attention to the production of architectural terra cotta and building material only.

Not all artware was marked, although examples of the crystalline-glazed pieces have been found bearing the impressed trade name *Norweta*.

NORWETA

1. *Book of Chicagoans* (1926), p. 435.
2. *Brick*, V (December 1896), pp. 172-76.
3. Terra Cotta Place in Chicago still runs for one short block near that intersection, its name taken from the factory which stood there according to Chicago Historical Society notes.
4. While the Northwestern Terra Cotta Company had extensive exhibits at the 1904 exposition, no art pottery is reported to have been shown (cf. S. Geijsbeek, *Transactions* of The American Ceramic Society, VII, 1905, p. 322).
* Information relating to this pottery is included in a separate chapter.

Oakland Art Pottery

Oakland, California

The original operation, the California Pottery and Terra Cotta Works, was founded by James Miller in 1875 at the corner of 12th and Park streets. The firm was jointly owned by Miller, who was responsible for the supervision of production, and Serril W. Windsor (also Winsor). Clays used were native to the Michigan Bar region of California.[1]

The partnership of Miller and Windsor was evidently dissolved by early 1887, as an extensive account of the California Pottery and Terra Cotta Works makes no mention of Miller and gives Joseph Tomaseck as superintendent and Windsor as owner.[2] At that time Miller's Oakland Art Pottery and Terra Cotta Works first appears in the Oakland city directories, at 1125 East 12th Street.

By 1901 it was reported that the Oakland Art Pottery and the California Pottery made practically all of the 600,000 vases, flowerpots and sundry articles of art pottery turned out in Alameda county.[3] The following year the Oakland Art Pottery was completely destroyed by fire;[4] it was thereafter rebuilt and artware was again produced.[5] At that time various sorts of ornamental vases, flowerpots, sewer pipe, chimney pipe and tops, tiling, water coolers and general terra cotta wares were produced.[6] Art pottery work would probably have been abandoned following the San Francisco earthquake and fire in 1906 and the resultant urgent need for building material, and it is doubtful that such work was ever resumed.

No marked or attributable examples have been found to date. It is possible to conclude, especially in the light of the extensive output noted above, that most work was not marked.

1. *Oakland and Surroundings* (1885); Stillwell's *Directory of the City of Oakland* lists the Miller and Windsor venture in its 1875/76 issue.
2. Oakland *Daily Evening Tribune*, January 20, 1887, p. 18.
3. *The Clay-Worker*, XXXV (April 1901), p. 416.
4. *Ibid.*, XXXVIII (August 1902), p. 152.
5. Both 1905 listings of art pottery producers compiled by *Glass and Pottery World* (XIII, May 1905, p. 27; June 1905, p. 28) include the Oakland Art Pottery.
6. *Structural and Industrial Materials*, p. 204.

Oakwood Art Pottery

Wellsville, Ohio

The manufacture of Rockingham and yellow ware was attempted in Wellsville—a town about four miles southwest of East Liverpool —before 1850, but results were not satisfactory and efforts were shortly abandoned.[1] One of the earliest yellow ware firms established at Wellsville on a permanent basis was that of John Patterson & Sons Pottery Company, which was organized in 1882. The original two-kiln plant, erected for the manufacture of Rockingham and yellow ware, was later expanded to four kilns.[2]

The pottery was reorganized in 1900 as the Patterson Brothers Company, with John W. and George G. Patterson the owners.[3] Underglaze decorated artware was introduced in late 1911, making the Patterson operation one of the last to begin production of this type of line.[4] Designated as Oakwood Art Pottery in advertisements, it is

1911 advertisement; *Pottery & Glass.*

uncertain if this was in any way related to the Oakwood Art Pottery established in the area in 1900. The latter's production at that time consisted of large-sized creamers upon the face of which appeared the likenesses of army and navy officers, presidents and other notables.[5]

Production of the artware was short-lived, and was advertised only for about a year.[6] In 1917 the factory, located on Commerce Street between 11th and 12th Streets, was sold to the Sterling China Company, producers of vitrified hotel china,[7] who continued to operate it as late as 1971. Numerous additions have been made to the original plant by Sterling, including modern equipment for the production of dinnerware.

No marked examples of the Oakwood artware are known to exist, although several unmarked but attributable examples are in the family collection. Care should be taken to distinguish an "Oakwood Art Pottery" mark, should such be noted, from the incised mark of the Oakwood Pottery* of Dayton, Ohio, and from the impressed *Oakwood* mark of the Cambridge Art Pottery* of Cambridge, Ohio.

1. Horace Mack, *History of Columbiana County* (1879), p. 284.
2. W. Stout *et al., Coal Formation Clays of Ohio,* p. 73.
3. *The Clay-Worker,* L (September 1908), p. 306.
4. *Pottery & Glass,* VIII (January 1912), p. 25. One of the earliest advertisements for the line appears in the December 1911 issue of that journal, p. 72.
5. *Illustrated Glass and Pottery World,* VIII (December 15, 1900), p. 26.
6. The last noted advertisement appears in *Pottery & Glass,* IX (November 1912).
7. Stout, *op. cit.,* p. 73.
* Information relating to this pottery is included in a separate chapter.

Oakwood Pottery

Dayton, Ohio

As was noted in the chapter on the Dayton Porcelain Pottery*, little has been recorded about the pottery work in Montgomery County, Ohio, and especially in Dayton. The Oakwood Pottery, to be distinguished from the Oakwood Art Pottery* of Wellsville, Ohio, was founded about 1877 and first appears in the Dayton directory of 1877-78.[1] It was organized by Bernard Goetz and his two sons, Isidore J. and Louis J. Later another son, Charles C., joined the firm. Clay was largely dug from the Hogans Brass region south of Dayton.[2]

The pottery itself was located at 1425 South Brown Street in Dayton, and in the mid-1890s was listed as "manufacturers of and wholesale and retail dealers in all kinds of earthen and stoneware,

Louis J. Goetz at work (c. 1919); *Montgomery County Historical Society.*

flower pots, hanging baskets, vases and all kinds of crocks."[3] Art pottery was evidently produced from time to time, as evidenced by two examples of elaborately decorated artware with applied modeled decoration in the style of some of the early Cincinnati potters, including T. J. Wheatley*. These pieces, in the Goetz family collection, were executed about 1880. In 1904 a matt green ware from the Oakwood Pottery was exhibited at the St. Louis exposition.[4]

The final directory listing appears in 1926. It was about that time that National Cash Register acquired the property along the west side of Brown Street where the pottery stood and expanded their plant into that area. There is apparently no connection between the Goetz pottery and other Oakwood wares and potteries.[5]

Early examples of art pottery were marked with an incised "Oakwood Pottery/Dayton, Ohio" designation. There is no record of how the later work was signed.

Early Oakwood ewer, dark blue gloss glaze with applied decoration of yellow roses and green leaves, c. 1880; h. 14⅜" (36.7 cm). Incised mark. *Goetz family collection.*

1. The first listing as the "Oakwood Pottery," however, appears in the 1895-96 directory.
2. Recollections of Mrs. Hugo Goetz, widow of the son of Leo, a fourth brother who was not connected with the pottery.
3. Dayton city directory, 1895-96.
4. S. Geijsbeek, *Transactions* of The American Ceramic Society, VII (1905), p. 350.
5. In addition to those cited herein, another Oakwood Pottery was incorporated in Ohio in mid-1923, the principal location of whose business was to be in Roseville. This firm was voluntarily dissolved in 1926.
* Information relating to this pottery is included in a separate chapter.

Oakwood Pottery Company

East Liverpool, Ohio

A small pottery, organized at the turn of the century by Harry Benty and H. C. Schmidt, was in operation by the fall of 1900 and designated the Oakwood Pottery Company.[1] According to reports of the period, artware was produced until early 1902, when equipment was installed for the production of white tableware.[2]

It is uncertain how much longer the firm was in operation or what type of artware was produced in the earlier period, but by the end of 1904 the Oakwood facilities on Laura Avenue, East Liverpool, were being used by the newly-formed Craven Art Pottery*. Care should be taken to distinguish the Oakwood Pottery Company from the various other Oakwood operations.

Marked examples of artware of this firm are unknown. An unmarked piece is at the Ceramic Museum of East Liverpool (# HC 171). To it is affixed the information "Frank Patterson Irwin . . . had a pottery on Laura Street near McKinley School, E. Liverpool, Ohio, between 1900-06. His partner was Harry Benty. This bowl of white on blue was made at this plant."

1. *China, Glass and Lamps,* XX (September 27, 1900), p. 2. There is no record of the incorporation of this firm as either the Oakwood Pottery Company or the Benty Pottery Company in Ohio or West Virginia.
2. *Brick,* XVI (May 1902), p. 235.
* Information relating to this pottery is included in a separate chapter.

Odell & Booth Brothers

Tarrytown, New York

When this entry for the first edition was prepared, little was known and no marked pieces were available for study. Since that time a considerable amount of material has been discovered, including a number of marked examples.[1] The firm was organized in 1880 by Charles Mortimer Odell, joined by Henry and Walter Booth. Both Booth brothers had come from Staffordshire, where they had been in business with their father. Production was begun in early 1881 at the leased plant on the north side of the lower end of Main Street,[2] with ninety employees—at least half of whom were in the decorating department, headed by J. B. Evans. At that time a report on the firm observed:

> Odell & Booth Bros., Tarrytown, N.Y., have one of the most complete pottery structures in this country. Their productions are artistic pottery in faience and Limoges decoration, and we saw some very handsome specimens of vases, which for workmanship and beauty of decoration were truly excellent. One of the leading houses in fancy china . . . has the agency for these goods, which are sold side by side with foreign vases. In umbrella stands there are several handsome patterns both in faience and Limoges. They also manufacture cylinders and vases for chandeliers and lamps; and one of the latest novelties which they will bring out this season is a lamp where the fount and stand will be made in faience and Limoges decoration to match. This will be both unique and handsome. In plaques there are several large designs in landscapes, animal figures, and birds, which are beautifully executed. Tiles are made by this house in any style and design desired. They are also large producers of majolica ware. Messrs. Odell & Booth Bros. received the silver medal at the Mechanics' Fair in Boston.[3]

(continued on page 374)

Odell & Booth, Buttermilk Falls, West Point; h. 14" (35.7 cm). *Rubin-Surchin.*

Overbeck Pottery
Cambridge City, Indiana

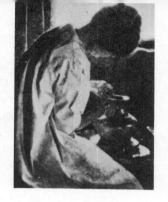

Elizabeth G. Overbeck.
The American Ceramic Society.

The Overbeck Pottery[1] was established in 1911 by four sisters: Margaret, Hannah B., Elizabeth G., and Mary F. Located in the old Cambridge City family home with a large yard, the workshop was in the basement, a studio was on the first floor and a Revelation kiln (Pewabic*) was in a small separate building behind the house.

Margaret, who had been an art teacher at DePauw University, Greencastle, Indiana, died the year of the pottery's opening. She had studied at the Cincinnati Art Academy and at Columbia University under Arthur W. Dow. A keen student of china painting at the turn of the century, she received numerous awards in *Keramic Studio* competitions, in whose pages her designs can regularly be found.

Hannah was an invalid for many years. She too produced designs for *Keramic Studio* and supplied numerous designs for the decoration of the Overbeck work prior to her death in 1931.

Elizabeth Gray studied ceramics in 1909-10 at the New York State School of Clayworking and Ceramics, Alfred, under the renowned Charles F. Binns. At the pottery she was in charge of the technical part of the operation, including the development of glazes and clay mixtures, as well as the building and throwing of the ware. Overbeck work under her guidance was awarded an Honorable Mention at the 1934 Third Ceramic National Exhibition at Syracuse, New York; in March 1937, just nine months prior to her death, she was made a Fellow of The American Ceramic Society.[2]

Mary Frances, the youngest sister, had been a public-school art teacher and also a student of Dow at Columbia. Like Margaret and Hannah, she had also done designing for *Keramic Studio*. Prior to Elizabeth's death she was in charge of the artistic part of the work. After 1936 she continued the production on a much smaller, studio-type scale.

Artware of the pottery from the beginning displayed original design and work. While a number of molds had been made, they were seldom used prior to 1937 except for the manufacture of cups and saucers; emphasis was rather on the thrown and built pottery produced by Elizabeth. During this period the clay was a mixture of Pennsylvania feldspar, Delaware kaolin and Tennessee ball clay.[3] Occasionally some red-firing native clay from the Overbeck orchard was also used.

Later a dried white-firing earthenware clay was bought, then soaked and finished at the works.

Two primary methods of decoration of the art pottery were used in the pre-1937 period: glaze inlay and carving. The glazes, of which the "hyacinth," "turquoise" and a creamy yellow are considered the most handsome, were developed by Elizabeth. At first the glazes were mostly of the matt variety in subdued colors, but later bright glazes with more color were introduced.

Early output was primarily vases, bowls, candlesticks, flower frogs, tea sets and tiles. Before the death of Elizabeth, ceramic sculpture was undertaken. In the studio period of the operation (post-1936) output gradually narrowed until it consisted mainly of small figurines, four to five inches in height, which were often molded.[4] These figurines included ladies and gentlemen in old-fashioned costumes, grotesque and humorous figures of people, animals and birds. Special real-life commissions were undertaken of parents, friends, pets and other sentimental and favorite objects. Specially designed ceramic brooches were made after 1942, often displaying the figures of women and birds. In this latter period, Mary F. carried on the work alone, preparing the clay, glazes and designs, gradually decreasing her activity until her death in 1955.

The Postle Collection of Overbeck work at the Cambridge City Library is the most extensive and comprehensive; other collections are maintained by The Art Association of Richmond (Indiana) in the McGuire Memorial Hall, the Wayne County Historical Museum (Richmond), the Indianapolis Museum of Art and The American Ceramic Society (Columbus, Ohio).

Mary F. Overbeck. *The American Ceramic Society.*

Vase with soft green ground and mosaic of paler green, lemon-yellow, deep brown, fuchsia and bright turquoise, designed by Mary Overbeck; h. 11" (28.0 cm). *Postle collection.*

Vase designed by Hanna Overbeck depicting birds in swift movement in a continuous pattern through the trees; beige figures on gray-green ground; h. 6" (15.3 cm). *Postle collection.*

The pottery produced by the Overbecks usually bears their mark, the OBK cipher. On items produced prior to 1937 that were made by Elizabeth and decorated by Mary or Hannah, the letter "E" placed below the mark to the left indicates fabrication by Elizabeth; "H" to the right of the mark indicates decoration by Hannah, whereas an "F" in the same position indicates decoration by Mary F. In the studio period, pieces continued to bear the pottery cipher (sometimes even with the "E"), but with a conjoined MF cipher for Mary F. Elizabeth also signed the pieces she produced at Alfred with the stylized E.O. as illustrated, often with the 1910 date.

1. Unless otherwise indicated, the primary sources for the material herein presented are *The Bulletin* of The American Ceramic Society, XXIII (May 15, 1944), pp. 156-58; and Kathleen R. Postle, *Spinning Wheel*, XXVIII (May 1972), pp. 10-12.
2. *The Bulletin,* XVI (February 1937), p. 67.
3. Lilian H. Crowley, *International Studio,* LXXV (September 1922), p. 544.
4. K. R. Postle, personal correspondence.
* Information relating to this pottery is included in a separate chapter.

J. B. Owens Pottery

Zanesville, Ohio

John B. Owens began his pottery business in 1885[1] at Roseville, Ohio; a modest production of flowerpots was successfully carried on, and within three years twenty-three men were employed.[2] The firm was incorporated in Ohio in 1891 as the J. B. Owens Pottery Company, and construction was begun that year on a large plant in Zanesville, to which all work was moved the following year. By 1893 sixty workers were employed, making it equal in number of employees to Weller* and of a similar annual capacity of $100,000.[3] Manufacture of Rockingham-type glazed jardinieres and teapots was begun in 1895,[4] and in 1897 slip-painted underglaze decorated artware was introduced.[5] This line at Owens was designated *Utopian,* and was decorated with flowers, animal and human figures, some of the most successful being the Indian representations. Utopian was originally offered in high-gloss and later in both high-gloss and matt finishes.

W. A. Long, G. Bradshaw and S. Geijsbeek were only three of many competent figures associated with Owens during the decade art pottery was produced. Others include Frank Ferrel, future art director of Roseville*; Karl Langenbeck, founder of the Avon Pottery*; John Herold, developer of Roseville's Rozane Mongol and Mara lines and founder in 1908 of the Herold China Company of Golden, Colorado; Albert Radford, who established the Radford Pottery in 1903; and John Lessell, one of the incorporators of the Arc-En-Ciel Pottery* and later of Lessell Art Ware*. While Lessell was at Owens in 1905 he produced work similar to the LaSa line, which he later introduced at Weller, and and provided Owens with a luster line competitive with Weller's Sicardo ware.[6]

The arch-rivalry among Zanesville's Big Three—Owens, Weller and Roseville—was responsible for the offering of a great many lines by each. Many were out-and-out imitations of another's successful line, while others were skillful design and decorative achievements. In addition to Utopian, other Owens lines[7] include *Lotus,* which was similar to Utopian but with lighter backgrounds and which was also later offered in a matt finish. *Alpine* ware is characterized by soft mellow tints in blue, green and brown colors with an overglaze freehand decoration in a matt finish, chiefly depicting flowers and fruits.[8] The *Henri Deux* line, introduced in 1900,[9] features intricate

Owens Lotus vase; h. 9⅜" (23.9 cm). Impressed Owens mark, artist initials "H.L." on body. *Charles Aghem.*

Art Nouveau designs cut into the moist clay, the incisions then being filled with plastic decorations in color. *Corona,* introduced by late 1902,[10] has an earthenware body decorated with mineral colors to suggest the varieties of bronze wares. A variation of that line is the *Corona Animals,* which have an unglazed earthenware body shaped to simulate various animals. *Cyrano,* similar to Weller's Turada, is a ware of a dark body to which is applied filigree designs in white, buff or brown. *Venetian* has as its special feature a metallic glaze possessing an iridescence whose effect is made more intense by the irregular surface of the ware. *Feroza Faience,* another line of metallic ware and first shown in 1901, has a bronze-like appearance which more resembles "being made from metal than by any clays."[11] Somewhat related to these is the *Gun Metal* ware, which consists of an unglazed earthenware body with an iridescent finish resembling a dull gun-metal into which was often engraved an intricate design. *Mission* was characterized by mineral decorations in splash effects depicting views of the old missions of Spanish America. A unique feature was a receptacle of weathered oak made purposely to fit the piece and also serving to bring it into harmony with the then-contemporary Mission style of home decoration. Both Mission and a line of *Wedgwood Jasper* were first introduced in 1903, the latter undoubtedly the work of Radford. *Rustic,* a 1904 line of jardinieres and window boxes, was shaped to resemble stumps, sawbucks and the like. *Opalesce,* introduced at Portland, Oregon, in 1905, was the usual native American clay body coated with decorations in gold and other metallic colors overglazed. On a background, usually of irregular or wavy lines of olive green or light tints, the inlaid design is traced or brought out with the metallic finish. A variation of this line is *Utopian Opalesce,*

[left] Owens vase with squeeze-bag decoration; h. 6¼" (15.9 cm). Impressed Owensart mark/1177. *Private collection.* [right] Three-sided matt Owens Utopian slip-decorated vase; h. 6¼" (15.9 cm). Impressed Owens/Utopian in italics and "119". *Private collection.*

Owens Feroza Faience vase; h. 5½"
(14.0 cm). Mark obscured by glaze.
New York, private collection.

differing from the inlaid ware in that the decoration is underglaze and resembles the motifs of the Utopian line. *Art Vellum* is characterized by an underglaze decoration in warm tints of autumnal foliage, while the finish is very soft to the touch. *Red Flame* is decorated with an embossed flower design which is covered with a red glaze. *Aborigine,* a line in imitation of Indian pottery in the collection of the Smithsonian, was introduced in mid-1907,[12] presumably a copy of that introduced at Clifton* by W. A. Long. *Sunburst* would appear to be a later line, an adaptation of the earlier Utopian.

Output expanded continuously after 1895 both in production of molded and decorated art pottery and in the manufacture of commercial ware, which by 1902 included a daily output of 1,200 cuspidors, filters and gas logs. A fully equipped printing office, under the direction of G. Brush (later to establish the Brush Pottery Company in 1906), was maintained to produce advertising material as well as *The Owens Monthly,* a widely distributed trade journal.[13] Additions were made to the original plant completed in 1892 nearly every year thereafter, the largest of which was completed in the spring of 1901 and nearly doubled capacity. The pottery was hit by a disastrous fire in early 1902 which totally destroyed the plant and offices and almost all the molds and models.[14] Rebuilding was swiftly undertaken, and the operation and remarkable growth of the Owens works resumed by that August.[15]

The events of 1905 and thereafter are confused, but they were no less so to observers at that time. Apparently in 1905 Owens decided to devote considerable effort to the production of tile. Extensive expansion of the plant was undertaken, and that segment of the business was designated the Zanesville Tile Company.[16] Art pottery production was continued, but all the cheaper, mass-manufactured lines of jardinieres, cuspidors and vases were dropped; emphasis was placed on the output of artware of the highest quality, which was designated

Owensart.[17] Hugo Herb, a noted wax worker from Berlin, was employed as a modeler, and Guido Howarth of Austria-Hungary was secured to design some of the new lines.[18] It was at this time, also, that F. Ferrel joined Owens, for whom he designed, modeled and decorated the new artware. The *Soudanese* line, in ebony black matt with decorations in light color effects of pearl, lavender and white, was introduced,[19] as were several other high-quality lines including *Aqua Verdi,* a matt glazed artware with embossed decoration often in an Art Nouveau motif, and three new versions of Lotus. The Lotus trio, *Lotus, Parchment Lotus* and *Brushmodel Lotus,* were all finished with a matt glaze with a "soft and wax-like luster." These latter lines were extensively shown at the Jamestown exposition in 1907, along with the Owens Indian ware.[20]

The Zanesville Tile Company, under Owens' direction, evidently priced their tile considerably below that of other manufacturers in the area, and to eliminate the problem a syndicate was formed by the Tile Manufacturers' Association to make Owens an offer for his plant. The move was successful and agreed to by Owens; his plant was taken over by the syndicate and closed shortly thereafter.[21] From all indications,

Early advertisement, 1897. *Illustrated Glass and Pottery World.*

209

Owens Aqua Verdi vase as shown in 1907 *Glass and Pottery World.*

Owens Soudanese vase as shown in 1907 *Glass and Pottery World.*

art pottery production ceased prior to this time. Two years later Owens began tile work at a new Zanesville location as the J. B. Owens Floor and Wall Tile Company,[22] which was subsequently renamed the Empire Floor and Wall Tile Company. This operation, incorporated in Ohio in 1923, was expanded several times and into several states, both through mergers[23] and through the building of new facilities in Metuchen, New Jersey, and Pennsylvania (under the name Domex Floor and Wall Tile Company of Greensburg). The main Empire plant was totally destroyed by fire in 1928 and was rebuilt. Owens failed in the economic collapse of 1929, and both the Zanesville and Metuchen plants were closed; the Domex company having failed in 1927, Owens retired to Florida, where he died in 1934.[24]

A small collection of Owens pottery, especially of underglaze-decorated Utopian ware, is to be found at the National Museum of History and Technology (Smithsonian Institution). A small collection is also maintained by the National Road/Zane Grey Museum of The Ohio Historical Society.

A great deal of the Owens pottery was marked, with any one of several different ciphers used by the pottery during its operation, or with one of the various marks with the full pottery designation. In many instances work was artist-signed,[25] and the names of the various lines were often found impressed, sometimes without the Owens name. The Owensart mark was adopted in 1906; and, as in the case of Rookwood*, trial pieces sometimes bear process marks whose meanings are largely unknown today.[26] Because of the movement of individual designers and decorators among the various Zanesville art potteries and their offshoots, it is almost impossible to attribute unmarked artware to a specific pottery.

HENRI
DEUX

Owens
Utopian

OWENSART

OWENS FEROZA

OWENS
UTOPIAN

1. While there are several conflicting dates for the establishment of the Owens operation, W. P. Jervis appears to have had access to a primary source of information for *The Encyclopedia of Ceramics* (pp. 426-28) and indicates its establishment on January 11, 1885, with a capital of $300.
2. Henry Howe, *Historical Collections of Ohio* (1907), Vol. II, p. 348, as cited in William Watson Wilson, "A History of the Roseville Village School District" (a thesis presented for the degree of Master of Arts at The Ohio State University, 1939), p. 88.
3. *Report of The Geological Survey of Ohio,* VII (1893), p. 91.
4. As advertised in *China, Glass and Lamps,* XI (January 22, 1896), p. 38.
5. Announcement was made early in 1896 (*China, Glass and Lamps,* XI, March 18, 1896, p. 14) that the contracts had been let for an enlargement of the Owens works by the addition of a four-story building "to be used for the manufacture of art wares." At that time George Bradshaw, who became superintendent of the Florentine Pottery*, was superintendent at Owens. It appears he was succeeded in 1896 by Samuel Geijsbeek, a graduate that year of The Ohio State University, who is responsible for the successful reproduction at Owens of the underglaze decorated artware in the style of Cincinnati faience (*Brick,* VI, June 1897, pp. 317-18; *The Bulletin* of The American Ceramic Society, XXIII, February 15, 1944, p. 66). Geijsbeek was succeeded as art director in 1899 by W. A. Long, organizer of the Lonhuda* works (*Glass, China and Pottery Review,* V, August 1, 1899, p. 42).
6. See L. & E. Purviance and N. Schneider, *Zanesville Art Pottery in Color,* plate 13.
7. Unless otherwise noted, lines are as reported in M. Benjamin, *American Art Pottery,* pp. 33-36; Jervis, *op. cit.,* pp. 426-27; and Purviance and Schneider, *op. cit., passim.*
8. An assortment of Alpine vases is shown in *China, Glass and Pottery Review,* XV (February 1905), p. 37.
9. *Crockery and Glass Journal,* LII (September 13, 1900), p. 30. Molds for this line were later acquired by Brush-McCoy (J. W. McCoy*) in 1912 and the ware reproduced as their Navarre line.
10. Pictured, *ibid.,* LVI (Holiday issue 1902). It remains unclear as to the relationship of the Corona wares to the report in *The Clay-Worker,* XXXVIII (August 1902), p. 152, that Owens had bought the "little Corona pottery plant at Corona, L.I." for

the manufacture of artware. This was probably the Volkmar Pottery*, but that works was reported as vacant by *Crockery and Glass Journal,* LVIII (December 17, 1903), indicating that the plan was never completed.

11. *Clay Record,* XX (January 14, 1902), p. 25; also *Crockery and Glass Journal,* LIV (December 12, 1901); *Illustrated Glass and Pottery World,* IX (December 1901), p. 16.

12. *Glass and Pottery World,* XV (August 1907), p. 12.

13. Jervis, *op. cit.,* p. 428.

14. *Illustrated Glass and Pottery World,* X (March 1902), p. 8; also *The Clay-Worker,* XXXVII (April 1902), p. 455. Consideration, for a time, was given to rebuilding the plant in East Liverpool, but union dominance of that area and other problems forced abandonment of the idea (see *Illustrated Glass and Pottery World,* X, April 1902, p. 19).

15. *The Clay-Worker,* XXXVIII (August 1902), p. 152.

16. *Clay Record,* XXVII (October 16, 1905), p. 31; Everett Townsend, *The Bulletin* XXII (May 15, 1943), p. 142; H. Ries and H. Leighton, *History of the Clay-Working Industry in the United States,* p. 168. There is no evidence of any formal incorporation under this title in the State of Ohio, however.

17. *Glass and Pottery World,* XIV (January 1906), p. 34. The Owenzart [sic] designation apparently was introduced in 1905 at Portland, where it was used with the new Opalesce line (*Glass and Pottery World,* XII, August 1905, p. 23).

18. *Ibid.,* XIV (July 1906), p. 33. Herb had previously been associated with Weller and was responsible for many of the Weller mementos produced at the St. Louis exposition in 1904, according to L. & E. Purviance and N. Schneider, *Weller Art Pottery in Color,* plate 4.

19. *Glass and Pottery World,* XV (June 1907), p. 28; *ibid.,* XV (July 1907), p. 34.

20. *Ibid.,* XV (October 1907), pp. 24, 41.

21. Townsend, *op. cit.,* p. 142, indicates 1908; however, the sale is reported in *Glass and Pottery World,* XV (July 1907), p. 28, and also in *Clay Record,* XXXI (July 30, 1907), p. 28. The J. B. Owens Pottery Company was dissolved on April 19, 1907, according to records at the office of the Ohio Secretary of State, and Owens' replacement as general manager of Zanesville Tile was announced in *The Clay-Worker,* XLVIII (July 1907), p. 42. Appointment of a receiver for Zanesville Tile is reported in *Clay Record,* XXXI (November 30, 1907), p. 27. This account erroneously lists the officers of the firm prior to its sale. On the whole, the account of the Owens ventures provided by Townsend's source is somewhat prejudiced against Owens, especially as it chronicles events taking place while Owens was not co-operating with the Tile Manufacturers' Association.

22. *The Clay-Worker,* LII (September 1909), p. 323; W. Stout *et al., Coal Formation Clays of Ohio,* p. 29, makes no distinction between J. B. Owens Floor and Wall Tile, the Enterprise operation or the original J. B. Owens Pottery Company, indicating the extent of the confusion even while the Owens organization was active. There is no record of the incorporation of the J. B. Owens Floor and Wall Tile Company in the State of Ohio.

23. *The Clay-Worker,* LXVII (December 1917), p. 569.

24. Townsend, *op. cit.,* p. 142.

25. The most complete listing of earlier artist marks is contained in E. A. Barber, *Marks of American Potters,* p. 133. To this listing should be added Blanche Mallen and Charles Niblock, mentioned by Jervis, *op. cit.,* p. 427. To date no listing of artists of the post 1903-04 period has been compiled.

26. Barber, *op. cit.,* p. 134.

* Information relating to this pottery is included in a separate chapter.

Paul Revere Pottery

Boston, Massachusetts
Brighton, Massachusetts

The Paul Revere Pottery was an outgrowth of a club known as the Saturday Evening Girls. The "S.E.G.," as it was called, was an association of young immigrants who met on Saturday evenings for reading and craft activities. The latter were expanded to include ceramics, and with the encouragement of the group's patron, Mrs. James J. Storrow, a small kiln was bought in the winter of 1906. An English ceramist formerly with the Merrimac Pottery* was engaged to teach some glaze formulas and to fire the early built pottery of the girls.[1]

At the end of six weeks in Brookline, where the first regular production was begun in 1908, quarters were moved to the Library Club House at 18 Hull Street, Boston, in the shadows of the Old North Church. The name Paul Revere was suggested by his historical association with the area.[2] The basement and the rear half of the first floor contained the complete pottery plant. The top floor of the four-story building served as the apartment for Miss Edith Brown, the designer and director of the pottery, and the remaining space was used for clubrooms.

Known also as the "Bowl Shop," the pottery in the next few years developed rapidly and grew steadily, but instead of making money it required thousands of dollars to subsidize it.[3] The decorators at Paul Revere were girls just out of school, who after a year's training were able to undertake the more skilled aspects of the work such as the incising of designs on the ware in the biscuit stage or the application of

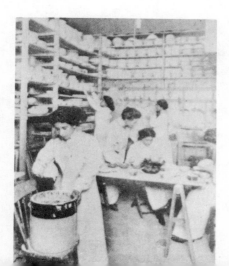

The Saturday Evening Girls' Club at work, as pictured in 1912. *The House Beautiful.*

colors. It was intended that those who were interested in permanent work should also learn the potter's art—not only those aspects of it requiring skill of hand and ripe judgment in the management of materials, but those involving the chemistry and art of original designs both of form and decoration. Prior to 1915 a designer, ten girls, one boy, a skilled potter and a man responsible for the firing of the kiln were employed.[4]

A pottery building in the Rookwood-Van Briggle style, designed by Edith Brown and given by Mrs. Storrow, was built in 1915 at 80 Nottingham Road, Brighton, Massachusetts. The work there was done under ideal conditions, and the number of employees ranged between fourteen and twenty. There were four kilns, presided over by an English potter named Ellis.[5]

Items produced ranged from plain vases, which sold for anywhere from 75¢ to $15 depending on size, to decorated vases offered for as much as $50. Electric lamps were made to order for $31. Open-stock dinner services were available, as were breakfast or tea sets. Paperweights, ink wells and bookends were among other objects produced.[6] A set of thirteen tiles illustrating the ride of Paul Revere proved to be very popular. Most popular of all, however, were the children's breakfast sets, which consisted of a pitcher, bowl and plate, all decorated with popular juvenile motifs of chicks, rabbits, ducks and the like. Upon special order, monograms or initials could be incorporated in the design of these sets.

The Chrysanthemum Vase was one of Paul Revere's most successful and expensive; h. 9" (22.9 cm). *The House Beautiful.*

Paul Revere vase; h. 8⅜" (21.3 cm). Im-
printed S.E.G. and dated October 1914;
artist initialed S.G. *Janeen & James Marrin.*

Paul Revere Pine Tree Vase as illus-
trated in 1914. *The House Beautiful.*

Some decorated ware was outlined with the incised technique
popularized by the Newcomb Pottery* and F. H. Rhead (Rhead
Pottery*), but a great deal was simply painted with mineral colors.
The design was outlined in black and filled in with flat tones in the
manner of the period's illustrational style. Soft in color and texture,
pieces most often were glazed in the popular Art Nouveau matt shades
of yellow, blue, green, gray, white and brown. A number of pieces were
also decorated with a high-gloss glaze, in colors ranging from jade to
metallic black.

As at Fulper*, when World War I curtailed shipments of toys from
abroad, an attempt was made at the production of dolls' heads. For a
time a small head with socket neck was produced. The fired clay was
rough, but the modeling was good. Several thousand chalk-white
bisque heads were made before it became clear that the wigs and eyes
promised from abroad would never arrive. The heads were discarded
after the war and remained undiscovered until a cache of them was
found in 1950, all bearing the incised initials P.R.P. on the back.[7]

In spite of great popular acceptance and acclaim for its technical
accomplishment,[8] operation of the pottery required continual subsidi-
zation. After the death of Edith Brown in 1932, several optimistic
directors followed her; but it was all too plain that expenses could not
be met, nor could the price of the items ever be raised to cover the cost
of production of the hand-decorated ware. As a result, the pottery
closed in January 1942.

A comprehensive collection of Paul Revere work is to be found at
The Society for the Preservation of New England Antiquities, Boston.

Paper labels bearing the "Bowl Shop" designation were often affixed
to ware prior to the 1915 move to Brighton in addition to the pottery's
regular impressed or imprinted mark depicting Paul Revere on horse-

back. Pieces are also to be found with a date and the initials of the pottery, P.R.P. or S.E.G. painted on the base. Decorators sometimes initialed their work, but no records of the identification of such appears to have been maintained. An impressed *Revere Pottery* mark in script with a Boston address has been noted, but this was not a mark of the Paul Revere Pottery but rather of the Revere—or Roman—Pottery, an entirely unrelated, later operation.

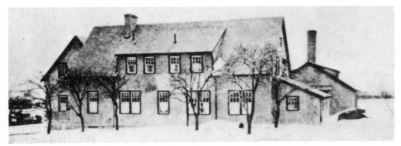

"New" Paul Revere pottery. *The Art World.*

1. *The Story of Paul Revere Pottery,* a post-closing undated account of the pottery, p. 3. The first listing of the pottery as the Paul Revere Pottery appears in the 1912 Boston directory.
2. *Paul Revere Pottery,* a pottery brochure, c. 1925.
3. *The Story,* pp. 4-5.
4. *Handicraft,* III (February 1911), pp. 411-16; also "S.E.G. Bowl Shop," reprint by the pottery of an article originally appearing in the Boston *Herald,* c. 1912.
5. Livingston Wright, *The Art World,* II (September 1917), p. 579.
6. Catalog and price list of the pottery, c. 1922. Illustrations of such work are plentiful in the popular magazines of the period; see especially Margaret Pendleton, *The House Beautiful,* XXXII (August 1912), p. 74; Mary H. Northend, *The House Beautiful,* XXXVI (August 1914), pp. 82-83; *The House Beautiful,* LI (January 1922), p. 50.
7. Ruth F. Pochmann, *Spinning Wheel,* XIX (November 1963), pp. 24-25.
8. C. F. Binns, director of the New York State College of Clay Working and Ceramics at Alfred, evaluating pottery in America (*The American Magazine of Art,* VII, February 1916, p. 135), wrote "To Miss Edith Brown is due a large part of the credit for the quality of the work produced. A distinctive character has been maintained both in design and technique, and too high praise can scarcely be awarded to the wares."

* Information relating to this pottery is included in a separate chapter.

Pauline Pottery

Chicago, Illinois
Edgerton, Wisconsin

The Pauline Pottery was established by Pauline (Mrs. Oscar I.) Jacobus. Prior to the erection of her kiln, she held classes in china painting in her home in Chicago, using a muffle kiln for the firing of the china paints. It was not long before she became interested in art pottery and went to Cincinnati to study the pottery operation of another china painter, Maria Nichols of Rookwood*, who had made the transition to the production of art pottery.[1] In 1883 she established a commerical workshop in Chicago "which consisted of one small kiln and employed a single presser and a couple of decorators."[2] Artware with a yellow earthenware body decorated either underglaze or with monochrome glazes was produced,[3] as was an incised and gilded redware.[4] The work of the pottery was an early success, and in 1886 a second plant was opened.[5] During this time Wilder A. Pickard, later to become famous for his hand-painted Pickard china produced at Antioch, Illinois, was the pottery's selling agent.[6] Work was handled by Tiffany's in New York City, Kimball's in Boston and Marshall Field's in Chicago.

Clays for the Pauline work in Chicago were obtained in Ohio; but when a closer source of supply was found in Edgerton, Wisconsin, the pottery was moved there in the spring of 1888. In Edgerton, the Pauline Pottery Company was incorporated under the laws of the State of Wisconsin, with the financial backing of Edgerton businessmen and E. W. Babcock as president. The E. C. Hopkins warehouse was purchased and the plant with six kilns, built by John Sargeant of Cincinnati, was erected on adjacent land.

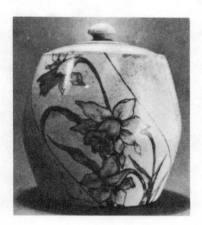

Pauline covered jar of light buff earthenware with clear glaze over handpainted decoration, some gold embellishment; h. 6½" (16.5 cm). Unmarked but from an identical mold as a marked example (imprinted crown). *The State Historical Society of Wisconsin (#47.980), gift of Mr. & Mrs. Forest Middleton.*

217

Ewers, vases, flowerpots, bonbon boxes, candlesticks, teapots, lampstands and fireplace tiles were produced, primarily decorated by brush under a clear glaze on a cream ground. The most common subjects were various floral and geometric patterns drawn by Pauline Jacobus and often reproduced by students. In addition to the artware, which was under the direction of Mrs. Jacobus, porous cups for electric batteries, principally for the Bell Telephone Company, were made under the direction of Mr. Jacobus.[7] At the busiest times of the year about forty people were on the staff,[8] approximately one-third of whom were women who executed the decoration of the art pottery.[9]

In the spring of 1891 Thorwald P. A. Samson and Louis Ipson, young potters from Denmark, joined the Pauline Pottery staff. Samson was an artist and modeler and Ipson a molder. After working there just over a year they left and formed the American Art Clay Works*. After the death of Oscar Jacobus in May 1893 and the failure of the cup-making business, which was a casualty of the dry-cell battery, the pottery closed. In April 1894 the works was sold as a result of bankruptcy proceedings, and a new company, the Edgerton Pottery*, was organized to take it over. Careful distinction must be made between the Edgerton Pottery and the Edgerton Art Clay Works, which was the successor to the American Art Clay Works of Edgerton. Available records indicate that the two were not related, and that Louis Towne of the Edgerton Art Clay Works was in no way involved with either the Pauline Pottery or the Edgerton Pottery, although the same artists may have worked for both firms at one time or another.[10]

When the Edgerton Pottery failed in 1902, Pauline Jacobus acquired one of the original Sargeant-built kilns and reassembled it at her home in Edgerton. Later that year she resumed making pottery on a small studio scale. With the help of student assistants who came to

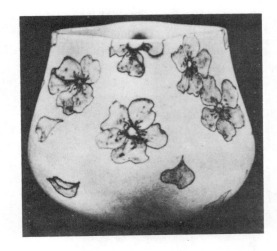

Pauline Pottery vase, cream ground with underglaze painted decoration, darker cream petals and flecks of dark red; h. 4¼" (10.8 cm). Imprinted crown-and-C designation; shape number 90. *Michiko & Al Nobel.*

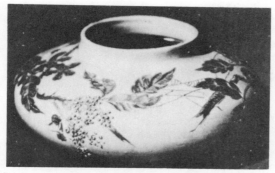

Pauline bowl of the Chicago period (1883) with heavy Ohio stoneware body, buff color and smear glaze; h. 3¾" (9.5 cm). "Springer" incised. *The State Historical Society of Wisconsin (#1956.1769), gift of Gertrude Springer.*

Pauline artware, red-brown ground with white daffodil design; h. 18" (45.9 cm). Unmarked. *The State Historical Society of Wisconsin (#1956.4396), gift of Mr. and Mrs. Forest Middleton.*

learn potting during the summers, hundreds of bisque forms were produced. These were then decorated the following winter by Mrs. Jacobus, sometimes assisted by her daughter. The work was advertised regularly in the Edgerton newspaper in early December, offering Pauline Pottery for sale. The last such series of announcements appeared in December 1909, worded: "Mrs. Jacobus announces the closing out of the pottery. A choice collection will be on sale at Stewart's Jewelry store, and at the pottery where will be found 'seconds' at greatly reduced prices. Pottery will be closed Dec. 15."[11] In 1911 the home and studio burned, and the Pauline Pottery operation was permanently ended. Pauline Jacobus died at Dousman, Wisconsin, in 1930.

The clay used during the Wisconsin period fired to a near white, which can be clearly seen where surfaces have been chipped. The low-fired ware is characteristically marked by a crazing of the glaze,

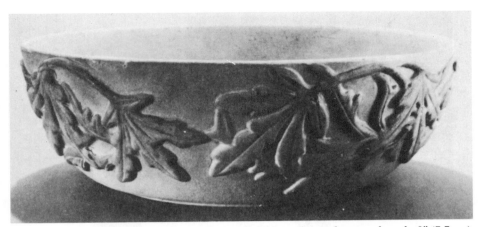

Low bowl, light buff stoneware, smear glaze, relief decoration and green glaze; h. 3" (7.7 cm). Imprinted crown mark and shape number 166. *The State Historical Society of Wisconsin (#1969.375.7), gift of Mr. & Mrs. Forest Middleton.*

the result of uneven expansion and contraction between glaze and body. When water has remained in the vases, it has sometimes seeped through the porous body and spotted the surface. Also produced during this time were a few pieces of fine red ware, probably of clay from the same source as that used by the American/Edgerton Art Clay Works.[12]

While underglaze decorated ware was initially the most successful, Pauline Jacobus liked to experiment. She produced a majolica-appearing ware and later, in the post-1902 period when a considerable amount of experimentation was carried on, she perfected a fine method of blending glazes. The most noteworthy of these blends was "peacock," which brought together a deep blue and a dark green. Some "very good" examples of the underglaze decorated faience were shown at St. Louis in 1904.[13]

Several pieces from the early Chicago period are included in the collection of the museum of The State Historical Society of Wisconsin at Madison.[14] Another collection, largely the gift of Eugenia A. Hutchinson, who worked at the pottery during the Edgerton period, is at the Neville Public Museum, Green Bay, Wisconsin. Several excellent examples are also to be found at the Lincoln-Tallman Museum, Rock County Historical Society, Janesville, Wisconsin.

Not all Pauline Pottery, which was both thrown and molded, was marked. The early marks were incised or impressed; the later ones were incised or imprinted beneath the glaze. The Pauline name and trademark were also used in the 1902-09 period.[15] The most commonly found mark is the crown with the P and reverse P for Pauline Pottery forming either side.[16] Some pieces bear the mark of the artist, as in the case of Eugenia A. Hutchinson (E.A.H.).

PAULINE POTTERY

1. Bertha K. Whyte, *Spinning Wheel,* XIV (April 1958), pp. 24, 26, 38; a similar account is contained in a talk given by Mrs. Morris Hitchcock to the City Federation of Women's Clubs (c. 1939).
2. E. A. Barber, *The Pottery and Porcelain of the United States,* p. 332. While at Cincinnati Pauline Jacobus learned that the Chicago Pottery Club, organized in 1882, had completed arrangements for the erection of a kiln for the firing and glazing of pottery and had hired Joseph Bailey, Sr., of Rookwood to supervise the operation (*The Inland Architect and Builder,* I, April 1883, p. 37). Bailey's departure for Chicago is reported by *Crockery and Glass Journal* (XVIII, September 27, 1883, p. 44); under his direction work of the Club at 795 West Congress Street (the address, also, at which Bailey is listed in the 1884 Chicago directory) continued for two years "at a great expense and disadvantage as the clay had to be brought from a distance" (*Clay Record,* I, August 12, 1892, pp. 84-85). In 1885 Bailey returned to Cincinnati to rejoin the Rookwood Pottery. Marked examples of the artware production of the Chicago Pottery Club during the 1883-85 period have not been located.
3. H. Ries and H. Leighton, *History of the Clay-Working Industry in the United States,* p. 85.
4. Joan L. Severa, "The Pauline Pottery," an unpublished monograph at The State Historical Society of Wisconsin, Madison.
5. According to the Chicago directories, the first pottery was located at 71 - 36th Street. This listing appears for 1883-85. The second shop is first listed in 1886 at 57 Walsh, in addition to that on 36th Street. Both are listed the following year, and neither in 1888.
6. Severa, *op. cit.,* p. 3.
7. Thelma Shull, *Victorian Antiques* (Rutland, Vermont: Charles E. Tuttle, 1963), pp. 155-60.
8. *The Clay-Worker,* XIX (January 1893), p. 49.
9. Barber, *op. cit.,* p. 332.
10. Cf. the account by Whyte, *op. cit.,* p. 26. Credit for the untangling of the various Edgerton operations belongs to E. Marvin Raney, principal authority on those potteries (see especially Raney, *Rock County Chronicle,* VIII, Spring 1962). According to Raney, contemporary newspapers show conclusively that two completely separate plants existed at Edgerton during the 1890s.
11. Personal correspondence with E. M. Raney.
12. Severa, *op. cit.,* p. 5.
13. S. Geijsbeek, *Transactions* of The American Ceramic Society, VII (1905), p. 351.
14. Some of the pieces in this collection are marked "Springer," the designer, and dated 1883.
15. Bertha Jaques, *The Sketch Book,* V (June 1906), p. 381.
16. The meaning of the letter designation which is sometimes found within the crown is not clear. According to Barber, *Marks of American Potters,* p. 164, it stood for Chicago. The mark, however, was also used at Edgerton (cf. #1953.10.7 in the Rock County Historical Society collection with the crown mark and the "c" enclosed, which is dated 1893).
* Information relating to this pottery is included in a separate chapter.

Peters and Reed Pottery

Zanesville, Ohio

John D. Peters and Adam Reed entered into partnership in 1898[1] and began operations in the Linden Avenue pottery built by the Clark Stoneware Company about six years earlier.[2] When they were unable to exercise their option on the property later that year, it was acquired by the Roseville Pottery*, which continued its operation.[3] Thereafter Peters and Reed secured their permanent location in South Zanesville. Their company was formally incorporated in Ohio in mid-1899, and production of red earthenware, made from local clays, was pursued.

Common flowerpots and jardinieres comprised the major portion of the firm's output until cooking ware was introduced about 1903. The body of this ware was of weathered shale and the white lining largely of clay. Production of kitchen utensils was suspended about 1906.[4] Occasionally artware was attempted, the first report of which appears in late 1901, designed and modeled by Reed.[5] Production of artware was not seriously undertaken, however, with the primary output of the newly enlarged plant in 1907 consisting of flowerpots, painted jardinieres, fern pots and cuspidors.[6] Two years later a line of inexpensive jardinieres with hand-painted decorations on a glazed surface was offered in matt green, high-gloss red, green and blended glazes.[7]

In 1912 *Moss Aztec,* first of the artlines usually associated with Peters and Reed, was introduced.[8] This ware was designed by Frank

Interior of Zane Pottery showing variety of ware produced. *N. Schneider.*

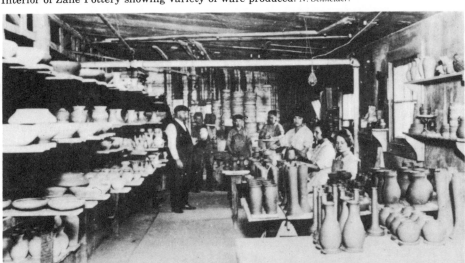

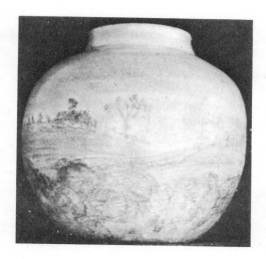

Peters and Reed/Zane Pottery's Chromal ware; h. 7" (17.8 cm). Unmarked. *Mr. & Mrs. Zane Field.*

Ferrel (sometimes spelled Ferrell) and had originally been suggested by him to Weller*, in whose employ he had been until 1905. Moss Aztec was made from the locally mined red clay with molded designs in relief. This was then sprayed with a green coloring which was wiped from the high points of the design, leaving the "moss" effect on the lower portions. Thus were combined "the rich red brown tones of the Historic Aztec Indians ... with the apparent mossy deposit of Nature."[9] The interior of Moss Aztec was coated with a clear glaze to render it waterproof.

Following the introduction of Moss Aztec, the company offered several other art lines including *Pereco,* with a semi-matt finish in plain green, orange and blue colors; *Landsun,* which was finished in blended effects of different colors; *Chromal,* basically the same as the Landsun line but with scenic designs employed rather than random blendings; *Persian,* produced in blue and brown semi-matt finishes; and *Montene,* which was decorated in either a copper-brown iridescent or a green variegated semi-matt finish.[10]

After Peters retired, Reed succeeded him as president, and the firm's name was changed to The Zane Pottery Company in early 1921. Reed retired from the business in early 1922 and died later that year. He was succeeded by Harry S. McClelland, who had worked for Peters and Reed since 1903. C. W. Chilcote was placed in charge of design, and production of a diversified line of flowerpots, garden and artwares was pursued. Most of the artwares of the Peters and Reed era were continued and several new ones added, among the most successful of which were *Sheen,* in four colors with a semi-matt glaze; *Powder Blue; Crystaline,* in orange and green with a hard semi-matt glaze; and *Drip,* covered with a glaze of one color and a second glaze of another dripped irregularly around the top.[11]

McClelland died in 1931; his family continued operation of the pottery until 1941, when it was sold to the Gonder Ceramic Art Pottery Company.

Marked pieces of Peters and Reed pottery are unknown, although attribution of unmarked examples is often relatively easy. Zane Pottery was marked with the impressed mark shown; and, since Zane changed from a red to a white body in 1926,[12] establishing the early Zane production is simplified.

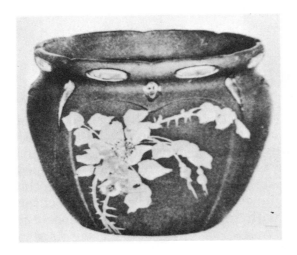

Handpainted Peters and Reed jardiniere introduced in 1909. *Pottery & Glass.*

ZANE WARE
MADE IN U S A

1. H. Ries and H. Leighton, *History of the Clay-Working Industry in the United States,* p. 192.
2. W. Stout *et al., Coal Formation Clays of Ohio,* p. 73.
3. Norris F. Schneider, Zanesville Times Signal, September 15, 1957, p. B-16.
4. Stout *et al., op. cit.,* p. 61.
5. *Glass and Pottery World,* IX (October 1901), p. 248; *ibid.,* X (January 1902), p. 15.
6. *Ibid.,* XV (June 1907), p. 28.
7. *Pottery & Glass,* II (June 1909), p. 302.
8. *Ibid.,* IX (October 1912), p. 21; an early advertisement appears in *Crockery and Glass Journal,* LXXVI (December 19, 1912), p. 216.
9. Undated Peters and Reed catalog (c. 1916) in the collection of The Ohio Historical Society, Columbus.
10. *Ibid.*
11. Schneider, *loc. cit.*
12. *Ibid.*
* Information relating to this pottery is included in a separate chapter.

Pewabic Pottery
Detroit, Michigan

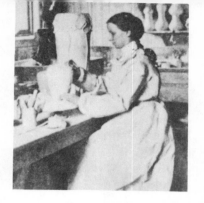

Mary Chase Perry (Stratton) at work in coach house studio shortly after the pottery's beginning. *Keramic Studio.*

The initial inspiration for the Pewabic Pottery, founded in 1903, goes back to the 1880s when Mary Chase Perry (Stratton) became interested in naturalistic china painting, which was then very much in vogue. She attended art schools in Cincinnati and New York and was active in the National League of Mineral Painters.[1] In partnership with Horace James Caulkins she began the Revelation Pottery, which after a short time evolved into the Pewabic Pottery. Caulkins was the producer of the Revelation overglaze china decorating kilns used by Miss Perry and others to fire their decorated china, and of the Revelation pottery kilns which were later used by art potteries from coast to coast, including Marblehead*, Newcomb*, Van Briggle*, Arequipa*, Buffalo* and Pewabic.[2]

The shop was initially set up in an old coach house in the rear of the Cornelia S. Fox mansion on Alfred Street, Detroit. Mrs. Stratton, who studied for a time with Binns at Alfred, was the artist who developed forms and glazes; Caulkins was the clay specialist. "Pewabic," which in Chippewa meant "clay with a copper color," was chosen as a tribute to the Upper Michigan Peninsula copper country. At first the only glaze available was a dark green matt which covered the earliest bowls, vases and jars.[3] By 1904 when the work was exhibited at St. Louis, the simple shapes of the thrown ware—thrown by a potter employed for that purpose—were decorated with flowing yellow, buff and brown matt glazes of a very satisfying texture.[4] By 1911 her popular Persian or Egyptian blue had been perfected.[5] Decoration of this early ware sometimes consisted of simulated leaf forms, occasionally in two tones, which were modeled and then applied when the work was in a plastic state.

A new pottery, built at 10125 East Jefferson Avenue, Detroit, in 1906 and occupied late the following year, was designed by the firm of William Buck Stratton, who was to marry Miss Perry in 1918. It was a cross between a studio and a laboratory with little of the factory idea. A miniature Crossley clay outfit was set up in the basement and in 1910, when the building was enlarged, it was replaced by a full-sized blunger, filter press and pug mill.[6] By that time flow glazes in various shades of orange-yellow and brown or blue, purple and white had been introduced and other glazes developed. These included a satisfactory

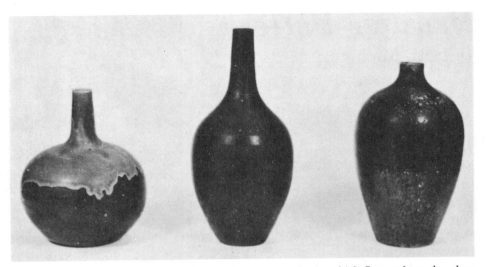

Group of Pewabic ware, left to right: matt brown ground over which flows a lavender glaze covering the neck and shoulder, h. 9½" (24.2 cm); green/black matt glaze, slightly pitted surface, h. 13⁵/₁₆" (34.0 cm); blue-black glaze with iridescent markings, h. 11½" (29.2 cm). All have circular Pewabic/Detroit mark impressed. *The Detroit Institute of Arts (#46.245; 46.239; 46.232), gift of Mr. & Mrs. J. Inglis, Mrs. A. McGraw, Dr. W. R. Parker, W. Pope, Mrs. R. H. Webber, G. D. Pope in memory of Mary Soper Pope.*

crystalline glaze as well as a volcanic-type with a heavy glaze of one or more shades trickling down a ground of a different tint with successive firings. Later iridescent and luster glazes were introduced and skillfully used.[7] A high-fired body was developed, incorporating clays from England and the United States. According to Mrs. Stratton, it could be classified as "neither earthenware nor porcelain," and could be used with either gloss or matt finishes, although the latter were used more extensively in the earlier years.[8]

Detroit art connoisseur Charles Lang Freer was an early supporter of the pottery and acquainted many artists and architects with the Pewabic work. It had its effect, and the tile business, begun in the very early days of the pottery, provided Pewabic with their greatest commissions. Ralph Adams Cram, architect for St. Paul's Cathedral, Detroit, chose Pewabic to produce the pavement tile for the building's Gothic interior.[9] After that noteworthy installation, Pewabic tiles were chosen for use in large churches throughout the country, including the Cathedral of St. John the Divine in New York City and the crypt at the Shrine of the Immaculate Conception in Washington, D.C. In 1923, the year of Caulkins' death, one of Pewabic's most ambitious undertakings in ceramic mosaics to date was executed: "The Seven Ages of Man," designed by Frederick J. Wiley, for the loggia of the reading room of Detroit's main library. A number of story-telling tiles for the fireplace in the Children's Room were also done at the same

time. Then came what Mrs. Stratton wished to feel is the lasting record of the Pewabic Pottery—the fountains, alcoves and risers for stairs in The Detroit Institute of Arts.[10]

One of the chief prides of the Pewabic operation in addition to its work was that the methods of big business never overtook the intimacy of the pottery. The creative work was kept consistently in the hands of the artist, and the technical end of the operation was achieved with the simplest equipment needed for the job. Above all, the focal point of the pottery was its skillful workers, who virtually grew up with the operation. Personnel in the 1920s included the potters who threw most of the ware, a general foreman, a few men who tended the fires, a few women who did the mosaic work, a claymixer and a bookkeeper.[11] Twenty years later Mrs. Stratton praised the "small force of loyal helpers," the four mainstays of the pottery averaging more than thirty years of service.[12]

The pottery encountered serious hardships during the 1930s, but it survived and continued production, especially of artware, until the death of Mary Perry Stratton in 1961 at the age of ninety-four. During her lifetime she had taught ceramics to Wayne State University and University of Michigan students, emphasizing the trial-and-error method in potting. Her book, *Ceramic Processes,*[13] included "how-to-do" instructions as well as portions which were designed to lead the students' interests to museums and collections by reference to similar methods and glaze types. In 1968 the pottery was reopened by Michigan State University, to which it was given, to put her philosophy into effect by the operation of a studio/school under the name Pewabic Pottery.[14]

Important collections of Pewabic work can be found at the Freer Gallery of Art (Smithsonian Institution), The Detroit Institute of Arts and The Fine Arts Gallery of San Diego (California).

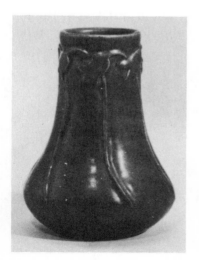

Early Pewabic matt green vase; h. 5⅞" (15.0 cm). Pewabic/maple-leaf mark impressed. *Private collection.*

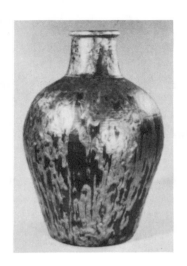

Pewabic vase with iridescent gold glaze decoration on blue ground; h. 18¾" (47.8 cm). Mark obscured by glaze. *The Detroit Institute of Arts (#12.11), gift of Charles L. Freer.*

Art pottery work was carefully marked, although in many instances the heavy glazes completely obscure the impressed mark. Paper labels were also used. Some early pieces bear Miss Perry's incised initials, M.C.P., and occasionally William Stratton executed pieces which bear his incised initials "W.B.S." The Revelation Pottery mark, used for less than a year and bearing Miss Perry's initials, was imprinted.[15] For a brief time the maple-leaf mark was impressed. This was followed by the impressed circular mark. In addition to the imprinted and impressed marks, "Pewabic Pottery" was sometimes incised. The marks M-1, M-2 and M-3 sometimes found over the glaze are a marking system devised by C. L. Freer to indicate museum quality examples which were set aside for study and exhibition. Much of the pottery's finest work is so marked.

Pewabic-type pottery was still being made in 1971 by Mrs. Stratton's secretary of many years and her husband, who was one of Pewabic's last potters. In their small home studio, Ira and Ella Peters use a wheel from the pottery and Pewabic glaze formulas. The die for the circular mark of the pottery is in their possession; while "Pewabic"

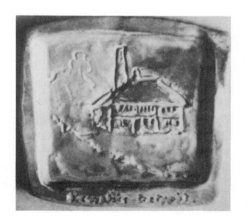

Memento of Pewabic Pottery with incised drawing of pottery plant and iridescent glaze. Impressed circular mark. *Janeen & James Marrin.*

has been ground off leaving the "PP" (for the two Peters, in this case) and "Detroit," the mark will cause considerable problems for future students of Pewabic pottery. In some cases "Ira" or "I.P." is incised in addition to the impressed mark.

1. *Keramic Studio,* V (February 1904), p. 215; *ibid.,* VI (February 1905), pp. 218-19.
2. Advertisements for Revelation Kilns by H. J. Caulkins & Co. appear regularly in *Keramic Studio* between 1916 and 1919.
3. M. C. P. Stratton, *The Bulletin* of The American Ceramic Society, XXV (October 15, 1946), pp. 364-65. The Stratton interest in the matt green glaze of Grueby is amply recorded in an article by her, *Keramic Studio,* II (April 1901), pp. 250-52.
4. *Keramic Studio,* VI (February 1905), pp. 218-19. Examples of her early work are also depicted, including pieces which show the extent of the Grueby influence on the modeled designs.
5. Helen Plumb, *Art and Progress,* II (January 1911), p. 64.
6. *The Clay-Worker,* XLV (May 1906), p. 608; also Stratton, *The Bulletin, loc. cit.*
7. E. A. Barber, *Marks of American Potters,* p. 167; Barber, *The Pottery and Porcelain of the United States,* p. 567.
8. M. Benjamin, *American Art Pottery,* pp. 39-40.
9. See "Pewabic Art in Cathedral Tiling," by M. C. Stratton, *St. Paul's Cathedral: One Hundred Years* (1924), pp. 50-52.
10. Stratton, *The Bulletin, loc. cit.*
11. Unidentified newspaper account entitled "Pottery Glazes Have Wide Fame," c. 1925.
12. Stratton, *The Bulletin, loc. cit.*
13. Copyright 1941, privately published in 1946.
14. According to Roger Ault, the pottery's director (*Impresario,* VII, February-March 1968, pp. 16-17, 55-56), "We have four objectives in our plans. One: to establish the Pottery as an adult ceramic crafts educational center; Two: to establish studio facilities for a group who may become known as the Detroit Ceramic Guild, which will be a club of semi-professional potters, and others who are qualified to work on their own; Three: to establish the Pewabic showrooms to exhibit the permanent collection of Pewabic pottery, the work of the instructors and other professional potters from across the country, and to maintain the historic and artistic traditions of the Pottery through token production of individual decorative tile and plates; and Four: to provide offices, reception and display space for a nonprofit service organization related to the field of fine arts."
15. A piece bearing this mark is in the collection of Greenfield Village and the Henry Ford Museum, Dearborn, Michigan (#62.53.2); another is in the collection of The Detroit Institute of Arts (#73.197).
* Information relating to this pottery is included in a separate chapter.

Poillon Pottery

Woodbridge, New Jersey

The C. L. & H. A. Poillon Pottery was organized about 1901 by Mrs. Cornelius (Clara Louise) and Mrs. Howard A. Poillon, who, like numerous other women of the period, first became interested in claywork through china painting.[1] Initially located at 9 Fleet Street, Jersey City Heights, and using "broken machinery and worn out kilns" they grappled with "every known and unknown disadvantage."[2]

Clara L. Poillon was the leading figure in the pottery, which was formally incorporated in New Jersey in 1903 by C. and C. L. Poillon and James E. Andrews for the "manufacture of glazes, colors and pottery ware . . . and the sale of the products of its manufacture."[3] At that time the new capital allowed for the erection of a new kiln at the location of the old Salamander Works. The Salamander Works[4] had been established in Woodbridge by 1825, and purchased in 1867 by William Poillon.[5] In 1871 Poillon incorporated the pottery,[6] and his son, Cornelius, became president of that operation about 1890; production continued until the works were destroyed by fire in 1896.[7]

Early output of the Poillon pottery was limited entirely to artware.[8] While working in Woodbridge the Poillons lived in New York City, which afforded C. L. Poillon and her associates the opportunity to take part in the many New York City ceramic exhibitions. One of the earliest such exhibitions at which Poillon work was shown was that of the New York Society of Keramic Arts held in December 1901 to display examples of clay bodies and glazes.[9] Poillon earthenware was decorated with gold and orange lusters, matt[10] and high-gloss glazes of which the blue, green and yellow were of special note.[11] These were all developed and produced by C. L. Poillon and considered quite an accomplishment.[12] Work of Joseph Insco and T. H. Pond, who were associated with the pottery, was shown at the St. Louis exposition.[13]

By 1904 output had been expanded to the production of garden wares and kitchen utensils,[14] which included well-designed, inexpensive coffee and teapots.[15] Work apparently evolved toward greater emphasis on these lines, while fireplace tiles and pottery lamp bases were also produced.[16]

In 1928 C. L. Poillon retired from business,[17] although her work continued to be exhibited between that time and her death in 1936.[18]

From all indications, output of the pottery was relatively limited and the artware was not particularly noteworthy. A single pitcher is in the National Museum of History and Technology (Smithsonian Institution; #379,597).

Two marks have been noted, the monogram of Clara L. Poillon used either without or within a circle,[19] and an incised "Poillon/Woodbridge/N.J." designation.

1. An interview with C. L. Poillon, reported in the New York *Daily Tribune,* July 21, 1902. For an extensive autobiographical account of C. L. Poillon's early ventures see *Brick,* VIII (February 1898), pp. 75-77.
2. Letter from C. L. Poillon to the Worcester [Massachusetts] Art Museum, January 10, 1903.
3. Articles of Incorporation on file, Trenton, New Jersey. The corporation was voided in 1910.
4. The Salamander Works is often erroneously placed in New York City because of a mark used by the firm which includes the address of their New York City sales office (cf. E. A. Barber, *The Pottery and Porcelain of the United States,* p. 559).
5. New Jersey Geological Survey, Report on Clays (1878), p. 1.
6. Notes relating to this operation provided by M. Lelyn Branin, who is preparing a manuscript on New Jersey potters and potteries.
7. *The Pottery and Porcelain of New Jersey, 1688-1900* (1947 exhibition catalog of The Newark [New Jersey] Museum), pp. 46-47.
8. *The Clay-Worker,* XL (December 1903), p. 586; also *Glass and Pottery World,* XI (December 1903), p. 19.
9. *Keramic Studio,* III (January 1902), p. 219.
10. E. A. Barber, *Marks of American Potters,* p. 70.
11. Margaret Noel, *Arts and Decoration,* I (August 1911), p. 412.
12. Newark, New Jersey, *Sunday Call,* January 31, 1915, p. IV-2.
13. *Keramic Studio,* VI (April 1905), p. 269; S. Geijsbeek, *Transactions* of The American Ceramic Society, VII (1905), p. 348.
14. *China, Glass and Pottery Review,* XII (May 1903), p. 30. An advertisement in *Country Life in America,* VI (May 1904), offers tree tubs, sundials, window ledge boxes, well curbs and wall pockets among other things, in addition to a catalog upon application. An Art Nouveau sundial is illustrated.
15. *China, Glass and Pottery Review,* XV (February 1905), p. 37.
16. *The Art Digest,* III (mid-April 1929), p. 22.
17. New York *Times,* August 25, 1936, p. 19.
18. *The Art Digest, loc. cit.* The pottery works was apparently disposed of prior to 1931, as there is no reference to it in the will of C. L. Poillon drawn up May 27, 1931 (copy provided courtesy of M. Lelyn Branin).
19. E. A. Barber, *Marks, loc. cit.*

A. Radford Pottery

Tiffin, Ohio
Zanesville, Ohio
Clarksburg, West Virginia

A. Radford at work. *Fred W. Radford.*

Albert Radford, a skilled modeler and potter, emigrated to the United States from England in 1882. He worked at potteries in Baltimore; Trenton; Broadway, Virginia; and Tiffin, Ohio.[1] At the last-mentioned location he began production of Jasper-type cameo decorated ware at the Radford Art Pottery in 1896.[2]

At the turn of the century Radford moved from his Greenfield Street location in Tiffin to Zanesville, where he worked for the Weller Pottery* and later the Zanesville Art Pottery* as general manager.[3] Prior to the establishment of his own pottery at Zanesville in 1903,[4] he worked for Owens* as a designer[5] and was undoubtedly responsible for Owens' Wedgwood Jasper line. The A. Radford Pottery Company was formally incorporated in Ohio in June 1903. A one-kiln plant, electrically operated, was in production for several months, during which time ware with the Wedgwood-type molded decorations was produced.

The body colors of the Radford work are usually tan, pink, light or dark blue, or gray, and often have an applied decorative outercoating

Radford Jasperware, tan body and dark brown lava-textured overcoating, white eagle cameo (on reverse, George Washington cameo); h. 7" (17.8 cm). Incised "20". *K & T. Dane.*

232

1905 advertisement. *Glass and Pottery World.*

in any of several colors including dark brown and slate gray. These have different textures, the most common being orange peel or frosted, and were used to set off the molded ornamentation. According to F. W. Radford,[6] "the Zanesville Jasperware was made entirely differently from the Tiffin product . . . made from an entirely different body . . . [and] the cameos on most of the shapes were made as an integral part of the mold, the cameos being painted in the mold by anyone with the minor skill to handle an artist's brush, and then the solid colored slip cast over them . . . The Zanesville Jasper, in addition to costing less to produce than the Tiffin Jasper, was also a much inferior product."

In July 1903 Radford was evidently forced to sell the works to the newly-formed Arc-En-Ciel Pottery*. The remaining Radford stock was not included in the sale and was removed from the Zanesville factory.[7] Radford moved from Zanesville and the A. Radford Pottery Company was re-established at Clarksburg, West Virginia.[8] A two-kiln plant was erected; Radford was appointed general manager of the new pottery bearing his name,[9] and Albert Haubrich, early Weller decorator, served as head of the decorating department.[10] Operation was begun in July 1904, and the following month Radford died suddenly of a heart attack. He was succeeded as general manager by W. J. Owen, of the Owens pottery in Zanesville.[11] Later general managers at Radford were Charles M. Raile and H. E. Marquardt.[12]

It does not appear that Radford's Jasper-type ware was produced at Clarksburg. Several art lines were executed there and included *Ruko,* a brown underglaze-decorated ware similar to McCoy's* Loy-Nel-Art; *Radura,* a matt-glazed line most often green in color; and *Thera* (to be distinguished from the Terrhea line of the Cambridge Art Pottery*), which had a matt surface with slip decorations similar to Clifton's*

Tirrube and Owens' Matt Utopian. These were offered in addition to regular utility, toilet and kitchen wares.

In 1912 all the molds, dies, saggers, formulas and goodwill of the A. Radford Pottery were sold to Brush-McCoy,[13] and the pottery buildings were taken over by the Clarksburg Pottery.[14] Beginning about 1970 A. Radford's grandson, Fred W. Radford, reproduced A. Radford's Jasper-type decorated ware of the Zanesville variety, using original molds.[15] These usually bear an impressed mark reading "An A. Radford/Reproduction/by F. Radford."

The higher-quality Jasper-type Radford ware produced at Tiffin was sometimes signed with an impressed "Radford Jasper;" Zanesville-produced ware most often bears only a shape number on the base.[16] The artware produced at Clarksburg bears only the impressed or in-mold line designation and not the Radford name.

[THERA.] RADURA. RUKO RADFORD JASPER

1. Fred W. Radford, *A. Radford Pottery: His Life and Works* (Columbia, South Carolina: privately published, 1973), pp. 1-4.
2. Incorporation of the firm in Ohio on December 9, 1895, was announced in *Brick*, IV (February 1896), p. 168. The pottery is listed in the Tiffin directory of 1897-98 and appears in the 1899 issue.
3. Radford, *op. cit.,* pp. 12-13; N. F. Schneider, Zanesville *Times Recorder,* February 23, 1969, p. B-3.
4. Plans for the new pottery were announced in *Glass and Pottery World,* XI (February 1903), p. 20.
5. W. P. Jervis, *The Encyclopedia of Ceramics,* p. 427.
6. Radford, *op. cit.,* pp. 13-14.
7. *The Clay-Worker,* XL (August 1903), p. 157.
8. The firm was incorporated in West Virginia in October 1903, and work upon the new plant was to have been "started immediately" according to a report in *The Clay-Worker,* XL (December 1903), p. 586.
9. *Ibid.,* XLII (August 1904), p. 170.
10. N. F. Schneider, Zanesville *Times Recorder,* February 27, 1972, p. C-6.
11. *Glass and Pottery World,* XII (August 1904), p. 22; also *China, Glass and Pottery Review,* XV (August-September 1904), p. 28.
12. Local Clarksburg directories, 1905-11. F. Radford, *op. cit.,* p. 26, indicates that D. C. Applegate, who had previously been associated with Weller and the Zanesville Art Pottery, was also a general manager.
13. *Pottery & Glass,* VIII (May 1912), p. 16.
14. Local Clarksburg directories. The last listing for the Clarksburg pottery is 1917.
15. Pieces being offered in 1973 are described by F. Radford, *op. cit.,* p. 41.
16. *Ibid.,* pp. 8, 14.
 * Information relating to this pottery is included in a separate chapter.

Revere, Paul, Pottery

Boston, Massachusetts
Brighton, Massachusetts

(see entry: Paul Revere Pottery)

Rhead Pottery

Santa Barbara, California

F. H. Rhead working at Santa Barbara.
Florence Pierce Watt.

Born in Hanley, Staffordshire, England, in 1880, Frederick Hurten Rhead followed in the ceramic tradition of his father, Frederick Alfred Rhead, becoming art director of the Wardle Art Pottery, Hanley, before the age of twenty.[1] At that time he also assisted his father in building and organizing the art pottery for Wileman & Co., Longton.[2] Coming to the United States in 1902, Rhead became associated with William P. Jervis at the Vance/Avon Faience* works. After leaving Vance, Rhead went to Weller* and in 1904 became art director of the Roseville Pottery*. He continued there until 1908, when he rejoined Jervis at the Jervis Pottery* on Long Island. The following year he was named instructor in pottery at the University City Pottery*, St. Louis. In 1911 he joined the Arequipa Pottery*, where he remained until 1913; then he moved to Southern California and organized the Pottery of the Camarata.[3] This was incorporated in California as the Rhead Pottery; the plant was located in a most picturesque setting in Santa Barbara's Mission Canyon.

By his own admission, Rhead was not agile at the wheel; to facilitate production he employed an Italian and an English thrower. The Italian potter was most skilled at throwing the larger pieces, producing daily 12-20 pieces averaging three feet in height. These, for the most part, were garden ornaments. The Englishman was skillful in making the smaller wares, his day's production being 50-100 shapes averaging six inches.[4] The designs were all Rhead's, however, as were the glaze formulas. Rhead himself did almost all the decorating, although in some instances he would design the decoration and it would be executed by Mrs. Agnes Rhead, Miss Lois Whitcomb,[5] or one of his students.

The shapes of the pieces show a predominantly Oriental influence, the inspiration for these being obtained largely from examples from the Ming and Ch'ien Lung periods in the extensive collection of Nathan Bentz, who also handled Rhead's work at his State Street store in Santa Barbara.[6] Designs reflected the Egyptian interest of the period, often combined with Art Nouveau flourishes. Favorite subjects of Rhead were the scarab, the peacock and landscape scenes.[7]

A foremost decorating technique employed by Rhead at Santa Barbara, especially on vases and decorative architectural tiles, was the inlaid process. This was effected by painting the decoration in outline, then applying the background slip and finally filling in the decoration with slips of various colors—all while the piece was not harder than green. The ware was allowed to dry to a hard green condition; then, using a sharp-toothed tool, the slip was cut back either to the outline color or to the body itself. "There are few kinds of pottery work," explained Rhead, "which display the individuality of the potter to the same extent as this inlaid process."[8]

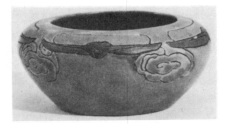

[above] Rhead Pottery low vase in matt green with pink and dark blue glazes within incised decoration; h. 2¼" (5.7 cm). Impressed 142/circular Rhead Pottery/Santa Barbara/potter-at-wheel. *Private collection.* [left] Rhead Pottery vase with inlaid blue, purple, white and gray decoration; h. 7¾" (19.7 cm). Impressed circular mark with potter-at-wheel. *Private collection.*

Just as Hugh Robertson of the Chelsea Keramic Art Works* had been fascinated by the Oriental oxblood and crackle glazes, so Rhead was captivated by the Chinese black glazes. His prize after fifteen years' research was the recreation of the Chinese mirror or reflecting black.[9] This glaze was used on a number of pieces, including the three- or five-piece garniture sets (made in various sizes, consisting of two or four vases and a covered jardiniere). Clay for Rhead's work was almost exclusively from California, Santa Barbara being the source for about

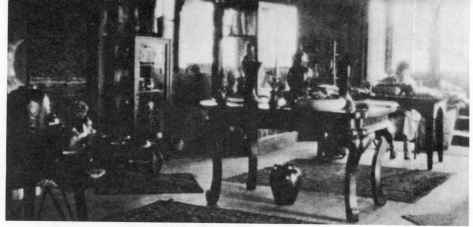

Rhead Pottery showroom and studio. *Florence Pierce Watt.*

a dozen kinds; others came from the Elsinore and National City areas.[10]

As an adjunct to the pottery Rhead began *The Potter,* a monthly magazine specializing in the art of pottery-making as a whole: historical, artistic, technical and practical.[11] Dr. E. A. Barber, famed ceramic scholar, served as editor of the historical department and was to contribute special articles. His feature "Palissy and His Imitators," in Volume 1, Number 1, December 1916, was his first and last; the third issue carried Barber's obituary. That issue of February 1917 was also the final one of the magazine.

Rhead was a great artist and an extremely skilled technician, but a poor businessman. Both *The Potter* and the Rhead Pottery were abandoned in 1917; Rhead returned to the east, where he joined the American Encaustic Tiling Company of Zanesville as director of research. At American Encaustic he executed a number of art pottery specialties in addition to his regular work, including sets of zodiac tiles which were designed by Lois W. Rhead.[12] He also executed a considerable number of porcelain-based pieces at American Encaustic while developing a porcelain body for bathroom fixtures. Rhead remained at Zanesville until 1927, when he became art director of the Homer Laughlin China Company, Newell, West Virginia, a position he held until his death in 1942. His work at the Rhead Pottery earned him a Gold Medal at the San Diego exposition in 1915, and his later work the Charles F. Binns medal in 1934.

Nearly all Rhead's work at Santa Barbara bears an impressed mark. Often the potter-at-the-wheel was enclosed in the circular "Rhead Pottery/Santa Barbara" mark. Some commercial, molded pieces were marked with just the potter-at-the-wheel and not with the Rhead name, or they simply bore a paper label which in many cases has disappeared. The impressed numbers found on many pieces are shape numbers. Special note should be taken that the "F.H.R./Los Angeles" impressed mark is not that of Frederick H. Rhead, but rather of Fred H. Robertson of the Robertson Pottery*.

Directory advertisement, 1915.

Whitcomb cipher

**RHEAD
SANTA BARBARA**

1. *Who's Who in America,* XX (1938-39), p. 2082. Prior to this, Rhead had served as an apprentice at the Brownfield Pottery in Cobridge.
2. *The National Cyclopedia of American Biography,* IV (1956), p. 204.
3. The first listing in Santa Barbara's directories, 1913-14, names the Pottery of the Camarata. See also G. P. DuBois, "The Pottery of Camarata," reprinted from Los Angeles *Times,* November 4, 1914.
4. *The Potter,* I (January 1917), p. 85.
5. Lois Whitcomb, who became the second Mrs. Rhead in the latter part of 1917, was his assistant at Santa Barbara and a competent artist in her own right.
6. Advertisement, Santa Barbara *Morning Press,* December 27, 1914, p. 2.
7. Designs of Rhead frequently appeared in the pages of *Keramic Studio,* beginning as early as December 1903 (V), p. 178.
8. *Keramic Studio,* XI (November 1909), pp. 159-60.
9. *History of Santa Barbara, San Luis Obispo and Ventura Counties, California* (1917), Vol. II, p. 683. It reports that Rhead made over 11,000 formulas for the mirror black glaze before achieving what he considered success. For a technical discussion of this particular glaze, see F. H. Rhead, *The Potter,* I (December 1916), p. 24, in which he concludes: "Columns could be written on this subject. The writer has spent some years in developing blacks of temperatures varying from cones 1-3 to 8-10, and finds astonishing possibilities of variation with a very slight change of formula and manipulation." Another successful Rhead black glaze was his "Elephant's Breath," a black with a misty gray surface.
10. *History of Santa Barbara,* p. 683.
11. *The Potter,* I (February 1917), p. 117.
12. Work done by Lois Whitcomb Rhead at American Encaustic was signed L.W.R. to distinguish her from the other Rheads, especially Louis, brother of F. A. Rhead and uncle of Frederick H. Rhead. Often, however, she signed her full name on the base or the back of objects. At the Rhead pottery she used the L.W. cipher as shown.
 * Information relating to this pottery is included in a separate chapter.

Robertson Pottery

Los Angeles, California
Hollywood, California

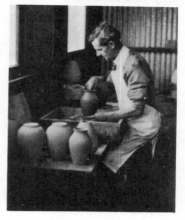

Fred H. Robertson at Claycraft.
Robertson family.

While the Robertson Pottery was not established in name until 1934, it was established in fact as early as 1906 when Fred H. Robertson joined the Los Angeles Pressed Brick Company and began producing art pottery which he fired in their kilns. Fred H. Robertson had been associated with his father, Alexander W. Robertson, at the Roblin Art Pottery* and following the San Francisco earthquake and fire moved to Los Angeles.[1]

As a clay expert at Los Angeles Pressed Brick, he produced numerous experimental pieces using new mixtures of clay. The first dated examples of his gres work at Pressed Brick were executed in 1913. The following year he became interested in luster and crystalline glazes and by 1915 was producing very successful examples. This latter-type work was awarded Gold Medals at the San Diego and San Francisco expositions.[2] During this time lamps in the Fulper* style with ceramic bases and ceramic shades with inlaid glass designs were also made. Often the bases were decorated with the crystalline glaze; one of the most popular motifs found in the shades were stained glass butterflies through which the light could shine.[3] This was largely an experimental period, and little of the work was marketed. When it occasionally was, prices were so high as to discourage sales.[4]

In 1921 the Claycraft Potteries Company was incorporated in California for the manufacture of chemical stoneware, decorative tiles, garden pottery and kindred vitreous products.[5] Shortly thereafter Fred H. Robertson joined the firm as general superintendent. George B. Robertson, Fred H. Robertson's son, joined Claycraft about 1925 as assistant superintendent. During the next ten years the Claycraft works produced a large variety of common and art tile, garden decorations and fountains, and a general line of tile and other specialties (including lamp bases). At Claycraft the attention of the two Robertsons was devoted to development of bodies, glazes and effective designs, the body and glaze work the emphasis of Fred H., the designing the work of George B.[6]

The Robertson pottery, as such, was organized in 1934 by George B. Robertson, and at his urging his father joined him. Fred H. worked at the wheel while George, because of a hand infection which the moist

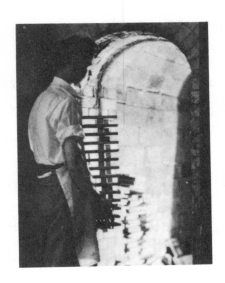

George Robertson at Claycraft. *Robertson family.*

clay irritated, decorated the work. It was almost a studio operation, but it continued the tradition of the Robertson potters which was begun in this country at the Chelsea Keramic Art Works*. At first the pottery was located at 3221 San Fernando Road, Los Angeles.[7] In 1935 it was moved to 18846-48 Ventura Boulevard in North Hollywood, where it remained until 1940. For the next three years work was continued on Riverside Drive, Los Angeles, and from 1943 until it closed it was located at 6809 Hawthorne Avenue, Hollywood. The pottery showroom was at 2310 North Highland, Hollywood, across from the Hollywood Bowl, from 1934 until 1950.

Most early work was turned on the wheel assembled and used by Alexander W. Robertson, but molds were also developed—in some instances from earlier Chelsea Keramic Art Works pieces. Many of the glaze formulas which had been developed by the family were adapted for use at the Robertson Pottery, including a handsome crackle glaze similar to that used at the same time at the Dedham Pottery* Monochrome glazes—which ranged from Persian blue, green and chartreuse

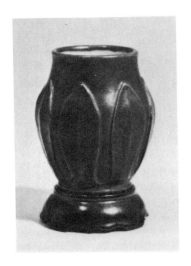

Robertson Pottery miniature matt green glazed vase with modeled leaf decoration and glazed ceramic base; h. 3" (7.7 cm). Impressed F.H.R./Los Angeles. *Private collection.*

to oxblood, robin's-egg blue, rose and white—were, on the whole, much more vivid than the classical Chelsea glazes.[8] Hand-painted Persian designs were often used to decorate work under the crackle or clear glaze. These were executed by George Robertson and often based on the study of classical examples found in the collection of The Metropolitan Museum of Art in New York. Output, which was sold nationally, included vases, urns, decorative plaques, plates, cigarette sets and buttons, all decorated with either monochrome glazes or Persian underglaze designs.[9]

The Robertson Pottery outlived that at Dedham by nine years, closing in 1952. Thus ended the artware production of four genera-

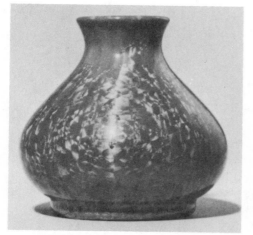

Robertson green crystalline glazed vase, h. 4¾" (12.1 cm). Impressed F.H.R./Los Angeles.
Private collection.

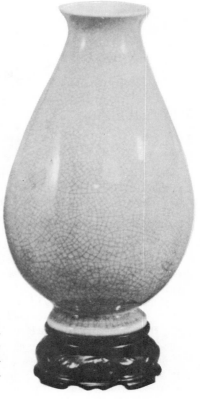

Robertson vase with Dedham-type crackle glaze and ceramic base. This shape, number 214, was offered from 1934 until the pottery closed either for $8 with one of several monochrome glazes or for $16 elaborately decorated.

tions of the Robertson dynasty of potters in the United States. Fred died later in 1952 and George B. in 1966.

Several different marks were used on the Robertson pottery, the earliest an impressed "F.H.R./Los Angeles" designating the work of Fred H. Robertson at Los Angeles Pressed Brick. This is not a mark of Frederick H. Rhead, and care should be taken not to associate it with the work of the Rhead Pottery*. Little Claycraft work was marked,

George Robertson at left, Fred H. at right in front of Robertson pottery, Ventura Blvd., North Hollywood. *Robertson family.*

with the exception of some specialty pieces such as scarab paperweights, on which the Claycraft name was incised. Some of the work of the Robertson Pottery, Hollywood, bears an impressed mark, but the majority is marked with either an incised or imprinted "Robertson/Hollywood" or an imprinted or incised "R" designation.

F. H. R.

Los Angeles

ROBERTSON

HOLLYWOOD

R

Los Angeles

1. Most of the information contained here is from personal interviews and correspondence with surviving members of the Robertson family. Family scrap books with numerous newspaper clippings were also an invaluable resource, but for the most part such clippings are unidentified and undated.
2. *The Potter,* I (December 1916), p. 38. At the same time, the work of Alexander W. Robertson at Alberhill* also received a Gold Medal at San Diego.
3. Los Angeles *Express,* March 28, 1914, p. 11.
4. One particular crystalline piece remaining in the family collection still bears the price tag of $1,000.
5. *The Clay-Worker,* LXXVI (December 1921), p. 590.
6. Some of the Claycraft tiles closely resemble the work of its contemporary rival, the Batchelder works (see Elva Meline, *Spinning Wheel,* XXVII, November 1971, pp. 8-10, 65).
7. This was just a short distance from the Claycraft location, 3101-3111 San Fernando Road.
8. Glazes similar to those used at the Robertson Pottery were also used by American Ceramic Products of Los Angeles on their *La Mirada* ware. There was undoubtedly some exchange of information between the two, as Cecil Jones, formerly with the American Encaustic Tiling Company, Zanesville, was responsible for glaze development at American Ceramic Products (see H. Stiles, *Pottery in the United States,* pp. 149-50), and his daughter had married George B. Robertson in 1933.
9. *Yesterday and Tomorrow: The Story of Robertson Ceramics,* a brochure published by the Robertson Pottery, c. 1937.
* Information relating to this pottery is included in a separate chapter

Robineau Pottery

Syracuse, New York

A. A. Robineau working on Scarab
Vase at University City.

Adelaide Alsop Robineau, like M. L. McLaughlin (Losanti*), Susan Frackelton* M. L. Nichols (Storer) of Rookwood* and others, began her career in ceramics as a china painter. She painted and taught that subject until her marriage to Samuel Edouard Robineau in 1899; in May of that year, at Syracuse, the Robineaus founded *Keramic Studio* (later *Design*), a practical magazine for china decorators, of which she served as editor. She soon became frustrated with the consideration of the ceramic art simply as a background for superficial painting efforts, and as a result of her husband's encouragement began making her own earthenware and, later, porcelain.[1]

Through the study of the early pages of *Keramic Studio* one can trace her rising interest in ceramics.[2] Her earliest pieces, two un-glazed examples modeled from clays of Charles Volkmar (Volkmar Pottery*), were exhibited in 1901.[3] Two years later her first experimental porcelain was shown in the pages of *Keramic Studio*.[4] These early efforts were largely cast, but shortly thereafter she began throwing all her own work, realizing that throwing not only avoids the tedious repetition of similar shapes but also allows the artist to constantly work for their improvement.

Continually encouraged by S. Robineau, who fired her work and played an invaluable supportive role,[5] A. Robineau in 1902 obtained the treatise by Taxile Doat, then of Sèvres and later of the University City Pottery*, in which the Sèvres formulas for porcelain paste and glazes were given, as well as the most minute directions for making the ware. These were translated by S. Robineau and first published in *Keramic Studio* the following year and still later in book form.[6] Assimilation by A. Robineau of Doat's work "proved the decisive event in my career," she wrote.[7] She could not, of course, follow Doat's directions exactly as they applied to French materials and clays, so she used the work as a foundation for her grand feu or high-fired ware, developing a body and glaze which would best suit her work and lend it originality as well.

The 1904 St. Louis exposition introduced Robineau ware to the world. Hand thrown and carved pieces were shown, all with porcelain bodies fired at cone 9 (about 2,400°F.). The glazes were of a unique matt finish and texture, as can be achieved only on a porcelain body,

243

Robineau home at left, pottery at right, separated by rose garden. *Good Housekeeping.*

and appeared in a wide range of colors, a soft brown with various shadings the most frequently used. Robineau crystalline glazes were shown later that year at The Art Institute of Chicago.[8] These ranged from blue and copper-green to yellow-brown and pearly yellow.[9] Even with the brilliant and often unexpected effects of the crystalline glazes, A. Robineau prided herself more in her carved and modeled vases decorated with matt and semi-matt glazes,[10] perhaps because of the commercialization of the crystalline glaze. Between 1905 and 1910 porcelain doorknobs, bearing the Robineau pottery signature, were produced with a wide variety of glaze treatments; these provided a generous income so long as they remained in vogue.[11]

By 1907 the palette of glazes had expanded to include dark and light green, a dark blue which was very difficult to control (sometimes coming out brilliant instead of matt, or streaked with flashes of bright glaze), pale blue (which on occasion came out a bright glaze with purplish flashes), orange red, creamy white and black, the latter often used to glaze stands for the vases.[12] Early the following year S. Robineau exhibited sixteen experimental pieces, which had been thrown by A. Robineau, in flammé reds of copper from the dark purplish browns through the various shades of red and peachblow.[13]

Taxile Doat came to the United States in 1909 in conjunction with the beginning of the University City Pottery, and the Robineaus joined him on the staff there. During their eighteen months' stay at University City the Robineaus perfected the technique of excising,[14] and achieved the development of a glaze of semi-opaque texture which retained its translucence without being too brilliant.[15] Both of these triumphs were combined in the execution of the Scarab Vase, without doubt one of the most elaborate pieces ever executed and the result of over a thousand hours of carving. Considered by A. Robineau as the most important work of her career, the Scarab Vase is now part of the

extensive collection of Robineau pieces at the Everson Museum of Art, Syracuse.[16] The porcelaneous body used for the work at University City was the same as that developed at the Robineau Pottery using primarily Texas kaolin, which produced a remarkable whiteness and translucence. While at University City A. Robineau also experimented with grand feu stoneware (grès), which differs from porcelain in that it neither has a white body nor is translucent. This work was not pursued extensively, and only a few examples are to be found.

A good piece of work at the Robineau pottery was never left imperfect, and the average for success on the first firing was considerably less than fifty percent. All the unsatisfactory pieces were reglazed and refired until they were acceptable or entirely spoiled. A particularly outstanding crystalline-glazed vase was fired a total of seven times before it was considered successful. The Scarab Vase itself came from its first kiln with several gaping cracks around the base. These cracks were carefully filled with ground porcelain, and the piece was reglazed and refired. It emerged from the second firing in perfect condition.[17]

At several times during her career, A. Robineau experimented with the execution of egg-shell porcelains.[18] This excising of designs on a coupe of paper-like thinness was some of the most difficult work undertaken by her, and some of the most time-consuming.[19] Of the twelve specimens on which she worked, only three were considered successful.[20] One of these was broken beyond repair, another is in the

[left] Brown vase with golden crystals on shoulder and neck; h. 6¾" (17.2 cm). Excised mark and the notation that piece was made at University City in 1910. *Private collection.* [right] Early matt glaze vase of Indianesque color and design, made in 1905; h. 7½" (19.1 cm). Excised mark, incised "484". *Private collection.*

Robineau Pottery. Early titanium matt glazed vase executed in 1905; h. 4¾" (12.1 cm). Excised mark and incised 485. *Private collection.*

collection of The Metropolitan Museum of Art (#26.37) and the third, originally in the Booth Collection of The Detroit Institute of Arts, is now at the Cranbrook [Michigan] Academy of Art (#1944.154).

It is no wonder that the success of the Robineau Pottery was never measured in dollars. Production was amazingly small, and sales records reveal that only about 600 pieces were sold in twenty-five years, for a total income of about $10,000.[21] Success, however, could be measured in other ways, Numerous awards were granted the Robineau work, the first major one being the Grand Prize at the 1911 International Exposition at Turin, Italy. While the award was to University City, it was actually a personal award of A. Robineau.[22] Following that were the Grand Prize at the San Francisco exposition in 1915 and her appointment as a medalist in The Arts & Crafts Society, Boston, the same year.

At the time of World War I, economics forced the abandonment of the pottery as it had operated. Following a period of retrenchment, A. Robineau joined the faculty of Syracuse University in 1920 as an

Robineau Lantern with reticulated and excised decoration, matt glazes of titanium; h. 8⅛" (20.7 cm). Incised cipher and dated 1908. *Everson Museum.*

Poppy Vase by A. A. Robineau with in-
cised design and inlaid porcelain slip
decoration; h. 6¼" (15.9 cm). Excised
mark and incised University City de-
signation and 1910 date. *Everson Museum.*

instructor of pottery and ceramic design. At that time her kiln was
given to the University pottery and thereafter maintained by them.
Under her direction her students produced a low-fired earthenware
which was known as *Threshold Pottery.*[23] A. Robineau herself con-
tinued to produce porcelain wares, although not of as complex design
as during the period 1904-16, until illness forced her retirement in
1928. She died the following year at the age of sixty-four.

A large portion of the work of the Robineaus was sold to leading
museums in the United States, in itself an acknowledgement of the
stature achieved by the pottery. The Newark [New Jersey] Museum
acquired several pieces in 1914 which are still in their collection. Two
years later the Everson Museum of Art, Syracuse, acquired forty
pieces. In 1919 and 1920 a large collection of important Robineau work
was given to The Detroit Institute of Arts; a portion of this remains at
that location, while some of the balance is at the Cranbrook
[Michigan] Academy of Art. In 1922 The Metropolitan Museum of Art
made its first purchase, and in 1930 the Everson Museum of Art more
than doubled the size of its collection to include some of the pottery's
most important work.

Several marks have been used on the wares produced at the
Robineau Pottery, the circular excised monograph of Robineau being
the most common. The first mark used on early experimental, mostly
cast pieces was the A-R. The lettered, conjoined monogram appears
primarily on the stoneware work. A square monogram was also used
for a time and should be distinguished from a quite similar square-
shaped mark with the letters RP, which is found on cast pieces only.[24]
In one or two of the first molds a mark consisting of four trees in a
square was impressed in the mold, but it did not come out distinctly

and was soon abandoned.[25] After 1908 all work was dated. Dates on significant earlier pieces can usually be determined from their illustration in *Keramic Studio* shortly after their execution. Work produced at University City in 1910 and 1911 also bears the U.C. initials. Some examples of porcelain hotelware of The Onondaga Pottery Company of Syracuse can also be found with the A-R mark, as A. Robineau executed underglaze designs for that firm for a brief period shortly after locating in Syracuse.[26]

1. A. A. Robineau, autobiographical notes prepared for The Arts & Crafts Society, Boston, in 1906. A history of the development of *Keramic Studio/Design* appears in *Design,* XXXVII (December 1935), pp. 20-22, 41.
2. An outline of this progression is provided by William Hull, *Bulletin* of the Everson Museum, Syracuse, XXII (No. 2, 1960).
3. *Keramic Studio,* III (November 1901), p. 143.
4. *Keramic Studio,* V (June 1903), p. 38. The chief interest in these pieces was their accompanying apologia for the casting of ware. As noted above, however, Robineau shortly abandoned that process and with it the idea of large-scale production (see S. Robineau, *Design,* XXX, April 1929, p. 202). Thereafter the kilns, equipment and personnel to achieve that end were also eliminated (Irene Sargent, *The Keystone Magazine,* LVII, September 1929, pp. 133, 135.)
5. See *Spinning Wheel,* XXVII (April 1971), p. 43.
6. T. Doat, *Grand Feu Ceramics,* published by the Keramic Studio Publishing Company, Syracuse, New York, 1905.
7. A. A. Robineau, *op. cit.*
8. *Keramic Studio,* VII (May 1905), p. 7. Several pieces of grand feu porcelain had been shown at the 1904 annual exhibition of the New York Arts and Crafts Society, as reported in *Keramic Studio,* VI (May 1904), p. 24.
9. *Keramic Studio,* VII (May 1905), p. 7.
10. Catalog, *Porcelains from the Robineau Pottery,* Tiffany & Co., agents, c. 1907. Tiffany & Co. became the agents for the Robineau Pottery in 1905, and their name is first carried in the Robineau Pottery advertisement in *Keramic Studio,* VII (November 1905), p. I.
11. Sargent, *op. cit.,* p. 133.
12. *Porcelains from the Robineau Pottery.*
13. *Keramic Studio,* IX (February 1908), p. 230.
14. In an article in *The Art World* (III, November 1917, pp. 154-55) A. A. Robineau discussed the different processes of porcelain carving. Excising—as illustrated in the vase with wistaria decoration (pictured in *Design,* XXX, April 1929, p. 206)—consists in cutting out the background so that the design stands out in relief. The background can be cut to any depth desired, such as evidenced in the Scarab Vase (which represents over a thousand hours of work); or the background may be cut out entirely, producing a reticulated piece such as the Lantern of 1908 (which represents over three hundred hours' work of cutting and carving). A variation of this, employed in The Chapel (illustrated in *Design,* XXX, April

1929, p. 208), was the filling in of the open work with colored translucent glazes. In the incising process the design is carved into the background; sometimes this would be filled with colored porcelain slips. An example of this inlaying technique is the Poppy Vase (Everson Museum collection).

15. S. Robineau, *Keramic Studio*, XIII (August 1911), pp. 80-84 (reprinted from *Pottery & Glass*, VI, February 1911, pp. 16-19). An excellent treatise on the technical aspects of the Robineau accomplishments, especially with regard to the carving of porcelains, is offered by F. H. Rhead in *The Potter*, I (February 1917), pp. 81-88. Rhead therein notes that Mrs. Robineau "has produced works which rank with the finest pottery of any period, ancient or modern, and which not only have the highest qualities of conception and technique, but her work possesses that quality beloved of all collectors — rareness." Somewhat prophetically he added "in a few years' time, collectors will pay any price for the possession of even the less significant pieces."

16. Not everyone agreed with A. A. Robineau's judgment of the Scarab Vase. F. H. Rhead, with his usual candor, was to observe that "the 'one thousand hour' Scarab Vase is a monstrosity. I would not have it in my collection if I was paid for storing it. It is the sort of thing which a criminal condemned for life will whittle to pass the time. So are a dozen other 'impossible' pieces. But the production of fifty or a hundred such pieces would not lessen her reputation or lessen the beauty of her other work. I classify these elaborately carved pieces as experiments in technique."

17. S. Robineau, *Design*, XXX (April 1929), pp. 201-09.

18. The first reference to this work and the picturing of a bisque Japanese-style tea cup which was "carved with a little border of plum blossoms, the background being cut so thin that even before firing the light shines through the clay," appears in *Keramic Studio*, IX (November 1907), pp. 178, 180.

19. In an undated letter (c. 1922) to the Society of Arts & Crafts, Detroit (*Archives of American Art*, D 280, frame 608), Robineau writes "this last year all my spare time has been given to working on egg-shells . . ."

20. Sargent, *op. cit.*, p. 137; S. Robineau, *Design*, XXX (April 1929), p. 205.

21. S. Robineau, *Design*, XXX (April 1929), p. 206. Interestingly enough, Robineau's total output fulfilled a much earlier prediction of F. H. Rhead (*op. cit.*, p. 84). Writing of the high quality and rarity of her work he concluded "it is extremely doubtful if the entire output of Mrs. Robineau in twenty-five years would furnish one sizeable collection as collections go."

22. All fifty-five pieces sent to Turin by University City were executed by A. Robineau. Fifteen were made at University City; the remaining forty were produced in Syracuse prior to 1910 (*High Fire Porcelains*, a brochure of Robineau work prepared for the Panama-Pacific International Exposition, San Francisco, 1915).

23. S. Robineau, *Design*, XXX (April 1929), p. 206. A discussion of a name for this ware is carried on by A. Robineau in an undated letter (c. 1921) to the Society of Arts & Crafts, Detroit (*Archives of American Art*, D 280, frames 0014-6). "The only suggestions I had so far are 'Priscilla [a Robineau daughter] Porch Pottery'—'Peggoty Pottery' because of their quaintness and a sort of 'peasant' quality. They should have a name with the same sort of naïve feeling."

24. When molded work ceased, two molds continued to be used for the application of trial glazes. One of these bore the RP mark, the other was unmarked (*High Fire Porcelains*, 1915).

25. *Porcelains from the Robineau Pottery.*

26. E. A. Barber, *Marks of American Potters*, p. 81.

* Information relating to this pottery is included in a separate chapter.

Roblin Art Pottery

San Francisco, California

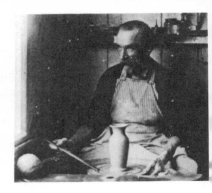

Alexander W. Robertson at Roblin pottery. *Robertson family.*

Alexander W. Robertson, who by 1866 had founded the predecessor of the Chelsea Keramic Art Works*, permanently settled in California in 1884. "California," declared Robertson, "is the only state in the Union that has all the clays necessary for the production of the finest grades of pottery."[1]

During 1891 Robertson met Linna Irelan, wife of the California State Mineralogist (1886-1892), through an article she had written for the Ninth Annual Report of the State Mineralogist (1889) which was largely devoted to the clay resources of California. He brought pieces which he had made from California clays, and she was so impressed by his achievement that from that point on both worked toward establishing a pottery which would use California material exclusively. After examining the exhibits of American pottery at the Columbian Exposition (Chicago, 1893), Robertson and Mrs. Irelan began to make definite plans for an art pottery.[2]

A small shop was rented on Twentieth Street at Treat Avenue in San Francisco, and work commenced in a very primitive way. Due to unforeseen conditions, it was shortly thereafter abandoned. Production was resumed and again abandoned. Then in early 1898 work was begun which was to continue for eight years. A signboard near the roof identified the location of the Roblin Art Pottery, the name derived from the first three letters of Robertson's name combined with the first three of Mrs. Irelan's given name, Linna.

Some domestic wares such as bowls and mugs were produced, but the primary output was in vase forms. Red, buff and white clays were used for the body, and all pieces were thrown by Robertson in shapes reminiscent of those he had produced at Chelsea. Often the vases were left in the bisque or with only the interior glazed. Others were glazed,

Roblin Art Pottery, San Francisco.

again using only native California materials. Robertson was responsible for the potting and firing, Linna Irelan often doing the decorating.[3] Almost all decorative techniques were employed at Roblin: underglaze slip painting, clay carving, incising, modeling, hammering (a technique Robertson had perfected at Chelsea) and slip painting. Mrs. Irelan's forte was modeling, and pieces with modeled decorations, sometimes to an extreme, were produced by her. These included mushrooms and lizards in particular and often obstructed an appreciation of the basic shape of the piece. Robertson's own tastes were far more severe and classical, and frequently the only embellishment he would employ was finely executed handles, beading, or application of a high-gloss glaze of a quality equal to the finest produced anywhere.

Display of Roblin ware at the pottery. *Robertson family.*

It was the intention of the founders to develop around the Roblin Art Pottery a pottery club, similar to that in Cincinnati, and eventually to evolve into an operation much like Rookwood*. As early as 1891 the Keramic Club was active in San Francisco,[4] and to allow for the expansion necessary to implement such an operation consideration was given to the establishment of a major pottery.

Robertson was a realist when it came to calculating the costs for such an undertaking. Several times he had received offers for the erection of a plant to produce tableware, but each time he refused, considering the amount insufficient to assure success. On one occasion he was approached by a San Francisco merchant as to whether he thought clay could be obtained nearby from which a white granite ware of good quality could be made. Robertson gave an emphatic yes,

and the merchant asked what sum would be needed to start a pottery for such manufacture in sufficient capacity to supply the coast market. Robertson indicated that not less than $50,000 would be needed to start, with future requirements running to six figures. The merchant quickly abandoned his speculation.[5]

The California Art Pottery and Tile Association was organized in 1901 under the laws of South Dakota. Directors, all of whom were San Franciscans, were William Corbin, John E. Firmstone, E. D. Cooley, J. E. Young and L. A. Jeffery. The stated purpose of the Association was the manufacture of tiles, artware, Rockingham-type ware, yellow ware and other commercial wares from the clays of California. Plans called for the building of several large kilns and the absorption by the Association of the Roblin Art Pottery plant, retaining Robertson and Mrs. William Irelan, Jr. Capital requirements were set at $500,000,[6] and when only $100,000 was raised, this effort too was abandoned.

Production of art pottery continued at the 3244 Twentieth Street location, housing under one roof the works, studios, reception and show rooms, adjacent to which was the kiln built by Robertson himself. At the same time Robertson continued his experiments with

Roblin white slip decorated terra cotta vase; h. 3¾" (9.5 cm). Impressed Roblin and bear mark, dated 1898 and signed by Linna Irelan. *Private collection.*

Roblin fancy-footed vase, unglazed white body; h. 3½" (8.9 cm). Impressed Roblin cipher, incised A. Robertson initials and dated February 1906. *Private collection.*

native clays and other materials, with much the same dedication as Hugh Robertson's in his experiments with glazes at Chelsea.

In April 1906 the pottery, the pottery school established a short time before,[7] a large portion of the prized collection of the most successful ware, and the firm's stock were destroyed in the San Francisco earthquake and subsequent fire. After the holocaust Alexander Robertson, then sixty-six years old, and his son Fred H. Robertson, who had joined him in 1903, left for Southern California, and Mrs. Irelan gave up all work with the pottery. Young Robertson was employed by the Los Angeles Pressed Brick Company (see Robertson Pottery*), which also made a studio available to Alexander.[8] There he intermittently continued his work until departing in 1910 for the Halcyon Pottery*.

Just a month prior to the destruction of the pottery, Robertson sent three examples of his work to the National Museum of History and Technology (Smithsonian Institution), where they remain today (#237,954-6). Two examples are in the collection of The Oakland [California] Museum, and a single piece is in the Norton collection at the Museum of Fine Arts, Boston. Two items given to the Philadelphia Museum of Art in 1904 have both been dispersed.

Pieces were marked with the impressed bear or the firm name, Roblin, often with both. Robertson's initials are often found on pieces which he executed, and many of the important ones are also dated. Mrs. Irelan's initials, full name or hallmark (an incised spider and web) can also be found in addition to the regular Roblin marks. Another mark is an impressed lozenge-shaped cipher with the letters RAPC, almost identical in appearance to the CKAW cipher of the Chelsea Keramic Art Works.

Roblin Art Pottery. Group of miniature vases typical of the work of Alexander W. Robertson. Left to right: h. 2 1/2" (6.4 cm), impressed Roblin marks; h. 3" (7.7 cm), impressed Roblin, incised 4/05 and A.W.R.; h. 2 5/8" (6.7 cm), impressed Roblin marks and "A.W.R." incised. *Oakland Museum, (#s 75.75.27-29).*

 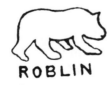 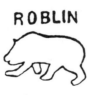

1. San Francisco *Chronicle,* May 21, 1905, Sunday Supplement, p. 1.
2. San Francisco *Call,* January 15, 1899, p. 19. The special significance of this article is that it was written by Linna Irelan.
3. *Keramic Studio,* III (January 1902), p. 190; *Illustrated Glass and Pottery World,* IX (May 15, 1901), p. 121.
4. *The Wave,* IX (December 10, 1892), p. 8. Their work was exhibited at Chicago in 1893 (see *Final Report of the California World's Fair Commission,* 1893, pp. 37, 57, 85, 124).
5. *Illustrated Glass and Pottery World,* X (September 1902), p. 15.
6. From the Association's prospectus.
7. M. Benjamin, *American Art Pottery,* pp. 36-37. Benjamin mistakenly refers to the pottery as the "Irelan Art Pottery."
8. Los Angeles *Herald,* September 27, 1906, p. 4.
* Information relating to this pottery is included in a separate chapter.

Rookwood Pottery

Cincinnati, Ohio

This, the most successful and famous of the Cincinnati potteries, was a relative latecomer to the scene.[1] Cincinnati faience—later identified as Rookwood's Standard ware—was already being produced at Coultry's*, Dallas'* and Wheatley's* potteries at Cincinnati by November 1880, when the first Rookwood kiln was drawn.[2] The first experiments of Maria Longworth Nichols Storer in ceramics were during 1879, growing out of an earlier interest in china painting. With the financial backing of the Longworth family, she was able to secure the services of the most competent local ceramic workers, and the pottery itself was able to survive the debacle so common to less well-endowed establishments. "It was at first," wrote Mrs. Storer, "an expensive luxury for which I, luckily, could afford to pay."[3]

First located in an old schoolhouse at 207 Eastern Avenue, Cincinnati, the pottery was named "Rookwood" after the Longworth estate in

The Rookwood Pottery on Mt. Adams, Cincinnati.

Walnut Hills, where Mrs. Storer grew up. "As a business its success was very slow. In the beginning, when it was not a matter of importance whether it paid or not, a great many new things were tried and experiments made in search of improvement in material and effect . . . It was only after 1883, when [William Watts] Taylor took charge as my manager, that things began to assume a 'business' air, and the artistic Pegasus had, to a certain extent, to be harnessed to the commercial art."[4]

One of Mrs. Storer's earliest associates was Clara Chipman Newton, a former schoolmate who was secretary of the Cincinnati Pottery Club and also a close friend of M. L. McLaughlin (Losanti*). For want of a

better job description, she was identified as Secretary, "a title that sounded impressive so far as the pottery was concerned . . . sufficiently elastic to cover the many-sided work that really came under my supervision."[5] Another early, influential employee was Joseph Bailey, Sr., who joined the pottery in 1882, and except for a temporary absence was associated with the works until his death in 1898.

Whether M.L.N. Storer or Taylor ever cared to acknowledge it,[6] the evidence is rather conclusive that McLaughlin's method for the production of Cincinnati faience was the basis of similar work at Rookwood.[7] "The earliest type of Rookwood characterizes the period of about four years from 1880 to about 1884. The variety of subjects in the painted decoration is limited and on the plastic side tends toward heavy reliefs. It was during this time that most of the work of Mrs. Storer and of lady amateurs was done, and the clay pieces were treated with a great variety of methods, not always appropriate to this material. The glaze was colorless, and gilding was so freely used as to be one of the marked characteristics of pieces of the period. What is known as 'smear glaze' was also largely used—mainly for designs incised or stamped in the clay in connection with color, giving something the effect of stoneware."[8]

These various decorative techniques gradually disappeared, and efforts were principally concentrated on underglaze slip-decorated ware; its appearance was immeasurably enhanced by Laura Fry's application of colored slips by use of an atomizer in mid-1884. This technique was expanded to the application of background colors, which soon encompassed dark browns, reds, orange and yellow under a yellow-tinted high glaze, all of which were designated *Standard*

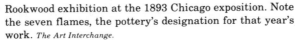

Rookwood exhibition at the 1893 Chicago exposition. Note the seven flames, the pottery's designation for that year's work. *The Art Interchange.*

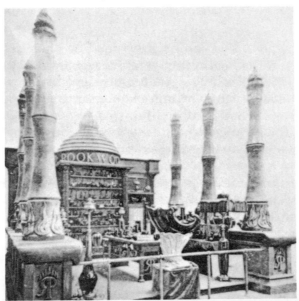

Rookwood. With more competent and skilled artists, decorative subjects rapidly expanded, and this work characterized the period from 1884 until 1898.

1889 was a turning point in two important ways: that year Rookwood was awarded a Gold Medal at the Universal Exposition at Paris, placing the enterprise at the forefront of the world's potteries; it was also that year which marked the establishment of Rookwood as a financially profitable industry. The following year Mrs. Storer retired from active participation, and the Rookwood Pottery Company was incorporated in Ohio with Taylor as president. Two years later the first of the pottery's buildings on Mt. Adams was completed and occupied.[9]

Rookwood's first chemist, Karl Langenbeck (Avon*), was secured in 1885. In 1892 Stanley G. Burt joined the pottery in the same capacity, and upon Bailey's death six years later he took complete charge as Rookwood's chemist and superintendent. *Iris* and *Sea Green,* introduced in 1894, were attempts to develop new glazes retaining the richness and depth of the Standard, but practically colorless and admitting light shades and cooler colors. These types were first prominently exhibited at the 1900 Paris exposition.[10]

As early as 1886-87 Rookwood experimented with a matt glaze,[11] but its application was not pursued as all the facilities of the works were devoted to the development of the Standard ware and the search for the "secret" of the related aventurine *Tiger Eye* glaze. In 1896 experimentation was resumed, and at the Buffalo exposition in 1901 a wide range of colored matt glazes was shown, as were vases painted by decorators using the colored matt glazes as an inlay.[12] The next introduction was *Vellum,* a matt glaze developed by Burt which was transparent enough to be used over colored slip decorations. This was first publicly shown at the St. Louis exposition in 1904, and was seen by Taylor as "the connecting link between the bright and the dull glazes."[13] *Ombroso,* a distinctive matt finish in tones of gray and brown with occasional accents of other colors, was brought out in 1910.[14]

Rookwood's *Soft Porcelain* made its first appearance in 1915, signaling a partial return from the matt to bright glazes. A new body was used, but the chief new technical work was in the choice of glazes. These were rich, heavy and simple in color, flowing over simple forms.[15] Each of these new decorative treatments relied less heavily on individual decorative artists, and gave Rookwood the chance to compete with other potteries in the mass-production market. Pieces without artist signatures began to appear regularly in the early years of the twentieth century, and the output of such "unsigned" ware continued to increase.

Taylor died in 1913. He was succeeded by Joseph H. Gest, who continued as president until he resigned in 1934, unable to cope with the financial crises brought on by the Depression. John D. Wareham was named his successor. Burt retired as superintendent in 1929 and Harold F. Bopp was his replacement. Bopp left in 1939 to establish what was to become Kenton Hills Porcelains*. Two years later Rookwood entered bankruptcy. It was sold later that year to Walter E. Schott.[16] Wareham remained in charge through the transfer from Schott to the Institutum Divi Thomae, which sold the pottery operation to George S. Sperti, a director of the Institutum. The pottery survived the war, but output was markedly inferior and progressively so. Sperti sold the works in 1956 to two Cincinnati businessmen who in turn sold it to the Herschede Hall Clock Company in 1959; Herschede moved the pottery operation to Starkville, Mississippi, the following year. Some work was executed there prior to the cessation of production in 1967.[17] In late 1971 the assets of the pottery, including 3,000 block molds, 5,000 glaze and clay formulas, equipment, trademarks and medals won by the pottery, were sold to Briarwood Lamps, Inc., of Starkville. It was their intention to produce a line of lamps, based on Rookwood designs, to be marked under the name Rookwood Gallery.[18]

The primary collection of Rookwood Pottery is at the Cincinnati Art Museum, but most of the important museums in this country and abroad have (or had) pieces in their collections. Three examples of work from the early 1950s are included in the large collection at the National Museum of History and Technology (Smithsonian Institution).[19]

Rookwood, without doubt, is one of the most thoroughly marked of the art potteries of the United States. Six different categories of marks can be distinguished. **Factory Marks.** Several factory marks were used prior to the impressed "Rookwood" adopted in 1882. Beginning in 1886 the RP monogram, apparently developed by Alfred Brennan in 1883,[20] replaced the previous mark. In 1887 a flame was placed over the RP mark, with another flame added each year until there were fourteen flames in 1900. Thereafter under the cipher including the

Rookwood vase with green glaze at top, shading to yellow and warm orange at bottom; h. 13⅛" (33.5 cm). Impressed 8-flame RP mark and shape number 581C. Decorator cipher of Albert R. Valentien is incised. *Museum of Decorative Art, Copenhagen (#U. 595), courtesy Frame House Gallery.*

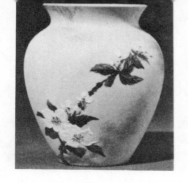

Rookwood vase by Artus Van Briggle, 1887. Pink matt ground with slip decoration and burnished with gold; h. 5¾" (14.6 cm). Impressed 1-flame RP mark, "S" indicating a special piece, shape number 363 (designed in 1887 by William Auckland), code W7, artist cipher. *K. & T. Dane.*

fourteen flames, a Roman numeral indicated the year of manufacture. After 1942 the name was occasionally written out and the location added, especially after the move to Starkville. Anniversary marks, such as commemorations of the fiftieth, sixtieth, seventieth and seventy-fifth, were imprinted on ware. **Clay Marks.** Clay marks include "G" indicating a ginger body, "O" for olive, "R" red, "S" sage green, "W" white, "Y" yellow, and "P" soft porcelain.[21] **Shape Marks.** Almost all ware produced at Rookwood was given a shape number. Prior to 1884 shape numbers are not in the order in which they were introduced, but following that date the numbers are usually in the sequence in which the shapes were created.[22] **Process Marks.** A number of miscellaneous marks were used by the pottery from time to time, only the most common of which are given here. An "X" impressed on either side of the shape number indicates a trial or experimental piece. "X" ground into the base after firing denotes a second-quality piece which was sold at a reduced price. An "S" preceding the shape number indicates a piece made directly from a sketch bearing that number; alone it indicated a specially-thrown piece. "V" indicates the use of the vellum finish, and "Z" following the shape number indicates shapes designed for a matt glaze finish. "Y" was used following the shape number for work of the architectural department established by Rookwood in 1902. **Decorators' Marks.** Decorators usually signed their work with their initials or a cipher thereof. Over a hundred decorators worked at the pottery, most of whose numbers have been recorded with brief biographical notes by Peck.[23]

 R.P.C.ÐM.2.N.

1. The most definitive work yet produced on Rookwood is *The Book of Rookwood Pottery* by Herbert Peck. This chapter will only touch upon some highlights of the operation, drawing from the notes of those closely associated with the works, rather than attempting to condense what Peck has so effectively covered in his book. For a setting of the perspective of the Cincinnati art pottery industry at the time of Rookwood's formation, see P. Evans, *Spinning Wheel,* XXVIII (September 1972), pp. 16-18.

2. The first kiln was fired with "pitchers, teapots, etc., of a simple red and yellow clay and of pretty shapes, after the fashion of early Doulton ware and with Mrs. Storer's decorated work," according to Clara Chipman Newton, *The Bulletin* of The American Ceramic Society, XVIII (November 1939), p. 445.

3. M. Nichols Storer, *The Bulletin,* XI (June 1932), p. 158—excerpts from a brochure written in 1895 and published in Paris in 1919.

4. *Ibid.*

5. C. C. Newton, *loc. cit.*

6. See Peck, *op. cit.,* pp. 47-48.

7. A full discussion of this appears in the chapter devoted to Losanti.

8. William Watts Taylor, pottery reprint from *The Forensic Quarterly,* September 1910, pp. 6-7.

9. *Ibid.*

10. *Ibid.*

11. Harold F. Bopp, *The Bulletin,* XV (December 1936), p. 445.

12. Stanley G. Burt, *Journal* of The American Ceramic Society, VI (1923), pp. 232-34. For a critical analysis of this aspect of Rookwood's work, see *Keramic Studio,* III (November 1901), pp. 146-48.

13. Taylor, *op. cit.,* p. 11.

14. Bopp, *loc. cit.*

15. Burt, *op. cit.,* p. 233; Bopp, *loc. cit.*

16. *The Bulletin,* XX (November 1941), p. 423.

17. Peck, *op. cit.,* esp. Chapter 21.

18. *The Bulletin,* L (September 1971), p. 774.

19. Their #59.64-66, dated 1952, 1953 and 1955 respectively. For a survey of museum collections see Peck, *op. cit.,* Afterchapter IV.

20. See Peck discussion, *Auction,* III (September 1969), pp. 22-23. A piece bearing this cipher and Brennan's own is in the collection of the Cincinnati Art Museum (#1883.897). Several others in that collection also bear the RP cipher prior to its adoption in 1886.

21. Clays at first were from Ohio, but by the early part of the twentieth century the raw materials were largely from other states (H. Ries and H. Leighton, *History of the Clay-Working Industry in the United States,* p. 181).

22. Preservation of the shape records has been undertaken by Herbert and Margaret Peck, *Catalog of Rookwood Art Pottery Shapes* (1971, 1973). Part I reproduces shapes 1 through 1299, covering the period 1880 until 1907. Part II begins with shape 1303, introduced in 1907, and concludes with shape 7301, the last entry before the pottery ceased production in 1967.

23. Peck, *op. cit.,* Afterchapters I and II. Several additional decorators are identified by H. Peck in the introduction to *Rookwood Pottery,* catalog of 1971 exhibition at Frame House Gallery, Louisville, Kentucky, p. 4.

* Information relating to this pottery is included in a separate chapter.

Rose Valley Pottery
Rose Valley, Pennsylvania

William P. Jervis at Rose Valley.

The Rose Valley Association was established in 1901 as an arts and crafts colony "for the purpose of encouraging the manufacture of such articles involving artistic handicraft as are used in the decorating and furnishing of houses."[1] The plan was incorporated with five members constituting the Board of Control, one of the first of whom was Howard Fremont Stratton, director of the School of Industrial Art of the Pennsylvania Museum (Philadelphia Museum of Art).[2] Under the leadership of William Lightfoot Price, an artist and architect, and Hawley McLanahan, Price's business associate, a tract of fifty-two acres was purchased between Nether Providence Township and Middletown Township. The location was then an almost-deserted mill village, the Rose Valley mill built in 1789 giving the community its name.[3]

By the summer of 1901 the community had been settled by artisans "trying some experiments in economic gravitation."[4]

> Strong in their faith, men, women and children to the number of sixty or more have made their homes at Rose Valley. Here they have established a furniture shop in which no work is done that will not bear the most severe scrutiny as to honesty and thoroughness of construction; no sham, no pretense to do something outside of its evident use, will pass for good work. Here a metal working shop is being set up. Here the weaver, the potter, the printer and whatever other craftsman you will may have his shop . . . Here are slowly gathering together people who do things—writers, musicians, craftsmen, art workers, and those who think a simple life with some human touch worth more than the strain and show and haphazard of your ordinary communities. Here the tiniest cottage may be built side by side with a more spacious neighbor. And why not? Certainly our fitness to associate together upon simple human conditions should not be gauged by our incomes. There is no land speculation at Rose Valley, vaunting the beauties of nature in the marketplace.[5]

By 1904 William P. Jervis had established a pottery shop in the Guild Hall side room, presently known as the "Green Room." The Guild Hall, since restored as Hedgerow Theater, dates from 1841, when it was known as Hutton's grist mill. It was the social, civic and art center of the Association, housing the painting studio of Stratton and the bookbindery, in addition to a library, an auditorium and the Jervis pottery.[6]

Jervis, previously associated with the Vance/Avon Faience* works and immediately prior to coming to Rose Valley with the Corona Pottery*, remained at Rose Valley only a short time. He left to join the staff of the Craven Art Pottery* in mid-1905, at which time it appears the pottery work at Rose Valley ceased. Many of the buildings of the settlement are still standing, however, and several descendants of the "Rose Valley Folk" still reside in the picturesque community.

While at Rose Valley, Jervis continued his experiments in colored glazes,[7] achieving successful matt glazes which range from intense blues and greens to oranges and yellows. A unique matt glaze of rich mottled colors was used on decorative pieces of artware, sometimes with as many as half-a-dozen colors appearing on a single piece. It was intended to extend the use of this glaze to articles for domestic use as well,[8] but no evidence of such work has been found. Examples of the art pottery with "wrinkled" and metallic glazes as well as the mottled matt were shown at the 1905 exhibition of the New York Society of Keramic Arts.[9] Jervis, also much impressed by Brouwer's fire-painting used at Middle Lane*, possibly attempted to master the technique, although there is no indication that he was successful.[10]

The Association produced no pottery of its own; rather, it invited

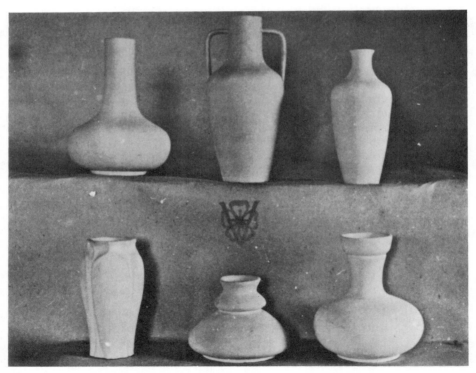

Display of Rose Valley ware. Price negatives, No. 232B. *George E. Thomas.*

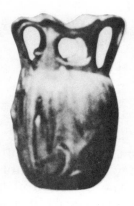

Rose Valley vase; h. 8¼" (21.0 cm). Raised nub mark. *Mr. & Mrs. Samuel Ward.*

accredited craftsmen such as Jervis to work in its shops under the patronage of its emblem. This emblem, systematically stamped upon Rose Valley products, was "the Association's guarantee that the workman has conformed in every item to competent mechanical and artistic standards. The device adopted is that of a buckled belt—a symbol of unity and brotherhood—encircling a wild rose with a letter V imposed on its petals."[11] A cluster of six raised nubs, apparently the center of the wild rose and an adaptation of the Association mark, appears on Jervis' Rose Valley work, although it was originally indicated in *The Artsman* that the rose-and-V mark as shown was to be used. On some pieces Jervis' incised signature is also to be found.

ROSE VALLEY

w fr Jervis

1. W. P. Jervis, *Crockery and Glass Journal*, LX (December 15, 1904).
2. Howard F. Stratton, *Historic Sketch of the Organization and Operation of the Rose Valley Association.*
3. *Rose Valley, Then and Now* (1966). For a general description of the Rose Valley community see M. Elizabeth Cook, *Sketch Book*, VI (October 1906), pp. 76-84; and Mabel T. Priestman, *House and Garden*, X (October 1906), pp. 159-65. See also Peter Ham, *et al.*, *A History of Rose Valley* (Rose Valley, Pennsylvania: privately published, 1973).
4. *The Artsman* (Rose Valley community publication), October 1903.
5. *Ibid.*
6. *Historic Sketch* and *Rose Valley, passim.*
7. E. A. Barber, *The Pottery and Porcelain of the United States*, p. 568.
8. Jervis, *op. cit.*
9. *Keramic Studio*, VII (June 1905), pp. 26-27.
10. Priestman, *op. cit.*, p. 163; cf. Jervis, *The Encyclopedia of Ceramics*, pp. 72-74.
11. *The Artsman, op. cit.*
* Information relating to this pottery is included in a separate chapter.

Roseville Pottery

Zanesville, Ohio

Organized in 1890 in Roseville, Ohio, the Roseville Pottery Company began with the production of stoneware in the plant formerly owned by the Owens Pottery*. Under the direction of George F. Young, general manager and later principal owner, it was incorporated in Ohio in early 1892, and by the following year forty-five workers were employed. Expansion continued, and in 1898 it acquired the Midland Pottery of Roseville, a producer of utilitarian stoneware, and also the Linden Avenue plant at Zanesville, originally built by the Clark Stoneware Company about 1892 for the manufacture of stoneware specialties. In 1901 a fourth plant—formerly that of the Mosaic Tile Company—was acquired on Muskingum Avenue, providing a second Zanesville location. Facilities in both Roseville and Zanesville were maintained until 1910, after which all work was done at the latter location: artware produced at the Linden Avenue plant, cooking ware at Muskingum Avenue.[1]

In 1900, immediately following the appeal verdict which upheld the lower court decision against Fry's patent of the atomized blended grounds,[2] Young hired Ross C. Purdy to create an artline to compete with Weller* and Owens. The new ware was named *Rozane,* formed from the firm name and the Zanesville location where it was produced, art pottery never having been made at Roseville.[3]

Rozane was hand-decorated with portraits, animals and flowers on a blended ground in imitation of Rookwood's Standard ware and similar to Long's Lonhuda*, Stockton's* Rekston, Weller's Louwelsa and Owens' Utopian. Following its success, other prestige lines were

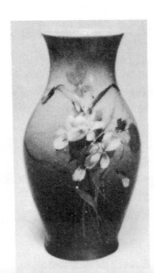

Roseville Rozane vase with pastel slip decoration on light blended ground ranging from green/blue at base to yellow/white at neck; h. 8" (20.4 cm). Rozane Ware seal detached, artist signature not decipherable. *National Museum of History and Technology (Smithsonian Institution; #379,611), Benjamin collection.*

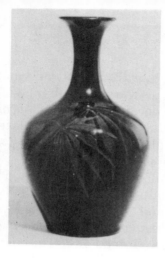

Early Rozane vase; h. 7⅜" (18.8 cm). Impressed Rozane/RPCo/ 836. *K. & T. Dane.*

created. With the appearance of the new Rozane wares, as the prestige lines were designated, the original line was renamed *Rozane Royal* and offered with both light and dark blended grounds. Other Rozane lines, according to the company's 1905 catalog, were *Mara,* a metallic luster ware designed to compete with Weller's Sicardo, and *Mongol,* an excellent high gloss rouge flambé or oxblood glaze, both of which were developed by John J. Herold;[4] *Egypto,* having embossed designs with a matt green glaze, was identified as "reproductions of Egyptian art antiques;" *Woodland* had primarily floral designs incised in the moist clay and colored, on bisque backgrounds sometimes embellished with stippling.

The 1906 catalog does not feature Mara, Woodland or Mongol, although these continued to be sold. In their place appear three other Rozane lines: *Crystalis,* a crystalline-glazed ware which represented a considerable technical achievement, but like Mongol met with only limited success; *Fudji,* like Woodland but with stylized rather than naturalistic designs, both lines reportedly designed by Gazo Fujiyama;[5] *Della Robbia,* decorated using a sgraffito process and applying the design—usually of the conventionalized variety—by means of a copying ink stencil or freehand, incising the outline by means of specially ground darning needles set in handles with the incised clay coming out the eye of the needle, then chiseling out the background to the second layer of color, and then painting in colored slips where additional color was desired.[6] Designed by Frederick H. Rhead, art director at Roseville 1904-08, Della Robbia is probably the finest and most original line produced there. Rhead also introduced the squeeze-bag technique at Roseville, as he had done at Vance/Avon* and Weller.

One of the only other Roseville lines requiring individual decoration was *Azurean* (Azurine), introduced about 1902, which had blue and white underglaze slip decoration on a blue and white blended ground. Frederick Rhead left in 1908 to join the Jervis Pottery* and was

succeeded as art director by his brother, Harry Rhead. Shortly thereafter all individual decoration of artware was abandoned; designs were either embossed or applied by decalcomania, and decoration was executed en masse by unskilled labor. Alexander relates that an artist-decorator who previously might have spent a day on a piece was then expected to finish more than 300 items a day.[7]

Rozane Royal continued to be produced on a very limited basis until 1919; but the standard underglaze slip-decorated ware had gone out of vogue, as had the competition among the Zanesville art potteries to produce prestige lines which yielded little profit. New lines were introduced regularly; *Donatello,* with fluted borders at top and bottom separated by embossed cherubs and trees, marked a definite turning point. Its immediate acceptance in 1915 established high-volume production, resulting in the installation three years later of the first continuous tunnel kiln in a pottery of this type.

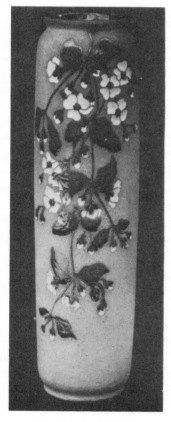

Roseville Woodland vase; h. 14¾" (37.6 cm). Rozane/Woodland seal, artist cipher possibly Gazo Fujïyama. *Charles Aghem.*

Roseville Della Robbia vase; h. 11⅛" (28.3 cm). In addition to Rozane Ware seal this piece has the incised decorator initials G.B. *The American Ceramic Society (#545).*

George Krause had succeeded Carl E. Offinger as head of technical supervision and development in 1915, and in 1918 George Young retired and Harry Rhead resigned as art director. The latter was succeeded by Frank Ferrel, who had worked for Weller until 1905 and later while at Peters and Reed* designed Moss Aztec. From 1918 until 1954 he modeled at least one new line a year, primarily of floral patterns, although the most successful was his *Pine Cone* design introduced in 1935.[8] Beginning with Ferrel's tenure, Roseville must definitely be considered a producer of industrial artware rather than of art pottery—a distinction which should be carefully drawn.[9]

Following World War II, sales, which had reached $1,250,000 for 1945, declined steadily. After an attempt at producing high-gloss glazes and Raymor oven-to-table dinner ware, the operation was closed and the plant sold in 1954.

Small collections of early Roseville work are maintained by the National Museum of History and Technology (Smithsonian Institution), The American Ceramic Society (Columbus, Ohio) and the National Road/Zane Grey Museum of The Ohio Historical Society.

Roseville's art lines are marked in numerous ways. Prior to the adoption in 1904 of the circular Rozane seal in relief, a variety of Rozane, Roseville and RPCo marks were used. The last designated mark should not be confused with the early mark of Rookwood or the RRPCo mark on Robinson-Ransbottom stoneware. Since at almost all times there was a considerable overlapping in the marks used, establishing the date of a particular item from its mark is haphazard at best. Decorator signatures or initials on the hand-decorated work are not uncommon,[10] although without the firm name on the ware it is difficult to attribute pieces to a particular pottery, as many decorators worked for other Zanesville potteries at different times. As with Weller, many pieces are found with mismarked line designations, and a considerable number bore only a paper label. Seconds were also sold, and these included pieces which had been "over-molded," being much heavier than designed. Later marks were generally imprinted or in-mold and include the R-with-V and the various script signatures.

1. William Watson Wilson, "A History of the Roseville Village School District" (a thesis presented for the degree of Master of Arts at Ohio State University, 1939),

p. 96; J. Hope Sutor, *History of Muskingum County* (1905), pp. 176-77, 494-95; *Report of the Geological Survey of Ohio,* VII (1893), p. 91; N. F. Schneider, *Zanesville Art Pottery,* pp. 19-21.

2. For a discussion of the Fry process and related litigation, see chapter on Lonhuda.

3. The Rozane name was registered as a trademark of the pottery November 29, 1904, by the United States Patent Office (#43,793). "This trade-mark consists of the arbitrarily-selected and fanciful word 'Rozane.' This trade-mark was adopted by said corporation for use in its business on or about January 1, 1904, since which date it has been continuously used. The class of goods to which this trade-mark is appropriated is pottery, and the particular description of goods comprised in such class on which it is used by said corporation is hand-decorated under-glaze art pottery. The trade-mark is affixed to each article of goods by stamping or imprinting it thereon or by affixing to the article a label containing and displaying the mark." The dating of January 1, 1904, as the earliest use is definitely in error as *The Clay-Worker,* XXXIX (April 1903), p. 439, makes reference to the "celebrated 'Rozane' ware," it evidently being a familiar appellation by that time.

4. *The Clay-Worker,* LXXIX (May 1923), p. 572; L. & E. Purviance and N. Schneider, *Roseville Art Pottery in Color,* plate 3. While the first successful oxblood produced in the United States was developed at the Chelsea Keramic Art Works*, the pieces were so costly to produce that it was impossible to sell them at commensurate prices. Roseville overcame this obstacle and Mongol became one of the oustanding lines offered by the pottery, earning for it a First Prize at the 1904 St. Louis exposition. According to Schneider (*Zanesville Art Pottery,* p. 21), it did not appeal to the public and unsold heaps of it lay under the stairways for years. An example of the line is in the collection of the National Museum of History and Technology (Smithsonian Institution; #237,930), a gift from the pottery in 1906.

5. Purviance & Schneider, *op. cit.,* plate 2. There are numerous spelling variants of the Fujiyama name, the most common variant being Fudji, as it appears in the 1905 Zanesville directory and the 1906 Roseville catalog, reprinted at Zanesville, Ohio, in 1970 by Norris F. Schneider. Fujiyama also worked for Weller, where his ware was identified as "Fudzi."

6. F. H. Rhead, *The Potter,* I (January 1917), p. 57. In this presentation Rhead recounts the development of this process at Roseville and his relationship with the "quarrelsome Dutchman," John Herold, who was Roseville's shop superintendent at the time. Excellent insight is offered into the introduction of a new technique and the careful division of labor at large art potteries such as Roseville. Rhead indicates that new help after two months' training could execute an average of one large or four to six small pieces a day using this sgraffito method of decoration.

7. D. E. Alexander, *Roseville Pottery for Collectors,* p. 18.

8. Line designations at Roseville, principally those by Ferrel, bear much closer relationship to the decorative motif than those of Weller (cf. note 16, Weller). A listing of Roseville lines with dates of introduction appears in Purviance & Schneider, *op. cit.,* plates 20-23.

9. For a brief resume of the history of the 1918-44 period, dominated by Krause, Ferrel and Frank Barks, and especially as relates to the management of the firm, see *The Bulletin* of The American Ceramic Society, XXIII (July 15, 1944), pp. 221-22.

10. A listing of names and initials of decorators is presented by Purviance & Schneider, *op. cit.,* plate 5.

* Information relating to this pottery is included in a separate chapter.

Shawsheen Pottery

Billerica, Massachusetts
Mason City, Iowa

Shawsheen ware as pictured in 1911. *Pottery & Glass.*

The Shawsheen Pottery was originally established in Billerica, Massachusetts, in the spring of 1906 by Edward and Elizabeth Burnap Dahlquist and Gertrude Singleton Mathews. The first public showing of forty pieces of their ware was held at Doll & Richards', Boston, in November 1906. Work was hand coiled and made of clay from Gay Head, Massachusetts. The color was described as a warm black, with tones of bronze and copper on it, rich in effect and recalling the Etruscan potteries and bronzes seen in museums. Ornamentation, usually a simple geometric pattern, was incised or excised on the moist surface with wooden tools.[1] The following year the operation was moved to Mason City, Iowa,[2] where the pottery was located at 310 North Main.[3]

In Iowa the Dahlquists taught ceramic classes at both the pottery

Shawsheen ware as pictured in 1911. *Keramic Studio.*

and their home in Clear Lake, at first using the hand-coiled method by which they had achieved notable success. Later, a considerable portion of their work was thrown. Shawsheen, the name of a brook near their home in Massachusetts, is an Indian word meaning "meandering" and connoted the lack of formalism achieved through the hand-crafting of their ware.

It is uncertain as to whether the Dahlquists were associated with the Brush Guild* before establishing their own pottery in Billerica, or whether Lucy F. Perkins (Ripley) of that Guild was associated with the Dahlquists in Massachusetts; but it was Lucy Perkins who was responsible for the Dahlquists' turning their attention from painting to the hand-coiling and modeling of clay. Both Dahlquists had been art students in Minneapolis and later at The Art Institute of Chicago.

The Dahlquists did the designing, throwing or building, decorating, glazing and firing of their own work. However, since considerable time was devoted to teaching, especially in Iowa, many pieces from the Shawsheen kiln were the work of students. It has been reported[4] that Edward Dahlquist taught at the Memorial University at Mason City. This short-lived institution opened in 1902 and closed mid-year of the 1909-10 term for lack of funds. Edward Dahlquist, about that time, joined the staff of the University City Pottery* as the instructor of built pottery.[5] It would appear that he left the University City works with the Robineaus in 1911 and returned to Iowa to resume work there.[6] Shortly thereafter the Dahlquists moved to Chicago, where Edward taught pottery periodically at the Art Institute and Elizabeth taught art and pottery classes in her studio.

About 1915 Elizabeth Dahlquist opened The Ho Ho Shop in Chicago, which specialized in objets d'art, with emphasis originally on Chinese porclains. As this venture became more demanding on her time, all ceramic work was abandoned. Presumably it was here that the most successful Shawsheen work was sold, as few examples are extant in the immediate family.[7] Elizabeth died in 1963 and Edward nine years later at the age of ninety-four.

Shawsheen output included vases, jardinieres, tea sets and bowls. One of the most handsome pieces is illustrated.[8] Recently the acquisition of examples of the Dahlquists' work has been undertaken at the Pioneer Museum and Historical Society of North Iowa in Mason City, and a well-marked tea set is now in their collection.

The mark of the Shawsheen Pottery is the imprinted or incised SP cipher. Often the heavy glaze has obscured the mark, and in many instances no mark was used.

1. Boston *Evening Transcript*, November 3, 1906, p. II-14. The work of the pottery was highly commended by H. Winthrop Pierce, president of the Copley Society, Boston, who commented on the artistic success of their show. He wrote (in a letter which is in the possession of the Dahlquist family): "You are doing the unusual and do it well."
2. *Keramic Studio*, XIII (September 1911), p. 105.
3. Local directory, 1910.
4. Private correspondence with the reference librarian of the Mason City Public Library.
5. *The Pioneer*, I (April-May 1911), p. 10.
6. The *Keramic Studio* article (*loc. cit.*) evidently evolved from the acquaintance made by the Robineaus and Dahlquists at University City. That article, dated September 1911, is written in the present tense, beginning "Shawsheen Pottery is made by a guild of three members." It would seem to indicate either that Elizabeth Dahlquist remained in Iowa operating the pottery while Edward Dahlquist was at University City or else that operation of the Shawsheen works was resumed for a short time in 1911 in Iowa.
7. Private correspondence with the family.
8. Other work is illustrated in *Keramic Studio*, XIII (September 1911), p. 104; and *Pottery & Glass*, VII (December 1911), p. 26.
* Information relating to this pottery is included in a separate chapter

Sinclair Art Pottery

Chester, West Virginia

Sinclair Art Pottery is another firm which appears never to have begun production. The only noted reference to it was made in early 1904 by *The Clay-Worker,* which reported that "the Sinclair Art Pottery Co. is a new concern in East Liverpool, Ohio, whose plant is now in the course of construction at Chester, W.Va., opposite the city. Mr. George Sinclair is at the head of the new plant which will turn out only hand-decorated goods."[1]

There is no record of incorporation in either West Virginia or Ohio. No marked examples are known to exist.

1. *The Clay-Worker,* XLI (February 1904), p. 280.

Stockton Art Pottery
Stockton, California

Clay-working in California has a long history. The earliest attempts by the white man date back prior to 1784 when adobe bricks were made for building walls. In that year it is reported that roofing tiles were made in Santa Barbara. Coarse pottery was in production in San Francisco and other places by the turn of the nineteenth century, and the industry expanded quickly as a result of the rapid settlement of the state in the 1850s.[1]

Important potteries were in operation in the Los Angeles, San Francisco (Oakland Art Pottery*) and Sacramento areas by December 1890, when the Stockton Terra-Cotta Company was formed for the manufacture of sewer and stove pipe and fire brick.[2] The location, on the Mormon Channel in Stockton, was chosen because of the availability of water and rail transportation and the area's ample resources of clay and labor.

While it was suggested as early as 1891[3] that an art pottery be established at the works, to which A. W. Robertson (Roblin*) was willing to lend his talents,[4] it was not until 1894, under the direction of Thomas W. Blakey and his son, John W., both expert Scottish potters, that manufacture of fancy pottery and artware was begun at Stockton Terra-Cotta. The body of these lines was semi-porcelaneous, and output included teapots, creamers and sugars, mostly decorated in-mold with an entwined ivy pattern. In addition, work with hand-painted

Stockton presentation vase, one of a matched pair; h. 10" (25.5 cm). On base is the notation "To Miss J. H. Weber/First semi-porcelain product of the Stockton Terra-Cotta Co./Sept. 1894", the letters S.T.C.Co. and an unknown artist's cipher. *Private collection.*

273

gold decoration over a high-gloss glaze was produced. Two rare and finely executed vases which have been examined are not only marked "Stockton Terra-Cotta Co." and dated "Sept. 1894," but bear the inscription "First Semi-Porcelain Product" as well as the artist's rebus.[5] For the semi-porcelain artware New Jersey clay was used. Later, and especially for the Rekston art line, a plastic yellow California clay from the Valley Springs region was employed.[6]

It is important to understand in perspective Stockton's production of *Rekston,* an underglaze, colored-slip decorated art pottery with a blended brown background, similar to that of the Ohio art potteries. It was introduced just prior to the summer of 1895, when the Stockton Terra-Cotta Company became insolvent—Rekston (originally spelled "Reckston") compounded by taking that firm's name and eliminating the duplicate letters, and using those which remained with the exception of the "a"; the "c" was dropped apparently when the line was later produced by the Stockton Art Pottery Company.[7] With the establishment of this early date of the Rekston line, it becomes contemporary with Weller's introduction of this type of ware and pre-dates Owens'* Utopian and Roseville's* Rozane (Royal).

By late 1895 the clay industries in California were in the midst of a severe depression. Building operations were at a standstill, and little or no sewer work was being done. Prices of clay products were the lowest in many years, forcing numerous operations out of business, including that at Stockton.[8]

With widespread local financial backing and a great infusion of new capital by Arthur C. Hopkinson, who had been the company's manager since 1893, the Stockton Art Pottery was formed in 1896 and incorporated in California that October. The plant was headquartered at the southeast corner of Sacramento and Taylor, adjacent to the older

Rekston vase with Mariposa Pottery designation; h. 12" (30.5 cm). Regular impressed Stockton/Rekston mark and additional notation in slip "Mariposa Pottery/Stockton/California". *Private collection.*

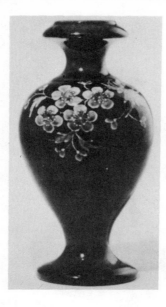

Stockton Rekston ware vase; h. 7⅞" (20.0 cm). Impressed Stockton/Rekston mark. *Private collection.*

works at Union and Taylor. George W. Tatterson was the company president and Charles W. Weber, son of the founder of the city of Stockton, was treasurer. Hopkinson was plant manager, a position he had held in the earlier operation, and Thomas Blakey remained superintendent of the works. All claims against the Stockton Terra-Cotta Company were assumed, and operations begun.[9] Nathan, Dohrmann & Company of San Francisco and New York acted as the new firm's distributor for decorative artware, which once again was offered.[10] In addition to Rekston, monochrome glazed work was offered in brown, blue, mustard and green, as were various mottled glazes of these colors and an excellent imitation of tortoise-shell. One of the earliest dated pieces—April 14, 1897—with the Stockton Art Pottery mark is a shaving mug in the collection of the Pioneer Museum in Stockton with a dark blue monochrome glaze and gold overglaze decoration.

By the fall of that year ten women were regularly employed as artists for decorating Rekston ware and other lines, output of which was about a hundred pieces a day of various sizes.[11] Operation of the pottery was suspended after the holiday season, undoubtedly to give it time to reorganize its work after the sudden death of Thomas Blakey in mid-December, as well as to make improvements and to allow for the sale of unsold stock. The pottery's production, foremost of which was Rekston, met with considerable success, and orders for over $20,000 worth of goods were secured during February 1898.[12] With those in hand, the directors ordered the resumption of business in all departments including the decorating rooms, and named John Blakey to succeed his father as superintendent.

By early 1900 economic conditions again forced the plant's closure. In August of the following year the Stockton Brick and Pottery Company was formed by capitalists who had found some important clay deposits on their property, and work was resumed on the 27th of that

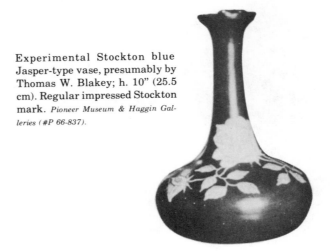

Experimental Stockton blue Jasper-type vase, presumably by Thomas W. Blakey; h. 10" (25.5 cm). Regular impressed Stockton mark. *Pioneer Museum & Haggin Galleries (#P 66-837).*

month. The first production was of sewer pipe and brick. For their work the plant was expanded to three large kilns, in anticipation of a full line of clay goods including drain tiles, chimney pipe, flue lining, fire-clay goods, assayers' crucibles and furnaces, terra cotta trimmings, brick of all kinds and Rekston artware.[13] John Blakey served as foreman and W. C. Neumiller directed the pottery's operation, which proved to be extremely profitable.

After further new discoveries of valuable clay deposits the pottery planned the extensive manufacture of glazed white sanitary and art ware in addition to other items. Before either could be effected, the entire plant was destroyed by fire in November 1902. The building in which the molds for the art lines were stored was saved, and early post-fire speculation looked for the resumption of art pottery production.[14] This was not the case, and while clay-working operations were resumed, they did not include the making of art pottery.

Extensively cast, artware production included vases, pitchers, jardinieres, umbrella stands and bowls. Decoration, especially of the Rekston line, was in almost all instances of various naturalistic flowers and was far superior to the technical aspects of the pottery. Some experimental work was undertaken which included a blue Jasper-type ware with pâte sur pâte decoration. Examples of such work from the personal collection of the Blakeys are to be found at Stockton's Pioneer Museum.

Not all Stockton artware was marked. With the above-noted exception, no marked examples of the Stockton Terra-Cotta works have been found. In some "unmarked" cases of the Stockton Art Pottery's production, the heavy glaze over the base has simply obliterated the mark, but with careful scrutiny it can often be discerned. Unmarked

examples can frequently be identified by Stockton's distinctive molded handles or shapes, or by the designs of the decoration in the case of the Rekston ware. These designs are easier to attribute than the work of the Ohio producers, as there was not the interchange among potteries of decorative artists that was so prevalent in the East. The impressed circular mark is common to all the Stockton Art Pottery's artlines, with the Rekston designation impressed below it on that underglaze-decorated brownware. Some pieces were also marked "Mariposa Pottery" in slip, beneath the glaze.[15] Decorators were not encouraged to sign their pieces.

REKSTON

1. Hubert Howe Bancroft, *History of California* (1884), Vol. 1, p. 617.
2. *Ibid.,* (1890), Vol. 7, p. 99.
3. Stockton *Evening Mail,* July 8, 1891, p. 1. Specifically suggested by Charles Bailey were a line of Rockingham-type ware of yellow clay and jet art goods of red clay.
4. Robertson, according to the Oakland, California, directory for 1892, had removed to Stockton. A hand-built pitcher was glazed and fired at the Stockton plant by him on July 15, 1891, according to the incised inscription on the piece. This was the same day that the San Francisco *Call* (p. 3) reported that "Stockton's terra-cotta works are now in successful operation with a force of twelve men."
5. These particular pieces are shown as figures 1 and 7, *Spinning Wheel,* XXVII (October 1971), pp. 24, 26.
6. *The Structural and Industrial Materials of California,* Bulletin No. 38 (1906), California State Mining Bureau, p. 212.
7. *Brick,* VII (November 1897), p. 185; E. A. Barber, *Marks of American Potters,* pp. 164-65.
8. *The Clay-Worker,* XXVI (September 1896), p. 226; *ibid.,* XXVI (November 1896), p. 396.
9. *Ibid.,* XXVI (December 1896), p. 475; *Clay Record,* IX (July 14, 1896), p. 17.
10. See advertisement, *Crockery and Glass Journal,* XLIV (July 1, 1897), p. 39.
11. *The Clay-Worker,* XXVIII (December 1897), p. 474; see also Stockton *Evening Mail,* September 6, 1897, p. 1.
12. *The Clay-Worker,* XXIX (March 1898), p. 266; *ibid.,* XXIX (January 1898), p. 541.
13. *Ibid.,* XXXVI (September 1901), p. 264; also see the Stockton *Daily Record,* August 22, 1901, p. 1.
14. Stockton *Daily Record,* November 17, 1902, p. 1.
15. The use of this name is perhaps related to an account in *Brick* (VIII, April 1898, p. 204) that "the Stockton (Cal.) Art Pottery Company will soon change the name of its special ware, formerly called the Rekston. This suggestion comes from eastern buyers, who are of the opinion that it will meet with even more ready sale if the name carries with it something of a suggestion that it is a California product."
* Information relating to this pottery is included in a separate chapter.

Teco Pottery

Terra Cotta, Illinois

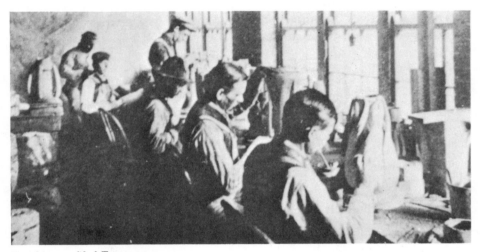

Finishing molded Teco vases. *Sketch Book.*

Teco Pottery is not the name of a producer but rather the designation of the art line of the American Terra Cotta and Ceramic Company. Sometimes known as the Gates Potteries, the firm was founded in 1886 in Terra Cotta, forty-five miles northwest of Chicago, for the manufacture of sewer pipe, brick and terra cotta. This last achieved for the firm considerable renown for the quality of its architectural application.[1]

William Day Gates was a lawyer by training and practiced for a short time in Chicago. He became interested in clay about 1880, later establishing the clay works, which were incorporated in 1887, and of which he served as president. This successful operation provided a solid base from which to venture into art pottery. Whereas many of the art potteries were faced with heavy initial expenditures to set up operations, all necessary equipment was available for the Teco pottery prior to its introduction to the public in 1901,[2] and it could therefore offer its output at considerably lower prices than other similar producers. The name Teco—derived from the first letters of Terra and Cotta—was a registered trademark and was used on the experimental art pottery as early as 1895.[3]

Most such experimental work was conducted by Elmer E. Gorton, a graduate of the department of ceramics at Ohio State, assisted by two of Gates' four sons, William Paul (Pat) and Ellis Day, both graduates of the same institution. Thus, from the beginning, Teco had plenty of room and the best of workmen, with unlimited research and kiln facilities. Gates himself designed many of the early forms, some of which were original and quite complicated. Others were executed by friends in the architectural profession, and by Fritz Albert, Mrs. F. R. Fuller, Hugh M. G. Garden, J. K. Cady, W. K. Fellows, Blanche Os-tertag, W. J. Dodd, F. Moreau, N. Foster, M. P. White, W. B. Mundie and others. A few pieces were thrown, but the standard ware was extensively molded.[4] Local clays and clays from Brazil, Indiana, were used.[5]

Early, experimental artware was first glazed in subdued reds of different tones, then in buffs and later in browns. When architectural terra cotta was produced with a marbled or mottled surface, experiments producing similar effects on the art pottery were also undertaken.[6] The rapid rise in interest in the matt green glaze popularized by Grueby* at the turn of the century provided Teco with a specific focal point, and for almost a decade only "Teco green" glazed ware was offered commercially by the pottery.[7] While this was akin to the matt greens of the period, it had a distinguishing grayish (silver luster) effect.

Successful experiments had been pursued for a time with numerous other glazes of both high gloss and matt types. In addition to an aventurine glaze, crystalline glazes, which had been one of the ceramic novelties of the 1893 Chicago exposition, were also produced at Teco. By 1901 minute crystals had been achieved on artware,[8] and in 1904 at the St. Louis exposition Teco became the first art pottery of the United States to exhibit such work. Critics felt they did not have the variety of Royal Berlin or the depth and texture of Sèvres, Royal Copenhagen or Rostrand crystallizations; this was primarily the fault

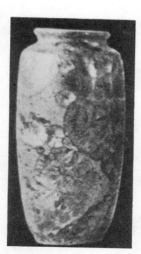

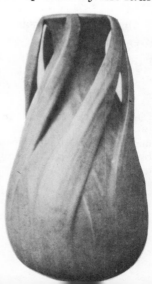

[left] Experimental Teco porcelain vase with crystalline glaze. *Keramic Studio.*

[right] Teco vase designed by F. Albert, number 192 in Teco catalog; h. 14¾" (37.6 cm). Impressed mark. *Janeen & James Marrin.*

279

of the inferior semi-porcelaneous body and not of the glaze.[9] Over 500 shapes constituted Teco's offerings in 1910, when new glaze colors were offered on a commercial basis. All of the matt variety, these were: several different shades of green; four gradations of brown; and gray, blue, rose, purple and yellow.[10]

Painted decoration on artware was avoided. The early and most successful designs were of the sculptured variety, rivaling the somewhat similar work of Van Briggle*, Tiffany* and others, using naturalistic mofits—most often leaves and flowers—as an integral part of the body.

Garden pottery, some of a mammoth scale, was also produced under the Teco name, as was a line of tea ware; a set of this consisted of pot, cups, saucers, cream pitcher and sugar bowl, most often in a pinkish tan or pearl gray.[11] In 1912 a new line of the then-popular faience tile was shown, including polychrome faience work. That same year the pottery's masterful sculpturing of ten terra cotta panels depicting the life of Lincoln was completed. Karl Schneider, at that time head of the pottery's force of sculptors, produced the panels,[12] which in 1970 were still a part of Lincoln Hall at the University of Illinois, Urbana.

Beginning in 1904 Teco was nationally marketed and extensively advertised, especially in *The House Beautiful* and *The Craftsman*. It is interesting to study the objects illustrated and see what started out with creative artistry steadily decline, like so many of its rivals, into mass-produced containers of uninspired design. The elaborate molded designs required careful finishing and trained personnel, and were early abandoned; and production costs, always at a minimum, were further reduced by the use of the single Teco-green glaze until 1910. Presumably to add some interest to what had become a rather dull line, the new colors were introduced at that time and continued, it would appear, through 1922,[13] about the last year such work was produced. In 1930 the American Terra Cotta and Ceramic Company was sold, and five years thereafter Gates, the spirit of the operation, died.

There are several pieces of Teco in museum collections scattered about the country, but these are rarely of elaborate design. Rather plain early examples are to be found at the Worcester

[far right] Teco vase, matt green glaze; h. 18" (45.9 cm). Impressed mark. *Private collection.* [right] Teco matt green vase; h. 13¾" (35.0 cm). Impressed mark. *Private collection.*

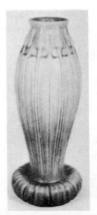

[Massachusetts] Art Museum and at the National Museum of History and Technology (Smithsonian Institution).

The distinguishing mark of Teco, with the long-stemmed T and its extended cross-line on the right, below which the remaining letters are arranged, was normally impressed. Designers are not known to have signed their work; model numbers were regularly used.

1. *The Clay-Worker*, XLIX (January 1908), pp. 31-34. The unsigned author quotes Gates extensively, giving insight into both Gates and the development of his pottery. The pages of *The Clay-Worker* are perhaps the best source for following the developments of Gates' work as he was one of their leading contributors, and considerable space was devoted to depicting the Gates operation and its production.
2. M. Benjamin (*American Art Pottery*, pp. 25-26) is in error when he indicates a 1903 date. In fact, most of Benjamin's material regarding Teco is erroneous, as is L. Henzke's (*American Art Pottery* [Camden, New Jersey: Nelson, 1970]), who repeats Benjamin almost verbatim. For a more accurate account see Walter E. Gray, *Brush and Pencil*, IX (February 1902), pp. 289-96, in which is illustrated a full line of artware which "has as yet scarcely been introduced to the public." A portion of Gray's material is reproduced in *Illustrated Glass and Pottery World*, X (May 1902), pp. 16-17. *The Clay-Worker*, XXVIII (October 1897), p. 272, pictures Gates in his studio at work on his art pottery experiments.
3. Papers filed with the United States Patent Office for Trade Mark No. 50,994, registered April 3, 1906.
4. Gray, *op. cit., passim*. An actual presentation of the potting process involved in the production of Teco ware is given by Elmer C. Mitchell, *Brush and Pencil*, XV (April 1905), pp. 70-75 (one must overlook, however, the picture of Van Briggle's Harry Bangs which appears at the opening of the article, p.67), and also in more general form by S. S. Frackelton, *Sketch Book*, V (September 1905), pp. 13-19. In the following issue of *Sketch Book* (V, October 1905, pp. 73-80), Frackelton studies some of the work of Albert and also of Hardesty Gillmore Maratta.
5. H. Ries and H. Leighton, *History of the Clay-Working Industry in the United States*, p. 85.
6. Gray, *op. cit.*, pp. 291-92.
7. William H. Edgar, *International Studio*, XXXVI (November 1908), p. xxix.
8. Gray, *op. cit.*, p. 292.
9. *Keramic Studio*, VI (February 1905), p. 219; S. Geijsbeek, *Transactions* of The American Ceramic Society, VII (1905), p. 346.
10. Charles Crosby, *Arts and Decoration*, I (March 1911), p. 214; Evelyn M. Stuart, *Fine Arts Journal*, XXV (August 1911), p. 103. An earlier article by Stuart appears in *Fine Arts Journal*, XX (June 1909), pp. 340-45.
11. Jonathan A. Rawson, Jr., *The House Beautiful*, XXXIII (April 1913), p. 151.
12. *The Clay-Worker*, LVII (February 1912), pp. 247-51; *ibid.*, LVII (April 1912), pp. 605-10.
13. Lilian H. Crowley, *International Studio*, LXXV (September 1922), p. 543.
* Information relating to this pottery is included in a separate chapter.

Tiffany Pottery

Corona, New York

The introduction of Tiffany pottery continues to be erroneously linked with the cessation of Grueby's art pottery production, which had furnished Tiffany with ceramic bases for their glass shades.[1] This was not the case, as would be indicated by a careful study of the facts, not the least of which is that Grueby continued art pottery production for several years after Tiffany introduced its ceramic line.

Experiments with pottery at the Tiffany studio were undertaken as early as 1898 at Corona.[2] After a few years of such experimentation, Tiffany Furnaces' Favrile (meaning "hand made") pottery was publicly shown at the Louisiana Purchase Exposition, St. Louis, in 1904;[3] and again in April of the following year at the New York Society of Keramic Arts several "old ivory" vases were exhibited.[4] The ware was not commercially offered, however, until the latter part of 1905, when a large display of the pottery was arranged in the new building of Tiffany and Company on Fifth Avenue in New York City. As the building was opened on September 5, 1905, this initial commercial offering may well have been in conjunction with that event. While not listed in Tiffany's *Blue Book* of 1905 (prepared in October 1904), the pottery was included in the 1906 *Blue Book* (prepared in October 1905).[5]

Regardless of when Tiffany began to make pottery, the underlying intention of the operation is what requires clarification. Tiffany did not go into ceramics because Grueby had ceased to be a source of supply. Tiffany entered the field because of his fascination with all forms of artistic expression, including not only ceramics but jewelry, enamelware, textiles, mosaics, china and glass as well.

Some Tiffany pottery was thrown, but by far the vast majority was cast from molds using a white clay which was very high fired. The body designs offered another avenue for Tiffany's Art Nouveau-influenced naturalism, and all forms of native flora are found depicted. Whereas Tiffany's glass carries out the decorative motif only on the surface of the object, the pottery incorporates the motif into the design as well. One particular method used by Tiffany for the execution of such was the spraying of natural subjects, such as flowers, plants and foliage, with shellac until they were rigid, after which plaster-of-Paris molds were made.[6]

Originally the color of Favrile pottery was almost exclusively a light yellow-green shading into darker tones and hence resembling "old ivory," the name sometimes applied to it. By 1906 green tints were successfully employed.[7] There were also matt, crystalline and iridescent glazes; the superb application of the Tiffany glazes was an achievement as important as the sophisticated forms with which they harmonized.[8] The "Bronze Pottery"—pieces whose interior was glazed and whose exterior was covered with a bronze plating much in the style of Clewell's* work—seems to have been a late development, appearing in the 1911 *Blue Book*.[9]

The ceramics line is purported not to have been one of Tiffany's most successful commercial ventures. Perhaps this was because unique designs and glazes required too much time and labor to produce; perhaps the ceramics were simply overshadowed by Tiffany's work in glass. In the case of glassware, Tiffany consigned it to retail outlets, and if it was not sold after three months it was returned to stock. If it was not sold after being displayed at three retail showrooms, it was either offered to employees at a discount, given as a gift or destroyed.[10] It is reasonable to assume the same was the case with Tiffany pottery, and this might also account for its relative scarcity today. The offering of Tiffany pottery ceased between 1917 and 1920, but even by 1914 the past tense was being used in regard to Tiffany's interest in pottery,[11] and pieces offered after that time may well have been from stock.

The most extensive public collection is to be found at the Chrysler Museum at Norfolk, Virginia.

All Tiffany pottery is marked, primarily with the incised L.C.T. cipher. In addition "L. C. Tiffany," "Favrile Pottery," or "Bronze Pottery" were often etched into the base. In contrast to Rookwood*,

[left] Green glazed Tiffany vase with arrowroot plants and snake; h. 8" (20.4 cm). Incised cipher and L.C.Tiffany Favrile Pottery/P682. *New York, private collection.*
[right] Tiffany vase, ivory glaze with maple leaves and pods; h. 7¾" (19.7 cm). Incised cipher and 7/P704/L. C. Tiffany Favrile Pottery. *New York, private collection.*

Grueby*, Newcomb*, and Buffalo*, where artists' signatures were encouraged or even required, these never appear on Tiffany pieces, as all the work was attributed to Tiffany's studio itself.[12] The code "A-Coll.", as with Tiffany glass, indicates that the piece on which such a mark is affixed was designated for Tiffany's personal collection.

1. Lucile Henzke, *American Art Pottery* (Camden, New Jersey: Nelson, 1970), p. 274, among others.
2. Martin Eidelberg in his definitive study of Tiffany Pottery (*The Connoisseur*, CLXIX, September 1968, p. 61, note 6) reports that a single piece of pottery was included in a loan to The Metropolitan Museum of Art by the Tiffany Foundation, which indicated it to have been made in 1898. *Keramic Studio*, II (December 1900), p. 161, announced "that Mr. Louis Tiffany is busy experimenting in pottery, which no doubt means that he will finally produce something as artistic as his Favrile glass. In an interview with the manager, our representative was told that as yet, Mr. Tiffany is in the experimental stage, but that he had been so charmed with the work of artist potters at the Paris exposition, that he came home with the determination to try it, and that he would probably produce something in the lustre bodies."
3. Brice Garrett (*Spinning Wheel*, XIX, July-August 1963, p. 33) indicates that three pieces of Favrile pottery were shown at St. Louis.
4. *Keramic Studio*, VII (June 1905), p. 26.
5. Eidelberg, *op. cit.*, p. 61, note 11.
6. A. Christian Revi, *American Art Nouveau Glass* (Camden, New Jersey: Nelson, 1968), p. 87. In personal correspondence Revi has indicated that both J. Stewart and Mrs. A. Douglas Nash confirmed that real flowers and plants were used to make the molds for some of the pottery and metalware. A particular illustration of this technique is shown by Revi, p. 89, figure 156.
7. Clara Ruge, *International Studio*, XXVIII (March 1906), p. xxiv.
8. Clara Ruge, *Pottery and Glass*, I (August 1908), p. 5.
9. According to Eidelberg, *op. cit.*, p. 61, note 14, this line is not listed in the 1909 *Blue Book*.
10. Revi, *op. cit.*, p. 90.
11. Eidelberg, *op. cit.*, p. 61, note 24.
12. *Ibid.*, p. 60. Little is known of anyone involved with Tiffany ceramics. Eidelberg notes that "it is perhaps just and proper that only the name of Tiffany was associated with his ceramics . . . While it was certainly left to trained technicians to perfect the individual glaze formulas, still the basic concepts which dominated the experiments—a dependence on chemical interaction, and the subtle but vivid coloration—are wholly in accord with Tiffany's own aesthetic. In the same way, while individual designers may have worked out the specific details of each design and may have incorporated ideas of their own, always the presence of Tiffany is to be felt throughout."
* Information relating to this pottery is included in a separate chapter.

Trentvale Pottery

East Liverpool, Ohio

In early 1901 the Trentvale Pottery was organized to acquire the California Pottery plant—so named because it was so far from the other potteries—of East Liverpool.[1] This eastern Ohio city had early become one of the pottery centers of the United States. From the small beginnings in 1839 of James Bennett, who had found in the area a good source of clay, by 1868 East Liverpool could boast twenty-nine kilns which turned out Rockingham-type and yellow ware made from local clays. In 1872 white ware was first introduced by Knowles, Taylor and Knowles; and by 1907 the value of pottery produced in the district approached the $6 million level or nineteen percent of the total production in the United States.[2]

The California Pottery was built by Edward McDevitt, Stephen Moore, Ferdinand Kepper and others. McDevitt and Moore assumed full control of the pottery in 1871 and produced a good grade of Rockingham-type and yellow ware. As the two aged the plant deteriorated, and about 1900 it was closed, to be reopened the following year by Trentvale.

Trentvale's original art pottery was similar to Rookwood's Standard underglaze decorated ware. Another type of work was identified by Jervis as jet ware, a red body covered with a blue glaze producing a brilliant black called jet.[3] Artware production was of short duration, and within a year the plant closed. It was started up again early in 1902 by Trentvale, but output was principally "specialties" as opposed to artware.[4] Nothing further is known of Trentvale's operations, which were short-lived.

1. *China, Glass and Lamps,* XXI (January 17, 1901), p. 2; *Brick,* XIV (February 1901), p. 114.
2. H. Ries and H. Leighton,*History of the Clay-Working Industry in the United States,* pp. 184-88. Also see W. Stout *et al., Coal Formation Clays of Ohio, passim;* also note 1, Edwin Bennett Pottery. An extensive, revised record of the pottery industry in the East Liverpool district appears in *The Bulletin* of The American Ceramic Society, XXIV (August 15, 1945), pp. 282-88.
3. W. P. Jervis, *The Encyclopedia of Ceramics,* pp. 567, 324.
4. *The Clay-Worker,* XXXVII (March 1902), p. 370.

University City Pottery

University City, Missouri

Edward Gardner Lewis, a man of many talents and ambitions which centered largely around a group of co-related publishing, educational and business enterprises, launched the American Woman's League in 1907.[1] An editorial in the March 1, 1910, issue of *American Woman's League*[2] indicates that the plan and purpose of the League—dedicated to "the integrity and purity of the American home, with wider opportunity for American women"—centered about the People's University. Members of the League were entitled to enroll in correspondence

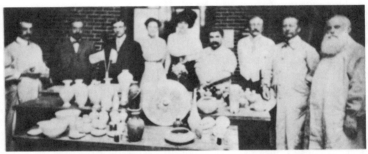

The distinguished staff of the University City Pottery and Art Institute. From left to right: F. H. Rhead, S. Robineau, E. Lewis, A. Robineau, K. Cherry, E. Labarriere, G. J. Zolnay, E. Diffloth and T. Doat; April 1910, with the results of the first kiln.

courses, and during the first year of full operation in 1910 a total enrollment in excess of 50,000 had been recorded. All instruction was given by that means, with one exception: women of superior talent were invited to University City as honor students to study under the personal instruction of the staff there assembled.

At University City, schools of education, language, commerce and administration, journalism, and photography were planned,[3] but none were developed to the extent of the Art Institute. The germ of that Institute was Lewis' own artistic interests and his amateur ceramic work, a skill which was self-taught using Taxile Doat's textbook, *Grand Feu Ceramics,* translated by Samuel Robineau.[4] The faculty of the Institute was most impressive: George Julian Zolnay, internationally renowned sculptor, was Dean and Director. John H. Vanderpoel, Director of the School of Painting, was the leading instructor at

The Art Institute of Chicago. Antoinette P. Taylor was the Instructor of Metal and Leather Work, and Mrs. Prudence Stokes Brown of Elementary Handiwork.[5] Taxile Doat, known throughout the world for his exceptional work at the National Manufactory of Sèvres, was engaged as Director of the School of Ceramic Art.[6]

After joining Sèvres in 1877 at the age of twenty-six, Doat made a specialty of pâte-sur-pâte decoration and flambé, crystalline and metallic glazes, giving great evidence of his artistic skill and his chemical and technical knowledge.[7] He came to the United States in June 1909 "for a conference with the League's architects in order that the erection of one of the most perfectly designed and equipped art potteries in the world might be immediately begun."[8]

Doat returned to France to pack his permanent ceramic collection of almost 200 pieces, which the art museum of the League had contracted to purchase. Eighteen of these are presently in the collection of the City Art Museum of St. Louis, the balance having been publicly auctioned by the museum in 1945.[9] In December 1909 Doat returned and set about the organization of the pottery, which was to produce both low-fired earthenware and porcelain wares—although the making of outstanding art porcelain received priority. The first major kiln was fired under Doat's direction on April 2, 1910.[10]

Associated with Doat in the ceramics school were Frederick Hurten Rhead (Rhead Pottery*),[11] Instructor of Pottery; Mrs. Adelaide Alsop Robineau (Robineau Pottery*); and Mrs. Kathryn E. Cherry, Instructor of China Painting and also of Ceramic Design. Assisting Rhead in the pottery course were Edward Dahlquist (Shawsheen Pottery*), built pottery; Frank J. Fuhrmann, throwing and turning; and Eugene Labarriere and Emile Diffloth, both associates of Doat's whom he brought from Europe with him. The former had been the foreman of a

University City gourd shapes; left to right: high gloss green glaze, h. 6¾" (17.2 cm); blue, light green and white crystalline glaze, h. 8¾" (22.3 cm); the two pieces at the right are from the identical mold, the second from the right (h. 8¼"; 21.0 cm) has an earthenware body, the far right (h. 7¾"; 19.7 cm) has a porcelain one. All marked U. C. and dated 1913 with the exception of the piece at the far left, which is similarly marked and dated 1912. *Private collection.*

pottery in the suburbs of Paris, and the latter, Director of Art at the Boch Brothers Pottery, La Louviere, Belgium.[12]

For a short time the University City Pottery had the most notable group of ceramic artists and experts thus far associated with an institution in this country. Their experiments determined that native United States clays were superior to the finest of Europe and were available in greater abundance. Exhibits from their kilns were made at The Art Institute of Chicago, The Arts & Crafts Society (Boston), and the Museum of Fine Arts (Boston), where they received numerous prizes. The greatest recognition of the University City work came at the International Exposition (1911), at Turin, Italy. There, in competition with all the famous potteries of Europe, it was awarded the Grand Prize, adjudging their work to be the finest porcelains produced in the world.[13]

In addition to the superior bodies, the glazes were particularly noteworthy. These included matt and gloss glazes, colored and colorless, all of the matt greens of various textures, alligator skin, crystalline, Oriental crackle, and a matt white similar to Rookwood's* vellum finish. In all glazes, the coloring oxides were thoroughly incorporated and then fired at the same temperature as the body. In order to keep a wide range of colors, a body was successfully developed which would fire at as low a temperature as hard porcelain can be made, about 2,400° F.

The vicissitudes of the operation were continual and largely related to Lewis' other activities, which were periodically probed by the United States government. These episodes are amply recorded, with a definite bias in favor of Lewis, in *The Siege of University City*.[14] The American Woman's League foundered in 1911, and Rhead and

[left] University City St. Louis Vase executed by Mabel G. Lewis (note cipher and 1913 date on body just below the pâte-sur-pâte decoration). Three cameos encircle the vase: one depicts St. Louis, king of France; another, hops and grain; the third is inscribed "St. Louis, Mo."; h. 6½" (16.5 cm). Marked U. C. and 1913 on base in addition to the marks illustrated on the body. *Private collection.*
[bottom] Atascadero plaque designed by Mabel G. Lewis with center of light blue glaze; h. 4½" (11.5 cm) diameter. Impressed University City Porcelain Works mark and 1914 date. *Private collection.*

the Robineaus left during that year. The Robineaus returned to their work in Syracuse, New York, and Rhead headed west to establish the Arequipa Pottery*. Doat continued his work with the assistance of W. V. Bragdon (California Faience*) as chemist, Frank J. Fuhrmann as artist decorator and Thomas Parker as turner, replacing Diffloth, Labarriere and the others who had left. The pottery was reorganized

F. H. Rhead in his studio at University City.

in 1912 and regained its momentum, continuing to produce outstanding work through 1914, this last year being devoted to production of wares for the San Francisco exposition.[15]

Both Lewis and his wife, Mabel G., modeled, decorated and fired earthenware and porcelains, and examples of their work can be found with their names or initials. So great was their interest that when Lewis founded the town of Atascadero, the California colony of the American Woman's Republic, in 1912 and built a home there, he included a small kiln. At one time it was contemplated that the Institute be moved from University City to Atascadero, but that never materialized.[16] Plaques modeled by Mrs. Lewis were made by Doat at University City for the new colony. These bore the facial designation "Atascadero: Nymph of Springs," one possible meaning of the town name. While Doat made several visits to California, there is no evidence that he ever worked there before permanently returning in 1915 to France, where he died in May 1938. All production at University City had ceased by early in 1915.

The most significant collection of important pieces of University

City Pottery is to be found at the library in University City. Another somewhat smaller collection is at the library at Atascadero.

Not all pieces of the pottery are marked, although most were, and with a great many different styles. The earliest bore an impressed U-P. This was followed by several marks designating the American Woman's League and the U. C. initials. In some cases only the "A.W.L." designation is found. About 1911, pieces were imprinted with the circular mark of the Woman's Industrial Corp., with the identification "Glenmoor Pottery."[17] Later work carried an impressed or imprinted "University City, Mo." designation, an imprinted or incised "U.C." or the circular impressed mark of The University City Porcelain Works. Numerous artists' ciphers appear on the work and pieces are often dated, the latest date found being 1914.

Taxile Doat working on the University City Vase.

1. Sidney Morse, *The Siege of University City: The Dreyfus Case in America* (St. Louis, Missouri: University City Publishing, 1912, p. 761).
2. p. 3.
3. Morse, *op. cit.*, p. 763.
4. *Ibid.*, p. 187. *Grand Feu Ceramics* was originally published in *Keramic Studio*. In

1905 it was published in book form by the Keramic Studio Publishing Company, Syracuse, New York.

5. *The Pioneer,* I (April-May 1911), p. 10.
6. By the time he arrived at St. Louis, Doat's work had captured for him two Grand Prizes, three Diplomas of Honor, seven Gold Medals, the Hors-Concours diploma and Knighthood in the Legion of Honor.
7. W. P. Jervis, *The Encyclopedia of Ceramics,* pp. 155-60.
8. *The Woman's Magazine,* July 1909, p. 24.
9. Acknowledged to be the finest collection of Doat's work (*Dictionnaire de Biographie Francaise,* 1967, p. 407), these are not pieces which were produced in the Sèvres factory and signed with their mark, according to Doat's private papers at the City Art Museum, St. Louis. Such pieces remained the property of the French government, which usually reserved them for its own national museum, for exchanges with foreign museums and for diplomatic presents. In his free time Doat had executed many examples of his various types of work at his own Sèvres city property, the Villa Kaolin. It was from this laboratory and those kilns that Doat's personal collection of artistic and technical ceramics came—the collection which was purchased by the Art Museum of St. Louis. Each piece of the collection was different in subject, color and technique; Doat felt they best represented his various methods in porcelain and stoneware, and hence were important teaching aids. An independent appraisal of this collection for the museum in 1912 reported: "In regard to the Taxile Doat porcelains, we are pleased to state that we consider them technically faultless. There are few men in the world engaged in this work, who combine the great artistic qualities and the draftsmanship [*sic*] with such technique."
10. A plaque bearing this inscription is in the collection of the University City Library. The second successful firing was reported by *Keramic Studio,* XII (June 1910), p. 23.
11. It was in this capacity and in conjunction with the correspondence courses that Rhead produced at this time his manual *Studio Pottery,* which was published by the People's University Press and illustrated by the author.
12. *Keramic Studio,* XI (January 1910), p. 185; T. Doat, *Grand Feu Ceramics,* p. 25.
13. Morse, *op. cit.,* p. 398. See also *Hard Porcelains and Grès Flammés Made at University City, Mo.,* brochure of The University City Porcelain Works, c. November 1914. It would appear, however, that this was actually a personal award of A. Robineau as all fifty-five pieces sent to Turin were executed by her, fifteen of which were made at University City. The remaining forty were produced in Syracuse prior to 1910 (*High Fire Porcelains,* a brochure of Robineau work prepared for the Panama-Pacific International Exposition, 1915).
14. This is described by Morse in the opening pages (vi) as " . . . the only comprehensive and authentic history of the great Lewis case in existence." Lewis' difficulties followed him to California, where the government finally won a conviction in 1927.
15. No evidence has been found that any work of The University City Porcelain Works was exhibited at the 1915 exposition in San Francisco.
16. The Atascadero *News* of April 22, 1916, p. 4, reports that Doat visited Atascadero in 1914, checking on local clay for his art porcelain works which he was to establish after World War I at Atascadero. The kilns, machinery and other equipment of the pottery were shipped to Atascadero in 1916. Their arrival there was reported in the Atascadero *News,* July 15, 1916, p. 4.
17. A piece so marked is in the collection of the University City library.
 * Information relating to this pottery is included in a separate chapter.

C. B. Upjohn Pottery

Zanesville, Ohio

Charles Babcock Upjohn, after having worked for the Weller Pottery* since 1895,[1] joined the Cambridge Art Pottery* as designer and modeler at the time of their organization in late 1900.[2] He remained there for about a year and then returned to Weller*,[3] where he was responsible for designing their second Dickens line, introduced in 1900.[4]

Grandson of the famed architect Richard Upjohn,[5] Charles Upjohn organized his own art pottery firm, the C. B. Upjohn Pottery Company, in 1904 and incorporated it in Ohio. A new two-kiln plant was built and placed in production by mid-1904.[6] The firm was evidently undercapitalized at $10,000 and the capitalization was doubled in December of that year. It appears that even the additional funds were not sufficient, and by March 1905 the pottery was idle "with a fair stock on hand,"[7] and again an increase in capital was anticipated. There is no indication in the records at the office of the Ohio Secretary of State that such an increase was approved, and in June of that year Upjohn was succeeded by F. L. Whartenby,[8] after the sale of the pottery to other Zanesville interests.[9]

Upjohn joined Trent Tile in Trenton, New Jersey, where he was commissioned to design the floor of Trenton's Roman Catholic Cathedral. In 1916 he joined the art faculty of Teachers' College, Columbia University, where he remained until 1940.[10] The Upjohn plant in Zanesville after his departure for a short time produced a line of kitchen utensils, but this was also abandoned and the pottery again became idle.[11] In 1907 it was acquired by the Brush Pottery Company (see McCoy*) for the manufacture of stoneware utensils, and in 1908 it was destroyed by fire.[12]

An impressed mark is shown. **UPJOHN**

1. N. F. Schneider, Zanesville *Times Signal*, March 23, 1958, p. D-44. The Zanesville directory of 1896 lists Upjohn as a designer at Weller.
2. *Illustrated Glass and Pottery World,* IX (February 15, 1901), p. 45. The notation that Upjohn had a long connection with the principal pottery at "Francesville, Ohio, is evidently a misreading for Zanesville, the firm in question being Weller.

3. One of Upjohn's sons was born in Cambridge in 1901, another in Zanesville in December 1902. Upjohn is not listed in the Zanesville direcory for 1901 and appears against in that of 1903.

4. See footnote 7, pp. 328-29.

5. In his early twenties, C. B. Upjohn worked for the sculptor responsible for the Great Doors of Trinity Church, New York. Because of the Upjohn family connection with Trinity (Richard Upjohn being the architect), a bust of Charles was included in the bronze door frame, the third from the bottom on the far right.

6. *The Clay-Worker,* XLI (May 1904), p. 644.

7. *Glass and Pottery World,* XIII (March 1905), p. 23.

8. *Ibid.,* XIII (June 1905), p. 22.

9. *Clay Record,* XXVI (April 29, 1905), p. 35; *ibid.,* XXVI (May 31, 1905), p. 35.

10. Private correspondence with Upjohn family.

11. *Glass and Pottery World,* XV (June 1907), p. 28.

12. N. F. Schneider, Zanesville *Times Recorder,* September 16, 1962, p. A-6.

* Information relating to this pottery is included in a separate chapter.

Valentien Pottery

San Diego, California

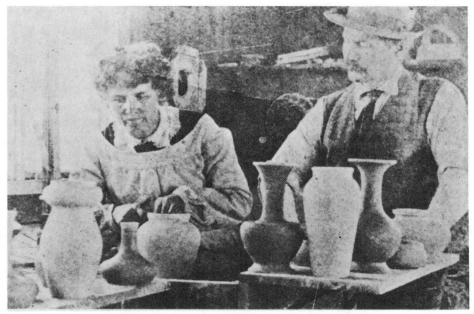

Albert and Anna Valentien, presumably at their San Diego pottery. *Hobbies.*

With the possible exception of the Grand Feu Art Pottery*, few important art potteries in the United States have proved as elusive as the Valentien[1] works. It is a rather well-substantiated hypothesis that such a venture existed. An unidentified source reports that "A. R. Valentine is planning to build an art pottery in Southern California and mentions the Elsinore clay as being very beautiful and pliable."

Albert Valentien was a native of Cincinnati, where he attended the Art Academy and was a pupil of T. S. Noble and F. Duveneck. He worked for a time at T. J. Wheatley & Company*, and in 1881 joined the newly-organized decorating department at Rookwood*, becoming its first full-time decorator.[2] As other permanent decorators were added, Valentien assumed charge of the decorating department; and in 1887 he married Anna Marie Bookprinter, a member of that department and a competent artist in her own right. Albert and Anna Valentien both studied abroad, the latter with Rodin. Influenced by

his sculptured forms, she tried unsuccessfully to interest Rookwood in designs of that type;[3] it was these sculptured designs, decorated with the then-popular matt finish, which were to be pursued at the Valentien Pottery on the West Coast.

The Valentiens left Rookwood in 1905 but remained in Cincinnati until 1908, when they relocated in San Diego. The move was evidently prompted by a commission received that year from Miss Ellen Scripps for Albert to paint all the California wild flowers. The work, which took ten years to complete, included not only wild flowers but native grasses and trees and comprised 1,100 sheets and about 1,500 pictures.[4]

The Valentien pottery works evidently began operation about 1911. The 1913 directory of the *American Art Annual* includes both Valentiens, giving their 3903 Georgia Street, San Diego, address; Albert is listed as "painter, potter" and Anna as "sculptor, potter." The San Diego directory for 1913 indicates that a local banker, J. W. Sefton, Jr., was located at the same address as the Valentiens.

Sefton, a native of Ohio (he possibly knew the Valentiens there), is also listed as a pottery manufacturer whose plant was located at the corner of University and Texas. The pottery building was designed for Sefton by Irving Gill in early 1911.[5] A letter from Sefton to Fred H. Robertson (Robertson Pottery*) in March 1912 reads in part: "I will be very pleased to talk pottery to your father [Alexander W. Robertson]

Valentien Pottery vase with Art Nouveau floral design, semi-matt mauve glaze; h. 8" (20.4 cm). Impressed mark and "Z21". *Private collection.*

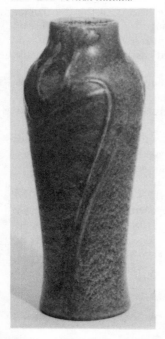

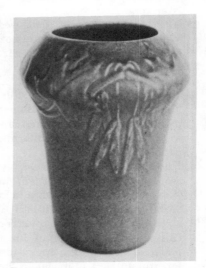

Rust colored Valentien vase; h. 6½" (16.5 cm). Impressed mark and "Z23". *Michiko & Al Nobel.*

when we open up again, the plant being closed down now for about six months owing to some delay in receiving machinery." It is not clear whether the Valentien works were in production prior to 1911, but a tentative dating for their operation would place it in the 1911-14 period.[6]

In San Diego, Albert Valentien was active in the Art Association and in 1915 was awarded a Silver Medal for his painting at the San Diego exposition. Since no art pottery appears to have been exhibited there, such work had evidently ceased by that time. Albert Valentien died in 1925 and Anna a quarter century later.

Until proven otherwise, it is contended that the Valentiens operated an art pottery in San Diego and that their impressed mark, as shown, was placed upon it.[7] Pieces studied also bear an impressed shape number prefixed with a Z, perhaps connoting shapes designed for matt glaze decoration, as was the case at Rookwood where the Z followed the shape designation.

1. Valentien spelled his name both as given here and as "Valentine." For the sake of consistency a single spelling has been adopted, the one used by Valentien in his later years.
2. H. Peck, *The Book of Rookwood Pottery*, pp. 16-17, 32. Examples of some of Valentien's earliest work at Rookwood are in the collection of the Cincinnati Art Museum (#1881.29, 1881.31, 1881.47).
3. *Ibid.*, p. 143.
4. San Diego *Union*, December 28, 1924, p. 12; *The Art News*, XXIII (August 15, 1925), p. 6. This collection of drawings is now at the library of the San Diego Natural History Museum, Balboa Park. A smaller group of about fifty wildflower paintings is at the California State Library, Sacramento. A sizeable collection of watercolor sketches of California wildflowers is also at the library of the Cincinnati Art Museum.
5. The drawings for this and a cottage designed several months earlier for the same property, both by Irving Gill, are with the Gill papers at The Art Galleries, University of California, Santa Barbara (Helen McElfresh Ferris, *The Journal of San Diego History*, XVII, Fall 1971, p. 18).
6. A photograph of the Valentiens engaged in ceramic work (Thelma Shull,*Hobbies,* LIII, July 1948, p. 93) is of this period, and evidently at their San Diego pottery plant as some of the shapes (especially the tall vase, second from left in the foreground) do not appear in the Rookwood shape book.
7. It is the author's hypothesis that the illustrated mark is that of the Valentien Pottery. Pieces with this otherwise unidentified mark with a California poppy have been studied and, as can be seen from the illustrations, are of the type the Valentiens would have produced.
 * Information relating to this pottery is included in a separate chapter.

Van Briggle Pottery
Colorado Springs, Colorado

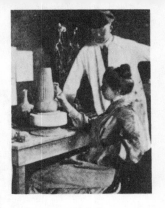

Artus and Anne Van Briggle in Colorado Springs studio. *House and Garden.*

Artus Van Briggle began his ceramic work as a student of Karl Langenbeck at the Avon Pottery* in 1886, and joined Rookwood* in 1887. By 1891 he was considered a senior decorator, and had an individual studio in the new Rookwood Pottery on Mt. Adams.[1] Two years later, in recognition of his great potential as an artist, he was sent to Europe by Rookwood. There he studied under Jean Paul Laurens and Benjamin Constant and soon took a number of prizes at the Julian Art Academy for drawing and painting.[2] While in Europe he had the opportunity to study Oriental ceramics and was particularly attracted to those pieces with a dead—or very "dry" matt—glaze.

Upon his return to the United States in 1896 he resumed his duties as a decorative artist at Rookwood, working primarily in the then-popular Standard technique. His spare time was devoted to experimentation to perfect a dead glaze, and by the fall of 1898 he had produced successful examples.[3] Some of this early work was exhibited by Rookwood at the Paris exposition in 1900, where they attracted immediate attention.

Tuberculosis, however, forced Van Briggle to relocate in Colorado in 1899. By the end of that year he resumed his experiments at Colorado Springs, in the laboratory of Colorado College.[4] In his work he was assisted by a friend, chemist William H. Strieby, who was on the college staff. Using native Colorado clay, he fired his pieces in the assayer's kiln in Strieby's laboratory. Two years later he achieved the glaze which he had so painstakingly sought. Encouraged by Anne Gregory, a competent artist herself whom he was to marry in 1902, and with the backing of his friend and patron, Maria Nichols Storer of Rookwood, the original pottery was built at 615 North Nevada Avenue. By the end of 1901 the first commercial pieces were available.[5]

The ware was well-received by the public, and it soon became obvious that some expansion was required. In the beginning two assistants worked with Van Briggle: a skilled thrower, Harry Bangs, and a boy who did odd jobs around the pottery. In 1902 the Van Briggle Pottery Company was formally organized, and with the new capital the plant was extended; by the following year the staff had also been expanded to fourteen, accommodating a complete division of labor as at Rookwood.[6]

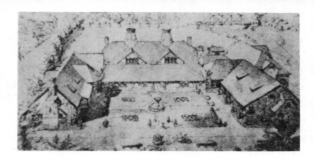

Architect's drawing of the 1907-08 pottery building. *The Clay-Worker.*

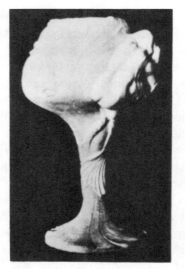 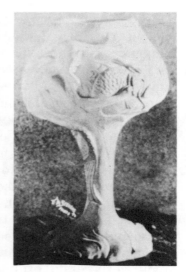

Two views of the Van Briggle Toast Cup, 1901. *Brush and Pencil.*

Success followed success and Van Briggle pottery captured important awards in the 1903 Paris Salon and at the St. Louis exposition.[7] Not only did the glaze meet with an immediate positive response, the form of his work was also noteworthy.[8] Some of the early decoration is best termed structural, with the modeled design in low relief, a combination of sculpture and ceramics. Avoiding the simple application of designs in high relief as effected at the Chelsea Keramic Art Works* during its middle period, or slip-painted underglaze decoration as executed by Van Briggle at Rookwood, the decoration fused with and became part of the body of the piece itself. This union of sculpture and ceramics is similar to that executed at Grueby*, Teco* and Tiffany*, but less formal in line. Some of the most notable achievements were *Despondency,* the figure of a man, and the *Toast Cup* and *Lorelei,* figures of women, in which the subjects flow into and emerge from the overall form.[9] Other motifs were adopted from floral or plant forms and occasionally from the animal world. Influenced by the Art Nouveau trend, a great deal of Van Briggle's own work reflects the free-spirited line so typical of that movement, and some authorities

consider Van Briggle's work as marking the high point of that style in the art pottery of the United States.[10]

Modeling was done by Artus and Anne Van Briggle and George Young or else by a decorator who followed their designs. From each original shape a mold was made (to allow what was intended to be a very limited production of a design, each copy being carefully retouched and remodeled by hand[11]). After the pieces were molded and allowed to dry they were biscuit-fired and then glazed and refired. Most often the glaze was applied with an atomizer operated by compressed air, with another color sometimes added to the first. If it was desired that certain lines should be accentuated with darker or lighter tones, the glaze was rubbed off in those places and the desired color glaze applied with a brush.[12] Some of the most popular colors were different shades of green, gray, yellow, blue and rose.

In 1904 at the age of thirty-five, Van Briggle died. His widow assumed the presidency of the firm, and it continued to grow and receive regular awards for its work. Construction was begun in 1907 on a new pottery at 300 West Uintah Street as a memorial to the founder. F. H. Riddle, who was acting foreman of the pottery early in 1904 when Van Briggle was in Arizona for his health, returned as superintendent of the plant, and Anne Van Briggle served as art director. Built in the Old World style, the new structure incorporated a great deal of the firm's work, especially highly-colored matt and iridescent glazed tiles. The plant, in full operation in the fall of 1908, was designed for making as wide a range of products as possible. Output at the time included art pottery, commercial objects, glazed terra cotta for mantels, chimney tops, interior decorations, tiles, flowerpots and garden ornaments, almost all of which were cast.[13]

Recently produced example of Despondency Vase, matt white glaze; h. 16" (40.8 cm). Regular mark. *Private collection.*

299

Riddle remained at the pottery until 1910, when another of the periodic reorganizations occurred.

Periods of the pottery can be established by the various reorganizations, which mark changes in philosophy. At the end of the early developmental period, 1901-10, emphasis was shifted to expanding the market, and commercial wares and novelties were extensively produced.[14] During the middle period, 1910-20, art pottery was still dated and produced primarily from early models or designs, often by Ambrose Schlegel. In 1920 the firm was again reorganized and art pottery was replaced with mass-produced industrial artware. New molds were made which only hinted at early Van Briggle designs; since 1920 there has been a steady deterioration in the quality of design, execution and glazes, the only reminder of the art pottery output being the addition of "Art Pottery" to the firm's name as the production of art pottery ended.

Artus Van Briggle had offered an apologia for his use of molds, saying that a fine, slowly-developed model was far preferable to the execution in each case of a new idea which often entailed careless and inartistic work.[15] It was not Van Briggle's idea, however, that molds were to be used for mass manufacture, which they were in the late period—to the extent that aging of the molds resulted in considerable loss of detail until they were eventually discarded or recut. In the early 1970s one could still buy copies of Lorelei, Despondency and numerous other early designs at the pottery, located at 600 South 21st

Van Briggle vase, Persian rose to bottom of conventionalized swans' heads, remainder gray; h. 6" (15.3 cm). Regular mark, shape 5, III, 1902. *Michiko & Al Nobel.*

Van Briggle low bowl, medium brown matt glaze; h. 3½" (8.9 cm). Regular mark, shape 393, 1906. *Private collection.*

Street, the building erected in 1907 having been sold to Colorado College in 1968.

Important examples of Van Briggle pottery which reflect the wide range of standard and experimental glazes of the early and middle period, but which were rarely produced after 1920, can be studied at the National Museum of History and Technology (Smithsonian Institution), The Newark [New Jersey] Museum, the Colorado State Historical Society Museum (Denver), and the Pioneers' Museum (Colorado Springs).

The conjoined-A mark, standing for Artus and Anne Van Briggle, has been the firm's incised or impressed hallmark since the pottery's beginning.[16] Most pieces from 1901-20 were dated, and the majority bear shape numbers.[17] Those examples made during the pottery's first three years are often found with Roman numeral designations. Records fail to indicate the code, but it is Bayer's hypothesis that it indicated the artist: III was Artus, I was probably Anne, and II Harry Bangs.[18] Between 1904 and 1920 the name or initials of the projector were occasionally included, such as A. Schlegel. After 1905 the designation "Colorado Springs" was sometimes added. Some articles bear the designation "original," which indicates in the post-1920 period a thrown rather than molded piece. A line of high gloss and lava-type glaze ware was introduced, a great deal of which bears the name "Anna [sic] Van Briggle." While claims are made that Artus Van Briggle was working on this at the time of his death, it is highly unlikely as he found the high-gloss glazes very unappealing. The conjoined-A mark does not appear on this ware, manufactured in the 1950s and 1960s, until after 1965.[19]

VAN BRIGGLE VAN BRIGGLE

1. H. Peck, *The Book of Rookwood Pottery,* p. 45.
2. George D. Galloway, *Brush and Pencil,* IX (October 1901), p. 1; also D. McG. Bogue, *The Van Briggle Story,* p. 7.
3. Bogue, *op. cit.,* p. 9; Peck, *op. cit.,* pp. 53-54, 58.
4. *Glass and Pottery World,* XI (June 1903), pp. 16-17.
5. *Clay Record,* XIX (October 28, 1901), p. 22; Bogue, *op. cit.,* p. 19.
6. *China, Glass and Pottery Review,* X (May 5, 1902), p. 59. See also Irene Sargent, *The Craftsman,* IV (September 1903), p. 423.
7. A description of the 1903 Salon exhibit is to be found in *Glass and Pottery World,* XI (June 1903) pp. 16-17. Awards at St. Louis are reported in *China, Glass and Pottery Review,* XV (November 1904), p. 43; *Keramic Studio,* VII (May 1905), p. 8; *The Clay-Worker,* XLIV (December 1905), p. 602.
8. *Keramic Studio,* V (June 1903), p. 36, observed that "the Van Briggle Pottery is perhaps the most important of the new work. The shapes, modeled decorations and color are simple and artistic . . . It is quite individual and relies more on modeling and general color effect than on local application of design in color . . . [Van Briggle's] work promises to add appreciably to the reputation of American faience."
9. An example of Despondency is reported to have been purchased by the Museum of Decorative Arts, Paris, for $3,000 (Robert Koch, *Art in America,* LII, June 1964, p. 121). If this was the case, the piece is no longer in their collection. A late reproduction of the Lorelei vase is in the collection of The Brooklyn Museum (#60.79).
10. Martin Eidelberg, *The Arts and Crafts Movement in America 1876-1916,* p. 158.
11. *House and Garden,* IV (October 1903), p. 168.
12. Galloway, *op. cit.,* pp. 7-8.
13. An extensive description of the layout and mechanical equipment of the new plant is provided by F. H. Riddle in *Transactions* of The American Ceramic Society, X (1908), pp. 65-75; also *The Clay-Worker,* XLIX (June 1908), pp. 792-97.
14. Bogue, *op. cit.,* p. 47.
15. Sargent, *op. cit.,* p. 424. A similar statement was offered by Anne Van Briggle in the Colorado Springs *Gazette,* December 3, 1908.
16. The conjoined-A mark with the 1901 date is illustrated by Galloway, *op. cit.,* p. 6, and an example so marked and dated is part of the Gates-Wessels Memorial Collection of the Pioneers' Museum, Colorado Springs (#5370). In addition, the 5" green jug with handle (shape #50) bears the Roman numeral II and is marked "H.E.G." for (Howard E. Gates) and "Aug. 25, 1901" on the surface of the vessel.
17. Shape numbers as high as 900 have been noted. A single number applied to a specific shape, regardless of size, which is not indicated as it is in the case of Rookwood. Generally, between 1901 and 1906 the shape numbers were impressed and from 1906 to 1920 they were incised. It appears that shape numbers to about 300 were designed or approved by Van Briggle himself.
18. Ralph E. Bayer, *Western Collector,* VI (March 1969), p. 113. Evidence to support this hypothesis has not been established by the author.
19. Private correspondence with the pottery.
 * Information relating to this pottery is included in a separate chapter

Vance/Avon Faience

Tiltonville, Ohio
Wheeling, West Virginia

About 1880 James Gisey and some other Wheeling potters organized a cooperative company and built a pottery at Tiltonville, seven miles north of Wheeling, for the manufacture of yellow and Rockingham-type ware. Several years later it was taken over by the Tiltonville Pottery Company, which added a line of novelties to the output. After about two years' operation the works were leased to John Schneider & Company, who operated them for about a year; then they

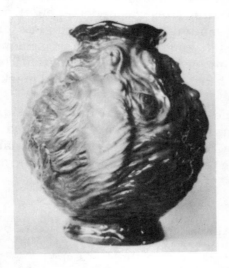

Vance Faience vase with inmold mermaid decoration in high relief; h. 12" (30.5 cm). Vance Faience mark. *Private collection.*

were leased to the Western Sanitary Ware Company, which began operations on a modest scale in 1892. Its only product, plain sanitary ware, was not very successful, and that firm failed in 1894 following the rebuilding of the works after a fire the previous year. The plant was then operated until the fall of 1897 as the Tiltonville Sanitary Company by Wilbur L. Medill, who had operated it earlier as the Tiltonville Pottery.[1] When that business failed the plant remained idle[2] until it was acquired by several Wheeling businessmen, in November 1900, with the intention of making it the nucleus of one of the country's largest manufacturers of high-grade artware.

The Vance Faience Company was incorporated in West Virginia by

J. Nelson Vance of the National Tube Company, J. D. Culbertson of the Riverside Iron Works, and Charles W. Franzheim, who in 1879 had founded the successful Wheeling Pottery Company, producers of semi-porcelain and utilitarian wares.[3] The plant, with three kilns and preparation for four more, was in operation by early March 1901, under the direction of James Platt. The general manager was C. E. Jackson, a young ceramic engineer trained at Ohio State University. Most of the workers—within six months numbering about 100—were drawn from the various Zanesville potteries.[4]

No work of the pottery was placed on the market until a year after production was begun. During that time considerable experimentation was undertaken in both utilitarian and ornamental lines. Early output included reissuing the four-quart Greatbach pitcher, the molds of which, originally used at the United States Pottery of Bennington, Vermont,[5] came into Vance's possession via South Carolina and Peoria, Illinois, where Greatbach had sold the mold for his pitcher after the closing of the United States Pottery.[6] This was so successful that in 1904 reproduction in three sizes was undertaken[7] in a variety of glazes including orange shading to brown, high-gloss blue and white Delft-like colors, and matt green. None, as far as is known, were produced with a Rockingham-type glaze as at Bennington. The pitchers produced at Tiltonville bear the impressed Vance mark on the base.[8]

Some of the earliest and most successful artware was designed and executed by William P. Jervis (Jervis Pottery*), who had become manager of the pottery by September 1902 when the name was changed to the Avon Faience Company. Under his direction, and with

[left] Avon Faience underglaze decorated vase with stylized trees outlined against a dark green ground, lighter green grass and orange sky; h. 8⅞" (22.6 cm). Avon/164-1241 incised into glazed base. *Private collection.*

[right] Early Vance Faience vase illustrated in 1902. *Illustrated Glass and Pottery World.*

the assistance of Frederick Hurten Rhead (Rhead Pottery*), who had joined the Avon staff by early 1903,[9] a particularly artistic line of artware was developed. It was decorated underglaze with a variety of Art Nouveau motifs in a wide range of original colorings,[10] sometimes outlined with squeezed white slip giving evidence to its parentage of the "Jap Birdimal technique" introduced by Rhead later at Weller* and still later at Roseville*. In-mold decorations in high relief were also used. Several competent artists were employed at Vance/Avon during the Jervis-Rhead period; one was Albert Cusick, who was later associated with the Zanesville potteries and was one of the incorporators of the Craven Art Pottery*.

In December 1902 the Wheeling Potteries Company was incorporated in West Virginia, absorbing the Wheeling, La Belle and Riverside potteries as well as Avon Faience. Each was then operated as a department of the Wheeling firm. The Avon works continued to produce artware and experiment in new applications of artistic and decorative techniques, although the body of the ware continued to be extremely heavy.[11] Great emphasis was now placed on efficiency; and the more profitable utilitarian objects encroached upon more and more of the Tiltonville facilities, resulting in the departure of both Jervis and Rhead by mid-1903. Jervis associated himself with the Corona Pottery* and Rhead with Weller. At that time the production included artware vases, jardinieres, umbrella racks, steins, tobacco bowls, and teapots with metallic lids.[12] While preparations were made for the entry of the Vance/Avon ware at the St. Louis exposition in 1904, this was given up because suitable exhibition space could not be secured.[13]

All artwork at Tiltonville ceased in late 1905, and production of the Avon line was moved to Wheeling. At that time, to effect further economies, the body of the ware was changed from earthenware to the semi-porcelain type then in use at Wheeling, thus permanently ending the output of artware. The Ohio plant was retained by the Wheeling Potteries for the manufacture of sanitary ware including bathtubs and washtubs, lavatories, drinking fountains and kitchen sinks, thereby going full circle in less than a decade.[14]

The Wheeling empire was seriously affected by the 1907 panic, and the following year it abandoned its general ware plants—the La Belle and Wheeling departments—which produced semi-porcelain table, toilet, china and commercial decorative wares. Operation of the Riverside and Tiltonville plants was anticipated for the production of sanitary goods. Attempts at reorganization were not successful, and the firm entered receivership in late 1908. The Tiltonville plant was, after a time, operated as the Wheeling Sanitary Manufacturing Company.[15]

Initially art pottery bore one of the Vance Faience marks as shown. After adoption of the Avon designation in 1902, several incised "Avon" marks were used in addition to the impressed and imprinted mark designed by Jervis bearing the Avon name with the "W. Pts. Co." cipher for the Wheeling Potteries Company.[16] Artware bearing any Avon designation other than the impressed mark of the Avon Pottery* of Cincinnati can be safely attributed to the Vance/Avon works.

VANCE F. CO. Avon, F. Co. Tiltonville

1. Joseph B. Doyle, *Twentieth Century History of Steubenville* (1910), pp. 294-95; W. Stout *et al., Coal Formation Clays of Ohio*, p. 88; H. Ries and H. Leighton, *History of the Clay-Working Industry in the United States*, p. 236; *Brick*, I (October 1894), p. 265; *ibid.*, I (November 1894), p. 351.
2. *Crockery and Glass Journal*, LII (December 20, 1900), pp. 28-29; also *Illustrated Glass and Pottery World*, VIII (March 1900), p. 18.
3. *Illustrated Glass and Pottery World*, VIII (December 15, 1900), pp. 20-21.
4. *Crockery and Glass Journal*, LIII (February 28, 1901), p. 30; *ibid.*, LIII (March 14, 1901), p. 30; *Illustrated Glass and Pottery World*, X (February 1902), pp. 12-13.
5. W. P. Jervis, *The Encyclopedia of Ceramics*, pp. 579-80.
6. W. E. Cox, *The Book of Pottery and Porcelain*, p. 995.
7. *Glass and Pottery World*, XII (August 1904), p. 19. The Greatbach pitcher in question is confused in this source (an error later incorporated in M. Benjamin's *American Art Pottery*, p. 47) with a somewhat similar Greatbach hunting pitcher made earlier at the American Pottery Manufacturing Company of Jersey City, New Jersey, which apparently was later used at the Nichols & Austin Pottery at Burlington, Vermont. Cox, *loc. cit.*, carefully notes the distinguishing characteristics of the various Greatbach pitchers.
8. Examples of the Vance Greatbach pitchers are in the collection of The Bennington Museum (see R. C. Barret, *Bennington Pottery and Porcelain* [New York: Bonanza Books, 1958], p. 33) and the Henry Ford Museum, Dearborn, Michigan (#59.96.1).
9. *Illustrated Glass and Pottery World*, XI (February 1903), p. 8; *Keramic Studio*, V (May 1903), p. 1.
10. See *The Clay-Worker*, XXXVIII (October 1902), p. 366.
11. Jervis was later to note (*A Pottery Primer*, p. 173) that "owing to the poor potting" art pottery production had to be abandoned.
12. *Illustrated Glass and Pottery World*, XI (April 1903), p. 16. The "Mr. Reed" referred to therein is undoubtedly F. H. Rhead.
13. *Glass and Pottery World*, XI (December 1903), p. 15.
14. *Ibid.*, XIV (January 1906), p. 34.
15. Stout, *op. cit.*, p. 88.
16. *Glass and Pottery World*, XIV (February 1906), p. 32.
 * Information relating to this pottery is included in a separate chapter.

Volkmar Kilns
Metuchen, New Jersey

The Volkmar Pottery* operated in Corona, New York, until 1903, when Charles Volkmar and his son Leon established the Volkmar Kilns, Charles Volkmar & Son, in Metuchen.[1] Leon was born in France in 1879. He studied at the National Academy from 1898 to 1901, and joined his father in 1902 at Corona.[2] The younger Volkmar at first joined the staff of the Pratt Institute art department until the move to New Jersey was completed by the summer of 1903.[3] Thereafter the two Volkmars taught the making and modeling of pottery at Metuchen, with attention to the composition of the clays used, the techniques of modeling, glazing and the application of color under the glaze.[4] Later that year a school of pottery was established at the Pennsylvania Museum School of Industrial Art, and Leon Volkmar became head of the new department while continuing his work in Metuchen.[5]

At the beginning of its operation, output of the Volkmar Kilns included high-gloss ware as well as the semi-matt glaze developed at the Volkmar Pottery which Charles Volkmar found greatly preferable to the high-gloss glazes. Work continued to be well-received and was awarded a Bronze Medal at the St. Louis exposition in 1904.[6] Besides

Volkmar Kilns vase, matt green; h. 10¼" (26.1 cm). Incised Volkmar/1910. *New York, private collection.*

Volkmar Kilns vase with deep blue matt glaze; h. 13⅞" (35.4 cm). Marked Volkmar and dated 1910. *The Newark Museum (#11.507).*

Medium green matt vase, presumably of Volkmar Kilns period; h. 21½" (54.7 cm). Volkmar V mark. *Private collection.*

the artware, tiles, panels and plaques were produced, and it was this latter field in which the principal demand existed.[7]

Early in 1905 C. Volkmar reported to the Macbeth Gallery that "we are altering our whole product by changing our faience body to a hard porcelain one, similar to the 'grès flammé' now so popular in Europe. This new ware is on a hard porcelain body and glazed by reducing wood fires, which produces very rich and Occidental glaze effects."[8] A limited amount of underglaze decorations were continued, especially of matt landscapes, but these were mostly used on tiles.[9]

On artware vases there was a steady progression toward more simple forms with glazes of a remarkable quality and depth, of which the deep tints were prominent. Pieces which by design revealed the inside as well as the outside were often glazed with linings of pale orange or some other subdued color. One particular decorative technique employed was the application of one underglaze painting over another and then refiring the work after each painting.[10] Very effective results were also obtained by allowing a darker glaze of black or gray to create a pattern by its controlled flow down the side of the

Vase with textured green glaze by the Volkmar Kilns; h. 6" (15.3 cm). Incised V. *The Newark Museum (#11.509).*

object.[11] Pieces were regularly shown, especially at the annual exhibitions of the New York Society of Keramic Arts. Those shown in 1911 included a large green vase, "restrained and beautiful in form and satisfying in color," a peachblow vase and a collection of tiles.[12]

That was the last year of the father-son team. That fall Leon joined Mrs. Jean Rice, and production of ceramic artware was begun under the style of the Durant Kilns*. Charles Volkmar continued his work until his death at Metuchen in 1914.

As noted, a few examples of the work done at the Volkmar Kilns can be studed at The Newark [New Jersey] Museum.

Several marks were used by the Volkmar Kilns, the most common of which was the incised stylized "V." This was first used at the Volkmar Pottery, and was also used by Leon Volkmar, sometimes with the Roman numeral II to indicate the second Volkmar pottery.[13] An incised "Volkmar" mark was also used, as was the imprinted Volkmar Kilns mark as shown, particularly on tiles. In addition to the pottery mark, artware often bears an incised date.

VOLKMAR KILNS,
METUCHEN, N. J.

1. Land and a building were leased from Augustine Campbell, according to a report in *China, Glass and Pottery Review,* XII (May 1903), pp. 36-37; and three kilns were erected (*Keramic Studio,* V, July 1903, p. 54).
2. W. Cox, *The Book of Pottery and Porcelain,* p. 1056.
3. Correspondence between C. Volkmar and the Macbeth Gallery, New York City, *Archives of American Art,* NMc11, frames 1194-95.
4. *China, Glass and Pottery Review,* XIII (August 1903), p. 24.
5. *Ibid.,* XIII (January 1904), p. 32; also E. A. Barber, *Marks of American Potters,* pp. 36-37. Barber erroneously identifies the Volkmar Kilns as the "Menlo Park Pottery."
6. *Keramic Studio,* VI (March 1905), p. 251.
7. *Crockery and Glass Journal,* LX (December 14, 1905), pp. 115-16, reprinted from the New York *Herald.*
8. *Archives of American Art, op. cit.,* frame 1214.
9. A good example is a 7¾ x 7¾" tile depicting a group of birches. It is in the collection of The Newark [New Jersey] Museum (#11.466), as are three vases produced by the Volkmar Kilns (#11.507-9).
10. *Pottery & Glass,* I (August 1908), pp. 5-6.
11. William Walton, *The International Studio,* XXXVI (January 1909), pp. lxxv-lxxx.
12. Mira B. Edson, *Arts & Decoration,* I (April 1911), p. 260.
13. See discussion of marks, Volkmar Pottery and Durant Kilns.
* Information relating to this pottery is included in a separate chapter.

Volkmar Pottery

Tremont, New York
Corona, New York

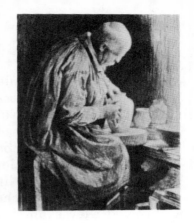

Charles Volkmar at work,
1903. By Edwin B. Child.
Newark Public Library.

Charles Volkmar belonged to a family of artists: his father was a well-known portrait painter and his grandfather an engraver of considerable prominence. He was born in Baltimore in 1841 and began studying art there, and as early as 1859 attracted attention as an etcher of merit.[1] At twenty he went abroad to study and remained there fourteen years, most of which time was spent in Paris. He came back to the United States in 1875 in time for the Centennial Exposition at Philadelphia,[2] where he saw the new Limoges or Barbotine ware and was fascinated with the possibilities it offered.

Volkmar returned to France, taking a house at Montigny-sur-Loing, near Fontainebleau, a Paris suburb. There he entered into an artistic alliance with a French potter who exchanged instruction in the ceramic art for Volkmar's decoration of his vases. After acquiring the essentials necessary for practical potting, Volkmar joined the Deck and later the Haviland factories, where he served an apprenticeship and learned the Haviland method of underglaze decoration.[3]

Volkmar again returned to the United States in 1879 and built a kiln at Greenpoint, Long Island.[4] The 1880 exhibition of The Salmagundi Club included a fireplace designed and executed by the Club in Limoges-type tiles, under the direction of Charles Volkmar, which was the first effort of the Club in such painting.[5] In the fall of 1881 the Club secured a portion of Robert Minor's Washington Square studio, and Volkmar is identified as the potter of the Club.[6]

By 1882 he had established his own studio, kilns, salesroom and home at Tremont (The Bronx), New York.[7] Originally clay from Woodbridge, New Jersey, was used, but it was shortly substituted with cream-color clay as used at Rookwood*. Work, usually plaques, tiles and vases, was adorned with either applied or underglaze decoration. This was executed either by Volkmar or by an assistant using Volkmar's designs. For grounds Volkmar preferred blue, brown or orange, softly dabbed on; the decorative motif apparently most preferred by the artist was a landscape with water and some living creature, often a duck, goose or cow. In all, about twelve colors were used: yellow, orange, light and dark blue, red, pink, light and dark brown, a "cold" and a "warm" green, and black.[8]

As at Rookwood, a division of labor was practiced, with the independent operation of the potting and decorating departments. The decorating technique used by Volkmar was unlike that used in Cincinnati. Instead of using the McLaughlin technique (Losanti*) Volkmar followed that of the Haviland firm, decorating the pieces, only after the clay was thoroughly dried, with a slip of previously burned and ground clay. The ware itself was both molded and thrown.

From Tremont Volkmar moved in 1888 to Menlo Park, New Jersey, where he joined J. T. Smith in establishing the *Menlo Park Ceramic Company* for the manufacture of art tiles and other interior ceramic decorations. This partnership was dissolved by 1893, when Barber reports that Volkmar had taken steps to organize the *Volkmar Ceramic Company* in Menlo Park, where he would continue to manufacture his widely acclaimed art tile.[9] These were decorated with an opaque rather than a transparent glaze, and lines in slight relief were

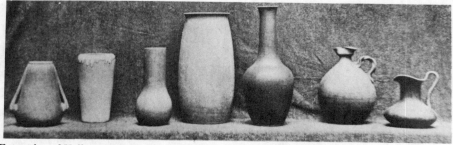

Examples of Volkmar work at the turn of the century. *Scribner's Magazine.*

Volkmar faience vase with pastoral scene slip decoration in greens, blue, yellows, white and brown; h. 12½" (31.9 cm). Molded Volkmar cipher in relief. *New York, private collection.*

Volkmar Crown Point Ware mug with underglaze decoration of white chrysanthemums on a black ground, green leaves and stems; h. 7½" (19.1 cm). Impressed Crown Point mark. *New York, private collection.*

used to achieve a design, rather than the high-relief effects then so popular.

No indication has been found that the Volkmar Ceramic Company ever began production, and by 1895 Volkmar had returned to New York and established the *Volkmar Keramic Company* at 39 Green-point Avenue, Brooklyn, again for the manufacture of art tile. Whiteware plaques, loving cups and beer mugs were produced with underglaze blue paintings in the manner of the then-popular Old Delft, generally depicting historical subjects of the United States.[10]

Drawing by Charles Volkmar of early (c. 1882) Volkmar faience. *The Art Amateur.*

Later that same year Volkmar was joined by Miss Kate Cory, a competent artist. They formed a partnership which operated under the style of *Volkmar & Cory* and began the manufacture of pottery at Corona (Queens), New York. Output was similar to that done by Volkmar in Brooklyn with a white ground and blue designs of some of this country's historical scenes and personalities executed under the glaze.[11] Their work received a Gold Medal at the Atlanta exposition of 1895.[12]

The Volkmar & Cory partnership was dissolved before the end of 1896, after which Volkmar managed the works alone, at first under the style of *Crown Point*.[13] The Crown Point ware was a significant departure from the earlier old Delft-type production. In this new work Volkmar's aim, as he defined it, was "for rich but delicate color qualities, subdued in tone; such effects as are only possible to secure in the underglaze treatment of pottery."[14] In addition, only material from the United States was incorporated into the work, New Jersey clay being the basis of the body of the ware.[15] Several vases and lamp bases of Crown Point ware were shown in a 1900 exhibition of the National Arts Club in New York City, where they drew considerable attention for the richness of color, excellence of form and beauty of the glazes.[16] And, to a far greater extent than previously, color was relied upon for decorative effect.[17] A new semi-matt glaze was also introduced.

During this time Volkmar served as a ceramic consultant,[18] taught classes in ceramic processes and methods of underglaze decoration,[19] and continued as potter for The Salmagundi Club. For the Club, beginning in 1899, he turned and fired each year twenty-four mugs or steins which were decorated by members of the Club and were then sold at auction.[20] After the first few years when a heavy glaze was used, burning without glaze was substituted.[21]

In 1902 Volkmar was joined by his son Leon, and together in 1903 they established the Volkmar Kilns* at Metuchen, New Jersey.

Relatively few museum collections of the early Volkmar work are extant. Undoubtedly the earliest pieces in a public collection are the pair of vases decorated with underglaze slip painting, c. 1881, which are at The Brooklyn Museum (#44.31.2-3), the gift of Leon Volkmar. An extensive collection of the various Delft-type historical plaques produced by Volkmar and Volkmar & Cory is at the National

Museum of History and Technology (Smithsonian Institution). Two Crown Point vases are in the collection of the Worcester [Massachusetts] Art Museum (#1903.4-5).

Marks were varied enough to make dating relatively easy between 1879 and 1903. According to Barber,[22] Volkmar used the CV monogram during the 1879-88 period. For a brief time in 1895 the Volkmar Keramic Company used the full Volkmar name in raised letters in an impressed parallelogram. This was followed in 1895-96 with the use of the single line impressed Volkmar & Cory designation. From 1896 to 1903 the full linear Volkmar designation was impressed. During this period the impressed Crown Point Ware designation was also used, as was the stylized "V" either in relief or incised.[23] This last mark can be the cause of considerable confusion as it was also used by Leon Volkmar, especially after 1920, although his work usually bears an incised date in addition to the incised "V".[24]

Two elaborately decorated vases by Charles Volkmar, late Corona period.
Scribner's Magazine.

 VOLKMAR & CORY

CHAS.VOLKMAR CROWN POINT WARE VOLKMAR

1. E. A. Barber, *The Pottery and Porcelain of the United States,* p. 377.
2. *Portrait and Biographical Record of Queens County, New York* (1896), p. 706.
3. Mary G. Humphreys, *The Art Amateur,* VIII (January 1883), pp. 42-43.
4. Barber, *op. cit.,* p. 378. Humphreys, *loc. cit.,* indicates that this time was spent in "desultory work and attention to teaching." The 1880 census places him in

Greenpoint (Brooklyn), as does that year's listing of The Salmagundi Club.

5. William H. Shelton, *The Salmagundi Club* (New York: Houghton Mifflin Company, 1918), p. 48.

6. *Ibid.*, p. 35.

7. *Crockery and Glass Journal*, XVI (August 3, 1882), p. 24, reports that "Volkmar, the artist in tile and china decoration of Tremont, has taken a contract with the Union Square Theatre to produce 1,200 hand-painted plaques for their anniversary night in February next." The first listing of Volkmar in Trow's New York City directory locates him on Madison Avenue at about E. 182nd Street, Tremont, in 1882-83.

8. Humphreys, *op. cit.*, p. 42.

9. Barber, *op. cit.*, pp. 377-81. Volkmar tiles had by that time been used in the Rockefeller mansion at Tarrytown, New York, the Boston Public Library and the Fulton National Bank in New York City.

10. E. A. Barber, *Marks of American Potters*, p. 82; *Clay Record*, VIII (January 14, 1896), pp. 22-23.

11. *Ibid.*, also Barber, *Pottery and Porcelain*, pp. 517, 562.

12. *Portrait and Biographical Record, loc. cit.* Volkmar & Cory also produced souvenir plaques for this exposition, examples of which are at the Smithsonian (#211,689; 379,551).

13. Advertisement, *The Art Amateur*, XXXIX (June 1898), p. 22. While this name was apparently used for a time, there is no indication that it was ever adopted as the firm's designation. An olive green glazed vase with yellow dogwood marked "Crown Point Ware" was included in the 1956 exhibition of New Jersey pottery at the New Jersey State Museum, Trenton (Item #181, page 33 of the catalog).

14. Margaret C. Whiting, *The House Beautiful*, VIII (October 1900), p. 616. Numerous illustrations of the Crown Point ware are included in this account.

15. The Brooklyn *Daily Eagle*, March 17, 1901; p. 14 (reprinted in *Crockery and Glass Journal*, LIV, December 12, 1901).

16. Whiting, *op. cit.*, pp. 613-17.

17. For elaboration, see the account of the Volkmar exhibit at the Pratt Institute Gallery reported in the Brooklyn *Daily Eagle*, October 19, 1900, p. 9; and *International Studio*, XII (November 1900), p. vi. The latter observes that if Volkmar "has not avoided commercialism entirely, he has at least avoided the creating of monstrosities of clap-trap baubles, such as the English potteries, Doulton and Royal Worcester, have turned out for the last decade, and confined himself to the simple shapes and single colour glazes with admirable restraint. His greens, blues, and yellows are pure, colourful, and even to a high degree." Further elaboration is provided in *Scribner's Magazine*, XXXIII (March 1903), pp. 381-82.

18. Advertisement, *The Art Amateur*, XLII (December 1899), p. 27.

19. Advertisement, *ibid.*, XLII (April 1900), p. 138. It was also Volkmar with whom A. Robineau (Robineau Pottery*) studied: *Keramic Studio*, III (November 1901), p. 143.

20. *Keramic Studio*, II (May 1900), p. 7; *ibid.*, III (May 1901), p. 7. For an extensive account of the mugs, their decoration and sale, and illustration of those to be sold in 1905 see William H. Shelton, *Brush and Pencil*, XV (April 1905), pp. 245-50.

21. Shelton, *Salmagundi*, p. 106. In 1911 a new shape for the mugs of the Club was designed and executed at Lenox, Trenton, New Jersey.

22. Barber, *Marks*, p. 82.

23. The Brooklyn *Daily Eagle*, March 17, 1901, p. 14.

24. See discussion of marks, Volkmar Kilns and Durant Kilns.

* Information relating to this pottery is included in a separate chapter.

Walley Pottery

West Sterling, Massachusetts

William Joseph Walley was born in East Liverpool, Ohio, in 1852. After the death of his potter father, he went to England to learn that trade. He began work for the Minton factory before he was ten years old and continued there until twenty-one, learning all areas of the business "from sagger maker to foreman . . . from modeling to kiln burning." He returned to the United States and began to produce art pottery in 1873 at Portland, Maine.[1] This association could well have been at or in conjunction with either the Portland Stone Ware Company or the J. T. Winslow Pottery, which had been in operation there since the late 1840s.[2]

The Portland experiment in art pottery "did not take,"[3] and Walley's next attempt at producing artware was in Worcester in 1885, when he evidently tried to continue the pottery business of F. B. Norton & Company. Frank B. Norton, grandson of the founder of the Bennington works, began the pottery in 1858 with Frederick Hancock, and by 1865 he was operating the plant alone. In 1873 the firm began the manufacture of emery wheels; twelve years later the Norton Emery Wheel Company was formed and the traditional pottery work terminated.[4]

Walley's work in Worcester did not prove to be a paying proposition and it was abandoned, only to be resumed in 1898 in West Sterling. There he bought the old Wachusett Pottery, which had operated under various styles for over a half-century. This firm, last owned by Marcus L. Snow, was sold in 1887 to the Sterling Emery Wheel Company, which abandoned the redware production and shortly moved to Tiffin, Ohio.[5]

Using local red clay, Walley did most of the work himself. "I am just a potter trying to make art pottery as it should be made," he was to write. "Make one man's ideas, one man's work. Everything [is] made by hand. To me there is more true art in a brick made and burnt by one man than there is in the best piece of molded pottery ever made. What I feel we want is to be true to ourselves and let the art come out."[6]

Candlesticks, vases, planters, bowls, lamp bases, mugs, tea tiles, hair receivers and powder jars were produced, as were cast paperweights, one of the most life-like being a turtle. Handles and decorations were sometimes cast and applied to thrown objects. The most

Walley vase with thick green glaze dripping over a smooth brown ground; h. 6½" (16.5 cm). Impressed WJW, paper label of The Arts & Crafts Society, Boston, from whom the piece was acquired in 1914. *The Newark Museum (#14.923).*

Walley mug, high glaze of brown and green; h. 6⅝" (16.9 cm). Impressed WJW. *Private collection.*

common glazes are green, both in matt and gloss, and variations of green and browns.

Walley's death in 1919 brought an end to the operation. A single example is in the collection of The Newark [New Jersey] Museum (#14.923) and another is reported to be at the Sterling Historical Society.

Pieces were marked with an impressed "W J W" usually produced in three separate impressions.

W ꝺ W

1. Autobiographical notes prepared for The Arts & Crafts Society, Boston, in 1906.
2. Such speculation, however, is not supported by the Portland directories of 1874, 1876 or subsequent years. For a comprehensive study of the Winslow works, see M. Lelyn Branin, *Old-Time New England,* LXI (April 1971), pp. 95-104.
3. Autobiographical sketch, *loc. cit.*
4. L. W. Watkins, *Early New England Potters and Their Wares,* p. 89.
5. *Ibid.,* pp. 95-97, 231-32. Watkins indicates Walley bought the pottery before 1890, but Walley's own autobiographical sketch indicates that he began work in West Sterling in 1898. According to the research of Rod MacKenzie of Lancaster, Massachusetts, a Worcester County atlas of 1898 lists Walley as the occupant of the pottery site and the lot diagonally across the street which is shown on an 1870 map as the property of Snow and Coolidge, an earlier partnership which owned the pottery.
6. Autobiographical sketch, *loc. cit.*

Walrich Pottery
Berkeley, California

While the Walrich Pottery was organized after the "close" of the art pottery era, like Kenton Hills*, this is one of the exceptions which prove the rule of establishing an inflexible dating for any period. Begun in 1922 by James A. Wall and his wife, Gertrude Rupel Wall, the pottery gives evidence of having been primarily a studio operation because of its small size. However, it was born of a dream to establish a commercial venture, and pieces were extensively cast and commercially sold by many important shops and stores throughout the west.[1]

The Walrich Pottery—whose name was coined from the couple's son's name, Richard Wall—was originally located at 2330 Browning Street, Berkeley. It was later removed in 1285 Hearst Avenue. This second location was chosen because it backed up against the Santa Fe railroad, and the day was envisioned when whole carloads might be shipped.

Actually the Walls decided fairly early that such extensive production was not their ultimate goal, and they dispensed with the idea of mass manufacture of wares. J. Wall had worked for a time at the Royal Doulton works in his native England, and as the mainstay of the pottery he compounded the clay bodies, slips and glazes. He was as much an expert on the wheel as he was a mold maker, throwing the plaster models on the wheel and then making the molds from them. About half-a-dozen different bodies were used, including earthenware and porcelain. Shapes were mostly cast, although a few examples were hand thrown, pressed or built.

The output of the pottery, as well as many of the techniques em-

Walrich vase, robin-egg blue semi-matt glaze; h. 5⅝" (14.3 cm). Marked "Walrich". *Private collection.*

ployed, reminds one of the Cowan Pottery*. Vases, flower bowls, figurines, sculptured heads, plaques, candlesticks, bookends, paperweights, lamp bases, dinner sets (on a special-order basis) and decorative and mantel tiles were produced. Two of the sculptors who developed figures and figurines at the pottery were Edgar Tauch and Jacques Schnier. Two examples of the latter's work from about 1927 are at The Oakland Museum (#66.31.10-11). Most of the glazes, many in the popular matt of the period, were developed by J. Wall, their rich blues being particularly noteworthy. Natural competitor of the Walrich Pottery was California Faience*, also of Berkeley. The extent of the rivalry is evidenced in their work and especially in the glaze treatment of the more ordinary pieces.

The Walrich work ended with the onset of the Depression, and the kind of artware production engaged in prior to 1930 was never resumed. Gertrude Wall taught thereafter in various arts and crafts programs, including one offered by the University of California extension department at Halcyon*. She continued her ceramic instruction until ill health forced her retirement. J. Wall worked for Westinghouse's Emeryville, California, plant, which manufactured high-voltage porcelain insulators, and still later for the San Francisco schools, firing for their art students. He died in 1952 and Gertrude R. Wall died nineteen years later, in 1971.

The principal collection relating to the work of the Walrich Pottery is at The Oakland [California] Museum. Included are a traveling case of glaze samples (#66.30.14) which well depict the variety of glazes achieved at Walrich, and a number of important and representative pieces given by Gertrude Wall.

Several marks were used, in particular an incised "Walrich" and the impressed "Walrich," after which "Berkeley, Cal." was sometimes impressed. A paper label was also used, as was the WP cipher, as shown, occasionally appearing as an in-mold mark on a raised disc.

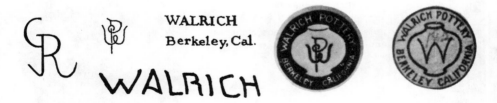

1. The primary source for the information herein presented is the transcription of an interview in 1965 with Mrs. Gertrude R. Wall, with corrections and additional notes by Richard Wall, both of which are in the files of The Oakland [California] Museum. This is supplemented by local directory information and W. F. Dietrich, *The Clay Resources and the Ceramic Industry of California,* p. 45.

* Information relating to this pottery is included in a separate chapter.

Wannopee Pottery

New Milford, Connecticut

The New Milford Pottery Company was organized in June 1887, and three months later the firm purchased three acres of land in New Milford.[1] By September of that year one kiln was in operation and another under construction. Financial difficulties forced a reorganization of the pottery in mid-1892. The new owners, W. D. Black, L. F. Curtis, Merritt Beach and the latter's son C. M. Beach, changed the name to Wannopee Pottery.

An extensive variety of ceramic products was made. *Duchess* ware, which is characterized by mottled glazes, was one of the most popular. A porcelain-bodied ware of the same type was also produced. Clock cases were a particular specialty, and for a period they accounted for a significant portion of the firm's income. Large cases were produced for the Gilbert Clock Company and small ones for the New Haven Clock Company. A blue-glazed ware was produced and often decorated with gold. Pieces of this line, which was seldom marked, included umbrella stands, jardinieres, pitchers and spittoons.

A line of semi-porcelain pitchers in three different sizes was first offered in 1895. It was decorated with relief medallion heads of McKinley,[2] Beethoven and Mozart. Another variety had a full bust of Napoleon. The modeling of the cameos was the work of Victor Galli-

[left] Rich tan glazed Wannopee vase; h. 19¾" (50.3 cm). Impressed Lang & Osgood cipher and 1012G/15. *Michiko & Al Nobel.*

[right] Wannopee Scarabronze vase, dark yellow glaze and brown mottling; h. 16" (40.8 cm). Marked with the Lang & Osgood impressed cipher and 101B/15. *Collection of Julius and Claire Gold.*

more of Trenton, New Jersey. Items of the line itself were considered a "cheap affair" by Barber.[3]

In 1901 the firm began production of lettuce-leaf ware. Based originally on their Italian majolica counterpart, later molds were made actually using cabbage leaves with the outline of the stem and large veins evident. This line, with a pale green or a pink glaze, was extended to some twenty-five sizes and shapes, and it sold extremely well.[4]

About the same time as the introduction of the lettuce-leaf ware, the pottery's finest artware made its debut. *Scarabronze,* as it was named, was designed by A. H. Nobel, pottery manager, and is characterized by a soft, satiny, metallic glaze suggestive of ancient copper. The colors of the kid-like surface range from dark bronze through reddish-copper to a tint bordering on sage green. The shapes, which are adaptations from old Egyptian forms, are simple in outline and most often without relief ornamentation. Egyptian characters and figures were painted on the surface of some of this ware using slip in which different metallic colors had been mixed. A local red clay body was employed, in contrast to clay imported from England and elsewhere which was used in most of the other work.[5]

Production at the pottery ceased in 1903, and the firm was liquidated the following year. The lettuce-leaf molds were sold to Charles Reynolds, who worked for the company as a decorator and designer. He moved to Trenton, New Jersey, and in association with the George H. Bowman Company of Cleveland, Ohio, manufactured the lettuce-leaf ware for a short time.

The most extensive and comprehensive collection of Wannopee work is maintained by the New Milford Historical Society.

Considerable confusion exists as to the designation of the pottery as the "Park Lane Pottery." Barber seems to have been the source of this apparent error,[6] and no evidence can be found that this name was ever actually used. Watkins, using Barber as a source, further compounds the error by citing a mark for Park Lane.[7] The mark, shown by Barber, which created the difficulty, ♇ , is the cipher for Lang & Osgood. Lang & Osgood were evidently the successors to Lang and Schafer, who were the New York agents for Wannopee and whose initials sometimes appear on the ware. The Lang & Osgood cipher is often found in conjunction with that of the scarab on the Scarabronze.

Regular pottery marks are also to be found. Early work, of the cream-colored variety, was marked with the pottery's initials, N.M.P.Co., within a square. In addition, a semi-opaque china was produced which bore the eagle mark as well as the firm's initials. Duchess ware was marked with Wannopee's most common mark, the impressed sunburst-W. Pieces of a porcelain body have the same mark with the word "Porcelain" impressed above it and the firm's initials,

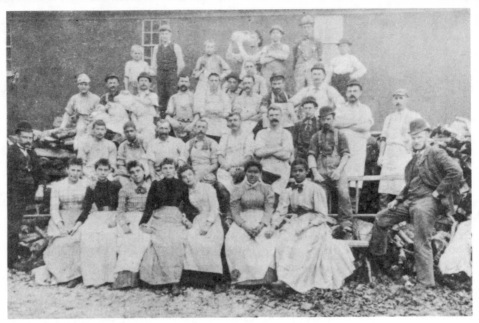

Workers at the New Milford Pottery. *New Milford Historical Society.*

W. P. Co., below it. Lettuce-leaf ware produced by Wannopee is marked with the standard impressed sunburst-W, and the later ware produced from the Wannopee molds bears the imprint "Trade/Lettuce Leaf/Mark." The Scarabronze line was always marked with a scarab which was most often either impressed (and sometimes completely obscured by the glaze) or applied in relief. Occasionally paper labels were used which depicted the scarab in gold. Both impressed and in-mold "Wannopee" marks have also been noted. As with the blue-glazed line with the gold decoration, many miscellaneous items were sold unmarked.

WANNOPEE WANNOPEE WANNOPEE TRADE "LETTUCE LEAF" MARK

1. The sources, unless otherwise noted, for the material presented are from the files of the New Milford Historical Society.
2. A pitcher with the McKinley medallion is in the collection of the New Milford Historical Society.
3. E. A. Barber, *Marks of American Potters*, pp. 98-99.
4. *China, Glass and Pottery Review*, VII (February 5, 1901), p. 37; *Glass and Pottery World*, XIII (September 1905), p. 29. An example of the Wannopee lettuce-leaf ware is in the collection of the Philadelphia Museum of Art (#'03-375) and marked with the sunburst-W. It was acquired from A. H. Noble in 1903.
5. E. A. Barber, *The Pottery and Porcelain of the United States*, pp. 504-05.
6. Barber, *ibid.; Marks, loc. cit.*
7. L. W. Watkins, *Early New England Potters and Their Wares*, pp. 232-33.

Weller Pottery

Zanesville, Ohio

Samuel A. Weller began business in 1872 in Fultonham, Ohio, where he was born. Prior to his entry into the art pottery field he produced jardinieres, hanging baskets, umbrella stands and painted flowerpots, much the same background as George Young's of the Roseville Pottery*, Weller's future principal competitor. In 1888 the pottery was moved from Fultonham to a small frame building on the river bank at the foot of Pierce Street in Putnam (now part of Zanesville), Ohio, a plant which was abandoned in 1890 in favor of a newly erected one on the "show grounds" between Pierce Street and Cemetery Drive. This plant and its contents were destroyed by fire May 10, 1895, but a new building was immediately erected and occupied that October.[1]

As early as 1893 Weller had produced the first fancy glazed ware in Zanesville.[2] Through the combination with the Lonhuda Pottery* late the following year, Weller gained Long and the Fry-patented process for blending several ground colors. Early in 1895 the Lonhuda

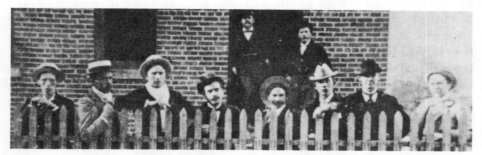

Early class in ceramics at the Weller pottery (c. 1896). S. A. Weller and W. A. Long in rear. *Brick.*

operation was moved to Weller's Zanesville plant, and after a year's time Weller had learned the Lonhuda process, dissolved the relationship with Long and begun producing underglaze decorated artware with atomized backgrounds.[3] This high-glazed ware, generally in red to brown colors and hand-decorated with fruits, flowers, or portraits (frequently of Indians), was named *Louwelsa*.[4]

By late 1897 several prestige lines were produced in addition to Louwelsa. These included Tourada, Samantha and Dickens' Ware.[5]

Drawing of the original Weller pottery.

Turada, as it is more commonly spelled, was designed by Weller himself and "consists of pieces of various colored clays, somber browns, orange and cream, with applied ornaments of pierced work judiciously and artistically introduced."[6] *Dickens' Ware*—what has become known as "First Line Dickens" or I Dickens—was similar to Louwelsa but with a solid ground. It bore no relationship to the more familiar II Dickens, for which some decorative subjects were taken from the French; others are of the poster order which were so popular at the time, while others were of Dickens characters. This second line was produced with high-gloss and light matt grounds with the decorations etched sgraffito-style in outline and filled in with bright colors.[7] This method of work was slow and costly and after a short time was replaced by III Dickens. This line, attributed to Frederick H. Rhead,[8] was far more simple in execution; the design was covered with a clear glaze, often bearing an applied black cameo-type disc with the head of Dickens in white and a Dickens inscription in white on a similar disc.

Two other lines related to the short tenure of F. H. Rhead are Jap Birdimal and L'Art Nouveau, the principal designs of both having been introduced earlier at the Vance/Avon* works. *Jap Birdimal* was produced by outlining the decoration—geometric, scenic or with a Japanese motif—with a white slip squeezed from a bag through a fine nozzle, usually on a gray or blue ground. The design or decoration was then filled in with a contrasting color. *L'Art Nouveau,* in its original high-gloss, high-relief forms, almost duplicates the effect of a similar line at Vance/Avon, also in Art Nouveau decor. This designation was also applied to a line of decorated ware in pastel matt colors.

Weller Aurelian ware, decorated by T. J. Wheatley; h. 14" (35.7 cm). Incised "Aurelian", Wheatley initials and dated 1898. *M. Mesre.*

By 1902 both Owens* and Roseville were also producing the successful Lonhuda-type ware. To maintain his first place among Zanesville competitors, Weller secured the services of Jacques Sicard. Sicard had come to the United States the previous year after an association of many years with Clement Massier of Golfe Juan, France.[9] Heeding the experience of Long, Sicard carried out his work in utmost secrecy.[10] Working only with his assistant, Henri Gellie, he decorated rather simple shapes with floral and other motifs in metallic lusters on an iridescent ground of different tints ranging from rose and blue to crimson and purple. *Sicardo* or *Sicardo Weller* was produced until 1907, when Sicard returned to France; he died there in 1923. Weller continued to offer his inventory of the line for sale until after 1912.[11]

Several other lines had been added by 1904.[12] *Eocean* (also spelled Eosian) is similar in technique to Louwelsa with underglaze slip

Weller Faience vase in style of Frederick H. Rhead (note similarity to Vance/Avon ware with flowing tree trunks and branches). Stylized tree foliage is medium green, outlined in white by squeeze-bag technique; branches and trunks are brown on a medium high-gloss blue ground; h. 8" (20.4 cm). Incised Weller Faience/E500½. *Michiko & Al Nobel.*

decoration, but with a blended ground of pale blue, gray and soft green color effects most characteristic. III Dickens is actually a particular type of decoration of Eocean ware, which was normally decorated with floral, fruit or figural subjects. *Aurelian* is a variety of Louwelsa with the background color applied by brush rather than with an atomizer.[13] *Auroral,* in blended shades of green with fish or flower decorations, derives its inspiration from Rookwood's* Sea Green ware. By 1906 Weller had secured the services of Gazo Fujiyama and later that year *Fudzi* ware was offered.[14]

Rookwood was the pace-setter of the period for the Ohio potteries. Its foremost interest was a distinguished artistic product, whereas its commercially oriented Zanesville imitators such as Weller, Roseville and Owens were primarily interested in producing items on a large-

One of several mammoth Aurelian vases measuring over five feet in height produced in the late 1890s. The piece illustrated on this postal card is presently in the *Purviance collection.*

Louwelsa vase with portrait of T. J. Wheatley as Treslox by Marie Rauchfuss, who later joined the Rookwood decorating staff; h. 19½" (49.7 cm). Regular impressed Louwelsa Weller mark and incised date "Xmas/1897". *M. Mesre.*

scale basis which could be sold at low prices. With a few notable exceptions, most Zanesville artwares were copies of each other's work or of Rookwood's latest artistic achievements: Weller's Louwelsa, Owens' Utopian, and Roseville's Rozane (Royal) were copies of Rookwood's Standard ware; Eocean at Weller, Lotus at Owens, and Rozane (Royal) Light at Roseville the copy of Rookwood's Iris glaze. In the quality of body or decoration, none of the Zanesville producers ever approached that of Rookwood; and even Weller's Louwelsa never achieved the quality of the Steubenville Lonhuda.

New lines were regularly added by Weller, who remained the unchallenged leader in the output of mass-produced artware until Roseville's triumph with its Donatello line. After 1910 most of the new lines required a minimum of individual artistic work, and by the beginning of World War I production of the prestige ware was abandoned; among the last to go were Louwelsa (which had been produced

in over 500 shapes and sizes) and Eocean.[15] Thereafter new lines of industrial artware were introduced at the rate of at least one a year.[16]

Unlike Roseville, Weller introduced several new lines of art pottery after the war. Two in particular were the work of John Lessell (Lessell Art Ware*), art director at Weller from 1920 until 1924: *LaSa,* an overglaze, hand-decorated line most often with a tree motif on a luster background of sky, water and land; and *Lamar,* an overglaze decorated ware with black trees on a deep red ground. With the departure of Lessell and the death of Weller in 1925, the development of art pottery per se at Weller came to an end.[17]

Weller was always expansion-minded. In 1908 the possibility was seriously entertained of building a pottery in Colorado Springs, Colorado, which would have been as large as that at Zanesville.[18] Although this plan was never carried out, Weller did expand in Zanesville by acquiring the Zanesville Art Pottery* in 1920. The Depression Era of the 1930s was marked, however, by contraction and the consolidation of Weller's several plants. After the late 1920s, when annual volume reportedly was close to $900,000,[19] it was almost a continual decline; and in 1947 the Essex Wire Corporation of Detroit bought the controlling stock in the Weller corporation formed in 1922. The following year pottery production was discontinued, and in 1949 the S. A. Weller Company was dissolved.

A small collection of early lines of Weller ware is at the National Museum of History and Technology (Smithsonian Institution); another small but important collection is at the National Road/Zane Grey Museum of The Ohio Historical Society.

There is almost no consistency in Weller marks, and the more one attempts to order them the more illogical and confusing they become. In the early period impressed or incised line designations often appear in addition to the impressed Weller name, although in numerous cases pieces bear the mark of one line and the decoration of another; many pieces were not marked at all. Decorator signatures and ciphers[20] do not offer much help in the definite attribution of unmarked pieces as decorators frequently moved from one Zanesville pottery to another, and often the various firm lines were so similar that without a mark they could not be told apart. On the cast ware produced after 1915 usually only the incised, imprinted or in-mold Weller name appears. Paper labels were also used during the 1930s and '40s, as were the script signatures. The Sicardo line is often signed on the face of the piece, as is LaSa. The original Weller Lonhuda line bears the impressed LF—for Lonhuda Faience—mark within the shield, as well as the impressed Lonhuda designation. The incised Weller Faience mark is found on Jap Birdimal-type ware, often in conjunction with "Rhead," designating F. H. Rhead.

1. Thomas W. Lewis, *Industrial, Mercantile and Picturesque Zanesville* (1895); J. Hope Sutor, *History of Muskingum County* (1905), p. 177. The term "Weller" is used throughout the text in reference to the S. A. Weller Pottery, which is to be distinguished from the short-lived H. A. Weller Art Pottery* operated by S. A. Weller's nephew.

2. Sutor, *loc. cit.*

3. *Clay Record,* IX (September 28, 1896), p. 15. After Long's departure from Weller, Fry also instituted a lawsuit against Weller in 1897 for infringement of her patented process of atomized colors. A decision in late 1898 on Fry's earlier suit against Rookwood* in the latter's favor resulted in the collapse of the case against Weller. (For a discussion of the Fry process and related litigation, refer to the chapter on Lonhuda.)

4. The name was coined from the first name of Weller's daughter, Louise, the first three letters of his surname and his first two initials.

5. *Illustrated Glass and Pottery World,* VI (January 1898), p. 22. It is possible that all of these lines were introduced as successors to the Louwelsa ware while the Fry lawsuit was pending, as all have solid, brushed grounds. With the settlement of the suit, Louwelsa production was resumed; the Dickens line was redesigned; Turada was sometimes produced with blended grounds; and Samantha disappeared.

6. W. P. Jervis, *The Encyclopedia of Ceramics,* p. 603.

7. II Dickens was originally introduced in the fall of 1900 (*Crockery and Glass Journal,* LII, December 27, 1900, p. 17) but was discontinued with the departure of

Upjohn (Upjohn Pottery*), the designer, shortly thereafter; it was re-introduced after his return in 1902 (*Illustrated Glass and Pottery World,* X, November 1902, p. 17; *China, Glass and Pottery Review,* XII, February 1903, p. 27). This latter source indicates that the name for the line was suggested by the fact that Sam Weller was the name of a Dickens character in *Pickwick Papers,* and Weller wished to return the compliment. A detailed account of how II Dickens was made is presented by N. Schneider in L. & E. Purviance and N. Schneider, *Weller Art Pottery in Color,* plate 3.

8. Purviance & Schneider, *loc. cit.* Rhead was at the Weller Pottery between his leaving the Vance/Avon pottery in mid-1903 and becoming art director of Roseville in 1904.

9. Arthur V. Rose, *China, Glass and Pottery Review,* XIII (October 1903), p. 19.

10. F. H. Rhead, a competent technician, reported that this type of decoration was produced by the painting of a metallic-ochreous mixture over a fired copper glaze and then subjecting this to a certain reducing fire (*The Potter,* I, January 1917, p. 44).

11. *Pottery & Glass,* IX (October 1912), p. 21. A well-executed example of Sicard ware is in the collection of The Metropolitan Museum of Art (#69.63). A sizeable collection of Sicard's work is at the Zanesville Art Center Museum.

12. As listed in E. A. Barber, *Marks of American Potters,* p. 131. Weller had extensive exhibits at the 1904 exposition at St. Louis, including examples of the various lines. S. Geijsbeek (*Transactions* of The American Ceramic Society, VII, 1905, pp. 349-50) noted that "of the different styles exhibited we found the Aurelian ware, Louwelsa ware, Eocean ware and Sicardo Lustre ware to be the best."

13. This would appear to have been another line which was introduced during the Fry court test (see note 5) and which continued as a style of decoration after the atomizing question was resolved. Benjamin (*American Art Pottery,* p. 31) indicates it was still being produced in 1905.

14. The 1906 *Catalog of the Tenth Annual Exhibition of The Art Association of Richmond, Indiana,* held from June 12-26, displayed and offered for sale ten Weller lines including *Fudzi.* It is therefore impossible to attribute Fudzi ware which does not bear either the Weller or Roseville designation to one or the other pottery, unless perhaps it was consistently spelled Fudzi at Weller and Fudji at Roseville. In most instances pieces do not bear a pottery identification.

15. Purviance and Schneider, *Weller Art Pottery in Color,* plate 1.

16. There is a bewildering array of names given to these lines, and since the designations rarely appear on the ware—except during the earliest years—their nomenclature is relatively unimportant. Schneider (*Weller Art Pottery in Color*) relates how employees jokingly said that the names were taken from Pullman cars as they passed the Weller factory.

17. Weller pottery catalogs used by Schneider in his research have been deposited in the library of The Ohio Historical Society, Columbus. Descriptions and illustrations of many of the late lines, by name, are contained in *Weller Art Pottery in Color.*

18. *American Pottery Gazette,* VIII (November 1908), p. 9; *The Clay-Worker,* L (November 1908), p. 538; *Pottery & Glass,* I (December 1908), p. 26; *Clay Record,* XXXIII (November 16, 1908), p. 31.

19. H. Peck, *The Book of Rookwood Pottery,* p. 171.

20. Ciphers and names of early decorators are recorded by E. Barber, *op. cit.,* p. 132. Schneider has expanded this listing considerably in *Weller Art Pottery in Color,* plate 2a.

* Information relating to this pottery is included in a separate chapter.

H. A. Weller Art Pottery

Zanesville, Ohio

For a short time in 1908-09 the nephew of S. A. Weller operated his own business, the H. A. Weller Art Pottery. Harry A. Weller received his ceramic training at the Weller Pottery* and for nine years managed the Marietta Street plant of that firm.[1] The H. A. Weller works operated in the old Nielson* pottery building in Zanesville[2] and produced jardinieres, umbrella stands, fern dishes, cuspidors and artwares. The latter were offered either high-glazed or in a matt finish, primarily in green.[3] There is no indication of this firm's existence beyond 1909. Upon the death of S. A. Weller in 1925, Harry Weller —who had been in charge of manufacturing at the Weller Pottery —became head of that firm, a position he held until his accidental death in 1932.[4]

Since no marked pieces have been found, it is improbable that the H. A. Weller ware was marked.

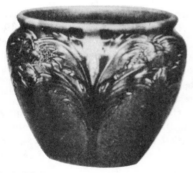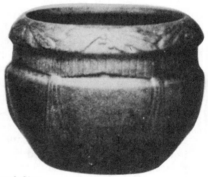

H. A. Weller jardinieres as illustrated in 1909. *Pottery & Glass.*

1. N. F. Schneider, Zanesville *Times Recorder*, February 4, 1962, p. B-3.
2. *Clay Record*, XXXIII (November 30, 1908), p. 30.
3. *Pottery & Glass*, II (April 1909), p. 202; *ibid.*, II (May 1909), pp. 235-36. An advertisement of the firm appears in *Pottery & Glass*, II (April 1909), p. 228.
4. *The Bulletin* of The American Ceramic Society, XI (November 1932), p. 262.
* Information relating to this pottery is included in a separate chapter

T. J. Wheatley & Company

Cincinnati, Ohio

A definitive chronicling of the early years of the art pottery move-
ment in Cincinnati is most difficult, as the success of Rookwood* so
overshadows the other operations. These early works, such as T. J.
Wheatley & Company (to be carefully distinguished from the Wheat-
ley Pottery Company established about 1900), which predates Rook-
wood by over half a year, have received little attention other than
when analyzed as to how they were related to the development of
Rookwood. Even "Cincinnati faience," the original name given to the
slip-painted underglaze decoration in the style of Limoges, came to be
identified as "Rookwood Standard" ware, in spite of Rookwood's hav-
ing been the last of the Cincinnati potteries to produce this style of
pottery.[1]

In 1879 Thomas Jerome Wheatley, then in his mid-20s and with
some background from Cincinnati's School of Design, became as-
sociated with the Coultry* works, firing his first piece there in April
1879.[2] Mary Louise McLaughlin (Losanti*), who had been success-
fully firing Cincinnati faience at that pottery for over a year, attracted
considerable publicity with her accomplishments, and Wheatley was
brought in to teach a class on the technique of the decoration of such
ware. Those enrolled included John and Martin Rettig, Albert Valen-
tien, Matt Daly and Clara Newton,[3] several of whom later became
Rookwood decorators.

At the same time McLaughlin formed the Cincinnati Pottery Club,
which also used the facilities of the Coultry pottery. The resulting con-
flict of the two groups prompted the Club's removal to the Dallas
Pottery*, where they were able to take advantage of two skilled tech-
nicians, Joseph Bailey, Sr., the Dallas superintendent, and William
Auckland, its potter.

Also in 1879 the Cincinnati Art Pottery* was formed, evidently to
offer new capital to the Coultry-Wheatley venture. That association
was short-lived, however; after a disagreement it ended in a lawsuit
over division of the large number of vases which were the assets of the
partnership.[4] Immediately thereafter, in April 1880, Wheatley
opened his own works at 23 Hunt Street, Cincinnati, where all the
processes including the preparation of the clays, molding, glazing, fir-
ing and decorating were done by him.[5]

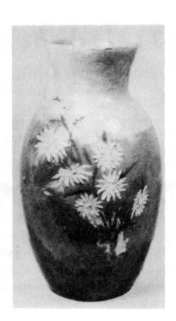

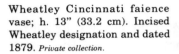

Wheatley Cincinnati faience vase; h. 13" (33.2 cm). Incised Wheatley designation and dated 1879. *Private collection.*

Wheatley claimed to have discovered the "Limoges method" of decoration in 1877 in New York, "but the color did not come out right because of imperfect burning."[6] Yet "his" method was precisely that developed earlier by M. L. McLaughlin, using an unfired clay slip on a damp body, rather than using a slip made from finely ground fired clay and then applied to a thoroughly dried piece, the technique used by Volkmar (Volkmar Pottery*) in New York and at the Haviland pottery itself.

To exclude competition, Wheatley filed for a patent on June 21, 1880, and Patent No. 232,791 was issued to him on September 28, 1880. The patent covered application of underglaze colors to pottery and other ceramics in such a manner as to cause the colors to become integral with the ware as soon as the latter is baked. "The first step in my improved art of ornamentation consists in forming the vessel . . . *and while yet moist or damp*[7] there is applied to it the background tint, which tint is composed of any appropriate oxide or underglaze color mixed with white slip. . . . While the background coat of tinted slip is yet damp the piece is decorated with landscapes, flowers, figures, animals or other desired ornamentation. . . . The appropriate oxide colors or other pigments used for these decorations are mixed with slip in any suitable proportions, and if the ornaments consist of a bunch of flowers or fruit or other simple group it is preferred to impaste the colors, so as to cause such a group to stand out in high relief after the piece is burned. . . . After being baked . . . this biscuit is now dipped in any

suitable glaze and then reheated, so as to give it the final or vitreous coating, which operation completes the process."

While Wheatley's patent did not withstand a court test, its negation had no immediate effect, and by the end of 1880 the pottery employed four artists, with the addition of two others anticipated.[8] Extensive sales of Wheatley pottery were being made to Tiffany & Company,[9] and two hundred pieces of Cincinnati faience by Wheatley and his pupils were exhibited at the Eighth Cincinnati Industrial Exposition that year.[10]

To assure continued expansion, the Cincinnati Art Pottery was formally incorporated in Ohio in December 1880, with Wheatley one of the incorporators. Output was temporarily interrupted due to a fire, but was resumed by February 1881.[11] Wheatley remained associated with the pottery through mid-1882, during which time it continued operation under the name of T. J. Wheatley & Company.[12]

Most of the Wheatley & Company work was executed in the yellow clay readily available close to Cincinnati, rather than red clay, which had to be imported from Zanesville. Examples of this early Wheatley pottery work are to be found in the collection of the Cincinnati Art Museum.

Wheatley carefully marked his ware, either with the incised initials "T.J.W. & Co." or with the full incised signature "T. J. Wheatley & Co." The "& Co." was apparently added in early 1880 after Wheatley's disassociation from Coultry, as pieces for which an earlier date of execution can be established do not include it. Work is often dated with the year of production, and those executed after the patent award usually bear the September 28, 1880, patent date. The latest dated pieces bearing the Wheatley & Company cipher are marked 1882.[13] This sys-

T. J. Wheatley vase with slip-painted daisies on dark blue ground; h. 9" (22.9 cm). Incised T.J.W. & Co. and patent date. *Milwaukee Public Museum (#45878/12850).*

tem of dating by year, as well as the shape identification which is often found incised on Wheatley pieces, was later incorporated into the marking system of the Rookwood Pottery.

1. An attempt to draw the various early Cincinnati art pottery producers—Coultry, Dallas, Wheatley and Rookwood—into an overall perspective was made by the author in *Spinning Wheel,* XXVIII (September 1972), pp. 16-18.
2. Cincinnati *Daily Gazette,* October 7, 1880.
3. M. L. McLaughlin, *The Bulletin* of The American Ceramic Society, XVII (May 1938), pp. 224-25; also W. P. Jervis, *The Encyclopedia of Ceramics,* p. 605. A piece executed by John Rettig, under Wheatley's direction in 1879, is in the collection of the Cincinnati Art Museum (#1970.626).
4. Cincinnati *Daily Gazette, loc. cit.* A description of Coultry-Wheatley pieces exhibited at the Seventh Cincinnati Industrial Exposition (1879) is to be found in *Crockery and Glass Journal,* X (October 2, 1879), p. 6.
5. Mrs. Aaron Perry, *Harper's New Monthly Magazine,* LII (May 1881), p. 840.
6. Cincinnati *Daily Gazette, loc. cit.*
7. Quotation from patent specification (italics are the author's).
8. Cincinnati *Daily Gazette, loc. cit.*
9. *American Pottery and Glassware Reporter,* III (October 1880), p. 4.
10. *Crockery and Glass Journal,* XII (September 16, 1880), p. 10.
11. *Ibid.,* XIII (February 10, 1881), p. 26.
12. The relationship between Wheatley & Company and the Cincinnati Art Pottery is more thoroughly explored under the latter entry.
13. A piece so dated is #1881.76 [*sic*] at the Cincinnati Art Museum. The following explanation is offered to account for the accession date (1881) predating the incised date (1882): According to the Women's Art Museum Association, this organization was collecting and exhibiting from at least as early as 1877. In September 1880 Charles West advanced $150,000 to build a museum, and the following March the women offered their collection to the future museum. On March 25, 1881, it was formally entered in their minutes that the offer had been accepted and an agreement signed transferring their collection to the Art Museum Association. On February 10, 1882, an exhibition was opened by the women in the temporary rooms of the Museum Association. The description of that exhibition corresponds almost word for word with the "Mar. 15/13, 1881" entry in the Donation Book of the Museum. It should also be noted that the "Mar. 15/13, 1881" entry is the only entry for 1881 and includes a variety of objects; that the 1882 entries are not dated but are simply given donation numbers; and that specific dates for donations begin only January 26, 1883. It would appear that someone about January 25, 1883, drew up a list of items given to the new Museum Association up to that date and used the February 1882 exhibition list as the Women's Art Museum Association contribution, backdating everything to the transfer of ownership date in March 1881.
* Information relating to this pottery is included in a separate chapter.

Wheatley Pottery Company
Cincinnati, Ohio

After disassociating himself in 1882 from the Cincinnati Art Pottery*, which until that time operated under the style T. J. Wheatley & Company*, Wheatley purportedly "built a commodious pottery at the Covington end of the Suspension Bridge, but it was destroyed by the flood of 1884."[1] After that time Wheatley does not appear to have been actively involved in any pottery operations until 1897, when he joined the Weller* staff.[2]

About 1900 Wheatley returned to Cincinnati and resumed the making of art pottery. In 1903, in association with Isaac Kahn, Wheatley established the Wheatley Pottery Company at 2430 Reading Road. The new plant was described as being about 50 x 200 feet and containing workrooms, studios and two large kilns, with all modern appliances for the making of the finest kind of pottery. Carrying a report from the Cincinnati *Enquirer, The Clay-Worker* noted that "after being nearly fifteen years without a pottery where they could carry out their artistic ideas in molding and decorating pottery, the women of Cincinnati . . . will, within the next month, have a place where they can take their work."[3]

The foremost artware line of the pottery was Wheatley ware, characterized by a colored matt glaze over relief work, chiefly in dark shades of green, yellow and blue. Unique effects were achieved on some pieces which show splashes of green on dark blue or black.[4] Imitations of the then-popular Grueby* green were offered, as were pieces with a raised dark-green crackle on a brighter green ground.[5] In addition to artware, garden pottery and architectural items such as mantels, brackets and panels were produced.

The last noted exhibition of Wheatley's artware was in 1907.[6] There is a possibility that such ware was produced as late as the destructive fire in 1910, when considerable loss was sustained by the works, including a great deal of finished work.[7] The plant was rebuilt and presided over by Wheatley until his death in 1917. At that time the firm's production consisted of faience tile, clay chimney pots and garden ware, including a line of matt green planters.[8]

Kahn succeeded Wheatley as manager and incorporated the firm in Ohio in 1921, with an infusion of new capital by John B. Swift. While the operation was moved to Swift's building at 4609 Eastern Avenue,

Kahn became president of the new corporation, a post which he held until 1927. With the move to new facilities, the work force was expanded from thirty to three hundred and output greatly increased, especially of the architectural faience line.[9] Production of garden pottery was also expanded, and by 1924 a wide variety of pedestals, fountains, jardinieres, flower boxes and lawn sets was produced. Wheatley's Plymouth gray ware, a blend of old ivory and buff tones, was a particular specialty.[10]

In 1927 the Cambridge Tile Manufacturing Company of Covington, Kentucky, acquired the Wheatley Pottery Company and it was reincorporated as the Wheatley Tile and Pottery Company, with its manufacturing plant at the Eastern Avenue location. This was operated as a separate unit by Cambridge until it was closed in 1930 and all operations transferred to a new Cambridge plant in Hartwell, Ohio. Also in 1927 the Cambridge-Wheatley Company was incorporated to sell the products of Cambridge Tile and Wheatley Tile. Both the Cambridge-Wheatley and Wheatley Tile firms were legally dissolved in December 1936.[11]

Two examples of the Wheatley art pottery of this period are in the collection of the National Museum of History and Technology (Smithsonian Institution; #237,943-4), a gift of the Wheatley firm.

Much of the artware of the Wheatley Pottery Company is unmarked today, having borne only a paper label at the time it left the pottery. The label read "Wheatley/Cincinnati, O." and displayed the firm cipher as shown.

Wheatley Pottery Company artware. Vase at left has grass green splotches on deeper green ground; h. 12¾" (32.5 cm). At right, textured and mottled deep gray-green glazed vase; h. 14⅛" (36.0 cm). Both marked with paper labels. *National Museum of History and Technolgoy (Smithsonian Institution; #237,944, 237,943).*

1. W. P. Jervis, *The Encyclopedia of Ceramics,* pp. 605-06. No material has been found to substantiate Jervis' report, with the possible exception of a reference to the Covington Pottery Company's having added a new kiln and doubling their capacity, which appears in the *Crockery and Glass Journal,* XXI (March 19, 1885), p. 17. The additional note, of particular interest, is that "The Covington ladies, who have quite a club in ceramics, will rejoice in their increased facilities."
2. Two pieces of Weller ware pictured in the chapter on Weller attest to this: one, by Marie Rauchfuss (who later joined the Rookwood*·decorating staff), is a portrait of Wheatley on Louwelsa ware, dated 1897; the other is an Aurelian ware piece signed by Wheatley and dated 1898. See also Jervis, *op. cit.,* p. 606.
3. *The Clay-Worker,* XL (August 1903), p. 152.
4. M. Benjamin, *American Art Pottery,* pp. 26-27.
5. *Keramic Studio,* VII (June 1905), p. 26.
6. *Ibid.,* IX (June 1907), pp. 39, 41.
7. *The Clay-Worker,* LIII (May 1910), p. 741.
8. *Ibid.,* LXVIII (November 1917), p. 432.
9. *Ibid.,* LXXV (March 1921), p. 396.
10. *Ibid.,* LXXXI (January 1924), p. 32.
11. From notes by W. S. Berger (President of Cambridge Tile from 1920-27 and later Treasurer of that firm), published in *The Bulletin* of The American Ceramic Society, XXII (May 1943), pp. 129, 131.
* Information relating to this pottery is included in a separate chapter.

White Pottery

Denver, Colorado

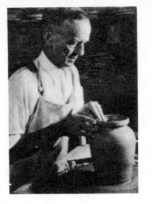

F. G. White at wheel of
Denver Art Pottery

Prior to the establishment of either the Denver China and Pottery* or the Van Briggle* works, Frederick J. White and his son, Francis George White, established a pottery in 1893 operated as F. J. White and Son. The senior White was born in 1838 in Bristol, England, and worked there at the Baptist Mills Pottery with his father, Joseph. He left England at the age of twenty-five and settled in New Brunswick, Canada, where Francis was born in 1869. At St. John's, New Brunswick, Frederick engaged in the manufacture of utilitarian pottery at the Courtenay Bay Pottery. In 1875 he returned to England and took charge of the Baptist Mills works, remaining there until 1892. The following year White and his son settled in Denver for the purpose of conducting experiments with Colorado clays. At first they worked in local stoneware factories, but in 1894 they began their own pottery and manufactured jugs, flowerpots, Rockingham-type teapots and yellow bowls at 1434 South Logan, using Colorado buff clay.[1]

By 1909[2] art pottery was being produced, and as output expanded the firm became known as the Denver Art Pottery, reflecting the shift in emphasis. In 1910 F. G. White went to Oklahoma City, Oklahoma, and attempted to establish a pottery there, but it was not successful and he returned to Denver the next year. The Denver works were moved to 808 South Broadway, where business continued to grow. In 1915 the plant was again moved, to 1546 South Logan, and it relocated in 1921 at its final address, 1560 South Logan, where it was operated by the younger White following Frederick's death in 1919. Clay was mixed in the basement in a converted washing machine and then thrown on a homemade wheel; no molds were used. The coal-burning downdraft kiln was located in a tin shed behind the home. Francis, who continued his work until the mid-1950s when poor health forced his retirement, died in 1960.

During the early period White's artware, first known as *Gray Ware,* was identified as *Denver Gray Ware.* Vases, lamp bases and jardinieres were produced in this line with its distinctive gray semi-matt, grainy-appearing glaze. A type of ware similar in appearance and technique to Niloak's* Mission ware was also produced, as was a slip-painted ware. A wide range of monochrome glazes, mostly developed by the Whites, was used on artware; this occasionally

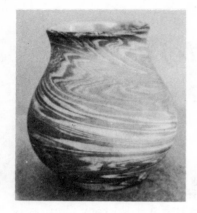

White Pottery's swirled clay work, similar to Niloak's Mission ware; h. 4" (10.2 cm). Incised Denver mark and W-within-the-D. *Berger collection.*

White Pottery "Gray Ware" vase; h. 5" (12.7 cm). Impressed White/Denver mark and dated 1910. *Private collection.*

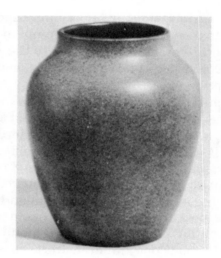

was also decorated with an impressed reeding of the type associated with the work of A. W. Robertson, especially at the Roblin* pottery.

Early work was incised "Denver," often with the addition of White's initial, "W," within the D. For a brief time about 1910 the impressed "White" and "Denver" designation was also used. The date was often incised on work produced up to 1920. Later artware (1920-c. 1955) bore the incised Denver designation; but during both periods a great deal of work was unmarked, and utilitarian ware such as dinner services and mugs was purposely left unmarked.

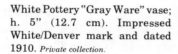

**White
Denver**

1. Primary sources for the information herein presented are notes from F. G. White taken by his sister-in-law; Bettie I. Lopez, Denver *Post* (Empire Magazine section), May 30, 1954, pp. 22-23; Denver *Times,* February 18, 1919, p. 9; Denver *Post,* March 18, 1960, p. 39; Denver *News,* March 19, 1960, p. 65.
2. The earliest dated piece of artware studied was produced in 1909.
* Information relating to this pottery is included in a separate chapter.

Zanesville Art Pottery

Zanesville, Ohio

In early 1896 a group of men headed by David Schmidt organized the Zanesville Roofing Tile Company and incorporated it in Ohio. The corporate name was changed to the Zanesville Art Pottery Company in 1900, when the firm shifted from the manufacture of roofing tile to art pottery.[1]

Schmidt, who was born in Germany in 1847 and came to the United States nineteen years later, served as president. In 1901 Albert Radford, later to organize the A. Radford Pottery*, was general manager and D. C. Applegate, who had previously been Weller's* general manager, was business manager for Zanesville Art Pottery.[2]

Cobalt blue jardinieres were produced; and a line of utensils for cooking and baking purposes, including brown and white lined bowls, coffeepots and teapots, nappies and casseroles, was introduced shortly after 1900.[3] At the time of the plant's first destructive fire in October 1901, about one hundred workers were employed.[4] The works were immediately rebuilt and the kilns refired by the spring of the following year.[5]

Art pottery of the firm, apparently of a luster type, was shown at the 1904 exposition at St. Louis. A line of hand-painted slip-decorated ware designated *La Moro* is similar to Roseville's* Rozane (Royal) and Weller's Louwelsa. It is uncertain exactly when this was introduced, but it could well have been as late as 1908, when *Pottery & Glass* reported that "rich glossy glaze forms an interesting feature of the new art lines of vases recently placed on the market by the Zanesville Art Pottery. The line is varied and contains numerous shapes. The decorations are all underglaze."[6] If this late date is correct, it would place its introduction contemporary with that of McCoy's*

Zanesville Art Pottery La Moro high-glazed ware; h. 7" (17.8 cm). Impressed La Moro/895/5. *Mr. & Mrs. Zane Field.*

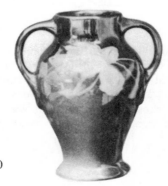

Loy-Nel-Art line. Also produced was a matt-ground ware with light-colored slip decorations, similar to Owens' matt Utopian and Clifton's* Tirrube.

The pottery was again destroyed by fire in early 1910, at which time two hundred persons were employed.[7] Again it was rebuilt, and operations including the production of artware continued under the name Zanesville Art Pottery until 1920, when it was sold to S. A. Weller.[8]

The mark common to the Zanesville Art Pottery is the impressed "La Moro" as shown. It appears on the high-glazed slip-decorated ware and also on the decorated matt-glazed ware.[9]

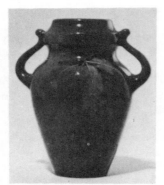

La Moro vase; h. 8⅛" (20.7 cm). Impressed La Moro/ /867/5. *Private collection.*

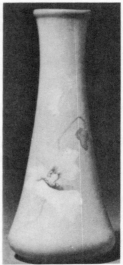

Matt La Moro vase; h. 8½" (21.6 cm). Impressed La Moro/307/4; incised W on base; artist's initials C.D. appear on the body. *Private collection.*

LA MORO

1. While this dating differs from J. Hope Sutor, *History of Muskingum County* (1905), p. 486, it is based on corporation records of the State of Ohio. See also *Clay Record*, XVII (October 15, 1900), p. 24; H. Ries and H. Leighton, *History of the Clay-Working Industry in the United States*, p. 192. Notation has also been made of the erroneous reference to this firm as the David Schmidt Art Pottery (*The Bulletin* of The American Ceramic Society, XXIII, July 15, 1944, p. 221).
2. N. Schneider, Zanesville *Times Recorder*, February 4, 1962, p. B-3.
3. W. Stout *et al.*, *Coal Formation Clays of Ohio*, p. 61.
4. *The Clay-Worker*, XXXVI (November 1901), p. 431.
5. *Ibid.*, XXXVII (May 1902), p. 564.
6. *Pottery & Glass*, I (August 1908), p. 22.
7. *The Clay-Worker*, LIV (August 1910), p. 194.
8. W. Stout, *loc. cit.*
9. Examples of both are illustrated in L. & E. Purviance and N. Schneider, *Zanesville Art Pottery in Color*, plate 21.
* Information relating to this pottery is included in a separate chapter

Art Pottery

A Bibliographic Survey, 1970-1987

The 1970 exhibition and catalog of The Metropolitan Museum of Art, *19th Century America: Furniture and other Decorative Arts*, and Lucile Henzke's *American Art Pottery* (Camden, New Jersey, 1970)[1] can be seen as the beginning of institutional and collector interest in the 'coming of age' of an appreciation of art pottery production in the United States. The erroneous information included in both provided a reminder of the need for and an impetus to serious research and analytical scholarship. What the Metropolitan exhibition catalog offered was an institutional imprimatur to what had been accomplished by the change in the tariff law in 1966 which established as "antique" anything made over one hundred years ago, instead of the earlier cutoff date of 1830. Suddenly the whole nineteenth century became the object of scholarship, and in the ensuing years the challenge was faced. Offering historical background and illustrative material, including marks, were Ralph and Terry Kovel's *Kovels' Collector's Guide to American Art Pottery* (New York, 1974) and Evans' *Art Pottery of the United States: An Encyclopedia of Producers and Their Marks* (New York, 1974).[2] In 1976 Feingold and Lewis republished Edwin AtLee Barber's *The Pottery and Porcelain of the United States* (3rd ed., 1909) combined with Barber's *Marks of American Potters* (1904), both basic and reliable references for most potteries in operation up to the time of writing.[3]

At first general exhibitions were held to provide some sense of the scope of the subject. The one which set the standard for others to follow was Princeton University's 1972 exhibition and catalog, *The Arts and Crafts Movement in America, 1876-1916* (Princeton, 1972), with Martin Eidelberg's important and extensively illustrated contribution on art pottery and his related paper, "American Ceramics and International Styles" (*Record* of the Art Museum, Princeton University, XXXIV:2, 1975, pp. 13-19). This was followed by the 1978 *American Art Pottery, 1875-1930* exhibition and catalog of the Delaware Art Museum (Wilmington, 1978) under the direction of Kristen Hoving Keen. The Everson Museum followed with the exhibition and text *A Century of Ceramics in the United States, 1878-1978* (New York, 1979), by Garth Clark and Margie Hughto. The publication is especially good for the post art-pottery period, with an extensive but uncritical bibliography and a collection of informative biographies. The latest

general exhibition, and perhaps the most important to date of some of the most significant pieces in private collections is the 1987 exhibition and catalog of The American Ceramic Arts Society, *From Our Native Clay: Art Pottery from the Collections of The American Ceramic Arts Society* (New York, 1987) edited by Martin Eidelberg, with an extensive essay by Robert A. Ellison, Jr.

Equal attention has been given to individual potteries, beginning in 1975 with the study of the early years of the Van Briggle Pottery, and followed by studies of Fulper, Robineau, Rookwood, Overbeck, Cowan, Newcomb, and others. Full listings of these are to be found in the Addenda under the specific pottery entry.

Study now is shifting from general surveys and individual histories to analyses of quality, design, and influences felt and exerted. Included here are the exhibition catalogs *California Design: 1910* (T. J. Andersen, E. M. Moore, R. W. Winter, eds.; Pasadena, 1974); *The Ladies, God Bless 'Em: The Women's Movement in Cincinnati* (Ohio: Cincinnati Art Museum, 1976); *Arts & Crafts in Detroit, 1906-1976: The Movement, The Society, The School* (Michigan: Detroit Institute of Arts, 1976); *Chicago Ceramics and Glass: An Illustrated History from 1871 to 1933* by Sharon S. Darling (Chicago: Historical Society, 1979); *The Potter's Art in California: 1885-1955* by Hazel Bray (California: The Oakland Museum, 1980); *The Arts & Crafts Movement in New York State, 1890s-1920s* by Coy L. Ludwig (Hamilton, New York, 1983); *Frederick Hurten Rhead: An English Potter in America* by Sharon Dale (Pennsylvania: Erie Art Museum, 1986); *"The Art that is Life": The Arts & Crafts Movement in America, 1875-1920* by Wendy Kaplan (Boston: Museum of Fine Arts, 1987); and *In Pursuit of Beauty: Americans and the Aesthetic Movement* by Doreen Bolger, et al. (New York: The Metropolitan Museum of Art, 1987).

Above all, resources for further research have also been increasing. Ruth Irwin Weidner's *American Ceramics Before 1930: A Bibliography* (Westport, Connecticut, 1982) and Susan R. Strong's *History of American Ceramics: An Annotated Bibliography* (Metuchen, New Jersey, 1983) are of great importance. The former lists books, pamphlets, publications, and periodical articles with an author and subject index; the latter is an annotated work listing books (or portions of books), pamphlets, exhibition and trade catalogs, theses, and dissertations published before 1983 which survey the subject from Colonial times to 1966 and contains author, title, and subject indices. Karen Evans Ulehla's *The Society of Arts and Crafts, Boston: Exhibition Record, 1897-1927* (Boston: Public Library, 1981) lists members and exhibitors for the Society's first thirty years, including numerous potters working at the height of the American arts and crafts movement. *The Newark Museum Collection of American Art Pottery* by Ulysses G. Dietz

(Newark, New Jersey, 1984) provides annotated illustrations of the art pottery in their collection (which is cited throughout *Art Pottery* entries).

A useful introductory reference work is Elisabeth Cameron's *Encyclopedia of Pottery and Porcelain: 1800-1960* (New York, 1986). While it is a worldwide survey, art potteries of the United States are well represented in this compilation from many credited sources—some more reliable than others; it is well illustrated. Paul S. Donhauser's *History of American Ceramics* (Iowa, 1978), if used, must be approached with caution as it is an unreliable and often careless presentation of pre-1945 subject matter and is cited here only to alert one to its difficulties. Finally, the *Dictionary Guide to United States Pottery and Porcelain (19th and 20th Century)* by Jenny B. Derwich and Mary Latos (Michigan, 1984), while not especially helpful for art pottery, does contain a wealth of material about small studio and commercial operations not readily available elsewhere. Regrettably, no index is provided.

Nor to be ignored is the continued growth of the material accumulating in the Archives of American Art. Study groups and publications have also provided many benefits, an example being the organization in New York City of the American Ceramic Arts Society, which is responsible for the 1987 exhibition and catalog cited above. Likewise, museums and other public institutions have obtained representative examples and, in some instances, extensive collections representing whole fields. Particularly notable is the Cooper-Hewitt Museum, New York, accession of the extensive Goodman collection of art pottery. Other important collection additions are noted in appropriate Addenda entries.

1. Reviewed by Paul Evans, *Spinning Wheel*, XXVII (October 1971), pp. 48, 50. A somewhat revised, re-titled republication of this appeared as *Art Pottery of America* (Exton, Pennsylvania, 1982).
2. Susan Strong in *History of American Ceramics: An Annotated Bibliography* (Metuchen, New Jersey, 1983), pp. 52-53, notes, regarding a comparison of Evans and the Kovels, "Published the same year as Evans, the Kovels' guide has more entries (over 180) because tile companies, architectural terra-cotta companies, and little-known firms are included (sometimes with scanty information). Some entries are longer than Evans'; some are shorter. The bibliographies are very helpful and the entries are informative. However, Evans' research is superior . . . Still there are many illustrations, the 'lines' are detailed, and many marks are shown."
3. The 1971 'reprint' of the first edition of Barber (1893) by G. L. Freeman, Century House Americana, can not be considered a reprint, but rather an incomprehensibly edited version of Barber, with material often rearranged or deleted (cf. P. Evans' review, *Spinning Wheel*, XXVIII, December 1972, pp. 46-47). A useful and extensive bibliography (pp. 407-35) was appended to the Freeman/Barber work, but this is largely superseded by Weidner's bibliography cited above.

Albery Novelty Pottery

Evanston, Illinois

Duane Faxon Albery and Frances Huxtable Albery, between 1913 and 1915, produced artware featuring simple shapes with matt and metallic glazes similar to those used at the American Terra Cotta and Ceramic Company (Teco*), where D. Albery had been employed in the ceramic laboratory for four years following graduation from Ohio State University with a degree in ceramic engineering.

With his wife he opened the short-lived but successful works in 1913 on Sherman Avenue, Evanston. The pottery closed in 1915 due to the high cost of materials, and D. Albery took a position in a ceramic laboratory at Perth Amboy, New Jersey. By 1922 he had returned to Evanston, where he worked for Northwestern Terra Cotta*.

Pieces bear an impressed "Albery", sometimes with "Evanston, Ill." also impressed.

ALBERY

EVANSTON, ILL.

1. The principal source for information on this firm is Sharon S. Darling, *Chicago Ceramics & Glass* (Chicago, 1979), pp. 72-73. Two examples are illustrated.
* Information relating to this pottery is included in a separate chapter.

Plate 24. Owens Utopian ware; h. 12" (30.5 cm). Impressed marks and "1055". *Private collection.*

Plate 25. Redlands bowl; h. 3½" (8.9 cm). *Gary Breitweiser.*

Plate 26. Biloxi Art Pottery of George Ohr; h. 4" (10.2 cm). Impressed mark. *Private collection.*

Plate 27. Edwin Bennett's Albion ware decorated by Kate Berg; h. 5" (12.7 cm). Regular E. Bennett mark, dated 1897. *Private collection.*

Plate 28. Weller vase decorated by F.H. Rhead; h. 14¼" (36.3 cm). "Weller Faience" incised, "AB 435" impressed, Rhead painted on side. *Private collection.*

Plate 29. Fulper molded artichoke design; h. 5⅜" (13.7 cm). Vertical impressed mark in cartouche. *Private collection.*

Plate 30. Overbeck vase in Art Deco style; h. 7" (17.8 cm). Overbeck mark and initials indicating piece was produced by Elizabeth and decorated by Hannah Overbeck. *Rubin-Surchin.*

Plate 31. Newcomb vase decorated by M. Sheerer; h. 11" (28.0 cm). Newcomb mark, registration number R99. *Private collection.*

Plate 32. Rettig-Valentien Cincinnati faience ware produced at the Coultry Pottery, decorated by Laura A. Fry; h. 12" (30.5 cm). R-V mark on base, and "80"; Fry initials incised on face. *Rubin-Surchin.*

Plate 33. Paul Revere vase with overall landscape in Arts & Crafts style by Edith Brown; h. 13½" (34.4 cm). Marked S.E.G., $^1/_{22}$, and plus-within-a-circle cipher of E. Brown. *Private collection.*

Plate 34. Roseville Della Robbia vase; h. 8" (20.4 cm). Rozane seal and initials "W Mc L" incised. *Rubin-Surchin.*

Plate 35. Rookwood Indian portrait; h. 12" (30.5 cm). Dated 1901, 787C, with Grace Young cipher. Incised on base, "Susie shot in the Eye (Sioux)". *Florence I. Balasny-Barnes.*

Plate 36. Rookwood Iris glaze vase; h. 14" (35.7 cm). Dated 1900 and decorated by J.D. Wareham. *Private collection.*

Plate 37. Odell & Booth Brothers; h. 11" (28.0 cm). Impressed "O. & B. B." mark and "Tarrytown. N.Y.". *Private collection.*

Plate 38. Brush Guild jardiniere by Lucy F. Perkins; d. 6" (15.3 cm). Incised "L.P." initials. *Florence I. Balasny-Barnes.*

Plate 39. Jervis Pottery; h. 5" (12.7 cm). Regular incised mark. *Private collection.*

Plate 40. Rose Valley mug; h. 4⅛" (10.5 cm). Incised mark of Rose-and-V, "Rose Valley", "W.P.J.". *Florence I. Balasny-Barnes.*

Plate 41. Zark low bowl; h. 2" (5.1 cm), d. 9½" (24.2 cm). Impressed mark and incised initials "S.A.C." *Florence I. Balasny-Barnes.*

Plate 42. American Art-Ceramic ewer with simulated metal glaze; h. 21" (52.5 cm). Impressed mark and "1595". *Florence I. Balasny-Barnes.*

Plate 43. Teco vase with swirling tendrils; h. 18¼" (46.6 cm). Impressed mark and design number 310. *Private collection.*

Plate 44. Rookwood vase by Laura A. Fry; h. 7" (17.8 cm). Marked Rookwood 1884G and "B80". *Rubin-Surchin.*

Plate 45. John Bennett vase; h. 8"
(20.4 cm). Regular mark, dated 1881.
Rubin-Surchin.

Plate 46. Frackelton vase; h. 7" (17.8 cm). Incised
cipher. *Private collection.*

Plate 47. Pewabic vase with modeled decoration of
tulip leaves and flowers; h. 10½" (26.8 cm). Impressed
maple-leaf mark. *Martin Eidelberg.*

Alhambra Ceramic Works

Chicago, Illinois

Sven Linderoth, a Swedish architect, produced art pottery as early as 1898 along with utilitarian ware at the Linderoth Ceramic Company at 5844 South Elizabeth Street.[1] About 1906 he began producing blanks for decoration by china painters and a year later shared his facilities with the Atlan Ceramic Art Club. About the same time he renamed his pottery the Alhambra Ceramic Works and offered a line of art pottery. A Swedish sculptor named LeVeau modeled vases and pitchers with intricately carved surfaces and elaborate applied ornamentation. The taste in decoration was criticized by *Keramic Studio* (VIII, April 1907, pp. 272-73), but its execution was pronounced "remarkably good".

In 1920 Charles Barnet Wirick and Jean Paul Wirick, two brothers who had previously worked at Chicago's Barnet Pottery, took over the Alhambra works, renaming it the Faenza Pottery. Their work replicated Spanish and Italian peasant pottery.

1. The information presented is excerpted from S. S. Darling, *Chicago Ceramics & Glass* (Chicago, 1979), pp. 72, 74, 80.

Art Tiles, 1870-1930

A Bibliographic Essay

While art pottery interest and research has increased greatly during the past decade, such has not been the case with the kindred field of decorative or art tile. It is not a matter of "if" but rather "when" more attention will be devoted to this.[1] To date the two most reliable general resources for such study are E. A. Barber's* *The Pottery and Porcelain of the United States* (New York, 1909; pp. 343-84, 517-22) and Thomas Bruhn's *American Decorative Tiles, 1870-1930* (Storrs, Connecticut: William Benton Museum of Art, 1979; 48 pp.).

Given the early date, Barber's book effectively covers the earliest firms (a total of fourteen), but none of the later faience tile producers are included. Bruhn offers an instructive historical survey and extends Barber's individual coverage almost threefold, giving capsule histories, bibliographic data, and extensive illustrations. Yet this is only a beginning: there were at least one hundred such firms operating in the United States during this period, some manufacturing tiles in conjunction with the production of art pottery as at Chelsea Keramic*, Marblehead*, Newcomb*, Owens*, Pewabic*, Rhead*, Rookwood*, and Weller*. At others—such as Grueby*, Low*, Northwestern Terra Cotta*, and Teco*—art pottery was an adjunct to tile production. The majority of tile-producing firms, however, were organized for the output of tile only.

Several studies of individual operations have been undertaken, a number of which are listed in R. I. Weidner's *American Ceramics Before 1930: A Bibliography* (Westport, Connecticut, 1982). Norris Schneider has chronicled the Zanesville, Ohio, producers in his research, especially as contained in the well-illustrated co-operative work *Zanesville Decorative Tiles* (Ohio, 1972; 32 pp.) by E. Stanley Wires, Norris F. Schneider, and Mose Mesre.[2] Barbara White Morse has delved into all aspects of the Low Art Tile Works in her numerous articles; and monographs such as Kathryn Smith's *Malibu Tile* (Los Angeles: Craft and Folk Art Museum, 1980; n.p.) have appeared. Based on her doctoral dissertation for Ohio State University (1979), Lisa Taft's exhibition catalog *Herman Carl Mueller: Architectural Ceramics and The Arts and Crafts Movement* (Trenton: New Jersey State Museum, 1979; 48pp.) draws together the various pottery and tile firms (including Kensington, Mosaic, Robertson, and Mueller's own

works) where the subject was involved. Another aspect of decorative tile is pursued in P. Evans' "Art Tiles of the New York Subway, 1904" (*Spinning Wheel*, XXXV, November 1979, pp. 8-12), which surveys the original subway line and identifies the tiles of Grueby and Rookwood manufacture.

Another source, which is "discovered" from time to time, is Everett Townsend's "Development of the Tile Industry in the United States" (*The Bulletin* of The American Ceramic Society, XXII [May 15, 1943], pp. 125-52). While it contains a great deal of information, it is a compilation of many sources (most of which are identified) ranging from accurate accounts to completely innacurate recollections. Townsend made no attempt to ferret out the good from the bad, with the result that nothing is to be relied upon without verification from independent sources. Examples are the information relating to an involvement of W. H. Grueby in the establishment of the Hartford Faience Company "after his first company had failed" (see *Art Pottery*, p. 122, footnote 3); the confusion of the various members and generations of the Robertson family (Chelsea Keramic Art Works*); and the two Wheatley potteries of Cincinnati treated as one. Since this material appeared it has reappeared with the errors intact in addition to Wires, as noted, in Julian Barnard's *Victorian Ceramic Tiles* (New York, 1972; 184pp.) and the *Kovels' Collectors Guide to American Art Pottery* (New York, 1974; 378pp.). With this caveat, both these volumes offer helpful material: Barnard's with a considered study of the role of William Morris and the Arts & Crafts Movement as it relates to the art tile industry, as well as other historical and stylistic influences, especially of British production; the Kovels with their ample illustration of both work and marks.

Magazines and trade journals suggested for careful examination include *The American Architect; The Architectural Record; The Mantel, Tile, and Grate Monthly; Pacific Coast Architect;* as well as *Brick; Brick and Clay Record; Brickbuilder;* and *The Clay-Worker.*

The most extensive public collection of art tiles is that of E. Stanley Wires at the National Museum (Smithsonian Institution).

1. Perhaps the coverage given by Alice Cooney Frelinghuysen in her contribution, "Aesthetic Forms in Ceramics and Glass", to *In Pursuit of Beauty* (New York: The Metropolitan Museum of Art, 1986, pp. 231-35) will mark a maturation of the subject.
2. An earlier effort by Wires, reprinted as "Decorative Tiles: Their contribution to Architecture and Ceramic Art" (*New England Architect and Builder, illustrated;* monograph nos. 14-17, 1960), is well illustrated and useful, but regrettably incorporates erroneous information from E. Townsend's unreliable material (see paragraph four above).
* Information relating to this pottery is included in a separate chapter.

Edwin AtLee Barber

The broad foundation upon which all research in art pottery of the United States rests is the work of Edwin AtLee Barber, and especially his magnum opus, *The Pottery and Porcelain of the United States*, and its smaller companion volume, *Marks of American Potters*. This work rests firmly on that foundation, which has withstood critical examination over an extended period of time. It seems appropriate, therefore, to emphasize Barber's importance to the study of art pottery in the United States by including this entry. No more effective tribute can be offered than that adopted by the Pennsylvania Museum (now the Philadelphia Museum of Art) at the time of his death.[1]

The Pennsylvania Museum and School of Industrial Art has to record a grievous loss, in the death of Dr. Edwin AtLee Barber, the Director of the Museum, who passed away on December 12, 1916.

At a meeting of the Museum Committee of the Board of Trustees, held on January 2, 1917, Mr. John Story Jenks, chairman, in the chair, the following resolutions were unanimously adopted as embodying the feelings of Dr. Barber's associates and co-workers:

"WHEREAS, In the death of Dr. Edwin AtLee Barber, which occurred on December 12, 1916, the Museum has lost a most valuable officer; and

Edwin AtLee Barber, *Elliot Evans.*

"WHEREAS, In the fifteen years of service as Director of the Museum and Secretary of the Corporation, he showed himself scrupulously accurate in his work, and gave his entire time and such acquirements as he possessed to the discharge of his duties, devoting himself especially to the department of English and American ceramics, of which he had made a special study, giving much of his attention to Mexican maiolica, Pennsylvania-Dutch, and German and English manufactures; and

"WHEREAS, Methodical in his habits and sincerely devoted to his trust, with no desire other than a single-minded pursuit of his chosen work as collector and curator, the institution of which he was the head proceeded safely and quietly, under his guidance, along the lines marked for its development; therefore, be it

"*Resolved*, That we, his colleagues who have been associated with him for many years, deeply deplore his removal from our midst, feeling that his place cannot readily be filled, and that in his death the Institution has met with a grievous loss. Also be it

"*Resolved*, That we wish to extend the expression of our most profound sympathy to his widow and daughter in their great sorrow, and that the Acting Secretary be and is hereby instructed to spread these resolutions at length upon the minutes of this meeting, and to send a copy thereof to Mrs. Barber."

Edwin AtLee Barber was born in Baltimore, Md., August 13, 1851. He is the eldest son of the late William Edwin Barber, Esq., and Anne E. Townsend Barber of West Chester, Pa.; grandson of John Barber, first superintendent of the Columbia and Philadelphia Railroad (1829-1833); great-grandson of James Barber, a captain in the Revolutionary war; great-great-grandson of Colonel Samuel John AtLee of the Pennsylvania State Battalion of Musketry, who was taken prisoner by the British at the Battle of Long Island, on August 27, 1776.

Mr. Barber went to West Chester, Pa., with his father in 1857, after having resided for a short time in Davenport, Iowa, and here his preliminary education was received in the Orthodox Friends' and the public schools. In 1868 he entered Williston Seminary, East Hampton, Mass., where he pursued an English course of studies, graduating in 1869. He then entered Lafayette College, class of 1873, where he continued his studies until 1872. The College conferred upon him the degree of Master of Arts in 1880 and, in 1893, that of Doctor of Philosophy.

Mr. Barber was appointed Assistant Naturalist on the United States Geological and Geographical Survey of the Territories in 1874, and in 1875 he accompanied a portion of the same Survey into the ancient ruin districts of southwestern Colorado and the adjacent territory in Utah and Arizona, as special correspondent for the New York *Herald*. From 1879 to 1885 he occupied the position of Superintendent of the West Philadelphia post office, and was Chairman and Secretary of the United States Civil Service Examining Board for the Philadelphia

post office.

In 1879 he was appointed Chief of the Department of Archaeology of the Permanent Exhibition in Fairmount Park, Philadelphia, an honorary position, and in 1892 was made Honorary Curator of the new Department of American Pottery and Porcelain at the Pennsylvania Museum, Philadelphia.

On February 5, 1880, Mr. Barber was married to Miss Nellie Louise Parker, daughter of the late Major William H. Parker, of the United States Marine Corps, and of Mary Louise Young Parker.

For several years Mr. Barber was one of the associate editors of the *American Antiquarian*. In 1885 he established and edited *The Museum*, an illustrated journal for collectors and young naturalists, of which, however, for lack of sufficient support, only four numbers were issued.

In 1901 he was elected Curator of the Pennsylvania Museum and Secretary of the Pennsylvania Museum and School of Industrial Art, and in 1907 he became Director of the Pennsylvania Museum.

1. *Bulletin* of the Pennsylvania Museum (no. 57; January 1917, pp. 1-4). For a more extensive outline of Barber's activities and contributions, see Diana Stradling and J. G. Stradling, eleven-page introduction to Bicentennial reprint of Barber's *Pottery and Porcelain* (New York: Feingold & Lewis, 1976). For insight into his work for the museum, see J. P. Claney, *Tiller*, I (November-December 1982), pp. 31-54.
2. For an appreciation of the scope of Barber's overall interests see *The National Union Catalog of Pre-1956 Imprints*. A comprehensive bibliography of his American ceramic writings appear in R. I. Weidner, *American Ceramics Before 1930: A Bibliography*, entries A 7-22, G 212-65.

John Bennett Pottery
New York City

John Bennett, born in 1840, was trained at the Staffordshire potteries and was then hired by Henry Doulton to establish a faience department to teach the method of richly colored underglaze decoration which he had developed.[1] Examples of his Lambeth faience were featured in Doulton's display at the 1876 Centennial Exposition, Philadelphia, and received much favorable notice. The following year he emigrated to the United States and settled in New York City.[2] Bennett was not a potter and at first he imported English biscuit, but was soon to build his own kilns and employ potters—using native clay—to make the cream-colored body he found so successful for the production of his "Bennett ware". He was also to decorate white bodied blanks made in Trenton, New Jersey.

> The shapes were simple and generally devoid of handles or moulded ornaments. The decorations consisted chiefly of flowers and foilage, drawn from nature in a vigorous and ornate style, and painted with very few touches. A background was worked in after the painting, in loose touches and delicate tints, and finally the whole design was boldly outlined in black or very dark color. The glaze was brilliant, even, and firm, and the coloring exceedingly rich, the mustard yellows, deep blues, and browns tinged with red giving the ware a bright and attractive appearance. . . . He also produced some pieces in the style of the so-called Limoges *faience*, by applying colored slips to the unfired clay.[3]

Bennett's principal style of painting and choice of subject matter had much in common with that of the English reformer designers William De Morgan and William Morris.[4] This can be contrasted with that of Charles Volkmar (Volkmar Pottery*), who worked at the same time and in the same city, but whose style was influenced by French developments, especially the "Limoges" method of underglaze decoration. Bennett's work was frequently exhibited in many parts of the country, and as a result of its great acclaim he achieved considerable prominence in the field.[5]

In early 1878 Bennett was engaged to offer classes in pottery decoration at New York's newly formed Society of Decorative Art, but was succeeded the following year by Charles Volkmar. He relocated in 1883 in West Orange, New Jersey, where he built a kiln but did little further ceramic work. He died there in 1907.

Examples of Bennett's work are to be found in the collections of The Metropolitan Museum of Art; the High Museum of Art, Atlanta; and the Museum of Art, Carnegie Institute, Pittsburgh.

Pieces executed in New York City are marked in dark freehand lettering "J Bennett, N.Y." with the location (101 Lex. Ave. [1877-78] or 412 E. 24 [1879-83]), date, and often an artist's cipher. Later pieces were marked "East Orange, N.J.".[6]

1. Catherine Hoover Voorsanger, "Dictionary of Architects, Artisans, Artists, and Manufacturers" in *In Pursuit of Beauty* (New York, 1986, pp. 402-03), has carefully researched and documented the Bennett chronology.
2. *The Art Journal*, IV (January 1878), p. 31. Care should be taken to distinguish between our subject and another by the same name who worked in New York City about the same time. His firm was Bennett & White, which specialized in china painting and firing at 4 Great Jones Street. In 1879 this firm was dissolved and Bennett entered into partnership with Edward Lycett at the same address (Voorsanger, *op. cit.*, p. 403).
3. E. A. Barber, *The Pottery and Porcelain of the United States*, pp. 305-06.
4. Alice Cooney Frelinghuysen, "Aesthetic Forms in Ceramics and Glass" in *In Pursuit of Beauty*, pp. 217-19, offers a critical and comprehensive analysis of Bennett's work, with black-and-white and color illustrations.
5. J. J. Young, *The Ceramic Art* (pp. 483-84; also pp. 370-73, includes illustrations).
6. Barber, op. cit., p. 308. An undated slip-decorated redware example has been noted marked "J. Bennett/Chicago", raising the possibility that Bennett may have been involved with the 1883-85 Chicago Pottery Club venture, with which Joseph Bailey, Sr. — who was so closely allied with the Cincinnati Pottery Club — was also involved (see p. 221, footnote 2; c.f. Frelinghuysen, *op. cit.*, p. 218 and pp. 249-50, footnote 60).
* Information relating to this pottery is included in a separate chapter.

Biloxi Art Pottery

(See principal entry beginning on page 27)

In 1973 Robert W. Blasberg published *George Ohr and His Biloxi Art Pottery*, a first view and review of the approximately 6,000 pieces exhumed a short time earlier (see *Art Pottery*, p. 31). The forty pages include considerable black-and-white illustration. Shortly after his death in 1986, Blasberg's second book on Ohr, *The Unknown Ohr: A Sequel to the 1973 Monograph* (Milford, Pennsylvania, 1986; 84 pp.), was published. Work continues by students in various aspects of Ohr's pottery, including Robert Ellison's attempt to analyze the development and evolution of his work and aesthetics, presented as a paper to The American Ceramic Arts Society, New York, in January 1986.

Charles Fergus Binns

One of the omissions of the first edition was C. F. Binns. Like Walrath*, he cannot be considered an "art potter" by the definition offered in the opening essay (pp. 1-8). For many other reasons, however, it seems appropriate to include him here, especially for his excellent work and generous contributions in the fields of ceramic art and art education, and his ability to inspire several successive generations of potters.[1]

Born in England in 1857, the son of a notable potter and director of the Royal Porcelain Works, Worcester, Binns served an apprenticeship at Worcester, which included coming to the United States with the firm's exhibit at the Chicago exposition, 1893. he returned to the United States in 1897 and took charge of a newly formed technical school of ceramic art in Trenton, New Jersey, at the same time being associated with the Ceramic Art (Lenox) Company. In 1899 he was one of the founding members of The American Ceramic Society and the following year became Director of the New York School of Clayworking, Alfred, upon its establishment, a position he held until his retirement in 1931. He died in 1934.[2]

Binn's work was primarily stoneware,[3] first hardened by a low fire to permit handling, glazed and then fired to cones 11 to 12, the body and glaze maturing at the same high temperature, below which the brilliant glaze of the true porcelain type cannot be fused. "There is as much character in a Binns glaze as there is in a Binns shape. Their full appreciation is had only by those who have time to look at them.

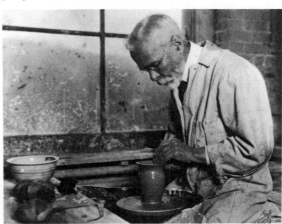

Charles Fergus Binns. *New York College of Ceramics at Alfred University, Alfred, New York.*

The glazes as well as the shapes they cover reflect the conservative nature of their master. . . Charles Binns considered that the proper glaze on a properly shaped and fired body made a piece of pottery."[4] As a technician he was always experimenting; as an instructor he regularly published his insights.[5]

Writing in *Design*[6] the editor observed "Charles F. Binns was a fine, honest, and thorough craftsman whose interests were absorbed with the logical use of clay as a medium for producing good, simple, utilitarian forms. Decoration and color played little part in his craft, but the quality of glaze received the greatest attention. There were sorrows and frustrations, but never a dearth of ideas and courage. He worked with a quiet assurance, an unhesitating recognition of what was good. His pottery bore the evidence of his own doctrine of beauty in fine craftsmanship and simplicity of form; it bore evidence of a great knowledge which, in a few bold strokes, laid claim to what is wanted. Directly or indirectly, he was responsible for a great part of individual production of merit in this country."

An extensive collection of Binns' work is to be found in what is now known as the New York State College of Ceramics at Alfred. Other examples are at The Detroit Institute of Arts, The Metropolitan Museum of Art, the National Museum (Smithsonian Institution), and The Newark Museum.

Binns' work is usually marked with an incised cipher of the initials "C.F.B." as shown. Pieces were normally dated.

1. Paul Cox, a Binns' student, has noted (*The Bulletin* of The American Ceramic Society, IV, September 1925, p. 421) that Binns "has fathered more studio potteries than any other American".
2. W. P. Jervis, *The Encyclopedia of Ceramics*, pp. 52-53; *The Bulletin*, XIV (January 1935), p. 24; Clark & Hughto, *Century of Ceramics*, pp. 276-77; Susan R. Strong, *American Ceramics*, I (Summer 1982), pp. 44-45, 48-49.
3. Binns contributed the chapter "American Clays for Grand Feu Wares" to Taxile Doat's *Grand Feu Ceramics*; he was, perhaps, challenged by his own observation that "the manufacture of gres belongs . . . to the category of coarse or natural wares and it is the more to the credit of the successful artist who takes this crude material and fashions it as he will" (p. 196).
4. J. F. McMahon, *The Bulletin*, XVII (April 1938), pp. 175-76.
5. Cf. R. I. Weidner, *American Ceramics Before 1930: A Bibliography*, entries A34-36, G293-372.
6. *Design/Keramic Studio*, XXXVI (January 1935), pp. 16-17

Byrdcliffe Pottery

(See principal entry beginning on page 38)

The Byrdcliffe Arts & Crafts Colony: Life by Design (Wilmington: Delaware Art Museum, 1985; Robert Edwards, guest curator) studies and illustrates work at the Byrdcliffe community, but concentrates on the ceramic work of the White Pines Pottery* rather than the Byrdcliffe Pottery. Jane Perkkins Claney, author of the ceramics portion of the catalog, does note (p. 16) that in 1923 Zulma Steele took over the Byrdcliffe Pottery and operated it until at least 1928. A Master's thesis by Allen Staley, "Byrdcliffe and the Maverick" (New Haven: Yale University, 1960), offers a good bibliography of material about Byrdcliffe and the broader Woodstock colony to which it gave rise.

* see entry in Addenda

California: Art Pottery

In 1975 The Oakland [California] Museum acquired the author's study collection of California art pottery, insuring that almost all the California artware pictured in *Art Pottery* identified as "private collection" is now available for public study at that museum. Hazel Bray's *The Potter's Art in California: 1885-1955* (California: The Oakland Museum, 1980) is the most comprehensive study of the subject to date and is especially good for the post-1930 period.

Canada: Art Pottery

Most coverage of "American" pottery ignores work north of the border. For such work Elizabeth Collard's *Nineteenth-Century Pottery and Porcelain in Canada* (Montreal: McGill University Press, 1967) is recommended. While there seems to have been little art pottery produced there, the artware of the Ecanada Art Pottery operated by George Emery has attracted collector notice (see C. Peter Kaellgren in *Canadian Collector*, XIV [March/April 1979], pp. 56-63).

Chelsea Keramic Art Works

(See principal entry beginning on page 46)

Two unusual, early (c. 1874-76) impressed marks have been observed, both of which are shown here. Pieces incised with "A.W.R." initials in the style of Alexander Robertson (*Art Pottery*, p. 51, no. 5) have also been noted, several post-dating Alexander's death in 1925. Research has determined that the initials are those of Arthur W.Rushmore of the Bottle Hill Pottery, Madison, New Jersey.

The miniature Chelsea redware vase by Alexander W. Robertson in 1876, possibly the earliest dated example of art pottery produced in the United States (foreground of illustration, page 47), is now in the collection of the National Museum (Smithsonian Institution; #1979.1150.1).

Conestoga Pottery

Wayne, Pennsylvania

Edmund deForest Curtis, Harvard-educated scientist, in 1912 leased the Van Briggle Pottery*, which he acquired in September 1913 after it was sold at auction.[1] He continued there until 1915; the following year he became the manager of the Enfield Pottery*, owned by J. H. Dulles Allen.[2] After a short tenure he left Enfield, to return in 1919. In 1920, after a course of study at the New York State School of Clayworking and Ceramics at Alfred, he established his own works, the Conestoga Pottery. Vases, bowls, and lamp bases were produced,[3] and equipment for schools and small potteries was supplied. This continued until about 1942, when Conestoga was closed because of difficulties in obtaining materials. During this time Curtis also served as Director of Pottery at the Pennsylvania Museum and School of Industrial Art (1921-38) and authored *Pottery, Its Craftsmanship and Its Appreciation* (1941).[4]

Two examples of Conestoga Pottery ware, acquired in 1922, are in the collection of The Metropolitan Museum of Art, New York (their numbers 22.166.2-3).

Pieces bear the "Conestoga" designation.

1. Arnest, Barbara A. (ed.), *Van Briggle Pottery: The Early Years* (Colorado Springs: Fine Arts Center, 1975), p. 23.
2. The Enfield firm was incorporated about 1913, according to a report in *Mantle, Tile, and Grate Monthly*, VIII (September 1913), p. 16.
3. See *American Magazine of Art*, XV (December 1924), p. 655, for a report of their exhibition at the Art Centre, New York.
4. Information from a curriculum vitae prepared by Curtis, c. 1942.
* Information relating to this pottery is included in a separate chapter.

Cowan Pottery

(See principal entry beginning on page 69)

Since 1974 the "small collection" of Cowan artware at the Rocky River Public Library has grown to over eight hundred pieces, largely the result of the accession of the John Brodbeck collection (see *Art Pottery*, p. 73, footnote 18). At that time a brochure, *Cowan Pottery Museum* (Rocky River: Public Library, 1978; 14pp.), was published and includes a brief history, marks, and notes on the collection highlights. The lack of index and bibliography is to be regretted. Examples of the work of Schreckengost, T. Winter, and Gregory are in the collection of the Everson Museum, Syracuse; note should also be taken of "Viktor Schreckengost and the Cleveland School" by James Stubblebine and Martin Eidelberg (*Craft Horizons*, XXXV [June 1975], pp. 34-35, 52-53), as Cowan proved to be the nucleus of what was to become the Cleveland School.

Paul E. Cox Pottery

New Orleans, Louisiana

Competing with Kenton Hills* as one of the final attempts at art pottery production is this operation, also established in 1939. Paul E. Cox, the second graduate of the New York State School of Clayworking and Ceramics, Alfred, joined the Newcomb Pottery* in 1910 and remained there until 1918.[1] From 1920 until 1939 he served as director of the Department of Ceramic Engineering at Iowa State College, working with the designer Mary Lanier Yancey, who handled the decorative aspect of the production of the artware sold with their mark.[2]

Cox Pottery vase marked with "CAP" cipher in the Newcomb style; h. 7" (17.8 cm). *Private collection.*

Returning to the New Orleans suburb of Hanrahan in 1939, Cox constructed a pottery on three-quarters of an acre next to the Mississippi River levee and equipped it with a huge kiln and very sophisticated machinery. Cox indicated that "the plant will be used as a sort of pilot plant and to develop a knowledge of the potential markets for ceramic wares, and then to promote larger industries, ranging from pottery for the home to certain types of unusual building materials. The little plant will serve, therefore, as a research laboratory as well

THE
PAUL B. COX
POTTERY
NEW ORLEANS
LOUISIANA

as a production plant." It was designed for large scale manufacture of utilitarian items such as strawberry canning pots for the Louisiana jam industry; production of dinnerware was anticipated.[3]

In addition, Cox sought to produce a high-quality artware in limited quantity, using some of the gifted artists in the vicinity.[4] Cox threw the ware and delivered it in a leather-hard state to the experienced decorators who were employed. They produced a Newcomb-type ware which was placed on sale at Hausmann's Jewellery store where Newcomb pottery had formerly been sold. The venture was not successful and with the onset of World War II it ceased.[5] Cox leased the pottery and sold it in 1946.

A linear impressed and a circular imprinted mark were used. Noted on Newcomb-type ware—undoubtedly the work of Cox—is an incised CAP cipher which could well have been a mark used by Cox.[6] Ormond and Irvine (see footnote 4) report such work was marked "Paul Cox ware after the Newcomb style".

1. J. Poesch, *Newcomb Pottery* (Pennsylvania, 1984), pp. 94-95.
2. Yancey, instructor of Pottery Decoration, signed her work with a Y within a circle in addition to the regular impressed "ISC/Ames" mark. A number of her pieces are in the college collection.
3. R. W. Staffel, an interview in *Craft Horizons*, XXXVII (April 1977), pp. 26-27; J. Pope, New Orleans *The States-Item*, July 2, 1975, p. B-1; *Ceramic Age*, LIV (December 1949), pp. 398-99.
4. *Arts and Industries*, I (September 1939), pp. 26-27. One of the decorators used by Cox was A. C. Arbo, according to S. Ormond and M. E. Irvine, *Louisiana's Art Nouveau* (Louisiana, 1976; p. 150).
5. Personal letter of P. E. Cox to Robert W. Blasberg, c. 1965.
6. David Rago, Collector's Spectrum, New York, catalog for sale of May 17, 1986 (items 224 and 225; illustrated p. 29),suggests a dating of work bearing the CAP incised mark as "while at or just before leaving Iowa State College shortly after leaving Newcomb College".
* Information relating to this pottery is included in a separate chapter.

Crossware Pottery
Chicago, Illinois

The Crossware Pottery was operated by Nellie Agnes Cross, who had been active in china painting and had served several terms as president of the National League of Mineral Painters, and her sons Richard Watson Cross, Jr., and Charles William Cross. Located on Farwell Avenue, pottery production was begun about 1905. *Keramic Studio* (X; August 1908) noted that "several pieces of Crossware consisting of some pleasing little pottery tiles, vases, bowls and a most refined green pottery fern dish" were shown at the 1908 Chicago Ceramic Asssociation exhibition.[1]

Their mark is a raised disc bearing "Crossware" and the illustrated device.

1. The information presented is excerpted from S. S. Darling, *Chicago Ceramics & Glass* (Chicago, 1979), p. 74.

Dedham Pottery

(See principal entry beginning on page 82)

The author, in *Spinning Wheel* (XXXV, October 1979, pp. 17-18), examined a reproduction of Dedham's Oak Block pitcher by the Revere/Roman Pottery (unrelated to Boston's Paul Revere Pottery*), 224 North Street, Boston. Francesco (Frank) N. Cacciagrani ("the Roman Potter") had worked at the Dedham Pottery and taught at the North Bennet Street School, Boston, and during the 1930s and '40s produced his own pottery. In addition to Revere Pottery's impressed mark with their full address, an impressed Roman helmet and RP, and an impressed RP are illustrated in the article.

The famed Dedham crackleware, rabbit pattern, has been reproduced for the past decade by the Potting Shed (see *Gourmet*, XXXVIII [December 1978], p. 205).

* Information relating to this pottery is included in a separate chapter.

Frackelton Pottery

(See principal entry beginning on page 105)

In 1975 *Susan S. Frackelton & The American Arts and Crafts Movement* was privately published. It was originally prepared as a Master's thesis by George A. Weedon, Jr., and offers an extensive catalog of Frackelton work, with full description of pieces and marks. A bibliography is also provided.

The tyg illustrated on page 108 is now in the collection of the National Museum (Smithsonian Institution; #75.76).

Laura A. Fry

One of the more neglected influential women of the art pottery movement in the United States is Laura Fry. A brief sketch of her ceramic activity is included in *Art Pottery* (pp. 141-142). It is now known that Fry was "intimately connected" with the beginning of the Pauline Pottery* as she had been with that of the Pottery Club (Dallas Pottery*), Rookwood*, and Lonhuda*. In a lost paper, "The Development of American Pottery", delivered to the Arts Convention at Nashville, Tennessee (reported in the Nashville *Banner*, October 5, 1897, p. 1; and *The Clay-Worker*, XXVIII [November 1897]), Fry recounted the beginning of the Pauline Pottery, as well as the founding and experiences of the Pottery Club of Cincinnati, the early history of the Rookwood Pottery (speaking "at length of the artists connected with its early history"), the men who started Lonhuda and the work of that pottery, which she considered ranking second only to Rookwood. The Pauline Pottery she ranked third.

An example of Fry's work executed at the Pauline Pottery, Chicago, dated 1883 is in the collection of The State Historical Society of Wisconsin, Madison, (#1954.2089; illustrated in S. S. Darling, *Chicago Ceramics & Glass* [Chicago, 1979], p. 53, no. 57). The most significant collection of Fry's pottery is at the City Art Museum of St. Louis, and includes the first piece done by her, in 1879 (#67:11); see also *Art Pottery* (p. 144, footnote 7).

* Information relating to this pottery is included in a separate chapter.

Fulper Pottery

(See principal entry beginning on page 109)

Since 1974 considerable material has become available on the Fulper Pottery. What has been published to date is best found in Robert W. Blasberg's *Fulper Art Pottery; An Aesthetic Appreciation, 1909-1929* (New York: Jordan-Volpe Gallery, 1979), which also served as an exhibition catalog. Well illustrated in color and black-and-white, it contains an overall survey as well as an attempt to establish some sense of when any one of the numerous marks might have been used by the firm. *Fulper: The Potter's Art*, containing the exhaustive research of Gordon W. Gray, in part made possible by a grant from the New Jersey Historical Commission, is yet to be published. One noteworthy aspect of his work is the Gray/Fulper trademark classification system, which should prove invaluable in the dating of Fulper art pottery.

An important collection of Fulper ware has been acquired by Wheaton Village, Millville, New Jersey.

Fulper marks (cf. *Art Pottery*, p. 112) other than Vasekraft and Fulper which have been noted are FLEMINGTON (horizontal:impressed and imprinted), PRANG (vertical: imprinted), and RAFCO (horizontal: impressed and incised).

Grueby Pottery

(See principal entry beginning on page 118)

A well-illustrated survey of Grueby work was presented in *Grueby* (Syracuse: Everson Museum of Art, 1981; 32pp.), an exhibition catalog with text by Robert W. Blasberg. Also to be noted is Neville Thompson's "Addison B. LeBoutillier: Developer of Grueby Tiles" (*Tiller*, I [November-December 1982], pp. 21-30).

Hampshire Pottery

(See principal entry beginning on page 128)

The Pappas-Kendall collection of Hampshire Pottery illustrated in their 1971 publication *Hampshire Pottery Manufactured by J. S. Taft & Company, Keene, New Hampshire* has been donated to the Colony House Museum of the Historical Society of Cheshire County, Keene. Comprising over 1,000 examples of this firm's work, it offers a comprehensive survey of their ware from the early stoneware and majolica to the later artware produced under Morton's direction. Also at the Society are pictures, photographs, stationery, catalogs, and several written and pictorial histories of the company.

Kenton Hills Porcelains

(See principal entry beginning on page 136)

Further information regarding David Seyler is to be found in Virginia Raymond Cummins' *Rookwood Pottery Potpourri* (Silver Spring, Maryland, 1979), pp. 72-73. Examples of Kenton Hills work are now in the collection of the National Museum (Smithsonian Institution), the gift of David Seyler.

Losanti

(See principal entry beginning on page 141)

It is important to note that the piece of M. L. McLaughlin's American Faience illustrated on page 146 (upper right; see text p. 147) was re-accessioned by the Philadelphia Museum in 1976 and re-assigned its original number, 95-65. Also, a tribute to McLaughlin, showing a considerable collection of her work, appears in the Cincinnati *Times-Star* (January 27, 1939, p.9).

Marblehead Pottery

(See principal entry beginning on page 157)

An account of the aims, objectives, and early work of Marblehead is provided by Herbert J. Hall and Mertice M. C. Buck in *Handicrafts for the Handicapped* (New York, 1916; especially chapter seven on pottery making). Roberta Stokes Persick prepared *Arthur Eugene Baggs, American Potter* as a Ph. D. dissertation (Ohio State University, 1963) to examine not only his accomplishments but also the setting out of which he emerged.[1] Perhaps the most candid picture of Baggs was offered by Paul Cox in private correspondence with Robert W. Blasberg dated March 4, 1967:

> For reasons peculiar to myself I put Arthur Baggs at the very top of a list of art potters. My reason . . . is that he surely did things as well as any have ever done them and his personal character was such that it did me good to be in his company . . . Baggs is the only one of a big number that *never* said anything about the work of another that was no[t] complimentary. For he knew his business so well that he could honestly find something always for which he had respect.

1. A related, unpublished manuscript is reported as being at the Abbot Public Library of Marblehead, which has refused to confirm this or provide bibliographic information.

Mott Pottery Works

Trenton, New Jersey

Primarily a sanitary ware producer, Mott about the turn of the twentieth century made a limited line of artware as well. In the style of the underglaze slip-decorated Cincinnati faience, on a porcelaneous body, the ware was designated *Tokalon*.

A single example is in the collection of The Newark [New Jersey] Museum (#76.187); another is in that of the New Jersey State Museum.

The mark, Mott's/Tokalon, is printed in brown.[1]

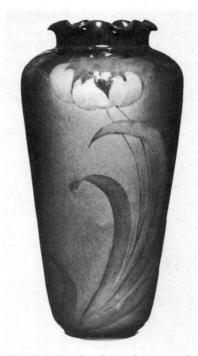

Mott Tokalon glazed porcelain vase, slip painted flower in rust and green; h. 9¼" (23.5 cm). *The Newark Museum.*

1. The information presented is excerpted from U. G. Dietz, *The Newark Museum Collection of American Art Pottery* (New Jersey, 1984), p. 80.

Newcomb Pottery

(See principal entry beginning on page 182)

In 1976 *Louisiana's Art Nouveau: The Crafts of the Newcomb Style* (Louisiana, 1976), by Suzanne Ormond and Mary E. Irvine, was published. While limited in scope and interest, it did offer an insightful study of Newcomb Pottery work (reviewed by P. Evans, *Spinning Wheel*, XXXIII [November 1977], p. 38). It was to be almost a decade before the careful, comprehensive, and well-documented research of Jessie Poesch was made available in *Newcomb Pottery: An Enterprise for Southern Women, 1895-1940* (Pennsylvania, 1984). In addition to the history Poesch provides, the list of craftsmen it contains must be considered as updating the Ormond and Irvine list, since that was available—although a note as to why some listed in 1976 were not included in 1984 would have been helpful. An even more extensive listing is offered by A. P. Antippas in *New Orleans* (IX, July 1975, p. 103), with names of pottery decorators not to be found in either book. A significant contribution to the Poesch work, which served as an exhibition catalog also, is Walter Bob's analysis of the pottery's basic marks and dating. Each Newcomb piece bears an individual registration number, and as a result of Bob's work can thereby be dated. Poesch's book is well illustrated in color and black-and-white and contains a bibliography, index, and list of agents handling Newcomb Pottery in May 1932.

Niloak Pottery

(See principal entry beginning on page 189)

In the light of research since 1974, the conclusion reached in the original Niloak entry (pp. 189-92)—attributing to Charles Hyten the successful mixing of clays to create Niloak's "unique" swirled ware— must be revised. The reasons for this appear in the Addenda entry for the Ouachita Pottery, at which the production of such ware was executed by Arthur Dovey some time before it was introduced at Niloak.

Northwestern Terra Cotta

(See principal entry beginning on page 195)

Northwestern Terra Cotta was incorporated in Illinois in 1887. In 1920, according to S. S. Darling (*Chicago Ceramics & Glass*, Chicago, 1979, p. 72), it acquired the Chicago Crucible Company (incorporated in Illinois in 1917). About that time the firm discontinued its Norweta line and began to produce a new line of artware bearing the Chicago Crucible designation. Two years later the name was changed to the Chicago Ceramic Company. Further information and illustration of the marks and ware of Northwestern Terra Cotta and Chicago Crucible are to be found in Darling (especially pp. 70-72), as is an account of the architectural work of Northwestern (pp. 168-69).

CHICAGO
CRUCIBLE C°
Chicago Ill.

Northwestern/Chicago Crucible vase; h. 6½" (16.6 cm).
Private collection.

Odell & Booth Brothers

(continued from page 202)

Evans resigned in 1882 and was replaced by Arthur E. Blackmore. The following year there was a falloff in demand for the Limoges-type ware, and in 1884 Wallace Booth returned to England. The firm was restyled "Odell & Booth", with a concentration on utilitarian ware. A disagreement between the partners forced closure of the pottery in 1885. Booth, with Warren C. Brown, organized the Tarrytown Pottery Company, a short-lived venture which closed after a few months of production.[4]

Odell & Booth Brothers artware was of three varieties: *Barbotine*, an earthenware body decorated with applied hand-molded flora and foliage in high-relief; *Limoges*, using clay slips in the French manner on an earthenware body, coated with a clear glaze and similar to the Limoges ware of Charles Volkmar*; and *Faience*, a white or cream-colored earthenware in the style of John Bennett*, with the design in natural colors surrounded by a dark outline on a sponged ground. In addition to decorated ware, undecorated blanks were sold for amateur use. Devoe & Company produced a catalog of the firm's Barbotine ware "for oil painting".

A plaque painted by J. B. Evans, "The Capture of Major Andre", is in the collection of the Historical Society of the Tarrytowns. A pair of mantel vases in the Limoges style is in the collection of the Newark [New Jersey] Museum (#83.65).

Both an impressed and an incised "O & B B" mark have been noted, as has the incised cipher of the conjoined initials.

1. The result of research during 1978 by Leigh Keno is to be found in *Arts & Antiques*, III (March-April 1980), pp. 96-101. This is the principal source for the account offered here.
2. W. Ketchum, *Early Potters and Potteries of New York State*, p. 66; see also W. Buxton, Tarrytown *Daily News*, March 28, 1974, p. 30.
3. *Crockery and Glass Journal*, XV (January 12, 1882), p. 16.
4. This might possibly have been succeeded by the Tarrytown Tile Company, to which brief reference is made by E. Townsend, *The Bulletin* of the American Ceramic Society, XXII (May 15, 1943), p. 127. Barber (*The Pottery and Porcelain of the United States*, p. 308), however, writing about 1892 notes "a few years ago . . . after remaining idle some time, [the works] were opened and operated by the Owen Tile Co., manufacturers of decorative tiles".
* Information relating to this pottery is included in a separate chapter.

The Ohio Pottery

Zanesville, Ohio

The Ohio Pottery was organized in mid-1900 for the manufacture of stoneware specialties, and a plant was erected in the Brighton section of Zanesville. Fifteen years later this firm was taken over by a group headed by Charles D. Fraunfelter, at which time John Herold joined the firm as plant manager.[1]

Herold, a native of Austria, came to the United States about 1890 and, after working as a glass decorator in New York, moved to Zanesville in 1898. There he worked for the Weller*, Owens*, and Roseville* potteries. During his tenure at Roseville as shop superintendent (while F. H. Rhead was art director) he developed their Mongol and Mara lines. About 1907 he contracted a severe case of tuberculosis, causing him to relocate in Golden, Colorado, the following year. He was influenced in his selection of that location by the proximity of the Colorado School of Mines. With little other help than that of a brother-in-law who had been of his assistants in Zanesville, he built a pottery and kiln and in 1910 organized the Herold China & Pottery Company, of which he was general manager.[2]

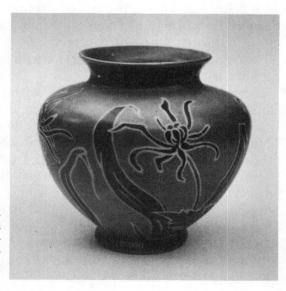

Ohio/Fraunfelter porcelain-bodied vase, red and silver decoration on a pink ground by John Lessell (note signature on base). Imprinted "Fraunfelter/U.S.A./93"; h. 4¼" (10.8 cm). *Private collection.*

By 1912, when Rhead visited him, he was producing a line of chemical porcelain in addition to porcelain tablewares and ornamental objects. According to Rhead, his work was "equal to the average German porcelain in quality and as delicately and lightly made as any china ware".[3] Lack of sufficient capital continued to plague the operation and, after new investors assumed control of the firm and built a new plant, Herold returned to Ohio in 1914. In 1917 this plant came under the management of Coors Porcelain, and in 1920 the Herold name was discontinued.[4]

Fraunfelter, born in Ohio in 1868, had been sales manager of Roseville during the Herold/Rhead period and had left that firm to join the Guernsey Earthenware Company (formerly the Cambridge Art Pottery*). Fraunfelter had kept in touch with Herold and, learning of the latter's dissatisfaction with the new managers of the Herold firm, persuaded him to go to Cambridge and make chemical porcelain there. Both men found working conditions difficult at Guernsey and Fraunfelter again persuaded Herold to join him—this time in a new venture.[5]

The old Ohio Pottery Company was taken over in 1915 with Fraunfelter in general charge and Herold as plant manager. Work was fired at a minimum temperature of cone fourteen, and the finished product was typical of Herold's high standard of excellence. The color and texture of the porcelain body were pronounced by Rhead as "comparable to the best European product", and the ware as "always beautifully finished".[6]

Initial output was bean pots, mixing bowls, and other kitchenware made from local stoneware clay. A line of restaurant and cooking ware with a hard porcelain body was introduced in 1918. Two years later the variety of their products was increased when a thinner, better-grade white china for decorators and dinnerware for hotels, clubs, restaurants, and dining-car service was added. About 1922 *Petruscan* artware was introduced.[7]

Herold died in 1923 and the Ohio Pottery was merged with American China Products of Chesterton, Indiana, forming the Fraunfelter China Company. Shortly thereafter another line of artware was produced. This work was on a porcelain-bodied ware bearing the Fraunfelter mark and decorated by John Lessell. Lessell (Lessell Art Ware*) had been associated with a number of art pottery firms, most recently with Weller. It is uncertain whether he was ever employed by Fraunfelter or whether he purchased and decorated Fraunfelter-marked blanks which he fired and sold.[8] In any case work bearing his name and the Fraunfelter mark is to be found. Within a short time Lessell established his own firm, the Art China Company, in Zanesville for the production of his work.

Had Herold lived longer, Rhead speculated, the Ohio Pottery would have developed into a factory of national reputation and occupied a position equivalent to that enjoyed by the national factories of Europe.[9] Just prior to Fraunfelter's death in 1926 he had supervised the expansion of the Zanesville plant and the consolidation of all work there. At that time the Chesterton facilities were closed. The Fraunfelter firm survived its namesake by five years, a casualty of the Great Depression. The company was reorganized in 1931 and reopened, again making dinner and specialty ware. After several attempts to continue, the pottery was finally closed in 1939.[10]

The imprinted marks found on artware are shown.

FRAUNFELTER
U. S. A.

1. Norris F. Schneider, Zanesville *Times Recorder*, January 21, 1962, p. B-5.
2. F. H. Rhead, *The Potters Herald*, April 14, 1932, p. 6.
3. *Ibid*.
4. See D. Dommel, "Coors Porcelain Company", *Spinning Wheel*, XXX (April 1974), pp. 20-22; also Coors Porcelain entry, Derwich & Latos, *Dictionary Guide*, p. 67.
5. F. H. Rhead, *op. cit.*, July 21, 1932, p. 6.
6. *Ibid.*, July 28, 1932, p. 6.
7. W. Stout *et al.*, *Coal Formation Clays of Ohio*, pp. 62, 89.
8. N. Schneider in personal correspondence dated December 4, 1976, indicates that Fraunfelter's son, George, maintained that Lessell never worked at Fraunfelter and that decoration of that firm's blanks was undertaken on his own.
9. F. H. Rhead, *op. cit.*, July 28, 1932, p. 6.
10. Ohio Secretary of State, corporation records; see Fraunfelter, Derwich & Latos, *op. cit.*, pp. 95-96.
* Information relating to this pottery is included in a separate chapter.

Ouachita Pottery

Hot Springs, Arkansas

Ouachita pottery, organized sometime between late 1905 and early 1906, was located on the corner of (305) Pleasant and Benton Streets, Hot Springs, Arkansas.[1] As local directories for this period are not available, a more accurate dating appears impossible. Nor has it been possible to identify the pottery organizer, although it is probable that it was Lee Worthington, who incorporated the firm in mid-1908.[2]

Arthur Dovey, a potter at Rookwood from 1890 until 1905, joined the Ouachita staff and appears to have been responsible for the early production of pottery, including the development of the swirled-clay technique later popularized by Niloak*. The line of work was quite broad, and a number of decorative techniques were employed. In addition to the swirled-clay effect (note bottom row of showroom table display), the Standard Rookwood-type ware was produced as well. Inmold designs were sometimes highlighted with incising or matt slip decoration. Applied designs of the type associated with the Chelsea Keramic Art Works* were also attempted, as can be seen from a study of the salesroom shelves.

A 1907 ad for the firm[3] indicates that the pottery was made exclusively from a deposit of white clay situated about nine miles from Hot

Ouachita Pottery. Arthur Dovey at wheel, left foreground; note swirled-clay ware at center of bottom row of table display at right. *Ward/Milot.*

Ouachita matt green vase, impressed mark and "M.D." incised; h. 11" (28.0 cm). *R. A. Ellison.*

Ouachita underglaze slip-decorated ware with ear-of-corn design; h. 7⅜" (18.8 cm). *Private collection.*

Springs. "This clay," the ad noted, "requires no additional clay or substance of any kind, but water, to prepare it for immediate use in the manufacture of art pottery, utility ware, pressed brick, tiling of all descriptions, sewer pipe, etc., etc. The ware made from this clay takes a beautiful finish in both matt and glost glazes; and as it is so high in silica, the latter, or Majolica glazes can be produced without crazing."

In early 1908, evidently to allow further expansion of the works for "the mining of clay and the manufactuer of pottery of a high grade," the pottery was incorporated by Worthington. At that time the Ouachita artware seems to have been discontinued and Dovey relocated in St. Louis as manager of the Ouachita Coal and Clay Products Company. The Hot Springs city directory for that year lists Worthington and Brown as proprietors of the Hot Springs Pottery, although Brown is not one of the officers of the new firm. The unidentified Brown could possibly have been George C. Brown of the Brown Press Brick Company of Hot Springs.

In about a year Dovey returned to the area, locating in Benton; he is listed as one of the incorporators of the Niloak Pottery in 1909 along with Charles D. Hyten and George Brown.[4] Dovey's presence in Benton at the time of the formation of the Niloak Pottery for the manufacture of the swirled artware, along with his technical knowledge, and the considerably earlier production of the swirled ware at Ouachita under his direction, would seem to indicate that it was Dovey and not Hyten who should be credited with the successful development of the "Niloak" technique.[5] Undoubtedly it was the intention of the Niloak firm to

patent the process at that time, as the earliest Niloak swirled-clay pieces bear the designation "Pat. Pend'g" and an impressed, non-artlettered Niloak mark. Dovey left Benton by 1911, however, and Hyten did not proceed with such plans (further attesting to Dovey's association with the technique). It was not until 1928 that Hyten patented the process, long after Dovey ceased to be involved in the ceramic industry.

Whether the production of artware at Ouachita was continued after Dovey's departure and the 1908 reorganization is uncertain. For several years thereafter Worthington is listed in the Hot Springs directories as a miner, his occupation as given in the local directories as early as 1897.

Two artist's ciphers have been noted on Ouachita artware in addition to the impressed mark shown: "S.E.S." and "M.D." The former is possibly that of Miss S. E. Smith, listed in the 1908 Hot Springs directory as an artist. "M.D." remains unidentified. Marked artware of the Hot Springs Pottery is presently unknown.

OUACHITA
HOT SPRINGS, ARK.

1. An early exhibition of the firm's work was at the Arkansas State Fair, October, 1906: see figure 1, *Spinning Wheel*, XXIII (July/August 1977), p. 33.
2. Incorporated as the Hot Springs Clay Products Company. A report in *The Clay-Worker* (XLIX, May 1908, p. 714) records "the principal business of the company will be the mining of clay and the manufacture of pottery of a high grade . . . It is the intention of the company to erect a large plant at once for the manufacture of pottery."
3. *Cutter's Guide to Hot Springs*, 1907, p. 71.
4. *The Clay-Worker*, LI (February 1909), p. 358.
5. Other producers of swirled-clay ware include Gay Head (see footnote 1, p. 192); White Pottery (top illustration, p. 339); Nonconnah (Walter Stephen, Pisgah Forest, pre-1916 work; see Pat H. Johnston, "Pisgah Forest and Nonconnah Pottery", *The Antiques Journal* XXXII [May 1977], p. 12ff.); Skag Ware of the Ozark Pottery, Eureka Springs, Arkansas; the trio of Boulder City, Nevada, operations, Desert Sands (see *Kovels' Collector's Guide*, p. 357, for illustration and mark), Mineral & Sands, and Pinto Pottery; and Henry Graack's work at Silver Springs, Florida (see Derwich & Latos, *Dictionary Guide*, p. 211; illustrated in *Kovels' Collector's Guide*, p. 366).
* Information relating to this pottery is included in a separate chapter.

380

Overbeck Pottery

(See principal entry beginning on page 203)

Kathleen R. Postle's *The Chronicle of the Overbeck Pottery* (Indianapolis: Indiana Historical Society, 1978) offers for the first time an extensive and detailed study of the Overbecks' pottery. It is extensively illustrated in color and black-and-white, well-annotated and contains a bibliography and index. Appendices include a study of the Overbeck marks, a selected listing of Overbeck exhibitions and awards, and a listing of the numerous Overbeck contributions to *Keramic Studio*.

Pauline Pottery

(See principal entry beginning on page 217)

It is now known that Laura Fry* was "intimately connected" with the beginning of the Pauline Pottery. For a scholarly survey of the history and work of this firm, set in its Chicago context, see S. S. Darling, *Chicago Ceramics & Glass* (Chicago, 1979), pp. 51-54.

* see entry in Addenda

Pewabic Pottery

(See principal entry beginning on page 225)

A wealth of material has come to light since 1974 on the Pewabic Pottery, not the least of which are the pottery records themselves, which have been microfilmed by the Archives of American Art (Smithsonian Institution). These include—in addition to an unpublished autobiography of Mary Chase Perry Stratton (Pewabic papers 1011-1020)—correspondence, files on commissions, consignments, and exhibitions; daybooks (16 volumes), order books (4 volumes), ledgers, legal documents, guest books, inquiries, recipes, and tests for clays and glazes; photographs; and information on the Pewabic pottery building. In addition there are records and daybooks of Revelation Kiln, and personal papers of Stratton's.

Thomas Brunk provided the material on the Pewabic Pottery in *Arts & Crafts in Detroit, 1906-1976* (Detroit, 1976; pp. 141-48, which has exhibition entries appended), and two years later published an extensive study, *Pewabic Pottery: Marks and Labels* (Detroit, 1978). The illustrated monograph, *Highlights of Pewabic Pottery* (Ann Arbor, 1977), was produced to provide background material for the pottery's 70th anniversary exhibition. The relationship between M. C. P. Stratton and the Detroit Society of Arts and Crafts is examined by Clark Pearce in the *Tiller* (II, November-December 1983, pp. 11-27). Lillian Myers Pear's *The Pewabic Pottery: A History of its Products and its People* (Des Moines, 1976) is a work from which one can extract considerable material. It includes an index, bibliography, and a list of major installations and collections.

Redlands Art Pottery
Redlands, California

Redlands bowl with shark decoration in low relief; h. 2" (5.1 cm), d. 5¼" (13.4 cm). Regular mark. *Heritage Room, A.K. Smiley Public Library.*

According to a promotional brochure published by the Redlands Art Pottery about 1905, Wesley H. Trippett discovered a bed of clay suitable for a pottery operation in the Redlands area (about seventy miles east of Los Angeles) at the turn of the century. Prior to beginning his ceramic work he had been engaged in designing and modeling in clay for architectural and decorative metal work.[1]

His ceramic activity was evidently undertaken alone and by trial-and-error, since he had no formal training in the making of pottery. It can be speculated that he was in touch with Alexander W. Robertson, who had a great interest in native California clay and who at that time was involved with the Roblin Art Pottery* in San Francisco. Indeed, some of Trippett's work resembles Robertson's at Roblin and later at the Halcyon Art Pottery*.

Trippett's ceramic output in Southern California makes it the earliest of the known art potteries in that area, the Valentien Pottery* not having begun work in San Diego until about 1911. Trippett was born in New York and went to California about 1895. While he lived in Redlands as early as 1899, he does not appear in the city directories until 1902-03 when he is listed as "sculptor". In the 1905-06 directory he is listed as "artist" and the 1907-08 lists him as "proprietor, Redlands Art Pottery". He disappears from the local directory in 1909, four years before his death in 1913 at the age of fifty.[2]

Redlands ware is well executed, both in design and craftsmanship. A few pieces were glazed, but most were left in the bisque state, displaying the natural color of the clays, varying in tint from cream to deep red. Vases, bowls, covered jars, and decorative tiles were all produced. Some were unadorned; others were ornamented with relief subjects including moon-and-clouds, lizards, rabbits, toads, crabs, and frogs.

Redlands pottery was offered in the Paul Elder, San Francisco, catalog of 1905,[3] along with Dedham*, Newcomb*, and Pewabic*, attesting to the respect it quickly earned.

Examples of the firm's ware are in the collection of the Public Library, Redlands.

Work bears a circular inmold mark "Redlands/Pottery" in relief.

1. Copy at the A. K. Smiley Public Library, Redlands.
2. Brief obituary notices to be found in the San Diego *Union*, January 12, 1913.
3. Page 19.
* Information relating to this pottery is included in a separate chapter.

Frederick Hurten Rhead

The exhaustive, well-documented research of Sharon Dale, *Frederick Hurten Rhead; An English Potter in America* (Pennsylvania: Erie Art Museum, 1986), offers invaluable insight into the various potteries with which Rhead was associated: Vance/Avon*, Weller*, Roseville*, Jervis*, University City*, Arequipa*, Steiger*, Rhead Pottery*, American Encaustic Tiling, and Homer Laughlin China, and even more importantly into Rhead himself. As an exhibition catalog it illustrates some of Rhead's most brilliant designs and significant technical accomplishments. A thorough bibliography of Rhead's publications is appended.

The same year as Dale's work appeared, on the other side of the Atlantic Bernard Bumpus published his study *Rhead Artists & Potters, 1870-1950,* an exhibition catalog organized by the Geffrye Museum (London, 1986). It surveys the versatility of the Rhead family from George W. Rhead (1832-1908) through F. A. Rhead's (1865-1933) generation, and down to F. H. Rhead, with the aim of setting his sister Charlotte's work in its proper context. Bumpus' material provides an excellent companion volume to Dale's.

One of the best ways to gain firsthand insight into Rhead the person is to read his regular weekly column, "Chats on Pottery", in *The Potters Herald* beginning May 21, 1931, (Vol. 38) and continuing through November 14, 1935, (Vol. 42), usually appearing on page 6.

* Information relating to this pottery is included in a separate chapter.

Robineau Pottery

(See principal entry beginning on page 243)

The most complete survey of Robineau's life, work, and associations is *Adelaide Alsop Robineau: Glory in Porcelain* (New York: Syracuse University Press, 1981), edited by Peg Weiss, with chapters by the editor, Martin Eidelberg, Richard Zakin, Phyllis Ihrman, Leslie Gorman, and P. Evans. Well documented and illustrated in black-and-white and color, it contains an extensive inventory of Robineau work in public collections in the United States. (To this can be added the major accession of several pieces by the Museum of Art, Carnegie Institute, Pittsburgh, the most important of which is the Urn of Dreams). An index and a bibliography are included.

An interesting adjunct to the preceding is the article "Edwin AtLee Barber and the Robineaus: Correspondence 1901-1916" by Jane Perkins Claney in the *Tiller* (I, November-December 1982; pp. 31-54).

Rookwood Pottery

(See principal entry beginning on page 255)

Herbert Peck, indefatigable Rookwood researcher, in 1985 published *The Second Book of Rookwood Pottery*, a companion to *The Book of Rookwood Pottery* (1970). It offers some corrections to the earlier work, adds considerable new material, and most importantly contains the complete record book of all Rookwood shapes from no. 1 (1880) to no. 7301 (1967). Also included are a survey of the firm's commercial work, a listing of the 84 different bookends made, and the identification of eleven previously unrecorded artists.

Kenneth Trapp, whose Master's thesis (Tulane, 1972), *Maria Longworth Storer: A Study of Her Bronze Objects d'Art in the Cincinnati Art Museum,* examined an obscure aspect of Rookwood-associated work, has written two exhibition catalogs for the Jordan-Volpe Gallery on areas of Rookwood's work: *Ode to Nature: Flowers and Landscapes of the Rookwood Pottery, 1880-1940* (New York, 1980), and *Toward the Modern Style: Rookwood Pottery, the Later Years; 1915-1950* (New York, 1983).

Virginia Raymond Cummins in her *Rookwood Pottery Potpourri* (Silver Spring, Maryland, 1979) offers candid accounts of the people who were associated with Rookwood, the result of her skilled research and close family ties to Rookwood, and provides an important companion volume to Peck's work.

Rose Valley Pottery

(See principal entry beginning on page 261)

An overview of the Rose Valley Association as an arts and crafts community is offered in *A Poor Sort of Heaven, A Good Sort of Earth: The Rose Valley Arts and Crafts Experiment* (Chadds Ford, Pennsylvania: Brandywine River Museum, 1983), William Ayres, editor. It contains a chapter, "The Rose Valley Pottery of William Percival Jervis", by Robert L. Edwards (pp. 61-65, 98).

Jervis was evidently interested in the arts and crafts community ideals. Coy L. Ludwig in *The Arts & Crafts Movement in New York State, 1890s-1920s* (Hamilton, New York, 1983; p. 99) illustrates an example of Jervis' pottery produced at or for Briarcliffe, "an Association of Craft Workers". This could have been done between Jervis' departure from Craven* and his establishment of the Jervis Pottery*, c. 1908.

* Information relating to this pottery is included in a separate chapter.

Steiger Terra Cotta & Pottery Works

South San Francisco, California

Sharon Dale in *Frederick Hurten Rhead* (Erie, Pennsylvania, 1986; p. 91) illustrates and documents a short-lived attempt at art pottery production, possibly in association with Rhead, about 1913. Steiger was a large manufacturer of a full line of terra cotta work for structural, ornamental, and other purposes, using clay from their own pits in Amador County, California (see L. E. Aubury, ed., *The Structural and Industrial Materials of California*, Sacramento, 1906; pp. 228-29). Steiger maintained an office in San Francisco; the pottery works were at South San Francisco and had been dismantled many years prior to 1928 (W. F. Dietrich, *The Clay Resources and the Ceramic Industry of California*, Sacramento, 1928; p. 215).

The impressed mark, "S.T.C & P.WK'S", is as shown.

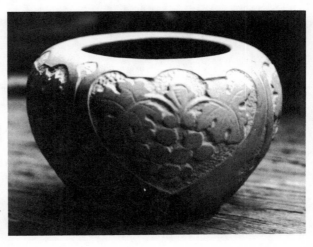

Steiger bowl; h. 3¾" (9.5 cm). Circular mark as shown. *Bob Schmid.*

Strobl Pottery

Cincinnati, Ohio

The J. H. Strobl Pottery appears to have been organized about 1901, when it is first listed in the Cincinnati directory, located at 909 Depot Street. The firm was incorporated in Ohio in 1906, which the 1907 directory listing indicates. During this period Strobl advertised itself as a "manufacturer of clay specialties and advertising novelties—vases and lamps a specialty".[1] The latter were generally undecorated, matt glazed artware items, marked as shown.

By 1910 efforts were concentrated on the production of faience tile and mantels. To reflect this, the name was changed at the end of that year to The Strobl Tile Company, by that time located in Winton Place, Cincinnati. A 1913 ad maintained that "ours are the only kilns in the United States fired exclusively for interior and exterior faience tile decorations".[2] In 1920 the product line was changed from tile to standard and electrical porcelain, and the name was changed to the Cincinnati Porcelain Company.[3]

The "SP" mark of Strobl Pottery was mistakenly identified in the first edition of *Art Pottery*[4] as being that of the Shawsheen Pottery. The "ST" mark of Strobl Tile is also shown.

Cincinnati directory, 1905.

1. Cincinnati directory, 1905, p. 2023.
2. *The Mantel, Tile, and Grate Monthly,* VI (March 1912), p. 42; cf. the news notice in the same issue, p. 32, that "a new line of jardinieres, window boxes, pottery baskets, etc." was being made.
3. W. Stout *et al., Coal Formation Clays of Ohio,* p. 87. Cincinnati Porcelain was incorporated in Ohio in 1922 and dissolved in 1928.
4. Shown on page 271, first edition, at left.

Swastika Keramos
Minerva, Ohio

Swastika Keramos is the line of art pottery produced by the Owen China Company of Minerva, Ohio, beginning in 1906. Owen China was founded in 1903 by Ted Owen and reorganized and incorporated in Ohio in 1908. Located about forty miles northwest of East Liverpool, the firm had access to good supplies of clay and also to the art pottery talent available in the Ohio region. Its principal reputation was for the production of semi-porcelain and hotel china. Tea and dinner services were also made with over- and underglaze decorations. The firm, sufficiently successful by 1920 to increase capacity by the addition of four kilns, was a casualty of the Great Depression, and the corporation charter was cancelled in 1932.[1]

Swastika Keramos work was first exhibited in April 1906 and received a very favorable reception. It was reported that "the various shades, both solid and blended, of bronze, brass, and copper, on unique designs on a high-class body . . . are artistic in conception, full of merit and extremely decorative, and will form a desirable addition to the collection of any enthusiastic connoisseur."[2]

Swastika Keramos pitcher, hand-painted landscape of trees in gray-green color outlined with gold. Background colors are copper and magenta; h. 10 1/4" (26.1 cm). *R. A. Ellison.*

Swastika Keramos vase with overall decoration of gold veining on a high-gloss green ground; h. 7 1/2" (19.1 cm). *Private collection.*

Examples of Swastika ware give evidence of a close decorative relationship to the work of John Lessell. Lessell had made a specialty of such decorative effects at the Arc-En-Ciel Pottery* and then at the J. B. Owens Pottery*. He is listed in the Zanesville city directory of 1905 as foreman of the J. B. Owens works, but is not listed in the 1907 directory. It is possible that Lessell left Owens during their 1905 upheaval and that it was he who can be credited for the Swastika ware. At Owens, Lessell was responsible for a line similar to LaSa, which he later produced at the Weller Pottery*; he was undoubtedly responsible for J. B. Owens' Opalesce line, introduced at the Lewis and Clark Exposition, 1905. Ware of both these types was produced under the Swastika name on a porcelaneous body. Either the Swastika ware was a meticulous copy of the Lessell work, or the decorative techniques were carried by Lessell to Owen China.

In any event, during the 1906-07 period, decorative art pottery presumably done under the direction of John Lessell was produced at Owen China and identified by the Swastika Keramos name. It would appear that production was of short duration, possibly ceasing when the pottery was reorganized in 1908. Thereafter the Owen firm concentrated on semi-porcelain and hotel china, and by 1911 Lessell was involved in the establishment of the Lessell Art Ware* firm.

The mark is an inmold raised seal which is applied to the ware in a fashion similar to the Roseville* Rozane Ware seal. Pieces are sometimes found unmarked, possibly with a number and letter designation in gold.

1. W. Stout *et al., Coal Formation Clays of Ohio,* p. 83; report of the Secretary of State, Ohio.
2. *China, Glass, and Lamps,,* XXVI (April 28, 1906), p. 17; see also *ibid.,* (June 9, 1906), pp. 14-15.
* Information relating to this pottery is included in a separate chapter.

Teco Pottery

(See principal entry beginning on page 278)

An early Teco design by F. Albert
Brush and Pencil.

Further studies of Teco ware are provided by Sharon Darling in *Chicago Ceramics & Glass* (Chicago, 1979; pp. 54-70) and by Diana Stradling, "Teco Pottery and the Green Phenomenon" (*Tiller,* I, March-April 1983; pp. 8-36). The former provides a documented history of the development of the ware and extensively illustrates the wide variety of the work; the latter includes an annotated list of designers and an extensive study of decorative techniques.

Examples of the more elaborately designed ware are to be found in the collection of the Western Reserve Historical Society. The Chicago Historical Society has assembled a large collection of Teco pieces.

University City Pottery

(See principal entry beginning on page 286)

A detailed history of "The University City Venture" as seen by F. H. Rhead was presented by P. Evans in *Adelaide Alsop Robineau: Glory in Porcelain* (Syracuse, New York, 1981; P. Weiss, ed., pp. 93-115, 214-16). Some notes from the correspondence of Samuel Robineau are contained in "Edwin AtLee Barber and the Robineaus:Correspondence 1901-1916" by J. P. Claney (*Tiller,* I, November-December 1982; esp. pp. 45-50). A well illustrated presentation is that of Lois H. Kohlenberger, "Ceramics at the People's University" (*Ceramics Monthly,* XXIV, November 1976; pp. 33-37). Also to be noted is Curtis R. Thomas' Master's thesis (University of Missouri, 1974), *Drawn from the Kilns of University City.*

Valentien Pottery

(See principal entry beginning on page 294)

At the time of the writing of the original entry for the Valentien Pottery (pp. 294-96) its existence was little more than a rather well-substantiated hypothesis. In the intervening years various factual pieces of the puzzle have fallen into place,[1] and the shape book was found.[2]

Bruce Kamerling has offered a scholarly presentation of the factual material, confirming and rounding out the account in *Art Pottery*.[3] In addition to Anna M. and Albert R. Valentien and their financial backer J. W. Sefton, Jr., Martin Sorenson and Arthur Dovey were associated with the firm.

Dovey, a potter at Rookwood* from 1890 until 1905 (the same year the Valentiens left Rookwood*), was thereafter associated with the Ouachita Pottery* and Niloak*. There he was apparently responsible for the introduction of the swirled-clay technique now associated with the Niloak name.[4] In 1911 Dovey joined the Valentiens at San Diego.

The short-lived operation (1911-13), in production for only about a year (1911-12), was plagued by external circumstances. These managed to overwhelm efforts to execute what are perhaps some of the finest sculptured designs of American art pottery—certainly on a par with the early Artus Van Briggle* designs, which also reflect the

Valentien Pottery designed by Irving Gill, at the northeast corner of University and Texas. *San Diego Trust & Savings Bank, Thomas W. Sefton.*

394

European influence. These sculptured designs, as in the case of Van Briggle's ware, were finished with monochrome matt or vellum-type glazes; the series of nonsculptured (plain) shapes were similarly glazed and occasionally slip-decorated with floral or geometric motifs.

Not only was there a delay in receiving machinery; Anna Valentien was to write "unfortunately we started [the pottery] in a residential district and had to discontinue on account of the smoke." Control of the kilns, as evidenced by the uneven glaze development on many pieces, was also a problem which seems never to have been resolved.

In spite of all, however, the inspiration and designs prepared provide insight into the dreams and possibilities of the Valentien Pottery. The shape book depicts forty-three plain shapes and another forty-eight shapes molded in low relief.

In keeping with the Rookwood tradition of carefully marking their ware, each piece bears the impressed Valentien mark (a California poppy in a rectangular cartouch with the letters V and P on either side; see page 296). The shape numbers of the sculptured designs are prefixed by a Z, whereas the plain shapes bear no alphabetical designation. The initials of either Albert R. or Anna Marie Valentien are also to be found on their work.

1. This has been due, in large part, to the assistance of Anna Valentien's grandniece, to whom the author is indebted.
2. Reproduction of the sketches from the shape book, sculptured designs Z1 through the last entry Z48, is to be found in *Spinning Wheel*, XXXV (September 1979), pp. 37-39.
3. Bruce Kamerling, *The Journal of San Diego History* of the San Diego Historical Society, XXIV (Summer 1978), pp. 343-66.
4. The basis for this conclusion is offered in the entry under Ouachita Pottery in the Addenda.
* Information relating to this pottery is included in a separate chapter.

Van Briggle Pottery

(See principal entry beginning on page 297)

Shortly after the publication of *Art Pottery*, *Van Briggle Pottery: The Early Years*, edited by Barbara M. Arnest, appeared (Colorado: Colorado Springs Fine Arts Center, 1975). It includes a great deal of information, a catalog of authenticated Van Briggle designs from 1901 to 1912 (nos. 1 through 904, the sketches of which allow for study of the design and decorative motifs of each), an analysis of marks, and a graphic study of the evolution of a Van Briggle vase design (p. 23). Based on that analysis of marks, by Robert Wyman Newton (pp. 14, 21-22), the hypothesis advanced by Bayer (*Art Pottery*, p. 301) is incorrect. The Roman numeral designations are a coding for the particular clay formula used.

Also of interest is the illustration in W. Kaplan's *"The Art that is Life"* (Boston, 1987) of Artus Van Briggle's art nouveau vase done at Rookwood in 1898 which was a prototype for Van Briggle's Lorelei (*Art Pottery,* plate 9).

Van Der Meulen & Wykstra Art Pottery

Dunkirk, New York

In 1906 Theake F. Van Der Meulen and Gerrit Wykstra established a partnership for the production of art pottery. Wykstra, a native of the Netherlands, had worked at the Gouda Pottery and at a Delft pottery factory. Located at 433 Brigham Road, Dunkirk, the firm produced what they called "Dunkirk Delft", a style of decorated pottery highly reminiscent of authentic Delft ware. The partnership ended in 1909, and for a time Wykstra continued to make pottery in Dunkirk, moving to Grand Rapids, Michigan, in 1920.[1]

Examples are in the collection of the New York State Museum, Albany.

Work was often marked *Dunkirk Delft* and had a conjoined VW cipher and the Dunkirk, N.Y., designation.

Van Der Meulen & Wykstra Art Pottery vase with decoration of two orange-red flowers on orange and green background; h. 9 1/2" (24.2 cm). Marked with VW device and "Dunkirk, N.Y.". *New York State Museum, Albany.*

1. The information presented is excerpted from Coy L. Ludwig, *The Arts & Crafts Movement in New York State, 1890s-1920s* (Hamilton, New York, 1983; p. 100), based on an undated Dunkirk *Evening Observer* article by M. Louise Ratkowski.

Vance/Avon Faience

(See principal entry beginning on page 303)

Numerous examples of F. H. Rhead's decorative work at Vance/Avon are pictured in Sharon Dale's *Frederick Hurten Rhead: An English Potter in America* (Erie, Pennsylvania, 1986; pp. 24-29). Frequently he employed the "squeeze bag" technique (trailed white slip outlines), often applying a line of verse with the decoration—something more typical of Rhead's work here than elsewhere. A biography of A. L. Cusick, one of the leading decorators at that time, is to be found in S. & B. Huxford's *The Collectors Encyclopedia of Brush McCoy Pottery* (Paducah, Kentucky, 1978; pp. 33-34).

An excellent piece exhibiting Rhead's work at Avon is in the collection of the Erie Art Museum (#1985.005).

The Vance/Avon works of Wheeling Potteries at Tiltonville. *Kathryn J. Evans.*

Frederick E. Walrath

Frederick E. Walrath holds a significant place in the Arts and Crafts Movement in the United States, but by the definition attempted in the opening essay (pp. 1-6), he can not be considered an "art potter". While such a definition is, ultimately, subjective, Walrath like Charles Binns* would seem to epitomize the studio potter.[1] He is included here because of the scholarly interest in his work, the excellence of his designs and their relationship to the work of several of the art pottery producers.

Walrath, born in 1871, was a pupil of Binns at the New York State School of Clayworking and Ceramics, Alfred. Between 1904 and 1906 he was an instructor at the University of Chicago's School of Education. He spent a brief and frustrating time in 1907-08 with Grueby*, and in 1908 became an instructor in the department of fine and applied arts at the Mechanics Institute, Rochester, New York. He was able to take full advantage of the Institute's well-maintained pottery, and produced much of his work here. He remained in Rochester until 1918, when he succeeded Paul Cox as ceramist at Newcomb Pottery*, a position ended by his untimely death in 1921.[2]

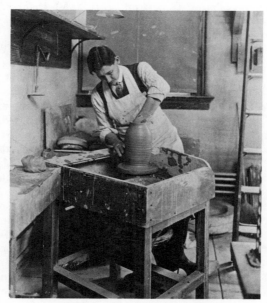

Frederick E. Walrath at Mechanics Institute
Rochester Institute of Technology.

Walrath's pottery was influenced by Arts & Crafts principles, most often either hand built or thrown. His initial work was decorated with monochrome matt glazes; after 1908 he began to produce two-color wares. Decorative motifs were generally conventionalized versions of plants, trees, and flowers. As early as 1904 he received a bronze medal at the St. Louis exposition. His work became well known through regular entries thereafter in ceramic exhibitions and it consistently received favorable reviews.[3] Writing in 1925, Paul Cox observed that "Walrath made a good many pieces of merit and had the temperament to produce a line comparable with the best that comes from abroad and a fondness for working alone so that from him we had a sort of college bred peasant pottery. His early death robbed us of much."[4]

Examples of Walrath work are included in the collections of the Newark Museum, the St. Louis Art Museum, and the Strong Museum in Rochester.

A number of incised marks were used by Walrath, including that shown with its stylized cipher of "M.I." for the Mechanics Institute of Rochester.

1. In "An Arts and Crafts Potter" (*American Craft*, XLVI, October/November 1986; pp. 58-61), Susan Williams seems careful to maintain this distinction. Her research and analysis provide the basis of this entry.
2. A more detailed account of this chronology is to be found in Williams, *ibid.* It appears that the *Keramic Studio* (III, May 1911; p. 8) report of the "Clifton-Walrath" pottery exhibition that year at the New York Society of Keramic Arts is erroneous, as other reports of that exhibition (*Arts & Decoration*, I, April 1911, p. 261; and *Pottery & Glass*, VI, March 1911, p. 14) make no such association.
3. M. Eidelberg, *The Arts and Crafts Movement in America, 1876-1916*, p. 180. Walrath's first appearance in the exhibitions of the New York Society of Keramic Arts was in 1907 (*Keramic Studio*, IX, June 1907; p. 38) where it was reported that he showed "a case of interesting work in several lines. Matt glazes in the style of Alfred Pottery, matt vellum in the style of Rookwood, interesting experiments in flambe red giving the dark red shot with blue, and a few crystalline glazes similar to some of those shown . . . by Mrs. Adelaide Alsop Robineau—altogether a clever lot of work". A review of the IV Annual Exhibition of the National Society of Craftsmen (*International Studio*, XLII, February 1911; p. lxxix) observes that Walrath "has successfully solved the difficult problem of incorporating flowers and leafage into the decoration of pottery without any suggestion of realism, without detracting in any way from the artistic ensemble".
4. P. Cox, *The Bulletin* of The American Ceramic Society, IV (September 1925), p. 421.
* Information relating to this pottery is included in a separate chapter.

Weller Pottery

(See principal entry beginning on page 323)

Some of the most thorough research to date on the Weller Pottery, by Anne Gilbert McDonald, has yet to be published to any great extent. Her work has provided the following corrections to the earlier Weller entry:

the *L'Art Nouveau* line (p. 324) was introduced just prior to Rhead's arrival (*Crockery and Glass Journal*, LIX, January 14, 1904);

Sicard made a plaque commemorating his departure on December 24, 1901, which would place his arrival in Zanesville early in 1902 (cf. p. 325), where he had a five-year contract with Weller.

Report of the sale of the important Purviance collection of Zanesville art pottery, which contained the pieces illustrated in the publications of Louise and Evan Purviance and Norris Schneider, and included the "world's largest vase" pictured on page 326, is found in the Zanesville *Times Recorder*, January 30, 1977, p. 1.

White Pottery

(See principal entry beginning on page 338.)

An illustrated study of the White Pottery is offered by Thomas G. Turnquist, *Denver's White Pottery: A Legacy in Clay* (Tulsa, Oklahoma, 1980). For the background of the White family in England and Canada before their coming to the United States see Elizabeth Collard, *Nineteenth-Century Pottery and Porcelain in Canada* (Montreal, 1967; esp. pp. 253-56). The example of White's "Gray Ware" on page 339 of *Art Pottery* is now in the collection of the National Museum (Smithsonian Institution; #75.75).

White Pines Pottery

Woodstock, New York

Ralph Whitehead, founder of the Byrdcliffe* colony,[1] with his wife, Jane, began their own White Pines Pottery about 1915.[2] Jane would seem to have begun ceramics lessons at the Byrdcliffe Pottery during the summer of 1913 and followed them up with instruction at the newly established Rhead Pottery* in Santa Barbara that fall (where the Whiteheads maintained a second home). Whitehead appears to have become interested the following year and by 1915 began to keep detailed records of his work at the White Pines Pottery, which operated beside White Pines, the Whiteheads' house at Byrdcliffe. Jane was the decorator and designer of their work, while Ralph took charge of the technical aspects, including mold-making and pottery production, although Jane threw some pots from which molds were later made.

A few pieces of White Pines pottery were decorated in relief, but most work was cast and adorned with various glaze treatments including oxblood, black luster, matt rose, sea green, turquoise blue, and aventurine. The ware was offered for sale at shops and exhibitions in Boston, New York, Philadelphia, Baltimore, Chicago, Cincinnati, Cleveland, Woodstock, and Santa Barbara, generally ranging in price from $1 to $25. 1926 was the year of Ralph's last entry in his notebooks, as it was of Jane's last reference to pottery making in her calendar. Ralph died in 1929, Jane in 1935.

White Pines pottery was marked with a paper label with what Edwards and Claney describe as a "winged arrow" or "wing and arrow" mark. This was sometimes incised or painted on the ware. Occasionally the incised initials of Ralph Radcliffe Whitehead are found with the winged arrow device. Most often pieces bear only an incised or painted code which in some cases can be coordinated with entries in Whitehead's pottery record books.

1. Staley, Allen, "Byrdcliffe and the Maverick", M.A. thesis, Yale School of Fine Arts, New haven, 1960, offers a good bibliography of material about Byrdcliffe and the broader Woodstock colony to which it gave rise.
2. Robert Edwards, "The utopias of Ralph Radcliffe Whitehead", *Antiques*, CXXVII (January 1985), pp. 260-76; and Jane Perkins Claney, "White Pines Pottery; the continuing arts and crafts experiment", in *Life by Design: The Byrdcliffe Arts and Crafts Colony* (Wilmington: Delaware Art Museum, 1985), pp. 15-20; are the two principal sources for the material presented here. Little was known of the White Pines work until after the Whiteheads' son Peter's death in 1976, when a large collection surfaced, including pieces in almost every state of completion. Apparently the documentary material from which this information is derived was also found at that time.

Zark Pottery

St. Louis, Missouri

Zark, like Teco* and Swastika*, is the name found on the ware of a firm by another name—in this case the art pottery produced by Robert Porter Bringhurst at the ozark Pottery, 1820 Locust Street, St. Louis.[1] Bringhurst was born in Illinois in 1855 and died in St. Louis in 1925. He is best known as a sculptor, receiving medals at the expositions at Chicago, 1893, St. Louis, 1904, and thereafter.[2] His sculptural work is to be found in numerous museums, including three busts at the St. Louis Art Museum.

Bringhurst, along with Clarence H. Howard and Arthur T. Morey, organized the Ozark Pottery Company which was incorporated in Missouri on September 6, 1906, "to produce, manufacture, use, buy, sell, and otherwise acquire and dispose of and deal in and with in any manner whatsoever, clays and other materials, kilns, pottery of all kinds, ceramics, artware, and art, and to do any thing and conduct any industry or business in connection therewith or incidental thereto."

Little, to date, has been found regarding a history of the operation,[3] although several pieces of Zark/Ozark work have been studied. Examples generally are earthenware, but high-fired ones have been reported.[4] One style of work is decorated with slip; another is sculpted in low relief, making use of Bringhurst's expertise in this medium.

It has been stated that "Zark Shops a.k.a. Ozark Pottery was founded on November 21, 1907".[5] Given the incorporation a year earlier, it is

Zark vase, incised mark and "F.S.";
h. 6 1/4" (15.9 cm). *Private collection.*

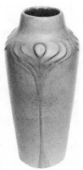

Zark vase, incised mark and "S.A.C.";
h. 9 1/2" (24.2 cm). *Private collection.*

possible that Ozark was organized at the earlier time and that Zark Shops was established to handle the work which was then marked Zark. Zark Shops is not listed in the St. Louis directories during this time, although there is a Zark Mining & Land Company listed in 1911, the latter incorporated in Missouri, October 30, 1906.

The pottery "continued for some years", but it had been abandoned by mid-1911[6]—probably sometime during 1910. The 1906-10 period in St. Louis was a fascinating one, with more aspects unexplored than explored. In addition to Bringhurst's work there was the formation of the University City* operation with Lewis, Robineau, Rhead, and Doat; there was the presence of Arthur Dovey, who had relocated in St. Louis for the Ouachita Pottery* and who was possibly involved in pottery-making there (a piece with an impressed mark "Ouachita/Saint Louis" has been reported). Finally there is the possibility that Cornelius Brauckman, born in St. Louis, remained there until just prior to this arrival about 1910-11 in Los Angeles, where he gave his ware the name of Doat's book on the subject, Grand Feu*.

An example of Zark Pottery is in the collection of the St. Louis Art Museum (#1814:1981).

Pieces usually are marked with either an incised or an impressed Zark, as shown. An apparently early piece, marked with an incised Ozark and a slip-painted Zark mark, has been noted. Often decorator initials are to be found, including.

C.B.B.	S.M.	
R.P.B.	F.S.	ZARK
S.B.	N.S.	
S.A.C.		

1. Care should be taken to distinguish the St. Louis Zark/Ozark Pottery from the Ozark Pottery of Charles Stehm at Eureka Springs, Arkansas, established a decade later. It produced "Ozark Skag", a swirled-clay ware of the Ouachita and Niloak* type (The Clay-Worker, LXXXVI, October 1926; p. 303).
2. Who Was Who in American Art (Chicago, 1943; I: 1897-1942; p. 139); American Art Annual (XIV:1917; p. 436).
3. Two almost identical reprints from an undated story in the St. Louis Republic appear in American Pottery Gazette, X (November 1909), pp. 33-34; and Pottery & Glass, IV (March 1910), pp. 23-24.
4. David Rago, Collector's Spectrum, New York, catalog for sale of May 31, 1987 (item 362, p. 43).
5. David Rago, Collector's Spectrum, New York, catalog for sale of May 17, 1986 (item 54, p. 8).
6. City Art Museum of St. Louis, Exhibition catalog (Series 1911; no. 16) of sculptural work of Bringhurst, p. 14. The reasons cited are "insufficient encouragement of this work and its inroad upon his career as a sculptor."
* Information relating to this pottery is included in a separate chapter.

Appendix I
Geographical Listing of Art Potteries

Arkansas
Niloak Pottery: Benton
Ouachita Pottery: Hot Springs

California
Alberhill Pottery: Alberhill
Arequipa Pottery: Fairfax
J. A. Bauer Pottery: Los Angeles
California Faience: Berkeley
Grand Feu Art Pottery: Los Angeles
Halcyon Art Pottery: Halcyon
Markahm Pottery: National City
Oakland Art Pottery: Oakland
Redlands Art Pottery: Redlands
Rhead Pottery: Santa Barbara
Robertson Pottery: Los Angeles, Hollywood
Roblin Art Pottery: San Francisco
Steiger Terra Cotta & Pottery Works: So. San
 Francisco
Stockton Art Pottery: Stockton
Valentien Pottery: San Diego
Walrich Pottery: Berkeley

Colorado
Denver China and Pottery: Denver
Van Briggle Pottery: Colorado Springs
White Pottery: Denver

Connecticut
Wannopee Pottery: New Milford

Illinois
Albery Novelty Pottery: Evanston
Alhambra Ceramic Works: Chicago
American Terra Cotta and Ceramic Company (see
 Teco); Terra Cotta
Chicago Terra Cotta Works: Chicago
Crossware Pottery: Chicago
Norse Pottery: Rockford
Northwestern Terra Cotta: Chicago
Pauline Pottery: Chicago
Teco Pottery: Terra Cotta

Indiana
Overbeck Pottery: Cambridge City

Iowa
Shawsheen Pottery: Mason City

Kentucky
Kenton Hills Porcelains: Erlanger

Louisiana
Paul E. Cox Pottery: New Orleans
New Orleans Art Pottery: New Orleans
Newcomb Pottery: New Orleans

Maryland
Edwin Bennett Pottery: Baltimore

Massachusetts
Chelsea Keramic Art Works: Chelsea
Dedham Pottery: Dedham

Grueby Pottery: Boston
Low Art Tile Works: Chelsea
Marblehead Pottery: Marblehead
Merrimac Pottery: Newburyport
Paul Revere Pottery: Boston, Brighton
Shawsheen Pottery: Billerica
Walley Pottery: West Sterling

Michigan
Markham Pottery: Ann Arbor
Pewabic Pottery: Detroit

Mississippi
Biloxi Art Pottery

Missouri
Ozark Pottery (see Zark): St. Louis
University City Pottery: University City
Zark Pottery: St. Louis

New Jersey
Clifton Art Pottery: Newark
Cook Pottery: Trenton
Fulper Pottery: Flemington
Mott Pottery Works: Trenton
Poillon Pottery: Woodbridge
Volkmar Kilns: Metuchen

New York
American Art Ceramic Company: Corona
John Bennett Pottery: New York City
Brush Guild: New York City
Buffalo Pottery: Buffalo
Byrdcliffe Pottery: Woodstock
Corona Pottery: Corona
Durant Kilns: Bedford Village
Faience Manufacturing Company: Greenpoint
Graham Pottery: Brooklyn
Halm Art Pottery: Sandy Hill
Jervis Pottery: Oyster Bay
Kiss Art Pottery: Sag Harbor
Middle Lane Pottery: East Hampton, Westhampton
Odell & Booth Brothers: Tarrytown
Peconic Pottery (see Kiss): Sag Harbor
Robineau Pottery: Syracuse
Tiffany Pottery: Corona
Van Der Meulen & Wykstra Art Pottery: Dunkirk
Volkmar Pottery: Tremont, Corona
White Pines Pottery: Woodstock

Ohio
Arc-En-Ciel Pottery: Zanesville
Avon Faience (see Vance/Avon):
 Tiltonville
Avon Pottery: Cincinnati
Cambridge Art Pottery: Cambridge
Cinicinnati Art Pottery: Cincinnati
Clewll Metal Art: Canton
Coultry Pottery: Cincinnati
Cowan Pottery: Cleveland, Rocky River
Craven Art Pottery: East Liverpool
Dallas Pottery: Cincinnati
Dayton Porcelain Works: Dayton
Wm. Dell Pottery: Cincinnati

405

Etruscan Antique Art Works: Sebring
Faience Pottery: Zanesville
Florentine Pottery: Chillicothe
Lonhuda Pottery: Steubenville
Losanti: Cincinnati
J. W. McCoy Pottery: Roseville,
 Zanesville
Matt Morgan Art Pottery: Cincinnati
Miami Pottery: Dayton
Nielson Pottery: Zanesville
Oakwood Art Pottery: Wellsville
Oakwood Pottery: Dayton
Oakwood Pottery Company. East
 Liverpool
Ohio Pottery: Zanesville
Owen China Company (see Swastika
 Keramos): Minerva
J. B. Owens Pottery: Zanesville
Peters and Reed Pottery: Zanesville
A. Radford Pottery: Tiffin, Zanesville
Rookwood Pottery: Cincinnati
Roseville Pottery: Zanesville
Strobl Pottery: Cincinnati
Swastika Keramos: Minerva
Trentvale Pottery: East Liverpool
C. B. Upjohn Pottery: Zanesville
Vance/Avon Faience: Tiltonville
Weller Pottery: Zanesville
H. A. Weller Art Pottery: Zanesville
T. J. Wheatley & Company: Cincinnati

Wheatley Pottery Company: Cincinnati
Zanesville Art Pottery: Zanesville

Pennsylvania
Conestoga Pottery: Wayne
Enfield Pottery: Laverock
Rose Valley Pottery: Rose Valley

Tennessee
Nashville Art Pottery: Nashville

Virginia
Massanetta Art Pottery: Harrisionburg

West Virginia
Avon Faience (see Vance/Avon):
 Wheeling
Lessell Art Ware: Parkersburg
A. Radford Pottery: Clarksburg
Sinclair Art Pottery: Chester
Vance/Avon Faience: Wheeling

Wisconsin
American/Edgerton Art Clay Works:
 Edgerton
Edgerton Pottery: Edgerton
Frackelton Pottery: Milwaukee
Norse Pottery: Edgerton
Pauline Pottery: Edgerton

Appendix II
Vital Statistics of Significant Art Pottery Figures

Baggs, Arthur E.	1886-1947	Mercer, Henry C.	1856-1930
Bailey, Joseph, Sr.	c.1826-1898	Meyer, Joseph F.	1848-1931
Barber, Edwin AtLee	1851-1916	Morgan, Matt	c.1839-1890
Bennett, Edwin	1818-1908	Nielson, Christian	1870-1955
Bennett, John	1840-1907	Ohr, George E.	1857-1918
Binns, Charles F.	1857-1934	Overbeck, Elizabeth G.	1875-1936
Bragdon, William V.	1884-1959	Overbeck, Hannah B.	1870-1931
Brauckman, Cornelius W.	1864-1952	Overbeck, Margaret	1863-1911
Broome, Isaac	1835-1922	Overbeck, Mary F.	1878-1955
Brouwer, Theophilus A.	1864-1932	Owens, John B.	1859-1934
Clewell, Charles W.	1876-1965	Poillon, Clara L.	1850-1936
Cowan, R. Guy	1884-1957	Purdy, Ross C.	1875-1949
Cox, Paul E.	1897-1968	Radford, Albert	1862-1904
Dahlquist, Edward	1877-1972	Rhead, Frederick H.	1880-1942
Dahlquist, Elizabeth B.	1875-1963	Robertson, Alexander W.	1840-1925
Doat, Taxile	1851-1938	Robertson, Fred H.	1869-1952
Dovey, Arthur	1870-1955	Robertson, George B.	1907-1966
Frackelton, Susan S. G.	1848-1932	Robertson, George W.	1835-1914
Fry, Laura F.	1857-1943	Robertson, Hugh C.	1844-1908
Fulper, William H., Jr.	1872-1928	Robertson, J. Milton	1890-1966
Gates, William Day	1852-1935	Robertson, James	1810-1880
Grueby, William H.	1867-1925	Robertson, William A.	1864-1929
Herold, John J.	1871-1923	Robineau, Adelaide Alsop	1865-1929
Hyten, Charles D.	1887-1944	Sicard, Jacques	1865-1923
Jacobus, Pauline	1840-1930	Solon, Albert L.	1887-1949
Jervis, William P.	1849-1925	Storer, M. L. Nichols	1849-1932
Langenbeck, Karl	1861-1938	Stratton, Mary C. P.	1868-1961
Long, William A.	1844-1918	Taft, James S.	1844-1923
Low, John G.	1835-1907	Tiffany, Louis C.	1848-1933
Lycett, Edward	1833-1909	Upjohn, Charles B.	1866-1953
McCoy, James W.	1848-1914	Valentien, Albert R.	1862-1925
McLaughlin, Mary Louise	1847-1939	Valentien, Anna Marie	1862-1947
Markham, Herman C.	1849-1922	Van Briggle, Artus	1869-1904

Volkmar, Charles	1841-1914	Weller, Samuel A.	1851-1925
Volkmar, Leon G.	1879-1959	Wheatley, Thomas J.	1853-1917
Wall, Gertrude R.	1881-1971	White, Francis G.	1869-1960
Wall, James A.	1877-1952	White, Frederick J.	1838-1919
Walley, William J.	1852-1919	Young, George F.	1863-1920
Walrath, Frederick E.	1871-1921		

Appendix III
Expositions Involving Art Pottery of the United States

1876	Philadelphia, Pennsylvania	Centennial Exposition
1881	Atlanta, Georgia	International Cotton Exposition
1884-85	New Orleans, Louisiana	Cotton Centennial Exposition
1889	Paris, France	Universal Exposition
1893	Chicago, Illinois	Columbian Exposition
1895	Atlanta, Georgia	Cotton States and International Exposition
1900	Pairs, France	Paris International Exposition
1901	St. Petersburg, Russia	St. Petersburg International Exposition
1901	Buffalo, New York	Pan-American Exposition
1901-02	Charleston, South Carolina	South Carolina Interstate and West Indian Exposition
1904	St. Louis, Missouri	Louisiana Purchase Exposition
1905	Portland, Oregon	Lewis and Clark Exposition
1907	Jamestown, Virginia	Jamestown Virginia Tercentennial Exposition
1909	Seattle, Washington	Alaska-Yukon-Pacific Exposition
1911	Turin, Italy	Turin International Exposition
1913	Knoxville, Tennessee	National Conservation Exposition
1915	San Francisco, California	Panama-Pacific Exposition
1915-16	San Diego, California	Panama-California Exposition

Appendix IV
Bibliography of Principal Reference Works cited in the Text
(see also the Bibliographic survey beginning on page 343)

Alexander, Donald E., *Roseville Pottery for Collectors* (Richmond, Indiana: privately published, 1970).

Altman, Seymour and Altman, Violet, *The Book of Buffalo Pottery* (New York City: Crown Publishers, 1969).

Aubury, Lewis E., ed., *The Structural and Industrial Materials of California* (Sacramento: State Printing, 1906), Bulletin 38.

Barber, Edwin AtLee, *The Ceramic Collectors' Glossary* (New York City: The Walpole Society, 1914).

_____, *The Pottery and Porcelain of the United States* (New York City: G. P. Putnam's Sons, 1893; 2nd and enlarged ed. 1901; 3rd and enlarged ed. 1909).

_____, *Marks of American Potters* (Philadelphia: Patterson & White, 1904).

Benjamin, Marcus, *American Art Pottery* (Washington, D.C.: privately published; reprinted from *Glass and Pottery World*, XV, 1907).

Binns, Charles F., *The Potter's Craft: A Practical Guide for the Studio and Workshop* (New York City: D. Van Nostrand, 1910; 4th ed. 1967).

Blasberg, Robert W., *George E. Ohr and his Biloxi Art Pottery* (Port Jervis, New York: privately published, 1973).

Bogue, Dorothy McGraw, *The Van Briggle Story* (Colorado Spring, Colorado: privately published, 1968).

Branner, John Casper, *A Bibliography of Clays and the Ceramic Arts* (Columbus, Ohio: The American Ceramic Society, 1906).

Cox, Warren E., *The Book of Pottery and Porcelain* (New York City: Crown Publishers, 1944), 2 vols.

Dietrich, Waldemar F., *The Clay Resources and the Ceramic Industry of California* (Sacramento: California State Mining Bureau, 1928), Bulletin 99.

Doat, Taxile, *Grand Feu Ceramics* (Syracuse, New York: Keramic Studio Publishing, 1905).

Eidelberg, Martin, "Art Pottery", *The Arts and Crafts Movement in America: 1876-1916;* Robert J. Clark, ed. (Princeton, New Jersey: Princeton University Press, 1972; pp. 119-86.

Frackelton, Susan Stuart, *Tried by Fire* (New York City: D. Appleton, 1886; revised and enlarged, 1895).

Hawes, Lloyd E., *The Dedham Pottery and the Earlier Robertson's Chelsea Potteries* (Dedham, Massachusetts: Dedham Historical Society, 1968).

Jervis, William Percival, *A Pottery Primer* (New York City: O'Gorman Publishing, 1911.

_____, *Rough Notes on Pottery* (Newark, New Jersey: privately published, 1896).

_____, *The Encyclopedia of Ceramics* (New York City: Blanchard, 1902).

Ketchum, William C., Jr., *Early Potters and Potteries of New York State* (New York City: Funk & Wagnalls, 1970).

Kovel, Ralph and Kovel, Terry, *Kovels' Collector's Guide to American Art Pottery* (New York City: Crown Publishers, 1974).

_____, *Kovels' New Dictionary of Marks* (New York City: Crown Publishers, 1986).

McLaughlin, Mary Louise, *Pottery Decoration Under the Glaze* (Cincinnati, Ohio: Robert Clarke, 1880).

Nelson, Marion John, "Art Nouveau in American Ceramics," *The Art Quarterly* of The Detroit Institute of Arts, XXVI (number 4, 1963), pp. 441-59.

_____ , "Indigenous Characteristics in American Art Pottery," *Antiques*, LXXXIX (June 1966), pp. 946-50.

Pappas, Joan and Kendall, A. Harold, *Hampshire Pottery Manufactured by J. S. Taft & Company, Keene, New Hampshire* (Manchester, Vermont: Forward Color Production, 1971).

Peck, Herbert, *The Book of Rookwood Pottery* (New York City: Crown Publishers, 1970).

Purviance, Louise; Purviance, Evan; and Schneider, Norris F., *Roseville Art Pottery in Color* (Des Moines, Iowa: Wallace-Homestead, 1970).

_____ , *Weller Art Pottery in Color* (Des Moines, Iowa: Wallace-Homestead, 1971).

_____ , *Zanesville Art Pottery in Color* (Leon, Iowa: Mid-America, 1968).

Rhead, Frederick Hurten, *Studio Pottery* (University City, Missouri: People's University Press, 1910).

Ries, Heinrich, *Clays of New York: Their Properties and Uses* (Albany: New York State Museum, 1900), Bulletin no. 35, vol.7.

_____ and Leighton, Henry, *History of the Clay-Working Industry in the United States* (New York City: John Wiley & Sons, 1909).

Schneider, Norris F., *Zanesville Art Pottery* (Zanesville, Ohio: privately published, 1963).

Stiles, Helen E., *Pottery in the United States* (New York City: E. P. Dutton, 1941).

Stout, Wilber; Stull, R. T.; McCaughey, William J.; Demorest, D. J., *Coal Formation Clays of Ohio* (Columbus: Geological Survey of Ohio, 1923), Bulletin 26, Fourth Series.

Strong, Susan R., *History of American Ceramics: An Annotated Bibliography* (Metuchen, New Jersey: Scarecrow Press, 1983).

Watkins, Lura Woodside, *Early New England Potters and Their Wares* (Cambridge, Massachusetts: Harvard University Press, 1950).

Weidner, Ruth Irwin, *American Ceramics Before 1930: A Bibliography* (Westport, Connecticut: Greenwood Press, 1982).

Young, Jennie, J., *The Ceramic Art: A Compendium of the History and Manufacture of Pottery and Porcelain* (New York City: Harper & Brothers, 1878).

Appendix V
Substantive Changes made in Original Text

Notation regarding marks or examples has been altered on the following pages (* indicates mark inserted):

11, 33*, 50, 68*, 75*, 104*, 140*, 152-53, 160*, 201, 202*, 248*, 263, 271, 292-93*.

Other changes:

page 21, footnote 6, line 4: date corrected;

113, footnote 9, line 2: volume number and date of reference corrected;

135, line 4: clarification;

202: entry completely rewritten;

239, line 10: clarification;

249, footnote 15, line 4: month of reference corrected;

295, line 6: date corrected;

311: picture of Merrimac pottery at center of page replaced with correct illustration of Volkmar work.

Appendices, with the exception of III, augmented.

Index reset to include corrections and Addenda.

A Directory Of Studio Potters
Working in the United States through 1960

Compiled from Lists of Entrants in the Robineau Memorial/
National Ceramic Exhibitions and from Other Sources as Noted.

The purpose of this Directory is to provide researchers with a beginning in the study of the development of artistic ceramic work in the United States in the years following the art pottery era. Since many studio potters marked their ware with their names or initials, it is hoped that the Directory will also provide a source of reference for those seeking to identify examples.

The growth and the appreciation and encouragement of studio potters in the United States had many concomitants, but certainly none was more important than the Robineau Memorial/National Ceramic exhibitions. These grew from a dream of Anna W. Olmsted of the Syracuse (Everson) Museum which she shared with Samuel Robineau in 1931. It was to present "an annual ceramic exhibit, with a jury of well known artists and prizes offered—with the idea of encouraging the individual artists who are working [on] their own ideas in the ceramic field (not the potteries) . . . open only to American potters, and made attractive enough by means of awards to make it worth their while."[1] Early the following year, Charles Binns, Charles Harder, and Carlton Atherton were on hand to judge the entries in the first annual exhibition. The objectives, as outlined by R. Guy Cowan, were "to improve the ceramic art of America; to educate the American public to take an intelligent interest in ceramic art and to realize that ceramics is a major art; [and] to make sales, secure commissions and positions for ceramic artists, and increase their income as well as their stature as ceramic artists".[2]

The exhibitions were held annually through 1941, were resumed in 1946 and continued through 1952; thereafter they became biennial. The last in this sequence was held in 1972.[3] These shows provided for individual potters what the earlier expositions (see Appendix III) had offered the art potteries, and the traveling portion of each provided a national forum for contemporary potters and their work.

The directory was orginally prepared as a checklist of entrants in the Robineau Memorial/National Ceramic exhibitions, the most important single source for such a compilation spanning the 1930-60 period. This has been augmented from other sources as cited. All United States entrants in the "Ceramic Nationals" from the second (1933) through the

twenty-first (1960)[4] have been included in the listing.[5] Many showed traditional ceramic vessels, a number produced only ceramic sculptural forms, while others limited their work to enamels (on clay and other material); some during the period were represented by several expressions. The 1960 date was chosen as a cutoff as by that time the shows had reached unwieldy proportions and seemed to lack a clear sense of definition. For each subject the location given is that of the last entry in the exhibitions or, in some instances, the last known.

Notes for the Directory follow the last entry.

1. Letter from Olmsted to Robineau dated August 6, 1931, in archives of the Everson Museum, Syracuse.
2. See also *Ceramics Monthly,* I (January 1953), pp. 12-15.
3. The list of prize winners of the first nine exhibitions is to be found in H. E. Stiles' *Pottery in the United States,* pp. 307-15. See also Margie Hughto in Clark and Hughto, *A Century of Ceramics in the United States, 1878-1978,* esp. pp. xii-xiv, and G. Clark, *ibid.,* esp. 95-97, 195-97. A collection of catalogs can be found in the archives of the Everson Museum, and that museum's extensive and important collection of studio pottery is composed of many of the prize-winning pieces. In 1987 the Exhibitions were resumed on a far more modest scale. For a critique by Edward Lebow see *American Craft* (XLVII, August/September 1987; pp. 26-33, 69-70).
4. Dates are listed for exhibitions held at Syracuse, from their exhibition catalogs. Traveling exhibition dates were often a year later, hence the exhibition number as well as the date are provided. Given the scope of this work, Canadian entrants have not been included.
5. The earlier exhibitions include work of a number of students who were to pursue a vocation apart from the field of ceramics, and of others who did not return to ceramic work after the hiatus of the second World War.

Abadie, Benard (Wilton, Conn.); 16(1951), 18(1954), 19(1956).

Abbe, Elfriede (Ithica, N.Y.); 12(1947).

Abbott, Charles E. (S. Berwick, Maine); 10(1941), 12(1947), 14(1949).

Abbott, Marcia (Boston, Mass.); 18(1954).

Abel, Louise (b. 1894; New York City); 2(1933), 6(1937), 7(1938), 10(1941), 19(1956); note 5.

Abernathy, J.T. (b. 1923; Ann Arbor, Mich.); 14(1949), 15(1950), 17(1952); 18(1954); 20(1958); ref: Derwich & Latos, *Dictionary Guide*, p. 19.

Abler, Morton (New York City); 12(1947).

Abrahams, Elizabeth (Newton Center, Mass.); 15(1950); cf. Woodman entry.

Acheson, Louis P. (Briarcliff Manor, N.Y.); 9(1940).

Achorn, Irving A. (Cuyahoga Falls, Ohio); 18(1954).

Achuff, James T. (Syracuse, N.Y.); 11(1946), 13(1948), 14(1949), 15(1950), 16(1951), 19(1956), 20(1958), 21(1960); note 7.

Ackerman, Evelyn (Los Angeles, Calif.); 16(1951), 18(1954: Jenev-Design Studio).

Ackerman, Jerome (Los Angeles, Calif.); 16(1951), 17(1952), 18(1954: Jenev-Design Studio).

Ackerman, Louise (San Francisco, Calif.); 10(1941).

Adachi, Isami (Los Angeles, Calif.); 17(1952).

Adams, Sadie (Flagstaff, Ariz.); 5(1936).

Agnew, Sarah O. (Boston, Mass.); 8(1939).

Aitken, Irene Anabel (Cleveland, Ohio); 5(1936) through 10(1941).

Aitken, Russell Barnett (b. 1910; Cleveland, Ohio); 2(1933), 3(1934), 5(1936) through 9(1940); note 2.

Albert, Beatrice & Joseph (Albert Pottery, Chamblee, Georgia); 12(1947), 13(1938), 15(1950), 17(1952), 18(1954).

Alberts, Thealtus (Lincoln, Neb.); 9(1940), 10(1941).

Albright, Hardie (Beverly Hills, Calif.); 11(1946).

Alden, Lowell (Houston, Texas); 11(1946), 12(1947), 13(1948).

Alexander, Nancy F. (Oakland, Calif.); 16(1951), 17(1952).

Allen, Don F. (Denver, Colo.); 12(1947), 14(1949).

Alling, Clarence (Topeka, Kansas; 21(1960).

Alsup, George W. (Gulfport, Miss.); 15(1950), 17(1952).

Altschule, Hilda (Rochester, N.Y.); 10(1941), 12(1947).

Amateis, Edmond (Brewster, N.Y.); 10(1941), 11(1946); 14(1949).

Ames, Arthur (b. 1906; Claremont, Calif.); 13(1948), 14(1949), 16(1951) through 20(1958); note 1.

Ames, Jean Goodwin (b. 1903; Claremont, Calif.); 11(1946), 13(1948), 14(1949), 15(1950), 17(1952) through 20(1958); note 1.

Amos, Eulala (Athens, Georgia); 15(1950), 16(1951), 17(1952).

Ander, Anne (Honolulu, Hawaii); 7(1938).

Anderson, Bruce (Santa Cruz, Calif.); 13(1948), 14(1949), 15(1950).

Anderson, Isabel (Providence, R.I.); 17(1952).

Anderson, James McC. (Shearwater Pottery, Ocean Springs, Miss.); 5(1936), 7(1938).

Anderson, Jim (Providence, Kentucky); 21(1960).

Anderson, Peter (Shearwater Pottery, Ocean Springs, Miss.); 4(1935), 5(1936), 9(1940), 11(1946), 14(1949).

Anderson, R.F. (Costa Mesa, Calif.); 21(1960).

Anderson, Walter Ingles (Shearwater Pottery, Ocean Springs, Miss.); 4(1935), 5(1936), 7(1938), 9(1940), 11(1946).

Anderson, Winslow (Milton, W. Va.); 11(1946), 12(1947).

Andreson, Laura F. (b. 1902; Los Angeles, Calif.); 7(1938), 9(1940), 11(1946), 13(1948); notes, 2, 3, 8.

Andrews, Mary Adelaide (Cleveland, Ohio); 10(1941).

Andrews, Michael F. (Columbus, Ohio); 15(1950).

Angelo, Domenick Michael (New York City); 16(1951).

Anthony, Edward J. (Detroit, Mich.); 15(1950), 17(1952), 18(1954).

Apel, Edna L. (Detroit, Mich.); 10(1941).

Arata, Sybil (Oakland, Calif.); 15(1950), 16(1951), 18(1954).

Arbo, Aurelia Coralie (New Orleans, La.); 7(1938); ref: J. Poesch, *Newcomb Pottery* (Pennsylvania, 1984), p. 96.

Archipenko, Alexander (1887-1964); 6(1937), 7(1938), 9(1940), 13(1948); note 2.

Arneson, Robert (b. 1930; Davis, Calif.); notes 2,7.

Arnold, Stephen L. (Warners, N.Y.); 4(1935).

Arnow, Edna (Chicago, Ill.); 19(1956).

Arntz, Michael (Los Angeles, Calif.); note 4.

Aronson, Charlotte (Chicago, Ill.); 17(1952), 19(1956).

Arsenault, Norman E. (Wellesley Hills, Mass.); 18(1954), 20(1958).

Artis, William Ellisworth (b. 1919; Chadron, Neb.); 9(1940), 12(1947) through 16(1951); note 1.

Atchley, Whitney (San Francisco, Calif.); 3(1934), 6(1937), 10(1941), 12(1947) through 15(1950).

Atherton, Carlton (Columbus, Ohio); 2(1933), 7(1938) through 10(1941).

Auer, Lili (Chicago, Ill.); 2(1933: Hull House Kilns).

Autio, Rudy (b. 1926; Missoula, Mont.); notes 2,8.

Avakian, Victoria (Eugene, Ore.); 9(1940) through 11(1946).

Ayars, Alice A. (Cleveland, Ohio); 2(1933) 4(1935), 5(1936), 7(1938) through 10(1941).

Babbington, Helen Brett (Jonesville, Mich.); 8(1939) through 13(1948).

Baca, Lufina (Santa Fe, N.M.); 3(1934).

Bacerra, Ralph (b. 1938; Los Angeles, Calif.); note 2.

Bachelder, Oscar Lewis (1850-1935); Omar Khayyam Pottery (ref: P. H. Johnston, *The Antiques Journal,* XXIX [September 1974], pp. 10-13, 48).

DIRECTORY

Bacher, Holland Robert (Rock Tavern, N.Y.); 4(1935).
Bacher, Will Low (Rock Tavern, N.Y.); 4(1935), 6(1937).
Backus, Lulu Scott (Rochester, N.Y.); 2(1933) through 4(1935), 6(1937) through 10(1941), 13(1948).
Baggs, Arthur E. (1886-1947); 2(1933) through 7(1938), 9(1940), 10(1941); see Marblehead Pottery*, also note 2.
Bailer, Sterling (Cleveland, Ohio; 3(1934).
Bailey, Clayton (b. 1939; Hayward, Calif.) note 2.
Bailey, H. (1874-1950); 5(1936); ref: J. Poesch, *Newcomb Pottery* (Pennsylvania, 1984), p.97
Bailey, Lucille (Alfred, N.Y.); 4(1935).
Baker, Jean (Atlanta, Georgia); 14(1949), 19(1956), 20(1958).
Baker, M. Phyllis (Randolph, Mass.); 21(1960).
Baldwin, Louise (Brookline, Mass.); 7(1938), 8(1939), 13(1948), 16(1951), 19(1956), 20(1958).
Ball, F. Carlton (b. 1911; Tacoma, Wash.); 10(1941) through 14(1949), 16(1951) through 21(1960); notes 2, 3, 7.
Ball, Kathryn Uhl (Oakland, Calif.); 10(1941).
Balmer, Jean (San Diego, Calif.); note 4.
Balsam, Geraldine (Brooklyn, N.Y.); 13(1948).
Balsham, Leah (Chicago, Ill.); 12(1947), 14(1949).
Barbarossa, Theodore (New Canaan, Conn.); 9(1940), 13(1948).
Barger, Eleanor (Toledo, Ohio); 17(1952), 18(1954).
Barlow, Mary Belle (Philadelphia, Penn.); 4(1935) through 9(1940).
Barnum, Fayette; ref: L.H. Alexander, *The House Beautiful,* XV (March 1904), pp. 238-39.
Barrett, Elizabeth, see Jensen, Elizabeth B.
Barron, Francis (Norwood, Ohio); 6(1937).
Barron, Harris (Brookline, Mass.); 18(1954) through 20(1958); note 1.
Barron, Rosalyn (Brookline, Mass.); 18(1954), 20(1958); note 1.
Bartell, Bonnie (Eugene, Ore.); 16(1951).
Bartell, James P. (Eugene, Ore.); 14(1949) through 16(1951).
Bartling, Jacqueline, see Ward, Jacqueline Bartling.
Barvian, Margaret (Alfred, N.Y.); 4(1935).
Bass, Elizabeth H. (New York City); 4(1935).
Bate, Gladys (Wichita, Kans.); 8(1939).
Bates, Kenneth Francis (Cleveland, Ohio); 5(1936), 7(1938) through 21(1960); note 1.
Bates, Ira (Los Angeles, Calif.); note 4.
Bauer, Arnold (Syracuse, N.Y.); 2(1933), 3(1934).
Bauer, Fred (b. 1937; Seattle, Wash.); note 2.
Baugh, Elizabeth Ann (San Antonio, Texas; 17(1952).
Baumgartner, Max (Berkley, Mich.); 18(1954).
Beacham, Helena K. (Gwynedd Valley, Penn.); 3(1934).
Bearson, Dorothy (Salt Lake City, Utah); note 4.
Beasley, Esther L. (San Anselmo, Calif.); 21(1960).
Beck, Peggy Paver, see Evans, Peggy Beck.
Becker, Edith C. (Providence, R.I.); 13(1948).
Beckerman, Luke (Scarsdale, N.Y.); 5(1936).
Becksmith, Luise Veach (Cincinnati, Ohio); 7(1938).
Beling, Helen (New Rochelle, N.Y.); 14(1949) through 17(1952), 19(1956), 21(1960).
Bell, Enid (Santa Fe, N.M.); 10(1941).
Bellardo, Paul D. (b. 1924; Boston, Mass.); 16(1951), 17(1952), 19(1956), 20(1958), 21(1960).
Bellis, Edda (St. Paul, Minn.); 11(1946), 13(1948).
Bengston, Billy Al (b. 1934; Los Angles, Calif.); note 2.
Bennett, A. Lee (Gladding, McBean, Los Angeles, Calif.); 5(1936).
Bennison, Jane Foster (Los Angeles, Calif.) 4(1935), 6(1937).
Bentley, Grace Mary (New Hartford, N.Y.); 21(1960).
Bentley, Harriet Jackson (Rochester, N.Y.); 3(1934).
Benua, Marjorie Post (Gahanna, Ohio); 9(1940), 10(1941), 12(1947).
Benwell, Zoe (Grand Forks, N.D.); 3(1934).
Bergey, Grace (b. 1913; Detroit, Mich.); 7(1938); ref: "Grace Bergey Berdan" entry; Derwich & Latos, *Dictionary Guide,* pp. 34-35.
Berl, Kathe (New York City); 13(1948), 14(1949), 16(1951) through 20(1958).
Bernhard, Vera (San Francisco, Calif.); 8(1939), 9(1940).
Bessom, Florence (Parsons, W.V.); 3(1934).
Berridge, Nelly (Bloomfield Hills, Mich.); 8(1939), 9(1940), 10(1941).
Bielefeld, Theodore (Oakland, Calif.); note 7.
Biesiot, Elizabeth Gall (Seattle, Wash.); 14(1949).
Bigler, Mary Jane (Detroit, Mich.); 14(1949), 15(1950).
Billmyer, John Edward (b. 1912; Denver, Colo.); 14(1949), 15(1950), 19(1956); note 1.
Binns, Charles F., see entry in text.
Binns, Elsie (Alfred, N.Y.); 3(1934).
Bishop, Mary B. (Flint, Mich.); 19(1956).
Black, David E. (Columbus, Ohio); 21(1960).
Black, Harding (San Antonio, Texas); 12(1947) through 18(1954), 20(1958).
Blackshear, Katherine (Chicago, Ill.); 18(1954).
Blank, Polly (Los Angeles, Calif.); 15(1950), 17(1952).

Blazey, Lawrence (b. 1902; Bay Village, Ohio); 7(1938) through 11(1946), 13(1948), 14(1949), 15(1950), 18(1954), 20(1958).

Blazys, Alexander (Cleveland, Ohio); 5(1936).

Blundell, Phyllis (New York City); 14(1949), 19(1956), 20(1958).

Blyler, Margaret Louise (Minneapolis, Minn.); 11(1946).

Board, Roberta (Los Angeles, Calif.); 5(1936), 8(1939).

Bodkin, Sally Grosz (New York City); 7(1938), 9(1940), 11(1946).

Bogatay, Paul (1905-1972); 2(1933) through 7(1938), 9(1940) through 19(1956), 21(1960); note 2.

Bohrod, Aaron (Madison, Wisc.); 18(1954) through 20(1958); note 1.

Bonnet, Elsie F. (Alfred, N.Y.); 3(1934).

Boone, Bernice (Helena, Mont.); 18(1954).

Bopp, Harold F. (Erlanger, Kentucky); 7(1938), 10(1941); Kenton Hills*.

Border, Betty (Baltimore, Md.); 12(1947).

Boru, Sorcha, see Sorcha Boru Studio

Bosart, Helen, see Morgan, Helen B.

Boschen, Lilian (Freehold, N.J.); 13(1948), 14(1949), 16(1951) through 20(1958).

Bosse, Myrna (New York City); 18(1954).

Bovingdon, Ivarose (Seattle, Wash.); 21(1960).

Bowden, Joe (Alfred, N.Y.); 15(1950).

Boyd, Nancy Wickham (Woodstock, Vermont); 11(1946) through 13(1948), 15(1950), 16(1951), 18(1954), 20(1958).

Boyer, Betty (Cleveland, Ohio); 10(1941), 11(1946).

Bradford, Bill (Las Vegas, Nevada); note 4.

Bradley, Beatrice Bertolis (Memphis, Tenn.); 12(1947).

Bradlock, Kermit (Carbondale, Ill.); 17(1952).

Brady, Esta Warren, Jr. (Sun Valley, Calif.); 14(1949), 15(1950).

Brady, George W. (Los Angeles, Calif.); 6(1937).

Brady, Justin Michael (Indianapolis, Ind.); 14(1949), 21(1960).

Bragg, Virginia (Alfred, N.Y.); 4(1935).

Braghetta, Lulu Hawkins (San Francisco, Calif.); 7(1938).

Brastoff, Sascha (Los Angeles, Calif.); 8(1939), 9(1940), 12(1947) through 17(1952), 20(1958); ref: Derwich & Latos, *Dictionary Guide*, p. 42.

Brate, Charlotte (Long Island, N.Y.); ref: U.G. Dietz, *The Newark Museum Collection of American Art Pottery* (Newark, 1984), p. 21.

Brewster, Anna Richards (Scarsdale, N.Y.); 3(1934).

Brindesi, Olympic (New York City); 3(1934).

Bronson, Barbara (Lake Forest, Ill.); 11(1946).

Brooks, Avis (Rochester, N.Y.); 4(1935).

Broudo, Joseph David (b. 1920; Beverly, Mass.); 11(1946), 15(1950), 17(1952), 18(1954), 19(1956), 21(1960); note 1.

Brough, Hazel Waterman (University, Ala.); 16(1951).

Brown, Ada Alpaugh (West Chester, Ohio); 10(1941).

Brown, Audrey Despot (Madison, Wisc.); 17(1952).

Brown, Bert (Los Angeles, Calif.), 12(1947).

Brown, Betsy (Los Angeles, Calif.), 12(1947).

Brown, Charles M. (Mandarin, Fla.); 19(1956), 21(1960); note 8.

Brown, Donald D. (Pocatello, Idaho); note 7.

Brown, Joseph W. (Cleveland, Ohio); 17(1952).

Brown, Sandra R. (Tuckahoe, N.Y.); 19(1956).

Browne, Marion Arnold (Manhattan Beach, Calif.); 12(1947).

Brownson, E. James (Lincoln, Neb.); 15(1950), 16(1951).

Bruntjen, Florence (San Francisco, Calif.); 11(1946), 12(1947).

Bryant, Olen Littleton (Clarksville, Tenn.); 16(1951); note 1.

Bubeshko, Emilia (Cornell, Calif.); 12(1947).

Buckley, Jean (Los Angles, Calif.); notes 6, 7.

Buegeleisen, Rachel, see Jones, Rachel B.

Bullen, Reese (b. 1913; Arcata, Calif.); 18(1954), 19(1956).

Bulone, Joseph (Cleveland, Ohio); 16(1951).

Bunker, Eugene F., Jr. (b. 1928; Asheville. N.C.); 18(1954), 21(1960); note 1.

Burg, Prudence (Cazenovia, N.Y.); 11(1946).

Burgess, Gertrude (Patchogue, N.Y.); 9(1940), 10(1941).

Burnham, Forrest (Alfred, N.Y.); 10(1941).

Bursztynowicz, Henry (Pittsburgh, Penn.); 12(1947).

Burt, Clyde E. (Melrose, Ohio); 18(1954) through 20(1958); ref: Derwich & Latos, *Dictionary Guide,* p. 49, also note 7.

Butler, Eleanor Pierce (Philadelphia, Penn.); 5(1936), 6(1937), 9(1940).

Butler, John (Ossipee, N.H.); 19(1956).

Buttrick, Sue K. (Brooklyn, N.Y.); 3(1934), 10(1941).

Butz, Inez (Danville, Calif.), 15(1950).

Buzzelli, Joseph Anthony (b. 1907; Huntington, N.Y.); 11(1946), 13(1948); note 1.

Cable, Margaret (Grand Forks, N.D.); 3(1934); ref: M.L. Barr, D. Miller, & R Barr, *University of North Dakota Pottery: The Cable Years* [1910-49] (Fargo: 1977).

Cabat, Erni (Tucson, Ariz.); note 4.

Cabat, Rose (Tucson, Ariz.); note 4.
Cada, Barbara F. (Chicago, Ill.); 15(1950), 16(1951).
Cadogan, Edwin A. (Kentfield, Calif.); 15(1950) through 17(1952).
Caffery, Charles Gaines (St. Petersburg, Fla.); 15(1950).
Caha, Ruby (Lincoln, Neb.); 19(1956), 21(1960).
Calandria, Juan Jose (New York City); 9(1940).
Calder, Clivia A. (Detroit, Mich.); 4(1935) through 11(1946).
Caldwell, Gladys (Denver, Colo.); 3(1934).
Caldwell, Olive M. (Allentown, Penn.); 13(1948).
Calvert, Mildred H. (Maumee, Ohio); 16(1951), 18(1954).
Cameron, Margaret (Bonsall, Calif.); 12(1947), 13(1948), 14(1949), 18(1954).
Cames, Vina (San Francisco, Calif.); 11(1946), 12(1947).
Camp, J. Robert (Bradenton Beach, Fla.); 18(1954).
Campbell, Alice (New York City(; 6(1937).
Canfield, Jane White (Mount Kisco, N.Y.); 16(1951).
Canfield, Ruth (New York City); 3(1934: Henry Street Pottery).
Cantini, Virgil D. (Pittsburgh, Penn.); 13(1948), 14(1949).
Capehart, Elizabeth (Coronado, Calif.); 3(1934).
Caravaglia, Angelo (Erie, Penn.) 15(1950), 17(1952).
Caravias, Celeste (New York City); 14(1949).
Carawan, Noel (Venice, Calif.); note 6.
Carey, Eve Nathanson (Mountain View, Calif.); 13(1948), 14(1949).
Carey, James Sheldon (b. 1911; Lawrence, Kans.); 7(1938), 10(1941), 11(1946), 12(1947), 14(1949), 15(1950), 16(1951), 19(1956), 20(1958), 21(1960); note 1.
Carmel, Barbara Cavender (Bloomfield Hills, Mich.); 15(1950) through 17(1952).
Carpenter, Lyman S. (Chicago, Ill.); 10(1941).
Carpenter, Virginia Lewis (Los Angeles, Calif.); 6(1937).
Carruthers, John (Los Angeles, Calif.); 15(1950).
Carter, Joseph C. (Washington, D.C.); 18(1954).
Carter, Mar (Chicago, Ill.); 10(1941), 13(1948) through 16(1951), 18(1954), 19(1956), 20(1958).
Cary, Edith S. (Shaker Heights, Ohio); 19(1956).
Casagranda, Herman A. (Denver, Colo.); 15(1950).
Casper, Melvin H. (Merritt Island, Fla.); 19(1956).
Cast, Marjorie (Shaker Heights, Ohio); 10(1941).
Castaing, C.K. (Stony Brook, N.Y.); 3(1934).
Casteel, Bette (Alameda, N.M.); note 4.
Cavanaugh, John William (Columbus, Ohio); 16(1951), 17(1952), 19(1956).
Cecere, Gaetano (New York City); 10(1941).
Cerny, George (New York City); 9(1940).
Chamberlain, Rolland Strome (Dresden, Ohio); 7(1938).
Chamberlin, Prince Albert (Cleveland, Ohio); 11(1946) thorugh 13(1948).
Chancey, William H. (Wales, Wisc.); 17(1952).
Chandless, Edward (N. Arlington, N.J.); 19(1956).
Chapman, Anne (Oxford, Mo.); 17(1952) through 20(1958).
Chasek, Denis (Akron, Ohio); 19(1956), 21(1960); note 7.
Chavarria, Frances (Santa Fe, N.M.); 3(1934).
Cheney, Merritt Briggs (Briggsdale, Ohio); 10(1941).
Chimes, Dawn DeWeese (Philadelphia, Penn.); 19(1956).
Chisholm, June (Alfred, N.Y.); 13(1948).
Chow, Fong (New York City); 14(1949) through 20(1958); ref: Glidden Pottery entry, Derwich & Latos, *Dictionary Guide,* pp. 101-02; notes 1 (entry under Fong), 7.
Choy, Katherine (1929-1958). 14(1949) through 19(1956); note 3.
Christensen, Ted, Jr. (Los Angeles, Calif.); 13(1948), 16(1951).
Christie, Anna J. (Grand Rapids, Mich.); 19(1956).
Clark, A. William (Oneonta, N.Y.); 18(1954), 19(1956).
Clark, Mary Andersen (Syracuse, N.Y.); 14(1949), 15(1950).
Clarke, Charles (Alfred, N.Y.); 4(1935).
Clarke, Robert B. (Palo Alto, Calif.); 14(1949).
Clarkson, Zelda (Bloomfield Hills, Mich.); 14(1949), 16(1951).
Clegg, Mildred L. (Syracuse, N.Y.); 2(1933).
Clemens, Ruth (Hollywood, Calif.); 8(1939), 10(1941).
Clemente, Vincent R. (Whitesboro, N.Y.); 18(1954), 21(1960).
Clough, Nancy (Walnut Creek, Calif.); 11(1946), 12(1947), 14(1949), 15(1950).
Clough, Robert (Walnut Creek, Calif.); 11(1946), 12(1947), 14(1949), 15(1950).
Cochran, Jean (Honolulu, Hawaii); 6(1937) through 11(1946).
Cochran, Ruth (Cleveland, Ohio); 16(1951), 17(1952).
Cocker, Neville Louise (Buffalo, N.Y.); 10(1941).
Cohen, Esther S. (New York City); 11(1946) through 13(1948).
Cohen, Herbert (Alfred, N.Y.); 17(1952).
Cohn, Abraham (Milwaukee, Wisc.); note 7.

Colbert, Betty (Sandoval, N.M.); note 4.
Cole, Grover (Ann Arbor, Mich.); 13(1948).
Cole, Robert M. (Whittier, Calif.); 11(1946).
Colgren, Monte (Oakland, Calif.); 18(1954); note 7.
Collin, Doris Maureen (Kirtland, Ohio); 15(1950).
Colson, Frank A. (Tallahassee, Fla.); 21(1960).
Combes, Herbert L. (Berea, Ohio); 13(1948), 14(1949).
Combs, Alex Duff, Jr. (Philadelphia, Penn.); 16(1951), 17(1952).
Compton, Max D. (Los Angeles, Calif.); 7(1938); authority on glazes at Gladding, McBean and probable developer of their oxblood glaze.
Conover, Claude (Euclid, Ohio); 21(1960).
Cook, May Elizabeth (b. 1863; Columbus, Ohio). ref: F.H. Rhead, *The Potter,* I (December 1916), pp. 1-6; *The Bulletin* of The Americn Ceramic Society, XXIII (December 15, 1944), pp. 451-56.
Cooper, Aileen (Port Washington, N.Y.); 14(1949).
Coronel, Raul Angulo (Los Angeles, Calif.); 19(1956); notes 4, 6, 7.
Corrao, Anthony W. (Warrensville Heights, Ohio); 21(1960).
Corsaw, Roger D. (b. 1913; Norman, Okla.); 6(1937), 9(1940), 13(1948), 14(1949), 18(1954), 20(1958), 21(1960); note 1.
Corsaw, Wilma (Norman, Okla); 16(1951).
Coulter, Mary B. (Bloomfield Hills, Mich.); 11(1946).
Cousino, Joe Ann Bux (Toledo, Ohio); 18(1954).
Cousins, Gail Hayes (San Jose, Calif.); 9(1940).
Cowan, R. Guy (1884-1957); 2(1933), 3(1934), 5(1936), 6(1937); see Cowan Pottery*, also notes 1,8.
Cowles, Hobart E. (b. 1923; Rochester, N.Y.); 13(1948) through 16(1951), 19(1956).
Coykendall, Vernon Russell (San Francisco, Calif.); 12(1947) through 14(1949); note 7.
Cramer, Tressa (Brisbane, Calif.); 11(1946), 12(1947).
Crawford, Annie Laurie (New York City); 4(1935) through 9(1940).
Crawford, Elizabeth (Liberty, Maine); 2(1933), 3(1934), 13(1948).
Crawford, Henrietta M. (Alfred, N.Y.); 2(1933), 3(1934).
Crawford, Virginia (Cleveland, Ohio); 6(1937).
Creamer, Forrest W. (Dennison, Ohio); 6(1937), 7(1938).
Cressey, David B. (Venice, Calif.); 21(1960); note 6.
Croll, Bea (New York City); 14(1949).
Cronbach, Robert (New York City); 14(1949).
Crook, Russell G. (So. Lincoln, Mass.); 6(1937); ref: U.G. Dietz, *The Newark Museum Collection of American Art Pottery* (Newark, 1984), p.38.
Crooks, Gladys V. (Mercer Island, Wash.); note 7.
Crotty, Harry J. (Oakland, Calif.); 15(1950), 16(1951).
Crotty, Jean Stewart (Oakland, Calif.); 12(1947), 14(1949), 15(1950), 16(1951).
Crouch, Philbrick M. (Nashville, Tenn.); 14(1949).
Crumrine, James A. (b. 1925; New York City); 13(1948), 14(1949), 17(1952), 19(1956).
Cruz, Crucita T. (Albuquerque, N.M.); 10(1941).
Cummings, Mary Barrett (New York City); 7(1938), 9(1940), 11(1946).
Curran, Jane (Toledo, Ohio); 7(1938).
Curtin, Ruth (Elmira, Ore.); 19(1956); cf. Curtis, Earle.
Curtis, E. deF. (Wayne, Penn.); 2(1933), 4(1935) through 10(1941).
Curtis, Earle W. (Elmira, Ore.); 14(1949); cf. Curtin, Ruth.
Curtis, James William O'Neill (Wayne, Penn.); 7(1938) through 10(1941).
Cushing, Ellen W. (Boston, Mass.); ref: U.G. Dietz, *The Newark Museum Collection of American Art Pottery* (Newark, 1984), p. 39.
Cushing, Val M. (b. 1931; Alfred, N.Y.); 19(1956) through 21(1960); note 2.
Cutler, Eleanor Pierce (Philadelphia, Penn.); 5(1936), 6(1937), 8(1939), 9(1939 entry under Butler), 10(1941).
Cutler, Philip S. (New York City); 15(1950).

Dahoda, Peter (Alfred, N.Y.), 17(1952).
Daley, William (b. 1925; Philadelphia, Penn.); note 2.
Dalton, Ann (Flushing, Mich.) 17(1952), 19(1956).
Dalton, William B. (Stamford, Conn.); 11(1946), 12(1947).
D'Amico, Mabel Maxcy, see Maxcy, Mabel C.
Darr, Willa Mae (Los Angeles, Calif.); 12(1947).
Daub, Dorothy Nelson (Cleveland, Ohio); 16(1951), 17(1952).
Daugherty, Joe (Monrovia, Calif.); 17(1952).
Davidson, Maryetta (Saratoga Springs, N.Y.); 5(1936), 7(1938).
Davidson, Myron R. (Cleveland, Ohio); 15(1950).
Davidson, Robert (Saratoga Springs, N.Y.); 4(1934), 6(1937), 9(1940) through 11(1946).
Davidson, Wenonah A. (Niagara Falls, N.Y.); 9(1940).
Davis, Grace Hays (Schenectady, N.Y.); 6(1937).
Davis, Harriet Farr (Indiana, Penn.); 12(1947), 13(1948).
Davis, Martha (New York City); 4(1935) through 8(1939).
Davis, T. Gilbert (Chagrin Falls, Ohio); 15(1950).
Day, Edward C. (San Rafael, Calif.); 12(1947) through 14(1949).
Day, Eleanor M. (Columbus, Ohio); 10(1941).

Day, Mary (Alfred, N.Y.); 3(1934).
deCarmel, Anne (New York City); 9(1940) through 12(1947).
deCausse, Diane Hamilton, see Hamilton, Diane.
deCausse, May Hamilton (Los Angeles, Calif.); 5(1936); ref: Vernon Kilns entry, Derwich & Latos, *Dictionary Guide*, pp. 234-35.
Deese, Rupert J. (Upland, Calif.); 16(1951) through 21(1960).
deGogorza, Julia Brodt (Rochester, N.Y.); 12(1947), 14(1949), 16(1951).
Deibert, Arthur W. (Weston, Mass.); 19(1956).
deLarios, Dora (Los Angeles, Calif.); 21(1960); note 6.
deMarco, Jean (b. 1898; New York City); 9(1940); note 1.
Dempsey, John (Kentfield, Calif.); 19(1956).
Denslow, Dorothea (b. 1900; New York City); 7(1938).
dePree, Cary (Grand Rapids, Mich.); 19(1956).
deRossi, Rose (Alfred, N.Y.); 4(1935), 5(1936); listed under Rossi.
Derujinsky[ana], Gleb W. (b. 1888; New York City); 7(1938); note 1.
deTrey, Marianne (Alfred, N.Y.); 10(1941).
Deutsch, Eugene (Chicago, Ill.); 6(1937), 12(1947), 13(1948), 15(1950), 16(1951).
deVore, Richard E. (b. 1933; Boulder, Colo.); 13(1948), 18(1954), 21(1960); note 2.
deWitt, Georgiana (Alfred, N.Y.); 3(1934).
Dhaemers, Penny (Oakland, Calif.); 18(1954); note 7.
Dickerhoff, Betty (Pasadena, Calif.); 16(1951).
Dickerman, Jane (Chicago, Ill.); 15(1950) through 17(1952).
Dickman, Rosemary (Erlanger, Ky.); 10(1941); married David Seyler (see Kenton Hills*).
Diebboll, Robert H. (Washington, Mich.); 16(1951), 17(1952), 21(1960).
Diehl, Margaret E. (Batavia, N.Y.); 7(1938) through 9(1940).
Diehl, Marilyn A. (Seattle, Wash.); 21(1960).
Dierck, Kenneth John (El Cerrito, Calif.); 21(1960).
Dieterle, Germaine (Binghamton, N.Y.); 10(1941).
Diller, David (Albany, Texas); 16(1951), 17(1952).
D'Orlando, Pauly (New Orleans, La.); 19(1956).
Dobervich, Jane (Bloomfield Hills, Mich.); 14(1949).
Dodge, Mrs. Edwin S. (Boston, Mass.); 3(1934).
Domnick, Majel J. (Piedmont, Calif.); 15(1950).
Donaldson, Amy (San Diego, Calif.); 18(19540, 21(1960); note 6.
Dooner, Emilie Zeckwer (Philadelphia, Penn.); 3(1934) through 9(1940).
Dorr, Mrs. R.L. (New York City); 3(1934).
Douglas, Murray (Royal Oak, Mich.); 8(1939), 9(1940), 11(1946) through 16(1951), 18(1954), 19(1956), 20(1960).
Douglass, Patricia (Macon, Georgia); 16(1951).
Dowling, Jean O. (Corte Madera, Calif.); 12(1947) through 14(1949).
Dowling, John F. (Corte Madera, Calif.); 12(1947) through 14(1949).
Drerup, Karl (b. 1904; Campton, N.H.); 7(1938) through 10(1941), 12(1947), 13(1948), 15(1950), 18(1954), 19(1956), 20(1960); note 1.
Driscoll, Harold (San Diego, Calif.); 13(1948), 15(1950); note 3.
Dryfoos, Nancy Proskauer (New York City); 13(1948), 16(1951); note 1.
Duble, Lu (New York City); 16(1951).
DuCasse, Ralph S. (Piedmont, Calif.); 14(1949).
Duffey, Evelyn Gray (Athens, Ohio); 11(1946) through 14(1949)
Duhl, Bernice S. (Brookline, Mass.); 21(1960).
Duncan, Julia Elizabeth Hamlin (New York City); 6(1937) through 11(1946), 14(1949).
Dusenbury, Charles Y. (Bloomfield Hills, Mich.); 9(1940), 10(1941), 13(1948).
Dyer, Mrs. A.R. (East Cleveland, Ohio); 4(1935) through 11(1946).
Dysart, Ann (Columbus, Ohio); 11(1946).

Earl, Jack (b. 1934; Richmond, Va.); note 2.
Eaves, Winslow Bryan (b. 1922; West Andover, N.H.); 11(1946) through 14(1949), 19(1956), 20(1958); note 1.
Eckels, Robert (b. 1922; Ashland, Wisc.); 21(1960); note 1
Eckhardt, Edris (b. 1907; East Cleveland, Ohio); 2(1933), 4(1935), 6(1937) through 15(1950), 17(1952) through 20(1958); note 2.
Edelman, Bacia Stepner (Champaign, Ill.); 17(1952), 19(1956).
Edwards, Joel E. (Los Angeles, Calif.); 19(1956), 21(1960); notes 4, 6.
Edwards, Nancy Bixby (Chicago, Ill.); 5(1936), 6(1937), 8(1939).
Edwards, Thorne & Dorine (Memphis, Tenn.); 19(1956).
Ehrich, William (Rochester, N.Y.); 9(1940) through 12(1947).
Eichholz, Duane W. (Iowa City, Iowa); 19(1956).
Eisert, Winifred Ann (Alfred, N.Y.); 5(1936), 6(1937).
Elberg, Harold (San Anselmo, Calif.); 14(1949).
Elberg, Margo (San Francisco, Calif.); 11(1946), 14(1949).
Eldred, Dale (Ann Arbor, Mich.); note 7.
Eldredge, Harriet House (East Greenwich, R.I.); 17(1952).
Eldridge, Ruth (Alfred, N.Y.); 5(1936).

Eliscu, Frank (b. 1912; Ossining, N.Y.); 7(1938); note 1.
Elliott, Pauline (Ann Arbor, Mich.); 16(1951), 17(1952).
Ellison, Mary Ann (Oakland, Calif); 12(1947) through 14(1949).
Ellsworth, Cheryl (New York City); 14(1949).
Elrich, William (Buffalo, N.Y.); 5(1936).
Emery, Roene Eva (Long Beach, Calif.); 13(1948).
Emory, Mary J. (Alfred, N.Y.); 3(1934 as Emery), 4(1935).
Engle, Ella (University, Ala.); 17(1952).
Engle, Frank (University, Ala.); 11(1946), 16(1951), 17(1952), 20(1958).
Enomoto, Isami (Honolulu, Hawaii); 16(1951).
Erckenbrack, Mary (San Francisco, Calif.); 12(1947), 14(1949).
Erichsen, Viggo Brandt (East Jaffrey, N.H.); 9(1940).
Ernst, Dolly M. (Loveland, Ohio); 6(1937), 9(1940) through 11(1946).
Erythropel, Ilse (New York City); 7(1938).
Espenscheid, Carl R. (Lebanon, N.J.); 13(1948), 17(1952).
Etcheverry, Louisa A., see King, Louisa A.E.
Eustice, John (New Castle, Penn.); 14(1949).
Evans, Peggy P. Beck (Avon, Conn.); 7(1938), 9(1940) through 13(1948), 15(1950), 16(1951), 20(1958), 21(1960).
Evans, Stanley T. (Maple Heights, Ohio); 15(1950), 16(1951).
Everhard, M. (---); 7(1938).

Fagen, Barbara (Chicago, Ill.); 6(1937 as Fagan), 20(1958).
Fairbanks, Richard R. (Oakland, Calif.); 18(1954), 19(1956).
Fairlie, Julia Doremus (New Brunswick, N.J.); 7(1938).
Falardeau, Maybelle Muttart (Cleveland, Ohio); 15(1950), 16(1951), 18(1954), 20(1958).
Farnham, John D. (Ann Arbor, Mich.); 17(1952).
Farr, Charles Griffin (San Francisco, Calif.); 14(1949).
Farr, Fred (New York City); 11(1946).
Farrell, Marion (Berkeley, Calif.); 13(1948).
Farrell, William (b. 1936; Chicago, Ill.); note 2.
Fasano, Clara (b. 1900; New York City); 9(1940); note 1.
Fassbinder, John & Gretchen (Ellensburg, Wash.); 21(1960).
Feinstein, Mary (Ocean Park, Calif.); 9(1940).
Feldman, Sadie L. (Brooklyn, N.Y.); 5(1936) through 7(1938).
Ferguson, Kenneth R. (b. 1928; Helena, Mont.); 21(1960).
Ferrario, Louis C. (Mill Valley, Calif.); 15(1950), 17(1952).
Ferreira, Thomas (Long Beach, Calif.); 21(1960); notes 4, 6, 7.
Fetzer, George W. (Columbus, Ohio); 3(1934) through 7(1938, 9(1940), 11(1946), 13(1948).
Fetzer, Margaret Steenrod (Columbus, Ohio); 2(1933) through 7(1938), 9(1940) through 11(1946).
Feuerherm, Kurt (Rochester, N.Y.); 21(1960).
Feves, Betty Whiteman (b. 1918; Pendleton, Ore.); 17(1952) through 21(1960).
Fickert, Margaret H. (Brooklyn, N.Y.); 9(1940).
Fillous, Florence Y. (So. Euclid, Ohio); 19(1956).
Findlay, Mary Lynn (Niagara Falls, N.Y.); 18(1954).
Finegan, Don G. (Murray, Ky.); 17(1952).
Fiora, Hugo J. (Fallston, Md.); 17(1952).
Fishbein, Florence (New York City); 13(1948).
Fisher, Helen (New Canaan, Conn.); 18(1954).
Fitch, Frances G. (Mt. Pleasant, Mich.); 13(1948).
Fitzgerald, James & Margaret (Seattle, Wash.); 13(1948).
Flanagan, Norma B. (Greenwich, Conn.); 21(1960).
Fletcher, W.B. (Durham, N.C.); 14(1949), 15(1950).
Fling, Florence (Toledo, Ohio); 19(1956).
Flory, Arthur L. (b. 1914; Melrose Park, Pa.); 9(1940), 10(1941); note 1.
Flower, Violet S.M. (Philadelphia, Pa.); 10(1941).
Flowers, Margaret (San Antonio, Tex.); 15(1950), 16(1951), 19(1956), 20(1958).
Ford, Betty Davenport (Claremont, Calif.); 13(1948) through 18(1954), 20(1958).
Ford, Francis A. (Coralis Beach, Wash.); 11(1946), 13(1948), 16(1951).
Ford, Harold Harrison (Birmingham, Mich.); 14(1949).
Forsyth, Renee (Coronado, Calif.); note 6.
Fosdick, Marion Lawrence (1888-1973); 2(1933) through 7(1938), 9(1940) through 13(1948) , 15(1950), 20(1958); note 2.
Foster, John A. (1900-1980; Foster Ceramics, Birmingham, Mich.); 3(1934) through 5(1936), 13(1948), 14(1949), 17(1952), 20(1958); ref: Derwich & Latos, *Dictionary Guide*, p.93.
Foster, Norman (New York City); 5(1936), 7(1938), 9(1940).
Fowler, Lloyd & Marcia (Bradford, Penn.); 17(1952).
Fox, Lillian; ref: *Crockery and Glass Journal*, LXXXVIII (December 19, 1918), pp. 55-57.
Fox, Marilyn (Far Rockaway, N.Y.), 17(1952), 19(1956).
Frank, John N. (d. 1973); 2(1933), 3(1934); ref: Frankoma Pottery entry, Derwich & Latos, *Dictionary Guide,* p. 95.
Frank, Mary (b. 1933); note 2.
Frankel, Kitty (Toledo, Ohio); 19(1956).

Frankenthaler, Helen (b. 1928; New York City); note 2.

Frantz, Joan Stanley, see Meyer, Joan S.F.

Frazer, Margaret Lindsley (Bethesda, Md.); 8(1939).

Frazier, Bernard Emerson (1906-1976); 7(1938), 10(1941), 13(1948), 14(1949), 19(1956), 20(1958); note 2.

Frazier, Thelma, see Winter, Thelma F.

Frederick, George Francis (Vineyard Haven, Miss.); 7(1938); ref: U.G. Dietz, *The Newark Museum Collection of American Art Pottery* (Newark, 1984) p. 46.

Freeman, Charlotte Zallen (New York City); 18(1954).

Freigang, Paul (Jamaica, N.Y.); 7(1938).

French, Myrtle Meritt (Chicago, Ill.); 2(1933: Hull House Kilns); ref. S.S. Darling, *Chicago Ceramics & Glass* (Chicago: 1979), pp. 77-80.

Frey, Edwin F. (b. 1892; Columbus, Ohio); 15(1950).

Frey, Viola (b. 1933; Oakland, Calif.); note 2.

Friedman, J.S. (Johnson City, N.Y.); 16(1951).

Friedman, Jerrold (Los Angeles, Calif.); note 6.

Friedwald, Elaine, see Pirofsky, Elaine F.

Friley, Eugene B. (Columbus, Ohio); 12(1947) through 17(1952).

Frimkess, Michael (b. 1937); note 2.

Frith, Donald E. (Denver, Colo.); 16(1951) through 18(1954).

Fritz, Robert C. (Pleasanton, Calif.); 16(1951), 17(1952).

Fromhold, Hal (Los Angeles, Calif.); 21(1960); note 7.

Fuller, Esther Torosian (Oakland, Calif.); 12(1947), 15(1950) through 19(1956); note 7.

Fuller, Mary [Rubenstein] (Berkeley, Calif.); 12(1947), 13(1948).

Fuller, Mary Clio (Decatur, Georgia); 19(1956).

Fulop, Karoly (Los Angeles, Calif.); 14(1949).

Fusselman, Dorothy Watson (West Dearborn, Mich.); 19(1956).

Gage, Merle (San Diego, Calif.); 5(1936).

Gale, Eleanor S. (Pelham Manor, N.Y.); 11(1946) through 15(1950), 20(1958).

Gallagher, Joyce (Macon, Georgia); 15(1950).

Ganine, Peter (Hollywood, Calif.) 7(1938) through 14(1949), 20(1958).

Garzio, Angelo C. (Manhattan, Kans.); 19(1956) through 21(1960); note 7.

Gates, M. Louise (E. Cleveland, Ohio); 12(1947), 14(1949), 15(1950).

Gernhardt, Henry K. (Syracuse, N.Y.); 18(1954), 19(1956), 21(1960).

Gerson, Oscar (Berkeley, Calif.); 14(1949).

Getz, Dorothy (b. 1901; Delaware, Ohio); 17(1952) through 19(1956); note 1.

Giampietro, Alexander (Washington, D.C.); 12(1947), 13(1948), 18(1954).

Giampietro, Sandro (Cummington, Mass.); 11(1946).

Gibbs, Johnson L. (Little Falls, N.Y.), 17(1952).

Gibson, Blaine (Glendale, Calif.); 18(1954).

Gibson, Ira Blaine (Glendale, Calif.); 11(1946), 13(1948).

Gil, David (b. 1922; Bennington, Vermont); 16(1951) through 20(1958); ref. Bennington Potters entry, *Derwich & Latos, Dictionary Guide,* p. 34, also note 7.

Gilbertson, Warren A. (Alfred, N.Y.); 3(1934), 4(1935), 7(1938: Crabtree Kiln); 14(1949).

Gill, Harriett (Milwaukee, Wisc.); 11(1946).

Gilliard, Joseph Wadus (Hampton, Va.); 17(1952).

Ginstrom, Roy A. (Urbana, Ill.); 17(1952).

Giorgi, Clement C. (Cleveland, Ohio); 11(1946), 13(1948), 19(1956).

Giorgi, Fern (Cleveland, Ohio); 11(1946), 13(1948).

Gleaves, William (Lansdale, Penn.); 4(1935).

Glick, John Parker (b. 1938; Farmington, Mich.); 21(1960); note 2.

Glover, Robert L., Jr. (Ontario, Calif.); 21(1960).

Goberis, Theodora C.T. (Norwich, Conn.); 9(1940), 10(1941).

Goehring, Gordon Saunders (Akron, Ohio); 15(1950), 16(1951).

Goldberg, Helen D. (New York City); 14(1949).

Goldfarb, David (Bennington, Vermont); 12(1947) through 15(1950).

Goldman, Jerry (Englewood, N.J.); 13(1948), 21(1960).

Gonzales, Rose (Santa Fe, N.M.); 2(1933), 3(1934), 5(1936).

Goodman, Sherby (New York City); 13(1948).

Goodman, Violet (San Francisco, Calif.); 12(1947).

Gordan, Margaret Murray (Portland, Ore.); 10(1941).

Gordon, Jessie F. (Philadelphia, Penn.); 3(1934) through 5(1936).

Gorelick, Shirley (Levittown, N.Y.); 18(1954).

Gores, Walter J. (Ann Arbor, Mich.); 13(1948).

Goslee, Marjorie E. (Cleveland, Ohio); 14(1949), 17(1952), 21(1960).

Goto, Toshiko (Seal Beach, Calif.); note 6.

Gottesman, Hannah (New York City); 15(1950).

Gowdy, R. Ruth, see McKinley, Ruth Gowdy.

Grabill, Mary (Westerville, Ohio); 14(1949), 15(1950).

Gray, Florence (Dearborn, Mich.); 19(1956), 20(1958).

Gray, Verdelle (b. 1918; Asheville, N.C.); 14(1949), 19(1956); note 1.
Grebanier, Joseph P. (Brooklyn, N.Y.); 18(1954), 20(1958).
Green, Mary V. (San Antonio, Texas); 14(1949).
Greenberg, Stanley Rudy (Fitchburg, Mass.); 14(1949).
Greene, Elizabeth Boyd (West Kingston, R.I.); 17(1952: Peter Pots Pottery), 18(1954).
Greene, Mrs. Henry Jewett (Petersham, Mass.); 7(1938).
Greene, Olive W. (West Warwick, R.I.); 17(1952).
Gregg, Richard (Bloomfield Hills, Mich.); 14(1949).
Gregory, Waylande (1905-1971); 2(1933) through 11(1946); notes 1, 2.
Gregory, Yolande (Bound Brook, N.J.); 11(1946: Mountain Top Studio, with Waylande Gregory).
Grenbanier, Joseph P. (Brooklyn, N.Y.); 19(1956).
Griffith, Jean (Seattle, Wash.); 21(1960).
Griffiths, Ruth (San Jose, Calif.); 9(1940).
Grimes, Rosemary (San Francisco, Calif.); 13(1948), 14(1949).
Grimm, Jere M. (Portland, Ore.); 21(1960).
Grimm, Raymond M. (Portland, Ore.); 19(1956).
Grippe, Peter J. (b. 1912; New York City); 10(1941); note 1.
Grittner, James (Madison, Wisc.); 21(1960).
Grossman, Maurice K. (Tucson, Ariz.); 15(1950), 17(1952), 18(1954); note 4.
Grotell, Maija (1899-1973); 2(1933) through 21(1960); notes 1, 2, 7, 8.
Grove, Katherine B. (Columbus, Ohio); 3(1934), 5(1936).
Groves, Susanne (Canton, Ohio); 21(1960).
Grow, Georgia (Alfred, N.Y.); 5(1936).
Guilbeau, Honore (Peninsula, Ohio); 13(1948).
Gundee, Alice H. (New Rochelle, N.Y.); 10(1941).
Gustafson, Martha (Alfred, N.Y.); 2(1933).
Gutierrez, Lela (Santa Fe, N.M.); 3(1934).

Hadley, Mary Alice (Louisville, Ky.); 12(1947).
Haile, Thomas Samuel (1908-1948); 10(1941); note 2.
Hale, Aile Irene (Clifton, N.J.); 16(1951).
Hall, Doris (Lakewood, Ohio); 11(1946), 12(1947), 13(1948), 20(1958).
Hallock, Dorothy (Alfred, N.Y.); 2(1933).
Hallowell, Rowena Warner (Winchester, Mass.); 5(1936: Clay Craft Studio), 6(1937), 9(1940), 11(1946).
Halper, Estelle (Tuckahoe, N.Y.); 19(1956).
Halpern, Lea (Baltimore, Md.); ref. Exhibition catalog, The Baltimore Museum of Art, 1976.
Hamann, Ilse, see Ruocco, Ilse Hamann.
Hamel, Irene, see Rhode-Hamel, Irene
Hamilton, Diane (Alliance, Ohio); 2(1933), 3(1934).
Hamilton, Frank O. (Belvedere, Calif.); 18(1954), 19(1956).
Hamilton, [Gene] vieve (Los Angeles, Calif.); 3(1934), 5(1936); ref: Vernon Kilns entry, Derwich & Latos, *Dictionary Guide*, pp. 234-35.
Hamlin, Julia Elizabeth, see Duncan, Julia Hamlin.
Hamme, Harriet Bennett (Ann Arbor, Mich.); 21(1960).
Hammond, Mildred Welsh (Kansas City, Mo.); 9(1940).
Hamner, William M. (Rolling Hills, Calif.); 15(1950).
Hang, Joan, see Smith, Joan Hang.
Hanley, Ieda (New York City); 3(1934).
Hannell, Hazel (Chesterton, Ind.); 10(1941), 12(1947).
Hannell, V.M.S. (Chesterton, Ind.); 13(1948).
Hansen, Marc (b. 1925; Kalamazoo, Mich.); 14(1949) through 16(1951), 19(1956) through 21(1960).
Hanzakos, Michael (Sun Valley, Calif.); 21(1960).
Harder, Charles (1889-1959); 2(1933) through 5(1936), 8(1939); note 2.
Harding, Mrs. B. (Grand Forks, N.D.); 3(1934).
Hardy, Thomas Austin (Portland, Ore); 15(1950); note 1.
Harkins, Dorothy S. (Cleveland, Ohio); 13(1948).
Harmon, Charlotte (Newark, Ohio); 16(1951).
Harmon, Eloise Norstad (Pleasantville, N.Y.); 8(1939), 9(1940), 13(1948), 21(1960).
Harned, Patrick (Chicago, Ill.); 13(1948).
Harris, Prue M. (Philadelphia, Penn.); 2(1933) through 6(1937), 8(1939) through 10(1941).
Harrison, Kay (d. 1960; Detroit, Mich.); 13(1948); ref: Derwich & Latos, *Dictionary Guide*, pp. 114-15.
Hart, Merrill C. (Santa Barbara, Calif.); note 6.
Hartman, Eleanore P. (Lakewood, Ohio); 9(1940).
Hartman, Gertrude (San Francisco, Calif.); 12(1947).
Hartwig, Cleo (b. 1911; New York City); 9(1940); note 1.
Hatfield, Nina (Hoboken, N.J.); 5(1936) through 7(1938).
Hatgil, Paul P. (b. 1921; Austin, Texas); 18(1954).
Hatton, Clara (Fort Collins, Colo.); 11(1946).
Hausmann, Estelle A. (Pittsburgh, Penn.); 12(1947).
Hawkins, Forman R. (Columbia, Ky.); 13(1948).

Hay, Averill E. (San Jose, Calif.); 9(1940).
Hays, Dale (Berkeley, Calif.); 16(1951), 18(1954), 19(1956); note 7.
Hays, Elah Hale (Berkeley, Calif.); 12(1947), 15(1950); 16(1951), 18(1954), 19(1956); note 7.
Healy, Elaine E. (Kenosha, Wisc.); 16(1951), 17(1952).
Heath, Edith Kiertzner (b. 1911; Sausalito, Calif., Heath Ceramics); 11(1946) through 15(1950); note 3.
Heaton, Maurice (b. 1900; Valley Cottage, N.Y.); 13(1949), 16(1951), 19(1956), 20(1958); note 1.
Hebald, Milton E. (b. 1917; New York City); 13(1948); note 1.
Hebbeln, Jean Lamson (Sausalito, Calif.); 8(1939), 9(1940).
Heino, Otto (b. 1915; Ojai, Calif.); 15(1950), 18(1954), 21(1960); notes 2, 3, 6, 7.
Heino, Vivika Timiriasieff (b. 1909; Ojai, Calif.); 10(1941) through 12(1947), 15(1950), 18(1954) through 20(1958); notes 2, 3, 6, 7.
Heinrich, Christian (Brooklyn, N.Y.); 9(1940).
Heise, Bertha (So. Pasadena, Calif.); ref: note 3 [p. 74, footnote 36].
Helmuth, Louis W. (Lakewood, Ohio); 10(1941).
Hentschel, William E. (Erlanger, Ky.); 2(1933), 7(1938), 10(1941: Kenton Hills*); note 5.
Herz, Nora (North Arlington, N.J.); 19(1956).
Hetman, Harry Henry (Cleveland, Ohio); 6(1937).
Hieb, Richard Jacob (Lodi, Calif.); 14(1949) through 16(1951), 19(1956).
Hipple, Marietta (Detroit, Mich.); 12(1947), 13(1948), 15(1950), 18(1954) through 20(1958).
Hirsch, Willard (b. 1905; Charleston, S.C.); 13(1948); note 1.
Hlobeczy, Jean Winslow (Cleveland, Ohio); 17(1952).
Hochberg, Emanuel (San Francisco, Calif.); 21(1960).
Hocking, Ralph I. (Ypsilanti, Mich.); 21(1960).
Hodgdon, Mary Yancey (Fullerton, Calif.); 7(1938) through 9(1940).
Hodge, Lydia Herrick (Portland, Ore.); 10(1941).
Hoesli, Eleanor Hess (Bourbonnais, Ill.); 19(1956).
Hoesly, Merle (Minneapolis, Minn.); 14(1949).
Hoffa, Harlan E. (Buffalo, N.Y.); 18(1954).
Hoffer, Margaret Eleanor (Springfield, Ohio); 8(1939).
Hoffman, Miriam (San Francisco, Calif.); 17(1952).
Hoffamn, Richard F. (Columbus, Ohio); 9(1940), 13(1948).
Holleman, Paul David (Boston, Mass.); 14(1949) through 18(1954).
Holmes, Frank G. (Trenton, N.J.); 5(1936), 7(1938: Lenox).
Holt, Winifred M. (Delmar, N.Y.); 19(1956).
Hooks, Earl J. (Gary, Ind.); 21(1960).
Horan, Claude Fredric (Kahaluu, Hawaii); 9(1940) through 12(1947), 14(1949) through 20(1958); note 7.
Horvath, Sally Simons (Cleveland, Ohio); 17(1952).
Houk, Phyllis S. (Toledo, Ohio); 18(1954).
Houser, Ivan (Keystone, S.D.); 5(1936), 7(1938).
Hotchkiss, Dorothy Larson (Washington, N.J.); 19(1956).
Hotek, Ronald Ray (Cedar Falls, Iowa); 21(1960).
Houston, Godfrey B. (Alhambra, Calif.); 11(1946).
Howald, Emelia (Columbus, Ohio); 17(1952).
Howald, John S. (Columbus, Ohio); 14(1949), 17(1952).
Howard, Robert A. (Sapulpa, Okla.); 14(1949).
Howell, Alfred H. (Cleveland, Ohio); 6(1937); note 1.
Howell, Harriet Roberts (Cleveland, Ohio); 4(1935), 6(1937).
Hubbell, James (Santa Fe, Calif.); note 6.
Huckfield, Flora (Grand Forks, N.D.); 3(1934); see reference for entry M. Cable.
Hudgins, Paul (1940-1968); note 8.
Hudson, Nancy Zerviah (Plainesville, Ohio); 11(1946); 12(1948).
Huebner, Richard H. (Wheeling, W. Va.); 4(1935) through 7(1938).
Huf, Maja Quiller (Richmond, Va.); 18(1954).
Hui, Ka-Kwong (b. 1922; Jamesburg, N.J.); 14(1949) through 21(1960); notes 2, 7.
Hughes, Laura Taylor (Wahpeton, N.D.); 3(1934), 16(1951).
Hull, Clem (Sante Fe, N.M.); 10(1941).
Hulteen, Rubert (Alfred, N.Y.); 3(1934).
Hundley, Ernest (Sebring, Ohio), 9(1940).
Hunsicker, Harold Wesley (Alfred, N.Y.); 7(1938) through 11(1946), 14(1949) through 17(1952), 19(1956) through 21(1960).
Hunt, Dorothy (Des Moines, Iowa); 14(1949).
Hunter, Milli (Los Angeles, Calif.); 12(1947).
Husted, Wayne Dale (Alfred, N.Y.); 17(1952).
Huxmann, Jayne (San Francisco, Calif.); 13(1948), 14(1949).
Hykes, Willis Elmer (Buffalo, N.Y.); 10(1941).
Hysong, J.L. (San Jose, Calif.); 19(1956), 21(1960).

Ichinose, William N. Jr. (Honolulu, Hawaii); 19(1956).
Imber, Arthur (Oakland, Calif.); 18(1954).
Imhoff, Helen (Cleveland, Ohio); 9(1940), 10(1941).
Irrera, Leo C. (Highland, N.Y.); 19(1956).
Irvine, David G. (Los Angeles, Calif.); 18(1954).

Irvine, Sadie A.E. (1887-1970); 11(1946), 13(1948); ref: J. Poesch, *Newcomb Pottery* (Pennsylvania, 1984), p. 100.
Irwin, Elizabeth (Oakland, Calif.); 18(1954), 19(1956); note 7.
Israel, Margaret (New York City); 19(1956).
Ivins, Anthony H. (Ontario, Calif.); 17(1952), 18(1954).

Jacobs, Charles W.F. (Portland, Ore.); 10(1941) through 12(1947), 14(1949).
Jacobs, Harry R. (Oakland, Calif.); 14(1949).
Jacobs, Marge W. (Alfred, N.Y.); 12(1947).
Jacobson, Albert Drexel (1895-1973); 5(1936) through 7(1938), 10(1941) through 13(1948), 15(1950), 20(1958).
Jacobson, Werner J. (Fort Washington, Penn.); 16(1951).
Jae, Norman (Columbus, Ohio); 13(1948).
Jalanivich, Manuel (1897-1944); 5(1936), 7(1938); note 3, also *Art Pottery*, p. 93.
James, Elaine (Oakland, Calif.); 15(1950).
James, Esta (San Fernando, Calif.); note 4.
James, George T. (Alfred, N.Y.); 13(1948).
Jamison, Virginia (Alfred, N.Y.); 5(1936).
Janas, Stephanie (Toledo, Ohio); 18(1954).
Japhet, Emily Jane (Houston, Texas); 18(1954).
Jarvis, Constance W. (Seattle, Wash.); 21(1960).
Jay, Edward D. (Los Angeles, Calif.); 16(1951), 17(1952).
Jeffery, Charles Bartley (b. 1910; Cleveland, Ohio); 5(1936), 6(1937), 8(1939), 9(1940), 11(1946) through 18(1954), 20(1958), 21(1960).
Jegart, Rudolf (Milwaukee, Wisc.); 11(1946), 14(1949).
Jenkins, Jean Foster (Baltimore, Md.); 17(1952), 18(1954).
Jenkins, Robert Herace (1882-1955); note 3.
Jenks, Jo (Ottsville, Penn.); 15(1950).
Jennewein, C. Paul (b. 1890; Bronx, N.Y.); 5(1936), 7(1938) through 9(1940).
Jennings, Ellen (Columbus, Ohio); 3(1934), 5(1936), 6(1937), 8(1939).
Jensen, Elizabeth Barrett (Cincinnati, Ohio); 7(1938); note 5.
Jensen, Jens (d. 1978); 2(1933), 7(1938), 11(1946); note 5.
Jensen, Rosamond Bell (Bloomfield Hills, Mich.); 8(1939).
Jeszke, Stella Chester (Cleveland, Ohio); 9(1940), 11(1946).
Jex, Patricia Overholser (Springfield, Ohio); 12(1947).
Jipp, Margaret H. (Oakland, Calif.); 11(1946) through 15(1950).
Johns, Donald Arthur (Elgin, Ill.); 19(1956).
Johnson, Frances H. (Philadelphia, Penn.); 14(1949).
Johnson, Margaret (Denver, Colo.); 17(1952).
Johnson, Sargent (1887-1967); 11(1946), 12(1947); note 3.
Johnson, Thano A. (Cleveland Heights, Ohio); 18(1954).
Johnston, Margot (So. Deerfield, Mass.); 7(1938).
Johnston, Randolph W. (So. Deerfield, Mass.); 13(1948).
Johnstone, Sandra (Los Altos, Calif.); note 6.
Jones, Cecil (d. 1949); 6(1937); note 3.
Jones, Clyde (Binghamton, N.Y.); 17(1952).
Jones, David W. (Montclair, N.J.); 21(1960).
Jones, Marjorie E. (Carmel, Ind.); 9(1940), 10(1941).
Jones, Paul Haller (Grand Rapids, Mich.); 13(1948), 15(1950).
Jones, Rachel Buegeleisen (Grand Rapids, Mich.); 11(1946) through 14(1949), 16(1951).
Jones, Thomas A. (Cincinnati, Ohio); 16(1951) through 18(1954).
Jordan, Suzanne (New York City); 7(1938).
Juarez, Miguel (Chicago, Ill.); 2(1933: Hull House Kilns).
Jungwirth, Leonard D. (East Lansing, Mich.); 12(1947).

Ka-Kwong, Hui, see Hui, Ka-Kwong.
Kaganoff, Sheldon (Claremont, Calif.); 21(1960).
Kalla, Erwin (Pittsburgh, Penn.); 12(1947) through 14(1949).
Kan, Michael (New York City); 19(1956), 21(1960).
Karnes, Karen (b. 1920; Stony Point, N.Y.); 16(1951) through 21(1960); notes 2, 7.
Karp, Ben (Montclair, N.J.); 11(1946).
Karrasch, John Charles (Los Angeles, Calif.); note 4.
Kasuba, Alexandra (Queens Village, N.Y.); 15(1950), 17(1952).
Katz, Charlotte (Philadelphia, Penn.); 19(1956).
Kaufman, Florence C.E. (White Plains, N.Y.); 10(1941).
Kaz, Nathaniel (b. 1917; New York City); 12(1947); note 1.
Keeler, Edith (Marion, Ohio); 5(1936), 6(1937).
Keidel, Julia L. (Baltimore, Md.); 6(1937) through 8(1939).
Keith, Ileen (San Francisco, Calif.); 9(1940).
Kelley, Adelaide (Oneida, N.Y.); 7(1938).
Kelly, Frank Reuss (Norwalk, Conn.); "one of our best American potters", Warren E. Cox. *Pottery and Porcelain* (New York City, 1944; p. 1067).

421

Kelsey, Luman P. (No. Canton, Conn.); 6(1937) through 12(1947).
Kelsey, Muriel Chamberlin (New York City); 11(1946); note 1.
Kempe, Margot (New York City); 14(1949), 15(1950), 18(1954), 19(1956).
Kendall, Lillian (Fairfax, Calif.); 12(1947).
Kennedy, Patrick (Oakland, Calif.); note 4.
Keppen, Mary (Alfred, N.Y.); 4(1935).
Kester, Bernard (Los Angeles, Calif.); 21(1960); note 7.
Key-Oberg, Ellen Burke (b. 1905; New York City); 11(1946) through 18(1954), 20(1958); note 1.
Key-Oberg, Rolf (New York City); 11(1946) through 17(1952), 20(1958).
Kilburn, Theola (Alfred, N.Y.); 3(1934).
Kim, Ernie (San Francisco, Calif.); 21(1960); note 7.
King, Albert Henry (b. 1900; Los Angeles, Calif.); 9(1940) through 12(1947: Lotus and Acanthus Porcelains), 16(1951), 17(1952), 18(1954), 20(1958); note 3.
King, Louisa A. Etcheverry (1910-1956); 10(1941) through 12(1947: Lotus and Acanthus Porcelains); note 3.
King, Robert J. (Alfred, N.Y.); 13(1948).
Kinnon, Ella Mae; Quaker Road Pottery, ref. see entry for Swift, Winifred.
Kinzie, G. Robert (El Segundo, Calif.); 21(1960).
Kirby, Earlleen (New York City); 9(1940).
Kirchmer, Paul (Bloomfield Hills, Mich.); 12(1947).
Kitchen, Annie Louise (Toledo, Ohio); 3(1934).
Kite, Annette Morris (Glendale, Ohio); 13(1948).
Kizer, Charlotte (Lincoln, Neb.); 5(1935).
Klassen, John P. (Bluffton, Ohio); 8(1939), 9(1940).
Klein, Jeanette (Kansas City, Mo.); 9(1940).
Kline, Robert C. (Bloomfield Hills, Mich.); 18(1954).
Kline, Svea Lindberg (Bloomfield Hills, Mich.); 11(1946), 13(1948) through 15(1950), 17(1953).
Klym, Jean I. (Syracuse, N.Y.); 21(1960).
Knapp, Sarah (Cazenovia, N.Y.); 10(1941).
Koch, Berthe Couch (b. 1899; Daytona Beach, Fla); 10(1941); note 1.
Koch, Martha D. (New York City); 13(1948).
Koch, Merle Robert (b. 1888; Daytona Beach, Fla.); 10(1941); note 1.
Koch, Rae (New York City); 9(1940), 10(1941).
Koechlin, Raymond (Inglewood, Calif.); 17(1952), 18(1954: Arkayo Ceramics).
Koelsch, Randolph Philip (Milwaukee, Wisc.); 15(1950), 17(1952).
Koepnick, Robert C. (b. 1907; Dayton, Ohio); 6(1937); note 1.
Kolodziej, Irene, see Musick, Irene K.
Konraty, Lola (Rochester, N.Y.); 9(1940).
Konzal, Joseph (b. 1905; Brooklyn, N.Y.); 18(1954), 19(1956).
Korpell, Margaret (Rochester, N.Y.); 21(1960).
Kottler, Howard William (b. 1930; Cleveland, Ohio); 19(1956), 21(1960).
Krebs, Rose (New York City); 14(1949) through 16(1951); 20(1958).
Kreis, Henry (Essex, Conn.); 8(1939), 9(1940), 11(1946) through 14(1949), 16(1951).
Kretschmer, Eva H. (Rochester, N.Y.); 12(1947), 14(1949), 16(1951), 17(1952).
Kretschmer, Wesley M. (Rochester, N.Y.); 14(1949).
Kring, Harry C. (Bloomfield Hills, Mich.); 15(1950).
Kring, Mary C., see Risley, Mary Kring.
Kring, Mary Colbert (New York City); 16(1951) through 19(1956).
Kring, Walter Donald (New York City); 16(1951) through 20(1958).
Krippendorf, Carl (Milwaukee, Wisc.); 17(1952), 18(1954).
Kruger, Helen Elizabeth (Floral Park, N.Y.); 6(1937), 7(1938), 10(1941).
Krutza, June (Charleston, Ill.); 17(1952), 19(1956).
Kubinyi, Kalman (Lakewood, Ohio); 11(1946), 13(1948), 14(1949).
Kudrna, Ethel, see Lewis, Ethel Kudrna.
Kulasiewicz, Frank L. (Milwaukee, Wisc.); 19(1956), 21(1960).
Kundman, Gertrude (Milwaukee, Wisc.); 6(1937), 7(1938).
Kunstadter, Sally Lennington (Princeton, N.J.); 21(1960).
Kusudo, Hoshiko (Los Angeles, Calif.); note 4.
Kwong, Hui Ka, see Hui, Ka-Kwong.

Labarre, Gertrude (San Jose, Calif.); 15(1950).
Lacy, Mattie Lee (Denton, Texas); 6(1937).
Ladd, Barbara C. (Cambridge, Mass.); 16(1951).
Laing, Rosemund Miller (Alameda, Calif.); 11(1946).
Lair, Jacklyn F. (Boston, Mass.); 17(1952).
Laird, E. Ruth (b. 1921; Houston, Texas); 16(1951) through 21(1960).
Lakofsky, Charles (b. 1922; Bowling Green, Ohio); 11(1946) through 21(1960); note 7.
LaMotte, Lois (Washington, D.C.); 10(1941).
Lamson, Jean Atherton, see Hebbeln, Jean Lamson.
Lancaster, Catherine (Douglaston, N.Y.); 2(1933).
Landawer, Julia (New York City); 9(1940).

Landis, Esther, J. (Chicago, Ill.); 19(1956), 20(1958).
Landis, Mildred (Beverly, N.J.); 3(1934), 4(1935), 10(1941).
Landolf, Richard L. (Chicago, Ill.); 19(1956).
Lappan, Charles A., Jr. (New Britain, Conn.); 9(1940).
Larkin, Donald F. (Rockland, Mass.); 19(1956).
Larson, Rosemary Ball (Corona del Mar, Calif.); 14(1949).
Larsson, Marta (Cleveland, Ohio); 11(1946).
Lasky, Hal (Santurce, Puerto Rico); 12(1947), 13(1948).
Lau, Florence (Honolulu, Hawaii); 19(1956), 20(1958).
Laughlin, David W. (Park Ridge, Ill.); 21(1960).
Lauritzen, Frederick L. (Carbondale, Ill.); 17(1952).
Lauritzen, Martha Middleton (Carbondale, Ill.); 11(1946) through 18(1954).
Lawrie, Doug (Claremont, Calif.); 21(1960).
Lawson, Gordon C. (Greenbelt, Md.); 18(1954).
Lawyer, Jean (Los Angeles, Calif.); 4(1935), 5(1936).
Lax, Michael (Charleston, W. Va.); 16(1951).
Leach, Georgia B. (Denton, Texas); 16(1951), 19(1956).
Leach, Richard B. (Albion, Mich.); 21(1960).
Leber, Roberta (Blauvelt, N.Y.); 5(1936), 7(1938), 9(1940) through 11(1946), 20(1958); note 1.
Lee, Aile (Las Vegas, N.M.); note 4.
Lee, Frank (New York City); 11(1946), 12(1947).
Lee, Lorraine (La Jolla, Calif.); note 6.
Leitch, Nancy V. (Pittsburgh, Penn.); 11(1946) through 13(1948).
Lent, Jack F. (Long Beach, Calif.); 21(1960).
Letcher, Henry Maxwell (Washington, D.C.); 6(1937).
Levin, Willy (New York City); 2(1933), 3(1934).
Lewis, Ethel Kudrna (Ann Arbor, Mich.); 16(1951), 21(1960).
Lewis, William A. (Ann Arbor, Mich.); 16(1951).
Lichtenstein, Carl W. (Chicago, Ill.); 15(1950).
Lichtenstein, Roy (b. 1923; New York City); notes 1, 2.
Lichtig, Lea M. (Cleveland, Ohio); 6(1937).
Lichtman, Shirley H. (Washington, D.C.); 15(1950).
Liebowitz, Virginia Brand (New York City); 3(1934), 9(1940).
Lienau, Henry E. (Oakland, Calif.); 15(1950), 16(1951).
Lietzke, Luke (b. 1909) & Rolland (b. 1909) (Mogadore, Ohio); 14(1949) through 17(1952), 20(1958).
Lifshey, Sonya D. (New York City); 11(1946).
Light, Lewis A. (Morris, N.Y.); 2(1933).
Lin, Henry H. (Athens, Ohio); 19(1956), 21(1960).
Lincoln, Richard M. (Fort Worth, Texas); 19(1956) through 21(1960).
Linde, Virginia L. (Menlo Park, Calif.); 21(1960).
Lindeheim, Mary Tuthill (Sausalito, Calif.); 12(1947) through 15(1950), 17(1952), 19(1956).
Lipman-Wulf, Peter (New York City); 13(1948), 14(1949), 19(1956), 20(1958); note 1.
Littlefield, Edgar (Columbus, Ohio); 2(1933) through 10(1941), 16(1951), 17(1952).
Littlejohn, Vicki (Pacific Palisades, Calif.); 21(1960).
Littleton, Harvey Kline (b. 1922; Verona, Wisc.); 16(1951) through 21(1960); notes 1, 7, 8.
Lockhart, William (Southern Pines, N.C.); 21(1960).
Loloma, Charles (Second Mesa, Ariz.); 13(1948), 14(1949).
Long, Wayne (Los Angeles, Calif.); 12(1947) through 15(1950), 17(1952), 18(1954), 20(1958).
Longenecker, Martha (La Mesa, Calif.); 11(1946); notes 4, 6, 7.
Longley, Laurance J. (Syracuse, N.Y.), 19(1956), 21(1960).
Looker, Dorothy (Washington, D.C.); 11(1946), 13(1948).
Lopez, Rhoda LeBlanc (b. 1912) & Carlos (La Jolla, Calif.); 14(1949), 15(1950), 16(1951); notes 1, 4.
Loree, John P. (Hornell, N.Y.); 21(1960)
Loring, Marg (b. 1905; San Diego, Calif.); 15(1950); notes 1, 3, 4.
Lou, Nils (Ann Arbor, Mich.); 21 (1960).
Lovera, James (b. 1920; San Jose, Calif.); 11(1946) through 14(1949), 17(1952), 18(1954), 20(1958), 21(1960); note 3.
Lukens, Glen (1887-1967); 4(1935) through 10(1941); notes 2, 3.
Lupori, Peter (St. Paul, Minn.); 16(1951).
Luse, Grace (Cleveland, Ohio); 7(1938) through 10(1941).
Lynn, Myra (Evanston, Ill.); 13(1948).
Lyons, Jerome Allen (Washington, D.C.); 14(1949), 15(1950), 17(1952).

McBride, Virginia Ailene (Berkeley, Calif.); 9(1940).
McCall, Martha Anton (Boston, Mass.); 14(1949).
McClain, Malcolm (b. 1933; Los Angeles); 19(1956); notes 2, 7.
McClatchey, Janka (Ann Arbor, Mich.); 21(1960).
McCloud, Virginia (Richmond Heights, Mo.); 14(1949).
McClure, Thomas F. (b. 1920; Ann Arbor, Mich.); 11(1946) through 17(1952), 20(1958); note 1.
McCrone, Elizabeth (San Francisco, Calif.); 11(1946), 13(1948) through 16(1951), 18(1954).
McCullough, George & Joyce (Tucson, Ariz.); note 4.
McCutchen, Earl Steuart (b. 1918; Athens, Georgia); 10(1941) through 13(1948), 15(1950) through 21(1960).

DIRECTORY

McDermott, Bernard (Akron, Ohio); 9(1940), 11(1946), 14(1949).

McDougal, Bruce (Des Moines, Iowa); 21(1960).

McDowell, John H. (Oakland, Calif.); 16(1951) through 20(1958); note 7.

McDowell, Phyllis (Pasadena, Calif.); 14(1949).

McFayden, Elizabeth C. (East Cleveland, Ohio); 15(1950), 17(1952 through 19(1956).

McGlauchlin, Tom (Madison, Wisc.); 21(1960).

McIntosh, Harrison E. (b. 1915; Claremont, Calif.); 11(1946) through 18(1954), 20(1958), 21(1960); notes 2, 3, 4, 7.

McKee, Charles (b. 1929; Oakland, Calif.); 21(1960).

McKee, Katherine (East Cleveland, Ohio); 12(1947), 13(1948).

McKinley, Ruth Gowdy (Wayland, N.Y.); 18(1954), 20(1958), 21(1960); note 7.

McKinnell, James F., Jr. (Deerfield, Mass.); 18(1954) through 2 1(1960); note 7.

McKinnell, Nan Bangs (Deerfield, Mass.); 18(1954) through 21(1960); note 7.

McLaughlin, M. Louise (Cincinnati, Ohio); 6(1937); see Losanti*.

McMillen, Dale (Cleveland Heights, Ohio); 6(1937).

McNellis, Francis (Fullerton, Calif.); note 6.

McVay, Harue Oyama (Honolulu, Hawaii); 14(1949) through 17(1952), 19(1956) through 21(1960); note 7.

McVay, Wade (Honolulu, Hawaii); 12(1947) through 16(1951).

McVeigh, Jane (Oakland, Calif.); 11(1946).

McVey, Leza S. (b. 1907; Cleveland, Ohio); 13(1948) through 21(1960); notes 1, 7.

McVey, William M. (b. 1905; Cleveland, Ohio); 14(1949) through 21(1960); note 1.

MacChesney, Caroline (San Rafael, Calif.); 16(1951).

Machlup, Mary (Belmont, Mass.); 14(1949).

Mackenzie, Alix (1922-1962); 21(1960); notes 2, 7.

Mackenzie, Warren (b. 1924; Stillwater, Minn.); 21(1960); notes 2, 7.

MacNab, Katherine T. (Milwaukee, Wisc.); 10(1941).

Madley, Elizabeth (S. Pasadena, Calif.); 17(1952).

Mahier, Lois (Baton Rouge, La.); 10(1941) through 12(1947), 15(1950).

Malcolm, Bonnie Jean (San Francisco, Calif.); 9(1940), 10(1941).

Mallette, Fredrika (St. Petersburg, Fla.); 9(1940).

Manbeck, Dorathee G. (Cleveland, Ohio); 15(1950), 17(1952), 19(1956), 21(1960).

Manes, Nancy C., see Plum, Nancy Manes.

Mango, Rocco (Hicksville, N.Y.); 21(1960).

Manker, William (b. 1902; Claremont, Calif.); 7(1938) through 12(1948); note 3.

Mankowski, Bruno (New York City); 14(1949), 15(1950), 20(1958); note 1.

Mann, Frank C. (Shelburne, Vermont); 13(1948), 14(1949), 17(1952), 21(1960).

Manning, Rosalie (New York City); 7(1938).

Mansfield, Barbara Wesley (Ypsilanti, Mich.); 21(1960).

Marable, Robert S. (Bishop, Georgia); 19(1956).

Marggraf, Zella Eckels (Los Angeles, Calif.); 15(1950), 17(1952), 18(1954).

Margolis, Ruth (Dayton, Ohio); 9(1940).

Marks, Lois Hall (San Fernando, Calif..); 12(1947), 15(1950).

Marks, Roberta B. (b. 1936); note 2.

Marley, Henry E. (Cincinnati, Ohio); 7(1938), 9(1940).

Marquis, John (Baltimore, Md.); 8(1939), 13(1948).

Martin, Hazel Small (Los Angeles, Calif.); 7(1938) through 11(1946), 13(1948).

Martin, Jerry (Claremont, Calif.); 21(1960).

Martin, Marvin B. (Champaign, Ill.); 13(1948).

Martinek, Joseph (Culver City, Calif.); 18(1954).

Martinez, Marie (b. 1884; Santa Fe, N.M.); 2(1933), 3(1934), 5(1936); note 2.

Martinie, Clara B. (Palo Alto, Calif.); 10(1941), 11(1946).

Martz, Jane Marshall (Veedersburg, Ind.); 18(1954).

Martz, Karl (Bloomington, Ind.); 5(1936) thorugh 10(1941), 12(1947), 16(1951) through 18(1954), 20(1958).

Marxhausen, Reinhold P. (Seward, Neb.); 21(1960).

Mason, Bertha (Larchmont, N.Y.); 19(1956).

Mason, John (b. 1927; Los Angeles, Calif.); 19(1956), 21(1960); notes 1, 2, 7, 8.

Mason, Rex (San Francisco, Calif.); 11(1946) through 14(1949), 17(1952), 18(1954), 20(1958), 21(1960).

Mathes, Robert Lewis (Columbus, Ohio); 8(1939), 10(1941).

Mathews, John M. (Emporia, Kans.); note 7.

Matters, Robert L. (Madison, Wisc.); 18(1954).

Matterson, Duane (Monterey, Calif.); 12(1947), 14(1949), 15(1950), 17(1952).

Mattson, Julia (Grand Forks, N.D.); 3(1934).

Maus, Rosalie (Rye, N.Y.); 13(1948).

Mavros, Donald Odysseus (b. 1927; New York City); 15(1950) through 17(1952), 20(1958).

Maxcy, Mabel C. (Denton, Texas); 9(1940), 10(1941), 12(1947).

Maxwell, Robert (Santa Monica, Calif.); note 6.

May, Juanita (Miami, Fla.); 21(1960).

May, Nancy (Santa Barbara, Calif.); 11(1946), 12(1947).

Mealey, Francis (Kansas City, Mo.); 9(1940).

Meeker, Dean Jackson (b. 1920; Madison, Wisc.); 16(1951); note 1.

Meinhardt, Robert H. (Sturbridge, Mass.); 16(1951), 18(1954), 19(1956).

Meisel, Alan Rice (Berkeley, Calif.); 19(1956); note 4.
Melchert, James (b. 1930); note 2.
Mendez, Louis E. (b. 1929; Goshen, N.Y.); 17(1952), 19(1956) through 21(1960).
Merriam, Alice F. (New York City); 2(1933: Inwood Pottery Studios).
Merrick, Gladys Deming (Glendale, Calif.); 10(1941), 12(1947).
Merris, Herbert A. (Whittier, Calif.); 11(1946).
Merten, Jack (Cincinnati, Ohio); 8(1939).
Mesmer, Elizabeth Anne (Grand Island, N.Y.); 17(1952) through 19 (1956).
Mestrovic, Ivan (Syracuse, N.Y.); 12(1947).
Meyer, Charles E. (Ann Arbor, Mich.); 19(1956).
Meyer, E. Lois (Penland, N.C.); 15(1960).
Meyer, Joan S. Frantz (Alfred, N.Y.); 13(1948), 14(1949).
Meyers, Marjo (East Lake, Ohio); 21(1960).
Micalizzi, Dave (Brooklyn, N.Y.); 14(1949).
Middleton, Martha R., see Lauritzen, Martha Middleton.
Mideke, Louis (Bellingham, Wash.); 19(1956).
Miller, Carol Hagaman (Ardmore, Penn.); 9(1940), 10(1941).
Miller, Christine Jane (Berea, Ky.); 12(1947), 13(1948), 15(1950).
Miller, Eliza (Gibsonia,, Penn.); 11(1946), 12(1947).
Miller, Ethel M. (Pittsburgh, Penn.); 7(1938), 10(1941).
Miller H. Garver (Chester, W. Va.); 9(1940), 10(1941).
Miller, Lois Ober (Chester, W. Va.); 9(1940).
Miller, Margaret N. (Columbus, Ohio); 9(1940).
Millis, Charlotte (Chicago, Ill.); 14(1949).
Mills, L. Sturdevant (Kansas City, Mo.); 9(1940).
Mills, Wesley Arnold (Pittsburgh, Penn.); 7(1938), 9(1940), 10(1941), 12(1947), 19(1956).
Mitchell, Eve V. (Berkeley, Calif.); 15(1950), 16(1951), 17(1952).
Mitchell, Helen (Oakland, Calif.); 12(1947), 17(1952), 18(1954); note 7.
Mitchell, Marguerite Eardley (Kansas City, Mo.); 11(1946).
Mitchell, Rose (Cleveland, Ohio); 16(1951).
Moburg, Leon F. (Topeka, Kans.); 19(1956); note 7.
Mohr, Olga (Tuscaloosa, Ala.); 16(1951).
Montgomery, Margaret J. (San Dimas, Calif.); 18(1954).
Montiverdi, M. (New York City); 7(1938: Greenwich House Pottery).
Montoya, Maximiliana (Santa Fe, N.M.); 3(1934).
Moodey, Jean Riddell (Cleveland, Ohio); 8(1939) through 13(1948).
Moore, Bill (Los Angeles, Calif.); 12(1947), 13(1948).
Moore, Gates (Norwalk, Conn.); 7(1938: Silvermine Pottery).
Moore, Helen Arnold (Grand Rapids,, Mich.); 15(1950).
Moore, Helen L. (Los Angeles, Calif.); 6(1937).
Moore, Hugh (Cleveland, Ohio); 21(1960).
Moore, Lorna H. (Fayetteville, N.Y.); 19(1956).
Moore, Patricia (Bronxville, N.Y.); 13(1948), 14(1949).
Morgan, Helen Bosart (b. 1902; Springfield, Ohio); 13(1948); note 1.
Morris, Dorothy Carol (Chicago, Ill.); 21(1960).
Morrison, Karl Raymond (Elsinore, Calif.); 12(1947).
Morton, Gustel S. (Cambridge, Mass.); 15(1950).
Moselsio, Herta (Bennington, Vermont); 6(1937), 10(1941).
Mosgo, Charles Francis (Cleveland Heights, Ohio); 6(1937) through 12(1947), 14(1949) through 17(1952), 19(1956).
Mossom, Patty (San Antonio, Texas); 15(1950), 16(1951).
Moule, Marian C. (Arcadia, Calif.); note 6.
Mount, Josephine R. (San Francisco, Calif.); 13(1948), 14(1949).
Mowry, LaVerne R. (Iowa City, Iowa); 11(1946) through 14(1949).
Mullavey, Dean Maxfield (Concord, N.H.); 16(1951), 18(1954).
Mundy, Ethel (Syracuse, N.Y.); 10(1941).
Munger, Anne Wells (Worcester, Mass.); ref: U.G. Dietz, *The Newark Museum Collection of American Art Pottery* (Newark, 1984), p. 81).
Munns, Helen C. (Syracuse, N.Y.); 2(1933).
Murphy, Robert J. (Oakland, Calif.); 15(1950) through 17(1952).
Murray, Marion (San Francisco, Calif.); 11(1946), 12(1947).
Musick, Irene Kolodziej (Colorado Springs, Colo.); 12(1947), 13(1948), 15(1950), 19(1956), 20(1958).
Myers, Alice Clark (Santa Fe, N.M.); 12(1947).
Myers, Harold W., Jr. (Seattle, Wash.); 21(1960); note 7.

Nadelman, Elie (1882-1946); note 2.
Nagle, Ron (b. 1939; Oakland, Calif.); note 2.
Nakian, Reuben (b. 1897; note 2.
Nash, Harold Siegrist (b. 1894; Cincinnati, Ohio); 8(1939) through 11(1946), 13(1948), 14(1949), 19(1956); note 1.
Nash, Simon, Jr. (Las Vegas, N.M.); 11(1947), 15(1950).
Natko, Jo. (Charon, Ohio); 12(1947) through 15(1950), 20(1958).

DIRECTORY

Natko, Michael (Chardon, Ohio); 13(1948) through 15(1950), 20(1958).

Natzler, Gertrude (1908-1971) & Otto (b. 1908; Los Angeles, Calif); 8(1939) through 14(1949), 16(1951), 18(1954) through 21(1960); notes 1, 2, 3, 7, 8.

Natzler, Nelly (Los Angeles, Calif.); 9(1940).

Naumberg, Ruth (Croton-on-Hudson, N.Y.); 3(1934).

Neff, Jane E., see Trucksis, Jane Neff.

Neff, Vera Odeyne (Cleveland, Ohio); 3(1934), 5(1936), 6(1937).

Negoro, Minnie (Mystic, Conn.); 11(1946) through 15(1950), 20(1958), 21(1960); note 7.

Nelsen, Paul E. (Seattle, Wash.); 21(1960).

Nelson, Clara K. (Alfred, N.Y.); 9(1940).

Nelson, Dorothy, see Daub, Dorothy Nelson.

Nelson, Glenn C. (Iowa City, Iowa); 17(1952).

Nelson, Janetta L. (Port Orchard, Wash.); 21(1960).

Neri, Emanuel J. (Helena, Mont.); 17(1952).

Nestler, Mabel Ballou (S. Norwalk, Conn.); 4(1935).

Netherby, Elena Montalvo (Oakland, Calif.); 12(1947) through 21(1960); notes 3, 7.

Neumann, William A. (Dallas, Texas); 14(1949) through 16(1951).

Nevelson, Louise (b. 1900; New York City); notes 1, 2.

Neville, Blanche (Cleveland, Ohio), 10(1941).

Newell, Carol Howe (Syracuse, N.Y.); 3(1934), 4(1935).

Newhall, Sally Ann (Framingham Centre, Mass.); 14(1949).

Newkirk, Betty (San Diego, Calif.); note 6.

Newsome, Evelyn M. (b. 1908; Rochester, N.Y.); 13(1948), 15(1950) through 17(1953), 19(1956) through 21(1960).

Ng, Win (b. 1936; San Francisco, Calif.); 21(1960); notes 2, 7.

Nicholson, Donna L. (b. 1938; Edinboro, Penn.); note 2.

Nicholson, Leona Fischer (1875-1976); ref: J. Poesch, *Newcomb Pottery* (Pennsylvania, 1984), p. 103.

Nickerson, Carol M. (Winchester, Mass.); 5(1936: Clay Craft Studio).

Nicodemus, Chester R. (Columbus, Ohio); 2(1933) through 7(1938), 9(1940) through 16(1951), 18(1954) through 20(1958).

Nicolas, Suzanne (Islip, N.Y.); 13(1948).

Niedelman, Hilda F. (New York City); 15(1950).

Nisbet, Jacquetta (New York City); 18(1954).

Noguchi, Isamu (b. 1904; Long Island City, N.Y.); notes 1, 2.

Nojima, Minoru (Berkeley, Calif.); 21(1960).

Norstad, Eric (Eugene, Ore.); 18(1954).

Norstad, Eloise, see Harmon, Eloise N.

Norstad, Lillian (Yucaipa, Calif.); 9(1940), 13(1948).

Norstad, Mrs. Magnus (Yucaipa, Calif.); 6(1937), 9(1940), 13(1948).

Nura (New York City); 7(1938), 9(1940), 11(1946).

Nutt, Lucille C. (Seattle, Wash.); 17(1952), 19(1956); note 7.

O'Brien, Helen (Arlington, Va.); 16(1951).

O'Brien, Rose M. (Grand Rapids, Mich.); 11(1946), 12(1947), 14(1949).

Ober, Mary Veronka (Alfred, N.Y.), 6(1937), 7(1938).

O'Burke, Ruby Baird (b. 1893; San Francisco); 11(1946) through 18(1954); note 3.

Odell, Frances R. (Lake Forest, Ill.); 7(1938), 8(1939: Crabtree Kiln).

Odell, Gine (Lake Forest, Ill.); 9(1940), 11(1946).

Odorfer, Adolf (b. 1902; Fresno, Calif.); 6(1937) through 17(1952), 20(1958); notes 1, 3.

Odorfer, Ella M. (Fresno, Calif.); 10(1941).

O'Hara, Dorothea Warren (1875-1963; Appletree Lane Pottery); 2(1933), 4(1935) through 10(1941); notes 1, 2.

Oikawa, T. Teri (San Francisco, Calif.); 21 (1960).

Okamoto, Henry (Acampo, Calif.); 15(1950).

Oldden, Steever B. (Seattle, Wash.); 6(1937).

Olds, Donald L. (Downers Grove, Ill.); 13(1948).

Openhym, George J. (Hartsdale, N.Y.); 2(1933), 3(1934).

Ordway, Priscilla (Newton Center, Mass.); 6(1937).

Orear, Elizabeth Laursen (Detroit, Mich.); 18(1954).

Orear, Gordon (Birmingham, Mich.); 18(1954); 19(1956).

Oshier, Edward R. (Lakewood Colo.); 16(1951) through 18(1954).

Osmond, Murray (Columbus, Ohio); 16(1951).

Ott, Peter Paul (Evanston, Ill.); 9(1940).

Otten, Mizi (New York City); 8(1939) through 10(1941), 13(1948).

Overbeck, Elizabeth G. & Mary F. (Cambridge City, Ind.); 3(1934); see entry in text.

Overman, Frederick R. (Detroit, Mich.); 12(1947).

Oyama, Harue, see McVay, Harue Oyama.

Paak, Carl E. (Albuquerque, N.M.); 21(1960); note 4.

Pacelli, William G. (New Haven, Conn.); 11(1946).

Pachl, Marg[ar]et (Grand Forks, N.D.); 12(1947), 17(1952), 18(1954).

Paddock, Laura S. (Blue Hill, Maine); 9(1940), 10(1941); Rowantrees Kiln (ref: *The Bulletin* of The American Ceramic Society, XXIV (February 15, 1943), pp. 43-46.

Pahle, William Robert (San Jose, Calif.); 13(1948).

Pain, Louise Carolyn (Chicago, Ill.); 10(1941).

Palmer, Richard (Atlanta, Georgia); 21(1960).

Palmer, Richard Terrell (Bloomington, Ind.); 16(1951).

Pancoast, Kay (Miami Beach, Fla.); 19(1956).

Paradis, Harry J. (South Bend, Ind.); 19(1956), 21(1960).

Parker, Glidden (d. 1980); 7(1938), 8(1939), 10(1941), 12(1947), 14(1949), 16(1951), 17(1952); Glidden Pottery (ref: Derwich & Latos, *Dictionary Guide*, pp. 101-02); note 4.

Parker, Mary Gertrude (Clarke Summit, Penn.); 10(1941).

Parker, Thomas (Wheeling, W. Va.); 5(1936).

Parmelee, Mathilde, see Sewall, Mathilde Parmelee.

Parry, William Dowd (Bala-Cynwyd, Penn.); 12(1947), 21(1960).

Parshall, Jane (Akron, Ohio); 19(1956), 21(1960); note 7.

Paskey, Marianne (Youngstown, Ohio); 21(1960).

Pastre, J. Phil (Elsinore, Calif.); 14(1949).

Pathe, Paquerette (Los Angeles, Calif.); 17(1948).

Patterson, Clare B. (Alfred, N.Y.); 13(1948).

Patterson, John W. (Sante Fe, N.M.); note 4.

Patterson, Nancy Jack (Los Angeles, Calif.); 16(1951) through 18 (1954: Lotus and Acanthus Porcelains).

Payne, Katharine Q. (Harrisburg, Penn.); 5(1936), 7(1938).

Peabody, Amelia (b. 1890; Boston, Mass.); 12(1947); note 1.

Peabody, Kenneth E. (Bloomfield Hills, Mich.); 12(1947).

Pearson, Joan Jockwig (San Francisco, Calif.); 13(1948), 14(1949), 16(1951), 18(1954), 20(1958); note 7.

Pearson, Lora B. (Alfred, N.Y.); 14(1949).

Peck, Glenna (Syracuse, N.Y.); 3(1934).

Pena, Juanita (Pueblo, N.M.); 2(1933).

Peotter, Ralph E., Jr. (Ann Arbor, Mich); 19(1956).

Pereny, Andrew (Columbus, Ohio); 2(1933) through 5(1936).

Perkins, Dorothy W. (Providence, R.I.); 14(1949), 17(1952), 21(1960).

Perkins, Lyle N. (Providence, R.I.); 8(1939), 12(1947), 13(1948), 17(1952), 21(1960).

Persick, William Thomas (Columbus, Ohio); 19(1956).

Petersham, Miska F. (b. 1923; Missoula, Mont.); 14(1949) through 20(1958).

Peterson, Susan (S. Pasadena, Calif.); notes 4, 6.

Petrencs, Jules A. (Pittsburgh, Penn.); 14(1949) through 17(1952), 20(1958), 21(1960).

Petrencs, Regina Fisher (Pittsburgh, Penn.); 21(1960).

Petrik, Isabelle R. (Union, N.J.); 19(1956).

Petrovitz, Andrew (Newark N.J.); 10(1941).

Pettee, Janice (Burbank, Calif.); 14(1949).

Pettee, Paul (Burbank, Calif.); 14(1949).

Petterson, Alice A. (Altadena, Calif.); 11(1946).

Petterson, Richard B. (b. 1911; Claremont, Calif.); 12(1947) through 15(1950); note 3.

Phelan, Linn Lovejoy (b. 1906; Almond, N.Y.); 2(1933) through 5(1936), 10(1941), 12(1947) through 15(1950), 19(1956), 20(1958); Lin[n]wood Pottery (ref: A.H. Eaton, *Handicrafts of New England* (New York, 1949), p. 157); note 1.

Phelps, Elizabeth (Flint, Mich.); 18(1954).

Phillips, Helen Clark (New York City); 4(1935) through 11(1946).

Phillips, Sara J. (Tully, N.Y.); 2(1933), 3(1934).

Phillips, Winifred Estelle (Wauwatosa, Wisc.); 2(1933) through 4(1935), 7(1938), through 14(1949), 16(1951), 17(1952), 20(1958).

Pichotta, Jean M. (Madison, Wisc.); 18(1954).

Pickens, Alexander L. (Athens, Georgia); 17(1952), 19(1956), 21(1960).

Pierce, Arthur Ray (Alameda, Calif.); 13(1948).

Pierce, C. Eleanor, see Cutler, Eleanor Pierce.

Pierce, Lillian (b. 1919; Detroit, Mich.); 12(1947) through 14(1949), 19(1956).

Pierce, Mona S. (Lubbock, Texas); 19(1956).

Pierson, Conway (b. 1927; Goleta, Calif.); notes 6, 8.

Pillin, Polia (b. 1909; Los Angeles, Calif.); 14(1949) through 21(1960); note 4.

Pirofsky, Elaine Friedwald (New York City); 17(1952), 18(1954).

Pitney, William E. (Birmingham, Mich.); 15(1950) thorugh 21(1960).

Plum, Nancy Manes (Dearborn, Mich.); 19(1956), 21(1960).

Polchert, Stephen Joseph (b. 1920; Ralston, Neb.); 14(1949) through 17(1952), 20(1958).

Pompili, Eleanor Frances (Fort Tilden, N.Y.); 16(1951), 19(1956).

Poor, Henry Varnum (1888-1970); 5(1936) through 13(1948), 18(1954), 20(1958); notes 1, 2, 7, 8.

Porter, Priscilla Manning (b. 1917; Washington, Conn.); 17(1952), 19(1956); note 1.

Portman, Frieda (Seattle, Wash.); 13(1948).

Porzio, Lee (Central City, Colo.); 13(1948).

Post, Marjorie Helen (Columbus, Ohio); 6(1937) through 8(1939).

Pots, Peter (Providence, R.I.); 14(1949); cf. entry for Greene, Elizabeth Boyd.

Poucher, Elizabeth M. (New York City); 2(1933: Inwood Pottery).

Pownall, Helen B. (Forest, Ohio); 6(1937) through 10(1941), 20(1958).

Powell, Naoma (Toledo, Ohio); 19(1956).

Prager, Samuel (Alfred, N.Y.); 13(1948).

Praznik, Joy Elaine (Parma, Ohio); 21(1960).
Price, Kenneth (b. 1935; Los Angeles, Calif.); 19(1956); notes 2, 8.
Price, Margaret (b. 1911; San Diego, Calif.); note 3.
Priebe, Allen J. (San Marcos, Texas); 13(1948).
Prieto, Antono Philip (1912-1967); 11(1946) through 20(1958); notes 3, 7.
Prieto, Eunice (Oakland, Calif.); 11(1946); note 7.
Prins, J. Warner (New York City); 13(1948).
Pruitt, Vernise Irene (Grand Rapids, Mich.); 5(1936), 7(1938).
Pulos, Arthur John (Urbana, Ill.); 9(1940), 10(1941), 12(1947).
Purkiss, Myrton (b. 1916; Fullerton, Calif.); 12(1947) through 17(1952); note 3.
Pursel, Lisle (Alexandria, Va.); 16(1951).
Purucker, David G. (Long Beach, Calif.); 21(1960).
Putney, Geórgie V.B. (New York City); 5(1936).
Pyndus, Natalie (Syracuse, N.Y.); 5(1936).

Rabner, Tina (New York City); 9(1940), 11(1946), 13(1948).
Radder, Mary (Alfred, N.Y.); 4(1935).
Raemisch, Ruth (Providence R.I.); 10(1941), 11(1946), 13(1948).
Raffo, Victor (Mount Vernon, N.Y.); 2(1933).
Ramsey, Robert Ward (Seal Beach, Calif.); 21(1960); note 6.
Randall, Ruth Hunie (b. 1896; Syracuse, N.Y.); 2(1933) through 13(1948), 15(1950) through 21(1960); notes 1, 8.
Randall, Theodore A. (b. 1914; Alfred, N.Y.); 15(1950) through 17 (1952), 20(1958), 21(1960); notes 1, 7.
Randazzo, Angelo (Elmira, N.Y.); 21(1960).
Ray, Betty (Murray, Ky.); 8(1939) through 10(1941).
Raynor, Louis Benjamin (b. 1917; E. Lansing, Mich.); 11(1946) through 14(1949), 16(1951) through 21(1960); notes 2, 7.
Reents, Hildred (San Gabriel, Calif.); 11(1946), 13(1948).
Rehm, Wilhelmine (1899-1967); 2(1933), 6(1937), 7(1938), 9(1940), 11(1946); note 5.
Reich, Jean Heyl (Cincinnati, Ohio); 8(1939) through 11(1946), 13(1948).
Reis, Helenrose (Cincinnati, Ohio); 11(1946)
Reitz, Donald L. (b. 1929; note 2.
Reitzell, Louise (Erie, Penn.); 10(1941).
Renzetti, Aurelius (Philadelphia, Penn.); 9(1940), 10(1941).
Reynolds, Eileen (1917-1977) and Rossi (San Francisco, Calif.); 11(1946) through 14(1949); note 3.
Reynolds, Elizabeth Rhoades (New York City); 7(1938).
Reynolds, Ernest C. (Seattle, Wash.); 14(1949).
Rhode-Hamel, Irene H. (San Francisco, Calif.); 14(1949), 16(1951), 17(1952), 19(1956); note 7.
Rhode-Hamel, Karl (San Francisco, Calif.); 14(1949), 16(1951), 18(1954).
Rhodes, Daniel (b. 1911; Alfred, N.Y.); 14(1949), 15(1950), 17(1952) through 19(1956); notes 2, 7, 8.
Rhodes, Hannah (Tappan, N.Y.); 10(1941).
Rhodes, Lillyan (Alfred, N.Y.); [18(1954)?], 19(1956), 20(1958).
Rice, Kathryn Clark (Cincinnati, Ohio); 4(1935).
Richards, Cecil Clarence (Austin, Texas); 12(1947), 13(1948).
Richards, Jeanne Herron (b. 1923; Alexandria, Va.); 15(1950); note 1.
Richardson, Florence Wood (Columbus, Ohio); 6(1937) through 8(1939).
Richardson, Harry S. (Cleveland, Ohio); 16(1951), 17(1952).
Richter, Aly (Boston, Mass.); 18(1954).
Richtmyer, Rene (Hornell, N.Y.); 9(1940).
Riegger, Harold Eaton (b. 1913; Mill Valley, Calif.); 4(1935) through 16(1951), 20(1958); notes 1, 2, 3, 7.
Riester, Dorothy W. (b. 1916; Syracuse, N.Y.); 18(1954) through 21(1960).
Righter, Sybil (Roxbury, Mass.); 6(1937).
Rinehart, Susan (San Francisco, Calif.); 16(1951).
Rippon, Ruth M. (b. 1927; Sacramento, Calif.); 16(1951), 18(1954) through 21(1960); notes 4, 8.
Risley, John H. (Middletown, Conn.); 13(1948), 18(1954), 20(1958); note 1.
Risley, Mary Kring (Middletown, Conn.); 14(1949), 16(1951), 17(1952), 18(1954).
Robbins, Dorothy Elaine (Cincinnati, Ohio); 13(1948), 15(1950).
Roberts, George (Ypsilanti, Mich.); 18(1954), 19(1956).
Robertson, Fred H. (Hollywood, Calif.); 6(1937; Robertson Pottery*.
Robertson, George B. (Hollywood, Calif.); 6(1937); Robertson Pottery*.
Robertson, J. Milton (Dedham, Mass.); cf. 6(1937); 7(1938); Dedham Pottery*.
Robinson, Maude (New York City); 9(1940): Greenwich House Pottery).
Robinson, Victor A.S. (Wilton, Conn.); 19(1956).
Rockwell, Robert E. (Columbus, Ohio); 14(1949).
Rogers, Janet Tran (Princeton, N.J.); 15(1950), 17(1952).
Rogers, Mary Lyell (Lakewood, Ohio); 19(1956).
Rollins, Henry (Seattle, Wash.); 21(1960).
Rolph, Mrs. Hosmer (Honolulu, Hawaii); 7(1938).
Ronnebeck, Arnold (Denver, Colo.); 3(1934).
Rood, Frank Woodworth (Cleveland, Ohio); 13(1948) through 20(1958).
Rood, Henry A. (Cleveland Heights, Ohio); 15(1950).
Rood, Nava W. (Cleveland Heights, Ohio); 14(1949).

Rosen, Leah R. (New York City); 14(1949), 15(1950).
Rosenbauer, Wallace (Kansas City, Mo.); 9(1940).
Rosenberg, Carl (Williamsburg, Va.); 12(1947).
Rosenberg, Yetta (Cleveland, Ohio); 4(1935) through 7(1938), 9(1940), 10(1941), 20(1958).
Ross, Frank (Carnegie, Penn.); 21(1960).
Ross, William E. (Des Moines, Iowa); 5(1936), 14(1949), 15(1950), 16(1951).
Rossbach, Ed. (Seattle, Wash.); 11(1946), 12(1947).
Rossi, David (Indianapolis, Ind.); 14(1949).
Rosti, Arpad (Brewster, N.Y.); 11(1946) through 13(1948), 16(1951) through 20(1958).
Roth, Rosalie H. (Elyria, Ohio); 18(1954).
Rothmaler, Ernita (Brooklyn, N.Y.); 9(1940), 15(1950).
Rothman, Jerry (b. 1933); note 2.
Rothstein, Irma (New York City); 11(1946) through 16(1951), 18(1954), 20(1958).
Rowand, Marian McMullen (New Canaan, Conn.); 6(1937).
Rowland, Donald A. (Alfred, N.Y.); 12(1947).
Rox, Henry (1899-1967); 13(1948) through 18(1954), 20(1958); note 1.
Roy, Mary (Cambridge, Mass.); 13(1948).
Roybal, Tonita (Sante Fe, N.M.); 2(1933), 3(1934), 5(1936).
Rubenstein, Bill (San Francisco, Calif.); 13(1948) through 15(1950).
Rubenstein, Leonard S. (Spencerport, N.Y.); 10(1941).
Rubenstein, Mary Fuller, see Fuller, Mary
Ruby, Charles (Ottsville, Penn.); 11(1946).
Ruiz, Jose (Chicago, Ill.); 2(1933: Hull House Kilns).
Ruocco, Ilse Hamann (La Mesa, Calif.); 7(1938), 11(1946).
Rushmore, Arthur W. (Madison, N.J.); Bottle Hill Pottery.
Russell, Margaret (Bedford, Ohio); 11(1946) through 15(1950).
Russin, Robert I. (b. 1914; Laramie, Wyo.); 11(1946), 14(1949); note 1.
Russum, Olin L., Jr. (Monkton, Md.); 13(1948), 14(1949), 16(1951), 18(1954) through 20(1958).
Rutter, John (Syracuse, N.Y.), 19(1956).
Rydell, Roy (Santa Cruz, Calif.); 13(1948).
Ryder, Thomas E. (Hershey, Penn.); 5(1936), 6(1937).

Saarinen, Lillian Swann (New York City); 9(1940) through 11(1946).
Sachs, Hannah (Chicago, Ill.); 12(1947).
Sacksteder, Aloys (Sandusky, Ohio); 5(1936) through 11(1946).
Safford, Harriet E. (Lakewood, Ohio); (1937).
Safranek, Frank (Cleveland, Ohio); 21(1960).
St. Gaudens, Annetta J. (Windsor, Vermont); 2(1933), 3(1934), 6(1937); see following reference.
St. Gaudens, Paul (1900-1954); 2(1933), 3(1934), 7(1938); Orchard Kiln Pottery, ref: C. Davis, *Spinning Wheel*, XXX (March 1974), pp. 54-56.
Sakamoto, Kane (Boulder, Colo.); 14(1949).
Salzer, Lisel (Seattle, Wash.); 11(1946) through 13(1948), 15(1950), 17(1952) through 21(1960).
Saltzman, William (Minneapolis, Minn.); 11(1946); note 1.
Samolar, Esther R. (Cleveland, Ohio); 9(1940).
Sanders, Herbert H. (San Jose, Calif.); 2(1933), 3(1934), 5(1936) through 12(1947), 14(1949), 15(1950), 17(1952), 19(1956) through 21(1960); notes 2, 3, 7.
Sanders, Morris B. (Los Angeles, Calif.); 9(1940: Gladding, McBean).
Sanford, O. Clark (Flint, Mich.); 19(1956).
Sardeson, Jean Lee (Erie, Penn.); 16(1951).
Sargous, Flora Wayne (Cleveland, Ohio); 11(1946).
Sawhill, Richard M. & Marion (Bedford, Ohio); 11(1946), 12(1947), 14(1949).
Scarlett, Pat (Palo Alto, Calif.); 19(1956).
Schalck, Sarah C. (New York City); 14(1949).
Schaumburg, Don (Claremont, Calif.); 15(1950).
Scheier, Edwin (b. 1910) & Mary (b. 1910) Durham, N.H.); 11(1940) through 21(1960); notes 1, 2, 7.
Scheller, Raymond (Rantoul, Ill.); 19(1956).
Scheller, Ruth (Rantoul, Ill.); 19(1956).
Schinnerl, Susi Singer, see Singer-Shinnerl, Susi.
Schlanger, Jeff (b. 1937); note 2.
Schlehr, Raymond (Cleveland, Ohio); 3(1934).
Schmeer, Stella F. (Syracuse, N.Y.); 3(1934).
Schmidt, James K. (Decatur, Ala.); 15(1950).
Schmitz, Carl Ludwig (b. 1900; New York City); 7(1938) through 16(1951), 20(1958); note 1.
Schnaidt, Margaret A. (Sioux Falls, S.D.); 14(1949) through 16(1951).
Schneider, Richard C. (Antigo, Wisc.); 19(1956).
Schmohl, Ruth C. (Cleveland Heights, Ohio); 11(1946).
Schoener, Jason (Utica, N.Y.); 15(1950), 16(1951).
Schreckengost, Don (E. Liverpool, Ohio); 8(1939) through 11(1946).
Schreckengost, Viktor (b. 1906; Cleveland, Ohio); 2(1933) through 19(1956); see Cowan Pottery*, also notes 2, 8.

Schrock, Ella (Bedford, Ohio); 14(1949).
Schulke, Harry Wyatt (Cleveland, Ohio); 11(1946), 12(1947), 14(1949).
Schwing, Lynn Miller (Greenville, Penn.); 14(1949).
Scott, Dorothy Moore (Coronado, Calif.); note 6.
Secrest, James D. (Canandaigua, N.Y.); 13(1948), 14(1949), 19(1956) through 21(1960).
Secrest, Philip J. (Canandaigua, N.Y.) 14(1949), 15(1950), 17(1952), 19(1956), 20(1958).
Sedestrom, Robert A. (Detroit, Mich.), 21 (1960).
Segal, Bernard (Philadelphia, Penn.); 11(1946), 15(1950).
Segal, Marguerite (Berkeley, Calif.); 13(1948), 14(1949).
Segal, Mayer (Berkeley, Calif.); 13(1948).
Seidman, Claire (New York City); 9(1940).
Sellers, Ezra L. (Athens, Georgia); 11(1946), 12(1947).
Sellors, Evaline C. (Fort Worth, Texas); 14(1949), 16(1951), 17(1952).
Selzer, Kayla (Beverly Hills, Calif.); notes 4, 6.
Sena, Carmine (Stockton, Calif.); 14(1949).
Senska, Frances (Bozeman, Mont.); 16(1951), 17(1952), 21(1960); note 7.
Serber, Frances (Philadelphia, Penn.); 3(1934), 5(1936), 8(1939) through 12(1947), 16(1951), 19(1956), 20(1958).
Sewall, Mathilde Parmelee (New Haven, Conn.); 6(1937), 9(1940).
Seyler, David Warren (b. 1917; Erlanger, Ky.); 7(1938) through 11 (1946); note 1, see Kenton Hills*.
Shafer, Calvin Manning (Angwin, Calif.); 14(1949).
Shagam, Helen Noel (Chicago, Ill.); 21(1960).
Shaner, David (b. 1941; Urbana, Ill.); 21(1960); note 2.
Shapiro, Lili (Boston, Mass.); 5(1936) through 7(1938).
Shattuck, Marjorie (Syracuse, N.Y.); 8(1939).
Shaw, Adrian (Scottsdale, Ariz.); note 4.
Shaw, George Eleanor (Worcester, Mass.); 9(1956).
Sheads, James C. (Indianapolis, Ind.); 15(1950).
Shearer, E.L. (New York City); 3(1934: Inwood Pottery).
Shedd, Agnes, J. (Columbus, Ohio); 5(1936).
Shedd, Marken S. (West Barrington, R.I.); 13(1948).
Sheffield, Thomas P. (Lincoln, Neb.); 19(1956).
Shellabarger, Anne (San Francisco, Calif.); 19(1956).
Shep, Larry (Sunset Beach, Calif.); 21(1960); ref: "Rose S. Shep" entry, Derwich & Latos, *Dictionary Guide*, pp. 209-10.
Sherman, Joseph (Albuquerque, N.M.); note 4.
Shirey, Esther M. (Los Angeles, Calif.); 11(1946), 12(1947).
Shirley, Alfaretta D. (Short Hills, N.J.); 9(1940).
Shoemaker, Charles W. (San Francisco, Calif.); 17(1952).
Shore, Robert (New York City); 19(1956).
Shores, Kenneth (Portland, Ore.); 21(1960).
Short, Emeline (San Francisco, Calif.); 11(1946).
Shrode, [Marejon] Sue (Santa Monica, Calif.); 15(1950) through 17(1952); note 6.
Siegfried, Don (San Francisco, Calif.); 13(1948) through 15(1950).
Siegl, Lillian Pierce (Mt. Vernon, N.Y.); 12(1947).
Sigmier, Robert A. (Broken Arrow, Okla.); 17(1952).
Sills, Esther Marshall (Redwood City, Calif.); 6(1937) through 8(1939), 10(1941), 15(1950), 17(1952); with John operated Skyline Pottery, Redwood City.
Sills, John (Redwood City, Calif.); 14(1949), 15(1950), 17(1952); see note previous entry.
Simches, Frances Goldsmith (Rensselaer, N.Y.); 14(1949), 16(1951), 19(1956).
Simmons, Alma H. (New Orleand, La.); 9(1940).
Simmons, Elizabeth, see Steever, Elizabeth Simmons.
Simms, Carroll H. (Bloomfield Hills, Mich.); 14(1949).
Simon, Margaret (New York City); 8(1939).
Simon, Rita Sargen (Chicago, Ill.); 15(1950), 16(1951).
Simons, Elvera Hustead (San Francisco, Calif.); 11(1946).
Singer, Helen (Syracuse, N.Y.); 15(1950).
Singer-Shinnerl, Susi (1895-1949); 10(1941) through 13 (1948), 16(1951).
Sinz, Walter A. (Cleveland Heights, Ohio); 17(1953).
Sliker, Marion Caps (E. Rochester, N.Y.); 11(1946), 12(1947).
Sloane, Phyllis Lester (Cleveland, Ohio); 16(1951), 17(1952).
Slusarski, Peter Adam (Dearborn, Mich.); 14(1949), 15(1950).
Small, Ruth Caroline (Milford, Mich.); 13(1948).
Smathers, Helen (Alfred, N.Y.); 2(1933).
Smillie, Grace C. (Essex Falls, N.J.); 7(1938), 9(1940).
Smith, Alice (Los Angeles, Calif.); 13(1948).
Smith, Anna M. (Allentown, Penn.); 19(1956).
Smith, Caroline (Berkeley, Calif.); 14(1949), 15(1950).
Smith, David (1906-1965); note 2.
Smith, Dido (Howlett, N.Y.); 16(1951).
Smith, Edna Weeks (Rochester, N.Y.); 12(1947).
Smith, Elizabeth MacLean (Boston, Mass.); 14(1949).
Smith, Etta Waddington (San Jose, Calif.); 10(1941), 11(1946), 14(1949), 15(1950).

Smith, Kenneth E. (Indianapolis, Ind.); 2(1933), 6(1937) through 10(1941), 20(1958); ref: J. Poesch, *Newcomb Pottery* (Pennsylvania, 1984), pp. 83-85.
Smith, Joan Hang (Redwood City, Calif.); 16(1951) through 18(1954), 20(1958).
Smith, Pat (Madison, Wisc.); 21(1960).
Smith, Paulina Janette (Indianapolis, Ind.); 15(1950).
Smith, Richard V. (Syracuse, N.Y.); 3(1934), 6(1937) through 9(1940), 11(1946) through 17(1952), 21(1960).
Smith, Thomas R. (Alfred, N.Y.), 21(1960).
Smith, Wilma (Alfred, N.Y.), 2(1933).
Snelgrove, I.P. (Grand Forks, N.D.); 3(1934).
Sobayashi, James (Los Angeles, Calif.); 13(1948).
Soderstrom, Shirley (Hollywood, Calif.); 5(1936) through 7(1938).
Soini, William (Brooklyn, N.Y.); 2(1933), 3(1934), 5(1936) through 12(1947), 15(1950) through 17(1952).
Soldate, Joe (Ontario, Calif.); note 4.
Soldner, Paul E. (b. 1921; Claremont, Calif.); 19(1956), 21(1960); notes 2, 4, 7.
Soles, William (East Hampton, N.Y.); 16(1951).
Solomon, Mitzi (New York City); 11(1946).
Sopher, Bernard (Hollywood, Calif.); 11(1946).
Sopo, Miguel (Syracuse, N.Y.); 11(1946), 12(1947).
Sorcha Boru Studio (San Carlos, Calif.); 4(1935) through 10(1941); ref: Derwich & Latos, *Dictionary Guide*, pp. 212-13; note 3.
Speelmon, C. Robert (Bellevue, Wash.); 16(1951), 21(1960).
Speelmon, Jeanne (Seattle, Wash.); 14(1949).
Spencer, Albert J. (St. Petersburg, Fla.); 17(1952), 20(1958), 21(1960).
Spencer, Lorene F. (Seattle, Wash.); 17(1952), 21(1960).
Spencer, Ralph E. (Seattle, Wash.); 21(1960).
Spencer, Sherlie Wheeler (Weston, Mass.); 15(1950).
Sperry, Alice DeK. (Fair Lawn, N.J.); 19(1956), 20(1958).
Sperry, Robert H. (Bothell, Wash.); 18(1954), 19(1956); note 7.
Springer, Franklin E., Jr. (Grand Rapids, Mich.); 19(1956).
Springweiler, Edwin (b. 1896; Wyandanch, N.Y.); 11(1946), 13(1948); note 1.
Stadnyk, Mary (Alfred, N.Y.); 6(1937).
Staehle, Henry C. (Rochester, N.Y.); 12(1947).
Staffel, Bonnie (Montpelier, Ohio); 17(1952).
Staffel, Rudolf (b. 1911; Philadelphia, Penn.); 7(1938), 9(1940), 15(1950), 17(1952) through 21(1960); note 2.
Stagg, Jessie A. (New York City); 3(1934).
Stangl, J.M. (Trenton, N.J.); 7(1938: Fulper Pottery*).
Starbird, Kenneth R. (Inkster, Mich.); 18(1954), 19(1956).
Stark, George K. (Buffalo, N.Y.); 17(1952) through 20(1958).
Steele, Juliette (San Francisco, Calif.); 12(1947).
Steele, Richard E. (Columbus, Ohio); 11(1946).
Steenrod, Margaret, see Fetzer, Margaret Steenrod.
Steever, Elizabeth Simmons (Chicago, Ill.); 7(1938) through 9(1940).
Steinzor, Benjamin (Tonawanda, N.Y.); 15(1950), 17(1952), 19(1956), 21(1960).
Steltzner, Richard M. (Piedmont, Calif.); 21(1960).
Stemmerman, Sophie K. (New York City); 2(1933: Inwood Pottery), 4(1935), 5(1936).
Stephen, Francis (McAllen, Texas); 17(1952).
Stephen, Walter B. (1875-1961); 4(1935), 9(1940); Pisgah Forest Pottery, note 8.
Stephenson, John H. (b. 1929; Ann Arbor, Mich.); note 2.
Stephenson, Suzanne G. (b. 1935; Ypsilanti, Mich.); note 2.
Stepner, Bacia R. (Urbana, Ill.); 13(1948), 14(1949).
Stevens, Marjorie (Liverpool, N.Y.); 3(1934).
Stevenson, Clyde L. (San Antonio, Texas); 16(1951).
Stevick, Richenda (b. 1903); note 3.
Stewart, Claire (b. 1906), see Sorcha Boru Studio.
Stewart, Claire (Georgia); 20(1958).
Stewart, Cliff (Los Angeles, Calif.); note 4.
Stewart, Frances (Atlanta, Georgia); 10(1941).
Stewart, Hannah H. (Houston, Texas); 18(1954), 19(1956).
Stewart, Jacqueline Carl (Los Angeles, Calif.); note 4.
Stewart, Jean, see Crotty, Jean Stewart.
Stierlin, Margaret (Chicago, Ill.); 10(1941), 13(1948) through 16(1951), 20(1958).
Stockton, Marion Brown (San Pedro, Calif.); 13(1948).
Stoller, Sahn (New York City); 9(1940).
Stone, Alice Balch (Jamaica Plains, N.Y.); 2(1933).
Strachan, Doris (Helena, Mont.); 17(1952).
Stratton, Alza (Erlanger, Ky.); 10(1941: Kenton Hills*).
Stratton, Mary Chase (Detroit, Mich.); 3(1934), 4(1935), 10(1941); Pewabic Pottery*.
Stratton, William B. (Detroit, Mich.); 4(1935); Pewabic Pottery*.
Straub, Elizabeth (New York City); 7(1938), 9(1940).
Strawn, Cecil G., Jr. (DeKalb, Ill.); 21(1960).
Strawn, H. Dean (Riverside, Calif.); 17(1952), 18(1954), 20(1958); note 6.
Streetman, Christine (Houston, Texas); 15(1950).

Stringer, Margaret (New York City); 7(1938), 9(1940).
Strong, Edgar H. (Geneva, N.Y.); 4(1935) through 6(1937), 11(1946).
Stueland, Maria K. (Wentworth, Wisc.); 14(1949).
Stump, Pamela (Birmingham, Mich.); 16(1951).
Sultz, Janice L. (Kansas City, Mo.); 21(1960).
Summers, James R. (Kansas City, Mo.); 12(1947).
Sumner, Frederick & Sarah (Springfield Center, N.Y.); 19(1956).
Sutton, Helen S. (Los Angeles, Calif.); 14(1949).
Swallow, William W. (Allentown, Penn.); 9(1940) through 17(1952), 19(1956), 20(1958).
Swart, Lois Marian (Carmichael, Calif.); 18(1954).
Swart, Margaret Beasom (Nashua, N.H.); 18(1954), 19(1956).
Swartz, Carrie Teale (Brooklyn, N.Y.); 3(1934), 6(1937).
Swarz, Sahl (New York City); 7(1938), 9(1940).
Sweet, Elliot (Bluehill, Maine); 7(1938: Rowantrees Kiln).
Sweyd, Janice R. (New York City); 19(1956).
Swift, Emily (Philadelphia, Penn.); 5(1936) through 7(1938).
Swift, Winifred; Quaker Road Pottery, ref. W.P. Jervis, "Women Potters of America", *The Pottery, Glass & Brass Salesman*, XVI (December 13, 1917), p.97.

Takaezu, Toshiko (b. 1922; Cleveland, Ohio); 14(1949), 17(1952) through 21(1960); notes 1, 7.
Takemoto, Henry (b. 1930; Los Angeles, Calif.); notes 1, 2, 6, 7.
Tamblyn, Joseph (Los Angeles, Calif.); 15(1950), 17(1952).
Tanner, Lou (Chicago, Ill.); 13(1948).
Taubes, Lili (New York City); 11(1946).
Tavelli, Louis W. (Williamstown, Mass.); 12(1947).
Taylor, Carrie Yoffe (Ann Arbor, Mich.); 15(1950), 16(1951).
Taylor, Joseph (Norman, Okla.); 3(1934: Frankoma Pottery); ref: Derwich & Latos, *Dictionary Guide*, p. 95.
Taylor, Julius (New York City); 18(1954), 19(1956).
Taylor, June Elizabeth (Westerville, Ohio); 13(1948) through 15(1950).
Taylor, Laura, see Hughes, Laura Taylor.
Taylor, Mildred (Charlotte, N.C.); 10(1941).
Taylor, Rosemary (Plainfield, N.J.); 19(1956); note 1.
Taylor, Sydney (New York City); 19(1956).
Tefft, Elden C. (Lawrence, Kans.); 14(1949).
Temple, Byron (Chicago, Ill.); 21(1960).
Tepping, Herbert (Dayton, Ohio); 9(1940) through 11(1946).
Terken, John R. (New York City); 14(1949).
Terr, Sam (New York City); 17(1952).
Terrill, Katie (Ashtabula, Ohio); 21(1960).
Tewanginema (Flagstaff, Ariz.); 5(1936).
Thalinger, Frederic Jean (Croton-on-Hudson, N.Y.); 6(1937), 13(1948).
Thielen, Louise (Sacramento, Calif.); 10(1941).
Thomas, Grace T. (Coronado, Calif.); 3(1934).
Thomas, Mary (Athens, Georgia); 16(1951), 17(1952).
Thompson, A. Russell (Goldsboro, N.C.); 17(1952).
Thompson, Harold W. (Riverside, Calif.); 9(1940), 10(1941).
Thompson, Tommy (San Francisco, Calif.); 12(1947: Allied Potters).
Thompson, W. Linwood (Pittsburgh, Penn.); 6(1937).
Thorngate, Lucille V. (Syracuse, N.Y.); 2(1933).
Thornton, James C. (Newark, Ohio); 5(1936), 6(1937).
Thurn, Haldon L. (Milwaukee, Wisc.); 11(1946), 12(1947).
Tilton, Charles & Floy (Tilton, N.H.); 14(1949), 15(1950).
Timiriasieff, Vivika, see Heino, Vivika Timiriasieff.
Tinoco, Hilarion (Chicago, Ill.); 2(1933: Hull House Kilns).
Tishler, Harold (New York City); 3(1934), 9(1940), 12(1947), 14(1949).
Tishler, Maynard (Plattsburgh, N.Y.); 21(1960).
Titze, Walter Karl (San Francisco, Calif.); 7(1938).
Todd, Priscilla (Bronxville, N.Y.); 15(1950).
Tolerton, David (b. 1907; Los Gatos, Calif.); note 3.
Tomsu, Jeanne W. (Grand Rapids, Mich.); 19(1956).
Topper, Vera (Chicago, Ill.); 10(1941).
Touster, Irwin (New York City); 15(1950), 16(1951).
Tracy, William T. (Sarasota, Fla.); 9(1940), 10(1941), 12(1947).
Train, Mary (Alfred, N.Y.); 3(1934).
Trapp, Frances E. (Boston, Mass.); 21(1960).
Trapp, Muriel (Benzonia, Mich.); 13(1948).
Travis, Betty Anne (Abilene, Texas); 16(1951).
Traynor, Edward H. (Pasadena, Calif.); notes 4, 6, 7.
Treadwell, Noni Eccles (Oakland, Calif.); 12(1947), 14(1949), 21(1960); note 7.
Trine, Robert (Hollywood, Calif.); 5(1936).

Trivigno, Helen M. (New Orleans, La); 19(1956).

Trucksis, Jane Neff (Columbus, Ohio); 8(1939), 15(1950).

Trujillo, Ruycita (Albuquerque, N.M.); 10(1941).

Turnbull, Gale (Sebring, Ohio); 3(1934).

Turner, Robert C. (b. 1913; Alfred Station, N.Y.); 12(1947) through 14(1949), 16(1951) through 21(1960); notes 1, 2, 7.

Turoff, Muriel P. (b. 1904; Riverdale, N.Y.); 11(1946); note 1.

Tury, Josef v. (Rockville Centre, N.Y.); 8(1939, with Karl Drerup).

Tuska, John R. (Murray, Ky.); 21(1960).

Tynys, Arvi (Brooklyn, N.Y.); 17(1952).

Tyson, John P. (Ypsilanti, Mich.); 21(1960).

Udden, Louise (Oakland, Calif.); 16(1951).

Ullman, Jane F. (Los Angeles, Calif.); 13(1948).

Ulrich, Herbert C. (Sandusky, Ohio); 11(1946).

Umlauf, Charles (b. 1911; Austin, Texas); 13(1948) through 15(1950), 20(1958); note 1.

Underwood, Wallace Albert (Matapoisett, Mass.); 13(1948).

Untracht, Oppi (Brooklyn, N.Y.); 18(1954).

Uyemura, Ken J. (Stamford, Conn.); 12(1947), 13(1948), 15(1950), 18(1954).

Vaidsnoras, Anthony (Cleveland, Ohio); 15(1950).

Vail, Carleton M. (Windham, N.Y.); 7(1938) through 9(1940).

Vail, Mary (White Plains, N.Y.); 9(1940).

VanAlstyne, Jayne (Bozeman, Mont.); 15(1950), 18(1954); note 7.

Vandenberge, Peter (b. 1935; Sacramento, Calif.); note 2.

VanHaren, John E. (Northville, Mich.); 19(1956).

VanHorne, Mary (Los Angeles, Calif.); 6(1937).

VanKleeck, Anne Gatewood (Berkeley, Calif.); 12(1947), 14(1949) through 21(1960).

VanLoon, Ruth (New York City); 7(1938), 9(1940).

Verenes, C. Rena (New London, Conn.); 15(1950).

Vergette, Nicholas (Carbondale, Ill.); 21(1960).

Vermes, Madelaine (New York City); 18(1954), 19(1956); note 1.

Vincent, Margaret (Blue Hill, Maine); 10(1941: Rowantrees Kilns); ref: see entry for Laura S. Paddock.

Vogel, Edna (Grosse Pointe Woods, Mich.); 10(1941) through 12(1947).

Volckening, Paul C. (Oakland, Calif.); 18(1954), 19(1956).

Volkmar, Leon (1879-1959); 4(1935), 5(1936), 7(1938), 11(1946); see Volkmar Kilns*.

Volz, Mariana E. (Cincinnati, Ohio); 15(1950).

VonAllesch, Marianna (New York City); 13(1948), 18(1954).

Vontury, Francis Joseph (Perth Amboy, N.J.); 11(1946), 12(1947), 18(1954) through 20(1958); ref: Derwich & Latos, *Dictionary Guide*, pp. 236-37.

Voorhees, Aimee LePrince & Harry (New York City); 2(1933) through 4(1935), 7(1938) through 9(1940); Inwood Pottery (ref: U.G. Dietz, *The Newark Museum Collection of American Art Pottery* [Newark, 1984]. pp. 69-70).

Voorhees, Billie Rainey (Old Lyme, Conn.); 9(1940).

Vosburg, Carolyn (Pontiac, Mich.); 16(1951).

Voulkos, Peter (b. 1924; Oakland, Calif.); 15(1950) through 21(1960); notes 1, 2, 3, 7, 8.

Vozech, Anthony (Toledo, Ohio); 7(1938).

Waegell-Edmondson (Pasadena, Calif.); 18(1954).

Wago, George (Honolulu, Hawaii); 13(1948).

Wagner, Ruth Towle (Cleveland, Ohio); 14(1949), 15(1950), 17(1952).

Waite, Noel (Bloomfield Hills, Mich.); 18(1954).

Wakeland, A. Ray (Monteagle, Tenn.); 19(1956).

Walker, Challis (New York City); 9(1940).

Walker, Charlotte (Oakland, Calif.); 16(1951).

Walker, Roy (b. 1910; San Francisco, Calif.); 18(1954).

Walkley, Jane L. (Alfred, N.Y.); 9(1940).

Wall, Gertrude (d. 1971); 4(1935), 6(1937); see Walrich Pottery*, also note 3.

Wallace, Homer Skee (Forest Knolls, Calif.); 12(1947), 13(1948).

Wallace, John Ingram (Forest Knolls, Calif.); 13(1948), 15(1950).

Wallace, Lysbeth (Bloomfield Hills, Mich.); 15(1950).

Walrath, Frederick E. (1871-1921); see entry in text.

Walters, Carl (1883-1955); 4(1935) through 10(1941), 11(1946), 12(1947), 14(1949): note 2.

Walters, Ellen V. (Cleveland, Ohio); 15(1950).

Warashina, Patti (b. 1939); note 2.

Ward, Arnold (Demorest, Georgia); 13(1948) through 15(1950), 17(1952).

Ward, Claribel (Allison Park, Penn.); 10(1941).

Ward, Jacqueline Bartling (Gainsville, Fla); 19(1956) through 21(1960).

Ward, Louise C. (Red Bank, N.J.); 18(1954).

Ward, Phillip Arthur (Gainesville, Fla.); 14(1949), 21(1960).

Wareham, J.D. (Cincinnati, Ohio); 2(1933), 7(1938), 8(1939); Rookwood Pottery*.

Warren, Gilbert W. (Providence, R.I.); 14(1949), 16(1951), 17(1952).

Wollschlager, Fred (Missoula, Mont.); 21(1960).
Wolock, Lilian (Oak Park, Mich.); 18(1954).
Wong, Jade Snow (San Francisco, Calif.); 11(1946) through 15(1950).
Woo, Marie (Ann Arbor, Mich.); 19(1956), 20(1958); note 7.
Wood, Beatrice (b. 1894; Ojai, Calif.); 8(1939) through 11(1946), 15(1950), 16(1951); notes 2, 4, 7, 8.
Wood, Donald G. (Columbus, Ohio); 12(1947) through 16(1951).
Woodbury, Robert D. (Providence, R.I.); 14(1949).
Woodham, Jean (New York City); 13(1938), 17(1952).
Woodman, Elizabeth Abrahams (b. 1930); note 2; cf. Abrahams entry.
Woolley, Ellamarie (1913-1976); 12(1947) through 16(1951), 18(1954) through 19(1956); note 4.
Woolley, Jackson (San Diego, Calif.); 13(1948) through 15(1950); note 3.
Worrall, Helen (Chesterhill, Ohio); 19(1956).
Wozniak, James L. (Fort Worth, Texas); 19(1956) through 21(1960).
Wright, Ann T. (Minneapolis, Minn.); 11(1946), 12(1947).
Wuerslin, Mrs. Siegfried (Syracuse, N.Y.); 14(1949).
Wuest, Barbara (San Francisco, Calif.); 12(1947: Allied Potters).
Wulf, Peter Lipman (New York City); 12(1947).
Wyman, Carl E. (Cleveland, Ohio); 11(1946) through 13(1948), 15(1950), 20(1958).
Wyman, Claire Witt (Cleveland, Ohio); 10(1941) through 15(1958), 20(1958).
Wyman, William (b. 1922; Weymouth, Mass.); 17(1952) through 21(1960); notes 1, 2, 7.

Yanz, Wayne (Wyandotte, Mich.); 19(1956), 21(1960).
Yaryan, Robert G. (Oakland, Calif.); 17(1952).
Yates, Edward W. (Reno, Nev.); 17(1952).
Yokoi, George (San Francisco, Calif.); 21(1960).
Yokoi, Rita (b. 1938; Berkeley, Calif.).
Yoshida, Raymond (Chicago, Ill.); 18(1954).
Young, Alys Roysher (Cleveland, Ohio); 3(1934).
Young, Jane (Chicago, Ill.); 13(1948) through 15(1950).
Young, Sara (Clinton, Tenn.); 16(1951), 18(1956; Eagle Bend Pottery).
Young, Stanley (Dublin, N.H.); 13(1948).
Youngert, Wilma Jean (Rock Island, Ill.) 18(1954), 19(1956).
Youry, Ward (Long Beach, Calif.); notes 4, 6.
Yuill, Margaret (East Lansing, Mich.); 17(1952), 19(1956).

Zagorski, Edward J. (Madison, Wisc.); 18(1954).
Zamantakis, Mark S. (Denver, Colo.); 21(1960).
Zegler, Richard Eugene (Indianapolis, Ind.), 14(1949).
Zerlin, Robert (Freehold, N.J.); 18(1954) through 20(1958).
Ziegler, Laura Belle (Columbus, Ohio); 11(1946), 13(1948), 17(1952).
Zukoski, Roselyn (West Bend, Wisc.); 17(1952).
Zwick, Rosemary (Chicago, Ill.); 16(1951), 17(1952), 19(1956).

Reference notes:

note 1: *Who's Who in American Art 1966:* (New York: The American Federation of Arts), Dorothy B. Gilbert, ed.

note 2: Clark, Garth and Hughto, Margie, *A Century of Ceramics in the United States, 1878-1978: A Study of its Development* (New York, 1979), esp. pp. 269-343.

note 3: Bray, Hazel, *The Potter's Art in California, 1885-1955* (Oakland, 1980), esp. pp. 43-76.

note 4: *Craftsmen of the Southwest*, n.p., American Craftsmen's Council, 1965.

note 5: Peck, Herbert, *The Book of Rookwood Pottery* (New York, 1970) and Cummins, Virginia Raymond, *Rookwood Pottery Potpourri* (Silver Spring, Maryland, 1979).

note 6: *Arts of Southern California — VI: Ceramics* (California: Long Beach Museum of Art, 1960).

note 7: *Design Quarterly,* nos. 42-43 (1958), pp. 55-64. Appreciation is due Thomas G. Turnquist for calling this resource to my attention.

note 8: Strong, Susan R., *History of American Ceramics: An Annotated Bibliography* (Metuchen, New Jersey, 1983).

Index

(Note: individuals listed in the preceeding *Directory of Studio Potters* are not included in this index.)

INDEX

INDEX

Credits

Editorial Consultant:
John DeCamp.

Design:
Richard Waller (revised edition)
Bernard L. Schuchart (original
edition).

Production supervision:
T K Rose, Inc.

Marks:
Drawn by Sylvia McCann and
Karen Weitz.

Photography:
Peter Xiques, 9, 20, (top), 29, 30,
44, 48, 50, 57, 60, 87, 89, 108,
110, 117, 137 (top), 174, 190,
195 (left), 207 (bottom), 227,
232, 236, 240 (bottom), 241
(left), 245, 253, 254, 259, 265,
274, 275, 287, 288 (left), 295
(left), 304 (left), 318, 341;
plates 3, 4, 5, 6, 8, 11, 12, 13,
14, 15, 17, 18, 19, 20, 22.

ADCO Photo, 241 (right).
Armen Photographers, 38, 307
(right), 317 (right).
J. M. Dibert, 61 (bottom), 166,
223, 340.
H. Harold Fisher, 239, 240 (top).
Jed Hickson, 58.
Eric Long, plates 7, 21.
Robert Matthews, 121 (left).
Moss Photographic, 94, 95.
T K Rose, 202, plates 24, 25, 27 to 47.
Elroy Sanford, 70.
Taylor and Dull, Inc, 111 (left),
121 (right), 159 (right), 283,
307 (left), 308 (bottom), 311
(bottom left and right).
Bill Threatt, 383.
Vaudrevils Pictures, 13.
Sarah Wells, 371.
Ernest N. Wheeler, Sr., 140.
Warren Whited, 47, 83.
Bob Wickstrom, 185 (right), 206
(top), 266 (left).
Ole Woldbye, 258.
A. J. Wyatt, staff photographer,
Philadelphia Museum of
Art, 142 (right).

About the author

Born in Elizabeth, New Jersey, in 1937, Paul Evans attended Drew University, the University of Buffalo, and completed graduate study at New Haven, Connecticut. Research for *Art Pottery of the United States* has taken the author to all the pottery centers of the country. He has examined trade and popular journals of the period and studied major private and public collections. He served as editor of the *Western Collector*, published in San Francisco, and western division editor of *Spinning Wheel*; he is an honorary member of the American Ceramics Arts Society, and has been included in *Who's Who in American Art*. In addition to lecturing across the country and writing for leading publications, he has acted as consultant to museums and other institutions. Like Charles Binns, Paul Evans was ordained to the priesthood by the Episcopal Church. Since 1982 he has made his home in New York's North Country community of Saratoga Springs.